Early Chinese Texts on Painting

On the title page: "A Breath of Spring," dated to 1360, Yüan Dynasty. Plum blossom painting flourished at the end of the Southern Sung Dynasty, and during the Yüan Dynasty it served as a form of cultural protest against the Mongol regime. This is the only known work by the Taoist hermit Tsou Fu-lei, whose purity of character was thought to be reflected in his subject. Handscroll (detail), ink on paper, 34.1 x 223.4 cm. Courtesy of the Freer Gallery of Art, Smithsonian Institution, Washington, D.C.

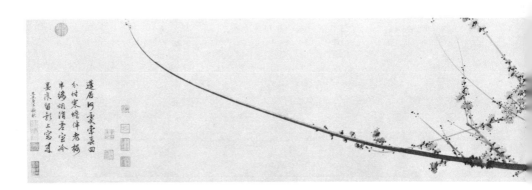

Published for the Harvard-Yenching Institute by
Harvard University Press
Cambridge, Massachusetts, and London, England 1985

Early Chinese Texts
on Painting

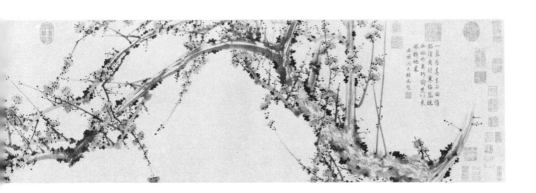

Compiled and Edited by
Susan Bush and Hsio-yen Shih

This book is printed on acid-free paper, and its binding
materials have been chosen for strength and durability.

Library of Congress Cataloging in Publication Data

Early Chinese texts on painting.

 Bibliography: p.
 Includes index.
 1. Painting—Technique. 2. Painting, Chinese—
Technique. I. Bush, Susan. II. Shih, Hsio-yen,
1933– .
ND1500.E25 1985 759.951 84-12859
ISBN 0-674-22025-0 (alk. paper)

To our teachers

Preface

THIS ANTHOLOGY is intended to help Western readers understand the cultural context in which the Chinese themselves have understood their painting. It offers an extensive coverage of the literature produced through the fourteenth century and includes new translations as well as revised versions of previously published material.

This volume is the outcome of a translation project initiated by James Cahill of the University of California at Berkeley under the sponsorship of the American Council of Learned Societies. In the early 1970s the editors were chosen and it was funded by a project grant from the National Endowment for the Humanities. We would like to express our gratitude to Professor Cahill, who has continued to offer advice and support at various stages.

Since the anthology is designed to be accessible to the nonspecialist, texts have been presented under topic headings and annotation has been kept to a minimum. For the reader's convenience, brief biographies of painters, critics, and calligraphers have been included in an appendix, which contains references both to Chinese biographical sources and to short English biographies of the men in question. For those who wish to follow certain translations in Chinese, references have been provided to a well-known compendium of Chinese texts on painting, Yü Chien-hua's *Chung-kuo hua-lun lei-pien*. The Chinese sources for less accessible texts as well as various bibliographic aids are listed in the annotated bibliography, which is intended as a guide for the more advanced student. Chinese versions of certain important texts can be found in William Acker's *Some T'ang and Pre-T'ang Texts on Chinese Painting*, Alexander Soper's *Kuo Jo-hsü's Experiences in Painting*, and Susan Bush's *The Chinese Literati on Painting*. The experienced sinologist will of course wish to compare texts and look into commentaries and punctuated versions in Chinese and Japanese.

The editors would like to thank the authors and publishers who have granted permission for the use of excerpts of published translations: E. J. Brill for material from *Some T'ang and Pre-T'ang Texts on Chinese Painting* (Vol. I); Professor James Cahill for his translation of the "Six Laws" of Hsieh Ho; Professor Herbert Franke for an excerpt from Wang I's *Hsieh-hsiang pi-chüeh;* the Harvard University Press for excerpts from *The Chinese Literati on Painting;* Professor Robert Maeda and Garland Publishers for excerpts from *Two Sung Texts on Chinese Painting and the Landscape Styles of the 11th and 12th Centuries;* Professor Kiyohiko Munakata and Artibus Asiae Publishers for material from *Ching Hao's Pi-fa chi: A Note on the Art of the Brush;* Professor Alexander Soper and the American Council of Learned Societies for material in *Kuo Jo-hsü's Experiences in Painting;* Professor Soper also for excerpts from Chu Ching-hsüan's *T'ang-ch'ao ming-hua lu* and Li Ch'ih's *Hua-p'in;* Professor Michael Sullivan and the University of California Press for the Fu Tsai excerpt in *Chinese Landscape Painting: The Sui and T'ang Dynasties;* Professor Ssu-yü Teng and E. J. Brill for an excerpt from *Family Instructions for the Yen Clan.* We would also like to thank Professor Tseng Yu-ho Ecke and Dr. Arthur Mu-sen Kao for material translated in their Ph.D. dissertations, available in University Microfilms International editions. These translations have been slightly modified in the interests of meaning, accuracy, and style.

In addition, the editors have made use of unpublished translations, most of which were commissioned in the early stages of the translation project. We are extremely grateful to these contributors: Professor Richard Barnhart, Professor John Hay, Dr. Sarah Handler, Professor Ellen Laing, Nancy Price, and Dr. Roderick Whitfield, who translated certain texts excerpted in chapters 3–5; Professor Chu-tsing Li and his students—Karen Brock, Dr. Arthur Mu-sen Kao, and William Lew—who compiled material for chapter 6. An unpublished translation of the *Li-tai ming-hua chi* biographies by Professor Hsio-yen Shih was a major source for the excerpts in chapters 1 and 2. Specific credit is given to each translator in the introductions to the chapters.

Contents

Illustrations follow p. 146

Abbreviations

Chinese Texts

CKHCJMTTT	*Chung-kuo hua-chia jen-ming ta-tz'u-tien,* comp. Sun Ta-kung, 1934.
CKHLLP	*Chung-kuo hua-lun lei-pien,* ed. Yü Chien-hua, 1957.
CKJMTTT	*Chung-kuo jen-ming ta-tz'u-tien,* comp. Fang I et al., 1921.
CKKSHL	*Chen-kuan kung-ssu hua-lu,* by P'ei Hsiao-yüan, ca. 639.
CKWHCTTT	*Chung-kuo wen-hsüeh-chia ta-tz'u-tien,* comp. T'an Cheng-pi, 1934.
ESSS	*Erh-shih-ssu shih* (Dynastic Histories, Chung-hua ed., 1957–).
HC	*Hua-chi,* by Teng Ch'un, ca. 1167.
HCPI	*Hua-chi pu-i,* by Chuang Su, ca. 1298.
HHHP	*Hsüan-ho hua-p'u* (Catalogue of Hui-tsung's Collection), ca. 1120.
HHP	*Hsü hua-p'in,* by Yao Tsui, ca. 552.
HLTK	*Hua-lun ts'ung-k'an,* ed. Yü An-lan, 1963.
HP	*Hua-p'in,* by Li Ch'ih, ca. 1098.
HS	*Hua-shih,* by Mi Fu, ca. 1103.
HSTS	*Hua-shih ts'ung-shu,* comp. Yü An-lan, 1962.
ICMHL	*I-chou ming-hua lu,* by Huang Hsiu-fu, ca. 1006.
KCHP	*Kuang-ch'uan hua-pa,* by Tung Yu, ca. 1120.
KHPL	*Ku hua-p'in lu,* by Hsieh Ho, ca. 535.
LCKCC	*Lin-ch'üan kao-chih (chi),* by Kuo Hsi, ed. Kuo Ssu, ca. 1110–1117.
LTMHC	*Li-tai ming-hua chi,* by Chang Yen-yüan, ca. 847.
MCPT	*Meng-ch'i pi-t'an,* by Shen Kua, ca. 1086–1093.
MSTS	*Mei-shu ts'ung-shu,* comp. Huang Pin-hung and Teng Shih, 1911–1936.
PFC	*Pi-fa chi,* by Ching Hao, ca. 925.
PWCSHP	*P'ei-wen-chai shu-hua p'u,* comp. Sun Yüeh-pan et al., ca. 1708.
SCMHP	*Sheng-ch'ao ming-hua p'ing,* by Liu Tao-shun, ca. 1050.

SHSLCT	*Shu-hua shu-lu chieh-t'i*, comp. Yü Shao-sung, 1932.
SKCS	*Ssu-k'u ch'üan-shu*, comp. 1773–1785 (in manuscript copy).
SKTSHHK	*Shih-ku-t'ang shu-hua hui-k'ao*, comp. Pien Yung-yü, ca. 1682.
SSCCC	*Shan-shui Ch'un-ch'üan chi*, by Han Cho, ca. 1121.
SSHY	*Shih-shuo hsin-yü*, by Liu I-ch'ing, ca. 430.
TCHCJMTT	*T'ang chien hua-chia jen-ming tz'u-tien*, comp. Chu Chu-yü, 1961.
TCMHL	*T'ang-ch'ao ming-hua lu*, by Chu Ching-hsüan, ca. 840.
THCWC	*T'u-hua chien-wen chih*, by Kuo Jo-hsü, ca. 1080.
THPC	*T'u-hui pao-chien*, by Hsia Wen-yen, ca. 1365.
TSHCJMTT	*T'ang Sung hua-chia jen-ming tz'u-tien*, comp. Chu Chu-yü et al., 1958.
TTCLC	*Tung-t'ien ch'ing-lu chi*, by Chao Hsi-ku, ca. 1240.
WSSHY	*Wang-shih shu-hua yüan*, comp. Wang Shih-chen et al., ca. 1590.
WTMHPI	*Wu-tai ming-hua pu-i*, by Liu Tao-shun, ca. 1059.

Western Dictionaries, Periodicals, and Institutions

ACASA	*Archives of the Chinese Art Society of America.*
ACLS	American Council of Learned Societies.
BD	*A Chinese Biographical Dictionary*, ed. H. A. Giles.
BMFEA	*Bulletin of the Museum of Far Eastern Antiquities.*
DMB	*Dictionary of Ming Biography*, ed. L. C. Goodrich.
IsMEO	Istituto italiano per il medio ed estremo oriente.
JAOS	*Journal of the American Oriental Society.*
OA	*Oriental Art.*
RAA	*Revue des Arts Asiatiques.*

Shortened References in the Text and Biographies

Acker	William Acker, *Some T'ang and Pre-T'ang Texts on Chinese Painting.*
Bush	Susan Bush, *The Chinese Literati on Painting.*
Cahill, *Hills*	James Cahill, *Hills Beyond a River.*
Cahill Index	*An Index of Early Chinese Painters and Paintings*, ed. James Cahill.
Li, *Autumn Colors*	Chu-tsing Li, *Autumn Colors on the Ch'iao and Hua Mountains.*
Loehr, *Great Painters*	Max Loehr, *The Great Painters of China.*
Sirén	Osvald Sirén, *Chinese Painting.*
Sung Biog.	*Sung Biographies* (2 vols.), ed Herbert Franke.
Sung Index	*Index to Biographical Materials of Sung Figures*, comp. Ch'ang Pi-te.
Yüan Index	*Index to Biographical Materials of Yüan Figures*, comp. Wang Te-i.
Yüan Masters	Chang Kuang-pin, *Yüan ssu-ta-chia* (The Four Great Masters of the Yüan).

Early Chinese Texts on Painting

Introduction

THE VOLUME of Chinese literature on painting is quite substantial, and the continuity of its development allowed for considerable contributions to art history and to the history of ideas in general. Although the earliest printed editions of painting texts that we know of dated from the sixteenth century, quotations in other forms of literature with earlier imprints give evidence that transmission of such works was steady. The Chinese emphasis on literary learning and China's early invention of printing meant that texts on painting were often a source of knowledge for those concerned with this art, even though the early paintings themselves no longer existed or were inaccessible. For example, ideas current in the third century B.C. were available to scholars of the fourteenth century A.D. Indeed, in China, writings about art became an impetus to further creative activity. Because the literature on painting, and indeed on all the arts, was so early established and expanded upon, the philosophy of art in China soon achieved a high degree of complexity and sophistication. The selections made for this compilation are intended to help the reader form a general view of this philosophy and of the development of the written history of Chinese art.

Over thirty texts are included in the anthology, some translated in their entirety and others only in part. They begin with the first discussion of pictorial images recorded during the foundation of imperial China in the Han Dynasty. The latest works included come from the period of Mongol occupation in the fourteenth-century Yüan Dynasty. The texts translated in this volume, then, span the development of painting in China to its full maturity.

The sequence of chapters is chronological, but within chapters selections from texts are grouped under different subject headings. This

ordering will facilitate the reader's focus on subject matter of special interest. It also will identify a variety of themes that emerge in the theoretical concerns of successive generations of thinkers and writers.

There are, of course, innumerable difficulties involved in understanding an ancient language, especially when the meanings of terms have evolved over a thousand years of use. Furthermore, since texts on painting not only record or report events and phenomena but also analyze, assess, and classify, understanding these writings is not merely a question of language. Chinese systems of thought and interpretations of perception, founded upon cultural bases quite dissimilar to those assumed in the West, must also be taken into consideration.

Various approaches to Chinese art theory are offered by different disciplines. Modern sinological training provides the methodology for linguistic principles—rules of syntax, morphology, lexical usage in different periods, and so forth. The study of Chinese poetics (closely related to theories of pictorial art in Chinese aesthetics) has made compatible materials available. And art historians draw upon the evidence of existing works in calligraphy and painting for further insights, relying as well upon the premises of general art historical theories.

In studying these translations, the reader will immediately notice that the concept of "beauty" does not figure in Chinese aesthetic concerns. Instead, what underlies all discussions about painters and painting is a vocabulary reflecting a Chinese system of natural philosophy. Such a complex of basic assumptions or agreements about phenomena, their organization and significance both in the cosmic order and in the human consciousness, was systematized by philosophers of the *yin-yang wu-hsing* or Five Phases School and is known to us mainly as transmitted through Confucian or Taoist writings. Two quotations from works associated with these theories of natural processes will introduce much of the terminology used in the painting texts and present some of the problems with which they dealt.

The first comes from the "Great Appendix" of the *I ching* (Book of Changes), a prognostic text of Confucian affiliation, and revolves about the character *hsiang* variously translated in the context of painting as "image," "representation," or "form."

> The sages set forth the diagrams and observed their *hsiang*.
> They appended words, thus clarifying good and evil omens.
> The firm and yielding act upon each other, thus giving
> birth to change [as, for example, in the broken (*yin*) and

unbroken (*yang*) lines of trigrams or hexagrams] . . . Change is the *hsiang* of progress and recession; the firm and the yielding are the *hsiang* of day and night . . . The sages, because they perceived the profundities of all beneath the heavens, could determine within them their formal appearances (*hsing-jung*) and could *hsiang* their physical properties (*wu-i*). That is why we call them *hsiang* . . . A closed door may be called the passive principle. An open door may be called the active principle. Opening, then closing it, may be called change. Going back and forth through it without cessation may be called penetration. Its visibility may be called *hsiang*. Its physical form may be called a tool (*ch'i*). Regulating, then using it, may be called a technique (*fa*). That which expedites its use as entry and exit, and which is used by all people, may be called the divine (*shen*).

In this text *hsiang* as a noun must have signified visible manifestations of phenomena which could be either abstract or material. As a verb, it indicates the action of making visible and material such phenomena. It is symbolic rather than descriptive in intent.

The second quotation comes from the first book, "Yüan-tao hsün," of *Huai-nan-tzu* (Book of the Prince of Huai-nan) and deals with the nature of man rather than that of general phenomena.

Man is tranquil when born, and this is his divine nature (*t'ien-hsing*). As he is activated by sensation, his nature is injured. As he perceives matter (*wu*) and responds to it with the spirit (*shen*), knowledge is activated. When knowledge and matter meet in conjunction, the passions are awakened. When passions assume form (*hsing*), man recognizes external stimuli. He will not be able to deny this in himself. Thus, divine principles (*t'ien-li*) perish. Those who arrive at the Tao do not permit themselves to deviate from the Divine. Though externally they transform as do natural phenomena (*wu*), internally they maintain clarity of mind (*ch'ing*) . . . What is it by means of which a man can see clearly, hear distinctly, control his body, discriminate between similarities and differences, and understand what is and what is not? It is through a sufficiency of pneuma [or vital energy] (*ch'i*) as communicated by the [human] spirit (*shen*). How do we know that this is so? When a person has will (*chih*) or volition, it is always fixed somewhere and the spirit is tied to it . . . [When he is absent-minded,] it is be-

cause his spirit lost its grip on the pneuma . . . Why is it
that a madman's vital parts (*sheng-chü*) are exactly like any
man's, yet he is mocked? It is because his material form
(*hsing*) and spirit (*shen*) have become separated from each
other. Thus, if a man's spirit is foremost, his material form
will follow it to his benefit. If his material form governs
and his spirit follows, he will suffer.

Between the fourth and second centuries B.C., natural processes
were perceived first through the interaction of dichotomies and then
in a chain of causes and effects. From the dualities of energy and
matter, sky and earth, benevolent deities and malevolent demons,
motor and sensory activities, voluntary and vegetative processes (*ching-
shen-jou-t'i*), a more organic stimulus and response theory of knowl-
edge was formulated. In the *Huai-nan-tzu* passage, Liu An (d. 122
B.C.) was concerned with how sensation led to perception and then
knowledge. A remnant of earlier dualistic juxtapositions may be de-
tected in his emphasis upon the dangers of separating pneuma from
spirit, or material form from spirit. Volition itself is possible only
through unification of the material and nonmaterial. One cannot know
if a partial response to early Buddhist influences may be implicit in
the Han Dynasty prince's arguments, but contemporary Confucian
and Taoist sources share the same concerns.

The *Shih-chi* (Historical Record) may be considered representative
of orthodox thought in the Former Han Dynasty. Its "T'ien-kuan
shu" or chapter on astrology (chapter 27) equates pneuma with *yin*
and *yang*, but does not measure the spirit by these. *Yin* and *yang*
produce transformation (*hua*) or the creative process, but the activity
of the spirit manifests itself in the totality of phenomena and their
transformation. Pneuma resides on earth and belongs to the phe-
nomenal world. It is unified and organized by the sages. Unification
is the Tao, organization is *li*. The Taoist work *Lieh-tzu*, supposedly a
record of the fourth-century B.C. philosopher Lieh Yü-k'ou's dis-
courses, expresses similar concepts.

These discussions were given new life and greatly changed in the
twelfth century by philosophers such as Chu Hsi, today called Neo-
Confucianists. More precise definitions of terminology were offered,
and systematizations of processes attempted. *Ch'i*, perhaps no longer
translatable as pneuma, is considered matter but not necessarily with
form. Solid, hard, and tangible condensation of *ch'i* is termed sub-
stance (*chih*). In its dispersed state, *ch'i* may be nonperceptible. It can,
thus, be consciousness (*chih-chüeh*), an activity of the spirit within the

mind (*hsin chih ling*). *Li* is primordial but unconscious. Together with *ch'i*, *li*, as the cosmic principle of order and organization or a dynamic pattern of creative process, produces consciousness. All things embrace both *ch'i* and *li*, but in addition there is a hierarchy of other elements for various things. Inorganic matter also has form (*hsing*), substance (*chih*), odor, and taste. Plants have further life-force (*sheng-ch'i*). Animals and man are distinguished by matter-energy correlation (*hsüeh-ch'i*), which is allied to the blood's circulatory system, and by consciousness or perception and sensation. *Li* implies that every thing has its own internal necessities; that is, its own nature. The operation of *li* is seen in fate or destiny (*ming*). Its inevitability is the Tao of Heaven or Nature's pattern (*tzu-jan fa*). While natural phenomena are formed without volition (*wu wei erh ch'eng*), or without consciousness, phenomena come into being and achieve substance according to the nature (*hsing*) of each thing. *Li* is, therefore, a hierarchy of wholes forming the cosmic pattern.

Why is such a summary of these aspects of Chinese philosophical thought considered necessary to an understanding of texts on painting? The answer may be found in another writer's caution about dealing with an aspect of Chinese writings. In this paraphrase, the words in square brackets have been substituted for those used in a different context.

> The [aesthetic] terms that will be examined all occur in philosophical treatises, and most of them have uses in everyday language. Because their meanings are conditioned by these [nonaesthetic] senses, it is well to bear in mind the distinction between the practical and theoretical meanings of terms. Philosophers and theorists usually give their fundamental concepts a logically precise and yet at the same time flexible and inclusive meaning; practical [art historians] appreciate terms with sharp and clear logical contours, yet prefer them narrowly and inflexibly defined.[1]

1. Paraphrased from Manfred Porkert, *The Theoretical Foundations of Chinese Medicine: Systems of Correspondence*, MIT East Asian Science Series, III (Cambridge, Mass.: MIT Press, 1974), pp. 166–167. Porkert is, of course, referring to "energetic terms," "non-medical senses," and "practical scientists." His discussion of such terminology forces even the art historian to rethink previous assumptions. The reader should consult as well the multiple volumes of Joseph Needham et al., *Science and Civilization in China* (Cambridge: Cambridge University Press, 1961–), and his "Human Laws and Laws of Nature in China and the West," *Journal of the History of Ideas*, 12 (1951), 3–30, 194–230. Also stimulating are the translation and notes of A. C. Graham for *The Book of Lieh Tzu* (London: Murray, 1960).

Chinese philosophy of art or aesthetics appeared for music and for literature much earlier than it did for painting. Poetics especially, and music in relation to poetry, share very similar critical bases and theoretical vocabulary.[2] Though it is impossible to provide even a synopsis of parallel developments in literary theories and critical opinions, it might be well to indicate some of their foundations.

The "Shang shu" section of the *Shu ching* (Book of Documents) includes the following passage: "Poetry is the expression of sentiments, and songs are those expressions set to music. Tones are prolonged according to rules of prosody and intervals chosen according to rules of harmony."[3] Ideas of content and form seem to be suggested in this early Confucian classic.

The "Great Preface" of the *Shih ching* (Book of Songs), whose authorship is attributed to Wei Hung in A.D. 25, expands upon Confucian moral didacticism. "The music of the epoch of good government is quiescent and [therefore] joyful, for the governing is harmonious. The music of the period of confusion is discontented and [therefore] wrathful, for the governing is deteriorated. The music of the country running to ruin is complaining and meditating, for the people [reached] misery."[4] This passage is followed by the naming of "six principles" (*liu-fa*) of poetry which had been listed without definition in the *Chou Li* (Rites of Chou). Three of these may be classifications of poetic genre—*feng* being the song, *ya* being the ode, and *sung* being the hymn. Three others seem to be "methodic concepts"—*fu* as description, *pi* as comparison, and *hsing* as allegory. As the exegesis defines the three former terms:

> Principals alter their subjects by the aid of the *feng*, and subjects criticize their principals by the aid of the *feng* . . . [which] should be fine (*wen*) . . . When the things of a principality are [linked to an individual,] . . . we speak of the *feng*. When the things "under heaven" are put into words and the customs of the four heavenly quarters are illustrated by the poem, then it is called the *ya*. The meaning

2. See Kenneth J. DeWoskin, *A Song for One or Two: Music and the Concept of Art in Early China* (Ann Arbor: University of Michigan Press, 1982).

3. Vincent Yu-cheng Shih, *The Literary Mind and the Carving of Dragons by Liu Hsieh* (New York: Columbia University Press, 1959), p. xi. The entire introduction to this annotated translation is useful as "a brief survey of the development of literary criticism in ancient China."

4. Ferenc Tökei, *Genre Theory in China in the 3rd–6th Centuries*, Biblioteca orientalis Hungarica, XV (Budapest: Akadémiai Kiadó, 1971), p. 32. This study is of particular interest, representing as it does both a Marxist and a structuralist approach.

of [the word] *ya* is regular (*cheng*). It puts into words the reasons why the "royal government" is deteriorated, and the reasons of its prosperity . . . The *sung* is [the poem] which sounds the praises of the [incarnations of] perfect virtue . . . and "advises" the spirits of their worthy deeds.[5]

Liu Hsieh (465–523), in the *Wen-hsin tiao-lung* (The Literary Mind and the Carving of Dragons), further explains the last three terms as elements of poetry—*fu* interpreted as narrative, *pi* as metaphor, and *hsing* as allegory.[6]

Fu means to arrange; it signifies arrangement of the patterns that give form to literature and expresses the feelings that conform to objective things.

Pi involves reasoning by analogy, and *hsing* response to a stimulus. When we reason by analogy, we group things by comparing their general characteristics; and when we respond to stimuli, we formulate our ideas according to the subtle influences we receive. The *hsing* is the result of our responding to a stimulus, and the *pi* a consequence of reasoning by analogy. Formally, the *pi* was a linguistic expression charged with accumulated indignation, and the *hsing* was an admonition expressed through an array of parables.[7]

Liu knew that *feng* referred, as did *ya*, to particular poetic forms, as when he mourned: "After the *feng* and *ya* were no longer written, nothing worthy emerged to continue the development."[8] But he also presented another interpretation for *feng*.

The Book of Poetry [Songs] contains six elements, and of these *feng*, or wind, stands at the head of the list. It is the source of transformation, and the correlate of emotion. He who would express mournful emotions must begin with the wind, and to organize his linguistic elements he must above all emphasize the bone (*ku*). Literary expressions are conditioned by the bone in much the same way as the standing posture of a body is conditioned by its skeleton; feeling

5. *Ibid.*, p. 33. See also J. R. Hightower, "The Wen Hsüan and Genre Theory," *Harvard Journal of Asiatic Studies*, 20 (1957), 519 n. 27.

6. Shih, *Literary Mind*, pp. 26 n.2, 45 n.2.

7. *Ibid.*, p. 195.

8. *Ibid.*, p. 25.

gives form to the wind very much as a physical form [*hsing*] envelopes the vitality [*ch'i*] which animates it. When expressions are organized on the right principles, literary bone is there; and when the emotion and vitality embodied are swift and free, there we find the purity of the literary wind. If a literary piece has nothing but rich and brilliant colors, without wind and bone to keep it air-borne, then one shaking is enough to destroy its splendor, lacking as it does the vigor which can justify fame. Therefore, a condition for organizing one's thought and planning one's composition is to develop to the full one's vitality; for when one is strong and whole, he will shine with fresh brilliance.[9]

The preceding passage not only echoes the cause and effect, stimulus and response, organic unities of Han Dynasty philosophers cited earlier, but also their application to the creative process in art which we shall see in nearly contemporary texts on painting.[10]

This transference of analysis from an objective classification of a particular art's forms and techniques to that of the creative process itself in subjective experience was not new to the fifth century. Almost two centuries earlier it had been expressed in poetic form. Lu Chi (261–303), in his *Wen fu* (Essay on Literature, in the form of a narrative poem), was clearly much influenced by Taoist concepts of metaphysics and even mysticism.

> A composition comes into being as the incarnation of many
> living gestures.
> It is (like the act of Tao) the embodiment of endless change.
> To attain Meaning, it depends on a grasp of the subtle,
> While such words are employed as best serve beauty's sake . . .
> Such moments when Mind and Matter hold perfect
> communion,

9. *Ibid.*, p. 162.

10. See also Donald A. Gibbs, "Notes on the Wind: The Term 'Feng' in Chinese Literary Criticism," *Transition and Permanence: Chinese History and Culture,* ed. David Buxbaum and F. Mote (Hong Kong: Cathay, 1972), pp. 285–293. He notes that *feng* may signify a distinctive, nameable attribute or quality. Applied to prevailing practices, it signifies customs, but it may also denote an invisible, life-giving energy. As such an intangible power, it is an influence or suasive force. Thus, "emotion that is swelled with *feng* is like a body filled with the breath of life [*ch'i*]." For a useful discussion of *ch'i* in this connection, see David E. Pollard, "*Ch'i* in Chinese Literary Theory," in Adele Austin Rickett, ed., *Chinese Approaches to Literature from Confucius to Liang Ch'i-ch'ao* (Princeton: Princeton University Press, 1978), pp. 43–66.

And wide vistas open to regions hitherto entirely barred,
Will come with irresistible force,
And go, their departure none can hinder.
Hiding, they vanish like a flash of light;
Manifest, they are like sounds arising in mid-air.
So acute is the mind in such instants of divine comprehension,
What chaos is there that it cannot marshal in miraculous
 order? . . .
For it is Being, created by tasking the Great Void.
And 'tis sound rung out of Profound Silence.[11]

Here, in the literature of poetry, we find a bridge to the philosophy of painting introduced in the first chapter of the translated texts.

Art historians studying Chinese writings on painting have had to struggle with correlating what appears to be contradictory evidence. For philosophers, the history of ideas need not be matched with specific events and institutions to hold validity. For literature scholars, the language of theory and that of the objects of theorizing are similar in nature, if not virtually the same. But, for those concerned with visual arts, the material reality of actual works of art must precede all other information acquired as knowledge. Our view of Chinese painting is necessarily conditioned by the works that have survived. In the last quarter of a century, archaeological finds have greatly expanded and somewhat altered the physical evidence with which we deal. Texts on painting have, therefore, to be related to what is in itself a gradually changing picture of visual reality.

Moreover, since figure painting preceded landscape painting in development both in China and the West, some interpretations of Chinese painting have derived, consciously or unconsciously, from general art historical theories based on Western models. And, in studies of Chinese art theory, there has been a related assumption that there must have been a major shift from representational to expressive concerns. However, the early texts would seem to present rather more complex and subtle approaches toward the art of painting.

But was theory indeed limited by practice in this art form? Even if the visual evidence for Chinese painting from the fourth through ninth centuries indicates increasing command of devices for conveying optical perceptions—for example, plasticity of forms, placement in space, light, and air, and so on—would texts of the period neces-

11. Chen Shih-hsiang, tr., *Essay on Literature* (Portland, Me.: Anthoesen, 1953), pp. xxiv, xxix, xxii.

sarily be confined to the discussion of representation or illustration? We have already seen that the material and immaterial, sensation and perception, the body and the mind, were distinguished by the early natural philosophers of China. That the art of painting required unification of dualities, as do the cosmic creative processes, was already acknowledged by the earliest painter to write on his art (see Ku K'ai-chih in chapter 1, "Criteria for Appreciation and Criticism"). The problems of matter leading to sensual response and then arousing emotion were considered by Tsung Ping (chapter 1 at "The Significance of Landscape"), and the art of painting was defended despite its bondage to form, subject matter, and at least one of the senses. His argument may be summarized as follows. Spirit (*shen*) is formless but resides in form, and its organizing principle (*li*) participates in all matter and substance, and their reflections. Therefore, the best visual description will stimulate the eye and mind to a response which activates the spirit to transcend such stimuli and to attain the Tao. Wang Wei, also discussing landscape painting in the fifth century, similarly presented form (*hsing*) and soul (*ling*) as combined in painting to affect the mind as well as the senses. It would seem that for Ku K'ai-chih as a figure painter, "to describe spirit through form" implied a conveyed sense of vitality, and in portrait painting specifically referred to capturing the personality of the subject. For Tsung Ping and Wang Wei, landscape painting evoked grander sympathetic responses to cosmic order, responses in which sensory stimulation brought forth thought and emotion that rose to mystical heights.

Since the acceptance of painting as an art beyond formal representation was expressed so early, the evolution of Chinese painting theory became inextricably involved with the nonformal and even nontechnical aspects of this art. Nowhere is this more clearly revealed than in the continuous discussions of Hsieh Ho's Six Laws (see chapter 1 at "Criteria for Appreciation and Criticism").

The Six Laws (*liu-fa*)—also translatable as canons, principles, or elements—cannot simply be seen as a formulation of the principles and methods of sixth-century painting. Their central importance in Chinese painting theory is the result of many later interpretations, and we have noted their possible antecedents in the literature on poetry.

It has been said that the Six Laws are as irreducible to a "definitive interpretation" as are the most obscure of the Taoist classics.[12] Nevertheless, some form of common agreement seems to have been reached

about all but the first two laws. The second pair, that is, the third and fourth laws, are taken to refer respectively to the depiction of forms and the application of colors. The fifth law evidently described the spacing and positioning of objects in the composition, while the sixth is usually thought to indicate the practice of copying as a means of preserving past styles and imparting artistic technique.

The first two laws have provoked innumerable commentaries in China and Japan throughout the ages. A survey of the most important studies in English on this subject may give some indication of the difficulties that they raise. See, for example, Michael Sullivan's comparative table of five well-known English translations in *The Birth of Landscape Painting in China*.[13]

In 1949 Alexander Soper gave his interpretation in "The First Two Laws of Hsieh Ho," where he discussed the translation in the context of earlier and contemporary usage of similar phrases. The second law, rendered as "structural method in the use of the brush," is seen as indicating appreciation of "boniness," an aesthetic derived from calligraphy. The first law, in which "spirit consonance" effects "animation," is interpreted in terms of the "mystical correspondences" presented in the *I ching* (Book of Changes). "Sympathetic responsiveness of the vital spirit" is, however, not thought to be associated with the painter, nor with figural images, but with the universal "spirit" of living beings in a painting that should respond to its like in nature.[14]

William Acker's translation of 1954 in *Some T'ang and Pre-T'ang Texts on Chinese Painting* is that given in chapter 1 of this anthology. He reinterpreted the grammar of Hsieh Ho's six-word phrases and briefly compared the Six Laws to the *sadánga* or "six limbs" of traditional Indian painting. His reading is based on the belief that Hsieh was quoting two-character terms from an earlier source and then defining them with more accessible contemporary terms. The first law is taken to describe the vital energy of the painter lingering in a vibrant state to produce the effect of life in a painting. The analysis of the second law mentions the use of "bone method" in physiognomy, where a knowledge of inner character was derived from outer bone structure, and ultimately understands the term to describe structural forces in brushwork, as in calligraphy.[15]

Acker's grammatical reconstructions were questioned in 1961 by

13. Michael Sullivan, *The Birth of Landscape Painting in China* (Berkeley: University of California Press, 1962), pp. 106–107.

14. Alexander Soper, "The First Two Laws of Hsieh Ho," *The Far Eastern Quarterly*, 8 (1949), 412–423.

15. William R. B. Acker, *Some T'ang and Pre-T'ang Texts on Chinese Painting*, 2 vols. (Leiden: E. J. Brill, 1954 & 1974), I, xxi–xlv.

James Cahill in "The Six Laws and How to Read Them." He argued that the Six Laws must be indivisible four-word phrases, as in the traditional reading of the text from T'ang times on, and further proposed that grammatical parallelism was present in each pair of the set. Thus, of the first two laws, the first was translated as "engender [a sense of] movement [through] spirit consonance"; and the second, as "use the brush [with] the 'bone method.' " Cahill also reinterpreted the third and fourth laws as indicating a conceptual "abstraction into images" in the mind which complements the objective "portrayal of outward appearances" on the basis of observation.[16] His translation of the Six Laws appears in chapter 2 at "Definition, Animation, and Expression."

In 1966 Wen Fong gave another reading of the first law in "*Ch'i-yün-sheng-tung:* 'Vitality, Harmonious Manner and Aliveness,' " where he traced these terms in contemporary as well as later usage. *Ch'i,* "the vital creative force," and *yün,* its harmonious expression, are both viewed as attributes of style, as in literary theory. *Yün* in painting is "grace" or "harmony" in the manner of representation, comparable to Ching Hao's use of the term in the *Pi-fa chi* (A Note on the Art of the Brush) or in later definitions. Various Chinese interpretations of the first law from the T'ang period on are listed for convenient reference including, for example, the Ch'ing Dynasty controversy as to whether *ch'i-yün* could signify the atmosphere in landscape paintings.[17]

The summaries of these writings merely touch on the substance of the discussion. Some of these issues, such as the possible Indian origin of the Six Laws, are still a matter for scholarly debate. Acker's controversial punctuation, though disputed by many, seems to have been independently arrived at in both China and Japan.[18] Among the ma-

16. Cahill, "Six Laws," pp. 372–381.

17. Wen Fong, "*Ch'i-yün-sheng-tung:* 'Vitality, Harmonious Manner and Aliveness,' " *Oriental Art,* n.s., 12 (1966), 159–164. For the Ching Hao text, see below in the "Introduction" and chapter 4 at "Technical Secrets."

18. See Ch'ien Chung-shu, *Kuan-chui pien,* 4 vols. (Peking: Chung-hua, 1979), IV, 1353; Nakamura Shigeo, *Chūgoku garon no tenkai* (Kyoto: Nakayama bunkadō, 1965), p. 140. For speculations on the Six Laws in a Buddhist context, see Erik Zürcher, "Recent Studies on Chinese Painting," *T'oung Pao,* 51 (1964), 389–392; also Susan Bush, "Tsung Ping's Essay on Landscape Painting and the 'Landscape Buddhism' of Mount Lu," *Theories of the Arts in China,* ed. Susan Bush and Christian Murck (Princeton: Princeton University Press, 1983), pp. 143–144. A recent translation reinterprets the first two laws in the light of Chinese physiological concepts: "In the resonating of the (primal Yang) energy, life is set in motion. In the patterning of structure, the instrument is the brush." See John Hay, "The Human Body as a Microcosmic Source of Macrocosmic Values in Calligraphy," *ibid.,* p. 95.

jority who read the laws as fundamentally indivisible four-word phrases, there are yet other interpretations of the grammar. Thus, one purist approach is to assume that the original syntax had been corrupted in textual transmissions and to take the structure of all the laws to be parallel, with the third character in each phrase having a verbal meaning.[19] Opinion is also divided on what part of each law should be stressed and whether certain phrases are emphasized or simply introduced. Unfortunately, the most commonly cited first law has the least easily determined syntax. Its second part, *sheng tung,* is variously interpreted as a binomial term functioning as a noun or adjective, or read as two characters functioning as adjectives, as an adverb and a verb, or as a verb and its object. Hence the first law has also been translated as: "spirit resonance or vitality," "make the spirit lively and the rhythm vigorous," and "the sign of *ch'i* [in objects] moves lively."[20]

Chinese art theory is part of a continuing tradition constantly being defined and redefined by artists and critics. To better understand the comprehensive associations that underlie many modern considerations of the first law, one may turn to the lengthy explanation offered by the Japanese court painter Tosa Mitsuoki (1617–1691). In his discourse on "the spirit's circulation—life's motion," *yün* (resonance) has been replaced by the homonym *yün* (movement or revolution) as is common in later Chinese art criticism:

> "The spirit's circulation" means that the painter, as he sets out to work, lets the spirit of his soul circulate through his body. When his soul is small and his spirit insufficient, his brushwork will be stunted, feeble, and always unsatisfactory . . . He should let the spirit expand through his body, with his soul filling up heaven and earth . . . "Life's motion" means that a painting, whether of a god or a devil or a man, whether of a beast or a bird or a tree, contains the spirit of the object and thereby makes the spectator feel as if the object were standing before his eyes . . . No ordinary artist can transmit such spirit into his work . . . The ultimate

19. See Wai-kam Ho, "Li Ch'eng and Some Guiding Principles in Northern Sung Landscape Painting," paper delivered at the Cleveland Symposium on Chinese Painting, March 1981.

20. Max Loehr, "Chinese Landscape Painting and Its Real Content," *Rice University Studies,* 59 (1973), 68; manuscript translation by Dr. Achilles Fang, as transmitted in a bibliographical study of the Hsieh Ho text by Dr. Ronald Egan; Nagahiro Toshio et al., *Kandai gazō no kenkyū* (The Representational Art of the Han Dynasty) (Tokyo: Chūōkōron bijutsu shuppan, 1965), English Summary, p. 8.

aim of painting is to represent the spirit of the object. In
every work of painting, whether it is of human life, a bird,
a beast, an insect, or a fish, the spirit of a living object can
be represented only by putting eyes into the painting.[21]

Here, a variation of the first law is linked to the painter in the act of
creation, to the objects in his painting, and to their effect upon the
viewer. It seems unlikely that all these associations were attached to
the first law either in Hsieh Ho's time or in his presumed earlier
sources. However, aspects of these concerns did evolve in time to form
a body of traditionally held opinions. The history of Chinese painting
theory must rest on what grew out of the articulation of the Six Laws.
As historians, though, we should try to discern how the transmutations
of theory occurred, and we can comprehend their ramifications only
by tracing the development of critical vocabulary.

Recent Japanese scholarship has tried to restrict universal inter-
pretations of the first law and to stress its initial application for paint-
ings of living beings alone.[22] If we hold that Six Dynasties writers on
painting were familiar with works in which human or divine beings
carried the significant content and, therefore, focused on individual
entities or objects in paintings rather than on whole compositions,
then the first law could mean that through "life-movement," or an
effect of vitality, painted images attain "spirit resonance." Accord-
ingly, the second law might suggest that brushwork is the tool that
creates the structural strength inherent in figural forms, as it were
their "boniness" (*ku*). In Ku K'ai-chih's writings, such terms as "spirit
vitality" (*shen-ch'i*) and "breath of life" or "vital energy" (*sheng-ch'i*), or
phrases like "to transmit the spirit" (*ch'uan shen*) and "to describe the
spirit through form" (*i hsing hsieh shen*), all occur in connection with
figure painting, in which posture, gesture, and gaze are the most
important aspects and the dotting in of eye pupils completes the total
effect (see chapter 1 at "Definition, Animation, and Expression" and
"Technique").

By the ninth century, Chang Yen-yüan's discussion of Hsieh Ho's
Six Laws still respected the concept of "spirit resonance," harmony
of the spirit or vital harmony (*ch'i-yün*), as applicable only to animate
beings, for inanimate objects have no vital movement (*sheng-tung*). In

21. Makota Ueda, *Literary and Art Theories in Japan* (Cleveland: Western Reserve
University, 1967), pp. 136–137.

22. See Nakamura, *Chūgoku garon no tenkai*, pp. 163–202, especially pp. 165–180;
Kohara Hironobu, *Garon* (Tokyo: Meitoku shuppansha, 1973), pp. 55–61.

painting, as an image of external reality, "spirit resonance" is to "formal likeness," or simulation of forms (*hsing-ssu*), as brush strength is to coloring; that is, an inner structure revealing the character or nature of that depicted. *Ch'i-yün* or *shen-yün* are terms used to express the energies in the "vital movement" of demons and divinities, as well as of human beings. The ability to convey these energies must inevitably lead to accurate representation, but verisimilitude alone will not bring about "breath of life," vital energy or vitality (*sheng-ch'i*), which is held impossible of attainment for the self-conscious painter. Relaxation of mind and body lead to the unity through which true painting imbued with an activating force emerges. Similarly, "bone energy," vitality or noble vitality (*ku-ch'i*), must supplement formal likeness in the representation of things. Both derive from the painter's mental conception and ultimately depend upon brushwork. It is for this reason that painting and calligraphy are seen to be two aspects of a single art (see chapter 2 at "Definition, Animation, and Expression" and "Brushwork").

Chang's discussion helped establish the authority of Hsieh's Six Laws, and emphasized the importance of *ch'i-yün*. Later writers reacted against this model to offer new interpretations. One indication of the shift in post-T'ang discussions of painting is a tendency to revise the Six Laws for contemporary usage and to associate *ch'i-yün* with different subjects or styles. The first significant revision occurred in Ching Hao's tenth-century text (see chapter 4 at "The Significance of Old Pines"), where the requirements of monochrome ink landscape painting were stated in Six Essentials (*liu-yao*). "Spirit" and "resonance" became separate concepts considered necessary attributes of images, which could be attained if one painted in the correct manner. "Thought" and "scene" were effectively substituted for the laws concerned with compositional placement and formal likeness, while "brush" and "ink" represented a more technical interpretation of the second law on brushwork. *Ch'i-yün* was now definitely associated with landscape elements and with brushwork (see chapter 4 at "Technical Secrets").

The most important redefinition of Hsieh Ho's first law was presented around 1080 by Kuo Jo-hsü (see chapter 3 at "Expressive Style and Quality"). *Ch'i-yün*, rendered as "spirit consonance" in Alexander Soper's translation of Kuo's text, was perceived by Kuo to reflect the painter's character, while the other five laws were defined as learnable techniques. The literati view that the expressive quality of a work must be related to its maker's nature and breeding led ultimately to a system

of classifying painters by social status (see the Teng Ch'un text in chapter 3).

However, during the eleventh and twelfth centuries, Neo-Confucian literati seem to have studiously avoided mentioning Hsieh Ho's terminology in connection with painting. Instead, they were struggling to arrive at a more fully developed and sophisticated subject-object distinction, that is, a distinction between the artist and the work of art. At the same time, they were more conscious of philosophical analogies in terms of cosmic creative processes or natural patterns of transfiguration. Su Shih, the eleventh-century poet-painter-statesman, considered that constant forms and constant principles (*ch'ang-hsing* and *ch'ang-li*) demonstrate the real nature of things, and that principles could only be appreciated and reproduced in art by a superior man. It was suggested that the true artist might achieve this through an empathetic and mystical process, possibly influenced by Buddhist meditative techniques—a process equally valid for correct connoisseurship. One could enter a state of absolute concentration in which an object was grasped through total identification (*ju-shen*) and then arrive at a fusion of the subject and object—the artist, or viewer, and the work of art (*shen-hui*). This was not, however, conceived to be a forced process. Instead, natural genius or talent (*t'ien-chi*) combined with complete immersion in study and ending in perfect mastery of skill would inevitably and spontaneously lead to natural configurations (*tzu-jan*). This concept of effortlessness in the creative act, though not necessarily in the discipline leading up to the act, reflects the influences of both Taoism and Ch'an Buddhism and emphasizes nonmental as well as nonrational processes (see chapter 5). One effect of this approach was that the subject of painting in itself held less importance. Bamboos could express *li*—cosmic principles of order and organization or a dynamic pattern of creative process—as meaningfully as a full landscape. The act of painting might "sketch ideas" or "describe mood" (*hsieh-i*) (see chapter 6 at "On Artists' Styles").

By the thirteenth century a more conservative spirit prevailed. Traditional art history and critical terminology were revived, though the concepts of painting involved were not always understood as their original exponents had intended. Then, too, a nostalgia for the past is evident in such terms as "antique spirit" (*ku-i*), which was usually associated with qualities of loftiness, unusualness, or purity (see chapter 6 at "On Artists' Styles" and "Scholars' Painting and the Spirit of Antiquity").

Beyond these issues of what painting is, the painter as artist, and

the values of both works of art and their creators, the reader will find many familiar problems dealt with in the translated texts. The social roles of painters, their techniques, matters of connoisseurship and taste, and other subjects can be traced through a millennia and a half of Chinese history. And exploration of these writings will lead on to other aspects of Chinese civilization and culture.

1

Pre-T'ang Interpretation and Criticism

EARLY PAINTING in China generally played the subsidiary role of or-
namenting objects for daily and ceremonial use or embellishing ar-
chitectural elements or carvings. Hence painting merely signified
decoration in the *Lun-yü* (Confucian Analects).[1] When T'ang writers
came to trace the origins of painting, they stressed its connection with
the symbolic imagery of the hexagrams of the *I ching* (Book of Changes)
or the auspicious designs embroidered on imperial robes. There were
few references to painting as such in pre-Han writings. Among the
early philosophic texts, only the Taoist *Chuang-tzu* (4th–3rd centuries
B.C.) exhibited an interest in artistic creativity. The story about the
painter who did not stand on ceremony is excerpted here, but there
were also tales about the technical skills involved in various crafts such
as wheel-making, wood-carving, and butchering.[2] Artisans of this pe-
riod who had perfected their skills to the point of losing consciousness
of themselves in the creative act were referred to by later critics such
as the Sung literati. A more pragmatic turn of mind is found in the
Legalist work, *Han Fei-tzu* (3rd century B.C.), where anecdotes about
painting occasionally illustrate certain points of argument. Thus the
decoration of a lacquered tablet with incredibly minute images is seen
as a waste of energy, since the object's use was the same as that of any
ordinary ceremonial tablet. The *Han Fei-tzu* text is the first to for-
mulate the problem of representation, and its suggestion that super-

1. For one interpretation see Lin Yutang, *The Chinese Theory of Art* (New York:
Putnam, 1967), p. 21. For another version see James Legge, *The Chinese Classics* (Hong
Kong: Hong Kong University Press, 1960), I, 157.
2. For one such story see Shio Sakanishi, *The Spirit of the Brush* (London: John
Murray, 1957), p. 18.

natural beings were easier to render than dogs and horses was to reverberate in the minds of later writers.

Representation and its significance were the main concerns of the philosophers, essayists, and poets who commented on painting in the Han. The art they described had evidently moved from the decorative to the practical realm. Strategic maps, inventory paintings of retainers in procession, illustrations of physical exercises, and diagrams of the spirit world that would be encountered by the deceased, all inscribed on silk, were found in second-century B.C. tombs excavated at Ch'ang-sha in Hunan province. A few references to painting appear in the contemporary collection of Taoist writings, *Huai-nan-tzu,* compiled at the court of Liu An (d. 122 B.C.). Besides these brief, and somewhat contradictory, statements, there is a general passage in Book I on the nature of perception and physical control that stresses the opposition between an individual's spirit (*shen*), and his bodily form (*hsing*), concluding: "if spirit is the guide, form follows and all is well." Spirit is thus "the master of form," which was thought to be so important in the characterization of different types of figures.

From pre-Han times on, mural paintings of mythological and historical subjects are known to have decorated palaces, towers, and gates. The didactic significance of these idealized portraits is generally interpreted in a straightforward Confucian fashion by writers of the Later Han Dynasty (A.D. 25–220) and the Three Kingdoms period (220–280). In prose poems on the topic of palaces, for example, such murals are described in detail, and their desired effect on the viewer is indicated. Thus moral paragons are said to be portrayed to serve as models for future conduct, while villains are represented as warnings to evildoers. Identification with these pictures is usually assumed to be instinctive and hence instructive, as is most forcibly stated by Ts'ao Chih (192–232), the Wei Kingdom poet and essayist. On the other hand, the skeptic Wang Ch'ung (27–ca. 100) had argued earlier that moral inspiration could only be derived from the written word and not from painted images. A concluding voice in the argument is the balanced view of the critic Lu Chi (261–303), assessing the relative value of both writing and painting in preserving past merit. This debate foreshadows later comparisons of the two arts on purely aesthetic grounds.

Although the early comments on painting consist of anecdotes or brief statements excerpted from the writings of literary figures with no experience of the art itself, short essays attributed to particular painters begin to appear in the so-called Six Dynasties period (3rd to 6th centuries). The earliest of them are versions recorded around 847

in artists' biographies in the *Li-tai ming-hua chi* (Record of Famous Painters of All the Dynasties) of Chang Yen-yüan, first known in Ming editions. Textual corruptions or abbreviations are quite frequent, since these essays were transmitted in manuscript form and evidently not fully understood by copyists. Problems of interpretation are further compounded by a lack of explanatory context and by the questions raised by certain attributions. Despite a rather clouded aura, these writings undoubtedly reflect some of the diverse artistic concerns of Eastern Chin (317–420) and the Southern Dynasties (420–589).

Several of these texts are associated with the famous Eastern Chin figure painter Ku K'ai-chih (ca. 345–ca. 406), in many ways the ideal type of literate artist. As a representative of Chin culture, known in his own time as a wit and labeled half-genius, half-fool, he was particularly appreciated by later scholar-critics. Contemporary anecdotes stress his interest in capturing a sitter's personality. For example, he might wait several years before dotting in eye pupils, since "the subtle point where the spirit can be rendered and perfect likeness portrayed lies just in these little spots."[3] Such stories are most relevant to the first two essays attributed to Ku, which certain commentators now prefer to combine under the single title of *Lun-hua* (Essay on Painting). Apart from a general opening statement ranking different types of painting, the first text or section consists primarily of critical assessments of individual paintings by third- or fourth-century masters. The second text, which is evidently mislabeled, deals mainly with the techniques of copying as did Ku K'ai-chih's "Essay on Painting" according to the *Li-tai ming-hua chi* entry. The concluding passage appears to be on figure painting in general, since it describes how to create a sense of life through posture, gesture, and gaze. It contains the term "to transmit spirit" (*ch'uan shen*), usually taken to describe Ku's aim in portraiture.

More tenuously connected with Ku K'ai-chih is the earliest text dealing with landscape painting, *Hua Yün-t'ai-shan chi* (Record on Painting the Cloud Terrace Mountain), which is, to judge from its verb forms, a tentative description of a projected work. Ku is not credited with this subject or known as a landscapist. However, he did write a poetic appreciation of the scenery of Mount T'ien-t'ai and presumably painted portraits of sages, recluses, or scholars sheltered by trees or caves. Furthermore, the last character in his name suggests a connection with the Taoist cult originally founded by Chang Tao-

3. Chen Shih-hsiang, *Biography of Ku K'ai-chih*, Chinese Dynastic Histories Translations No. 2 (Berkeley: University of California Press, 1961), pp. 14–15.

ling, the Heavenly Master who tested his disciples' fitness on the Cloud Terrace Mountain of Six Dynasties' legend.

As for the painting itself, it is still a matter of scholarly debate whether one, two, or three narrative scenes were to be illustrated. Most significant for future trends is the fact that landscape elements have a primary importance in the composition. Various aspects of the scenery seem to have a symbolic import or echo dynamic descriptions of landscape in contemporary poetry. Thus, the cinnabar-red cliffs and the lone pine hint at the Taoist quest for immortality, while purple boulders and watchtower peaks or pillars mark an ascending path toward the palatial dwelling of the Immortals.[4] The scenery of towering peaks, precipitous cliffs, and deep gullies emphasizes height and depth in an exaggerated fashion, and its dynamic aspect is underlined by the coiled, dragon-like thrust of a vertical ridge. The term *shih* (dynamic configuration) is used here to describe such a "momentum" or "effect."

More in the nature of aesthetic appreciations than guides for landscape composition are the texts recorded in entries on two Liu-Sung Dynasty artists, Tsung Ping (375–443) and Wang Wei (415–443). Both were members of scholarly families that had produced officials or writers for generations, and both were noted for their love of landscape and the Taoist pursuits of lute playing and wine drinking. Their essays suggest that painted scenery infused with the feelings of the viewer could serve as an effective substitute for nature. However, they differ somewhat in the type of painting they describe, and their outlooks stem from distinct philosophical contexts.

A typical mountain-climbing recluse who resolutely refused office, Tsung Ping is best known as a lay member of the famous Buddhist community on Mount Lu that was founded by Hui-yüan (334–416). Significantly, the bulk of Tsung's writings consists of Buddhist polemics. Thus, although his *Hua shan-shui hsü* (Introduction to Painting Landscape) quotes from the *Lun-yü* (Analects) and mentions Taoist practices such as breath control, the dominant frame of reference is likely to have been drawn from Buddhism, more specifically the "landscape Buddhism" fostered on Mount Lu. In this light the insistent mentions of sages and noble recluses take on a deeper meaning, since they apparently indicate the Buddhas and bodhisattvas that had materialized in the past. In an ingenious attempt to assimilate Chinese legend to a Buddhist world-view, it was inferred that these forerun-

4. For further commentary, see Michael Sullivan, *The Birth of Landscape Painting in China* (Berkeley: University of California Press, 1962), pp. 93–101.

ners prefigured the Way of the historical Buddha when they were "roaming in sublime freedom" during their ascent of sacred peaks. Furthermore, it would seem that a replica of a landscape, like a Buddhist icon, could serve as an aid to meditation and inner visualization if its proportions were correct. The ultimate aim of landscape viewing would thus be to stimulate and strengthen the human spirit by delighting it. In Tsung's text, "spirit" (*shen*), or "deified human soul," was what characterized the sages and what should be aroused in the viewer. It was also thought to exist in all living beings, and was used in Hui-yüan's contemporary interpretation to explain the doctrine of transmigration after death. In this intermingling of Taoist and Buddhist concepts, landscape would seem to have been seen quite literally as a "vale of soul-making."

The considerably younger Wang Wei, who served briefly as an official before succumbing to illness, was rather less of a mountain climber and more of a scholar than Tsung. The thought expressed in his *Hsü hua* (Discussion of Painting) is Neo-Taoist in origin, deriving from speculations on the *I ching* (Book of Changes). This essay was a general defense of the status of painting and conceived in response to a letter from the poet and calligrapher Yen Yen-chih (384–456), who had linked painting and calligraphy and the symbolic hexagrams of the *I ching*.[5] Since the text is evidently abbreviated, certain parts are extremely difficult to understand, particularly the phrases containing the terms "form," "soul," and "mind" (*hsing, ling,* and *hsin*). Wang does insist that painting is more than defining physical forms or mapping localities. He seems to assume that the artist could transcend the limits of a subjective view in space and time, and with calligraphic dots and lines create an effective image of the universe itself, placing all things in their proper order as did the conceptual symbols of the *I ching*. This is a painting's "achievement." Its reality or "true feeling" would lie in the imaginative response of viewers as they unrolled the scroll.

The interest in painting displayed by literary men of the Southern Dynasties ultimately led to painting's being judged by the standards applied to other art forms. Earlier, Wang I (267–322), a distant relative of Wang Wei, had had no doubts about the value of his own achievements in calligraphy and painting. A cultivated awareness of personal style in art began to be developed by such gentlemen-painters. Criticism of individual artists and their work is first known to

5. For Yen Yen-chih's definition in *LTMHC*, Book 1, see chapter 2 of this text at "Origins of Painting."

have appeared in two somewhat later texts that exist apart from the *Li-tai ming-hua chi* and were also printed in Ming times. The first is the *(Ku)hua-p'in(-lu)* (Classification of Painters) by Hsieh Ho (active ca. 500–535?), and the second, the *Hsü hua-p'in* (Continuation of the Classification of Painters) by Yao Tsui (535–602). Both were evidently composed during the Liang Dynasty (502–556) and inspired by recent works of literary criticism: Liu Hsieh's *Wen-hsin tiao-lung* (The Literary Mind and the Carving of Dragons) and Chung Hung's *Shih p'in* (Classification of Poets).

The form of the painting texts consists of introductions followed by brief entries on specific artists. In the case of the Hsieh Ho text, a grading system is used to rate quality. Six classes are distinguished in the extant version although the original number may have differed. This work is most famous for the Six Laws (*liu-fa*), six canons or principles of painting that are first defined in its preface and continually referred to by later writers (see the discussion in the Introduction). Typical of Southern Dynasties taste is the practice of characterizing a man's personality or achievements in pithy binomial terms such as "spirit resonance" (*ch'i-yün*). Similar atmospheric terms, often beginning with "spirit" (*ch'i*) or "wind" (*feng*), appear in the entries on individual masters, where they seem to refer to the artist's character or the artist's style or the figures in his paintings, depending on the specific context.

From a rather disparaging entry by Yao Tsui, we know that Hsieh Ho was a fashionable portrait painter, who must have been advanced in years when he finished his text if this was after 532 as is now thought. His successor Yao evidently wrote around 550 or 551 when he could have been no older than sixteen. His age may account for the emotional tone of his defense of Ku K'ai-chih's standing and for the dense literary allusions of the text, where style overshadows substance. He did not classify painters in grades, and thus was able to place the Prince of Hsiang-tung, his father's patron and later the Liang Emperor Yüan (r. 552–554), at the head of the list. The most effusive praise in the entries is given to this imperial artist, while Chang Seng-yu, the greatest mural painter of the previous generation, is treated rather coolly. Relevant to such critical discrimination are contemporary stories, related by Yen Chih-t'ui (531–after 591), of officials classed with artisans because of their skill in painting. Later, Sung critics were also to be influenced in their judgments by an artist's social status, and to make distinctions between the gentleman-painter and the professional.

In this chapter, excerpts from the Hsieh Ho and Yao Tsui texts

are modified versions of William Acker's translations, and the Yen Chih-t'ui extract is based on Teng Ssu-yü's rendering. Other excerpted material has been translated by Hsio-yen Shih. The punctuation and interpretations of the texts are generally those of two commentators, Yü Chien-hua and Nakamura Shigeo. The sequence of topic headings in this chapter underlines a progression from simpler to more developed attitudes toward painting.

Problems of Representation

Han Fei (d. 233 B.C.)

There was a retainer painting for the King of Ch'i, whom the King of Ch'i asked: "What is most difficult in painting?" He replied: "Dogs and horses are most difficult." "What is easiest?" He replied: "Demons and goblins are easiest. Since dogs and horses are things known by man, visible before us the day through, they cannot be completely simulated and thus are difficult. Demons and goblins are without form, and not visible before us, hence they are easy."[6]

> *Han Fei-tzu,* Book 11. *Chung-kuo hua-lun lei-pien* (Chinese Painting Theory by Categories, *CKHLLP*), p. 4.

Chang Heng (78–139)

For instance, artisan-painters dislike depicting dogs and horses, yet like to execute demons and goblins. Truly, this is because substantial entities are difficult to form, while insubstantial counterfeits are inexhaustible.

> Memorial against superstition in augury, *Hou-Han shu* (Later Han Dynastic History), Book 89, Chang's biography. *CKHLLP*, p. 9.

Ku K'ai-chih (ca. 345–ca. 406)

In painting, human figures are most difficult, then landscapes, then dogs and horses. Towers and pavilions are fixed objects, difficult to complete but easy to render well, and not dependent on a marvelous realization of the conveying of thought. If these are made with technical skill, they cannot lack quality.

> *Lun-hua* (Essay on Painting), cited in *LTMHC*, Book 5. *CKHLLP,* p. 347.

6. See the similar statement on artisan-painters' preferred subjects in *Huai-nan-tzu,* comp. Liu An, Book 13.

Optical Illusion

Han Fei (d. 233 B.C.)

There was a retainer who painted a tablet for the Lord of Chou, completing it after three years. When the lord saw that it had the same appearance as any lacquered tablet, he was very angry. The tablet's painter said: "Build a wall of ten planks' height and cut out a window of eight feet. Then, just when the sun is rising, place the tablet on the window and look." The Lord of Chou did this and perceived the tablet's appearance. It was entirely formed of dragons, snakes, birds, beasts, and horse-drawn chariots, the forms of myriad beings complete in every detail. The Lord of Chou was delighted. This tablet's achievement certainly shows the difficulties of work in small scale, yet its use is similar to that of any lacquered tablet without ornament.

> *Han Fei-tzu,* Book 11. *CKHLLP,* p. 4.

Didactic Subject Matter

Wang Ch'ung (27–ca. 100)

People like to look at paintings because noble scholars are represented in these pictures. How can the sight of these noble scholars' faces equal a view of their words and actions? Placed on a bare wall their formal appearances are preserved in detail, but people are not inspired by them because their words and actions are not visible. The writings bequeathed by sages of the past shine forth as recorded on bamboo and silk. Why [seek inspiration] in vain from the paintings on walls?

> *Lun-heng,* Book 13. *CKHLLP,* p. 8 (in part).

Wang Yen-shou (ca. 124–ca. 148)

Suddenly my vision is blurred by fluctuating images like the apparitions of spirits and demons. Here the universe is depicted with all its classes and types of life, its variety of strange and unusual creatures, and the spirits of the hills and seas. Their shapes are described and entrusted to paint. Of the infinite variations of nature, each entity is differentiated in form. In accord with appearance, likeness is imaged, and expression is captured with painstaking care. Recorded from the

remote past are the emergence of the universe from chaos and the beginnings of antiquity: the Five Dragon Kings wing to wing, the Nine Rulers, Fu-hsi with his scaly body, and Nü-wa with her snaky form. Austere is that immense wilderness and simple are its shapes. Then the Yellow Emperor, Yao, and Shun are visible in all their brilliance.[7] Accessories of rank accord with usage, and court costumes are now defined. From the later period of the Hsia, Shang, and Chou dynasties are shown the concubines who debauched their masters, loyal ministers and filial sons, noble scholars and virtuous women. No detail of their wisdom or stupidity, successes or failures, is omitted from these records. Their evil may serve to warn later generations while their good may be an example to posterity.

> "Lu Ling-kuang tien fu" (Prose Poem on the Palace of Spiritual Light in the State of Lu); *Wen-hsüan*, Book 11. *CKHLLP*, p. 10 (in part).

Ts'ao Chih (192–232)

Biographies [which comment on personalities] are written by men of letters; portraits are done by men of ingenuity.

> Quoted by Yao Tsui (535–602), *Hsü hua-p'in* (Continuation of the Classification of Painters, *HHP*), preface.

Of those who look at pictures, there is not one who, beholding the Three Majesties and the Five Emperors, would not look up in reverence; nor any that before a painting of the degenerate rulers of the Three Decadences would not be moved to sadness. There is no one who, seeing a picture of usurping ministers stealing a throne, would not grind his teeth; nor any who, contemplating a fine scholar of high principles, would not forget to eat. At the sight of loyal vassals dying for their principles who would not harden his own resolve, and who would not sigh at beholding banished ministers and persecuted sons? Who would not avert his eyes from the spectacle of a licentious husband or a jealous wife? And there is no one who, seeing a virtuous consort or an obedient queen, would not praise and value them. From this we may know that paintings are the means by which events are preserved in a state in which they serve as models [for the virtuous] and warnings [to the evil].

7. See Bernard Karlgren, "Legends and Cults in Ancient China," *BMFEA*, 18 (1946), pp. 199–365, for analysis of the mythology of primeval culture heroes in China.

Probably from a preface to a collection of eulogies on paintings; cited in *Li-tai ming-hua chi* (Record of Famous Painters of All the Dynasties, *LTMHC*), Book 1. *CKHLLP,* p. 12.

Ho Yen (d. A.D. 249)

Having respect for the complete sincerity of the ancient rulers and delight in the nonaction of [the legendary Emperor] Shun, [the Wei Emperor Ming who reigned 227–240] ordered all the artisans to make paintings and to clarify [distinctions] by their display of the five colors. They painted images from ancient times to serve as precepts, and the various consorts took these as models and examples. Looking at the face of the imperial concubine Yü-chi, they could arrive at an understanding of how to deal with deceitful ministers of the land. Seeing the Empress Chiang remove her jeweled ornaments, they would awake to that which had been respected in former ages. They would esteem Chung-li Ch'un for her forthright admonitions and admire Fan of Ch'u, who put her own interests last. They would commend the excuses of Lady Pan in declining to accompany the emperor in his sedan chair and extol the selection of neighbors by the mother of Mencius.[8] For those who wish to broaden their knowledge must first have heard much. But when one has heard many things, confusion will multiply and one may then be deceived about the truth. This condition can be prevented by the selection of [worthy] people [as models]. Therefore in seeking to establish virtue, one must first develop human sympathy. Because they desired a propriety beyond reproach, [the consorts] concentrated upon the people of old who had trod the Way. Does not examining [these paintings] day and night compare with [reading Confucius' sayings as did his disciple Tzu-chang from] the writings on his sash?

"Ching-fu tien fu" (Prose Poem on the Palace of Luminous Prosperity), *Wen-hsüan,* Book 11. The palace was built at the command of the Three Kingdoms Wei Emperor Ming in A.D. 232.

Lu Chi (261–303)

For appreciating the fragrance and perfume of great deeds the setting up of colors [that is, painting] may be compared to the writing of a

8. Stories about various exemplary women were collected and published by Liu Hsiang (77–6 B.C.) in the *Lieh-nü chuan* (Biographies of Illustrious Women). Many have been translated by S. F. Balfour, "Fragments from a Gallery of Chinese Women," *T'ien-hsia,* 10 (1940), pp. 625–683.

panegyric; for making things widely known nothing is greater than speech, but for reserving the appearance [of those things] there is nothing better than painting.

Cited in *LTMHC*, Book 1. *CKHLLP*, p. 13.

Definition, Animation, and Expression

Liu An (d. 122 B.C.)

If one paints [the legendary beauty] Hsi-shih's face so that it is beautiful yet not pleasing, or defines [the famous warrior] Meng Pen's eyes so that they are large yet not terrifying, [spirit,] the master of form will be lacking.

Seeking that which is beyond the usual, a painter will take pains with every hair but miss the total appearance.

Viewers of a dragon head painted in our time cannot tell what sort of a beast it is. Its form must be entire to be recognized without doubt.

Huai-nan-tzu, excerpts from Books 16, 17, and 21. *CKHLLP*, p. 6.

Ku K'ai-chih (ca. 345–ca. 406)

THE SMALLER VERSION OF ILLUSTRIOUS WOMEN.[9] Their faces seem to be grieving; [though] carved in detail to express their attitudes, they do not fully attain the breath of life. Then, when noblemen were inserted, their bodies and limbs were not naturally conceived, although their clothing, ornaments and various other objects are most unusual. The rendering of young women is especially beautiful. In their robes, coiffures, and movements, each dot and stroke combined to perfect their loveliness. Moveover, the forms of relative status and rank are perceptible and easily understood. It would be difficult to surpass [these aspects].

FU-HSI AND SHEN-NUNG. Although they do not resemble the people of today, they have exceptional bone [structure] and [effectively] combine the Beautiful and the Good. Their spirits are associated with

9. Both Hsün Hsü (ca. 218–ca. 289) and Wei Hsieh (active late 3rd–early 4th century) painted this subject; see *LTMHC*, Book 5.

primeval vastness, and the thought of Attaining the One[10] is demonstrably there.

ILLUSTRIOUS WARRIORS.[11] They are complete in bone [structure]. Yet [the hostage emissary] Master Lin Hsiang-ju is regrettably urgent and intense, without the noble appearance of courage and virtue. When seeking [models in] figures from the past, such should never be seen. As for the King of Ch'in confronting the "Noble" Ching K'o [the would-be assassin] from behind a large barrier, although paintings of this kind are beautiful, they are not morally good.

THREE HORSES.[12] Their noble bone [structure] is divinely unusual. Their leaping gait looks as though they were treading upon empty space. [This painting] has achieved excellence in the attitudes of horses.

> *Lun-hua* (Essay on Painting), excerpts evaluating individual works; cited in *LTMHC*, Book 5. *CKHLLP*, pp. 347–348.

Hsieh Ho (active ca. 500–535?)

TS'AO PU-HSING (3RD CENTURY, PLACED IN THE FIRST Class [IN HSIEH'S TEXT]). Scarcely any of Pu-hsing's works are still preserved. There is only a single dragon in the Secret Pavilion [of the imperial collection] and that is all. Considering its noble character, how can one say that his fame was built upon nothing?

WEI HSIEH (ACTIVE LATE 3RD–EARLY 4TH CENTURY, PLACED IN THE FIRST CLASS). With Hsieh the sketchiness of the ancient painters began to be refined. He was almost equally excellent in all Six Elements [or Laws]. Although one cannot say that he was perfect in the subtleties of form, he did attain vigorous spirit to a high degree. He strode beyond the crowd of other great men, a peerless master of the brush.

CHANG MO AND HSÜN HSÜ (CA. 218–CA. 289; BOTH PLACED IN THE FIRST CLASS). In noble manner and atmosphere they attained the utmost in subtlety and partook of the divine. However, they only captured the quintessential soul, abandoning the bone method. If one

10. "Attaining the One" alludes to a passage in the *Tao-te ching:* "Heaven attained unity and became clear. Earth attained unity and became tranquil. The spirits attained unity and became animated" (J. J. L. Duyvendak, trans. [London: John Murray, 1954], p. 39). As culture heroes, these two sages would have had unusual shapes or features.

11. The Chin Dynasty Emperor Ming (299–325) is recorded as having painted an "Illustrious Warriors from the *Shih chi* (Historical Records)"; see P'ei Hsiao-yüan, *Chenkuan kung-ssu hua-lu.*

12. Shih Tao-shih (active late 4th–early 5th century) painted this subject; see *LTMHC*, Book 5.

stresses their manner of rendering objects, then one will not see this pure essence [in their work]. But, if one considers them from [a point of view] beyond the forms, only then will one be satisfied with their richness. This may be called a delicate and subtle matter.

Ku Chün-chih (5th century, placed in the Second Class). In soul resonance and nervous energy he did not come up to the former sages, but in refinement and delicacy, painstakingness and detail, he sometimes surpassed wise men of the past. He was the first to develop the old and make the patterns for the new. Both in the laying on of colors and the delineation of form, he was the originator of new ideas.

Ku K'ai-chih (ca. 345–ca. 406, placed in the Third Class). His investigation of form was refined and subtle, and he never used his brush haphazardly. But his brushwork did not come up to his ideas, and his fame exceeds the reality.

Mao Hui-yüan (d. ca. 490, placed in the Third Class). In painting style he was complete and sufficient, and there was nothing that he tried that he did not accomplish perfectly. Now coming out and now going in, he exhausted the possibilities of the extraordinary. Now up and down, now back and forth, he let his brush run wild. His strength and impetuosity have resonance and grace, and his transcendent excellence was beyond all categories. In dexterity and deftness he never failed to reach the very height of subtlety, but when it was a question of making things look solid, then he was lumpish and his mastery in this was not yet complete. As for divinities, demons, and horses, he was confused about their physical structures and somewhat clumsy.

Wu Chien (5th century, placed in the Third Class). His stylistic methods were elegant and charming; his definition of composition was able and ingenious. He commanded the praise of his own time, and enjoyed renown at the capital, Lo-yang.

Chang Tse (5th century, placed in the Third Class). His ideas and thoughts ran riot, and he had but to move his brush to be original. His mind was his guide, and his views were his own; he was sparing in his adaptations from others. His versatile ingenuity was inexhaustible, like a circle's being without end, and in his scenes there is much that strikes the eye.

Ch'ü Tao-min and Chang Chi-po (later 5th century, placed in the Fourth Class). Both were good at painting on temple walls, and combined this with excellence in fan painting. In the proportions of men and horses they never missed by so much as a hair, and their skill in differentiating physical structures also penetrated to the divine.

LIU T'IEN (LATER 5TH CENTURY, PLACED IN THE FIFTH CLASS). His attention to detail was unremitting and close, and his style of painting slight and delicate, but his brushwork was confused and weak, and his delineation of form simple and abbreviated. Among the subjects in which he excelled, the best were his women. But, because of his excessive delicacy and detail, contrary to what he wished, he failed in his likenesses all the more. However, if one examines them with care, one finds that he renders their manner and attitudes very well.

THE CHIN EMPEROR MING (299–325, PLACED IN THE FIFTH CLASS). Although he was careless as to form and coloring, he was quite successful in capturing the spirit vitality. His brushwork is of surpassing quality and also of an unusual appearance.

TSUNG PING (375–443, PLACED IN THE SIXTH CLASS). Although Ping had some understanding of the Six Elements [or Laws], he was, after all, without the corresponding skills. Yet, whenever one sucks a brush and commands plain silk, there cannot fail to be losses and gains. His works are not absolute standards of quality, but his ideas are good enough to learn from and imitate.

> (Ku)hua-p'in(-lu) (Classification of Painters, *KHPL*), excerpts evaluating individual artists. *CKHLLP*, pp. 356–357, 360–366.

Yao Tsui (535–602)

HSIEH HO (ACTIVE CA. 500–535?). In painting people's portraits he did not have to sit opposite them. All he needed was one glance, and he would go to work and wield his brush. His dots and sweeps were polished and refined, and his attention was fixed on close likenesses. The expression of their eyes and the least hair, all was without a single slip or omission. Their festive robes and cosmetics changed according to the times, and he made straight eyebrows or curved forehead locks to suit the latest fashion. Such refinement in the differentiation of physical structure mainly began with Ho. As a result, he caused vulgar folk who pursue profit all to resemble [the ugly women] who imitated [the famous beauty Hsi-shih's] frown. In what concerns spirit resonance and essential soul, he did not fathom the meaning of vitality. The path of his brush was tenuous and weak, which ill accords with a feeling of vigor and classic elegance. Still, since the Chung-hsing reign [A.D. 501] no one has equaled him in portraying people.

CHANG SENG-YU [6TH CENTURY]. He excelled in making pictures for pagodas and temples and strode beyond the multitude of artisans. In court robes or country clothes, he never overlooked what was ancient or modern. In strange forms and odd appearances, or various locales whether foreign or Chinese, he truly entered into their subtleties . . . Yet his sages and wise men when narrowly examined are a little lacking in spiritual energy. But, how can one ask for perfection in one man? Although he appeared late he comes a close second to the best of his predecessors.

> *HHP*, excerpts evaluating individual artists. *CKHLLP*, pp. 370, 372.

Training

Wang I (276–322)

My older brother's son Wang Hsi-chih [309–ca. 365] is young but precocious and must eventually exalt our house. He is just beginning his sixteenth year and, besides his regular studies, whenever calligraphy and painting pass before his eyes he is able (to reproduce them). He came to seek my techniques in calligraphy and painting, and I painted Confucius and his Ten Disciples to encourage him. Alas, if Hsi-chih is not stimulated!

The painting is from my hand, as is the calligraphy. Though I am unworthy of serving as a model in other things, my calligraphy and painting can certainly be studied. In studying calligraphy, I would have you [Hsi-chih] realize that you can go far by amassing knowledge. In studying painting you should begin to travel on your personal path through learning the relationship of pupil to master. I will, moreover, assist you in both of these.

> Colophon on a painting of "Confucius and His Ten Disciples"; cited in *LTMHC*, Book 5. *CKHLLP*, p. 14 (phrase omitted).

Technique

Ku K'ai-chih (ca. 345–ca. 406)

All those who are about to make copies should first seek these essentials, after which they may proceed to their business.

Whenever I create any paintings, the plain silk scrolls must all extend to two feet three inches. Plain silks with warped threads cannot

be used, since after some time they will again become straight and the proper appearance [of forms] will be lost. When a copy is made on silk from silk, one should be placed over the other exactly, taking care as to their natural straightness, and then pressed down without disturbing their alignment.

When the brush moves forward while the eyes are looking in advance, then the new painting will come closer toward one. [Hence] one should habitually fix one's gaze near the brush. Then, since there is only an intervening layer of paper or silk, by which the version to be copied is separated from one, if a single copying [stroke] is mistaken, successive errors will be very few. One should cause the new brush strokes to cover the original but prevent their turning inward. To guard against this inward [tendency], it is best to make the brush pointed if an object is light, and to put pressure on strokes if it is heavy. Each [use of the brush] completes the thought. For instance in painting mountains, if strokes are pointed, then the thought is active and will detract from an effect of firmness. In using the brush, one may have an excessive smoothness, then there will be no substance to projecting angles. Or one may have too many curves and hooks, which will add angularity to what is smooth. The damage in not combining [these qualities] is as hard to describe as the expert wheelwright's [untransmittable] skill.

In drawing heads, rather go slowly and be without substance than go fast and lose [likeness to the original]. In all the various images, since each has its own difference in brushwork, one must cause the new to supplement the original. If length, texture, depth, breadth, and the detail of dotting in an eye-pupil should have one small fault in their placement, proportion, or tone, the spirit vitality will accordingly change completely.

One should use ink and color of light tone for bamboos, trees, and the earth, but pine and bamboo leaves should be rich in tone. In general, sizing and coloring should not reach the upper and lower [edges of the] silk. If yellow [discoloration] fills the silk on a fine painting, one should then simply leave the [copy's] sides clear. At each of the two borders of a scroll, for example, this should be for not quite three-tenths [of an inch].

Human figures have greater or lesser height. Once their distance has been set in accordance with their scrutinization of an object, one must not alter their spacing or misplace them higher or lower. No living person salutes with his hands or gazes with his eyes if there is nothing before him. To describe the spirit through form but omit its actual object is perverse as a means of trapping life and deficient as

an effort to transmit spirit. To lack such actual objects [of attention] is a great failing. To have an object but lack accuracy is a lesser failing. One should not ignore this. The clarity or ambiguity of a single image is not equivalent to penetrating to the spirit through [its] apprehension of an object.

> *Lun-hua* (Essay on Painting); cited in *LTMHC*, Book 5, under the title *Wei Chin sheng-liu hua tsan* (Eulogies on Paintings of/by Notables of the Wei and Chin Dynasties).[13]

The mountain has a main face, hence its back is shadowed. I would cause auspicious clouds in the west to flow to the east. For the colors of sky and water on a clear day, I generally use only azure pigment, finishing the white silk above and below as if in bright sunlight. In the mountain that stretches out to the west, I will distinctly define the relative distances, starting from the eastern base.

Shifting to not quite the midpoint, I will make five or six purple boulders like firm clouds which, buttressing a ridge, mount it and ascend. I will cause the [ridge's] momentum (*shih*) to writhe and coil and, like a dragon, embrace a peak to ascend vertically. Below it, I will make piled-up ridges and cause them to appear to ascend in a congealed mass.

There will be another peak, which is of rock. It towers up, confronting its eastern neighbors. The western side of this peak will connect with a westward-oriented, cinnabar-red cliff, below which will be placed a steep mountain gorge. In painting the red cliff near the top of the gorge, one should make its fiery pinnacle exalted and lofty to depict an effect of dangerous steepness.

The Heavenly Master [Chang Tao-ling of the Later Han Dynasty] sits on this peak and is partially shaded, together with the rock upon which he sits. Appropriately, in the gorge, a peach tree grows sideways from amidst the rocks. I will paint the Heavenly Master with emaciated form but far-reaching spirit vitality. Leaning over the gorge, he points to the peach while turning his head to talk to the disciples. Among these are two who approach the edge, their bodies all atremble, perspiring, and pale. I will render Wang Ch'ang sitting deep in thought, answering the question, and Chao Sheng lively in spirit and alert in attention while leaning to gaze at the peach tree.

Then, I will repeat Wang and Chao hastening [to leap after the Heavenly Master into the gorge]. One is concealed by the slanting

13. See Bibliography B for a discussion of this confusion of titles.

cliff of the west wall, with only his skirts visible. Another is completely in view within the void, and I would make him tranquil and indifferent.[14]

In painting figures, they must be seven-tenths [of their full heights] when seated. The colors of their garments should be distinctively subtle. This is correct, since when mountains are high, the people are far away.

On the east side of the middle section, a steep cliff of cinnabar shale, partially shaded, should be made to tower in lofty darkness, with a lone pine planted on it. It is placed opposite the cliff near the Heavenly Master to form a gorge. The gorge should be extremely narrow. I would like this closeness to cause [all space] between the two walls to be remote and pure, which must help to establish it as the dwelling place of the divinities.

I would make a purple rock stand erect at the top of the next peak, and thereby form the buttressing element of a lefthand watchtower. The steep cliff, lofty and dark, is linked on the west with the Cloud Terrace so as to indicate a road. The lefthand watchtower peak has a precipice for its base, and below this is a void. I will combine several boulders in a layered effect to support the precipice so that together with it they face the eastern gorge. To the west, a rocky torrent appears. However, as it adapts to its steep confines, I will cause it to flow down through the ridge as an underground stream that emerges after awhile to the east. It descends down the gorge as a stony brook that sinks into a deep pool. The reason for its falling now to the west and now to the east is that I wish to make the painting seem natural.

The northern and western faces of the Cloud Terrace should be depicted as one in a ridge that winds around them. At the top I will make two pillar-like boulders to stand for the left and righthand watchtowers. On one rock I will place a solitary wandering phoenix. It should be in a dancing pose with ornamental and detailed plumage, raising its tail and spreading its wings to gaze into the steep gorge.

The red flanking rocks of the last section should be made dispersed and agitated like rending lightning. These face the wall next to the

14. The story is of the last of seven tests given by the Taoist adept Chang Tao-ling to discover a worthy heir to his knowledge. Chao Sheng hurled himself into a chasm to reach the peach tree for whose fruit the master promised the Tao. Subsequently, both Chao Sheng and Wang Ch'ang followed their master in leaping into the chasm and, upon landing, were the only two of his numerous disciples to receive his instruction. See the *Shen-hsien chuan* (Tales of Immortals), attributed to Ko Hung (A.D. 4th century), Book 4.

phoenix, on the west of the Cloud Terrace, to form a gorge. There is a clear stream at the bottom of the gorge. At the outer face of the farther cliff wall, I will make a white tiger flattened on a rock to drink the water. After this, I will create a descending effect and finish.

In general, although the painting of a mountain in three sections is long in extension, it should be made compact, or else it will not be suitable. As for the types of birds and beasts that can be used when appropriate, one should decide on their poses and then use them. In creating the gorges below, objects and scenes are all inverted (as reflections in the water). Pure vapor girdles the mountain's lower part for at least one third (of its height) or more, so that it clearly defines two levels.

> *Hua Yün-t'ai-shan chi* (Record on Painting the Cloud Terrace Mountain); cited in *LTMHC*, Book 5. *CKHLLP*, pp. 581–582.

The Significance of Landscape

Tsung Ping (375–443)

Sages, possessing the Tao, respond to things. The virtuous, purifying their thoughts, savor images. As for landscape, it has physical existence, yet tends toward the spiritual. Therefore, such recluses as the Yellow Emperor, Yao, Confucius, Kuang-ch'eng, Ta-k'uei, Hsü Yu, and the brothers Po-i and Schu-ch'i from Ku-chu insisted upon roaming in the mountains K'ung-t'ung, Chü-tz'u, Miao-ku, Chi, Shou, T'ai- and Meng.[15] These have also been praised as the pleasures of the humane and wise. Now, sages follow the Tao through their spirits, and the virtuous comprehend this. Landscapes display the beauty of the Tao through their forms, and humane men delight in this. Are these not similar?

When I was deeply attached to the Lu and Heng mountains, and roamed with abandon the peaks of Ching and Wu,[16] I did not realize that old age was approaching. Ashamed of being unable to concentrate

15. Mountains are often associated with sages or immortals in Chinese mythology. See Karlgren, "Legends and Cults in Ancient China," for various traditions about heroes and rulers in prehistory, especially p. 279 for the hermit Kuang-ch'eng and the sage Ta-k'uei. Hsü Yu, and the brothers Po-i and Shu-ch'i, are all noted by Ssu-ma Ch'ien (145–ca. 74 B.C.) in *Shih-chi* (Historical Records), Book 61, as recluses who disdained worldly power.

16. All famous scenic areas in the Kiangsi, Hunan, Hupei, and Szechwan regions.

my vital breath and attune my body, I am afraid of limping among those [who climb Mount Lu's] Stone Gate.[17] Therefore, I paint images and spread colors, constructing cloudy peaks.

If truths that were abandoned before the period of middle antiquity may still be sought by the imagination a thousand years later, and if meaning that is subtler than the images of speech can be grasped by the mind in books and writings, what then of where one's body has strolled and one's eyes rested repeatedly when it is described form for form and color for color?

However, the K'un-lun mountains are immense and the eyes' pupils small. If the former come within inches of the viewer, their total form will not be seen. If they are at a distance of several miles, then they can be encompassed by inch-small pupils. Truly, the farther off they are, the smaller they will appear. Now, if one spreads thin silk to capture the distant scene, the form of K'un-lun's Lang peak[18] can be encompassed in a square inch. A vertical stroke of three inches will equal a height of thousands of feet, and a horizontal stretch of several feet will form a distance of a hundred miles. That is why those who look at paintings are only troubled by awkwardness in the likeness and do not consider that diminution detracts from verisimilitude. This is a natural condition. In this way, the lofty elegance of the Sung and Hua mountains as well as the soul of deep valleys can all be included in one picture.

If response by the eye and accord by the mind [to nature] is considered a universal law, when similitude is skillfully achieved, eyes will also respond completely and the mind be entirely in accord. This response and accord will affect the spirit and, as the spirit soars, the truth will be attained. Even though one should again futilely seek out remote cliffs, what more could be added? Furthermore, the spirit, which is essentially limitless, resides in forms and stimulates all kinds

17. Members of the monk Hui-yüan's religious community are known to have climbed this peak and to have celebrated it in poetry. See Susan Bush, "Tsung Ping's Essay on Painting Landscape and the 'Landscape Buddhism' of Mount Lu," in *Theories of the Arts in China*, ed. Susan Bush and Christian Murck (Princeton: Princeton University Press, 1983), pp. 144–152. This particular phrase can also be understood and translated as "I am distressed at being unable to concentrate my vital breath and to attune my body, thus falling into being like him at the Stone Gate." This alludes to a passage in the *Lun-yü* (Analects), Book 14; Legge, *Chinese Classics*, I, 290, in which a gatekeeper at the mountain pass of the Stone Gate comments on the futility of Confucius's actions, without attempting any positive action by himself.

18. The central peak of this semimythologized range to China's west is known for its height and for immortals thought to dwell there; cf. David Hawkes, *Ch'u tz'u: The Songs of the South* (Oxford: Oxford University Press, 1959), pp. 29, 136.

of life, and truth enters into reflections and traces. One who can truly describe things skillfully will also truly achieve this.

Thus, I live at leisure, regulating my vital breath, brandishing the wine-cup and sounding the lute. Unrolling paintings in solitude, I sit pondering the ends of the earth. Without resisting the multitude of natural promptings, alone I respond to uninhabited wildernesses where grottoed peaks tower on high and cloudy forests mass in depth. The sages and virtuous men who have shone forth throughout the ages had a myriad charms [of nature] fused into their spirits and thoughts. What then should I do? I rejoice in my spirit, and that is all. What could be placed above that which rejoices the spirit?

> *Hua shan-shui hsü* (Introduction to Painting Landscape); cited in *LTMHC*, Book 6. *CKHLLP,* pp. 583–584.

Wang Wei (415–443)

I was honored by a letter from the Imperial Household Grandee Yen Yen-chih [384–456], which says that drawing pictures should not stop with mere exercise of artistry, since the final product ought to correspond to the images of the *I ching* [Book of Changes]. However, those who occupy themselves with the seal and clerical scripts naturally place skill in calligraphy higher. I should like both to discriminate between calligraphy and painting and to examine how they are similar.

Now those who speak of painting ultimately focus on nothing but appearances and positioning. Still, when the ancients made paintings, it was not in order to plan the boundaries of cities or differentiate the locale of provinces, to make mountains and plateaus or delineate watercourses. What is founded in form is fused with soul, and what activates movement is the mind. If the soul cannot be seen, then that wherein it lodges will not move. If eyesight is limited, then what is seen will not be complete.

Thus, with one reed brush I simulate the form of the Great Void; with differentiated shapes I paint the perceptions of the inch-wide pupils. Crookedly I render the heights of Mount Sung; speedily I create Mount Fang-chang. With tortuous lines I mark Mount T'ai-hua; with curving dots I show its magnificent nose.[19] Their brows,

19. The "Great Void" has, of course, a metaphysical significance in Taoism, but it could also simply indicate the sky in sixth-century poetry. Mounts Sung and T'ai-hua are two of the Five Sacred Peaks, but Fang-chang may refer to either one of the three legendary isles of the immortals or in its literal sense of "ten yards square" to the hut of a Buddhist monastic, or by extension to that of the famous Buddhist layman Vimalakīrti.

foreheads, chins, and jaws are as if in a peaceful smile. Their lonely cliffs, luxuriant and flourishing, seem to spit forth clouds. Through horizontal changes and vertical transformations, movement is produced. With angled front and squared back, [forms] are brought out. After this, palaces and towers, boats and carriages, each object is assembled according to its kind; dogs and horses, birds and fish, each entity is differentiated according to its shape. This is the achievement of painting.

At the sight of the autumn clouds, my spirit soars on high. Before the spring winds, my thoughts expand in fluidity. Though one should have the music of bell and chimes, or a treasure of ceremonial jades, how could they compare to this? I unroll a painting and examine its inscription. It represents strange mountains and seas, verdant forests tossed by wind, white waters leaping and foaming. Ah, how could this have been accomplished easily. It must have come about through divine inspiration. This is the true feeling of painting.

> *Hsü hua* (Discussion of Painting); cited in *LTMHC*, Book 6. *CKHLLP*, p. 584 (the first two characters in the last line are reversed).

Criteria for Appreciation and Criticism

Ku K'ai-chih (ca. 345–ca. 406)

Beauty of form, exactness in calculation of scale, discrimination of *yin* and *yang* [the polarities of creative forces], and refinement of brushwork, all these are valued by the world. When [a painter has] divine principles within the mind, and hands in accord with eyes, a profound appreciation [of his work] will not then depend on verbal interpretations. If this were not so, one would truly be cut off from understanding of another's mind. One should not be deluded by a mass of critical writings. Those who depend on biased views to simulate understanding must also value thorough knowledge. Although I am unqualified to examine such points, these thoughts have covered more than half the ground.

> *Lun-hua* (Essay on Painting); cited in *LTMHC*, Book 5.

Hsieh Ho (active ca. 500–535?)

Now by classification of painters is meant the relative superiority and inferiority of all painters. As for painters, there is not one who does not illustrate some exhortation or warning, or show the rise and fall

[in man's affairs]. The solitudes and silences of a thousand years may be seen as in a mirror by merely opening a scroll.

Even though painting has its Six Elements [or Laws], few are able to combine them thoroughly, and from ancient times until now each painter has excelled in one particular branch. What are these Six Elements? First, Spirit Resonance which means vitality; second, Bone Method which is [a way of] using the brush; third, Correspondence to the Object which means the depicting of forms; fourth, Suitability to Type which has to do with the laying on of colors; fifth, Division and Planning, that is, placing and arrangement; and sixth, Transmission by Copying, that is to say the copying of models.

Only Lu T'an-wei [5th century] and Wei Hsieh [active late 3rd–early 4th century] were thoroughly proficient in all of these.

But, while works of art may be skillful or clumsy, aesthetics knows no ancient and modern. Respectfully relying upon remote and recent [sources] and following their classifications, I have edited and completed the preface and citations. Hence what is presented is not too far-ranging. As for the origins [of painting], it is merely reported that it proceeded from gods and immortals, but none was witness to such.

KHPL, preface. Compare Acker, tr., I, 3–5, and *CKHLLP*, p. 355.

Yao Tsui (535–602)

Now, the wonder of painting is so great that words can never wholly fathom it. For, though in essence it never departs from the concepts of antiquity, in its outward marks it changes according to present circumstances.

[Painters] can store myriad phenomena in their breasts and relate the events of a thousand years' span with a tiny brush. For truly all the immortals and spirits were represented on the nine-storied towers, and many wise men and sages were depicted on the lofty walls of the four-gated sacrificial halls [in the Chou Dynasty].[20] In the Cloud Terrace [of the Southern Palace in the Later Han Dynasty] paintings inspired emotions of reverence and awe; and even in the palace's private apartments they could bring about the leave-taking [of Chinese brides selected from their portraits by nomadic chieftains] to be mar-

20. For a discussion of *ling-t'ai* (towers) and *ming-t'ang* (halls) in the Chou Dynasty (1027–256 B.C.), see Laurence Sickman and Alexander Soper, *The Art and Architecture of China* (Baltimore: Penguin, 1956), pp. 367–371, 374, 378–379.

ried in distant countries.[21] But all such things of remote memory are hard to trace thoroughly. And in what is extant, the subjects are often lost in obscurity. Of course, unless one has deep perception and wide experience, how can one distinguish the fine from the coarse, and cast off snares and traps to arrive finally at the truth?

Still, there are opportune and inopportune times in human affairs, and man experiences prosperity and decline. Sometimes he is highly honored in his boyhood; sometimes fame comes to him in the prime of life. For truly that which precedes and that which follows are formed each according to the other, and the superior and inferior are opposed yet mixed [in all work].

As for the excellence of someone like Ku K'ai-chih, he commands the highest place in the records of the past, standing lofty and alone. In all time he had no equal. He had a sort of supernatural brilliance, which ordinary intelligence could never hope to realize. It was as though he upheld the sun and the moon. How should the insignificant learning [of others] be able even to glimpse him. Hsün Hsü, Wei Hsieh, Ts'ao Pu-hsing, and Chang Mo [all of the 3rd or early 4th century] were as nothing compared to him, and no man has ever been seen who could meet him on equal terms. That Hsieh Ho records of him "his fame exceeds the reality" is quite depressing enough, but that he should have placed Ku in a low class is something that I can bear with even less equanimity. This was simply because Hsieh's own emotional attitude was unstable, and had nothing to do with the merits or defects of the paintings themselves . . . I fear that the principles of classification have come to an end, are swept away and lost forever. Yet I have some hope that, by lifting one corner, I may be as one with the three profitable friends [of the upright, true unto death, and those who have heard much] . . .

If one studies the *Ho shu* [Interpretations of Divination Hexagrams] at length, then [one will find that] pictures existed before writing. To use the words of the *Lien-shan* [Book of Divination], "speech is rendered visible by means of visible forms."[22] Nowadays everyone admires

21. Between A.D. 58 and 76, idealized portraits of twenty-eight famous generals and four officials were painted on the walls of the Cloud Terrace to do them honor and to remind posterity of such models. Fan Yeh (d. A.D. 445), *Hou-Han shu* (Later Han Dynastic History), Book 22, biography of Ma Wu (d. A.D. 61). For one legend of a Chinese bride selected on the basis of a portrait see the *LTMHC*, Book 4, Acker translation, II:1, pp. 5–6.

22. For the connection between script and divination, see the *LTMHC*, Book 1, Acker translation, I, 85–99.

these bird-tracks [of script] while despising yonder [symbols in the] dragon-patterns [of the hexagrams]. But the mutual interchange of growth and decay has its natural cause. Therefore, [the legendary artisan] Ch'ui cut off his fingers, for skillful artifice should not be practiced.[23] . . .

The men that I include [in this book] are all people not mentioned by Hsieh Ho. Still, if this composition consists of only two scrolls, in them men whose *tao* seemed to have something worthy of note have been brought together into one group. While ancient and modern critical works on calligraphy must select calligraphers according to their relative merits, those who understand painting are not many, hence I have tried to be exhaustive. As the number of these men is so small, I have not tried to make any fine distinctions whatever. The relative excellence of each painter may be inferred from the tenor of my remarks.

HHP, preface with some passages omitted. *CKHLLP*, pp. 368–369.

Social Status and Creative Activity

Chuang-tzu

When the First Lord of Sung wished to have pictures painted, a multitude of his scribes arrived together. They received his commands respectfully, then stood in attendance. Of those licking brushes and mixing ink, at least half were outside [the ranks of painters]. One scribe arrived later, casually and without hurry. He received the commands respectfully, but did not stand in attendance, retiring immediately. The noble ordered someone to see what he was doing. Behold, he had loosened his robes and was sitting with his legs outspread, half-naked. The lord then said: "He will do. He is a real painter."

Chuang-tzu (late 4th–early 3rd century b.c.), Book 21. *CKHLLP*, p. 3.

23. Ch'ui is twice referred to in the *Shu ching* (Book of Historical Documents), sections "Yü shu" and "Ku ming," Legge, *The Chinese Classics*, III, 45, 555, as minister of works for the legendary emperor Shun and as a maker of bamboo arrows. *Chuang-tzu* (late 4th–early 3rd century b.c.), Book 10, "Ch'ü ch'ieh," James Legge, tr., *The Sacred Books of China: The Texts of Taoism*, The Sacred Books of the East, Vol. 39 (Oxford: Clarendon, 1891), Pt. 1, p. 286, contains the caution against art as destructive of natural experience.

Hsieh Ho (active ca. 500–535?)

Ku Chün-chih [5th century] once built a tower of several stories, which he used as his atelier. When wind and rain blustered and lowered, he would on no account take up his brush. But, on days when the skies were favorable and the air crisp, only then would he color his brush-tip. He would climb up into his tower and remove the ladder, so that his wife and children seldom saw him.

> *KHPL. CKHLLP,* p. 358.

Yao Tsui (535–602)

The Prince of Hsiang-tung [later the Liang Dynasty Emperor Yüan who reigned 552–554] was by nature a superior man and famous in his generation. Early taking advantage of an inborn wisdom, he penetrated in his studies beyond the nature of things, and his mind was schooled by all creation. He was such that not even the most virtuous could hope to equal. Yet painting has Six Elements [or Laws] which even true immortals would find difficult.

The Prince reached the utmost in divine subtlety in his imaging of people. He had a brilliant mind and a facile hand, never having to correct strokes or remedy errors. This was all done in his hours of leisure from hearing cases and administrative work, or in time left over from his literary discussions and various other artistic pursuits. Whenever he came across a suitable object, he would take up his brush and, in a short time, produce something startling beyond words . . . Although his output of pictures was very limited, his fame was heard beyond his own country. Neither repeated discussion nor mute acceptance can serve to praise him.

Chang Seng-yu [6th century] excelled in making pictures for pagodas and temples, and strode beyond the multitude of artisans . . . Making the day last into the night, he never wearied or grew bored. Whether in the company of others or by himself, his hand never left the brush. For the space of several dozen years, he simply never gave himself a moment's rest . . .

> *HHP. CKHLLP,* pp. 369, 372.

Yen Chih-t'ui (531–after 591)

To find amusement in looking at the art objects of all times is particularly valuable and enjoyable. But, if one's official position is not high

enough, one is frequently ordered to paint for the government or for private friends, and that is disgusting service. Ku Shih-tuan of Wu-chün started his career as an attendant secretary of the princedom of Hsiang-tung, and later on became an administrator of a criminal court in the prefecture of Chen-nan. He had one son named T'ing, an imperial secretary of the Western Court. Both the father and son were skillful calligraphers and lute-players, and were especially marvelous in painting. Whenever they were ordered [to paint] by the Emperor Yüan [reigned 552–554], they felt humiliated and harbored resentment.

Liu Yüeh of P'eng-ch'eng, son of T'o, with an official career from a secretaryship in the headquarters of a swift cavalry division to magistrate of P'ing-shih, was a very brilliant scholar with unsurpassed ability in painting. Later on, he followed the Prince of Wu-ling to Shu [Szechwan], where he suffered a defeat at Hsia-lao. Then [Yüeh] was compelled to paint the walls of the Chih-chiang temple for Protective General Lu, and to live together with other craftsmen. If these three scholars had been ignorant of painting, simply engaging themselves in their original professions, would they have met with such humiliations?

> *Yen-shih chia-hsün* (Family Instructions for the Yen Clan), Book 7. *CKHLLP*,
> p. 15.

2

T'ang Criticism and Art History

BUDDHIST ART reached its height under imperial patronage during the T'ang dynasty (618–906), and the eighth-century muralist Wu Tao-hsüan or Tao-tzu was considered the greatest painter of all times. Unfortunately many masterpieces of temple walls were destroyed during the Buddhist persecution of 845, which marked the end of an artistic era. This fact may have stimulated Chang Yen-yüan to produce his encyclopedic work, the *Li-tai ming-hua chi* (Record of Famous Painters of All the Dynasties). This collection of introductory essays and biographies, which was compiled around 847, is the main repository of facts about T'ang and pre-T'ang artists. Since the entries on specific painters include both the essays attributed to these men and critical comments on their work by T'ang writers, it is no exaggeration to say that this chapter and the preceding one could not have been composed without Chang Yen-yüan's collection. A few words should thus be said about the format and condition of this important source.

The text is substantially the same in five Ming editions, but may differ from the original T'ang work. It is known to have interpolations, possibly added in Sung times, and recent scholars have suggested that sections are not arranged in their order of composition. Inconsistencies in definitions and details occur in separate parts, which might indicate that not all the material is attributable to Chang Yen-yüan. The format appears to be modeled on that of official dynastic histories, with three preliminary books of essays on historical developments and more specific technical subjects, and seven succeeding books containing the biographies of painters arranged by their respective dynasties. Within each dynasty the ranking of artists appears to approximate roughly their official status, with members of the imperial clan placed first. The nine-fold grading system, consisting of three major cate-

gories (Upper, Middle, and Lower) each further subdivided into three, is applied mainly to pre-T'ang painters in notations after their names, and hence may be among the later interpolations in the text.

As a member of a family of officials who had practiced calligraphy and collected painting for several generations, Chang Yen-yüan had a historical perspective on both of these arts. He also edited essays on calligraphy in the later collection, *Fa-shu yao-lu* (Essential Records of Calligraphy Exemplars). This background prepared Chang for his major contributions to art criticism, a historical framework of development and connoisseurship of calligraphic line. Thus his essays traced the origins and significance of painting from the mythical past to more recent times when period styles could be distinguished, and emphasized the contrasts in style between T'ang and pre-T'ang paintings. His material came from various sources such as the dynastic histories, collections of anecdotes or legends, and texts on painting criticism, but many comments were based on personal observation. Since his eye had been trained by the traditional writing methods, he characterized past artists in terms of their calligraphic techniques and obviously valued brushwork more highly than the application of colors. He articulated the joys of appreciating paintings and the proper approach to connoisseurship, even adding such technical aids as the deciphered seals of earlier connoisseurs and collectors. Since he was broad-minded enough to include the critical opinions of others on specific masters, the *Li-tai ming-hua chi* is the main source for the excerpted comments from the writings of various T'ang critics, who will be discussed in a logical, if not strictly chronological, sequence.

Chang Yen-yüan cited in the *Li-tai ming-hua chi* at least two critics with whom he obviously disagreed. He disparaged the critical abilities of the seventh-century official P'ei Hsiao-yüan and quoted from a text that is evidently still extant in part, the *Chen-kuan kung-ssu hua-lu* (Record of Paintings in Public and Private Collections in the Chen-kuan Era, 627–650). This text has a preface dated to 639 relating the history of painting, and a postscript that corresponds to certain of Chang's quotations, praising contemporary artists such as Yen Li-pen (d. 673). Chang also disagreed with the monk Yen-ts'ung, presumably active in the capital at Ch'ang-an around 650. A *Hou hua-lu* (Later Record of Painters) attributed to his authorship is extant in a version generally considered a forgery based on quotations from Chang. It has a preface dated to 635 but deals with one painter active in the 660s. According to Chang, Yen-ts'ung's criticisms were particularly inaccurate, and the seventh-century official Tou Meng had also expressed his opposition to them. Tou was noted as a calligrapher and

connoisseur. His *Hua shih-i lu* (Amended Record of Paintings) is no longer extant, and the passages noted under his name in Chang's text may be post-T'ang interpolations.

Chang also quoted the official Li Ssu-chen (d. 696), of whom more is known from his biographies in the T'ang histories. A painter, he also wrote critical classifications of poetry, calligraphy, and painting, the last a sequel to the texts by Hsieh Ho and Yao Tsui. An extant work on painting is generally considered a later forgery based on Chang's quotations, but the original format of Li's classification of painting can be inferred from his better preserved *Shu hou-p'in* (Later Classification of Calligraphers) According to the preface of the *Shu hou-p'in*, to the regular grades of artists in the painting text Li added an "Untrammeled Class (*i-p'in*)" for four exceptional men. The concept of an *i* category, a "free," "untrammeled," or basically unclassifiable group of talents, was to be influential on later systems of classification. In his critical assessments of earlier masters, Li strongly defended the quality of Ku K'ai-chih's talent against Hsieh Ho's opinion, and resurrected Chang Seng-yu's reputation, which had been damned by Yao Tsui's faint praise. These views were echoed and elaborated by the later Chang Huai-kuan, active in the Han-lin Academy in the K'ai-yüan era (713–741), who was again quoted in the *Li-tai ming-hua chi*. His *Hua-tuan* (Opinions on Painting) is no longer extant, although a companion work on calligraphy, the *Shu-tuan* (Opinions on Calligraphy) has been preserved. The structure of the painting text was presumably parallel, and placed artists for the first time in three classes: the Inspired, the Excellent, and the Competent (*shen, miao, neng*).

Another important work extant from the T'ang period is Chu Ching-hsüan's *T'ang-ch'ao ming-hua lu* (Record of Famous Painters of the T'ang Dynasty). The Han-lin scholar Chu was obviously aware of the works by Li Ssu-chen and Chang Huai-kuan when he composed his own system of classification around 840. He subdivided the three classes of merit into three levels (Upper, Middle, and Lower), thus producing a nine-fold division comparable to that used to rank officials. Placed at the end in a separate "Untrammeled Class" were three men "who rejected all orthodoxy in painting." Since this work deals only with T'ang artists, three members of the imperial family were also kept apart at the beginning and excepted from the majority of painters graded into classes. Chu Ching-hsüan's system provided a model of classification for several post-T'ang critics, who would add certain modifications of their own. His work is especially valuable for its descriptions of specific painters' subjects and styles. Some of these

comments are evidently based on appreciations by other eighth-century writers, and occasional quotations from poems by Tu Fu (712–770) give the text a literary tone. It is far more limited in scope than the contemporary *Li-tai ming-hua chi*, yet presents many of the same anecdotes about T'ang artists and expresses a similar appreciation of calligraphic line.

Despite Chu Ching-hsüan's ready citation of poetic critiques, he does not focus exclusively on the act of creation as do certain T'ang literary figures. For example, Fu Tsai (d. ca. 813) vividly evokes the creative power of the contemporary artist Chang Tsao, and the well-known poet Po Chü-i (772–846) records his response to similar inspiration in Chang Tun-chien's works. For art criticism that parallels this literary approach, we must turn to a few passages in the *Li-tai ming-hua chi* on Wu Tao-tzu or the earlier Ku K'ai-chih. There the creative act is described in phrases that stress concentration of spirit and harmony with natural creation. The lingering influence of these Taoist concepts on literati art criticism will be discussed in chapter 5.

Chang Yen-yüan's *Li-tai ming-hua chi* has been translated in two volumes by William Acker. The excerpts in this chapter from the introductory essays (Books 1 to 3) are based on his version; excerpts from the biographies of painters are based on a translation by Hsio-yen Shih. Chu Ching-hsüan's *T'ang-ch'ao ming-hua lu* has been rendered in its entirety by Alexander Soper, and slightly modified excerpts are quoted here. Fu Tsai's essay was translated in part by Michael Sullivan, and a section of Po Chü-i's record by Susan Bush; slightly modified excerpts are quoted here. The passages from P'ei Hsiao-yüan's *Chen-kuan kung-ssu hua-lu* were translated by Hsio-yen Shih. The topic headings in this chapter generally follow a sequence suggested by the introductory essays of the *Li-tai ming-hua chi*.

The Significance of Painting

Chu Ching-hsüan (ca. 840)

I have heard that men of old said that a painter is a sage; doubtless because he searches out that which is beyond heaven and earth, and reveals that which is unillumined by the sun and moon. When he wields a fine pointed brush, an endless variety of things issues forth from his mind. When he displays his talent within a square inch, a thousand miles lie within his grasp. As for conveying the spiritual (*i-shen*) while determining the material (*ting-chih*), when the light ink

falls upon white silk that which has physical appearance (*hsiang*) is established, and that which is formless is created. [The painting] may have the beauty of Hsi-shih who could not hide her charms or be as true as the ugliness that Mu-mu could not alter. That is why terraces and pavilions exhibit the ardor of meritorious officials [in painted murals], while palaces and great halls display the fame of chaste and virtuous ladies. If the subtleties [of these works] penetrate to the spiritual (*shen*), then their quintessence (*ling*) will arrive at the sage-like.

> *T'ang-ch'ao ming-hua lu* (Record of Famous Painters of the T'ang Dynasty, *TCMHL*), preface. *CKHLLP*, pp. 22–23.

Chang Yen-yüan (ca. 847)

Now, painting is a thing which perfects civilized teachings and helps social relationships. It penetrates completely the divine permutations of nature and fathoms recondite and subtle things. Its merit is equal to that of the Six Classics,[1] and it moves side by side with the four seasons. It proceeds from nature itself and not from [human] invention or transmission . . .

Maps and pictures contain the greatest treasures of the empire, the strands and leading ropes which can regulate disorders . . . What has this in common with the mental activity required for [mere amusements like] chess or checkers? Without doubt, [painting] is one of the things which may be enjoyed within the teachings of Confucianism.

> *Li-tai ming-hua chi* (Record of Famous Painters of All the Dynasties, *LTMHC*), Book 1, "On the Origins of Painting." *CKHLLP*, pp. 27, 28, 29.

Origins of Painting

P'ei Hsiao-yüan (ca. 639)

After Fu-hsi received the Dragon Chart [of divination hexagrams], scribes became the officials responsible for pictures. They had the

1. The Six Classics are usually designated as the *Shih ching* (Book of Songs), *Shu ching* (Book of Historical Documents), *Li chi* (Book of Rites), *Yüeh ching* (Book of Music), *I ching* (Book of Changes), and *Ch'un-ch'iu* (Spring and Autumn Annals). Acker, I, 61, equates the *liu-ching* (Six Classics) with the *liu-i* (Six Arts) taught to the sons of Chou Dynasty rulers—ceremony, music, archery, charioteering, writing, and reckoning.

work of embodying entities (*t'i-wu*) so as to illuminate the distant and reveal the obscure, matching and ordering the multitude of images. Ever since heaven and earth's earliest beginnings, pictures have defined and regularized those things which have form and can be understood, as well as what remains of the activities of former worthies. All these were sought after and described. Coming to the periods of [the legendary emperor] Yü, and [the first dynasties] Hsia, Shang, Chou, Ch'in, and Han, all had scribes responsible [for pictures]. Though such [works] met with disaster and were dispersed, some ultimately returned [to official protection]. By the time of the Three Kingdoms' Wu and Wei, the Chin and Liu-Sung dynasties, the world was full of extraordinary people, all with minds and eyes intercommunicating, so that the Tao of paintings began to be renewed. Loyal officials and filial sons, the virtuous and the doltish, the beautiful and the ugly— all such examples were depicted on walls to instruct posterity so that thought of the meritorious would endure a thousand years and attention to the heroic for a hundred dynasties. Thus, [painters'] minds preserved such admirable remains and in contemplation constructed the proper forms. All other subtleties of moral example were absorbed and then realized [by them] accordingly. All that flies, floats, bounds, or scuttles, that can be examined by the eye, can be depicted in painting. Moreover, artistry and learning vary. Therefore, the classification of former worthies has a considerable range.

> *Chen-kuan kung-ssu hua-lu* (Record of Paintings in Public and Private Collections in the Chen-kuan Era, *CKKSHL*), preface, dated to 639, excerpt. *CKHLLP*, p. 16.

Chang Yen-yüan (ca. 847)

When the sages of antiquity and the first kings accepted Heaven's command and received the [divine] tablets, they thereby came to hold the magic power in the Tortoise Characters and the proffered treasure of the Dragon Chart . . . Accordingly [Ts'ang Chieh] combined the footprints of birds and [the markings] of tortoises and at last determined the forms of written characters. Then Creation could no longer hide its secrets, therefore showers of grain fell from the sky; supernatural beings could no longer hide their shapes, therefore the demons howled at night.

 At that time writing and painting were still alike in form and had not yet been differentiated. Standards for their formation had just been created and were still incomplete. There was nothing by which ideas could be transmitted, hence writing proper came into existence.

There was nothing by which shapes could be made visible, hence painting came into being. This was the intent of Heaven, Earth, and the sages.

According to that branch of learning known as paleography, there are six styles of script . . . of which the sixth is "bird writing." The bird heads which are depicted at the ends of characters on signal flags are, after all, a kind of painting . . .

The Director of the Imperial Banqueting Court Yen Yen-chih [384–456] said that the word for depiction (*t'u*) contains three concepts. The first is the representation of principles, and the forms of the hexagrams are such. The second is the representation of knowledge, and the study of written characters has to do with this. The third is the representation of forms, and this is painting.

Again, in the *Chou [Li]* (Rites of the Chou), the sons of princes and high officials are instructed in the Six Scripts. The third of these is given as the imaging of forms, which is the concept of painting. Hence, we may know that, though writing and painting have different names, they are yet of the same substance . . .

At the time when the [legendary] Emperor Shun's [ancient symbols] in the five colors were made, paintings became clearly distinguished; when there was an ornamental display [of designs], the correspondence to forms was deepened. Then ritual and music were widely developed, and culture was thereby raised. Therefore, men were able to behave with propriety and the empire was at peace; men were brilliant and literature was fully developed.

The *Kuang-ya* lexicon [compiled in the 3rd century A.D.] says: "To paint is to cause to resemble." The *Erh-ya* lexicon [compiled earlier in the 5th–4th century B.C.] says: "To paint is to give form." The *Shuo-wen* dictionary [A.D. 121] says: "The character for 'to paint' or 'painting' (*hua*) is [derived from] the raised paths between fields. It gives the appearance of boundary paths and edges of fields, and therefore is itself a drawing." The *Shih-ming* dictionary [A.D. 100] says: "[The character] *hua* has to do with [the character] *kua* [signifying to place upon, lay down or hang upon]. It means to set down the appearance of things with the use of colors."

Accordingly, when tripods and bells were inscribed, then imps and goblins were made recognizable, and supernatural evils were made known. When the designs on pennants were made clear, then rules and regulations were distinguished, and state institutions were fully established . . .

[Paintings of] the loyal and those with filial piety were complete on the Cloud Terrace [of the Southern Palace in the Later Han Dynasty],

and [depictions of] the valorous and those with distinguished service
were all placed on the Unicorn Pavilion [in the Former Han]. To see
the good is sufficient to warn against evil, and the sight of evil will
make men long for virtue. [These exemplars] were preserved in shape
and appearance in order to illustrate instances of the triumph of
morality. Full account was given of their successes and failures in
order to transmit some traces of the past. While written records and
chronicles served to relate their deeds, they could not convey their
appearance; odes and panegyrics sang of their beauty, but could not
give them shape. It is in the fashioning of drawings and paintings
that [appearances and shapes] may be included.

> *LTMHC,* Book 1, "On the Origins of Painting." *CKHLLP,* pp. 27–28.

Period and Regional Styles

Chang Yen-yüan (ca. 847)

The paintings of high antiquity were simple in technique and modest
in conception, yet had an elegant propriety. Such was the school of
Ku K'ai-chih and Lu T'an-wei [in the later 4th and 5th centuries].
The paintings of middle antiquity were delicate and dense, refined
and close-knit, yet exceedingly charming. Such was the school of Chan
Tzu-ch'ien and Cheng Fa-shih [in the later 6th century]. The paintings
of recent times were gorgeous and brilliant, aiming at perfection.
However, paintings of modern men are confused and messy, alto-
gether meaningless. These are the works of the mass of artisans.

> *LTMHC,* Book 1, "Discussing the Six Elements of Painting." *CKHLLP,*
> p. 32.

I shall now distinguish between three periods of antiquity by which
to determine relative values. The Han and Three Kingdoms may be
considered high antiquity . . . The Chin and Liu-Sung may be con-
sidered middle antiquity . . . The Southern Ch'i, Liang, Ch'en, East-
ern and Western Wei, Northern Ch'i and Chou, may be considered
later antiquity . . . The Sui and early T'ang have the value of recent
times . . .

The paintings of high antiquity were primitive and summary, and
their fame is empty, since examples of such cannot be examined in
sufficient measure. The paintings of middle antiquity combine grace
and primitive force and are valued by the world—works such as those

by Ku K'ai-chih and Lu T'an-wei being in urgent demand among men. The evaluation and classification of paintings from later antiquity are comparatively easy to understand, for these works have to do with things in which modern people take delight.

> *LTMHC*, Book 2, "On Grading by Name and Price." *CKHLLP*, pp. 1223–1224.

If one is to discuss costumes and equipages, local customs and peoples, each differs according to the period and [its origin] in either north or south. The proper way to look at paintings consists in close observation . . . If [a painter] carefully distinguishes between ancient and modern things and deliberately differentiates the usages of local custom in his description of events and depiction of forms, the period [of his painting] will be verifiable.

Some [men] lived their whole lives under a southern dynasty and never saw the people or things of the north. Some were accustomed to areas beyond the northern borders and were unacquainted with the mountains and streams south of the Yangtze River. Others dwelt and traveled in the lower Yangtze region, knowing nothing of the glorious capital at Lo-yang. These are not faults in painting . . . Those of meticulous understanding should carefully analyze the finest masterpieces of both north and south, as well as the famous works of ancient and modern times alike, then only should they discuss painting.

> *LTMHC*, Book 2, "Discussing the Schools and Their Transmission in the Period of North and South." *CKHLLP*, p. 447.

Definition, Animation, and Expression

Chang Yen-yüan (ca. 847)

Long ago Hsieh Ho said that painting has Six Elements [or Laws]. The first is called "engender [a sense of] movement [through] spirit consonance." The second is called "use the brush [with] the 'bone method.'" The third is called "responding to things, image [depict] their forms." The fourth is called "according [adapting?] to kind, set forth [describe] colors [appearances]." The fifth is called "dividing and planning, positioning and arranging." The sixth is called "transmitting and conveying [earlier models, through] copying and tran-

scribing."[2] Since ancient times few painters have been able to combine these. I will attempt to discuss the matter as follows.

The painters of antiquity were sometimes able to transmit formal likeness while endowing it with a noble vitality (*ku-ch'i*). They sought for what was beyond formal likeness in their painting. This is very difficult to discuss with vulgar people. As for today's painters, even if they attain formal likeness, they do not generate spirit resonance (*ch'i-yün*). If they were to explore painting through spirit resonance, then inevitably formal likeness would reside in it . . .

Now, the representation of things necessarily consists in formal likeness, but likeness of form requires completion by a noble vitality. Noble vitality and formal likeness both originate in the definition of a conception and derive from the use of the brush. That is why those who are skilled in painting often excel in calligraphy as well.

In any case, the palace ladies of yore did have dainty fingers and small bosoms, and the horses of antiquity, sharp muzzles and slim bellies; ancient terraces and pavilions were lofty and towering; and antique robes and ornament, ample and trailing. Accordingly, the paintings of olden times were not merely aberrant in appearance or of strange conception. Probably, the appearances of things were different.

As for terraces and pavilions, trees and rocks, chariots and horses, and artifacts in general, these have no vital movement that could be embodied and no spirit resonance that could be matched. They require placement and alignment, and that is all. As Ku K'ai-chih said: "In painting, human figures are most difficult, then landscapes, then dogs and horses. Towers and pavilions are fixed objects, and comparatively easy to do." These words are to the point.

As for demons, divinities, and human figures, they possess vital movement that can be described and require spirit resonance (*shen-yün*) for completion. If spirit resonance is not pervasive, then the display of formal likeness will be in vain. If brush strength is not vigorous, then excellence in application of colors will be in vain. This may be called unsubtle work. Therefore, Han Fei-tzu said: "Dogs and horses are difficult, but demons and divinities easy, for dogs and horses are generally and commonly seen, while demons and divinities

2. Here the Six Laws, cited as four-character phrases in the text, are given in James Cahill's translation in "The Six Laws and How to Read Them," p. 380. See chapter 1 at "Criteria for Appreciation and Criticism" for the Six Elements of Hsieh Ho; also see the discussion in the Introduction.

are deceptive and uncanny apparitions."[3] These words are to the point.

As for division and planning, or placement and arrangement, these are the universal requirements for all painting.

Works by Ku K'ai-chih, Lu T'an-wei, and their successors have rarely been preserved, so that it is difficult to give an exhaustive and detailed account of them. Only when we look at the works of Wu Tao-tzu can we say that the Six Elements were entirely perfected, hence the myriad phenomena were entirely exhausted, as though a divinity had borrowed his hand to reach the limits of creation itself. Therefore, such was his virile manifestation of spirit resonance that it could scarcely be contained upon painting silk, such the rugged freedom of his brushwork that he had to represent his ideas on mural walls. His painting in smaller scale was most dense and detailed, and this also is a divinely wonderful thing.

As for transmission by copying, or reproduction by imitating, this should be the painter's last concern.

However, contemporary painters are but roughly good at describing appearances, attaining formal likeness but without its spirit resonance; providing their colors but lacking in brush method. How can such be called painting? Alas, the men of today have not achieved excellence in this art . . . Painters now mix their brushes and inks with dust and soil, and combine their pigments with mud and lees. All they do is defile the silk. How can this be called painting?

> *LTMHC*, Book 1, "Discussing the Six Elements of Painting." *CKHLLP*, pp. 32–33.

Comments on Specific Artists (from the *TCMHL* of Chu Ching-hsüan [ca. 840] and the *LTMHC* of Chang Yen-yüan [ca. 847])

WU TAO-TZU (8TH CENTURY). Chang Huai-kuan (active 713–741) said: "In Master Wu's painting, spirit was there as soon as his brush descended. Thus he was the reincarnation of Chang Seng-yu."

> Quoted in the *LTMHC*, Book 9. *CKHLLP*, p. 403.

[Wu Tao-tzu] also painted the "Five Sages [T'ang Emperors] and Their Thousand Officials" in the Taoist Temple (Hsüan-yüan Miao).

3. See chapter 1 at "Problems of Representation" for both Han Fei-tzu's and Ku K'ai-chih's statements as cited elsewhere.

[The painting's] palaces and halls and figures in ceremonial dress, all seemed to aspire to the clouds and dragons, so that one's mind was turned to the creative powers of Nature. Therefore, the Assistant Department Director Tu Fu's poem said, "Their dense ranks turn the earth on its axis; / A wondrous perfection shakes the palace walls."

He painted, as well, five dragons in the Inner Hall, whose scaly armor moved in flight. Whenever it was about to rain, a mist would rise from them . . .

Early in the Yüan-ho reign [806–821], I was staying at the Temple of Dragon Ascension (Lung-hsing Ssu) while taking my examinations. There I found an old man [named] Yin, over eighty years of age, who once told of the time when Master Wu painted the halo on a divinity inside the central gate of the Temple of Renewed Virtue (Hsing-shan Ssu). Then all the people of Ch'ang-an, old and young, gentry and commoners, came rushing until the spectators were like a surrounding wall. For the halo, he raised his brush and swept it around with the force of a whirlwind. Everyone said that a divinity must have aided him.

I also once heard an old monk of the Temple of Brilliant Clouds (Ching-yün Ssu) relate that when Master Wu had painted a hell cycle in this temple, the capital's butchers and fishmongers were terrified for their sins on seeing it and occasionally changed their trades. All of the good deeds that he painted here generally also became models for men of later generations.

TCMHL, "Inspired Class, Top Grade."

CHANG HSÜAN (8TH CENTURY). He excelled in rough sketches, bringing things to life with a touch. In composition of scenery, he exhausted all the subtleties of pavilions and terraces, trees, flowers, and birds.

TCMHL, "Excellent Class, Middle Grade."

CH'EN HUNG (8TH CENTURY). He excelled in portraiture and in painting figures and gentlewomen . . . He also described the august visage of Emperor Su-tsung [r. 756–763] for the Palace of Great Purity (T'ai-ch'ing Kung) with the forms of the dragon countenance and phoenix posture, the forehead mounting like the sun and moon. Moreover, his brush strength was moist and rich, and his stylistic tone

distinguished and unusual as if to tally with the auspicious signs [of sovereignty]. Truly, Heaven lent him this ability.

TCMHL, "Excellent Class, Middle Grade."

WEI YEN (8TH CENTURY). With racing strokes, he would touch to life saddle horses, figures, landscapes, clouds, and mists. [His horses] had a thousand variations and myriad attitudes: prancing or reclining, eating or drinking, startled or still, walking or rising, standing alert or moving slowly . . .

TCMHL, "Excellent Class, Top Grade."

PIEN LUAN (ACTIVE LATER 8th–EARLY 9TH CENTURY). His forte was in flower and bird painting. He never acquired the subtleties of bent branches, grasses, and trees. If one examines the lightness and sharpness of his use of the brush, the freshness and clarity of his use of colors, [one sees that] he understood the varied postures of his birds and animals and captured the scent and beauty of flowers.

During the Chen-yüan era [785–804], the Kingdom of Silla sent some dancing peacocks as tribute. The Emperor Te-tsung [r. 780–805] commanded that they be painted in the Hall of the North (Hsüan-wu Tien). One was shown from the front, the other from the rear, with their iridescent colors moving with life, their golden plumage flowing and flashing; it was as if their clear voices were linked to the complicated measures of the dance.

TCMHL, "Excellent Class, Middle Grade."

CHOU FANG (CA. 730–CA. 800). When Chao Tsung's wife went home to visit her parents, [her father] Kuo Tzu-i [697–781] asked, "Who is it in these paintings [two portraits of her husband by Han Kan and Chou Fang]?" She answered, "The Board Vice-President Chao." He asked again, "Which is the better likeness?" She replied, "Both paintings are likenesses, but the second one is better." Again he asked, "Why do you say that?" She responded, "The first painting has merely captured my husband's appearance, while the second has also conveyed his spirit vitality (*shen-ch'i*). It has caught his personality and his manner of laughing and talking." Tzu-i demanded, "Who did

the second painting?" The answer was, "The Commandant Chou Fang."

TCMHL, "Inspired Class, Middle Grade."

WEI WU-T'IEN (8TH CENTURY). The characters of beasts may have the nobility of individual courage or the virtue of docile obedience to man, for they vary as do their claws and hooves, or pelts and manes. Painters of earlier generations might indicate an animal's anger by a gaping mouth, or its contentment with a lowered head, but none could distinguish its temperament with a single movement of the brush, or identify its species by dashing on a single hair. What the ancients could not do, only Master Wei could.

TCMHL, "Excellent Class, Top Grade."

T'AN CHIH-MIN (7TH CENTURY). Yen-ts'ung (ca. 650) said: "For buildings, towers, and terraces, with light and shadow opposed, one could look through all the past and only find them in this man's [work]."

Quoted in the *LTMHC,* Book 9. *CKHLLP,* p. 384.

HAN KAN (8TH CENTURY). He was most skilled in horse painting. First he studied under Ts'ao Pa, but later commanded himself alone. Tu Fu's "Song for Ts'ao Pa's Horse Painting" says

His disciple Han Kan early entered the sanctum;
Also competent at painting horses, he fathomed their special
 features.
But Kan only painted their flesh, and not their bones,
Allowing the noble steeds' vitality to decline and be lost.

I wonder how Tu Fu could have been considered a connoisseur of painting. Just because Kan's horses are plump and large, he ridiculed them as paintings of flesh.

There is an *Eight Steeds* scroll by an ancient painter, which some say was the work of Shih Tao-shih [active early 5th century], and others the work of Shih Ts'an [5th century]. All these horses are dragon-necked and bodied, shooting forth like arrows and darting like lightning, without the appearance of horses at all. During the Chin and Liu-Sung dynasties, such painters as Ku K'ai-chih and Lu T'an-wei were already extolled for changing the pace; in the Northern

Chou and Ch'i the schools of Tung Po-jen and Chan Tzu-ch'ien were also said to have changed attitudes. Though they eliminated distortions, theirs were still only the breed of Ch'ü [Shansi] and the colts of Shu [Szechwan], retaining an alert, prancing appearance and lacking a peaceful, leisurely mien. As for the coloring of their pelts, they were mainly tans, chestnuts, and grey or bay piebalds and had no other rarities.

Hsüan-tsung [who reigned 713–756] was fond of big horses, and the imperial stables contained some four hundred thousand of these . . . Once the empire had been unified, there came yearly tributes [of horses] from the Western Regions and Ta-yüan [Central Asia and the Uzbeck Region of Russian Turkestan], and so the Emperor commanded the establishment of grazing lands for horses in the highlands [Kansu] . . . Kan depicted all [the horses in the imperial stables], thus becoming the sole master [in this subject for all time].

> *LTMHC,* Book 9.

Training

Chu Ching-hsüan (ca. 840)

HAN KAN (8TH CENTURY). In the T'ien-pao era [742–755], Hsüan-tsung summoned him to serve at Court. The ruler ordered him to take Ch'en Hung [a slightly older contemporary] as his master in painting horses; then, being surprised to find [Han's work] dissimilar, [the Emperor] had him questioned. His explanation was: "I already have a master; the horses in the imperial stables are all my masters." The Emperor thought him unusual.

> *TCMHL,* "Inspired Class, Bottom Grade."

When Chou Fang (ca. 730–ca. 800) picked up his brush to begin painting, the people of the capital came struggling for a view at the temple, knocking against its garden gates. The wise and the ignorant alike came—some speaking of the painting's subtleties, others pointing out its flaws. He made revisions in accordance with their ideas. After a month or so, all talk of either merit or defects had ceased, and there was none but praised his refinement and subtlety. He became the foremost painter of the time.

> *TCMHL,* "Inspired Class, Middle Grade."

Chang Yen-yüan (ca. 847)

Once, T'ien Seng-liang, Yang Ch'i-tan, and Cheng Fa-shih [all late 6th–early 7th century] were together painting the small pagoda at the Temple of Luminous Light (Kuang-ming Ssu) in the capital [at Ch'ang-an]. Cheng made pictures on its east and north walls, T'ien on its west and south walls, while Yang painted the four sides of its exterior. These were called the "Three Incomparables." Yang used mats to conceal the place where he was painting, but Cheng stole a look at his work, then said to Yang: "Your painting could never be imitated, so why bother to conceal it with screens?" Yang especially entrusted Cheng with the arrangement of his marriage, for they were intimate as neighbors. Cheng also once asked for Yang's preparatory sketches, whereupon Yang led Cheng to the Imperial Court; pointing to its palaces and towers, the robes and caps of officials, their chariots and horses, he said: "These are my preliminary sketches." Therefore, Cheng greatly admired him.

 LTMHC, Book 8.

Brushwork

Chang Yen-yüan (ca. 847)

Someone asked how I would describe the brushwork of Ku, Lu, Chang, and Wu. I replied: "The [brush] strokes of Ku K'ai-chih [ca. 345–ca. 406] are strong in firmness and uninterrupted in continuity, circling back upon themselves in abrupt rushes. His tone and style are untrammeled and varied; his atmosphere and flavor sudden as lightning. His conception was formulated before his brush [was used], so that when the painting was finished the conception was present. Thus he completed its spiritual breath (*shen-ch'i*).

 Formerly Chang Chih [active mid-2nd century A.D.] studied the cursive script methods of Ts'ui Yüan [77–142] and Tu Tu [also of the Later Han Dynasty]. Relying on them and altering them, he formed the stylistic appearance of modern cursive script. He completed [a sequence of characters] in one stroke with a vein of nervous energy running continuously through it, and without breaks to divide columns. Only Wang Hsien-chih [344–388] understood these profound objectives, hence the character at the top of a line is occasionally connected with the preceding column. This is popularly known as "one-stroke calligraphy."

Later Lu T'an-wei [5th century] also made one-stroke painting without breaks in the continuity [of its brushwork]. Thus we may know that the brush is used in the same way for both calligraphy and painting. Lu T'an-wei's work is finely sharp yet smoothly charming, original, and infinitely subtle. His fame was at its height during the Liu-Sung Dynasty [420–478], and he had no rivals in his time.

Chang Seng-yu [6th century] made his dots, dragged strokes, hacking strokes, and sweeping strokes in accordance with the Lady Wei's [essay on use of the brush in calligraphy] "Battle Strategy of the Brush."[4] Each of his dots and strokes was a skill in itself. His hooked halberds and sharp swords bristle as dense as forests. From this too, one can see that the use of the brush in calligraphy and painting is the same.

Wu Tao-tzu [8th century] of the present dynasty stands alone for all time. He did not look back to Ku and Lu and will have no successors. He learnt his brush methods from Chang Hsü [active first half of 8th century] which shows yet again that the use of the brush in calligraphy and painting is identical. Since Chang was called the Madman of Calligraphy, Wu may well be known as the Sage of Painting. His spirit borrowed from the creative powers of Heaven, and so his noble genius was inexhaustible. While all others took pains to join the ends [of strokes], he for his part broke up and left spaces between his dots and strokes. While all the rest paid careful attention to verisimilitude, he rid himself of such vulgarities. His curved bows, straight blades, vertical pillars, and horizontal beams, did not require the use of marking lines or rulers. His bristling whiskers and curled coiffures stream out several feet, yet the firm strength with which each hair was rooted to the flesh is entirely satisfactory. There must have been some orally transmitted secret for this which no one [now] can know. In a painting dozens of feet high, he would sometimes begin with the arms, and at other times start from the feet. The interlacing of veins on the skins of these gigantic supernatural beings surpasses [comparable works by] Chang Seng-yu.

Again I was asked: "How was it that Master Wu could curve his bows, straighten his blades, make vertical his pillars and horizontal his beams, without use of marking line and ruler?" I answered: "He

4. The essay as it exists today, though attributed to a famous Later Han Dynasty calligrapher the Lady Wei (d. 140), is generally considered to be a sixth-century composition based on the ideas of Wang Hsi-chih (309–ca. 365). See Richard M. Barnhart, "Wei Fu-jen's *Pi-chen T'u* and the Early Texts on Calligraphy," *Archives of the Chinese Art Society of America*, 18 (1964), 13–25.

kept watch over his spirit, concentrating upon his own unity. Being
in harmony with the work of Creation itself, [his spirit] could borrow
Master Wu's brush. This is what was earlier described as 'formulating
the conception before the brush is used, so that when the painting is
finished the conception is present' . . . Now, if one makes use of mark-
ing line and ruler, the result will be dead painting. But if one guards
the spirit and concentrates upon unity, there will be real painting. Is
not plain plaster better than dead paintings? Yet even one stroke of
a real painting will show its breath of life (*sheng-ch'i*). Now, the more
one revolves thought and wields the brush while consciously thinking
of oneself as painting, the less success one will have when painting.
If one revolves thought and wields the brush without ideas fixed on
[the act of] painting, one will have success. [Painting] is not stopped
in the hand, nor frozen in the mind, but becomes what it is without
conscious realization. Though one may bend bows, straighten blades,
make vertical pillars, and horizontal beams, why should marking lines
and rulers enter into this?"

Again I was asked: "Now, if the brushwork of one who thinks
meticulously and profoundly is exact and detailed, what can one say
about those whose brushwork is sometimes incomplete?" I replied:
"The divine quality of Ku and Lu is that one cannot see the ends [of
their strokes], which is what you call exact and detailed brushwork.
The subtle virtue of Chang and Wu is that with just one or two strokes
the image is already reflected. They broke up and left spaces between
dots and strokes, and sometimes one sees their omissions, but this is
what may be described as complete conception though incomplete
brushwork. Only when you understand that there are two styles of
painting, the sparse and the dense, can you join in discussion about
painting."

> *LTMHC*, Book 2, "On the Brushwork of Ku, Lu, Chang, and Wu."
> *CKHLLP*, p. 35–37.

Now, fashioned and distilled by [the interaction of] *yin* and *yang*, the
myriad phenomena were strewn and spread [through the universe].
Mysteriously evolving without speech, [Nature's] divine work operates
by itself. Grasses and trees spread forth their glory without depending
upon cinnabar and azurite; clouds and snow whirl and float aloft, and
are white with no need for ceruse. Mountains are green without need-
ing malachite, and the phoenix is iridescent without the aid of the
five colors. For this reason one may be said to have fulfilled one's aim
when the five colors are all present in the management of ink [alone].

If one's mind dwells on the five colors, then the images of things will go wrong.

In painting things one should especially avoid a meticulous completeness in formal appearance and coloring, and extreme carefulness and detail that display skill and finish. Therefore, one should not deplore incompleteness, but rather deplore completeness. Once one knows [a thing's] completeness, where is the need for completing it [in painting]? This is not incompleteness. Should one not recognize [a thing's] completeness, that is true incompleteness . . .

There was a clever painter who said of himself that he could paint cloud vapors. I said to him: "The ancients never reached this final subtlety in their painting of clouds. If one moistens silk, dotting and filling in here and there with a light powder blown from the mouth, this is known as blown clouds. Such [a technique] is in accord with the principles of Heaven, but, though it may be called a subtle solution, one cannot see the brush strokes in it, therefore it cannot be called painting. It is comparable to the splashed ink [technique] of landscape painters, which also cannot be called painting as it is not suitable for copying."

> *LTMHC*, Book 2, "On Painting Materials, Tracing and Copying." *CKHLLP*, p. 37 (in part).

Comments on the Brush Techniques of Various Sui and T'ang Artists (from the *TCMHL* of ca. 840 and the LTMHC of ca. 847)

LIU HSIAO-SHIH (7TH CENTURY). Yen-ts'ung (ca. 650) said: "Though his dots and strokes are few, each is absolutely essential. His birds have unusual variations in movement and are most true to life."

> Quoted in the *LTMHC*, Book 9. *CKHLLP*, p. 382.

SUN SHANG-TZU (ACTIVE LATE 6TH CENTURY). Li Ssu-chen (d. 696) said: "He excelled in the style of the 'trembling' brush and had much vital strength (*ch'i-li*). His [painting of] clothing, hands and feet, tree leaves and river currents, all moved in trembling [lines]. Only in whiskers and hair were [the lines] disposed smoothly. Others who imitated this technique could never achieve it. This was his own extraordinary manner."

> Quoted in the *LTMHC*, Book 8. *CKHLLP*, p. 396.

FAN CH'ANG-SHOU (7TH CENTURY). Tou Meng (late 7th century) said: "Freely he seized and grasped the brush, dropping it on paper as if in flight. Although he lacked restraint, still he was a good painter."

Quoted in the *LTMHC*, Book 9. *CKHLLP*, p. 391 (in part).

WEI YEN (8TH CENTURY). The smallest [of his horses] might have its head made by a single dot, or its tail by a single sweep [of the brush]. For mountains he would lay down ink [washes]; for water he would rub with his hands. He completely exhausted the subtleties [of such techniques], accordingly [his work] is true to life.

TCMHL, "Excellent Class, Top Grade."

WU TAO-TZU (8TH CENTURY). During the K'ai-yüan era [713–742] . . . Master Wu became acquainted with General P'ei Min . . . At that time General P'ei Min invited Tao-tzu to the Temple of the Heavenly Palace (T'ien-kung Ssu) in Lo-yang, sending him handsome gifts of gold and silks which he was to use as he saw fit for his painting. Tao-tzu sealed and returned the gold and silks without taking a single article. He said to Min: "I have long heard of General P'ei. If you would perform but one sword dance for me, the honor would be quite sufficient, and the sight of its vigor might aid me in wielding my brush." Accordingly Min, though still in mourning robes, performed a sword dance for Tao-tzu. No sooner was it finished than the brush was seized and in no time [a painting] was completed. It was as though he had the help of some divinity, to such an extent was [Wu's painting] superior. Tao-tzu also personally applied its colors.

Whenever I have seen paintings by Master Wu, I have never thought that their ornamentation or mounting was very remarkable. Only the play of his brush is incomparable, in all cases profusely varied and with an untrammeled energy. Moreover, in some places his wall-paintings are carried out in ink alone, and no one in recent times has been competent to add color to them. Whenever he painted haloes he never used a compass, but completed them in a single stroke.

TCMHL, "Inspired Class, Top Grade."

Wu loved wine, which stimulated his vital breath. Whenever he wished to flourish his brush, he had to become intoxicated . . . Because he did not perfect the study of calligraphy, he became skilled in painting . . . In the K'ai-yüan reign the General P'ei Min excelled in sword dancing. Tao-tzu watched Min dancing with the sword, and so ob-

served the divine strength of its appearance and disappearance. When the dance was finished his wielding of the brush greatly improved . . . Thus, we know that the arts of calligraphy and painting both must be formed by mental vitality, and neither can be done by the timid.

LTMHC, Book 9.

CHANG TSAO (8TH CENTURY). He was skillful in his handling of the brush. Once he held a brush in each hand and used both simultaneously, creating a live branch with one hand and a decayed one with the other. [The tree's] vital spirit scorned mist and haze; its force defied wind and rain. Its crooked angular forms and scaly rough appearance were freely rendered according to his thoughts and emerged from obedient hands. The live branch was lush with the saps of spring; the decayed one forlorn as the colors of autumn.

TCMHL, "Inspired Class, Bottom Grade."

Earlier, the Senior President of the Crown Prince's Grand Secretariat, Pi Hung [8th century], was the period's most famous [painter]. Once he had seen [Chang Tsao's painting], he exclaimed in astonishment. He marveled that Tsao used only blunt brushes, or else rubbed the silk with his hands, hence he asked from whom Tsao had learned [his techniques]. Tsao replied: "Externally all Creation is my master. Internally I have found the mind's sources." Thereupon, Pi Hung put away his brushes.

LTMHC, Book 10.

WANG MO (D. CA. 800). He excelled in splattering ink to paint landscapes, hence he was called 'Ink Wang' . . . There was a good deal of wildness in him, and he loved wine. Whenever he wished to paint a hanging scroll, he would first drink, then after he was drunk he would splatter ink. Laughing or singing, he would kick at it with his feet or rub it with his hands, sweep [with his brush] or scrub, with the ink sometimes pale and sometimes dark. According to the forms and appearances [thus produced], he would make mountains and rocks, clouds and water. The response of hand to thought was as swift as Creation itself. He would draw in clouds and mists, and wash in wind and rain, as if with a divine dexterity. One can look closely and see no traces of the ink blots. Everyone finds this miraculous.

TCMHL, "Untrammeled Class."

Although [Wang Mo] lacked loftiness and distinction, he was good in the popular taste. When drunk he would take ink on his hair and paint by tossing it upon the silk . . . However, I do not feel that Mo's painting has anything very extraordinary about it.

LTMHC, Book 10.

Landscape

Chang Yen-yüan (ca. 847)

I have seen all the famous works dating from the Three Kingdoms period, Chin Dynasty, and later [that is, 3rd century on] that are still in the world at large. In their painting of landscape, the appearance of crowding peaks resembles hair ornaments or horn combs. Sometimes the water does not support [what is] floating [on it]; sometimes human beings are larger than mountains. Almost always trees and rocks are inserted to encircle areas [within the paintings], and the shapes of these ranked plantings are like the spread fingers of outstretched arms. To explain the significance of the ancients, one should focus upon demonstrating their strengths, and not concentrate on popular changes [in taste and style].

Early in this dynasty, Yen Li-pen and Li-te excelled in their architectural studies, and Yang Ch'i-tan and Chan Tzu-ch'ien concentrated their attention on palaces and towers. They gradually changed the inserted [dividers], yet still in representing rocks they strove for clear cut [lines] as sharp as ice fissures or axe blades; in painting trees they swept on branches, and [outlined] leaves as in fine engraving. [They painted] mainly the auspicious *wu-t'ung* and luxuriant willow, but in redoubling their efforts they only grew more clumsy, and were not worthy of the colors [used].

As for Wu Tao-tzu, he was endowed by Heaven with a vigorous brush, and even as a youth embraced the divine mysteries [of the art]. He sometimes painted the walls of Buddhist temples, boldly using strange rocks and rushing torrents that seemed as if they could be touched or poured out. Furthermore, while on the road to Shu [Szechwan], he described the looks of its landscape. As a result, the evolution of landscape [painting] began with Wu, and was perfected by Li Ssu-hsün [651–718] and Chao-tao [Ssu-hsün's son].

The shaping of trees and rocks became subtle with Wei Yen [8th century], while Chang Tsao exhausted its possibilities. Tsao was able

to use a purple bristled [brush] with a blunt tip, and rubbed color on with his palms. Ingenious ornamentation remains within [such brushwork] while on the surface it appears haphazardly formed.

> *LTMHC*, Book 1, "On Mountains and Waters, Trees and Rocks." *CKHLLP*, p. 603.

Comments on the Landscape Painting of Various T'ang Artists (from the *TCMHL* of ca. 840 and the *LTMHC* of ca. 847)

FAN CH'ANG-SHOU (7TH CENTURY). He enjoyed painting the appearances of popular customs, rural environments, scenery and figures, and many of his works are still owned by people. The modern style of folding screen was his creation. Whenever he painted landscapes, trees, and rocks, they would [seem to] wind forward out of the distance; his cattle, horses, and other domestic animals [seem to be] grazing freely over quiet pastures.

> *TCMHL*, "Excellent Class, Middle Grade."

LI SSU-HSÜN (651–718) AND HIS SON CHAO-TAO. Ssu-hsün's [work] was of a lofty and unusual character, and his landscapes were most subtle. His birds and beasts, grasses and trees, were all perfect in their characterizations. Although Chao-tao painted landscapes, birds and beasts as well, [his work] was too complicated and cunning, and he never equaled Ssu-hsün in intelligence and brush strength.

> *TCMHL*, "Inspired Class, Bottom Grade."

In painting landscapes, trees, and rocks, [Ssu-hsün's] brush character was strong and vigorous. His torrents and streams rush and flow; his clouds and mists dim and obscure. At times [one seems] to see the doings of divinities and immortals secluded amid the recesses of precipices and peaks . . . [Chao-tao] created the subtleties of seascapes.

> *LTMHC*, Book 9.

WU TAO-TZU (8TH CENTURY). Again, during the T'ien-pao era [742–755], Hsüan-tsung suddenly longed for the road to Shu [Szechwan] and the waters of the Chia-ling River. Thereupon, he lent Master Wu post horses and ordered him to go there and describe the scenery. On the day Wu returned, the Emperor enquired about the matter. Wu said: "I have not [brought back] a single sketch but all is recorded

in my mind." Later he was commanded to depict [what he had seen] in the Hall of Great Accord (Ta-t'ung Tien). He finished more than three hundred miles of Chia-ling River scenery in one day. At that time [*sic*] also lived General Li Ssu-hsün [651–718], whose landscapes were famous. The Emperor also commanded him to do a painting in the same hall. It was only completed after several months. Hsüan-tsung said: "Li Ssu-hsün's labor of several months and Wu Tao-tzu's work of a single day, both reached the heights of subtlety."

> *TCMHL,* "Inspired Class, Top Grade."

WANG WEI (701–761). In his painting of the Wang-ch'uan [estate], mountains and valleys are luxuriant and rugged; clouds and water fly and float along. His thoughts were far removed from [worldly] dust, hence unusual things took shape under the tip of his brush. He once wrote of himself in a poem: "In my present life I am wrongly called a poet; / In a former existence I must have been a painter." Such was his self-assurance.

> *TCMHL,* "Excellent Class, Top Grade."

[Wang Wei] was skilled in painting landscapes whose style embraced the present and the past. Those in people's collections were mostly done under his direct supervision by artisans. Spreading colors for the primeval wilderness and densely forming distant trees, they erred in the direction of clumsiness. Yet if they reverted to detailed artfulness, they only missed reality all the more.

The painting of his Wang-ch'uan [estate] on the walls of the Temple of the Pure Source (Ch'ing-yüan Ssu) is virile and forceful in brush strength . . . I once saw a landscape in the broken-ink [technique] in which his brushwork was strong and vigorous.

> *LTMHC,* Book 10.

CHU SHEN (8TH CENTURY). He mastered the subtleties of landscape [painting]. All the way from the [Yangtze] River and [Western] Lake to the capital [Ch'ang-an] his wall and screen paintings, as well as scrolls, are household treasures. It was on the west wall of the Lecture Hall at the Temple of Peace in the T'ang [T'ang-an Ssu] that he realized his ideas most successfully . . . in the shapes of precipitous peaks, the subtleties of layered depths, the limpid color of pools, and the fissure-like patterns of rocks. Cliffs tower upward under his brush; clouds rise from its tip. In the area of a square foot are the gloomy

depths of ravines, interminglings of pines and bamboos, and dark or pale clouds and rain. Though these may have emerged from the breasts of previous sages, they certainly became the models for later generations.

TCMHL, "Excellent Class, Top Grade."

[Chu Shen's landscapes] are deep and profound and firmly delimited, dangerously dark and grandly unconstrained. His torrential rapids [seem to] splash upon one, and his level plains extend to the limits of vision. He was quite famous in the Chien-chung era [780–783].

LTMHC, Book 10.

WANG TSAI (LATE 8th–EARLY 9TH CENTURY). His home was in western Shu [Szechwan]. During the Chen-yüan era [785–804], the Governor Wei Kao received him as an honored guest. In his painting of landscapes, trees, and rocks, he went beyond appearances. Therefore, the Assistant Department Director Tu Fu gave him a poem which said,

> Ten days to paint a rock,
> Five days to paint a stone,
> An expert is not to be hurried along;
> Only so will Wang Tsai leave a true work.

I once saw, in the audience chamber of the late Grand Secretary Hsi K'uei, a picture screen of two trees by a river, one a pine and the other a cedar. An old wisteria vine twisted around them, winding up towards the sky and reaching down to the water. Innumerable branches and leaves were criss-crossed, curved and bent, yet distributed without confusion. Some were withered and others blooming; some growing rank and others drooping; some straight and others inclined. Leaves were piled in a thousand layers, and branches spread forth in all directions. Men of understanding would prize [this work], but vulgar eyes find it difficult to comprehend.

Again, I saw at the Temple of Renewed Virtue (Hsing-shan Ssu) a screen painted with the four seasons. It was as if he had transferred creation itself, its climate and weather, the eight periods and the four seasons, all into one sitting room. It was the very ultimate in subtlety. Hence, for both his landscapes and his pines and rocks, he may be placed in the Excellent Class, Top Grade.

TCMHL, "Excellent Class, Top Grade."

[Wang Tsai] mostly painted the mountains of Shu, with a fine tracery of sunken valleys and the steep irregularities of ingenious peaks.

LTMHC, Book 10.

YANG YEN (727–781). He painted a screen with pines and rocks amidst cloudy emanations that was astir with the creative powers of Nature. Those who saw it all said that it was of an inspired originality.

TCMHL, "Excellent Class, Top Grade."

[Yang Yen] was good at landscapes, which were lofty and unusual, elegant and rich . . . I have seen a landscape painting by him in which, I think, one could see what he was like, imposingly grand yet freely vigorous.

LTMHC, Book 10.

WEI YEN (8TH CENTURY). He excelled in [painting] small horses, cattle, and sheep, as well as mountains and plains. Vulgar people know only that Yen excelled in horse [painting] and do not know that his pines and rocks were even finer. A thousand fathoms within a square foot, close growing branches massed in shadows, mist and haze in screening veils, wind and rain soughing and chill—their encircling contours are exactly like the forms of a parasol, and their sinuous turns completely similar to the shapes of coiled dragons.

LTMHC, Book 10.

CHANG TSAO (8TH CENTURY). The appearance of his landscapes was such that the higher and lower parts were both exquisite, and in the space of a foot there was depth upon depth. His rocks were so pointed that they seemed ready to topple; his springs rushed forward as if with a roar. His foregrounds gave the effect of pressing against one like a barrier; his distances seemed to reach the very limits of heaven.

TCMHL, "Inspired Class, Bottom Grade."

CH'EN T'AN (ACTIVE CA. 780–805). As Prefect of Lien-chou [in Szechwan], he was ordered to depict the appearance of that region's landscape and to submit [his work] to the court annually.

TCMHL, "Competent Class, Top Grade."

[Ch'en T'an] was skilled in [painting] landscapes that have an emotional flavor, but his peaks lack anything remarkable and are often overly profuse or fragmentary.

LTMHC, Book 10.

Appreciation and Connoisseurship

Po Chü-i (772–846)

Young Chang Tun-chien achieved the harmony of nature and the art of the mind, which accumulated to become action and emerged as art. His painting is the ultimate of art. There is no fixed [formula of] skillfulness in painting, resemblance is its skill, just as there is no constant model in learning, truth is the model. In sketching an idea or forming a thing, usually what has been turned over in the mind seems like spiritual insight (*shen-hui*) . . . [In Chang's paintings] he completely exhausted the potential of everything, moving or fixed, large or small, and there were absolutely no circumstances overlooked on any side, no forms concealed on any scale. When one stood back for viewing, it was as if they were [mirrored] in water that clearly defined their reflections. Afterwards one realized that learning that is in the bones and marrow is achieved by mental art, and skill matching creation comes from natural harmony. Chang merely received from his mind and transmitted to his hand, and it was so without his being conscious of its being so. When it comes to the beauty of the brushwork and the modulations of [a work's] tone, I am not a painter and am unable to tell about it. As for what I perceive, I merely see that the forms are true and complete and the spirit harmonious and whole, brilliantly and awesomely, they seem to emerge in front of the painting.

"*Hua chi*" (Record on Painting) in *CKHLLP,* p. 25.

Chang Yen-yüan (ca. 847)

In the days when the empire enjoyed peace, the Tao [of copying] was very popular, but after the troubles [of An Lu-shan's rebellion, 756–758] such things were gradually neglected. Therefore, when there is an unusually fine scroll available, those who make a traced copy of it will help to treasure it. Then one may infer the original work, and the traced copy may also be kept as documentation.

In looking over various paintings, I find that only Ku K'ai-chih's paintings of the ancient sages captured subtle principles. In the presence of these works one is able to look all day without growing weary. Concentrating his spirit and taking his thoughts afar, he gained insight into nature. Objects and self alike forgotten, he departed from form and rejected discrimination. The body can really be made to be like dried wood, the mind like dead ashes. Is this not also to have attained the subtle principle? It is what may be called the Tao of painting.

LTMHC, Book 2, "On Painting Materials, Tracing, and Copying."

A certain person said to me: "In the past Chang Huai-kuan [active early 8th century] wrote his *Shu ku* (Calligraphy Valuation) in which he discusses different grades with the utmost detail. Why do you not arrange famous paintings since ancient times in such order as to make a *Hua ku* (Painting Valuation)?" I, Chang-tzu, replied: "Calligraphy and painting are different Tao which should not be studied without discrimination." For calligraphy, one has but to estimate the [number of] characters in order to settle upon its value, but for painting there are no limits by which to determine the merit. Not only that, but the famous works of the Han Dynasty and Three Kingdoms period have long since vanished from the world. People of today value what they hear while underestimating what they see and are seldom capable of thorough connoisseurship. When the provenance is not in doubt and the object itself is still in existence, then [any] such painting will become an important treasure of a ruler or a great family . . .

Now, when an artist of the middle grade has a period of perfect equilibrium in his work, he can rise to the level of an artist in the top grade. When an artist of the top grade meets with an unsatisfactory day, he may suddenly fall to the middle grade. Only those of the bottom grade, even when in perfect equilibrium, cannot approach the top grade. As for men of wide understanding and experience, the beauty or ugliness [of each of their works] must be judged afresh at the moment of seeing it . . .

Now, there are differences in the use of the brush for large paintings and finely executed paintings. Those who reach the ultimate in their subtleties will have a number of styles. For example, in the calligraphy of Wang Hsi-chih [309–ca. 365], there are naturally a number of styles. Each of the forms of his cursive script merely depended upon the shallowness or depth of his own invention at the

moment. The ultimate subtleties of painting are the same as in calligraphy. This subject requires wide experience of viewing and far-reaching discussions, and cannot be grasped by hasty generalizations.

> *LTMHC,* Book 2, "On Grading by Name and Price." *CKHLLP,* pp. 1223–25.

Now, many of those who are knowledgeable about calligraphy, know about paintings as well, and since ancient times the people who have collected and treasured such works have certainly also been numerous. Therefore, some who formed collections were still unable to be connoisseurs; some were connoisseurs without being skilled in enjoyment of their viewing; some could look at and enjoy paintings yet were unable to mount and back them; and still others understood mounting and backing but entirely lacked any system of classifying paintings. All these are faults in a lover of art . . .

Now, works in the hands of those who do not know how to treasure and enjoy them are abused and insulted by each movement and glance. People who do not know how to roll and unroll scrolls soon cause damage by handling them roughly. People who do not understand mounting and backing will harm scrolls by casting them about casually. Is it not painful that, as a result, genuine works gradually diminish? Calligraphy and painting should not be foolishly entrusted to those who do not love these arts.

One should never look at calligraphy and painting near a fire or candle. Also, one should never look at calligraphy in wind or sunlight, or when one has just been eating, drinking, spitting, or blowing the nose, without first washing one's hands . . .

In the home one should set up a level and steady couch with a mattress on it and, after dusting and wiping it, unroll [the scrolls] and look at them. For big scrolls it is best to build a frame on which to hang them for viewing. All calligraphy and painting, if unrolled from time to time, may be kept free of insects and dampness.

Even since my youth I have been a collector of rare things, assiduous day and night in their connoisseurship and appreciation, and in mounting and putting them in good order. Whenever I hunted down a handscroll or encountered a hanging scroll, I would be sure to mend and repair it diligently, and spend whole days admiring it. When there was a chance of getting something, I would even sell my old clothes and ration simple foods. My wife, children, and servants nag and tease me, sometimes saying: "What good is it, doing [such a] useless thing

all day?" At which I sigh and say: "If one does not do such useless things, then how can one take pleasure in this mortal life?" Thus my passion grows ever deeper, approaching an irresistible craving.

Each clear dawn in quiet surroundings, with bamboos before the window and pines above the eaves, I find greater luxury of no consequence and deliberate austerity wearisome. As for the bonds beyond the body, I have no superfluous objects about me. Only in calligraphy and painting have I not yet forgotten emotion. Intoxicated by them I forget all speech; enraptured I gaze at and examine them. It is my constant regret that I have never been able to examine personally the famous works of the Imperial Repository and so derive instruction from the wide variety of calligraphy and painting in it. Also, lovers of these arts are reluctant to lend works. Worse still, they have few genuine examples. In calligraphy I have not been able to learn good brush methods and cannot compose characters [properly]. That I have thus allowed my family's fame to fall is my lifelong sorrow. In painting, too, my work does not come up to my idea, but then I do it to amuse myself alone. Does this not seem wiser, after all, than all that burning ambition and ceaseless toil when fame and profit war within one's breast?

> *LTMHC*, Book 2, "On Connoisseurship, Preservation, Collecting, and Appreciation." *CKHLLP*, pp. 1225–26.

Concerning pictures and manuscripts, the main thing is that they be complete from beginning to end. Famous works of art are not in a realm wherein one may lightly speak of cutting them up and altering them. If one wishes to place in order what has become confused, whether three or five sheets, or three or five panels, and again if their top, middle, and bottom grades [in quality] have become mixed up, or never had any logical sequence, then it will certainly be best to place the best part first, the worst parts next and the middle grade last of all. Why is this? Because, whenever people look at paintings, they are of course keen when the scroll is first opened, and grow indolent and tired about halfway through, but then if they come to a section of the middle grade they will continue without realizing it until they come to the end of the scroll.

> *LTMHC*, Book 3, "On Mounting, Backing, Ornamental Borders and Rollers." *CKHLLP*, p. 1227.

Classification

P'ei Hsiao-yüan (active 627–650)

There are still a good many ancient paintings in Lo-yang, but I have not had opportunity to examine them. Now I collect remains from the past which I have seen, selected for their techniques combined with their cunning conception. Only the brothers Yen Li-te and Li-pen [d. 656 and 673 respectively], Yang Ch'i-tan [later 6th century] and Lu T'an-wei [later 5th century], went far beyond the usual standard. Yüan Ch'ien and Chih [later 5th century], Chang Seng-yu and Shan-kuo [early 6th century], these pairs of fathers and sons, may then be placed next. Yen Li-pen originally studied the style of Chang Seng-yu, but can be said to have surpassed his master. In figures with all their official apparel, chariots and horses, pavilions and great halls, he captured the subtleties of both the north and south. Yang Ch'i-tan and the two Changs also show that their generations did not lack worthy ones. As for Yen Li-pen and Li-te, it can truly be said that it would be difficult to place one higher than the other. Students such as Ch'en Shan-chien [the late 6th-century follower of Cheng Fa-shih] and Wang Chih-shen [a 7th-century follower of Yen Li-pen] could capture only one out of myriad qualities in their masters. Though they certainly were not equal to their masters in nobility of spirit, still they labored after formal likeness. Works collected by people of today are mostly copies or tracings by Ch'en and Wang and not the true brush remains of Yang Ch'i-tan or Cheng Fa-shih. Whenever one wishes to appreciate genuine works, it is eminently suitable to make such fine distinctions.

> Probably an excerpt from a *Hua-p'in lu* (Classification of Painting), now included as a postface to the *Chen kuan kung-ssu hua-lu.*[5] *CKHLLP*, p. 17.

Chu Ching-hsüan (ca. 840)

The number of those who have discussed the problem of classifying ancient and modern painters is considerable. I do not presume to speak of the periods of Sui, Liang, and earlier. In the present dynasty, there has only been Li Ssu-chen [d. 696] who, in his *Hua-p'in lu,* has merely recorded artists' names without discussing their relative merits

5. See Bibliography B for an analysis of this work.

or grading quality. The result is that later students find him useless as a reference. I, in my humble way, love the art and search for its monuments. Things I have not seen I shall not record, but I shall write on everything I have seen. My investigations have been made whole-heartedly and without any fear of being seen as clumsy by others.

For my classification, I have used the three categories, "inspired (*shen*)," "excellent (*miao*)," and "capable (*neng*)," established by Chang Huai-kuan [active early 8th century] in his *Hua-p'in tuan* (Decisions on the Classification of Painters). A further triple division into top, middle, and bottom has been provided for each category. Outside of this system, for those not bound by any orthodox rules, there is an "untrammeled (*i*)" category, to show their relative excellence.

Now, painters give priority to the human figure, ranking birds and beasts next, then landscapes, and finally architectural subjects. Why is this? In the past Lu T'an-wei [later 5th century] placed buildings first. This was entirely because human figures, birds, and beasts are active beings of mobile disposition with an infinite range of variations in appearance. It is difficult, therefore, to concentrate their spirits and fix their images.[6] Thus Lu T'an-wei reached the full height of perfection in painting human figures, but when it came to landscapes, plants, and trees, he gave them no more than a summary treatment . . . Painters of the recent period were well pleased if they could establish a reputation by showing skill in one kind of thing alone. The one exception was Wu Tao-tzu [8th century] with his heaven-sent talent. As a unique figure in his age, he was able to match works with Ku K'ai-chih and Lu T'an-wei. After him came Chou Fang [ca. 730–ca. 800]. The other practitioners, 124 men, have been classified directly according to their abilities as painters, without regard for rank or mental capacities, though such factors have been briefly touched on during the classifying process. Connoisseurs of the future may judge that my principles are not false ones.

> *TCMHL*, preface. *CKHLLP*, p. 23.

Chang Yen-yüan (ca. 847)

To some degree I have taken advantage of my days of leisure to compile these records. Furthermore, I have taken up all the various critical judgments and used them to throw light on what was accom-

6. This could be a confusion between Ku K'ai-chih and Lu T'an-wei. The former did comment on this matter; see chapter 1 at "Problems of Representation."

plished. I have also delved deeply into the histories in order to broaden my knowledge.

Sometimes . . . contemporary classificatory works on those with ability in painting make no mention [of certain men]. When one goes into the matter in detail for both past and present, [one finds that] much has been neglected or forgotten. This was, no doubt, because works [by such men] were not yet to be seen in the world at large, or again simply because the men who wrote these works made no extensive searches . . .

During the 230 years since the founding of the Sacred T'ang Dynasty, artists of rare ability have been contemporaries, learning from each other through audial and visual contacts. In the K'ai-yüan and T'ien-pao eras [713–755], such men were especially numerous. Why must there be perfection in all the Six Elements [or Laws]? I have simply taken those painters who excelled in even one branch of the art.

Here are more than 370 men, from Shih Huang [of prehistoric mythology] down to the first year of the Great T'ang's Hui-ch'ang reign [841]. There are no discrepancies in the order of compilation, and the critical evaluation is now practically settled. More than this, I have searched far and wide and brought together all sorts of material. All that has been mirrored in my mind or eye I have spoken of without reserve.

> *LTMHC,* Book 1, "On the Vicissitudes of the Art of Painting." *CKHLLP,*
> p. 31.

From early times on, writers on painting have considered the works of Ku K'ai-chih [ca. 345–ca. 406] to be incomparable by nature, so that critics do not dare to determine whether he should be ranked first or second. I have seen Master Ku's critical discussion of Three Kingdoms' Wei and Chin Dynasty painters, in which he himself highly commends Wei Hsieh [mid-3rd–4th century] and so I conclude that Wei was not inferior to Ku . . . The approval of famous sages was surely not lightly given. How can the shallow and vulgar of later times examine such matters? In going over the criticism by Hsieh Ho [in the *(Ku)hua-p'in(-lu)* of the early 6th century], I find myself mostly in agreement; whereas I am not altogether satisfied with some of the verdicts of Yao Tsui [535–602, in the *Hsu hua-p'in*] or Li Ssu-chen [d. 696, probably in the *Hua hou-p'in*]. When Li reversed the judgment of Hsieh in saying that Wei ought not to be placed above Ku, it was

entirely because he was unable to recognize what was basic and original.[7] One may indeed feel sorrow at this . . .

Those who can be said to excel have ability in all categories they encounter. Yet all the vulgar will commend those who excel in only one specialty.

> *LTMHC*, Book 2, "Discussing the Schools and Their Transmission in the Period of the North and South."

Now, if one falls short of a natural spontaneity, then next is inspiration; if one falls short of inspiration, then next is subtlety; if one falls short of subtlety, then next is refinement; and when there is fault in refinement, carefulness and elaboration are produced.

The naturally spontaneous are highest in the top grade; the inspired middle in the top grade; the subtle low in the top grade; the refined highest in the middle grade; the careful and elaborate middle in the middle grade. I herewith establish these five grades with which to embrace the Six Elements [or Laws], and upon which to thread all [the types of] subtlety. Between and among these there could be several hundred levels of classification, but who could get to the end of them all?

> *LTMHC*, Book 2, "On Painting Materials, Tracing and Copying."
> *CKHLLP*, p. 37.

Criticism

Different T'ang Critics on Important Early Masters: Comments by Li Ssu-chen, Chang Huai-kuan, and Chang Yen-yüan

Although works by Wei Hsieh [active late 3rd–early 4th century] have spirit vitality (*shen-ch'i*), if one examines their bone articulation (*ku-chieh*), they are overly elaborate and complicated . . . The natural talents of Ku K'ai-chih [ca. 345–ca. 406] were outstanding; he was unique and without equal. How could Hsieh Ho have dared to place Hsün Hsü [ca. 218–ca. 289] and Wei above Ku?

Ts'ao Pu-hsing [3rd century] was also placed above Ku. Hsieh's criticism is most unsuitable. Master Ku's thought imitated creation itself, capturing subtle things through harmony with spirit. This was

7. See the section on "Criticism" below for a fuller account of these critical divergencies.

enough to cause Master Lu T'an-wei [5th century] to falter, and the
Marquis Hsün to prostrate himself in admiration. How can one group
talents such as Ku's in a single classification? To place him in a lower
grade is especially unsound. Now, let us invite Ku and Lu to stand
together in the top grade. [When Hsieh says of Lu,] "There is no
room to speak further, therefore I place him in the first place"—these
words exceed what is fitting. Be that as it may, according to the cal-
culations of the milfoil stalk, tortoise, scales, and mirror, [the prog-
nosticative media] of myriad generations, Ku and Lu should stand
together, first in the highest grade.[8]

Ku and Lu have already passed, but flourish in the first place. Only
Chang Seng-yu [6th century] is greatly extolled among later gener-
ations. Today's scholars look at his visible remains as they would those
of the Duke of Chou or Confucius. Why should they speak [in this
reverent manner] as of temples and pagodas? Still, while the human
figures, robed and capped, by Ku and Lu are truly worthy of praise
as perfect works, their other [subjects] have not been examined. As
for Master Chang, his bone vitality (*ku-ch'i*) is unusual and grand; his
masters and models were vast in scope. Not only did he embrace all
the refinements of the Six Elements [or Laws], in fact he was also
subtle in all the myriad classes [of phenomena]. Innumerable changes
and transformations, deceptive and fantastic forms, as they passed
before his eyes were controlled on his palm; attaining them with his
mind, he responded with his hand. By this I mean that, when heaven
sends down a sage for later generations, why should he need to vie
with [the cosmic forces of] *yin* and *yang* in the subtlety of his work-
manship? I request that Chang be placed in the upper grade, together
with Ku and Lu.

> Li Ssu-chen (d. 696), quoted in the *LTMHC*, Books 5–7 under the
> entries for these painters. Cf. *CKHLLP*, pp. 394–395.

Master Ku's expression of thought was refined and delicate; his in-
nermost spirit unfathomable. Although he recorded traces of these
with brush and ink, his spirit vitality (*shen-ch'i*) floated on high in the
cloudy empyrean and could not be sought in his paintings. In beauty
of figural images, Chang captured the flesh, Lu the bones, and Ku

8. This paragraph has been reconstituted from scattered references cited by Chang
Yen-yüan, but see also Acker, I, 6–19, as well as chapter 1, above, at "Definition,
Animation, and Expression." Li Ssu-chen was, apparently, more in agreement with
Yao Tsui's assessment of the standing of Ku; see Acker, I, 36.

the spirit. I consider Ku to have been foremost in the incomparable subtleties of the spirit. If I were to illustrate this with calligraphy, then Ku and Lu could be compared to Chung Yu and Chang Chih [of the Later Han Dynasty], while Chang could be compared to Wang Hsi-chih [309–ca. 365]. Together, they alone were unequaled in both past and present. How then can one fix them in grades? Hsieh's dismissal of Ku cannot be taken as a definitive criticism.

As for Ku, Lu, and Chang Seng-yu, critics each prefer one of them, and all are justified. Master Lu penetrated to the quintessence and brought forth its subtleties; his movements were in harmony with spirit; his brush strokes were strong and sharp as an awl. In his clear likenesses of men of superior character, we seem to sense a vital animation, such as to cause us to tremble as if in the presence of divinities. Though such subtleties filled his images, his thoughts did not go beyond the ink. Chang was inferior to Ku and Lu in portraying the noble character in figures.

Yao Tsui praised Chang [with these words:] "Although of a later generation, he came a close second to previous standards." These are not the words of a connoisseur. Moreover, Master Chang's thoughts were like a gushing stream. He received his talents from Divine Creation. With one or two strokes, his likenesses already corresponded. In using all the variety of subject matter, he stood alone in both past and present.

> Chang Huai-kuan (active 713–741), cited in the *LTMHC*, Books 5–7 under the entries for these painters. *CKHLLP*, pp. 402–403.

I was initially doubtful and ill at ease about placing Wei Hsieh's grade above Master Ku's, but then I read Ku's collected writings in which there is a *Lun hua* (Essay on Painting). In this, Ku himself praised Wei's paintings *North Wind* and *Illustrious Women,* feeling himself unable to equal them. Thus, there is no impediment to placing Ku below Wei. Whether Hsün Hsü should also stand above Ku, I cannot pretend to know.[9]

> Chang Yen-yüan (ca. 847), *LTMHC*, Book 5 in the entry for Wei Hsieh.

9. See also "Classification," above, for Chang's attitude toward earlier critics in the *LTMHC*, Book 2, "Discussing the Schools and Their Transmission in the Period of the North and South." He also stated his agreement with Chang Huai-kuan's assessments of Lu T'an-wei and Chang Seng-yu, thus, differing from Yao Tsui's view of the latter.

Different Critics on Northern Ch'i and Sui Dynasty Painters: Comments by Yen Li-pen, Yen-ts'ung, Li Ssu-chen, Tou Meng, and Chang Yen-yüan

Ever since the likenesses of people [have been painted], was it not Yang Tzu-hua [active 560s] alone who could painstakingly exhaust their subtleties, simplifying and setting their standards of beauty, so that nothing could be subtracted from their abundance and nothing added to their paucity?

> Yen Li-pen (d. 673), cited in the *LTMHC*, Book 8.

In everything that Chan Tzu-ch'ien [active 550s–early 600s] touched and let his feelings dwell on, his subtlety was entirely unrivaled. He especially excelled in painting terraces and pavilions, human figures and horses, and landscapes containing a thousand miles within a square foot.

> Yen-ts'ung (ca. 650), cited in the *LTMHC*, Book 8. Cf. *CKHLLP*, p. 381.

Yang Tzu-hua is placed in the first grade, below Chang Seng-yu but above Cheng Fa-shih [active 560s–590s].

Yang Ch'i-tan [late 6th–early 7th century] and T'ien Seng-liang [active 570s] were equal to Tung Po-jen [active mid–late 6th century] and Chan Tzu-ch'ien in both name and reality. They all thoroughly understood formal likeness. Master T'ien's paintings of country costumes and rustic carts were famous for incomparable brushwork. He is placed in the first grade together with Yang, and below Tung and Chan.

Cheng Fa-shih humbly followed Chang Seng-yu [6th century] as a disciple, and was known as the best. He came close to perceiving the mysteries [of his master's art], having all of Chang's form but in lesser degree. His vital resonance (*ch'i-yün*) was outstanding, his noble manner (*feng-ko*) vigorous and superior. With ornate tassels and long ribbons [of officials' hats], he captured the solemn majesty of ceremony; with tender mien and gentle attitudes, he plumbed the elegant appearance of those in deep seclusion [that is, ladies of the palace]. Even in the circumstances of a hundred years past, the pleasures of areas in both north and south, and the movement of chariots and troops in the tenth month like flowing waters and floating clouds, his painting has the noble vitality (*i-ch'i*) of [such great officials as] Chin Mi-ti [134–86 B.C.] and Chang An-shih [d. 62 B.C.], and the gorgeous

splendor of gem-stones. His lofty towers and many-storied buildings set within stately groves and handsome trees, his jade-green pools and silk-white rapids scattered within a variety of brilliant and fragrant grasses, all are certainly inviting with the [joyous] mood of ascending heights in spring. His perfect qualities are in these. The Noble Cheng is lauded as one who walked alone [without rivals] in the lower Yangtze area after Chang Seng-yu. He is in the first grade, below Yang Tzu-hua but above Sun Shang-tzu [late 6th–early 7th century].

Sun Shang-tzu and Cheng Fa-shih both followed Chang Seng-yu. Cheng's paintings of figures, towers, and terraces stood in the strongest place and were the best. Sun's painting of goblins and sprites penetrated the soul and partook of the marvelous . . .[10] He is in the first grade, below Cheng but above Tung Po-jen and Chan Tzu-ch'ien.

Tung and Chan were both naturally born with independent wills and accepted nothing from ancestral teachings. As they moved their brushes to achieve likeness of form, they created feeling that went beyond their paintings. This was enough to cause the renowned of the older generation to show astonishment and pale [in chagrin]. However, they dwelt in the level plains, lacking the aid of rivers and mountains. They added war-horses to their works, but were deficient in the dignity of the hairpin and official robe [that is, representation of courtiers]. These [motifs of dramatic scenery and ceremonial figures] were not [sufficiently] studied, but were not unattainable by them. If we should compare their relative merits, then they both exhausted the meaning of vital movement (*sheng-tung*) through [expression of] joy and sorrow, laughter and speech, and each captured the appearance of [horses] bounding and galloping in archery hunts. But Master Tung created the subtleties of lofty and magnificent buildings, while Master Chan was a thoroughbred when it came to chariots and horses. Tung had Chan's ability in painting chariots and horses, but Chan lacked Tung's ability in painting towers and terraces.

Li Ssu-chen (d. 696), cited in the *LTMHC*, Book 8. Cf. *CKHLLP*, pp. 395–397.

T'ien Seng-liang was subtle in all the skills, and not solely in rural scenes. He is inferior to Yang Tzu-hua and Sun Shang-tzu, but of the same level as Tung Po-jen and Chan Tzu-ch'ien.

Sun Shang-tzu's saddle horses, trees, and rocks, were not equaled

10. The omitted passage may be found in the section on "Brushwork: Comments on Brush Technique" above.

by those of Cheng Fa-shih. [Also,] his brushwork differed from Ku K'ai-chih's and Lu T'an-wei's. How can one single out his demons and divinities, and leave it at that?

Tung-Po-jen's towers, terraces, and figures are utterly incomparable in both past and present. His various paintings are all ingenious and rich. He could look down from his heights at Sun and T'ien. Moreover, he had innumerable different variations. Why limit [critical acclaim] to a single type of screen [as did Yen-ts'ung]?

Yang Ch'i-tan's works are not without virility and richness. When compared to Tung and Chan, he lacks refinement and delicacy.

> Tou Meng (late 7th century), cited in the *LTMHC*, Book 8. *CKHLLP*, p. 390 (in part).

I feel that T'ien Seng-liang's ideas in painting were like those of Chan Tzu-ch'ien, but he did not equal Chan in refinement and detail.

I consider the Grand Official Li Ssu-chen's criticism of Cheng Fa-shih as being below Yang Tzu-hua inappropriate. It would be fitting for Cheng to stand above Yang.

> Chang Yen-yüan (ca. 847), *LTMHC*, Book 8.

Different Critics on Early T'ang Painters: Quoted in Chang Yen-yüan's *LTMHC*

YEN LI-PEN (D. 673). Yen-ts'ung said: "Yen Li-pen learned from Cheng Fa-shih. He was inexhaustible in the unusual attitudes [of his figures], and he changed the old [methods] in his portrayals of living beings. All under heaven have adopted his canons."

P'ei Hsiao-yüan said: "Yen took Chang Seng-yu as his master, but the student was more brilliant than the teacher. In figures, costumes, chariots and horses, terraces and pavilions, he always captured their subtleties. If one looks through the past for those who took their canons from [their own] clever ideas, only Yen Li-te and Li-pen, Yang Tzu-hua and Lu T'an-wei went far beyond the usual standards. The Chang family, father and sons [Seng-yu, Shan-kuo, and Ju-t'ung], may be placed slightly behind them."

Li Ssu-chen said: "With Li-pen and Li-te, it is difficult to tell which is superior. Since Lu T'an-wei and Hsieh Ho have vanished from south of the Yangtze River, and Yang Tzu-hua has long departed from the Northern Dynasty, the two Yens have been hailed as the restorers of marvels in representing human beings. As for such sub-

jects as the myriad countries that come to court, respectfully offering the jades and silks of Mount T'u or a hundred barbarians with tribute receiving their correct precedence at the main palace gate . . . their bending and turning in regulated order, with the etiquette of straightened hairpins and tablets grasped in both hands, or their monstrous and cunning strangeness, with their peculiarities of drinking through noses, or letting their heads fly about . . . all these were completely described with the brush tip, replete with the people's emotions. The two Yens are together in the first grade."

Tou Meng said: "He only learned from his own mind, and his conceptions went beyond mere effort. He had no connections whatsoever with Chang Seng-yu or Cheng Fa-shih."

I say that although the two Yens, Yang and Lu, all painted beautifully, the Chang family's father and sons belong in the highest grade.[11] When P'ei says that the Changs are below Yen, his discussion is not correct.

WEI-CH'IH I-SENG (7TH CENTURY). Yen-ts'ung said: "His foreign demons and divinities, of strange form and odd appearance, have seldom been adopted by Chinese."

Tou Meng said: "He cleansed his thoughts, then used his brush. Though he differed from the Chinese way, still, since his spirit was upright and his works noble, he could be a companion of Ku K'ai-chih and Lu T'an-wei.[12]

WANG TING (ACTIVE 620s). Yen-ts'ung said: "He was insufficient in noble vitality (*ku-ch'i*) but had an excess of concentrated charm. His bodhisattvas and old monks are often strikingly perfect."

I add—Ting's painting was not very developed in noble vitality. If he lacked noble vitality, how then could he have been strikingly perfect [in anything]?[13]

LTMHC, Book 9. Also see *CKHLLP*, pp. 383–384, 391, 399.

11. Chu Ching-hsüan, *TCMHL*, has Yen Li-pen and Li-te as the first two in his "Inspired Class, Bottom Grade," with only two later painters preceding them—Wu Tao-tzu (8th century) in the Top Grade and Chou Fang (ca. 730–ca. 800) in the Middle Grade.

12. *Ibid.*, has him in the Inspired Class, Bottom Grade just below Yen Li-pen and Li-te: "Former generations spoke of Wei-ch'ih I-seng as comparable with Yen Li-pen. I have felt that in painting foreign peoples, Yen never exhausted their subtleties, and have never heard that Wei-ch'ih even attempted Chinese likenesses. Therefore, to judge them [one should say that] each worked at a different kind of painting."

13. *Ibid.;* he is listed in the Competent Class, Top Grade.

Social Status and Creative Activity

Fu Tsai (d. 813)

CHANG TSAO (8TH CENTURY). In no time at all, he was demoted to the post of Marshal of Wu-ling commandery [in Hunan]. He had no official work there and plenty of leisure time. Hence the local gentry were able bit by bit to acquire his paintings.

A gentleman of Ching-chou . . . spread a feast in his house. The deep porch was richly decorated; the wine cups and food dishes were fine. In the courtyard there were bamboo scattered in the sunlit air—a delightful scene. The master, spoiled with the generous gifts of Heaven, suddenly appeared at the party, roughly demanding fresh silk to display his extraordinary art. The host gathered his robes about him, got to his feet and answered him with a shout. On that occasion there were twenty-four guests, seated to left and right, who heard this [encounter]. They all stood up and stared at Chang Tsao. Right in the middle of the room he sat down with his legs spread out, took a deep breath, and his inspiration began to issue forth. Those present were as startled as if lightning were shooting across the heavens or a whirlwind sweeping up into the sky. Ravaging and pulling, spreading in all directions, the ink seemed to be spitting from his flying brush. He clapped his hands with a cracking sound. In a flurry of divisions and contractions, strange shapes were suddenly born. When he had finished, there stood pine trees, scaly and riven, crags steep and precipitous, clear water and turbulent clouds. He threw down his brush, got up, and looked around in every direction. It seemed as if the sky had cleared after a storm, to reveal the true essence of ten thousand things.

When we contemplate Master Chang's art, it is not painting, it is the very Tao itself. Whenever he was engaged in painting, one already knew that he had left mere skill far behind. His ideas reach into the dark mysteries of things, and for him, things lay not in the physical senses, but in the spiritual part of his mind. And thus he was able to grasp them in his heart, and make his hand accord with it.

> Excerpt from "Preface on Observing Secretary Chang Painting Pines and Rocks" in *CKHLLP*, p. 20.

Chu Ching-hsüan (ca. 840)

LI LING-SHENG (9TH CENTURY). He was undisciplined and never abided by the usual standards of excellence, but always loved land-

scape. Whenever he was painting on a screen, and it was not what he would have wished, he never forced himself to continue, for only in wine were his ideas born. He was proudly independent and did not recognize the prerogatives of princes and lords. When he painted a landscape, bamboo, or tree, he would achieve its image with a dot and a stroke. The appearances of his objects [seemed to] issue entirely from nature. Sometimes he made peaks and pinnacles rising between clouds; sometimes islets and spurs along rivers. The mode that he mastered was an exceptional one, matching the feats of creation itself. [His work] falls under no system of classification but achieves a flavor of its own.

> *TCMHL,* "Untrammeled Class."

Chang Yen-yüan (ca. 847)

From antiquity on, those who have excelled at painting have all been nobles with official positions, or rare scholars and lofty-minded men. They awakened the wonder of their times and left behind reputations for a thousand years, which is not something that village rustics could accomplish.

> *LTMHC,* Book 1, "Discussing the Six Elements of Painting." *CKHLLP,* p. 33.

CHIANG SHAO-YU (D. 501). He was quick of mind and ingenious, and skilled in calligraphy and painting, excelling in painting human figures and in sculpture. Although he had both talent and knowledge, he was usually surrounded by gouges and chisels, marking lines and ink, [working] by the sides of gardens, lakes, towns, and palaces. The cognoscenti bemoaned this, but Shao-yu was undisturbed, considering this his responsibility, and never spoke of fatigue.

> *LTMHC,* Book 8.

YEN LI-PEN (D. 673). A dynastic history says that T'ai-tsung and his attendant courtiers were once wandering about the park in spring. On the pond were some rare birds swimming at leisure along with the current. The Emperor admired them ceaselessly, ordering the attendant officials to compose odes and summoning Li-pen in haste to describe their appearance. Those in the council chambers transmitted the call for "the painting master Yen Li-pen." At this time, Li-pen was already a Senior Secretary in the Bureau of Nobles' Titles

[under the Board of Civil Office]. He rushed out, dripping with perspiration, to prostrate himself beside the pond. His hands flourished cinnabar and silk; his eyes were respectfully raised to the seated guests. He could not repress a mortified blush. Upon retiring [from the imperial presence] he cautioned his son, saying: "When I was young, I loved to read books and write literary compositions. Now, I am only recognized for painting and have to do menial tasks personally. What could be a greater disgrace? It is proper that I caution you seriously against practicing this art"[14] . . .

When Yen Li-pen became President of the Imperial Grand Secretariat, Chiang K'o [d. 672] was President of the Imperial Chancellery; together they managed the affairs of state. K'o had formerly achieved merit [as a soldier] on the border, while Li-pen was only good at painting, and so contemporaries referred to them with words from the *Ch'ien-tzu-wen* (Classic of a Thousand Characters)—"The Chief Minister extended sovereignty over deserts. The Vice Minister pursued fame in painting." These words meant that neither had ministerial capacities . . .

I will now comment as follows: Historians of the past have praised Emperor Ming of the Wei [reigned 227–239] for erecting the Pavilion of Ascending Clouds (Ling-yün Ko) and appointing Wei Tan [178–253] to inscribe its placard. However, the workmen made a mistake in nailing the placard up first. They had to raise Tan, who was dangling in a basket, some 250 feet above the ground. When he descended, his beard and hair were all white, and only then could he release what breath remained to him. Then, he warned his sons and grandsons against continuing with [their study of] the methods of formal script. Hsieh An [320–385] once discussed this affair with Wang Hsien-chih [344–388] who responded quite seriously: "Wei Tan was one of the great officials of the Wei. How could there have been such an affair? If it happened as you related, we may understand why the power of the Wei did not last long." I feel that Hsien-chih's remarks are very perceptive. Although the President of the Imperial Grand Secretariat Yen included painting among his skills, at that time he had already occupied various high offices. Moreover, T'ai-tsung was affable and close to his attendants, having the kindness to en-

14. Chu Ching-hsüan, *TCMHL*, has the painter first in the "Inspired Class, Bottom Grade," and a briefer account of this incident with a slightly different implication. Both the *Chiu* and *Hsin T'ang shu* (Old and New T'ang Dynastic Histories) relate the anecdote in terms close to Chang Yen-yüan's, but they were, of course, not yet written in his time.

courage his councilors. When receiving his subordinates, he was never aroused to the point of violence. How then could he have called out bluntly, "Painting Master," [as if] he had not read through the official roll? As to [Yen's] chasing after fame through painting [alone], he was aided by many talents. With Yen's talents and knowledge, one can also say that this was false calumny. The superficial custom of disdaining the arts and mocking ability has reached such a point! It is fitting that one should be disquieted by it.

> *LTMHC*, Book 9, biography of and comment on Yen Li-pen.

CH'IEN KUO-YANG (8TH CENTURY). Tou Meng said: "His garments were common and mean, not different from a base artisan's, but he elevated his stature through his own efforts to such an extent that he could stand forth from the masses."

I say when one speaks of "common and mean [like a] base artisan," how then could his stature have been "unvulgar"? Mister Tou's two phrases of criticism are mutually contradictory.

> *LTMHC*, Book 9. For the Tou Meng comment, also see *CKHLLP*, p. 392.

3

Sung Art History

THE SUNG DYNASTY (960–1279) can be thought of as the golden age
of Chinese painting. It was a period when the various pictorial genres
developed to their full extent, when landscape depiction reached peaks
of realism and idealism, and when painting itself began to be consid-
ered one of the fine arts. Writings on painting also proliferated during
this time, and they reflect these different concerns. Collections of
painters' biographies, which might or might not include historical
essays, continued to be produced: they are included in this chapter.
A new kind of text that claimed to impart the secrets of landscape
painting became popular by Sung times. Some of these works were
written as aids for professional landscapists, but others were evidently
composed for interested patrons and collectors: examples of both
types are given in chapter 4. Finally, influential scholar-officials, who
had strong artistic interests, came to define painting as an amateur
art and an integral part of scholarly culture. Practiced in the same
way as poetry and calligraphy, painting was to be an outlet for a
gentleman's emotions: comments in this vein are collected in chap-
ter 5.

As post-T'ang writers dealt with progressively longer sequences of
painting traditions, they developed a historical perspective on the past
and evolved different ways of classifying artists and their works. The
traditional grading system, in which painters were assessed on the
basis of quality in three classes (Inspired, Excellent, and Competent),
each subdivided into three grades of relative merit, continued to be
used in the *I-chou ming-hua lu* (A Record of the Famous Painters of
I-chou) attributed to Huang Hsiu-fu in a preface by Li T'ien dated
1006. This work covers the painters active in the Shu region (modern

Szechwan), from a period of over two hundred years up to the beginning of the Sung Dynasty. Its most original contribution to the classification system is the placing of the Untrammeled Class (*i-ko*) at the head of the listing, rather than at the end, so that it might contain a "sage of painting outside of the rules," the late-ninth-century muralist Sun Wei. Later painters of this type were not thought to have achieved greatness, hence the status of the Untrammeled Class declined. Indeed the traditional grading system soon came to be superseded by other forms of organization.

The number of subject categories that painters specialized in expanded during the Northern Sung period, when new genres were recognized. Biographies of artists from the formative eras of the Five Dynasties and early Northern Sung were recorded by Liu Tao-shun in the *Sheng-ch'ao ming-hua p'ing* (Critique of Famous Painters of the Present Dynasty) and later in the *Wu-tai ming-hua pu-i* (A Supplement on the Famous Painters of the Five Dynasties), which has a preface dated 1059. In these works he divided painting into subject categories or genres—such as figures, landscapes, and animals—and graded artists into the three traditional classes on the basis of their performance within each particular genre. This system allowed for a finer degree of discrimination in judgments of quality. The critique of style in the *Sheng-ch'ao ming-hua p'ing* was given separately at the end of the general biographical entry on an artist. In a preface or preliminary essay, Liu Tao-shun listed not only a set of Six Essentials (*liu-yao*), his reinterpretation of the Six Laws for painters, but also Six Merits (*liu-ch'ang*), his guidelines for connoisseurs phrased in *yin-yang* oppositions. Since this painstaking tendency to subdivide when categorizing was not congenial to later Sung writers, the method of organization in Liu's compilation represents a transitional stage between the classification in grades by personal qualities and the separation into categories on the basis of the subject painted.

A peak of interest in the latter method appears in the *Hsüan-ho hua-p'u* (Catalogue of Paintings in the Hsüan-ho Collection), presumably compiled by scholar-officials at the court of Hui-tsung (r. 1101–1126). Biographies of artists were placed in various sections according to the subjects of their paintings and then given in chronological order; grading by quality in classes was eliminated. This logical division into subject categories was mythologized and explained in a series of scholarly introductions to each section, where literary references gave authority to a particular genre and determined its sequence in the catalogue. Thus, there is a special emphasis on the

meaning of pictorial subjects as indicated in the *Book of Changes* or the *Book of Songs*, early classics in the Confucian canon. A highly artificial court production conceived shortly before the fall of the Northern Sung, the *Hsüan-ho hua-p'u* was not destined to influence later art history except as a source of artists' biographies. Although other Sung works continued to group the majority of professional painters by their specialties, classification by subject categories was rarely ever again the main principle of organization. Our translations of the introductions to these compilations of biographies are based on Richard Barnhart's versions.

Far more influential was the earlier *T'u-hua chien-wen chih* (An Account of My Experiences in Painting), which was finished around 1080 or earlier by Kuo Jo-hsü, a minor official at the Sung capital. Kuo conceived of his work as a sequel to the *Li-tai ming-hua chi* of Chang Yen-yüan and aimed at a comprehensive view of painting history, hence he only presented abbreviated entries on the artists active from 841 through 1074. The scope of the text also led him to dispense with classification on the basis of quality, which would have been impractical as well as unfair, and the masters of the late T'ang and Five Dynasties are simply listed in their respective periods. However, when he dealt with the contemporary painters of the Northern Sung, he felt it appropriate to divide the painting specialists into four main subject groupings; at the beginning he separately discussed an emperor, thirteen nobles and scholar-officials, and two recluses. This was the first limited application of classification by social status, the method of ranking biographies in the dynastic histories. This method would be used more extensively by Kuo's followers. The élitist view that supports such distinctions is evident in Kuo's redefinition of "spirit consonance" (*ch'i-yün*) as a kind of innate talent that reflects a man's character and social condition.

The high quality of Kuo Jo-hsü's historical perceptions made this text a definitive work in Sung times, and it was not to be surpassed by later writers. Like Chang Yen-yüan's text, Kuo's includes a series of essays on general topics or specific points at the beginning. The most important are discussions of the moral significance of painting, the standards to be achieved in each genre, the nature of "spirit consonance," and the proper approach to brushwork. Historical distinctions between past and present styles are also brought out in connection with particular subject categories. Kuo ended his work with two chapters of anecdotes about painting derived from his reading. The *T'u-hua chien-wen chih* was thus more of a true history of painting

than a simple compilation of biographies. Excerpts from it are given here, but it has been translated in its entirety by Alexander Soper.

Also included in this chapter are some of the notes on painting and its connoisseurship recorded by the mathematician and astronomer, Shen Kua (1031–1095), in *Meng-ch'i pi-t'an* (Casual Writings from the Garden of the Stream of Dreams) around 1090. Shen was a scholar-official who held high office for a short period. Still his technical and scientific interests were quite distinct from the prevailing poetical views on art voiced by the influential Su Shih (1037–1101) and his circle of friends. In fact, Shen belonged to an opposing political clique, and he seems never to have associated with these contemporary critics but instead derived his ideas from personal observations and the current literature on painting. Therefore, his comments will be considered here rather than in the later chapter on literati art theory. The translation of these excerpts is based on renderings by Roderick Whitfield.

Kuo Jo-hsü's influence was most strongly felt by Teng Ch'un in his *Hua-chi* ("Painting" Continued), which was written as a continuation of the *T'u-hua chien-wen chih* and covers painters active from 1075 through 1167. As Teng notes, he specifically followed Kuo's system of classification in establishing the categories of High Officials and Retired Scholars. Teng is also far more specific in listing various subdivisions such as high or low officials, Buddhist and Taoist priests, hereditary noblemen and ladies. Furthermore, he stresses Su Shih's association of literature with painting and frequently quotes poetic descriptions of pictures in the extensive biographies of scholar artists. Since Teng's grandfather and father held official positions at the capital during Hui-tsung's reign, he is able to give us an invaluable perspective on the Emperor's taste in art and the regulations in effect at his Academy of Painting. These comments have been translated by Robert Maeda, Richard Barnhart, and Tseng Yu-ho Ecke; excerpts are based on their versions.

For the most revealing short biographies on Southern Sung monk painters and academicians, however, one must turn to the *Hua-chi pu-i* (A Supplement to the *Hua-chi*), which was completed by Chuang Su in 1298 and covers artists active from 1131 to 1275. Written twenty years after the fall of Sung, this text presumably represents an early Yüan point of view in reaction to Sung court art, that of a disgruntled former official. But it is included here as a sequel to Teng Ch'un's work that continues to group painters according to their social status. The translation of these excerpts is based on that of Nancy Price. The

sequence of topics in this chapter generally highlights the different principles of classification.

The Significance of Figure Painting

Kuo Jo-hsü (ca. 1080)

The *I ching* (Book of Changes) states: "The holy sages were able to survey all the confused diversities under heaven. They observed forms and phenomena, and made representations of things and their attributes. These were called the images (*hsiang*)." It says further: "The images are reproductions."[1]

I have examined discussions of painting by former worthies. Their primary emphasis on the depiction of figures is not solely due to problems of spiritual vitality (*shen-ch'i*), structural method (*ku-fa*), drapery patterning, or spatial positioning. Those of the ancients who had to treat of formal representations of sages and worthies or historical events of bygone times, sucking their brushes and commanding silk to compose them into paintings, wished to appraise critically their worth or folly or to shed light on their stability or disorder. Hence circumstances of prosperity and decline were recorded in the Lu palace [murals], and officials of meritorious distinction were assembled in the Unicorn Pavilion [portraits][2] to plumb the hidden secrets of distant dynasties and bestow an infinity of luminous brilliance . . .

Wei [Hung-] chi of the T'ang, "as Prefect of T'an-chou, since the border peoples were rustic and uncouth and ignorant of the value of literary studies, restored the college and had portraits painted of the seventy-two disciples of Confucius and the celebrated scholars of Han and Chin, for which he himself composed eulogies. He was active in encouraging students and thus brought about a great reformation there."[3]

Are not examples like this a case of what literature can never ex-

1. The *I Ching*, tr. Richard Wilhelm (Princeton: Princeton University Press, 1976), pp. 324, 336.
2. See Wang Yen-shou's prose poem in chapter 1 at "Didactic Subject Matter"; also Chang Yen-yüan, *LTMHC*, Book 1, "On the Origins of Painting," in chapter 2 at "Origins."
3. Evidently quoted from the *Hsin T'ang shu*, Book 100; see Alexander Soper, *Kuo Jo-hsü's Experiences in Painting* (Washington, D.C.: ACLS, 1951), p. 118 n.84.

haust in composition, nor calligraphy adequately represent, then being completed in painting?

> *T'u-hua chien-wen chih* (An Account of My Experiences in Painting, *THCWC*), Book 1, "On Corrective Viewing in Antiquity." *CKHLLP*, pp. 55–56.

Critical Standards

Kuo Jo-hsü (ca. 1080)

It is sometimes asked how the best art of the present dynasty compares with that of the ancients. My answer is that, in relation to the past, [the art of] modern times has fallen behind in many respects but made progress in others. If one is speaking of Buddhist and Taoist subjects, secular figures, gentlewomen, or cattle and horses, then the modern [paintings] do not come up to the ancient. If one is speaking of landscapes, woods and rocks, flowers and bamboo, or birds and fishes, then the ancient [paintings] do not come up to the modern.

Let me try to explain myself. Ku K'ai-chih [ca. 345–ca. 406], Lu T'an-wei [5th century], Chang Seng-yu [6th century], Wu Tao-tzu [8th century], as well as the two Yen, Li-pen [d. 673] and Li-te [d. 656], were all single-minded, grave, courtly, and correct; their natures proceeded from heaven itself . . . Master Wu's work has become a standard for all time; he has been called "the Sage of Painting," and how truly! All the above reached their heights in Buddhist and Taoist subjects and secular figures.

Chang, Chou, Han, and Tai [all 8th century] all exceeded normal expectations in spirit consonance and structural method. These were all T'ang men. Chang Hsüan and Chou Fang of the T'ang were both skilled in [portraying] gentlewomen; Han Kan painted horses and Tai Sung was good at cattle . . .

The later men who studied [these masters] were never able to equal them; hence one can say that the modern do not come up to the ancient.

When it is a question of works like those of Li Ch'eng, Kuan T'ung, and Fan K'uan, or like those of Hsü Hsi and the two Huang, Ch'üan and Chü-ts'ai [all 10th–early 11th century], they had no indebtedness to a teacher in the past and were not to be equaled in the future. Even should men like the two Li and the three Wang rise up again, or types like Pien Luan and Ch'en Shu be reborn, how could they hope to compete in this company? Hence one can say that the ancient [painters] do not come up to the modern. The "two Li" were General

Li Ssu-hsün and his son Chao-tao [7th–8th century], the Vice-President of the Righthand Grand Secretariat of the Heir Apparent; the "three Wang" were Junior Assistant Wang Wei [701–761], Wang Hsiung, and Wang Tsai [8th century]; all of them were skilled in landscape. Pien Luan and Ch'en Shu [both 8th century] were skilled in flowers and birds. All were men of the T'ang.

Therefore, if in investigating the present or examining the past, circumstances are plumbed to the utmost and principles thoroughly sifted, a critic will necessarily distinguish between gold and brass, and not burn jade together with stone.

> *THCWC*, Book 1, "On the Relative Superiority of Past and Present." *CKHLLP*, pp. 61–62.

Expressive Style and Quality

Kuo Jo-hsü (ca. 1080)

In the words of Hsieh Ho: "The first [of the Six Laws of Painting] is called 'animation through spirit consonance.' "

> "The second is called 'structural method in use of the brush.' "
> "The third is called 'fidelity to the object in portraying forms.' "
> "The fourth is called 'conformity to kind in applying colors.' "
> "The fifth is called 'proper planning in placing.' "
> "The sixth is called 'transmission through copying.' "

This essential definition of the Six Laws has not been altered throughout antiquity. Now the last five, from "structural method in use of the brush" on, are open to study. However, "spirit consonance" (*ch'i-yün*) necessarily involves an innate knowledge; it assuredly cannot be secured through cleverness or close application, nor will time aid its attainment. It is an unspoken accord, a spiritual communion; "something that happens without one's knowing how."[4]

In trying to define this, I venture to note that the rare works of the past were mainly those by talented worthies of high position or superior gentlemen in retirement, who cleaved to loving-kindness and sought enjoyment in the arts or explored the abstruse and plumbed the depths, and their lofty and refined emotions were all lodged in

4. For this statement (in a different translation), see Chang Yen-yüan, *LTMHC*, Book 2, "On the Brushwork of Ku, Lu, Chang, and Wu" in chapter 2 at "Brushwork."

painting. If a man's condition has been high, his spirit consonance cannot but be lofty. If spirit consonance is already lofty, animation cannot but be achieved. As it has been said, "in the highest heights of the spiritual, he can deal with the quintessence."[5]

In general, a painting must be complete in spirit consonance to be hailed as a treasure of the age. Otherwise, even though it reaches the utmost in clever thought, it will be no more than common artisans' work. Although called "painting," it will not be painting. Therefore Yang Chu could not inherit from his teacher [Lao-tzu], nor the wheelwright [Pien] transmit to his son.[6] What it depends on is had from the motive force of heaven and comes from the dwelling place of the soul.

In a comparable fashion, moreover, in the common practice of judging personal signatures, these are called "mind-prints." They originate from the source of the mind and are perfected in the imagination to take shape as traces, which, being in accord with the mind are called "prints." If one enlarges on the myriad ways in which activities follow thought, implementing this accord with the mind, they may all be called "prints." Even more so in the case of calligraphy and painting, since they issue from emotions and thoughts to be matched on silk and paper, what are they if not "prints"? Signatures, furthermore, contain all of one's nobility or baseness, misery or prosperity. Hence, how can calligraphy and painting rise above the loftiness or baseness of spirit consonance?

Now painting is the equivalent of calligraphy, and as Master Yang Hsiung [53 B.C.–A.D. 18] said: "Words are mind-sounds, and calligraphy is mind-painting. When the sounds and the painting are formed, the gentleman or the small man is revealed."[7]

> *THCWC*, Book 1, "On the Impossibility of Teaching Spirit Consonance."
> *CKHLLP*, p. 59.

5. Quoted from *Chuang-tzu*, Book 12; see James Legge, tr., *The Sacred Books of China: The Texts of Taoism* (Oxford: Clarendon Press, 1891), I, 311.

6. Yang Chu (4th century B.C.), whose egotistical philosophy was attacked in *Mencius* (see James Legge, tr., *The Chinese Classics* (Hong Kong: Hong Kong University Press, 1960), II, 281–282, 464), also appears in Taoist works as a would-be student of Lao-tzu. For this story and that of the wheelwright, in *Chuang-tzu*, Books 13 and 27, see Legge, *Sacred Books of China: Texts of Taoism*, pt. I, pp. 343–344; pt. II, pp. 147–148.

7. This statement is from the *Fa-yen* (Canonical Sayings, ca. A.D. 5), Book 5.

Brushwork

Kuo Jo-hsü (ca. 1080)

Generally in painting, as spirit consonance originates from pleasing the mind, so spiritual character (*shen-ts'ai*) is produced by applying the brush. The problems of using the brush [properly] may be readily appreciated. Hence Chang Yen-yüan could only commend Wang Hsien-chih's ability to do single-stroke calligraphy and Lu T'an-wei's grasp of single-stroke painting. It was not merely that the writing on a page or the depiction of an object might be executed with a single stroke, but rather that from beginning to end the brush was responsive, that connecting links were interdependent and the flow of energy uninterrupted. Thus, "if the concept is formulated before the brushwork," when brushwork is complete the concept will be within, then "when the painting is finished, the concept will be present," its images will correspond and its spirit be whole.[8] Only when what is within is satisfied in itself will the spirit be tranquil and the concept settled. When the spirit is tranquil and the concept settled, the imagination will not flag, nor the brush labor . . .

There are, moreover, three faults in painting that are bound up with the use of the brush. The three are thus described: the first is "board-like," the second, "engraved," and the third, "knotted." In "board-like" [brushwork], the wrist is weak and the brush sluggish, completely lacking in give and take. The forms of objects are flat and mean, and there is no ability to turn and bend. If "engraved," the movement of the brush is uncertain, and mind and hand are at odds. In delineating an outline, one will produce sharp angles at random. If "knotted," one wishes to go ahead but does not or fails to break off when one should. It seems as if things are congested or obstructed, unable to flow freely.

Not yet having exhausted these three faults, I merely lift one corner [for those who understand]. Few painters are able to pay attention to them, hence viewers should take pains to clarify their eyesight. In general, if spirit consonance is lofty and brush delineation vigorous, the longer one examines it, the more beautiful it is. But should the style be mediocre and the brush-point weak, although [a work] may seem worthy of selection at first sight, on returning to it after some time its concept will seem lax.

> *THCWC*, Book 1, "On Virtues and Faults in the Use of the Brush."
> *CKHLLP*, p. 60 (in part).

8. Phrases and wording echo Chang Yen-yüan, *LTMHC*, Book 2, "On Brushwork of Ku, Lu, Chang, and Wu," in chapter 2, at "Brushwork."

as "appreciating by ear." Or again, there are those who, on looking at a painting, must rub it with their hand, believing the legend that those paintings are excellent whose coloring [in relief] is not concealed from the fingers. This is even lower than appreciation by ear, and is known as "trying a bone for sound" . . .

The wonders of calligraphy and painting must be intuitively apprehended (*shen-hui*). They can hardly be sought through formal elements. Nowadays, those who look at paintings can usually just pick out faults of form or placement and blemishes in coloring, but one rarely meets anyone who has penetrated their subtle ordering and mysterious creation. Thus, in discussing painting, Chang Yen-yüan [?] said that Wang Wei usually painted things without regard for the four seasons: when painting flowers, he often depicted peach, apricot, hibiscus, and lotus flowers in a single scene. In my collection there is a painting by Wang Wei, *Yüan An Lying in Bed After the Snowfall* [at Lo-yang], that has a banana palm growing in the snow.[10] Here then what was conceived in the mind was echoed by the hand, and as ideas arose they were immediately brought to completion. Hence the principles of his [mode of] creation partook of the divine, and in a special way he obtained the ideas of nature. This would be difficult to discuss with ordinary people . . .[11] This is true knowledge of painting.

> *Meng-ch'i pi-t'an* (Casual Writings from the Garden of the Stream of Dreams, *MCPT*), ca. 1090, Book 17, "Calligraphy and Painting"; see *CKHLLP*, pp. 1021, 43.

Classification in Grades by Qualities

Huang Hsiu-fu (ca. 1006)

The untrammeled class of painting is the most difficult to group. It is clumsy in the regulated drawing of squares and circles, and disdains minute thoroughness in coloring. Its brushwork is abbreviated yet its

10. This subtropical plant, frequently depicted in garden settings, was of course not native to Lo-yang, in Honan province. An anonymous painting of the paragon Yüan An (d. A.D. 92), who preferred to starve rather than beg, *Lying in Bed After the Snowfall,* was displayed in Nanking in Sung times: see Soper, *Kuo Jo-hsü's Experiences in Painting,* p. 92. Chang Yen-yüan's remark about Wang Wei is not found in the *LTMHC.*

11. Here Shen Kua first cites Hsieh Ho's comment on Wei Hsieh in a shortened form of the *LTMHC* version, and then the well-known lines from an Ou-yang Hsiu poem: c.f. chapter 1 at "Definition"; chapter 5 at "Poetry and Painting."

forms are complete, being attained through spontaneity (*tzu-jan*). None can imitate it, for it issues from the expression of concepts. Therefore, we designate it "the Untrammeled Class."

In general, the art of painting is "to depict forms in correspondence to objects."[12] But when the divine [creative] force whirls aloft, thought is joined to spirit. [The painter] creates concepts and establishes substance, and their subtleties combine with transformative powers. This is not to say that on opening a cabinet [of such paintings they] could leave on their own, or that they could remove themselves from a wall to fly away.[13] Therefore, we designate it "the Inspired Class."

Painting is done by men, and each man has his own nature. Brushwork may be refined and ink may be subtle without one's knowing how this came about. It is like [the expert butcher's] handling of a blade to cut up an ox, or like [the skillful artisan's] whirling an ax to clean [plaster] off a nose.[14] [Such art is] transferred from the mind to the hand, indirectly exhausting its hidden secrets. Therefore, we designate it "the Excellent Class."

[Some] paintings have characteristics which encompass the entirety of animals and plants, and artistry which vies with the achievements of heaven. As for [their] connected peaks and melting streams, diving fish and soaring birds, their formal resemblances have lifelike movement. Therefore, we designate it "the Competent Class."

ICMHL, "Introduction to the Classification." CKHLLP, pp. 405–406.

Sun Wei [late 9th century] . . . was careless and wild by temperament and his feelings were exceptional. Although he liked to drink wine, he was never a heavy drinker. He frequently consorted with Buddhist monks and Taoist priests. When men of power and position requested works, if there was the slightest discourtesy in their manner, it would be hard to get him to execute a single stroke even though they offered him much gold. Only art lovers would occasionally obtain his paintings . . .

In both these temples [of Ying-t'ien Ssu and Chao-chüeh Ssu, where around 886 Sun painted sets of Buddhist and Taoist murals], the Heavenly King [of the East], the crowd of retainers, men, and demons

12. The third of Hsieh Ho's Six Laws; see chapter 1 at "Criteria for Appreciation and Criticism."

13. For stories related to Ku K'ai-chih and Chang Seng-yu, see the *LTMHC*, Books 5 and 7. Acker, II, pt. 1, pp. 43 and 174.

14. For these Taoist stories of ultimate skill in *Chuang-tzu*, Books 3 and 24, see Legge, *Sacred Texts of China: Texts of Taoism*, pt. I, pp. 198–200; pt. II, pp. 100–102.

were all diversified. With spears and lances, drums and pipes, they [seemed to] feint and thrust here and there, and an intermingling of tapping and striking was almost audible. Things like falcons and dogs were all completed with three to five strokes; yet for objects like bow-strings and axe-handles, he could equally well take up the brush and sketch them as accurately as if following a marking line. [The paintings] had dragons clutching at dashing waters in a variety of attitudes and with the appearance of moving in flight. In his pines and rocks and bamboos in inks, the brushwork was refined and the ink-tones subtle; none could record or transmit the heroic vigor of their bearing. Unless Heaven grants such abilities—elevated feelings and an untrammeled quality—who will be able to equal him in these respects?

ICMHL, "Untrammeled Class."

Teng Ch'un (ca. 1167)

Since antiquity, connoisseurs have distinguished three classes, calling them: the "Inspired," the "Excellent" and the "Competent" (*shen, miao, neng*). Only Chu Ching-hsüan of T'ang, when compiling the "Record of Paintings by T'ang Worthies" [that is, the *T'ang-ch'ao ming-hua lu*], added the "Untrammeled" class apart from the other three.[15] Subsequently, Huang Hsiu-fu, in writing the *I-chou ming-hua chi* [or *lu*], considered the "Untrammeled" to be foremost, with the "Inspired," "Excellent," and "Competent" following in order. Although Ching-hsüan said that the "Untrammeled" classification was not within the bounds of orthodox rules, but was used to reveal relative merit, because of the loftiness of the "Untrammeled," how can it be appended after the three classes proper? Was not Hsiu-fu more correct in promoting it to the top position? Finally, since the Sovereign, Hui-tsung specifically esteemed the rules and regulations [of painting], he arranged [the classes] in this order: "Inspired," "Untrammeled," "Excellent," and "Competent" . . .

The untrammeled class of painting reached its zenith in Sun Wei [late 9th century]. Later men were often increasingly wild and reckless. Shih K'o [10th century] and Sun Chih-wei [11th century] may still be tolerated, although they did not escape being coarse and vulgar. Finally, as for types like Kuan-hsiu [832–912] and Chao Yün-tzu [late 10th century], there was nothing about which they had scruples. In their thoughts they wished to be lofty, yet they were never anything but uncouth. How true of these sorts of men!

15. See chapter 2 at "Classification."

Hua-chi ("Painting" Continued, *HC*), preface dated 1167, Book 9, "Concerning the Distant Past." *CKHLLP*, pp. 75–76, 78.

Classification in Subject Categories

Liu Tao-shun (mid-11th century)

. . . In general, looking at Buddhist imagery, one esteems grave sternness and compassionate perceptiveness. Looking at arhats, one esteems their devotion to the four images [of Buddha]. Looking at Taoists, one esteems their solitary leisure and the purity of antiquity. Looking at [Confucian] figures, one esteems their refined spirit and proper deportment. Looking at domestic and wild animals, one esteems tame docility or ferocious cruelty. Looking at flowers and bamboo, one esteems rich beauty or quiet fascination. Looking at birds, one esteems the plumage and their soaring aloft. Looking at landscapes, one esteems level distances and vast expanses. Looking at demons and spirits, one esteems muscular strength and varied strangeness. Looking at architectural constructions, one esteems sturdy beauty and deep distance.

Modern men sometimes cast aside the Six Essentials and reject the Six Merits, thinking that they can achieve these [qualities]. How does this differ from climbing trees to seek fish, or drawing from a stream to obtain fire? They will never be had thus.

> *SCMHP*, before 1059. Foreword with introduction to the six categories of "figure painting"; "landscapes, and forest trees"; "domestic and wild animals"; "birds and small creatures"; "demons and spirits"; "architecture." *CKHLLP*, pp. 408–409.

Hsüan-ho hua-p'u (ca. 1120)

In Ssu-ma Ch'ien's historical narrative, he placed the [Taoist texts of the] Yellow Emperor and Lao-tzu first, and the Six [Confucian] Classics later. His critics were numerous, but when we look at Yang Hsiung's writings it is said that the Six Classics complete the Tao.[16] Thus we know that the rationale of Ch'ien's history should be adopted. Now we have arranged this painting catalogue into a total of ten groups, and Taoist and Buddhist [subjects] are deliberately placed at the head of the various chapters for this reason.

16. Ssu-ma Ch'ien (145–ca. 74 B.C.) wrote *Shih-chi* (Historical Records). Yang Hsiung (53 B.C.–A.D. 18) was the author of *Fa-yen* (Canonical Sayings).

Men are endowed with the luxuriance of the Five Elements and are the quintessence of the myriad things. If noble, they are princes and dukes; if base, they are commoners. The forms of their caps and crowns, vehicles and garments, [or their surroundings of] mountains and forests, hills and valleys, should be selected accordingly. Therefore, figure painting is placed next.

In the time of high antiquity, [people] constructed holes or made nests, and used them as dwellings. The sages of later eras established the system of roof-beams above and eaves below as a provision against wind and rain. Thus, in the variety of palaces and mansions, terraces and pavilions, or in the crowds of common huts and village houses, along with their relative skillfulness or extravagance, one can generally see the customs of the time. Therefore, architectural subjects are next.

When the Son of Heaven possesses the Tao, [the empire] is protected from the four barbarians. Sometimes the passes are closed and hostages declined; at other times tribute of precious objects is brought, and all are on good terms. With [knowledge of] the Book of Songs, their music can be used; coming with gifts and with princes they are not despised as men. Therefore, we place barbarian tribes next.

Ascending and descending at will, they are never restrained. With transformations that none can fathom, they forget each other in rivers and lakes. Closely followed by clouds and mist, they find pleasure in moats and dams. Dragons and fishes are thus next.

With the Five Peaks acting as guardians and the Four Rivers issuing from their wellsprings, clouds gather densely and rain falls in torrents. In raging billows and startling cascades, ten thousand miles are in the space of a foot. With the gathering and expanding of clouds and mist, the brightening and darkening of dawn and dusk, it is as if the heavens were created and earth established. Therefore, landscape is next.

The ox carries heavy burdens traveling far, and the horse roams the earth without limits. And as for the brilliant tiger and the elegant leopard, or the sturdy dog and the crafty hare, although they have been described in books, they may still be used. Thus, domestic and wild animals are next.

As for the flowers and fruits of plants and trees or the flying and singing of birds, the issuing forth of plants and animals has perfected principles that are unspoken and run the course of the four seasons without words. The poets [of the Book of Songs] have chosen from them and created metaphors, allusions, and satires. Therefore, flowers and birds are next.

It supports the snow, chilled by frost, as though that were its unique

purpose; with empty heart and lofty morality, it is as if possessed of beauty and virtue. It is cut to become pitch pipes, and written on as bamboo slips. The most elegant of plants and trees have nothing to add to it. And since it has shed the "red and green," its plainness should be esteemed. Therefore, ink bamboo is next.

Whether carrying a pitcher [of water] to irrigate the fields or asking to study gardening, the Tao of nourishing life is the equivalent of daily food and drink. Yet the delicious flavor of beautiful fruits makes them worthy to be presented in baskets of bamboo and wood, or to be offered to the gods. Therefore, vegetables and fruit are placed at the end.

The sequence of men here is not divided into grades and classes, but is ordered specifically by chronology, so that all who read this book can find a painting by its subject, and thus a painter by his painting, and can judge the age through the painter. It should be understood that what is transmitted in this painting catalogue does not represent reverence for various men's [opinions but personal knowledge].

> *Hsüan-ho hua-p'u* (Catalogue of Paintings in the Hsüan-ho Collection, *HHHP*), preface dated 1120, "Introduction to Classification."

Buddhist and Taoist Subjects

Huang Hsiu-fu (ca. 1006)

The Grand Master Ch'an-yüeh . . . whose name was Kuan-hsiu [832–912] . . . took Yen Li-pen as a model and painted scrolls of the *Sixteen Arhats*. With their bushy eyebrows and large eyes, their pendulous jaws and prominent noses, as they leaned against pines and rocks or sat in mountain scenery, he rendered to perfection the characteristics of their Tartar features or Indian faces. When asked about them, he answered: "They were seen by me in a dream." He also painted the *Ten Disciples of the Buddha* in a similar fashion, and everyone marveled at them.

> *ICMHL*, "Competent Class, Bottom Grade."

Former men in painting Buddhist icons or arhats were transmitting either the Ts'ao or the Wu tradition. The former originated with Ts'ao Pu-hsing [3rd century] and the latter with Wu Chien [5th cen-

tury]. While Ts'ao painted drapery folds with close-set parallels, Wu painted them with a terse summariness . . . Chang Hsüan [8th century] painted his arhats in the Wu fashion.

> *ICMHL*, "Excellent Class Lower Grade," excerpt from the Chang Hsüan entry.

Kuo Jo-hsü (ca. 1080)

The two styles of Ts'ao and Wu are what students follow. According to the *Li-tai ming-hua chi* by Chang Yen-yüan of the T'ang, "Ts'ao Chung-ta of the Northern Ch'i was by origin a native of the realm of Ts'ao, who was highly esteemed for his skill in painting Indian icons."[17] Here is the Ts'ao referred to, while Wu Tao-tzu of T'ang is known as Wu. Wu's brushwork had an appearance of rounded curves, and his robes billowed upward; Ts'ao's brushwork was in a style of close-set parallels, and his robes clung tightly. It was for this reason that later men held that Wu's girdles were wind-tossed, while Ts'ao's garments had just come out of water . . . As for Ts'ao Chung-ta, he appeared in the Northern Ch'i dynasty [550–577], not long before the T'ang. Wu Tao-tzu's fame dated from the K'ai-yüan era [713–742], and figures painted by him are still extant, proving that the school traditions of recent times are in accord with the modes and standards of that former period . . .

Wu Tao-tzu's paintings make him unique in modern or ancient times. As Chang Yen-yüan said: "He did not look back to Ku and Lu, and will have no successors."[18] How true that was! In the past when I saw paintings by him on walls or scrolls, the fall of his brush was virile and strong, while the handling of colors was simple and light. Occasionally one finds wall surfaces on which the pigments have been laid heavily, but these are usually the embellishments of later men. Down to modern times, painters have had [a method of] touching on colors lightly, which they call "Wu decoration." For sculptured images there is also "Wu decoration" . . .

In looking at a succession of paintings by famous early masters of [Taoist] "golden boys and jade girls," genii and immortals, or constellations, one finds female forms and faces that, despite an appearance of severe correctness, inevitably have a spirit of antique beauty. Theirs is naturally a stately and dignified beauty, which inspires the viewer to look to them in reverence. But the painters of today lay

17. *LTMHC*, Book 9, see Acker, II, pt. 1, p. 193.
18. See chapter 2, at "Brushwork."

store only on pretty faces to captivate the eyes of the crowd. They do not penetrate to the principles and meanings of painting. The observer should bear this in mind . . .

The theory is sometimes propounded that it is not proper to collect Buddhist or Taoist icons, since it is difficult to unroll and enjoy them from time to time for fear of their being treated irreverently or becoming polluted. My own opinion is the reverse. It is a general rule that when scholars and gentlemen meet for the pleasure of seeing and discussing calligraphy or paintings, the place must be quiet and clean, and where there is only appreciation for skill and respect for the images preserved from the past, how could any irreverence of mind exist?

Further, the Buddhist or Taoist votive offerings executed by the men of old required concentration of mind and strong determination to wholly exhaust the wonderful . . . [Of these painters] there was no one who did not achieve merit through the Buddha or the Tao. Without the grandeur and majesty of Indra and Brahma or the illustrious transformations of the true Immortals, how would they have had any way of displaying the boundlessness of their mastery or of fulfilling the refinement and depth of their will to study?

It can thus be known that the opinion that it is improper to collect [icons] is of no importance.

> *THCWC,* Book 1, "On the Styles and Methods of Ts'ao and Wu," "On Master Wu's Use of Colors," "On Female Forms and Faces," and "On Collecting Icons." *CKHLLP,* pp. 60–61, 451 (in part).

Shen Kua (1031–1095)

Wu Tao-tzu once painted a Buddha, leaving out its halo. Then, in the midst of a great congregation of people, he lifted his hand and moved it in one motion before the multitude of spectators. The circle was perfectly regular, and all the onlookers were astonished.[19] Painters have explained that Wu had a natural technique. However, if one leans a shoulder against a wall and then moves the arm right around, there will naturally be a perfect circle. [To control] the thickness or thinness of the brush stroke, one has only to prop a finger against the wall as a gauge, and it will naturally be even. These are not enough to astonish one. Tao-tzu's subtle points were not in these techniques. They are only to surprise the eyes and ears of the vulgar.

19. See also Chu Ching-hsüan, *TCMHL;* see chapter 2 at "Definition, Animation, and Expression."

Painter-artisans painting the bodily radiance of the Buddha some-
times make a flat circle like a fan, then, if the body is turned sideways,
the halo is turned also. This is a great error. They have only seen
carved wooden Buddhas and do not know that this radiance must
always be circular. Then, again, there are those who paint a walking
Buddha with the halo trailing behind, calling it a "halo following the
wind." This is also an error. The Buddha's radiance is the radiance
of constant effect, which, though cut by the wind, could never move.
How could it waver with every breeze?

> *MCPT*, Book 17, "Calligraphy and Painting." *CKHLLP*, p. 449.

Hsüan-ho hua-p'u (ca. 1120)

"Set your heart upon the Way, support yourself by its power, lean
upon goodness, and seek distraction in the arts."[20] Art, therefore,
cannot be forgotten even by those who have "set their hearts upon
the Way." But one must specifically "seek distraction" in it, and that
is all. Painting, too, is an art, and when one has advanced to the
marvelous, one does not know whether art is the Tao or the Tao is
art. Like the carpenter Ch'ing carving the bell-rack and the wheel-
wright Pien shaping a wheel, the ancients also possessed that which
should be obtained.[21] Thus, the painting of Taoist and Buddhist im-
ages, as well as of the bearing and appearance of Confucian figures,
causes men to look upon them with reverence. If there is compre-
hension from created form, how can this be called a small advantage?
Therefore, the three religions [of Confucianism, Taoism and Bud-
dhism] are all included in the category of Buddhist and Taoist sub-
jects.

> *HHHP*, Book 1, "A Discussion of Taoist and Buddhist Subjects." *CKHLLP*,
> p. 466.

Teng Ch'un (ca. 1167)

In the west, in Central India, the priests of the Nalanda Monastery
often paint images of the Buddha, the bodhisattvas, and arhats on
Indian cloth. Their Buddhist representations are considerably dif-

20. This well-known quotation is from the *Lun-yü* (Analects); see Legge, *Chinese
Classics*, I, 196.

21. For these stories in *Chuang-tzu*, Books 13 and 19, see Legge, *Sacred Books of
China: Texts of Taoism*, pt. I, pp. 343–344; pt. II, pp. 22–23.

ferent from those of the Chinese. The eyes are somewhat larger, and the mouths and ears altogether strange. A cord [of the Brahmins] runs over their right shoulders; they sit or stand [half-]naked. First, the five mystic syllables are written on the back of the painting and then the five colors [green, yellow, red, white, and black] are daubed on the front surface. Either gold or vermilion is used for the ground. They say that ox-skin glue is offensive; therefore, they use a mixture of peach resin and water in which willow branches have been soaked, which is very strong and penetrating.

HC, Book 10, "Concerning the Recent Past." *CKHLLP*, p. 82.

Figure Painting

Kuo Jo-hsü (ca. 1080)

In general it is unquestionable that a painting's forcefulness and spirit consonance involve suitability of characterization. The requirements for each category cannot be left unstudied.

Those who paint secular figures must distinguish between the look of rich and poor and the robes and headgear of the different dynasties. In the case of Buddhist monks, the faces [should tell of] good works and practical expedients [to gain salvation]. In the case of Taoist figures, the cultivation of purity and other-worldliness is the standard that must be satisfied. In the case of monarchs, it is proper to honor their appearance of supreme sanctity, like the very orb of heaven. In the case of outer barbarians, one must catch their mood of devotion to the Chinese empire in respectful obedience. In the case of Confucian worthies, one makes visible their reputation for loyalty and faithfulness, correct conduct and sense of right. Warriors assuredly will often have a look of fierce bravery and gallant impetuousness. Recluses are instantly to be recognized by the signs of their retired lives and elevation above the world. Persons of high birth will obviously be admired for the brilliant gaiety and lavish extravagance of their appearance. With [guardian kings like] Indra, one should display a terrifying and auspicious, sternly imposing demeanor. With demon divinities, one creates an effect of hideousness and swift motion. Ladies should be richly endowed with blossoming loveliness and feminine charm. Peasants will naturally possess the very essence of unsophistication and country simplicity. Respectfulness or obstinacy, and joy or sorrow should also be evident.

In the painting of drapery folds or trees and rocks, the use of the

brush is exactly the same as in calligraphy. In the case of drapery folds, there will be some that are heavy and wide, and yet harmonious and fluent; while others will be fine and thin, and yet strong and vigorous. Hooked or loose, free or dragged, if they are controlled and not put down capriciously, they will form aspects of height or inclination, depth or obliqueness, turning or folding, swirling or billowing up . . .

From ancient times on down, the styles of robes and headgear have undergone frequent changes, hence it is essential to distinguish between periods in depicting the personages in any particular story . . . Generally, it is in planning and composing that one should be careful to make fine distinctions. Now Yen Li-pen [d. 673], in representing Wang Ch'iang, the Brilliant Concubine [1st century B.C.], as a captive bride, showed her wearing a veiled *"wei-mao"* hat while riding on a saddle-horse. Again, Wang Chih-shen [7th century] in painting Emperor Wu of the Liang [r. 502–549, sacrificing] in the Southern Suburb showed persons on horseback who were wearing ceremonial robes and hats. Obviously it was not known that the *"wei-mao"* hat was invented in the Sui dynasty, and that the formal carriage was only dispensed with from T'ang times on. Although [such lapses] cannot spoil a masterpiece, they too are among the faults in painting.

> *TWCHC*, Book 1, "On the Models for Composing" and "On the Different Styles of Robes and Headgear." *CKHLLP*, pp. 57, 82.

Shen Kua (1031–1095)

The old wall paintings in the Grand Secretary's Temple (Hsiang-kuo Ssu) are from the brush of Kao I [active later 10th century]. One of the most interesting depicts a group of musicians. People generally criticize [the detail of] a musician holding a *p'i-p'a* guitar and playing the lowest string incorrectly, since all the oboes are blowing the "fourth note" which should be on the top string of the *p'i-p'a*, so that on this note the covering of the lower string is a mistake. I disagree. The oboes make a sound when fingers are on [the holes], while the *p'i-p'a* makes a sound only after it has been plucked. In this case, as the lower string is covered, the sound must be coming from the upper string. If Kao I's composition is as competent as this, we can know his inventiveness . . .

Wang Ch'in-ch'en [11th century], when looking at paintings in my house, most liked Wang Wei's painting of "Hung-jen Leaving the

Mountains," because in its depiction of the two men, [the Ch'an Buddhist patriarchs] Hung-jen [602–675] and Hui-neng [637–712] the spirit resonance (*ch'i-yün*) was divinely ordered, and everything was in accord with their characters as men. Reading of these two men's lives and looking at this painting of them, one can imagine their persons.

MCPT, Book 17, "Calligraphy and Painting." *CKHLLP,* p. 448.

Hsüan-ho hua-p'u (ca. 1120)

As for Yin Chung-k'an's eyes and the hairs on P'ei K'ai's chin, "the essence of the spirit is found in these spots," and the "lofty recluse should be placed among hills and valleys."[22] These are not things that can be attained in critical discussions, for they are unspoken subtleties that painters possess in creating. It is for this reason that the painting of human figures is the most difficult in which to gain skill. Even though one may attain their formal likeness (*hsing-ssu*), they frequently lack resonance (*yün*). Therefore, from the Wu and Chin dynasties to the present, of those who have been praised as famous masters we have selected only thirty-three men.

HHHP, Book 5, "A Discussion of Figure Painting." *CKHLLP,* p. 467.

Architectural Subjects

Kuo Jo-hsü (ca. 1080)

When one paints architectural constructions, calculations should be faultless and brush drawing of even strength. Deep distances penetrate into space and a hundred diagonals recede from a single point. As for [artists of] the preceding Sui, T'ang, and Five Dynasties down to such men as Kuo Chung-shu [d. 977] and Wang Shih-yüan of the present empire, in painting towers and pavilions, they usually showed all four corners and their bracketing was arrayed in order. They made clear distinctions between front and back without error in the marking lines. Painters of the present mainly use the ruler uniformly to accomplish "ruled-line" painting. They calculate the bracketing in

22. These stories and remarks associated with Ku K'ai-chih (ca. 345–ca. 406) are reported in the *Chin shu* (Chin Dynastic History), Book 62; see Chen Shih-hsiang, *Biography of Ku K'ai-chih,* Chinese Dynastic Histories Translations (Berkeley: University of California Press, 1961), pp. 14–15.

brushwork that is intricate and confusing, lacking any sense of vigorous beauty or easy elegance.

> *THCWC*, Book 1, "On the Models for Composing." *CKHLLP*, p. 58.

Shen Kua (1031–1095)

Further, when Li Ch'eng [919–967] painted such buildings as pavilions or towers on a mountain, he always did the flying eaves as if one were looking up at them. The explanation is given that one is viewing what is above from below, just like a man on level ground looking up at house eaves sees their supporting rafters. This theory is wrong. Generally, the method of landscape painting is taking the larger view of the small, just as a man looks at an artificial mountain. If it were the same as the method of [viewing] actual scenery, then looking up from below, one would only see a single layer of the mountain. How could one see its whole, layer upon layer. Similarly, one would not see its valleys and other details. Again, in such things as buildings, one would not see inner courtyards or events happening in the rear lanes. When a man stands in the east, then the west of the mountain is the whole of his distant view; when he stands in the west, the east of the mountain is all of the distant view. How could one make a painting if it were to be like this? Master Li apparently did not understand the method of taking the larger view of the small, but his distinctions of height and distance naturally had a subtle rational order. How could this just be a matter of raising up the corners of buildings?

> *MCPT*, Book 17, "Calligraphy and Painting." *CKHLLP*, p. 625.

Hsüan-ho hua-p'u (ca. 1120)

When painters took up these subjects and completely described their formal appearance, how could it have been simply a question of making a grand spectacle of terraces and pavilions, or doors and windows? In each dot or stroke one must seek agreement with actual measurements and rules. In comparison with other types of painting, it is a difficult field in which to gain skill. Consequently, from the Chin through the Sui Dynasties there are no known masters, and over the three hundred years of T'ang and continuing through the Five Dynasties one finds only Wei Hsien [10th century], who gained fame for his painting of architectural subjects. After the appearance of Kuo Chung-shu [d. 977] of the present dynasty, one could pay attention to Wei Hsien and the like, but there are not enough of the rest to

number. Kuo Chung-shu's painting, however, is lofty and antique and has never been easy for common people to understand. There have been some who have laughed at it without having seen it.

HHHP, "A Discussion of Architectural Subjects."

Barbarians

Kuo Jo-hsü (ca. 1080)

Under the T'ang, in the third year of Chen-kuan (629), the eastern barbarian Hsieh Yüan-shen presented himself at court. His cap was made of black bear-skin, with a gold fillet across the forehead; his outer garments were of fur, and he wore leather leggings and shoes. The Vice-President of the Grand Secretariat Yen Shih-ku (581–645) introduced him with these words:

"In ancient times King Wu of the Chou governed [so as to] bring about universal peace, and far-distant lands turned in love to him. Such incidents were collected in the Chou History to form the chapter on "Royal Audiences." Today the myriad realms to which the imperial virtue has extended come to court in their garments of grass and feather ornaments, to meet together in the barbarians' guest quarters. Truly this should be represented pictorially for posterity, in order to exhibit the far-reaching extent of that virtue."

The All-Highest agreed and hence ordered Yen Li-te and others to make paintings of the subject.

TWCWC, Book 5, "Gleanings from History," on Hsieh Yüan-shen.

Hsüan-ho hua-p'u (ca. 1120)

When they sent their sons and younger brothers to study and happily offered tribute and fulfilled obligations, then, although their strange regions were far away and their customs, language, climate and ways different, the philosopher kings of old still never rejected them. That is why the barbarian tribes are seen in the tradition of painting. Painters, however, as if to be highly censorious, often choose [to portray them with] bows and swords at the waist or bows and arrows under the arm, in such amusements as roaming and hunting with dogs and horses. Still it is also because they consider the barbarian customs to be base, while revering the truth and sincerity of China's cultural heritage.

Of the painters that have appeared in the world from T'ang through

the present dynasty, there are five in all [to be noted]. In T'ang there were Hu Kuei and Hu Ch'ien [10th century] and in the Five Dynasties there was Li Tsan-hua [10th century], all of whose brushwork is worthy of transmission. Since Tsan-hua [of the Liao imperial clan] was a descendant of the northern peoples, he was enfeoffed as the Prince of Tung-tan. Consequently, what he always painted were the ancient customs of his native place, not the apparel of the Chinese.

HHHP, "A Discussion of Barbarian Tribes." *CKHLLP*, pp. 467–468.

Dragons and Fishes

Kuo Jo-hsü (ca. 1080)

In painting dragons, one distinguishes the "three equal sections" from head to shoulders, from shoulders to belly, and from belly to tail; and differentiates the "nine similarities," the horns being like a deer's, the head like a camel's, the eyes like a demon's, the neck like a serpent's, the belly like a sea-serpent's, the scales like a fish's, the talons like an eagle's, the feet like a tiger's, and the ears like a cow's. One should fully express the wonders of their swimming and diving, wriggling and winding, and catch the right aspect of their turning and coiling, soaring and descending. A further requisite of high quality is that the bristles of the mane and the hair on the hocks be drawn with a strong, lively brush, so that they [will seem to] grow right out of the flesh. It is generally easy to be skillful when painting dragons whose jaws are open, but hard to succeed if their jaws are closed. Painters speak of cats with open mouths and dragons with closed jaws as the two great problems.

In painting water, one deals with the single swell and the triple breaker. If one defines the aspects and forms of the character *chih* and the tiger's claws in an effect of flooding movement, causing viewers to sense the overwhelming vastness of lakes and rivers, this is sublime . . .

Unfortunately Ts'ao Pu-hsing's [dragon] head in the Privy Pavilion is no longer to be seen, [to indicate] whether or not present models are the same, nor is it known what the dragon that Master Yeh once encountered looked like. Since the death of the Master Dragon-raiser in ancient times, dragons have never again been tamed.[23] Humans

23. Master Yeh, who had had dragons painted on his walls, fled in terror at the sight of a real one, according to an anecdote by Liu Hsiang (77–6 B.C.) in the *Hsin-hsü* (New Arrangement). For the dragon rearers of the *Tso chuan*, see Legge, *Chinese Classics*, V, 731.

cannot attain or see [the creature] of the saying: "aloft he soars to heaven, hiding between the cloud layers, below he returns to the nether springs, penetrating into bottomless depths." In modern depictions the only difficulties are in regard to formal likeness. If one merely looks at draftsmanship or ink technique, in muscular strength and quintessential spirit these tally in principle with Wu Tao-tzu's painting of demon divinities. The "three equal sections" and the "nine similarities" mentioned above were also inherited as rules transmitted by craftsmen on account of people's normal inability to recognize real dragons.

> *THCWC*, Book 1, "On the Models for Composing" and "On the Essential Rules of Dragon Painting." *CKHLLP*, pp. 57–58 (in part).

Hsüan-ho hua-p'u (ca. 1120)

In the [explanation of the] hexagram *ch'ien* of the *I ching* (Book of Changes), the dragon is said to appear in the fields, in the depths, and in the heavens in order to explain its far-ranging transformations. It does not know restriction or restraint; thus the comparison [in the commentary on this hexagram]: "It furthers one to see the great man."[24] In the poem "Fish and Waterplants" of the *Shih ching* (Book of Songs),[25] it is said, "Beautifully streaked are their heads," "very pliant are their tails," and "snuggling close to the reeds" to describe their deep and distant roaming and swimming. "Forgetting each other in the rivers and lakes" [in *Chuang-tzu*] refers to the difficulty in gaining the services of virtuous men.[26] In the writing of the *Changes* and the editing of the *Songs*, the early sages did not neglect to speak of dragons or speak of fish. Although painting is a lesser Tao, there is certainly that in it which should be looked upon. The painting of dragons and fish is comparable in every way to the symbols in the *Changes* and *Songs*.

Although the formal appearance of dragons is not to be seen, still, Master Yeh was fond of them [yet scared by] a true dragon that came to him. Thus the painting of dragons has a long tradition . . . Tung Yü [10th century] of the present dynasty was subsequently famed for his dragons and water; truly, he is the incomparable master of recent times.

As fish give actual pleasure to our senses, there should be many masters. But painters often portray them as [if they were] things lying

24. See *I ching*, Richard Wilhelm tr., p. 8.
25. See Legge, *Chinese Classics*, IV, 400–401.
26. See Legge, *Sacred Books of China: Texts of Taoism*, pt. I, p. 253.

on the kitchen table, lacking therefore their potential [ambition] to ride the wind and break the waves. This point has not escaped notice in contemporary criticism

> *HHHP,* Book 9, "A Discussion of Dragons and Fishes."

Landscape

Liu Tao-shun (ca. 1059)

Kuan T'ung [early 10th century]: it is not known where he came from.[27] He first followed Ching Hao [ca. 870–ca. 930]. In his study of landscape painting, he was so determined and hardworking that he forgot about sleeping and eating. His intention was to surpass Ching Hao. Later on people commonly spoke of his work as "the Kuan landscape." For some time he became the center of artistic interest, as people vied for traces of his brushwork. The human and animal figures in his mountains, however, he had added by Master Hu [sometimes called Hu I] from An-ting [Shensi].

As for T'ung's painting style, above protrude eminent peaks, below one gazes into bottomless ravines,[28] of a majestic gravity and strength that T'ung was able to bring out with one brush stroke. Their prominent forms burst forth as if gushing out. And furthermore, everything was complete in the sombre vastness—the bluish green of peaks and cliffs, soil and rocks in groves and foothills, as well as land areas into the level distance and mountain paths remote and cut off, bridges and planks, hamlets and villages—hence the praise and esteem of his contemporaries.

> *Wu-tai ming-hua pu-i* (A Supplement on the Famous Painters of the Five Dynasties, *WTMHPI*), preface dated 1059, on the painter classified along with Ching Hao in the Inspired Class of Landscapists.

Liu Tao-shun (mid-11th century)

Fan K'uan [active ca. 990–1030], whose original name was Fan Chung-cheng, style Chung-li, was a native of Hua-yüan [Shensi]. Since he was by temperament liberal and broadminded, contemporaries nick-

27. In Kuo Jo-hsü's *THCWC,* Book 1, entry on Kuan T'ung, he is said to have been a native of Ch'ang-an (Sian), Shensi.

28. The *SKCS* text is followed here: also see Yü Chien-hua, *Chung-kuo hui-hua shih* (Hong Kong: Shang-wu, 1962), p. 146.

named him Fan K'uan [the Expansive]. He lived amid mountains and forests, and often sat on high for a whole day, letting his eyes gaze in all directions to seek out the best scenery. Even in snow or moonlight, he would have to wander about staring intently in order to stimulate inspiration. He studied the brushwork of Li Ch'eng [919–967], but, despite attaining a refined subtlety, was still his inferior. Then he created his own ideas confronting the scenery and did not choose to ornament abundantly but sketched the very bones of the mountains, forming his own style. Hence his aspect of hardy antiquity was not wrested from predecessors. Therefore, he became the equal of Li Ch'eng.

Only Fan Chung-cheng and Li Ch'eng may be called supreme among those who created landscapes since the Sung Dynasty has reigned, and up to modern times there have been no challengers. In the poet's criticism: "Li Ch'eng's brushwork, when seen from nearby, seems a thousand miles away; / Fan K'uan's brushwork, when seen from afar, seems right before one's eyes."[29] This is what can be called "creating from inspiration." However, Chung-cheng loved to paint effects of struggle against snow or of clouds forming, and there had the most spirit and structure.

Critique: Fan K'uan became famous through his landscapes, which were admired by everyone. Their real rocks and old trees thrust up alive under his brush. If one looks for their spirit resonance (*ch'i-yün*), it goes beyond the surface of things. Furthermore, he did not rely on ornamental beauty, and from antiquity there were no laws for him. He invented ideas on his own, and his achievements exhausted creation. As for tree roots being on the surface or an excess of mountains in the distance, these are minor flaws and do not detract from the essential effect. He may also be placed in the Inspired Class.

> *SCMHP*, on the painter classified along with Li Ch'eng in the Inspired Class of Landscapists.

Kuo Jo-hsü (ca. 1080)

In painting forests or trees, one deals with drooping branches and upthrust trunks, crooked joints and furrowed bark, splitting apart at their nodes into numerous twig tips or subdividing into myriad forms. One will create their aspects of furious dragons or fearful serpents,

29. Note Wang Shen's appraisal of these two artists in chapter 4 at "Connoisseurship of Landscape Painting."

and emphasize their attitudes of reaching to the clouds or screening the sun. It is proper that they should be proudly tall and luxuriantly abundant and that their coiling roots then be given an ancient sturdiness.

In painting mountains and rocks, one will often make [lumpy] alum-crystal tops, as well as multiangled surfaces. The fall of the brush will bring out their characteristics of firmness and weight, while texture-inking (*ts'un-tan*) will produce the shapes of hollows and protuberances. Often the silk is left white to form clouds, or the plain ground is used to indicate snow, but such effects in the graded ink are particularly difficult . . .

In the painting of landscape, only Li Ch'eng of Ying-ch'iu, Kuan T'ung of Ch'ang-an, and Fan K'uan of Hua-yüan were so wondrous in understanding as to enter the divine, so exalted in talent as to be beyond classification. These three masters will stand aloft like a tripod as the models for a hundred generations. Although there have been men in the past traditionally considered worthy of note like Wang Wei [701–761], Li Ssu-hsün [651–718], and Ching Hao [ca. 870–ca. 930] how can they come forward as equals? Even though there have been those in recent times of single-minded strength in study like Chai Yüan-shen, Liu Yung, and Chi Chen, they scarcely carry on a remnant of the tradition. Chai studied Li; Liu studied Kuan; and Chi studied Fan.

In Li Ch'eng's compositions there is a solemn sparseness to the general scene, a pure spaciousness in misty groves, a piercing acuteness to the brush point, and an exquisite subtlety in the ink technique. In Master Kuan's manner, there is a crystalline hardness of rock forms, a luxuriant density in combinations of trees, an antique elegance in terraces and pavilions, and a lonely peacefulness in human figures. In Master Fan's works, there is a full massiveness of peaks and summits, a virile strength in aspects and appearances, a perfect balance between texture dabs and brush-drawing, and a total simplicity in people and buildings.

Li Ch'eng first attained the marvelous in misty woods and level distances. His way of painting pine needles is called "converging needles"; his brushwork is without variations in tone but gives the natural hue of their flourishing density. Kuan in painting tree foliage occasionally uses an ink of soaking wetness, or at times produces a withered branch. The brush strokes have a vigor and acuteness that students will find hard to attain. When Fan paints forest trees, they sometimes slant or incline in shapes like an arc; this is one of his idiosyncrasies. As yet I have not seen any of his paintings of pine or

cypress. In doing buildings, he will first establish their structure, and then wash over them with ink, so that later people have called these "iron buildings."

> *THCWC,* Book 1, "On Models for Composing" and "On the Three Schools of Landscape." *CKHLLP,* pp. 57, 627.

Shen Kua (1031–1095)

In the Chiang-nan area [south of the Yangtze] during the time of the Southern T'ang's second ruler [r. 926–934], there was a Director of the Northern Park, Tung Yüan, who excelled in painting and was especially skilled in distant views with autumnal mists. He mainly depicted the real mountains of Chiang-nan and did not make brush-drawings of extraordinary heights. After him, the monk Chü-jan of Chien-yeh [Nanking] followed Yüan's method and fathomed marvelous principles. Generally the brushwork of Yüan and Chü-jan should be viewed at a distance. Their use of the brush is very cursory and, if [their paintings are] seen from nearby, they may not seem to resemble the appearance of things; but, if viewed from afar, scenes and objects are clear, and deep feelings and distant thoughts [arise], as if one were gazing on another world. In the case of Yüan's painting of a sunset, it has no merit when seen from nearby; but, if viewed from afar, there is a village half-obscured in the deep distance. In details it is an evening scene, with the summits of remote peaks having just a trace of reflected color. These are its marvelous points.

> *MCPT,* Book 17, "Calligraphy and Painting." *CKHLLP,* p. 625.

Hsüan-ho hua-p'u (ca. 1120)

The mountain peaks are protective and the rivers, numinous; the ocean submerges and the earth supports. The divine grace of creation, the light or darkness of *yin* and *yang*, a distance of a thousand miles— all this can be captured in the space of a foot. Unless one naturally possesses hills and valleys in his breast that issue forth to be seen in their formal aspects, this will never be understood. Moreover, those who have gained renown in the painting of landscapes from T'ang to the present dynasty are not in the same class as professional painters, but often come from the ranks of officials or scholars. Still, those who attain spirit resonance (*ch'i-yün*) may be lacking in brush technique (*pi-fa*), or, should they attain brush technique, they will generally fail

at composition. It is commonly difficult to find a man who can possess and combine all the subtleties.

Now the ancients had "streams and rocks in their vitals, and clouds and mists as a chronic illness,"[30] and were ridiculed as recluses and hermits. It is thus true that, as a type of painting, landscape would perhaps not find a market in the eyes of the world if displayed in the public streets . . . Coming to the present dynasty, Li Ch'eng stood out alone. Even though he took Ching Hao as his master, he assumed the fame of one who had surpassed his teacher, and the methods of the various other artists were swept away without a trace

> *HHHP*, Book 10, "A Discussion of Landscape." *CKHLLP*, p. 658.

Different Models for Landscapists

Liu Tao-shun (mid-11th century)

Kao K'o-ming [active ca. 1008–1053] was a lover of seclusion and silence, who often wandered in the wilds. His pleasure can be known, since he would sit in contemplation all day long, gazing at the beauties of mountains and forests. On returning home he would remain in a quiet room, shut off from all thoughts and cares, and let his spirit roam beyond material things. When conditions [were right] for creating, he would lower his brush and gradually make far and near areas.

> *SCMHP*, "Excellent Class of Landscapists."

Kuo Jo-hsü (ca. 1080)

Liu Yung, a native of the capital [at K'ai-feng], was skillful at painting landscape. He first studied under the monk Te-fu, doing pines and rocks. Later on he made a general investigation of the various schools of landscape and selected their strong points to imitate. Then he saw a work of Ching Hao and realized that there was a realm beyond the attainments of any school. One day, again, he looked at a painting by Kuan T'ung and sighed to himself: "Here, truly is one who won fame by the perfection of his art! It is like the old saying: 'When [Confucius] climbed the Eastern Hill, the kingdom of Lu seemed small to him.' "[31]

30. See the *Chiu T'ang shu* (Old T'ang History), Book 192, the biography of T'ien Yu-yen (7th century).

31. For this quotation from *Mencius*, see Legge, *Chinese Classics*, II, 463.

Whereupon he gave up all his other studies, and modeled himself solely on Master Kuan. As a result he finally achieved success and won fame for himself in his day . . .

Chai Yüan-shen, a native of Pei-hai [Shantung], was a skillful landscape painter who made a study of Li Ch'eng. As a youth he belonged to an orchestra in his home district. One day, on the occasion of a prefectural assembly, he beat his drum out of time. The orchestra leader complained of his offense to the prefect, who heard the case in person. Yüan-shen said: "Insignificant though I may be, Heaven has granted me a nature which makes me love to paint landscapes. At the time in question I was pounding away at my drum when all at once I caught sight of a cloud mounting into an extraordinary mountain peak [formation], just made to be the model for a painting. It is hard to look at two things clearly at the same time, hence I suddenly broke down in my music." The prefect was pleased and released him. Yüan-shen studied Li Ch'eng until he achieved an extreme degree of likeness. Only in the works which he thought out for himself was his inferiority noticeable . . .

The monk Tse-jen of Yung-chia [Chekiang] was good at painting pines. He first culled the best points from the various schools and studied them. Then he had a dream in which he swallowed several hundred dragons, after which his achievements were divinely wonderful. He was a habitual wine bibber, who whenever he got drunk would splatter ink onto silk or a whitewashed wall. When he sobered up he would add and fill in [until there were] a thousand shapes and myriad forms of the most extraordinary sort. Once he was drinking wine in a Yung-chia marketplace and got very drunk. Catching sight of a newly plastered wall, he took a dish towel, soaked it in ink, and splattered it on. The next day he made a very few additions and corrections, and there were wild branches and decaying roots. Painters all pay homage to his inspired brush.

THCWC, Book 4, "Landscapists."

Shen Kua (1031–1095)

Some time past, Sung Ti [11th century] once saw a landscape painted by Ch'en Yung-chih [active ca. 1023–1032] of Hsiao-yao Village, a good painter, and said to him: "Your painting is truly skillful, yet it lacks a natural flavor (*t'ien-ch'ü*)." Yung-chih pondered these words and replied: "It is just this point that has always made me lament that I could not reach [the standards of] the ancients." Ti said: "That is

not so difficult. You should first look for a damaged wall, and then stretch plain silk against it. Gaze at it day and night. When you have looked for a sufficient length of time, you will see through the silk the high and low parts, or curves and angles, on the surface of the wall, which will take on the appearance of landscape. As you hold this in your mind and your eyes consider it, the high parts will become mountains and the low parts, water; crevices will become valleys and cracks, torrents; the prominent parts will seem to be the foreground and the obscure, the distance. As your spirit leads and your imagination (*i*) constructs, you will see indistinctly the images of human beings, birds, grasses, and trees, flying or moving about. Once they are complete in your eyes, then follow your imagination to command your brush. Silently, through your intuitive apprehension (*shen-hui*), the natural scene will be spontaneously achieved, and [hence] it will be unlike the work of men; this is called the 'live brush.' " After this, Yung-chih made daily progress in his painting style.

 MCPT, Book 17, "Calligraphy and Painting." *CKIILLP,* pp. 625–626.

Teng Ch'un (ca. 1167)

According to tradition, Yang Hui-chih and Wu Tao-tzu [8th century] both learned under the same master. Tao-tzu was accomplished in his studies, hence Hui-chih was afraid of being compared with Wu's fame, and instead became a sculptor. [In their areas] both men were first in the world. Consequently, in the central plains area of the north, there are many of Yang Hui-chih's landscapes modeled on walls. When Kuo Hsi [11th century] saw them, he produced a new concept. He ordered the plasterers to cease using their spatulas and to simply push the plaster onto the walls with their hands, no matter that it was here concave or there convex. When it was dry, he traced the outlines with ink, turning them into mountain peaks and forested valleys, and adding such things as buildings and human figures. It was as if created by heaven. They were called "shadow walls." Afterwards, such compositions were extremely common. This was a reinterpretation of Sung Ti's stretching of silk over ruined walls.

 HC, Book 9, "Concerning the Distant Past." *CKHLLP,* p. 78.

Domestic and Wild Animals

Kuo Jo-hsü (ca. 1080)

The general requirements for painting tame or wild animals are good proportioning and three-dimensionality, muscular strength and vital energy, plumply rounded fleshy parts, and a subtle relief to hair and bones. Beyond this one should differentiate the natural characteristics of the movements of various creatures. Among quadrupeds, it is only the rabbit which has fur on the pads of its feet, and hence is called "erect-fur."

THCWC, Book 1, "On the Models for Composing." *CKHLLP*, p. 58.

Shen Kua (1031–1095)

Ou-yang Hsiu [1007–1072] once obtained an old painting of a clump of peonies beneath which was a cat, but was uncertain of its merits. The minister Wu Yü [1004–1058], who was related to Ou-yang by marriage, as soon as he saw it, said: "These are peonies at mid-day. How do I know this? The flowers are wide open and their colors are dry; these are the flowers of the middle of the day. The cat's eyes have thread-like black pupils; these are a cat's eyes at mid-day. Flowers with dew on them have closely gathered petals and their colors are moist. A cat's eyes have round pupils in the morning and evening, but during the day they gradually narrow and lengthen, so that by mid-day they are just like a thread." This is also a good way of seeking the brush conception of the ancients . . .

In paintings of cattle and tigers the hair is always painted; with horses alone it is not. I once asked an artisan-painter about this, and he replied: "The hair of horses is too fine to paint." I made difficulties for him, saying: "The hair of mice is still finer, then why should it be painted?" And he could make no answer.

Generally, when one paints horses, their size does not exceed a foot. This is thus the reduction of a large thing,[32] hence the hair is fine and cannot be painted. Mice are painted in actual size, and it is natural to paint their fur. With cattle and tigers it is also a matter of reduction, and logically one should not see their hair; but cattle and tigers have thick hair, while that of horses is thin, hence in principle there should

32. Shen Kua distinguishes between the principle of reduction, "making the large small," in this passage, and that of the overall view in broad perspective, "taking the larger view of the small," in a following section; see "Architectural Subjects," above.

be a distinction. For this reason, when famous artists depict small tigers or cattle, though they paint the hair, they do so merely lightly touching the surface. If one were to strive for detail, one should on the contrary make the hair extra long. When one merely lightly touches the surface, [the cattle and tigers] will naturally have a divine appearance and an extraordinary life-movement. This is difficult to discuss with ordinary people. If one paints horses in the same scale as cattle and tigers, in principle their hair should be painted. Perhaps because men saw that small horses were without hair, they did not make it [on large ones] as well. This is a case of vulgar people imitating others, and one should not discuss principles in their connection.

> *MCPT*, Book 17, "Calligraphy and Painting." *CKHLLP*, pp. 1021, 1022.

Hsüan-ho hua-p'u (ca. 1120)

The hexagram *ch'ien* symbolizes heaven. "Heaven, in its motion, has strength"; it is thus the horse. The hexagram *k'un* symbolizes the earth. Earth carries a heavy burden and is receptive. It is thus the ox. The horse and the ox are animals, but in the larger sense of the *ch'ien* and the *k'un* they are symbolic. The means by which they "carry heavy burdens," and "reach distant places" were later derived from the hexagram *sui* in the *Book of Changes*. For this reason, professional painters who have portrayed horses and oxen and gained renown are numerous.

As for tigers, leopards, stags, boars, roebucks, and jack-rabbits, they are untamed animals, and painters portray them in barren or wintry wilds, leaping and coursing without halters or hobbles, simply in order to find lodging for the unrestrained spirit of their brush.

Dogs, sheep, and cats, however, as the animals that live in close intimacy with man, are extremely difficult to do skillfully. When painting these among the flowers or beyond the bamboo, on small mats or in embroidered netting, one should avoid attitudes of wagging the tail or servile begging. Consequently, those whose skill reaches this level are difficult to find in the world.

> *HHHP*, Book 13, "Discussion of Domestic and Wild Animals." *CKHLLP*, p. 1039.

It has been said that scholars were often fond of painting horses, because the horse served them as an analogy for every sort of career that a scholar might have in the world, through having the qualities

of a nag or a thoroughbred and being slow or quick, retiring or distinguished, fortunate or unlucky.

HHHP, Book 13 on Li Hsü.

Flowers and Birds

Kuo Jo-hsü (ca. 1080)

In painting flowers, fruits, grasses, or trees, one naturally deals with the seasons and the weather, light and shade and three-dimensionality, the age or youth of shoots and stems, and the order of appearance of buds and calices. Everything down to garden vegetables and wild grasses has its own form and nature in emerging from the ground.

In painting feathered creatures, one must by all means be acquainted with body forms of the various birds and their nomenclature. To begin with, there are the bill and mouth, the face and eyelids, the "thicket" down on the head and the "rain-cape" down on the back. Wings have tips and oyster-shaped areas. The wing as a whole has large and small joints at its top and large and small covering feathers leading out to the six tips. There is also [the lesser plumage]: the "wind-measurers," the "grass-robbers," the fanning tail-feathers, the tail-squeezing [coverts], the down on the belly, the leg feathers and the tail point . . .

Everything mentioned above has its own terminology, form, and position, all of which must be clearly understood; in no particular is a lapse permissible . . .

As the saying goes: "The Huangs were rich and noble; Hsü Hsi was rustic and free." Not only did each express his own inclinations, but probably what they were accustomed to experience [in nature] was also attained by the hand and then responded to by the mind. How do we know this was so?

Huang Ch'üan [903–968] and his son Chü-ts'ai [933–ca. 993] first served the Shu [Szechwan] regime together as painters-in-attendance . . . Chü-ts'ai was again enrolled as a painter-in-attendance [under the Sung], and all of his duties were performed in the Forbidden Palace. He most often sketched the rare fowl, auspicious birds, unusual flowers, and grotesque rocks found in the imperial park. Still in existence at the present time are such subjects [by the two Huangs] as peach-blossoms and falcons, pure white pheasants and rabbits, doves by a golden bowl, peacocks, and tortoises and cranes. In the structure

and spirit of their feathered creatures an opulent fullness is stressed. They rendered sky and water in different colors.

Hsü Hsi was a retired scholar of Chiang-nan [the region south of the Yangtze], at once noble in character and independent and unconventional. He most often depicted the waterside blooms, the wild bamboo, the aquatic fowl, and the deep-swimming fish of rivers and lakes. Still in existence at the present time are such subjects as wild geese, egrets, rushes and reeds, shrimps and fishes, clustered blooms and plucked branches, garden vegetables and herbs. In the formal structure of his feathered creatures a light beauty is emphasized. His sky and water have a common color. In saying "he most often depicted . . ." I have followed common report. As a tentative differentiation between the practices of the two schools, one might also venture this provisional definition: broadly speaking, the art of the Chiang-nan [lower Yangtze valley school] usually fell below that of the Shu men in structure and spirit, while it surpassed them in sublimity and freedom.

The two are the orchid of springtime and the chrysanthemum of autumn; both enjoy a solid reputation. When they brought down their brushes, they created treasures, and every flourish of their points can be imitated . . .

Hsü Hsi of Chiang-nan and his school once took sheets of double-thread silk and painted on them clustered blooms and heaped rocks with herbs sprouting from their sides, combining them with the subtleties of birds, bees, and cicadas. They then presented [these works] to Li Yü [r. 961–975], who had them hung as furnishings in his palace. They were referred to as "flowers [or decoration] to spread over a palace," and then called "flowers to deck out a hall." The idea embodied in the designs was severe and correct, and they were set out together in an orderly and dignified way. But, for the most part, they failed to catch natural, life-like attitudes, so that viewers usually did not examine them very intensively.

> *THCWC*, Book 1, "On Models for Composing" and "On the Differences between the Styles of Huang and Hsü," and Book 6, "Anecdotes of Recent Times," entry on "Flowers to Spread over a Hall." *CKHLLP*, pp. 58, 1023 (in part).

Shen Kua (1031–1095)

At the beginning of the present dynasty the commoner Hsü Hsi of Chiang-nan and the painter-in-attendance at the Han-lin Academy of the Shu pretender, Huang Ch'üan, were both renowned for their

excellence in painting, and especially for their strength in painting flowers and bamboo. When Shu was pacified, Huang Ch'üan and his two sons, Chü-pao and Chü-shih, as well as his younger brother Wei-liang, all served in the Painting Academy of the Han-lin, and were extolled in their time. Later, when the Chiang-nan region was pacified, Hsü Hsi reached the capital [at K'ai-feng] and sent works to the Painting Academy for assessment of his painting style. In all of Huang's flower paintings, the subtlety lay in the application of colors. His use of the brush was extremely fresh and delicate, so that one could scarcely see the traces of ink, but he washed over and finished with light colors, calling this the "sketching of life" (*hsieh-sheng*). Hsü Hsi painted with an ink-filled brush in a very summary way and applied only a little cinnabar and white. A divine vitality (*shen-ch'i*) issued forth [in his work], which also had the quality of life-movement. Ch'üan, who feared that Hsü Hsi might be more successful than himself, said that this coarse and detestable manner was not in any style, and rejected him. Hsi's [grand]son [Hsü Ch'ung-ssu] then imitated the style of the Huangs, and went even farther in not using an ink-filled brush but depicting directly with colors, calling these works "boneless paintings" (*mo-ku t'u*). As his skill was no less than that of the Huangs, Ch'üan and others could no longer find fault, and hence he received academic ranking. However, his vitality (*ch'i*) and harmony (*yün*) were both far from reaching his [grand]father Hsi's level.

MCPT, Book 17, "Calligraphy and Painting." *CKHLLP*, p. 1020.

Hsüan-ho hua-p'u (ca. 1120)

The essence of the Five Elements is concentrated in heaven and earth. With a single exhalation of *yin* and *yang*, [all the plants] are spread out in their glory; with a single inhalation they are gathered back. The luxuriance of petaled flowers seen on the hundred plants and myriad trees cannot be enumerated. Each has its own shape and color, although Creation never paid much heed to this. Their decoration beautifies the eternal seasons; their patterns brighten the world. And since they are gazed at by everyone, they harmonize all spirits.

There are some three hundred and sixty species of birds, with their musical sounds and varied colors, and their attitudes of drinking and pecking . . . Therefore, in the "six poetic types" of the poets [of the *Book of Songs*][33] much was known about the names of birds and animals,

33. For these six poetic types, see Legge, *Chinese Classics*, IV, 341. The "six principles" of the *Shih ching* are discussed in the Introduction.

or plants and trees. And in the four seasons of the calendar, their periods of flowering or withering and singing or silence are also recorded in terms. Hence in the most subtle type of painting, men often lodge their exhilaration in these subjects, just as the poets did.

Now the camellia and the peony among flowers, and the phoenix and the peacock among birds, must be made to seem rich and aristocratic; the pine and bamboo, plum and chrysanthemum, or the seagull and egret, swallow and wild duck must be seen as reserved and quiet. As for the lofty dignity of the crane, the attack of the hawk, or the beauty of the spreading branches and leaves of the willow and *wu-t'ung* tree, the hardiness of the stately pine and the generousness of the ancient cypress, revealed in painting they possess the ability to exhilarate men's thoughts. For the most part, [such works] are able to capture creation and transmit quintessential spirit and let the imagination roam as if it were viewing these things on the spot.

> *HHHP*, Book 5, "A Discussion of Flowers and Birds." *CKHLLP*, p. 1037.

Ink Bamboo, Vegetables, and Fruit

Kuo Jo-hsü (ca. 1080)

Wen T'ung (1019–1079), called Yü-k'o, was a native of Yung-t'ai in Tzu-t'ung [Szechwan]. At the present time he is Second Secretary to the Board of Patents and Grants and curator of the Imperial Library. He is an excellent painter of ink bamboo, which he endows with an air of purity and freedom that surpasses the elegance of ornamental trees. One would think that a breeze could move them. Without having existed as shoots, they are fully formed. In addition he loves to form decayed or felled trees and ancient stumps on white screens or high walls. His style and content are simple but significant, and are made much of by connoisseurs.

> *THCWC*, Book 3, "Art History II."

Hsüan-ho hua-p'u (ca. 1120)

Those who pursue formal likeness in the art of painting will lose it if they give up coloring [to work in ink monochrome]. What do they know of [true] values in painting? The possession of brushwork does not depend on the skillful use of red, green, scarlet and lead white. Thus, when there are [bamboos] brushed in light ink with strokes,

now upright, now slanting, which do not emphasize formal likeness but simply succeed in what lies beyond the image, they usually are not produced by professional artists but often appear among the works of poets and writers. No doubt [the bamboo] contained in their breasts was easily eight or nine times the extent of the Yün-meng marshes, as well as all that the brush and ink of a writer cannot describe. Hence, once lodged in brush tip and paper, [these bamboo] will reach the clouds in a lofty wintriness, or withstand the snow to rise like jade. Furthermore, with their attitude of beckoning the moon or whistling in the wind, despite a boiling heat, one will feel the need for winter clothing. As for the suggestiveness of simple scenes, though they fill but a foot, one may speak of ten-thousand miles. Thus, how could a common craftsman reach this level?

Of those who have painted ink bamboo as well as small scenes, from the Five Dynasties to the present reign, we have selected only five men.

> *HHHP*, Book 20, "A Discussion of Ink Bamboo (Including Small Scenes)."

The poets [of the *Book of Songs*] knew much about the nature of grasses and trees, or insects and fish, and when painters, by seizing creation with their brushes, penetrate to wondrous subtleties with their thoughts, it is also the act of poets. Such things as grasses and insects are frequently seen in the metaphors and allusions of the poets, hence they are included here.

Now from the Ch'en Dynasty [557–589] to the present reign, of those whose names have been transmitted and whose paintings are preserved, we have selected only six men.

> *HHHP*, Book 20, "A Discussion of Vegetables and Fruit (with the Category of Herbs Including Grasses and Insects)." *CKHLLP*, p. 1036.

Classification by Social Status

Kuo Jo-hsü (ca. 1080)

His Imperial Majesty Jen-tsung [r. 1022–1063] was endowed by Heaven with keen understanding. His saintly artistry had an inspired originality. When in the flush of enthusiasm he flourished his brush, he far outstripped common men. This humble person has heard that when the blindness of the imperial aunt, Hsien-mu of the realm of Ch'i, was beginning, the All-Highest in person painted [an icon of]

the Bodhisattva Nāgārjuna, which he had traced by a painter-in-attendance and printed by woodblock for distribution. The goodness and filial piety of his saintly mind defy an unworthy subject's attempts at praise.

I, Jo-hsü, once had in my collection an imperially executed painting of an imperial horse, with a reddish-brown coat and a bridle set of white jade. At the top was an imperially written inscription which read: "Ching-li fourth year [1044], seventh month, fourteenth day, painted by the Emperor"; in addition there was a signature and a seal . . . That, thus far, I have not been able to see it again, is a sorrow which I shall bear to my dying day.

The Supreme All-Highest in his mind's recreation is hardly to be ranged with his subjects; therefore I have honored him at the head of this chapter . . .

Of princes, nobles, and scholar-officials who have "cleaved to loving-kindness and sought enjoyment in the arts," attaining the utmost therein, there have been thirteen men.

THCWC, Book 3, "Art History II."

Teng Ch'un (ca. 1167)

I have thought often that since the Hsi-ning era [when Kuo Jo-hsü wrote], although those [lofty spirits] whose minds have roamed in this art have been extremely numerous in the ninety-four springs and autumns down to the present, there have been no further enthusiasts to record these men. Now, I have examined the written documents, added what I have some knowledge of, and compared this with what I have personally enjoyed, beginning with the year at which Jo-hsü stopped [1074] and continuing to the third year of the Ch'ien-tao era [1167]. The nobility is placed above and the professional craftsmen below, for a total of two hundred and nineteen men, some alive and some dead, all of whom are included here in their entirety. I have also listed the remarkable works that I have seen in the homes of collectors, works that I have loved and been unable to forget, thus compiling "Surpassing Works Engraved in My Mind." As to general matters pertaining to painting that should be transmitted and recorded, they have been assembled in the writing of this book, which I have divided into ten chapters and entitled *"Painting" Continued.*

Although Jo-hsü did not add classification and ranking by grade, in his discussion of "animation through spirit consonance" he maintained that it could not be transmitted by teaching, and that it was

often in talented worthies of high position or superior scholars of the cliffs and grottoes that lofty and refined emotions found lodging[34] ... Alas! Among those of subtle understanding and refined capability, who since antiquity have won the esteem of the world, must be included such men as Ku K'ai-chih, Lu T'an-wei, Wang Wei, and Wu Tao-tzu. How can ordinary craftsmen and commonplace fellows, [with their imitations] by the cartload and by the bushel, dare even to gaze after the [following] dust that trails behind the blue clouds [of lofty inspiration]? Some may say that Jo-hsü's opinions are too extreme, but I do not believe so. Therefore I have now in a similar fashion specifically established the two categories of High Officials and Retired Scholars in order to lodge my own insignificant ideas therein. The discriminating and understanding will surely give a nod of assent.

This year, the twenty-ninth day of the second month, Teng Ch'un, Kung-shou, of the Chinese Empire wrote this preface.

HC, preface.

Painting is the acme of culture. Hence, ancient and modern men in great numbers have written their opinions on it. A majority of the successive generations of painters whom Chang Yen-yüan enumerated were officials. In the T'ang Dynasty, Tu Fu composed songs that minutely described formal appearance, and Han Yü wrote accounts that did not neglect the slightest trifle. In our dynasty, Ou-yang Hsiu, the Su family, Hsün, Shih and Ch'e, the Ch'ao brothers, Pu-chih and Yüeh-chih, Huang T'ing-chien, Ch'en Shih-tao, Chang Lei, Ch'in Kuan, Li Ch'ih, Mi Fu, and Li Kung-lin have either criticized and classified with refinement and loftiness or painted in an extraordinary and outstanding way. Accordingly, how can it be said that painting is merely an art? My opponents think that since antiquity there have been literary men, besides these several I have mentioned, who had no ability and, furthermore, no love for it. I would answer them: "Those who are well versed in literature but do not understand painting are few; those who are not versed in literature and yet understand painting are few."

The uses of painting are truly vast. As for all of the myriad things that fill heaven and earth, one can thoroughly exhaust their characteristics by licking the brush and revolving thoughts. But there is only

34. Excerpts are quoted from Kuo Jo-hsü, *THCWC*, Book 1, "On the Impossibility of Teaching Spirit Consonance"; see "Expressive Style and Quality" in this chapter.

one method by which characteristics can be thoroughly exhausted. What is that? It is called: "to transmit the spirit (*ch'uan shen*), that is all." People merely know that human beings have spirit and do not realize that things have spirit. Thus, when Kuo Jo-hsü deeply despised common artisans, saying [of their work] "although called 'painting,' it will not be painting," it was because they were only able to transmit the form and could not transmit the spirit. Therefore, "animation through spirit consonance" is the first of the laws of painting, and Jo-hsü was right when he only attributed it to those in high position or in retirement . . .

I have selected from the literary collections of both the T'ang and Sung dynasties every poem and record about painting, and have studied them exhaustively. Thus I am able to roughly assess the criticisms of various gentlemen. Huang T'ing-chien alone is truly refined and exacting. Mi Fu had a lofty mind and an excellent eye, but there were occasions when his proposed theories exceeded moderation. The two old gentlemen, Tu Fu and Su Shih, even though they did not exclusively devote their thoughts to the matter, had inborn instincts of fundamental loftiness, and naturally achieved suitability, against expectations, in the precision of each word . . .

In writing this record I have only praised the two categories of the "lofty and refined" [emotions of officials and recluses]. As for the rest, I have not troubled to establish critical distinctions. Now, those who see [a painting] can then hand down comments, but should those who hear about it be allowed to criticize slightingly?

HC, Book 9, "Concerning the Distant Past." *CKHLLP,* pp. 75–76.

Scholars' Painting

Kuo Jo-hsü (ca. 1080)

[There follow] two men, who "highmindedly esteeming their own work" painted for their own pleasure . . .

Li Ch'eng [919–967] was called Hsien-hsi. His forebears were of the T'ang imperial clan and went as refugees to Ying-ch'iu [Shantung], which became the family seat. His grandfather and father were both celebrated in their times for their classical learning and administration of affairs. Ch'eng, however, by inclination esteemed peaceful solitude, and loftily declined honors and advancement. In addition to being widely versed in the classics and histories, he was a most excellent painter of landscape with wintry forests. His inspired versatility was

the quintessence of the spiritual and went far beyond normal capacities. In the K'ai-pao era [968–976] nobles or wealthy men in the capital [at K'ai-feng] frequently sent him letters of invitation. Ch'eng would usually not respond. His study was not for other men, but for his own pleasure alone. Eventually he wandered off to Huai-yang [Honan], where he fell ill and died in the fifth year of the Ch'ien-te era [967] . . . His paintings of such scenes as *Hazy View at Dawn, Wind and Rain,* landscapes of the four seasons, pines and cypresses, and winter forests are still in existence.

> *THCWC,* Book 3, "Art History II," on the painter classified with Sung Hsieh in the special category of recluses.

Teng Ch'un (ca. 1167)

The snow scenes of landscape painters are often commonplace. I once saw a snow painting by Li Ch'eng in which the mountain peaks, forests and buildings were all done in light inks, while the empty areas of water and sky were entirely filled in with white powder. It was altogether wonderful. Whenever I tell painters about it, they smile or laugh without being startled or surprised, and that is enough to show how mediocre and inferior these later-day men are.

Li Ch'eng was a scholar of many talents and satisfactory learning. When he was young he had great ambitions, and repeatedly took [the examinations] but never passed; in the end, since he was unsuccessful, he set forth his ideas in painting. The wintry groves that he painted are often set amongst cliffs and grottoes, and exhibit [signs of] cutting and pruning, to allude to gentlemen in retirement. As for all other plants and trees, they grow on level ground to allude as well to the petty men who hold positions. Such ideas were indeed profound . . .

It is difficult to achieve completeness in all of the Six Laws of painting. Only Wu Tao-tzu of the T'ang and Li Kung-lin [1049–ca. 1105] of the present dynasty were able to combine them all. Wu's brush, however, was vigorous and unrestrained. Unlimited by long walls or great scrolls, he produced wonders without end. Kung-lin was painfully self-denying; only on "Pure Heart [Hall]" paper did he transmit wonders and display his skill. If no large-scale work by him has ever been seen, it is not because he was incapable of it but because he actually repressed it, fearing that he might approach the practice of the common craftsman.

Mi Fu [1052–1107] said, "I first started painting during the three years that Kung-lin's arm was incapacitated [with arthritis]." Although

it may seem that he was yielding to Kung-lin, of himself he said that he imitated the noble antiqueness *(kao-ku)* of Ku K'ai-chih and did not employ one stroke in the manner of Master Wu, and that he specialized in painting portraits of loyal men and worthy sages of antiquity. Such an inflexible spirit as his could not bear to be placed below Kung-lin.

HC, Book 9, "Concerning the Distant Past." *CKHLLP,* p. 77.

The Emperor as Connoisseur and Artist

Teng Ch'un (ca. 1167)

Moreover, [in painting] the Emperor Hui-tsung [r. 1101–1126] has keen discernment in all areas and a natural gift with brush and ink. He depicts all objects in an excellent fashion and has completely mastered the Six Principles. His attention is focused primarily on bird painting, and he often uses natural lacquer to dot in the eye pupils subtly, to about the size of a bean above the surface of the paper, so that they almost seem to be moving. None of the academy artists are able [to equal this] . . .

When the Wu-yüeh-kuan [a Taoist temple dedicated to the Five Sacred Peaks] was first built [in 1012], famous masters throughout the empire were assembled.[35] Several hundred men who responded to the summons were all set to painting, but most did not meet the imperial requirements. Thereafter, there was an increasing emphasis on painting studies. In the instruction of the various craftsmen, as in that of the *chin-shih* (accomplished scholar) degree graduates, [Hui-tsung] had topics set to select candidates. He then established the post of *po-shih* (professor or dean) to assess artistic talents. In that era my late grandfather happened to be in the government, and he recommended Sung Ti's nephew, Sung Tzu-fang, as suitable for selection as the professor. At that time Tzu-fang's brushwork and use of ink were the most outstanding of his generation, hence everyone said that he was the appropriate choice.

35. The Temple of the Five Sacred Peaks, officially known as the Hui-ling-kuan, was built from 1012 on, as an offshoot of construction on the Taoist shrine, the Yü-ch'ing-chao-ying-kung (at K'ai-feng) from 1009–1114. Murals of the Five Peaks in mountain form and landscape screens for the five halls were painted ca. 1117 by a certain Li Yin from the Kansu region in a style that must have resembled the landscape backgrounds of later Tun-huang cave murals. See Soper, *Kuo Jo-hsü's Experiences in Painting*, pp. 59, 166 n. 467, 174 n. 510.

One of the topics set for the examination was: "Deserted waters, without men crossing;/ An empty boat, horizontal the whole day." From the second best man on down, most attached an empty boat to the side of a bank, with perhaps a perching heron on the edge of the deck, or settling crows on top of the mat-roof. But the best candidate did nothing of this sort. He painted a boatman lying at the stern of the boat with a single flute placed "horizontally." His interpretation (*i*) was that it did not mean "without a boatman," just "without travelers." Therefore he showed the boatman in a state of total relaxation. Another topic was: "Mountains in confusion, hiding an ancient monastery." The winner painted barren mountains that filled the scroll, with a Buddhist flag pole sticking out above to indicate the concept of "hiding." The rest of the men revealed the top of a pagoda or the eaves of a roof, and there were even those who showed temple hall or shrine, in which case there was no longer any idea of "hiding."

After the period of confusion [on the fall of the Northern Sung capital], there were a few former academicians who made their way to Shu [Szechwan province]. They told me that, when they were in the Academy, every ten days as a special privilege two boxes of scroll paintings were brought out of the palace storehouses and, on the Emperor's command, escorted to the Academy by important officials, to be shown to the painting students. Usually there were written orders charging the military to guard against loss or damage. Hence the artists of the period all did their utmost to carry out the Emperor's intentions. Later on [in 1116] for the completion of the Pao-lu (Precious Insignia) Palace, painted murals were supplied by the Academy of Painting. Occasionally the Emperor came to inspect the work, and if anything was not to his liking he would have it plastered over and specifically indicate his commands. Even with supervision of this sort, the majority of artists, being limited by their personal characters, were bogged down in rules and techniques in their work and could not rise above the commonplace. Ultimately they perverted the aims (*i*) of the sage-ruler's instruction . . .

When the Lung-te (Dragon Virtue) Palace of Hui-tsung was completed, he ordered the painters-in-attendance to execute paintings on the screens and walls of this palace. All [these men] were among the best of their time. When the Emperor came to inspect [their work], he praised none of it. All he did was to look at the *Tea Rose on a Slanting Bough* on the entablature of the verandah of the Hu-chung Hall. He then asked who the painter was. In fact, he was a youthful newcomer. The Emperor was pleased and conferred upon him the dark red silk [for the sixth grade and above], and rewarded him with

extreme favor. No one could determine the cause for this. Then an intimate attendant requested an explanation from the Emperor, and his reply was: "There are few who are skillful enough to paint the tea rose, for its flowers, stamens and leaves all differ with the four seasons and the time of day. Here, without the slightest error, he painted one at noon on a spring day. That is why I rewarded him richly."

In front of the Hsüan-ho Hall was planted a lichee tree. When it bore fruit, it brought a smile of pleasure to the Emperor's face. By chance a peacock went beneath it. Quickly, the Emperor summoned the members of the Painting Academy and ordered them to paint it. Each one exerted his skills to the utmost so that splendid colors glittered, but the peacock was about to mount a cane stool and was [depicted] raising its right leg first. The Emperor said: "Unsatisfactory!" The academicians were alarmed, for none understood. After several days they were again summoned and questioned by the Emperor, but they did not know how to reply. Thereupon he announced: "When the peacock ascends to a high place, it invariably raises its left leg first." The academicians were abashed and apologetic . . .

During the Cheng-ho era [1111–1118], whenever the Emperor painted a fan, everyone in the Six Palaces and the residences of the nobility vied to copy it. For a single design there were sometimes as many as several hundred copies. Among those noblemen and close associates, there were some who frequently sought the imperial seal [as a signature].

During the days when my grandfather was in the Bureau of Military Affairs, there was a decree granting him a mansion in the vicinity of the Dragon Stream Bridge. My late father as a vice-minister served as Director [of construction], and, as usual, he sent an Inner Bureau Envoy to oversee repairs. When it came to refurbishing the wall paintings, they were such things as birds and animals, flowers and bamboo, as well as "Family Celebration" pictures, all done by academicians. One day my father went to inspect them. He saw the mounter using an old landscape painting on silk to wipe a table. Upon examination, it was a Kuo Hsi [11th century] painting. He asked from whence it came, but the mounter said that he did not know. He also asked the Inner Bureau Envoy who said: "This was discarded from the Inner Storage. Formerly, Shen-tsung [r. 1067–1085] loved Kuo Hsi's paintings and had the walls of one hall covered solely with his works. But, after the present Emperor [Hui-tsung] ascended the throne, he replaced them with ancient paintings. There were more besides this one which were put into storage." My father said: "Please inform His Majesty that if I could only receive this discarded painting, I should

be satisfied." The next day a decree was issued awarding them all to him and, moreover, ordering that they be delivered to the house. Hence, on the walls of our house, there were nothing by Kuo Hsi paintings. Truly, it was a once-in-a-lifetime opportunity!

> *HC,* Book 1, "The Art of the Sage [Emperor Hui-tsung]"; Book 10, "Concerning the Recent Past." *CKHLLP,* pp. 79, 80 (in part).

The Academy of Painting

Teng Ch'un (ca. 1167)

The "ruled-line paintings" of the Painting Academy were very skillful, and new concepts in them were particularly appreciated. I once saw a scroll that was really lovable and delightful. It depicted the verandah of a palace, in dazzling gold and green. A scarlet door was half open, and a palace lady was partially revealed outside the door in an attitude of throwing away nutshells contained in a dustpan. Such varieties as gingko nuts, lichee nuts, walnuts, yew-nuts, chestnuts, hazelnuts, and water chestnuts could each be distinguished, and each was separate from the other. There exist [Academy paintings] of this sort, in which brushwork is refined and ink subtle.

According to the old system of the founding emperors, for all artists-in-attendance beginning their careers, there were only six classes. These were: copyists and engravers, stone inscribers, mounters and refinishers, workers in ruled-line, specialists in "flying white" brushwork, and painters of balustrades and trim. Although Hui-tsung was so fond of painting, he still did not wish on account of his love and pleasure in it to suddenly introduce new titles. Consequently, those who attained office in the Painting Academy were appointed with the titles of the six classes in accordance with the old system. This sufficiently illustrates the bent of his sage's mind.

According to the old system of the present court, although they could wear the dark red and purple silks [of the sixth and fourth ranks and above respectively], none who entered in the arts were permitted to wear the fish pendant at the waist. During the Cheng-ho and Hsüan-ho eras [1111–1126], only outstanding officials in the Calligraphy and Painting Academies were allowed to wear the fish pendant as an exceptional distinction. Further, whenever the various officials-in-attendance lined up according to rank, the Calligraphy Academy was at the head with the Painting Academy next, while the

Music Academy and all the artisans such as the carvers of chess-pieces or jade were ranked below. Moreover, in the Painting Academy those with student status were permitted to study, and whenever anyone who was registered committed a misdemeanor, he was allowed to merely pay a fine [rather than submit to corporal punishment]. If the crime was serious, he could appeal to the Emperor for a decision. In addition, the daily compensation of artisans in the other departments was called "food money," whereas only that of the two departments [of Calligraphy and Painting] was called "salaries." If one compares the monetary payments made elsewhere, [painters] were not treated like the majority of artisans. At the Jui-ssu (Astute Thoughts) Hall, there was a daily order that a versatile artist from the painters-in-attendance lodge there for the night in order to be ready for any unexpected imperial summons. In none of the other departments did they do this.

In the Painting Academy, those summoned from all areas for examination came incessantly. Many of them were unsuitable and were rejected. What was esteemed at that time was formal likeness alone. If anyone had personal attainments and could not avoid being expressive or free, then it would be said that he was not in accordance with the rules or that he lacked a master's instruction. Hence, what he did would be merely the tasks of artisans, and he would not rise.

Generally, the selection of men for the Painting Academy was not solely on the basis of brush technique. Often a man's personality was the foremost consideration. If he was summoned to an audience unexpectedly, he might fear being subjected to scrutiny and questions. And thus Liu I, through being afflicted with the abnormality of tumors, never obtained an audience, despite serving as His Majesty's painter. He regretted it to the end of his life.

HC, Book 10, "Concerning the Recent Past." *CKHLLP*, p. 81.

Southern Sung Monks and Academicians

Chuang Su (ca. 1298)

The monk Fan-lung, whose style was Mao-tsung, was a native of Wu-hsing [Chekiang]. He sketched Buddhist icons, and his brush technique was very similar to Li Kung-lin's. Kao-tsung [r. 1127–1162] liked his painting so much that each time he saw one he immediately inscribed an evaluation . . .

The monk Fa-ch'ang called himself Mu-ch'i. He was expert at drag-

ons and tigers, secular figures, rushes and geese, and paintings of various other subjects. His desiccated and pallid rustic wildernesses are certainly not for elegant diversion, but are suitable only for a Buddhist's chamber or a Taoist's hut as a complement to the pure and secluded atmosphere . . .

Li Sung was from Ch'ien-t'ang [Hang-chou]. As a youth he was a carpenter, but was rather put off by rules and restrictions; later he became the adopted son of [the Academy painter] Li Ts'ung-hsün. During the reigns of three emperors, Kuang-tsung, Ning-tsung, and Li-tsung [1190–1264], he was a painter-in-attendance in the Painting Academy, and recaptured Ts'ung-hsün's conceptions. Although he was accomplished in various types of painting, he did not fulfill the Six Laws. His "ruled-line" painting and secular figures, in particular, are somewhat entertaining, but there is nothing worthwhile about the other types . . .

Li An-chung [active ca. 1110–ca. 1140], who lived in Ch'ien-t'ang, was a painter-in-attendance in the Painting Academy at the same time as Li Ti [last half 12th century]. He also painted birds and animals, flowers and bamboo, and was somewhat superior to Ti. He was particularly skilled in painting hunting scenes, capturing attitudes of predatory fierceness and frightened escape.

Li Kung-mao was An-chung's son. He transmitted his father's [manner] in painting birds and animals, flowers and bamboo, but fell far short of his father . . .

Ma Yüan, a descendant of Ma Hsing-tsu, was a painter-in-attendance in the Painting Academy. Following the family tradition, he did paintings of various subjects. His flowers and birds are rather well done, but I would not venture to recommend his landscape and figure painting . . .

Ma Lin was the son of Ma Yüan. He was also skilled at doing paintings of miscellaneous subjects. He was not as good as either his father or uncle. Loving his son, Ma Yüan frequently signed "Ma Lin" on his own paintings, hoping that his son would thereby gain a reputation . . .

Chia Shih-ku, who lived in Ch'ien-t'ang, was a painter-in-attendance in the Painting Academy. He painted secular figures which are quite well characterized, capturing their easy and relaxed attitudes. He was not well-known for anything else.

Liang K'ai was the best of Chia Shih-ku's students, and he also was a member of the Painting Academy. His free and easy drawing surpassed that of his teacher, and people of the day all praised him . . .

Hsia Kuei, from Ch'ien-t'ang, was a painter-in-attendance in the

Painting Academy during the reign of Li-tsung [1225–1264]. He painted landscapes and secular figures that are exceedingly vulgar and bad. Toward the end of the Sung Dynasty, when manner and morals had lost their meaning and people's beliefs were breaking with the past, Kuei acquired an inflated reputation of which he was, in fact, not worthy. It is enough to recognize his name as an artist working in this period. His son, Sen, also carried on the family tradition.

Hua-chi pu-i (A Supplement to the *Hua-chi*), preface dated 1298.

4

The Landscape Texts

LANDSCAPE PAINTING was thought to have reached its high point early
in the Northern Sung, and a series of specialized works soon came to
be written on this subject. Three of them have quite distinctive styles
and represent different stages of development. The first is the *Pi-fa
chi* (A Note on the Art of the Brush) by Ching Hao (ca. 870–ca. 930),
a Confucian scholar who painted pines and rocks as well as landscapes.
It is couched in the form of a Taoist fable but presents Confucian
views, contrasting the complementary polarities of inner substance
and external ornament and emphasizing the moral education of the
artist to enable him to convey the essential character (spirit resonance)
of the pine tree. Certain features are typical of the landscape texts in
general: the imparting of technical secrets—here given as the Six
Essentials, a revision of the Six Laws in terms of monochrome paint-
ing—and the listing of definitions of landscape elements. More par-
ticular to Ching Hao's interests are the discussion of brushwork in
the terminology of T'ang calligraphy and the selective assessment of
earlier models for the new monochrome landscape style. This text
has been translated by Kiyohiko Munakata and is quoted with slight
modifications.

The second of these works is the *Lin-ch'üan kao-chih(chi)* (The Lofty
Message of Forests and Streams) by Kuo Hsi (after 1000–ca. 1090),
the most famous Academy landscapist of his time. Hsi's son, Kuo Ssu
(active ca. 1070–after 1123), a scholar-official who served at Hui-
tsung's court, was responsible for the compilation and transmission
of this essay. He states in the preface that from an early age he had
been accustomed to note down his father's opinions on art and com-
ments at points in the text on Hsi's method of working. According to
Ssu, Kuo Hsi used to wander about sketching the natural scenery and

had studied Taoism in his youth. This may account for the nearly mystical appreciation of the actual landscape that characterizes the essay, as well as for its spiritual definition of creativity. Kuo Hsi's approach to earlier landscape traditions is quite sophisticated, and his section called "The Secrets of Painting" presents a detailed description of the monochrome technique. All these aspects combine to make this text—the most important of its genre—tower above the other texts like the main peak of a range. The translation is based on John Hay's version. Selections from the *Hua chi* (Notes on Paintings), a section recording Kuo Hsi's artistic career at court, are translated by Susan Bush.

The third work is *Shan-shui Ch'un-ch'üan chi* (Ch'un-ch'üan's [Harmonious and Complete] Compilation on Landscape) by Han Cho (active ca. 1095–ca. 1125), who was a minor official at Hui-tsung's court. Since the preface is dated to 1121, this text can be seen as an illustration of the encyclopedic interests of the time. Landscape elements are now explained in dictionary definitions and, in addition to the usual listing of mountain formations, there are sections on rocks, water, clouds, and figures and accessories in landscapes. Han Cho quotes from earlier writers like Ching Hao and Kuo Jo-hsü and discusses the oppositions between reality and ornament, or spirit resonance and formal likeness, in connection with the faults to be avoided in brushwork. Although Han Cho focuses mainly on painting technique, he also includes a section on connoisseurship, for which the ideal standard was set by his patron, the Imperial Son-in-Law Wang Shen (ca. 1048–1103). The concluding exhortations to study emphasize the academic tone of the work. Excerpts have been selected from the text, which has been translated in its entirety by Robert Maeda.

Besides these works, whose time and place or style can be pinpointed, there are several short landscape texts that range in date from T'ang through Sung and may present some of the traditional instructions that had been transmitted orally from master to pupil. These are attributed, often interchangeably, to famous earlier artists and writers like Wang Wei (701–761), Ching Hao, and Li Ch'eng (d. 967). Three of these are particularly noteworthy because they provide the anonymous context or provincial counterpart of literary classics of the genre, such as the Kuo Hsi text. Of an earlier affiliation, and hence not included here, is the *Shan-shui sung-shih ko* (On the Categories of Landscapes and Pines and Rocks), attributed to Emperor Yüan of the Liang (r. 552–554) but certainly not composed before

T'ang times.[1] It described the painting of these specific subjects on walls and screens in "broken ink" technique and color and used the early metaphor of a dragon to describe the parts of a mountain. This text was in circulation during the Northern Sung, since phrases from it were quoted by Han Cho as statements made by Wang Wei. The two works attributed to Wang Wei, however, exhibit a different character.

The first, *Shan-shui chüeh* (Secrets of Landscape), begins by noting the superiority of monochrome paintings (*shui-mo*) and goes on to mention the principal and secondary, or "host" and "guest," mountains that determine the layout of the composition. Literary documentation suggests that this essay was extant by the eleventh century. A slightly abbreviated version, the "Kuang-chung Stone Text" appeared in a mid-sixteenth-century edition of Wang's collected works, where it is said to have been engraved on stone in 1057 along with a supposed Wang Wei painting. The essay, like the painting, may have been a contemporary fabrication, and certain phrases have a consciously literary tone.

A second text commonly attributed to Wang Wei, and sometimes printed together with the first, is often entitled *Shan-shui lun* (Discussion of Landscape). It exists in slightly different versions as *Hua shan-shui fu* (Prose-Poem on Painting Landscape), which is usually attributed to Ching Hao. The literary form is indeed that of a *fu*, although the rhyme scheme is not consistent. The first "stanza," which deals with the relative proportioning of landscape elements, is quoted in part by Kuo Hsi and appears to have been known to Han Cho under the Wang Wei attribution. Although "guest" and "host" mountains are mentioned, the term "monochrome" is not used, and there are hints of the use of color in the descriptions of seasonal landscapes. Aspects of landscape formations are distinguished in simple anthropomorphic imagery, a possible indication of the popular origins of such instructions to painters. Mountains, for example, have "heads" and "waists"; in later texts they will also have "feet." And the character "head" (*t'ou*) is preferred to "summit" (*ting*), which generally indicates the tops of mountains in the more literary texts by Sung writers. Definitions of different mountain types and a list of painting titles are also included in this work.

The *Prose Poem on Painting Landscape* was once attributed to Li

1. See Shio Sakanishi, *The Spirit of the Brush* (London: John Murray, 1957), pp. 55–57.

Ch'eng, and it is his name that is associated with the last essay in this series of landscape texts, once again entitled *Shan-shui chüeh* (Secrets of Landscape). This work does not appear to have been known to the Northern Sung writers on landscapes. In a somewhat longer and more coherent version it forms the main portion of *Hua shan-shui chüeh* (Secrets of Painting Landscape), which has an author's preface of 1221 by Li Ch'eng-sou (b. ca. 1150) of Hsiang-chung, Hunan, as well as a concluding section of "General Comments." No other information is available about this artist, whose shortened name is similar in sound to that of Li Ch'eng. Since the earliest known publication of both texts was in the late-sixteenth-century *Wang-shih hua-yüan* and its supplement, questions of dating must be resolved, if possible, on the basis of internal evidence.

The "Li Ch'eng" section is obviously in the tradition of the Wang Wei texts. Apart from a discussion of the layout of landscape elements and of the proper application of brushwork and ink wash, the essay consists of a series of disjointed notes characterizing individual motifs in concrete terms. Anthropomorphic imagery continues to be used, as it will be even later in the Huang Kung-wang text of the Yüan Dynasty. Although such aspects of the scenery as strangely shaped stones and grasping tree roots, or the indications of spatial recession and atmospheric effects, might seem to suggest the landscape style associated with Li Ch'eng and Kuo Hsi, they could equally well be found in other types of landscape painting practiced in the Southern Sung.

Thus, there is no definite proof that the "Li Ch'eng" text preceded the Li Ch'eng-sou version of 1221; instead, it is quite possible that the former was an abbreviation of the latter. But if this is the case, the author may have been recording or revising traditional painting instructions. Li Ch'eng-sou concludes this section, after quoting the standard ending of the Wang Wei *Secrets of Landscape*, with an editorial phrase: "Respectfully arranged." His own tastes in scenery along the Yangtze River and Academy landscape styles are given in the author's preface and the final "General Comments." As a provincial artist, he continued to revere the earlier founders of the Southern Sung Academy tradition rather than contemporary court painters; as a southerner in a divided China, ruled in the North by the Jurchen Chin Dynasty (1115–1234), he looked down on the turgid compositions of northerners. The distinction between the faults of northern and southern painting styles, which is included in his remarks in "General Comments," effectively gives this version of the text a point of view

appropriate to the early thirteenth century. The renderings of this series of landscape texts are based on translations by Ellen Laing. The sequence of topic headings in this chapter roughly follows the presentation of content in the Kuo Hsi text, progressing from general to more technical discussions both of landscape and of landscape painting.

The Significance of Old Pines

Ching Hao (ca. 870–930)

Among the T'ai-hang Mountains there is a valley called Hung-ku where I cultivated half an acre or so of field and sustained myself. One day I climbed to Shen-cheng Ridge to have a view of all four directions. [On the way back], following a winding path, I happened to enter a huge doorway leading to a rock cave. Inside there was a moss-grown path dripping with water, and along it were strange stones enveloped in a mysterious vapor. I went along the path quickly and found an area covered solely with old pine trees. One of the trees had grown to occupy a huge area by itself. Its aged bark was covered with green lichen. It looked as if it were a flying dragon riding the sky, or as if it were a coiling dragon aiming at reaching the Milky Way. The trees that formed a grove looked fresh in spirit and were flourishing in their mutual sustenance. Those which could not form a group crouched by themselves as if to keep their own creeds within themselves. Some trees exposed their winding roots out of the ground; others lay directly across a wide stream; others were suspended over the cliffs and still others crouched in the middle of the ravine. Some grew tearing mosses and cracking rocks. I marveled at this curious sight and walked around admiring the scenery.

From the next day onward I brought my brush to this place and sketched the trees. After I had sketched some ten thousand trees my drawings came to look like the real trees. In the following spring I went to the Stone-Drum Cave and met an old man. Answering his questions, I explained in detail what I had experienced. Then he asked: "Do you know the art of the brush?" To this I replied: "Your appearance is that of an old rustic. How can you know the art of the brush?" The old man retorted: "But how can you know what I hold inside?" Hearing this, I was both ashamed and surprised.

The old man said: "If you, a young man, like to study, you can

accomplish it in the end. Now there are Six Essentials in painting. The first is called 'Spirit (*ch'i*).' The second is called 'Resonance (*yün*).' The third is called 'Thought (*ssu*).' The fourth is called 'Scene (*ching*).' The fifth is called 'Brush (*pi*).' And the sixth is called 'Ink (*mo*).' "

I said: "Painting [hua] is equivalent to a flowering [outward appearance, *hua*]. That is to say, one obtains reality when one devotes oneself to attaining lifelikeness. How could this [simple truth] be distorted?" The old man answered: "Not so. Painting is equivalent to measuring (*hua*). One examines the objects and grasps their reality (*chen*). He must grasp the outward appearance from the outward appearance of the object, and the inner reality (*shih*) from the inner reality of the object. He must not take the outward appearance and call it the inner reality. If you do not know this method [of understanding truth], you may even get lifelikeness but never achieve reality in painting." I questioned: "What do you call lifelikeness and what do you call reality?" The old man answered: "Lifelikeness means to achieve the form of the object but to leave out its spirit. Reality means that both spirit and substance are strong. Furthermore, if spirit is conveyed only through the outward appearance and not through the image in its totality, the image is dead."

I thanked him and said: "Now I understand that calligraphy and painting are to be learned only by the wise. I am only a farmer and have no qualification for learning these. Although I enjoy myself playing with the brush, I could not achieve anything in the end. I am ashamed to say this, but I am sure that I would not be able to paint the right way even if I should have the luck of receiving your kind teaching of the Essentials." The old man said: "Limitless desire is a threat to life. This is why wise people thoroughly enjoy playing the *ch'in* lute, calligraphy, and painting. They replace worthless desires with those [worthy ones]. Since you have already familiarized yourself with a good thing [like painting], you should make up your mind to study it from the beginning to the end. Never hesitate in the middle of the way . . .

"Since you like to paint clouds and trees, mountains and streams, you must understand clearly the fundamentals of every natural object. When a tree grows, it follows the true nature which it received from heaven. The true nature of a pine tree is as follows—it may grow curved, but never appear deformed and crooked. It looks sometimes dense and sometimes sparse, and neither blue nor green. Even as a tiny sapling it stands upright and aims to grow high, thus already showing its posture of independence and nobility. Even when its branches grow low, sideways or downwards, it never falls to the ground.

Fig. 1. Hsi K'ang with His Lute and Juan Chi Whistling: Two of the "Seven Sages of the Bamboo Grove." Rubbing of a detail of a fifth-century multiple-brick tomb mural from Hsi-shan-ch'iao, Nanking. Six Dynasties Period. Nanking Museum. Courtesy of Nicholas Cahill.

These third-century literary figures are typically represented as engaged in cultural or Taoist pursuits in a natural setting. Their portraits are known to have been painted by such famous Six Dynasties artists as Lu T'an-wei and Ku K'ai-chih.

Fig. 2. The Buddhist Layman Vimalakīrti, from the "Debate with Mañjuśrī." Detail of an eighth-century mural in Cave 103 at Tun-huang, T'ang Dynasty. The illustration from *Ancient China* by John Hay is reproduced by permission of The Bodley Head.

An ideal model of secular piety, Vimalakīrti is usually shown concluding the debate with the Bodhisattva of Wisdom by a thunderous silence. The emphatic, modulated brushline used in this mural to suggest three-dimensional form may derive from the style of Wu Tao-tzu, then popular at the T'ang capital, Ch'ang-an.

Fig. 3 (*opposite*). Ts'ui Po (active late 11th century). "Magpies and Hare," dated to 1061, Northern Sung Dynasty. Hanging scroll, ink and colors on silk, 193.7 x 103.4 cm. Courtesy of the National Palace Museum, Taipei, Taiwan, Republic of China.

A member of the Imperial Academy of Painting, Ts'ui Po specialized in flower and bird paintings and created a new style that eventually influenced Emperor Hui-tsung. The mood and concerns of autumn are effectively suggested in this signed and dated masterpiece.

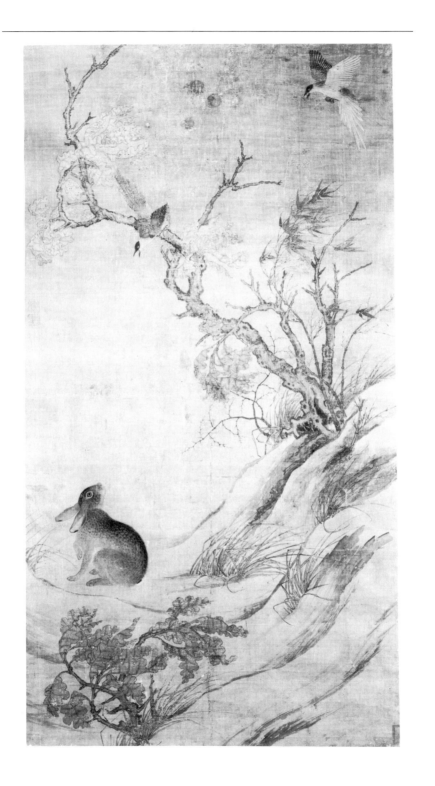

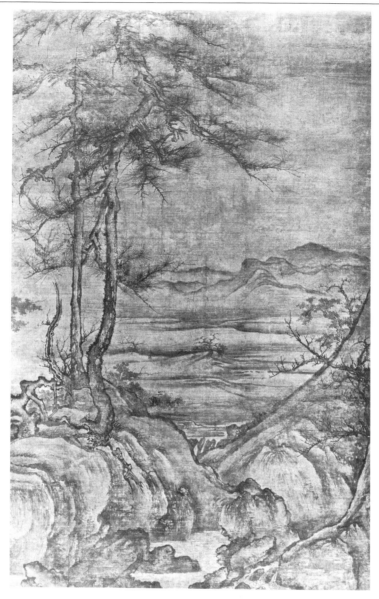

Fig. 4. Attributed to Li Ch'eng (10th century). "Tall Pines in a Level View," Northern Sung Dynasty. Hanging scroll, ink on silk, 205.6 x 126.1 cm. Chōkaidō Bunko, Yokkaichi. Courtesy of Chūō Kōran-sha.

 Although attributed to a Five Dynasties master, this painting is more likely to be by a late eleventh-century follower. The view afar into a level distance through cloud-like boulders and darkly inked pines is in the Li tradition, but the evocation of poetic mood in the monochrome ink technique is a Northern Sung development associated with Kuo Hsi.

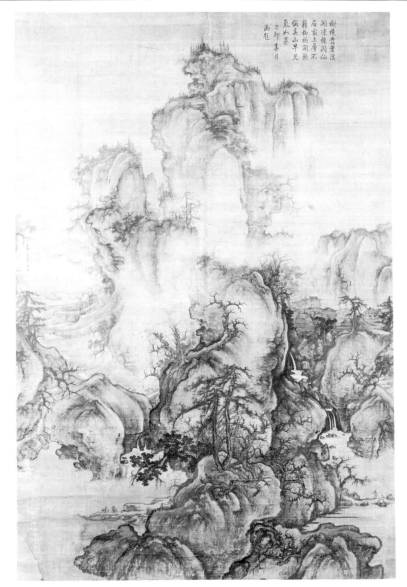

Fig. 5. Kuo Hsi (ca. 1010–ca. 1090). "Early Spring," dated to 1072, Northern Sung Dynasty. Hanging scroll, ink and light colors on silk, 158.3 x 108.1 cm. Courtesy of the National Palace Museum.

A follower of Li Ch'eng, Kuo Hsi was the most famous court artist of Shen-tsung's reign (1067-1085), and the Emperor commissioned innumerable landscape screens for palace buildings. This landscape illustrates Kuo's concern with seasonal and atmospheric effects as well as his interest in presenting the various angles of mountain ranges and suggesting openings into depth to invite the viewer into the scene.

興可自言湖州墨竹高而不得
第一流俾三百有餘載後之人蓋
更趨逐造意避碌碌欲畫骨
藏乎胸誰得到如兔起鳥隼
落乎紙橫出斜入神入新意
緑雲裹不見其葉但見葉庭回翔
俯欲下來飄飛音聲滿人耳世間
物性本不同有能隨他工拙
由來美人姿不似君子德全貞
萬遍歌緑如箕揚搖得此來我諸
我今已老才力衰顧君芳力任愛
惜奈吾衛武試為師

秦和王廷筠題

壁上里君不解語萬仞陵首
陽要看凜霜前凜冽為真
自長寫真誰是文才許我
他年作主無差關納凉清夜永
平安時報故人書
誰畫裊天態石好葛七春膠錦
漆婆玉堂妙筆父修畫吞無
慶水瀲波老可當年每畫一兩
堂寫客動秋思亦過雨影三壁
別出奇差王一枝
誰是丹青三昧手晴霜振一亢清畝五
軒忠萬謝誰肯水霜振一亢清畝五
月寒我為看真水湛竹裏一枝
實王墨晴烟逢逢窮秋相引
衣被清陰吾我師

秦漢宗伯題

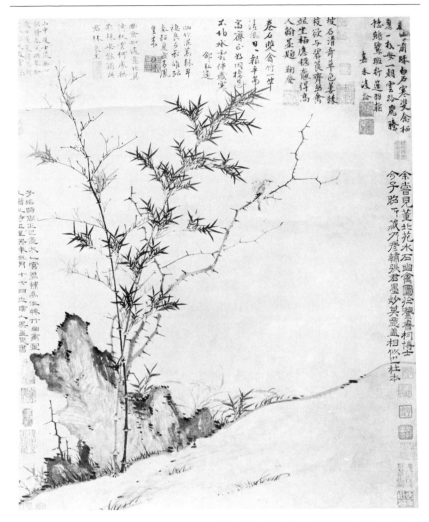

Fig. 6 (*opposite*). Attributed to Wen T'ung (d. 1079). "Bamboo," Northern Sung. Hanging scroll, ink on silk, 132.6 x 105.4 cm. Courtesy of the National Palace Museum.

Wen T'ung was a scholar-official whose ink bamboo paintings were especially appreciated by his cousin, the famous literary figure Su Shih. Conventionally associated with the gentleman, bamboo became a favorite subject of the scholar-painter, and its depiction in ink inevitably brought to mind the expressive possibilities of calligraphy.

Fig. 7 (*above*). Chang Yen-fu (1st half 14th century). "Thorns, Bamboo, and Quiet Birds," dated to 1343, Yüan Dynasty. Hanging scroll, ink on paper, 76.2 x 63.5 cm. Courtesy of the Nelson-Atkins Museum of Art, Kansas City, Missouri (Nelson Fund).

A priest of the T'ai-i sect of Taoism active in Peking under the Mongol regime, Chang painted horses and landscapes as well as studies of bamboo and rocks, and old trees. Chang's free brushwork was appreciated by contemporary literati critics, many of whom wrote comments on his works.

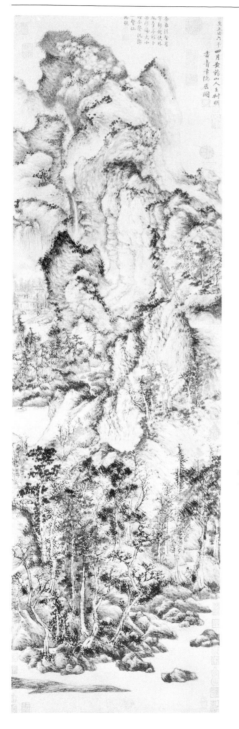

Fig. 8. Wang Meng (d. 1385). "The Ch'ing-pien Hermitage," dated to 1366, Yüan Dynasty. Hanging scroll, ink on paper, 141 x 42.2 cm. Courtesy of the Shanghai Museum.

A scholar-official who served both under the Mongol regime and after the Ming restoration, Wang Meng is best known for his skill in landscape painting. Specific sites such as a family estate in the Pien Mountains are depicted for friends in reinterpretations of tenth-century compositions, where uptilted ranges are enlivened by dramatic highlighting and exaggerated forms, and the texture of nature is recreated by an extremely varied brush technique.

In the forest, the horizontal layers of its branches appear to be piled one upon the other. Thus [appearing as a breeze blowing gently over the swaying grasses], they are like the breeze of the virtuous [which passes over the bowed heads of the humbly respectful]. Sometimes a pine tree is painted as a flying or coiling dragon, with its branches and leaves growing in maddening disarray. It does not represent the spirit resonance of pine trees.

"The cypress tree has the following true nature—it grows full of movement and has many turnings. It is luxuriant but not showy. Its trunk has many knots and is clearly sectioned. Its twisting patterns grow so as to follow the movement of the sun. Its leaves are (rugged) like knotted threads and its branches are [angular] like hemp clothes [on the body]. Sometimes the tree is painted with its leaves [smooth] like snakes and its branches [supple] like silk clothes. Or at times it is drawn with its inside hollow and its twisted patterns inverted. Those are all wrong.

"Each species of tree, such as catalpas, pawlonias, camellias, oaks, elms, willows, mulberries, and pagoda-trees, differs from the others in its form and character. These matters are so obvious that [as in the popular saying] even thinkers far from each other come to the same conclusion. Each one may be clarified by yourself . . .

"Now, I have given you all the necessary instructions, although I still feel that I have not been thorough enough in explaining details."

After some hesitation I brought out and presented to him the sketches which I had drawn of the extraordinary pine trees. The old man said: "The flesh of the brushwork does not conform to the basic rules, and the muscle and bone are not well applied. How can this deficient handling of brush serve to paint such extraordinary pine trees? I have now taught you the art of the brush" . . .

Saying this, he brought out a few scrolls of silk and let me paint on them. Then he said: "Your hand moves now just as my mind wishes. It has been said that one must examine people's words, besides knowing what they do. Would you compose a poem for me?"

I thanked him and said: "Now I realize that 'teaching is a job for the virtuous and wise, who will not resign from the job even if they are not paid; and the deeds of those who are taught are nothing but what they perceive and respond to in the teaching.' Since you invite me to try, I will obey you and compose a poem."

Thus I composed the following "Eulogy to an Old Pine Tree":

> Not withered, but not embellished,
> Is only that chaste pine.
> His force is high and steep,

Yet he is humble and polite.
The leaves spread open a green umbrella,
And the branches coil a red dragon.
He holds vines in the lower part
And growing grasses under his dark shadow.
How did he get his life
With his force nearing the peak of the clouds?
In a view up the lofty trunk,
The piled layers of leaves are a thousand folds.
As he towers in the middle of a ravine,
His green contours are enveloped by the mist.
The branches growing downward
Wander freely, and
When they come to meet the vulgar water below,
They are friendly, without being equalized.
What the ancient poems praised in him
Was his noble air of the superior man.
The breeze is pure and keeps blowing;
Its faint sound is crystallized in the sky.

The old man was very much impressed, and after awhile he said: "I wish you would keep working hard. Only when you reach the state of forgetting the technical matters of brush and ink, do you achieve the real landscape painting . . . My place of living is within the Stone-Drum Cave and my intimate name is Shih-ku yen-tzu (The Master of the Stone-Drum Cave)." I asked him: "Please let me follow and serve you." He answered: "You need not." Finally, after expressing my gratitude and saying farewell to him, I left.

Some days later I visited his place and found no traces of him. I have since studied his teaching of the brush. Now I have put together and edited what I received from him and have been treasuring, in order to present it as the standard rules of painting for later generations.

Pi-fa chi (A Note on the Art of the Brush). *CKHLLP*, pp. 605–606, 607, 608–609.

Han Cho (active ca. 1095–1125)

Trees must be well-proportioned and possess force. They should not be too tall, or else they will lose their force and strength. They should not be too short either, for then they will become vulgar and confused.

It is from possessing formal structure that trees derive their strength. Trees without structure twist and wind in a confused fashion and are deficient in force. But, if only stiffness and hardness are stressed, without turns and bends, then they are deficient in a sense of life (*sheng-i*). If the brushwork is too finicky and the ink too sparing, then the trees are weak. In general, select practical methods that are appropriate.

We value trees that are green and vigorous, or old and rigid. Their shapes are numerous. Some trees stretch out high their spreading branches; some twist and turn and bob up and down; some bend their trunks as if they were bowing; some are like drunken men wildly dancing; some are like men with dishevelled hair grasping swords— all of these are pine trees. Furthermore, some have the force of angry dragons or frightened young dragons, and some have forms like ascending dragons or crouching tigers; some appear wild and strange, or buoyant and graceful; and some seem proud and haughty, or humble and modest; some spread out and lean over a bank as if to drink from the middle of a stream; some lean over from precipices of lofty mountain ranges with their trunks bending upward. These are the attitudes of pines, whose aspects are manifold and whose transformations are inestimable.

In painting tree roots, those trees which lean and rise at river banks have roots which seem to rise and fall as they push the earth away. They are unrestrained and scattered. But, as for ordinary standing trees, one should paint them with large roots deeply embedded in banks. Nearby, scatter small roots that are about to come out of the earth. In painting withered trees and branches, one must simply pay attention to their hollows and sunken cavities.

Again, pine trees are like noblemen; they are the elders among trees. Erect in bearing, tall and superior, aloft they coil upward into the sky and their force extends to the Milky Way. Their branches spread out and hang downward, and below they welcome the common trees. Their reception of inferiors with reverence is like the virtue of the gentleman whose conduct should be "catholic and not partisan." Ching Hao [ca. 870–ca. 930] said: "The trees that formed a grove were vigorous and tall of trunk; those not of the grove held themselves in restraint and bowed in natural submission." There are those which bend to shade and whose branches coil, whose heads droop over and whose waists are twisted—these are peculiar pines. Those that have old bark, green scales, withered branches, and few needles are old pines. Wang Wei [701–761] said: "Pine trees are not to be distinguished as elder brother and younger brother," which means that

their positions should be in accord with their inferiors. Similarly he said: "There are children and grandchildren," which means that those that have new branches added on are young pines. Their tips tower aloft and rise upward; their needles intertwine and their shade is great.[2]

Generally, deciduous trees are valued for their abundant and dense foliage. But, when it comes to a winter forest, it is essential that its groves rise up in deep layers; that they be dispersed but not scattered. Furthermore, one ought to make withered twigs and old fallen trees, and use thin ink in the background to paint secondary kinds of trees, causing them to be harmonious. Then, a lonely, expressive purity of mood will be obtained. Forest intervals should not be left blank. One should rather paint gleaming pockets of mist. It was, indeed, Li Ch'eng who was highly accomplished in these marvelous practices.

> *Shan-shui Ch'un-ch'üan chi* (Ch'un-ch'üan's Compilation on Landscape, *SSCCC*), preface dated to 1121, "Concerning Forests and Trees." *CKHLLP*, pp. 665–666.

The Significance of Landscape

Kuo Hsi (after 1000–ca. 1090)

In what does a gentleman's love of landscape consist? The cultivation of his fundamental nature in rural retreats is his frequent occupation. The carefree abandon of mountain streams is his frequent delight. The secluded freedom of fishermen and woodsmen is his frequent enjoyment. The flight of cranes and the calling of apes are his frequent intimacies. The bridles and fetters of the everyday world are what human nature constantly abhors. Immortals and sages in mists and vapors are what human nature constantly longs for and yet is unable to see. It is simply that, in a time of peace and plenty, when the intentions of ruler and parents are high-minded, purifying oneself is of little significance and office-holding is allied to honor. Can anyone of humanitarian instinct then tread aloof or retire afar in order to practice a retreat from worldly affairs? And, if so, will he necessarily share the fundamental simplicity of [legendary recluses such as Hsü

2. The two phrases said to be from Wang Wei's text actually appear in the *Shan-shui sung-shih ko* (On Categories of Landscapes, Pines and Rocks) attributed to the Liang Emperor Yüan (r. 552–554), but generally considered to be of later date. The Ching Hao passage cited above differs slightly from the text in the *Pi-fa chi;* it has also been interpreted differently in translation; cf. at the beginning of this section.

Yu, associated with] Mount Chi and the River Ying, or participate in
the lingering renown of [the Han Dynasty's] Four Old Men of Mount
Shang?[3] Their songs, such as the "Ode to the White Pony" and the
"Hymn to the Purple Fungus,"[4] are of what has passed away and is
unattainable. But, are the longing for forests and streams, and the
companionship of mists and vapors, then to be experienced only in
dreams and denied to the waking senses?

It is now possible for subtle hands to reproduce them in all their
rich splendor. Without leaving your room you may sit to your heart's
content among streams and valleys. The voices of apes and the calls
of birds will fall on your ears faintly. The glow of the mountain and
the color of the waters will dazzle your eyes glitteringly. Could this
fail to quicken your interest and thoroughly capture your heart? This
is the ultimate meaning behind the honor which the world accords
to landscape painting. If this aim is not principal and the landscape
is approached with a trivial attitude, it is no different from desecrating
a divine vista and polluting the clear wind.

There is a proper way to paint a landscape. When spread out on
an ambitious scale it should still have nothing superfluous. Restricted
to a small view it should still lack nothing. There is also a proper way
to look at landscapes. Look with a heart in tune with forest and stream,
then you will value them highly. Approach with the eyes of arrogance
and extravagance, then you will value them but little. Landscapes are
vast things. You should look at them from a distance. Only then will
you see on one screen the sweep and atmosphere of mountain and
water. Figure paintings of gentlemen and ladies done on a miniature
scale, if held in the hand or put on the table, may be taken in at one
glance as soon as they are opened. These are the methods of looking
at paintings.

It is generally accepted opinion that in landscapes there are those
through which you may travel, those in which you may sightsee, those
through which you may wander, and those in which you may live.

3. Hsü Yu refused the throne when offered it by the mythical emperor Yao; see
Bernard Karlgren, *Legends and Cults in Ancient China*, BMFEA, 18 (1946), 292. The
"Four Old Men" or "Four Greybeards" retired from the world in protest against the
Ch'in Dynasty, but re-emerged to support the rightful Han heir. See Burton Watson,
Records of the Grand Historian of China (New York: Columbia University Press, 1961), I,
146–149.

4. For the "Ode to the White Pony of the *Shih ching* (Book of Poetry)," see James
Legge, *The Chinese Classics* (Hong Kong: Hong Kong University Press, 1960), IV, 299–
300. The "Hymn to the Purple Fungus" is said to have been composed by the "Four
Old Men" when in retirement.

Any paintings attaining these effects are to be considered excellent, but those suitable for traveling and sightseeing are not as successful in achievement as those suitable for wandering and living. Why is this? If you survey present-day scenery, in a hundred miles of land to be settled, only about one out of three places will be suitable for wandering or living, yet they will certainly be selected as such. A gentleman's thirst for forests and streams is due precisely to such places of beauty. Therefore, it is with this in mind that a painter should create and a critic should examine. This is what we mean by not losing the ultimate meaning . . .

Someone learning to paint flowers puts a plant into a deep hole to look at it from above. This shows the flowers fully in the round. Someone learning to paint bamboos selects one branch as the moonlight reflects its shadow on a plain white wall. This brings out its characteristic form. Is there any difference in learning to paint a landscape? You must go in person to the countryside to discover it. The significant aspects of the landscape will then be apparent. To discover the overall layout of rivers and valleys in a real landscape, you look at them from a distance. To discover their individual characteristics, you look at them from nearby.

Clouds and vapors in a real landscape differ through the four seasons. They are genial in spring, profuse in summer, sparse in autumn, and somber in winter. If a painting shows the major aspect and does not create overly detailed forms, then the prevailing attitude of clouds and vapors will appear alive. Mists and haze [on mountains] in a real landscape differ through the seasons. Spring mountains are gently seductive and seem to smile. Summer mountains seem moist in their verdant hues. Autumn mountains are bright and clear, arrayed in colorful garments. Winter mountains are withdrawn in melancholy, apparently asleep. If a painting shows the major idea (*i*) without distracting signs of technique, then the atmospheric conditions will seem correct.

Wind and rain in a real landscape can be grasped when seen from a distance. Near to, you may be fascinated by the motion but will be unable to examine the overall pattern in the confused flow. Shade and light in a real landscape can be comprehended if seen from a distance. From nearby your grasp will be narrowed and you will not obtain a picture of what is hidden and what revealed by light and dark. On mountains, figures indicate paths and roads; look-out pavilions indicate scenic spots. On hills, vegetation is light or dark to differentiate respective distances; streams and valleys are cut short or continuous to differentiate depths of recession. On the water, fords,

ferries, and various bridges hint at human activity; fishing skiffs and tackle hint at human interests.

A great mountain is dominating as chief over the assembled hills, thereby ranking in an ordered arrangement the ridges and peaks, forests and valleys as suzerains of varying degrees and distances. The general appearance is of a great lord glorious on his throne and a hundred princes hastening to pay him court, without any effect of arrogance or withdrawal [on either part]. A tall pine stands erect as the mark of all other trees, thereby ranking in an ordered arrangement the subsidiary trees and plants as numerous admiring assistants. The general effect is of a nobleman dazzling in his prime with all lesser mortals in his service, without insolent or oppressed attitudes [on either part].

A mountain nearby has one aspect. Several miles away it has another aspect, and some tens of miles away yet another. Each distance has its particularity. This is called "the form of the mountain changing with each step." The front face of a mountain has one appearance. The side face has another appearance, and the rear face yet another. Each angle has its particularity. This is called "the form of a mountain viewed on every face." Thus can one mountain combine in itself the forms of several thousand mountains. Should you not explore this? Mountains look different in the spring and summer, the autumn and winter. This is called "the scenery of the four seasons is not the same." A mountain in the morning has a different appearance from in the evening. Bright and dull days give further mutations. This is called "the changing aspects of different times are not same." Thus can one mountain combine in itself the significant aspects of several thousand mountains. Should you not investigate this?

In spring mountains, mists and clouds stretch out unbroken and people are full of joy. In summer mountains, fine trees offer profuse shade and people are full of satisfaction. In autumn mountains, bright and clear leaves flutter and fall, and men are full of melancholy. In winter mountains, dark fogs dim and choke the scene, and men are full of loneliness. To look at a particular painting puts you in the corresponding mood. You seem in fact to be in those mountains. This is the mood (*i*) of a painting beyond its mere scenery. You see a white path disappearing into the blue and think of traveling on it. You see the glow of setting sun over level waters and dream of gazing on it. You see hermits and mountain dwellers, and think of lodging with them. You see cliffs by lucid water or streams over rocks, and long to wander there. To look at a particular painting puts you in the corresponding frame of mind, as though you were really on the point

of going there. This is the wonderful power (*miao*) of a painting beyond its mere mood.

> *Lin-ch'üan kao-chih(chi)* (The Lofty Message of Forest and Streams, *LCKCC*), "Advice on Landscape Painting." *CKHLLP*, pp. 632–633, 634–635.

Figures in Landscape

Kuo Ssu (d. after 1123)

I once saw my father paint a range of hills with a view of a pine, which conveyed in one glance the idea of a continuity toward the top of the scroll. An old man, who caressed the large pine before him with his hand, was painted for the purpose of leading the viewer's eye into the distance. This old man looked as if he had been placed there by the God of Longevity . . .

RIDERS IN THE WESTERN HILLS. When my father was at Hsing-chou [Hsing-t'ai-hsien, Hopei], he made this to give to me. Its mountains were autumnal in feeling. Deep in the hills several men were galloping on horses out of the mouth of a valley, and one of them was falling off a horse. The men and horses were not large but their spirit-vitality was lifelike. My father pointed to them and said: "Those who rush forth hastily are like that." Below this point was a long plank bridge, where several men with black banners [of the militia] were departing, riding on slow horses. My father pointed them out and said: "Those who withdraw quietly are like that." Also, in a cove near a cliff wall, in the shade of a dark grove, a rustic skiff was partially revealed. On the boat was a dilapidated cabin, within which was a simple wine container and some books. In front of the cabin was a bare-headed, half-dressed man with the appearance of one in deep communion, as if looking up to view white clouds or bending down to listen to flowing water. At the boat's side a man was managing a paddle. My father pointed to indicate the significance, saying: "This is even more lofty."

PINES IN A SINGLE VIEW. My father took over two feet of a narrow piece of silk and made an old man leaning on a staff in front of a precipice under a large pine. Behind this point he painted innumerable pines, large and small in relative sequence. In a gorge below a twisting range there were several thousand pines in one uninterrupted view. Throughout the past there never had been a composition of this sort. This painting was made for the [60th or 80th?] birthday of Wen Yen-po [1006–1097, a long-term minister, enfeoffed] Duke of

Lu. The idea was to express the wish that his sons and grandsons be dukes and ministers in unbroken succession. The Duke of Lu was greatly pleased.

> Comments in Kuo Hsi's *LCKCC,* from "The Secrets of Painting" and "Additions on Painting Exemplars." *CKHLLP,* pp. 645, 647. (The text followed is that of the *SKCS* manuscript in Taipei: see Kuo Hsi in Bibliography B.)

Han Cho (active ca. 1095–ca. 1125)

Whenever painting figures, one should not use coarse, vulgar types, but value those that are pure and elegant and in lonely retirement. As they are proud retired officials dwelling in seclusion, they are different in body and appearance from village-dwelling old peasants and fishermen. If one glances at the figures in the landscapes of antiquity, they really are men of leisure and refinement; there are none who are vulgar or hateful. As for recent productions, they are frequently coarse and vulgar, extremely wanting in the ancients' attitudes . . .

In classifying the scenes of the four seasons, it is absolutely necessary to be clear about nature's rules and knowledgeable about human activity. Pictures of spring should be painted with figures that are happy and at ease treading the grass in the countryside, sauntering along the green paths, or competing at the rope swing. Depict fisherfolk singing, ferry boats crossing water, returning herders, tilling cultivators, mountain sowers, and fishermen.

Pictures of summer should be painted with figures that are peaceful and at ease in the sunlit and shaded spots of mountain groves; or travelers may be resting in waterside pavilions and rest-houses, and avoiding the heat of summer by getting the cool breezes. Depict figures playing in water and floating boats, washing near a river, fetching water from a well at dawn, wading through water, or crossing on a ferry in wind and rain.

Pictures of autumn should be painted with mournful-looking figures gazing at the moon, or figures gathering water-chestnuts, or washing thin silk, or fishermen playing their flutes, or figures pounding silk or threshing at night, or ascending heights [for the autumn festival], or admiring chrysanthemums.

Pictures of winter should be painted with quiet and subdued figures gathered around a stove drinking wine, traveling officials in the grievous cold, or chilled men with snow-covered bamboo hats, people trans-

porting grain in mule-drawn carts or at a fording place on a snowy river, figures hunting in the snow in wintry winds or treading on ice.

SSCCC, "Concerning Figures . . ." CKHLLP, pp. 669, 670–671.

On Creativity

Kuo Hsi (after 1000–ca. 1090) and Kuo Ssu (d. after 1123)

There is a good discussion on the art of writing by [the T'ang author] Liu Tsung-yüan[5] that, in my opinion, does not only apply to writing. Every task has its secret, a proper way of doing it, painting not least of all. How can one express it? Each scene in a painting, regardless of size or complexity, must be unified through attention to its essence. If the essence is missed, the spirit will lose integrity. It must be completed with the spirit in every part, otherwise the essence will not be clear. The artist must accord his work overriding respect, otherwise the thought will have no depth. Fastidious attention must be given throughout, otherwise the scene will seem incomplete.

If the creative energy that you gather is listless and you force it, the results will be insipid and indecisive. The fault is that of not attending to the essence. If your energy is dulled and you use it distractedly, the appearance will be crude and lifeless. The fault is that of not putting spirit in every part. If you heedlessly trifle with the subject, its forms will be summary and inadequate. The fault is that of not according overriding respect. If you abruptly disregard the subject, its construction will be careless and not cohesive. The fault is that of not paying fastidious attention.

If indecisive, a work will offend the canon of spaciousness. If lifeless, it will offend the canon of refreshing purity. If it is inadequate, it will offend the canon of composition. It not cohesive, it will offend the canon of alternating rhythm. These are the gravest failings of artists, yet they can serve as a guide for the intelligent.

{In the past I saw my father working on several paintings. Sometimes he would put one aside and ignore it. For perhaps ten or twenty days he would not give it a glance, then after thirty days he might add to it. It was a case of losing interest in the work, and is this not the listless energy he mentioned? When working at a peak of interest

5. Liu Tsung-yüan (773–819) noted the dangers of a "trifling mind," "an indolent mind," "dulled energy," and "brash energy," in an essay on literature, "A Reply to Wei Chung-li Discussing the Tao of a Teacher."

he would completely forget about everything else. When his concentration was disturbed by even a single external interruption, he would put his work aside and ignore it. Is this not exactly the dulled energy he mentioned?

Each time he put his brush to work, he would sit by a bright window at a clean table. To left and right were lighted incense. He would lay out fine brush and ink, wash his hands, and clean the inkslab as though he were receiving a major guest. His spirit at ease and his interest settled, only then did he proceed. Is this not exactly what he said about not daring to trifle heedlessly? Once the composition was laid out, he would work through it in detail. Once the painting was built up, he would add the enriching shades of ink. Though the first time seemed enough, he would work over it again, and perhaps yet again. Every painting would be reworked several times from start to finish, and he would be alert as though on guard against some insidious enemy until it was done. Is this not exactly what he said about not daring to abruptly disregard the subject? Whatever task you care to mention, no matter large or small, it can only thus be properly concluded. If my father so often repeated this advice in different fashions, was it not to teach me to honor it to the end of my life, taking it as a path to progressive self-cultivation?} . . .

People only realize that an artist puts his brush to work and makes a picture; they do not realize that it is no easy task. Chuang-tzu's story of a painter loosening his clothes and sitting with his legs spread out really got to the point of a painter's method. You should nourish in your bosom a state of relaxed alertness. As it says [in the *Li-chi*, Book of Rites], "your mind becomes fully calm, upright, loving, and sincere."[6] Then the varying emotions and aspects of men, and the different characteristics of objects, will spontaneously order themselves in your mind and appear without effort under your brush.

Ku K'ai-chih [ca. 345–ca. 406] of the Chin Dynasty had to build a tower for his studio.[7] Thus he was truly the penetrating mind of antiquity. If he had not done so, then, as he crouched in some cranny with his will already undermined and hampered, how could he have given form to the condition of creatures and laid bare the thoughts of men?

Suppose an artisan is to carve a lute and finds a solitary *wu-t'ung*

6. See James Legge, *The Sacred Books of China: The Texts of Confucianism: Li Ki* (Oxford: Clarendon Press, 1885), IV, 125.

7. Ku Chün-chih was the builder of the studio in Hsieh Ho's *(Ku)hua-p'in(-lu)*. See chapter 1 at "Social Status and Creative Activity."

tree on Mount I's south slope.[8] If he has manual skill, brilliant ideas, and great inner clarity, while the material is yet growing in the ground, the leaves and twigs yet unstripped, the instrument perfected by Lei [the T'ang Dynasty lutemaker] already exists in his mind's eye. If someone has confused ideas and unresponsive hands, is clumsy and uninspired, he will see only the sharp chisel and knife and will have no idea where to begin. How would he ever attain the five tones of [Ts'ai Yung's] Chiao-wei lute, whose sounds carried with the clear wind and flowing water?[9]

Again, as our predecessors said, "a poem is a painting without form and a painting is a poem with form." Wise men often talked of this, and it has been our guide. Hence on idle days I used to leaf through poetry of various times and styles. Among them were beautiful lines that gave full expression to the feelings that pass through men's hearts and the scenes before their eyes.

If, however, you do not rest quietly at ease, sitting at a clean table by a bright window, a stick of incense beside you and every anxiety suppressed, then you will not perceive the beautiful lines and the fine meanings. You will be unable to imagine the elusive feelings and the flavor of beauty.

How can the primary significance of painting be easy to attain? Circumstances must be ripe, and the mind and hand mutually responsive. Then, when you begin, you will freely achieve excellence, taking from all sides and "penetrating to the source" [as Mencius said].[10] When people of this generation go to work, they follow their inclinations excited by feelings and only roughly achieve their ideas.

{I have recorded the lucid compositions and elegant phrases of ancient poets that my father often recited. They are such as express beautiful thought and are fit to be painted. Together with others that my father said were usable, and some which I picked up along the way, I record them below—}

> LCKCC, "Advice on Landscape Painting" and "The Meaning of Painting," with comments by Kuo Hsi's son Kuo Ssu (within braces). *CKHLLP*, pp. 633–634, 640–641.

8. This phrase from the *Shu ching* (Book of Documents) indicates high quality wood; see Legge, *Chinese Classics*, III, 107.

9. Ts'ai Yung (132–192) was a Han official, calligrapher, and musician.

10. For this phrase in a different translation, see Legge, *Chinese Classics*, II, 323.

Traditions and Models

Ching Hao (ca. 870–ca. 930)

I asked: "Among those who have learned [the art of painting] since ancient times, whom do you think the best equipped [with the Six Essentials]?"

The old man said: "There are only a few who reached perfection. Hsieh Ho classified Lu T'an-wei [5th century] as one of the best. Yet, nowadays, it is difficult to find his genuine works. The paintings left by Chang Seng-yu [6th century] greatly lack the basic principles. The principle of 'follow kind; applying color' [of Hsieh Ho, active ca. 500–535, that is, coloring technique] has been well achieved by artists from ancient times onward. However, such techniques as 'watered ink for graded wash,' after all only began in our T'ang Dynasty.

"Chang Tsao [8th century], the Second Secretary, painted trees and rocks full of [the essentials of] spirit and resonance. He amassed all details with [the perfect use of] brush and ink. In his works true thought is preeminent. He attached little importance to the five colors. There is, indeed, no artist like him in either ancient or modern times. Ch'ü T'ing and the priest Po-yün [Ssu-ma Ch'eng-chen, 647–735] captured the mysterious sublimity of natural phenomena in their paintings, showing their comprehension of the true nature of the universe. Because of the extraordinary means used, their works are undefinable and immeasurably deep. Wang Wei [701–761], the Junior Counselor, is elegant and beautiful in his use of brush and ink. Spirit and resonance in his works are noble and pure. His representation is skillful and his execution is complete. He should also be called a master for exercising true thought.

"General Li Ssu-hsün [651–718] shows a deep understanding of the principles [of nature] and wide thought. His brushwork is very fine and detailed. His works exhibit skillfulness and ornamental beauty, but lack greatly in application of ink wash. Hsiang Jung [late 8th–early 9th century], the hermit, painted trees and rocks hard and coarse, but without clearly indicating their angular edges. He obtained the secret of mysterious truth only in the usage of ink, and he has no bone in his use of brush. However, his mind was so untrammeled that he never lost the spiritual atmosphere of the true essence of the universe; and with this basic, truthful atmosphere dominating, he managed to reduce the skillful prettiness [which is otherwise a common characteristic of the works lacking bone in their brushwork]. Wu Tao-tzu had a brushwork excelling in drawing shapes, and bone-spirit

came of itself into his work to a high degree. Thus, he achieved painting which made rival artists speechless. Unfortunately, his weak point was a lack of ink. The Second Secretary Ch'en and the monk Tao-fen and some others, are just a little above the ordinary class. Their works generally lack ingenuity, and their handling of brush and ink too obviously show their intentions."

> *Pi-fa chi* (A Note on the Art of the Brush). *CKHLLP*, pp. 607–608.

Kuo Hsi (after 1000–ca. 1090)

Painting also has its laws of physiognomy. The descendants of Li Ch'eng flourished in large numbers, and all his foothills and ground areas were substantial and generous; lofty above and abundant below, they correspond to the indications of progeny. This is not merely in accord with physiognomy, but with general principles [of development] as well.

When you learn to paint, it is no different from learning calligraphy. If you select as models calligraphers such as Chung Yu [151–230], Wang Hsi-chih [309–ca. 365], Yü Shih-nan [558–638], or Liu Kung-ch'üan [778–865], after long study you should certainly achieve some similarity. Great masters and understanding scholars do not restrict themselves to one school, but must select from many for comparison, and discuss widely to investigate on a broad basis in order to achieve their own style eventually. At present, artists from Ch'i and Lu [modern Shantung province] work exclusively in Li Ch'eng's style, and artists of Kuan and Shan [modern Shensi province] work exclusively in Fan K'uan's style. Moreover, since [the areas between] Shantung and Shensi extend for several thousand miles, should they then be painted province after province, district after district, person after person? Exclusive specialization has always been a fault. It is just like someone who plays but one tune and will not listen to anyone else. He cannot blame those who will not listen to him. As evidence shows, an experience common to all mankind is that human senses delight in what is new and are wearied by what is old. Hence, I consider the fact that great masters and understanding scholars do not restrict themselves to one school to be a similar phenomenon.

> *LCKCC*, "Advice on Landscape Painting." *CKHLLP*, p. 633.

Han Cho (active ca. 1095–ca. 1125)

Since ancient times the most refined art of enlightened scholars has been painting. Accordingly, there ought to be a great many who

are skilled in painting. For generations, my family has been in the learned circle and gathered offices and renown. [But] my disposition was undisciplined and unrefined, and my bent was always toward a fondness of painting. I sought out as models intelligent men of the past and investigated the least remains of ancient and modern times. From childhood I have been very fond of it, and even now that I have reached old age my interest in it has not flagged. I only worry that the time for learning is short, and naturally it has become an obsession. However, this is all due to my inborn characteristic! . . .

Nowadays there exist paintings by famous high-ranking scholar officials. Making it their leisure time hobby of relaxation and enjoyment, they grasp the brush and wet the tip and by wielding the brush try to realize their ideas. Many rely on a simple method in order to obtain a pure, untrammeled taste, a quality which stems from natural purity and has not one iota of vulgarity. But, if one takes the present generation's concept of ancient standards, these cannot be recognized [in their work]. However, all of the famous gentlemen painters of antiquity adhered to standards. Indeed, since the Southern T'ang period, in the case of painters such as Li Ch'eng, Kuo Hsi, Fan K'uan, Yen Su, Sung Ti, Li Kung-lin, Wang Shen [all 10th and 11th centuries] and the like, it is indeed true that they were knowledgeable about all these standards.

Those men who are without learning may be said to be without standards; that is, without the standards and methods of the ancients. How can such men discard standards and methods and consider themselves superior to the renowned ancient and modern sages? A gentleman said to be of scant learning is one whose nature is excessively impetuous. There are three types of such self-deceivers. As for those who have difficulties in learning, there are two types. What is meant by this? Of the three types, there is one who is so ambitious that he unashamedly seeks knowledge from inferiors and relies merely on pilfered learning; he is self-deceiving. Then there is one who is by nature clever and whose talents are great, but who studies haphazardly, is confused and without a definite purpose; he is self-deceiving. Then there is one who, during his youth, was precocious and effortlessly became rather well versed, but who is lazy and does not study; he is self-deceiving.

But, what about those who learn with difficulty? There is the negligent scholar who does not understand the principles of scholarship and carelessly trusts to luck. Then there is the scholar who pretends to study with laborious efforts, but who exerts his energies for a

purpose which is obscure and confused, without even investigating into truth. Such types are really inferior.

How does one transmit the least remains of the ancients or arrive at the secrets of former sages? "No one has ever become skilled by not studying." How true are these words! Generally, a scholar should first adhere to one school's fixed methods. Then, after he has successfully mastered them, he may change them to create his own style. Ah! If one's roots are deep, one's reputation will endure. One who manifests propriety will reflect correctness. Accordingly, it is study that leads to the creation of the "marvelous," and to the perfection of purity in art. Those who possess these essentials are indeed like this.

> *SSCCC*, "Concerning Acumen in the Examination of Painting" and "Concerning Ancient and Modern Scholars." *CKHLLP*, pp. 659–660, 676–677, 677–678.

Li Ch'eng-sou (ca. 1150–after 1221)

Landscape painting has existed for a long time. In recent times, since the removal of the capital to the South [that is, Hang-chou], although there were the two masters Li [T'ang] and Hsiao [Chao, 11th–12th century],[11] during the several decades afterwards, painters were insignificant and without reputation. Why? Because they lacked ways by which they could build.

Although I, Ch'eng-sou, am lowly and mean, since my childhood I have set my mind on this matter and have investigated it for more than sixty years. This is indeed a long time. Although I have not yet achieved an understanding of the subtleties, I have somewhat grasped a score of matters. I merely set forth one of these ways and discuss it in order to bequeath a tiny fraction of it to like-minded people of the future.

Written on an auspicious day of the sixth month in the *hsin-ssu* year of the Chia-ting era [1221] by Li Ch'eng-sou of Hsiang-chung [Hunan province] . . .

Famous painters of landscape from the recent past who attained their proper level were certainly not few. Such masters as Kuan T'ung,

11. The painters Li and Hsiao of the text must refer to Li T'ang and Hsiao Chao, the master and pupil who founded the Southern Sung Academy landscape tradition. Li Ch'eng-sou did not comment on the work of later academicians like Ma Yüan and Hsia Kuei, who were presumably his contemporaries.

Fan K'uan, Kuo Chung-shu, Kuo Hsi, Li Ch'eng, Ho Chen, Chang Chien, and Kao Hsün [all 10th–11th century], each established his own style. They either emphasized extensive scenery or minute details, either tight and firm brushwork or lightness or elegance. All perfected their strengths to put together their scenery, and there were many who achieved this. Only the two masters, Li T'ang and Hsiao Chao, transformed the styles and synthesized them, and instantly surpassed modern and ancient painters. Their simplicity and blandness, quickness and immediacy is indeed appropriate to the divine class.

In Master Li's paintings the application of ink is thick and stiff, and the opening up of space is simple and direct. One can say that in substance there is emptiness. In Master Hsiao's paintings, the scenery is grasped through mists, clouds, vapors, and fogs. One can say that in emptiness there is substance. If one were able to combine these two styles, to turn them around and mix them up, that would indeed be what is called "the top of the divine class" . . .

Those who paint flowers and bamboos must seek information from old gardeners and observe from dawn to dusk, only then will they see the aspects of budding, flowering, withering, and falling without missing anything.

Those who paint landscapes must travel everywhere and observe widely, only then will they know where to place and move the brush. How do I know this? From youth on, I, Ch'eng-sou, have observed the landscape of Hsiang-chung and roamed at length in the Three Gorges and the K'uei Gate. Whether land or water, I completely absorbed its aspects, and after a long while I involuntarily perceived my capacity for monochrome painting. It is necessary for students to understand this.

In northerners' landscapes, the compositions are stilted and turgid, the techniques rough and simple. This is because their plains are vast and broad, their scenery lacking in intricacies.

As for the figures in landscapes, do not emphasize their size. Figures, animals, buildings, and bridges only need to be done with a dot and a dash. If there is a resemblance, it is enough.

The younger generation does not understand technique. They draw minutely and add wash cleverly in order to charm the uncultivated eye. Such works are just figures and scenery assembled in a patchwork, definitely not landscapes.

From Chiang-ling [Hupei province], as one ascends by the Three Gorges and the K'uei Gate, the Yangtze flows more than three thou-

sand miles. Multiple sandbars, agitated shallows, swirling eddies, reck-less billows, whirlpools, cross-currents, heavy breakers, and rapid waves all are there. If one is mountain climbing, then go westward from I-ling [I-ch'ang]. Overhanging precipices and sheer walls, abrupt gorges and towering peaks, steep ranges and plunging cliffs, dark springs and luxuriant valleys, tigers' caves and dragons' pools, the dangerous and the perilous, sudden winds and wild rains, there is nothing that one will not encounter. All these are the models for today's painting. How can it not be all-encompassing? This is indeed what is called "reaching into a bag and finding something easily."

If one intuitively grasps subtle principles and expresses them through the brush-tip, how can a work suffer from mediocrity? Artists who think like this and study like this cannot avoid becoming famous.

> *Hua shan-shui chüeh* (Secrets of Painting Landscape), preface dated to 1221 and "General Comments." *CKHLLP*, pp. 622–623 (in part).

Landscape Formations

Ching Hao (ca. 870–ca. 930)

[The old man said:] "The different appearances of mountains and streams are produced by the combinations of vital energy (*ch'i*) and dynamic configuration (*shih*). Thus, there are a 'peak' which has a pointed top, a 'summit' which has a flat top, a 'hump' which has a round top, 'ranges' which have connected peaks, a 'cavern' which has a hole on the side, a 'cliff' which has a steep wall, a 'grotto' which is a space between two cliffs or below a cliff, a 'gorge' which is a pass going through mountains, a 'gully' which is a pass blocked at one end, a 'ravine' which is a gully with running water, and a 'torrent' which is a stream running through a gorge. Although the peaks and the humps high above are separated, below them the hills and ranges run together. [Further below] the forests and springs are seen here and hidden there. The impressions of the far and the near are thus clearly revealed. If you paint landscapes without distinguishing among these different formations, you are wrong. There are some paintings of running water whose brush strokes are in wild disorder, with wave patterns like scattered threads and no differences of height among individual waves. These paintings are also wrong. Fog, clouds, and mist are heavy or light depending upon the time. Their states are sometimes changed by wind, and they have no constant forms. In

summary, you must eliminate unnecessary elements and grasp the essentials [in observing nature]. Only after learning these fundamentals of nature well may you start learning the art of the brush."

Pi-fa chi (A Note on the Art of the Brush). *CKHLLP*, p. 607.

Shan-shui lun

When one paints landscapes,
Even slopes with pointed summits are "peaks";
Lofty heights connected together are "ranges";
Those having caves are "creviced peaks";
Sheer walls are "precipices";
Overhanging rocks are "cliffs";
Shapes which are rounded are "humps";
Courses which go through are "streams";
Passages coming between two mountains are called "ravines";
Waters coming between two mountains are called "torrents";
Those [hills] which are high and resemble a range are called
 "mounds";
Those which are level as far as the eye reaches are called
 "plateaus";
Whoever relies on this will know approximately what a
 landscape is like.

Attributed to Wang Wei (701–761), *Hua-hsüeh pi-chüeh* (Secrets of the Study of Painting), excerpt. *CKHLLP*, p. 596.

Kuo Hsi (after 1000–ca. 1090)

That mountains in the southeast are often strange and beautiful is not because the universe is especially partial to that area. The land there lies very low, and flood waters return through it, scouring out and exposing the subsurface. Thus the soil is thin and the waters are shallow. The mountains abound in strange peaks and precipitous cliffs, seeming to protrude far out beyond the stars. Waterfalls are a thousand feet high, plunging down from out of the clouds. The scarcity of waterfalls like that on Mount Hua [in Shensi] is not due to [mountains] not being a thousand feet high. But, even though there are solid and massive mountains, they mostly rise from the surface of the earth and not from its center.

That mountains of the northwest are often solid and massive is not because the universe is especially partial to the area. The land there

is very high and full of water sources that are buried in the bulging contours of the earth. Hence the soil is thick and the waters are deep. The mountains have numerous piles of peaks, twisting through unbroken ranges of a thousand miles or so. Great hills have summits (*ting*) and wind along to eminent heights in every direction of the wild terrain. The scarcity of mountains like the central Shao-shih peak of Mount Sung [in Honan] is not due to the lack of exceptional heights. But, even though there are peaks which thrust up to exceptional heights, they mostly rise from the center of the earth and not from its surface.

Mount Sung has many fine streams; Mount Hua has many fine sharp peaks; Mount Heng has many fine creviced peaks; Mount Ch'ang has many fine ranges; Mount T'ai has an especially fine central peak. Among the famous mountains and magnificent districts of the empire are T'ien-t'ai and Wu-i, Lu, [Heng,] and Yen-t'ang, Min, O [-mei] and the Wu Gorge, T'ien-t'an and Wang-wu, Lin-lü and Wu-t'ang. There the earth shows her treasures and hides away the cave where sages dwell. Strange and towering, god-like in their beauty, their essential wonder cannot be fathomed.

If you wish to grasp their creation, there is no way more spiritual than love, no way finer than diligence, no way greater than wandering to your satiety or gazing to your fill. If all is ordered in detail in your bosom, your eye will not see the silk and your hand will be unaware of brush and ink, and through the immensity and vastness [of your mind] everything will become your own painting. Thus did Huai-su [8th century] hear the nighttime waters of the Chia-ling River, and this sage of draft-writing achieved yet greater beauty. Thus did Chang Hsü [8th century] see the sword dance of Lady Kung-sun and the power of his brush became yet more noble[12] . . .

A mountain has the significance of a major object. Its form may rear up, may be arrogantly aloof. It may be lofty and broad, may sprawl. It may spread vast and extensive, may be solid and bulky. It may be heroic and martial, may be sacred or awe-inspiring. It may glare down or hold court to its environment. It may be capped with further peaks or ride upon lesser slopes. It may have others which lean upon it in front or depend upon it in the rear. It may seem to gaze down from its eminence and survey the ground below. It may seem to wander down to direct its surroundings. Such are the major formations of mountains.

12. Compare with the story of Wu Tao-tzu (8th century) and the general Pei Min in chapter 2 at "Brushwork."

Water has the significance of a living object. Its form may be deep and peaceful, may be lithe and slippery. It may spread to the horizon or circle back again. It may be fat and oily, may spray out in a screen, or shoot out like an arrow. It may have many sources and may flow far into the distance. It may fall piercing the heavens and may thunder into the ground. It may bear anglers at their ease, and may border happily murmuring foliage. It may embrace mists and clouds, elegant and enticing. It may shine in valleys and gorges, bright and splendorous. Such are the living formations of water.

A mountain has water as blood, foliage as hair, haze and clouds as its spirit and character. Thus, a mountain gains life through water, its external beauty through vegetation and its elegant charm through haze and clouds. Water has the mountain as its face, huts and pavilions as eyes and eye-brows, anglers as its soul. Thus, water gains its charm through the mountain, its vivacity through huts and pavilions, its ranging freedom through the anglers. Such is the interaction of mountain and water.

There are high mountains and low mountains. The arteries of the high mountain run low. Its limbs spread wide and its base is powerful and solid. Ridge lines of rounded crests or creviced peaks crowd together and interweave in unbroken gleaming links. Such is a high mountain. Thus, this type of mountain is called well supported and unified. The arteries of a low mountain run high. Its head [summit] comes halfway down, merging straight into its neck. The base is broad spread, and earthen mounds erupt in profusion. It extends deep down into the earth, none can measure how far. Such is a low mountain. Thus, this type of mountain is called substantial and coherent. If a high mountain is isolated, it is because its body is not unified. If a low mountain is slight, it is because its aspects do not cohere. Such are the configurations of mountain and water.

Rocks are nature's bones and, with bones value is placed on their being strong and well covered, not poking through the surface. Water is nature's blood and, with blood, value is placed on its circulating and not congealing.

LCKCC, "Advice on Landscape Painting." *CKHLLP,* pp. 636, 638–639.

Han Cho (active ca. 1095–ca. 1125)

In depicting rocks, we admire largeness and boldness, hardness and roughness, alum-crystal tops and multiangled surfaces, the thickness or thinness of layering, the weight or depth of rock pressure. Use ink

to bring out their firmness and solidity, and the depth or shallowness of concavities and convexities. Brush in texture strokes in light and dark tones, and add dots evenly with tones of high to low intensity. Such are the effects of the "broken ink" technique.

Large, even rocks are called "boulders." Yet, rocks do not have one appearance. Some are piled up in layers, refined and smooth; some are rocky summits, sheer and dangerous. There are precipices with irregular outlines and peculiarly shaped rocks which have tumbled down from above. There are some which are immersed in water and whose depth cannot be fathomed. Some have only their bases submerged but they are supported by other rocks. As for rocky crags that are precipitous and jagged, in myriad wondrous ways they spread out horizontally and vertically; their shapes are unlimited.

In addition, there are various kinds of texture strokes. There is the "hemp fiber" stroke, the "ornamental dot" stroke, the "cutting mountain" stroke, the "horizontal" stroke, the "uniform and connected water" stroke. For each of these lines and dots there are ancient and modern schools, a number of whose rules still exist.

The ancient said: "Not ten paces away, rocks seem real; ten miles away, mountains are distant." Moreover, rocks being of the same substance as mountains, one should value their quality of spirit resonance (*ch'i-yün*)[13] and not that of dry lifelessness (*k'u-tsao*). When painting rocks, do not depart from these views.

SSCCC, "Concerning Rocks." *CKHLLP*, p. 667.

Atmosphere and Spatial Recession

Kuo Hsi (after 1000–ca. 1090)

A mountain without haze and clouds is like spring without flowers and grass. If a mountain is without clouds, it is not refined; without water it is not charming. Without paths it is not living; without forests it is not growing. Without deep distance it seems shallow; without level distance it does not recede and without high distance it stays low.

Mountains have three types of distance. Looking up to the mountain's peak from its foot is called the high distance. From in front of the mountain looking past it to beyond is called deep distance. Looking

13. The *Shuo-fu* edition has "moist dampness" (*jun-tse*) instead of "spirit resonance."

from a nearby mountain at those more distant is called the level distance. High distance appears clear and bright; deep distance becomes steadily more obscure; level distance combines both qualities. The appearance of high distance is of lofty grandness. The idea of deep distance is of repeated layering. The idea of level distance is of spreading forth to merge into mistiness and indistinctness.

Figures in the three distances appear as follows. Those in the high distance are clear and distinct; in the deep distance they are fine and tiny; in the level distance they are remote and undisturbed. If they are clear and distinct then they cannot be short. If they are tiny then they cannot be tall. If they are remote then they cannot be large. Such are the three distances.

Mountains have three degrees of size. A mountain appears larger than a tree and a tree larger than a man. If a mountain is not greatly larger than a tree then it is not large at all. The tree which is not greatly larger than a man is not large at all. In comparing the size of a tree against the size of a human figure you begin with the leaves. In comparing the size of a human figure against a tree you begin with the head. A number of leaves can be approximated to a human head. A human head can be made in the size of a bunch of leaves. The sizes of figures, trees, and mountains, all acquire their standard in this manner. Such are the three degrees of size.

You may wish to make a mountain high, but if it is visible throughout its entirety it will not appear high. If mists enlock its waist, then it will seem high. You may wish the river to flow afar, but if it is visible throughout its entirety, then it will not appear long. If hidden sections interrupt its course, then it will appear long. If a mountain is visible in its entirety, not only will it no longer reach its height through soaring aloft, but you might as well paint a giant pestle. If a river is visible in its entirety, not only will it no longer go afar through twisting and bending, but you might as well paint an earthworm.

The streams and hills and woods and trees in the center twist and wind and are arranged to come forward from the distance. If you do not avoid these details, they will satisfy the viewer's nearby scrutiny. The level plains and lofty ranges to the sides are linked together in successive layers and disappear into misty obscurity. If you do not overlook these distances, they will stretch to the utmost the beholder's far vision. [According to Wang Wei:] "Distant mountains have no texture strokes; distant water has no waves; distant figures have no eyes." They do not really lack them, but merely seem to do so.

LCKCC, "Advice on Landscape Painting." *CKHLLP*, pp. 639–640.

Han Cho (active ca. 1095–ca. 1125)

Kuo Hsi says: "There are three types of distance in mountains. Looking up at a mountain from below and seeing faint mountains in the background is called 'high distance'; looking from in front of a mountain and glimpsing what lies behind is called 'deep distance'; looking from a near mountain toward neighboring, low-lying mountains is called 'level distance.' " I suggest that there are another three distances. When there is a wide stretch of water by the foreground shore and a spacious sweep to distant mountains, this is called "broad distance"; when there are mists and fogs so thick and vast that streams in plains are interrupted and seem to disappear, this is called "hidden distance"; when scenery becomes obliterated in vagueness and mistiness, this is called "obscure distance."

SSCCC, "Concerning Mountains." *CKHLLP,* p. 662.

Technical Secrets

Ching Hao (ca. 870–ca. 930)

[The old man said:] "Here I will give you the detailed instructions of the Essentials of painting. Spirit is obtained when your mind moves along with the movement of the brush and does not hesitate in delineating images. Resonance is obtained when you establish forms, while hiding [obvious] traces of the brush, and perfect them by observing the proprieties and avoiding vulgarity. Thought is obtained when you grasp essential forms, eliminating unnecessary details [in your observation of nature], and let your ideas crystallize into the forms to be represented. Scene is obtained when you study the laws of nature and the different faces of time [different times of the day or seasons of the year], look for the sublime, and recreate it with reality. Brush is obtained when you handle the brush freely, applying all the varieties of strokes in accordance with your purpose, although you must follow certain basic rules of brushwork. Here you should regard brushwork neither as substance nor as form but rather as a movement, like flying or driving. Ink is obtained when you distinguish between higher and lower parts of objects with a gradation of ink tones and represent clearly shallowness and depth, thus making them appear natural as if they had not been done with a brush."

He continued further: "There are the divine, the sublime, the distinctive, and the skillful classes of painting. Divine work is that in which there are no artificial elements and the images are formulated

spontaneously as the brush moves. Sublime work is that achieved by thought, which has passed through heaven and earth, and searched the character of all the existence in the world. Thus, both the outward appearances and the inner natures of the objects accord with the proprieties; [as it is stated in the *Book of Changes,*] 'all the objects are [appropriately] settled into [their forms]' by the brush. Distinctive work is that in which the brushwork is untrammeled and unexpected. The objects deviate from the real scene or are unbalanced in the basic principle. Works of this class may be said to have brush but not thought. Skillful work is that in which there exist minutiae of seductive beauty, which are meticulously carved out and pieced together. It may pretend to follow the basic principles of nature, but in actuality it heedlessly copies the outer appearances of things, and more and more diverges from the true images filled with vital force. Works of this kind may be said to lack 'reality' but possess an excessive 'outward beauty.'

"There are four types of forces (*shih*) in brushwork—muscle, flesh, bone, and spirit. If a stroke with thickening and thinning width is filled with substantial inner force, its force is called 'flesh.' If a stroke is vigorous and upright, with force to give life to dead matter, its force is called 'bone.' If each stroke delineating the whole painting is un-defeatable, the total force is called 'spirit.' From this it may be under-stood that a stroke with the ink of too thick and unrefined quality loses its structural integrity, while a stroke with the ink of weak color is defeated in the right 'spirit.' The stroke whose force of 'muscle' is dead cannot have the force of 'flesh' either. The stroke which is com-pletely interrupted has no 'muscle.' The stroke with conscious beauty has no 'bone.'

"There are two kinds of faults in painting. One comprises those faults not connected with form, the other, those connected with form. The faults concerned with form include—flowers and trees out of season, houses smaller than human figures, trees higher than moun-tains, and bridges not leading to the banks. These are calculable faults and the painting can be corrected by changing the forms. The faults not connected with form include—absence of spirit and resonance, and objects which violate the rules of nature. In these cases, even if brush and ink are applied, the total painting is dead matter. Since these paintings are categorically inferior, they cannot be corrected by changing details."

Pi-fa chi (A Note on the Art of the Brush). *CKHLLP*, p. 606.

Shan-shui chüeh

Now, among the ways of painting, monochrome is by far superior. It originates in the nature of the self-existent and perfects the efforts of the creator. Thus, in the few inches of a painting, a hundred thousand miles of scenery may be drawn. East, west, south, and north seem to be before the eyes; spring, summer, autumn, and winter are produced under the brush.

First, define the limits of the rivers and avoid making floating mountains; then set out the roads and paths without making continuous ways.

The "host" peak, as is most fitting, is tall and lofty; the "guest" mountains should hasten toward it.

Monasteries may be placed in enclosed mountain sites; houses may be set upon land by river margins.

In villages and farmsteads several trees are set out to form groves; their branches should grow close to the trunks. On mountains and precipices water gathers together and falls as cascades; water sources should not flow at random.

It is only correct that ferrying places be quiet and peaceful, and travelers should be few and scattered.

Bridges which let through large boats should be high and lofty; if suitable for fisherman's skiffs, they can be low without there being difficulties.

On overhanging cliffs and perilous heights, it is good to set strange-shaped trees; in places with palisades and escarpments, there cannot be pathways.

Distant peaks and clouds merge together in appearance, and colors of faraway sky and water blend in the light.

From the midst of places where mountains interlock, streams flow out most copiously; in spots on paths where one encounters peril, cantilevered plank roads may be set.

On level land with towers and terraces, it is rather appropriate to have tall willows shading the houses; on famous mountains with Buddhist and Taoist temples, it is eminently suitable to have strange-shaped fir trees enhancing the towers and pavilions.

Distant scenery is mist-wrapped; deep cliffs are cloud-locked.

Wineshop flags should be suspended high above a path; travelers' sails should hang low on the horizon.

Distant mountains must necessarily incline in rows; only nearby trees should rise to prominence.

In addition to practicing with brush and inkstone, occasionally play

while lost in absorption. After many long months and years, one will have fathomed the hidden secrets somewhat. For those who understand intuitively, there is no need to say more; those good at studying can still follow the standard methods.

> Attributed to Wang Wei (701–761), *Hua-hsüeh pi-chüeh* (Secrets of the Study of Painting). *CKHLLP*, p. 592.

Shan-shui lun

When one paints landscapes,
Concept precedes brushwork.
Mountains are of ten feet, trees of a foot,
Horses of an inch, people of one-tenth.
Distant people have no eyes,
Distant trees have no branches,
Distant mountains have no rocks
And are minute like eyebrows,
Distant waters have no waves
And rise to blend with the clouds.
These are the secrets.

Midpoints [waists] of mountains are cloud-filled,
Walls of rock are spring-filled,
Towers and terraces are tree-filled,
Roads and paths are people-filled.
In stones, one sees three faces,
In paths, one sees two ends,
In trees, one sees the crowning tops,
In water, one sees the wind's footprints.
These are the methods . . .

In observing, first notice general characteristics,
Then distinguish lights and darks.
Determine the hierarchy of "guests" and "host,"
And fix the dignified bearing of the clustered peaks.
If too many, they are confused,
If too few, they are lackadaisical.
If not too many nor too few,
One must separate far and near.
Far mountains should not be linked with near mountains,
Far waters should not be linked with near waters.

Temples and monasteries may rest
In enclosed pockets of mountain midpoints.
Small bridges may be set up
On sloping banks of fissured shores.
Where roads are, there are groves and trees,
Where riverbanks end, there are old ferries,
Where waters are interrupted, there are misty trees,
Where waters are extensive, there are travelers' sails,
Where groves are thick, there are dwelling places.
Old trees near cliffs
Have roots broken off and entwined with vines,
Rocky shores near streams
Have inclines strangely shaped and water-furrowed.

When one paints groves and trees,
Those afar are sparse and even,
Those nearby are tall and dense,
Those with leaves have delicate and pliant branches,
Those without have rigid and stiff branches.
Pine bark is like fish scales,
Cypress bark enwraps the trunk.
Those growing in soil are long rooted and straight stemmed,
Those growing on rocks are twisted and despondent.
Old trees have numerous joints and are half dead,
Wintry groves are widely spaced and desolate.

When there is rain,
One cannot separate sky and land,
One cannot distinguish east and west.
When there is wind without rain,
It is only to be seen in the tree branches.
When there is rain without wind,
Tree tops droop under pressure,
Travelers have umbrellas and bamboo hats,
Fisherfolk have rain clothes of coir.
When the rain is clearing,
Clouds disperse, the sky is blue,
Slight mists are thinner and lighter,
Mountains are even more green and glossy,
The sun sets in slanting rays.

If it is a morning scene,
A thousand mountains are about to be dawn-brightened,
Mists and clouds are fewer and fewer,

Pale and dim the remaining moon,
The aspect of atmosphere is murky and vague.
If it is an evening scene,
Mountains restrain the red sun,
Sails are furled on river islets,
Travelers hasten along the road,
Half-shut are the brushwood gates.

If it is a spring scene,
Fog-locked and mist-wrapped,
Long vapors stretch out white,
Water is like blue wash,
Mountain colors are moistly green.
If it is a summer scene,
Old trees conceal the sky,
Green water has no waves,
Waterfalls thread through clouds,
Secluded pavilions approach the water.
If it is an autumn scene,
The sky is like the color of water,
Secluded groves are crowded together,
Wild geese are on autumn waters
With reedy islets and sandbars.
If it is a winter scene,
With the plain ground for snow,
Woodgatherers carry firewood,
Fishing skiffs moor at banks,
Water is shallow with level sandflats.

When one paints landscapes,
They must accord with the four seasons.
They may be called "Mist-Wrapped and Cloud-Enveloped,"
Or "Returning Clouds over the Peaks of Ch'ü,"
Or "Clearing at Dawn in Autumn Skies,"
Or "A Broken Stele in an Old Cemetery,"
Or "Spring Colors on Lake Tung-t'ing,"
Or "People Confused on Paths in the Wilds."
Such phrases as these are known as "painting titles."

Mountain tops [heads] should not be aligned,
Tree tops should not be uniform.
Mountains rely on trees for clothing,
Trees rely on mountains for framework.

> Trees should not be numerous,
> Since the mountains' elegant beauty must be seen.
> Mountains should not be confused,
> Since the trees' essential spirit must be displayed.
> One who can accomplish this, can be called a master of
> landscape painting.

Attributed to Wang Wei (701–761), *Hua-hsüeh pi-chüeh* (Secrets of the Study of Painting). *CKHLLP*, pp. 596–597.

Shan-shui chüeh

When painting landscapes, first establish the position of the "guest" and "host" mountains; next decide the configurations of the background and foreground. Afterwards, precisely weave in the scenery and arrange the relative heights.

The application of the brush should not be too heavy. If so, the work will be muddy and unclear. Nor should it be too light. If so, the work will be dry and lusterless. If the use of wash is excessive, there will be no continuity; if the compositional plan is intricate and detailed, it will lack spirit . . .

Lofty mountains have mists obliterating their mid-sections [waists]; long mountain ranges have clouds obscuring their feet.

Although distant rivers twist and wind forward, still use clouds and mists to interrupt their courses. Although strange-shaped rocks stand like steep cliffs, they still need earthen embankments to support their bases.

Broad plains are boundless and unbroken; green hills adjoin their low, shallow places.[14]

Rocks should be rounded out with the sharp edges multiangled on all sides. Trees should be interlaced with their straight trunks bare or leafy according to the season . . .

The trees of misty groves should be spaced out. If they are crowded together, it will be intricate and tedious.

Repeated cliffs must not be uniformly level; for clustered peaks it is even more appropriate that there be variations in height.

Single peaks are placed far away: rivers in plains recede into the distance.

Roads and paths are sometimes hidden, sometimes visible; bridges can be used or not.

14. Here the version of the text given in Li Ch'eng-sou's *Hua shan-shui chüeh* seems preferable—"level valleys adjoin their flat, shallow places."

In the distance beware of darkness and gloominess; in the foreground guard against heaviness and murkiness.

On rows of cliffs, strange-shaped stones should not be used incessantly; on lofty ranges, decayed stumps should also be sparingly used . . .

Among lofty trees rising vertically, have one or two twisted, gnarled trees. Among scattered stones in piles and masses, have two or three curious, strange-shaped stones.

When applying dots for tree foliage, use a scattering of them to divide the clusters; when applying texture strokes for rock veins, use heavy ones to set off the light ones . . .

Tree roots are implanted, and their "dragon claws" appear as if clutching and grasping.

Rocks are set out multiangled, and their bases must, moreover, be in contact with the ground.

Zigzagging rivers should not exceed three bends; splashing rapids should not exceed two levels . . .

Tall trees are scattered on level plains; short scrub is thick on mountain tops [heads].

Isolated mists rise from the water's edge; thin clouds cling close to the foot of cliffs . . .

Young trees are sleek and glossy, thus cliffs and rocks should be cracked and hoary. Old trees are split and forked, yet the surroundings still should be luxuriant and attractive.

Differentiate the clear strokes from the turgid, so that light and heavy brushwork intermingles to some extent. If it is entirely heavy or entirely light, the error results in a rigid partiality that injures the substance.

If there are a thousand cliffs and myriad valleys, they must be low and high, clustered and scattered, and not identical. Multiple ranges and layered peaks must rise and fall, lofty and high, and yet each different.

If not confused in one way or another, you may spontaneously play while lost in absorption.

> Attributed to Li Ch'eng (d. 967). *CKHLLP*, pp. 616–617; cf. pp. 620–622.

Kuo Hsi (after 1000–ca. 1090)

When planning to paint, you must first balance heaven and earth. What is meant by this? Supposing you have a foot and a half of material, you should leave heaven its due portion above and earth its

place below, and then with ideas in mind set up the scenery in between. If you watch how most people learn to paint, you will find they pick up a brush and put it to work as soon as they lean against the table. They plan their ideas hastily excited by emotions and smear over the entire painting. Your eyes clog up at the sight and your thoughts do not quicken. What hope would there be of finding pleasure in pure beauty, of seeing emotions on a lofty plane?

In landscape, first pay attention to the major mountain, called the master peak. When this one is established you can turn to others, near and far, large and small. We call it the master peak because, in this manner, it is sovereign over the entire scene. It is like the hierarchy of lord and ministers.

In scenes of rocks and trees, first pay attention to the largest pine, called the venerated ancient. When it is established, you may proceed in turn to various lesser flora and small rocks. We call it the venerated ancient because, in this manner, it stands out among all other objects on the mountain. It is like a noble gentleman among lesser mortals.

There are mountains covered in earth and mountains covered in rocks. An earthen mountain is covered in rocks, and the trees rise tall and gaunt. A rock mountain is covered in earth, and the trees are thick and vigorous. There are trees on a mountainside, and trees by the waterside. Where they grow in thick-soiled mountain areas, you may find pines a thousand feet high. Where they grow in thin-soiled areas by the water, you may find stumps only a few feet high. There are flowing waters and great rocks. There are waterfalls and bizarre rocks. Waterfalls come flying down from beyond the trees. Bizarre rocks crouch tiger-like beside the path.

There is rain on the point of falling and snow on the point of falling. There is heavy rain and heavy snow. There is rain clearing and snow clearing. There is bustling wind and evening cloud. There is strong wind and light cloud. Strong wind has the power to blow up sand and send clouds rolling. Light cloud has the appearance of thin gauze or stretched silk.

Shops and houses lie on small rivers and not on large watercourses. They lie on small rivers to be near the water and not on large watercourses because of the danger. If some happen to be by a large watercourse they will be in a spot where there is no danger from floods. Villages lie in open ground and not on mountains. This is for the convenience of cultivation. On mountains, arable land would be far away. If there happen to be some on a mountain there will also be arable land in the mountain.

A large pine or a large rock must be painted on a great cliff or on

a great slope. You cannot depict them near a shallow bank or a level mud-flat.

In all cases, you should master the brush and not be mastered by it; you should use the ink and not be used by it. Brush and ink may be trivial matters, but if you are unable to manage the two of them you will never achieve the finest results. It is, moreover, not too difficult. You may approach the problem through calligraphy, which is just the same. Thus, when people say that Wang Hsi-chih [309–ca. 365] loved geese, the point is that he thought their flexing necks were like a calligrapher turning his wrist to form a character as he held a brush. This is just like discussing the use of the brush in painting. Hence it is commonly said that good calligraphers are often good painters. This is probably because, in using the brush, they are extremely fluent in their wrist movement.

When someone asks me what ink he should use, I answer: "Use burnt ink, ink that has been kept overnight, receding ink, ink made from fine dust. One is not sufficient. You cannot achieve the desired effects through only one ink."

For rubbing the ink, use a stone, a tile, a porcelain bowl, or a piece of earthenware. For the ink, simply make sure you use an excellent ink. It is not necessary to use a famous brand. For the brush, use ones that are pointed and rounded, thick and thin, like a needle and like a broom.

In manipulating ink, sometimes you use light ink and sometimes dark, sometimes scorched, kept or receding ink. At times you use ink made with soot scraped from the stove and at times ink mixed with blue in a diluted form. If you build the ink tone up with six or seven layers of light ink, then the color will be moist and rich, not harsh and dry. Thick and scorched ink are used for emphasizing outlines prominently. Therefore, if they are not used the angles of pines and the corners of stones will not stand out sharply. When you have thus brought them out, go over them with watered blue color and the tones of the ink will be distinct, as if emerging from mist or dew.

The repeated application of light ink in circling strokes is called "circling with the light." Picking out an object with staccato strokes of a sharp brush, held almost horizontal, is called "texture stroke scrubbing." To soak an area with three layers of wash is called "adding washes." To moisten with a well-mixed wash is called "to cleanse." To point with the brush head held straight out away from you is called "to strike." To point with the brush head held downwards is called "to pull." To accent with the tip of the brush is called "to dot." Dotting is suitable for figures and also for tree leaves. To draw the brush

steadily in a line is called "to delineate." This is suitable for buildings and also for pine needles.

For the coloring of snow use light and dark ink for the contrasts, but the tones of the ink should not be uniform when applied. For the coloring of mist, take the original tone of plain silk and brush around it with light wash to tint it so that no sign of brush or ink can be seen. The coloring of wind may be achieved through yellow earth and dust ink. The coloring of earth is obtained through light ink and dust ink. The coloring of stone is obtained through combining the blue and black ink in different shades. Achieve the effect of waterfalls by leaving the plain silk bare and simply using scorched ink to indicate the sides.

In spring, water is mineral green and in summer, jade green. In autumn it is blue and in winter black. In spring, the sky is full of light and in summer, brilliant blue. In autumn it is clear and in winter dark. The place for painting should catch the sun in winter and remain cool in summer. It should be spacious and secluded. The painter's attitude should be one of indifference to all common anxieties. His spirit should be firm and his mind clear. Tu Fu's poem gets the precise point:

> Painting one stream in five days and one rock in ten,
> In perfect control and yielding to no pressure,
> Only then was Wang Tsai willing to create his real work.[15]

LCKCC, "The Secrets of Painting." *CKHLLP,* pp. 641–644.

Faults of Landscape Painting

Kuo Hsi (after 1000–ca. 1090)

Those who wield a brush nowadays do not nourish that within to expansive fullness and do not examine that without to the point of thorough familiarity. What they experience is not comprehensive and what they discover is not quintessential. Yet, as soon as they find a piece of paper or clean off a patch of wall, they then fling down some ink quite unaware of how to pluck a scene from beyond misty reaches or to reproduce inspiration atop stream-filled peaks. In my brash opinion, their faults can be enumerated.

What is meant by nourishing to expansive fullness? Recently a painter

15. For the type of landscape painted by Wang Tsai (late 8th–early 9th century), see chapter 2 at "Landscape: Comments."

did a picture on the classic theme "A Benevolent Man Takes Pleasure in the Mountains," which had one old man sitting with chin in hand near a peak. In a picture on the companion theme "A Wise Man Takes Pleasure in the Water,"[16] he made one old man inclining his ear before a cliff. These suffered from the fault of not reaching expansive fullness. The first theme should be depicted as in Po Chü-i's famous picture of his "thatched lodge" retreat, which over-flows with the mood of dwelling in the mountains. The second theme should be as in the equally famous picture by Wang Wei of his Wang River estate which has the pleasure of dwelling by water to the full.[17] How could the pleasure of wise or benevolent men be seen in one single figure?

What is meant by examining to the point of thorough familiarity? Artists of the present generation, when painting mountains depict no more than four or five peaks. When painting water they depict no more than four or five waves. These suffer from the fault of not achieving thorough familiarity. In painting mountains, high and low, large and small, all should be appropriately harmonious or full to front and rear; their heads [summits] should bow in due order and their limbs respond in perfect unison. The beauty of the mountains will then be satisfying. In painting water, be its surface regular or disturbed, curling in furious flight or drawn out in great stretches, its form should be completely natural and self-sufficient. The aspects of water will then be adequate.

What is meant by not having comprehensive experience? Painters of recent generations, if born in Wu or Yüeh, depict the protruding gauntness of the southeast. If they live in the Hsien or Ch'in [districts of Shensi], then they express the powerful breadth of the northwest. Those who study Fan K'uan [ca. 960–1030] lack the elegant beauty of Li Ch'eng [919–967]. Those who take Wang Wei [701–761] as a teacher lack the structural power of Kuan T'ung [10th century]. In all these cases, their fault lies in not having comprehensive experience.

What is meant by not discovering the quintessential? In a thousand mile stretch of mountains it is impossible to appreciate all the wonders. In ten thousand miles of water how can one appreciate all the beauties? The T'ai-hang mountain range is pillowed against the Hua-hsia region

16. These statements come from the *Lun-yü* (Analects); see Legge, *Chinese Classics*, I, 192.

17. Wang Wei's poems and versions of his painting of his Wang River estate are well known. The T'ang poet Po Chü-i (772–846) is not listed as a painter. A painting illustrating the T'ang writer Lu Hung's composition on his "Thatched Lodge" is in the National Palace Museum, Taipei.

while it faces Lin-lü. Mount T'ai bestrides the Ch'i and Lu districts [of Shantung], while its most remarkable scenery is at Lung-yen. To paint the whole extent in one would simply produce a map. All works which do so suffer from the fault of not discovering the quintessential.

Concentrating on sloping banks leads to clumsiness. Concentrating on secluded retreats leads to insignificance. Concentrating on figures leads to vulgarity. Concentrating on lofty buildings leads to mundaneness. If you concentrate on stones, then the bones will show. If you concentrate on earth, then it will be over-fleshy. If brushstrokes are not blended together, they are called "coarse," and if coarse they lack true significance. If ink tones are not moist and rich, they are called "bone-dry," and if dry they do not come alive. Water that does not flow is said to be dead water; clouds that are not natural, to be frozen clouds. Mountains without light and dark areas are said to lack light effects; mountains without hidden and visible parts, to lack atmospheric haze. Since, on a mountain, where the sun shines it is light and where the sun does not shine it is dark, the constant form of a mountain is defined through light effects. Hence, if light and dark are not distinguished, it is said to lack light effects. Since, on a mountain, places which have atmospheric haze are hidden and places which do not are visible, the constant aspect of a mountain is defined by atmospheric haze. Hence, if hidden and visible areas are not distinguished, it is said to lack atmospheric haze.

LCKCC, "Advice on Landscape Painting." *CKHLLP*, pp. 636–638.

Han Cho (active ca. 1095–ca. 1125)

Now, if you rely too much on ink, you destroy the real substance of things and injure the brushwork, as well as muddy the painting. But where the use of ink is excessively feeble, the spirit becomes timid and weak. Both excess and insufficiency are defects.

By all means follow rules and standards, but base your painting on spontaneous spirit resonance (*ch'i-yün*). By doing so you will certainly attain a sense of life (*sheng-i*) in the painting. A work that is successful in this is a perfect thing, but one that fails is defective. How can one discuss investigations of this sort with foolish and vulgar people?

Generally, before you even grasp the brush, you must concentrate your spirit and clarify your thoughts, then the image will seem to be before your very eyes. Hence, "the idea exists before the brush." Afterwards, if by means of standards you have carried out your ideas, then it can be said that what has been obtained from the mind has been responded to by the hand. As for the use of the brush, it may

be simple and easy, yet completely meaningful; it may be skillful and dense, yet exquisitely refined. One may either select a spirited style marked by strokes which are virile and powerful, or a pleasing style in which the strokes are flowing and unbroken. There are all sorts of variations which exist in the use of the brush.

However, there are many defects in the practice of painting, the most serious of which is vulgarity. It arises from shallowness and superficiality and conforms to what is base. If a painter does not know standards and has no technical discipline, yet dashes things off confusedly aiming at spontaneity, or if he forces an antique blandness or dry lifelessness, even though in a kind of exquisite and delicate way, he will merely produce a kind of fake antique brushwork that is fundamentally unnatural. These are to be discussed as defects in brush and ink, standards, and spirit resonance . . .

In addition to the preceding [brushwork faults listed by Kuo Jo-hsü], I should also like to suggest a painting defect which I wish to call "hardness." That is when a painter only pays attention to trifling matters and foolishly adheres to inessentials in his brushwork, being completely devoid of versatility; hence even though brush and ink are in action, they are like dead things, and his forms seem to have been carved. This is the defect of "hardness."

Generally, in using the brush, the first thing painters must seek is spirit resonance. Next, they must decide upon stylistic essentials and afterwards upon subtleties. If, before the completion of the formal structure, the painter applies cleverness and subtleties, then he will perforce lose the spirit resonance. If he but strives for spirit resonance, then, as a matter of course, formal likeness (*hsing-ssu*) will be present in his work.

Moreover, painters should study the principles of landscape painting well. They should preserve reality (*shih*) in their painting. If reality is insufficient, one may as well throw away the brush, since there will be excessive showiness (*hua*). Reality connotes substance or corporeality. Showiness connotes floweriness or ornamentation. The former originates from nature, while the latter is a man-made thing. Reality is essential, whereas showiness is inessential; nature is the underlying basis, and art its application. Hence, how can one neglect what is fundamental and pursue inessentials, or be unmindful of the basis and involved in technique? This is like the case of the painter who has only paid attention to showiness and seductiveness so that the basic methods (*t'i-fa*) are lost; or like that of one who has only paid attention to softness and delicacy so that spiritual vitality (*shen-ch'i*) is destroyed. These are, indeed, examples of the defect of vulgarity!

How can such painters know about the principles of preserving reality and eliminating showiness?

Furthermore, brushmanship is sometimes coarse, sometimes delicate; sometimes uneven, sometimes even; sometimes heavy and sometimes light. If there is no clear distinction between each of these strokes in the arrangement of far to near, then they will seem spiritually weak and not make a painting.

If the brushwork is too coarse, this weakens the painting's sense of order. If the brushwork is too delicate, this terminates the flow of spirit resonance. Each texture stroke, dot, hook, and axe-chop, has a traditional significance. If one does not follow the painting methods of the ancients and merely copies an actual mountain without distinguishing nearness and farness, or shallowness and depth, the result will be a geography book illustration. How can such a painter attain standards and spirit resonance?

> SSCC, "Concerning Defects in the Use of Brush and Ink, Standards and Spirit Resonance." *CKHLLP*, pp. 671–673.

Connoisseurship of Landscape Painting

Han Cho (active ca. 1095–ca. 1125)

Generally, when examining paintings, the first thing to look for is the spirit resonance (*ch'i-yün*) of the general aspect; the next thing to investigate is the level of standards, that is, the rules and practical methods of former worthies' traditions. If a sense of vitality (*sheng-i*) is undiluted and elements are in accord with the natural order, and if practical methods are perfected and standards are on a high level, a painting has doubtless succeeded within these limits. But, what about a painting that, despite such qualities, confuses the traditional styles? Well, if one were to paint in the style of Li Ch'eng [919–967], why mix it with that of Fan K'uan [ca. 960–1030]? Similarly, in the methods of calligraphy, one would not mix the styles of Yen Chen-ch'ing [709–785] and Liu Kung-ch'üan [778–865], nor practice the seal and official scripts at the same time. Hence the saying: "If what is grasped cannot be unified, then there will be discrepancies." How true this is! When turning to the past and examining the present, can one who is good at looking at paintings make no distinctions? Yet both ancient and modern landscape styles are painting. Those who understand painting methods will comprehend the vitality of spiritual perfection, but those who study copying methods will possess the defects found in geography book illustrations. One must not ignore these points.

Painters nowadays tend to study but one school, and there are many who do not understand the accomplishments of the various famous traditions. While there are able men of wide acquaintance with the various traditions, few are they who are deeply conversant with any one of those masters. And artists' works are confused in spirit and thought, mixed up in their models and rules, and, for these reasons, extremely difficult to judge. As for elucidating the older masters' methods it is only the gentlemen possessing deep comprehension who can discuss their principles clearly. It is the man who has investigated the stars thoroughly who then verifies geomantically the tomb siting. Even though one's undertakings are numerous, if there is order to them then there is no confusion; even though things are multitudinous, if they are in sequence, then there is no disorder. In each of these cases there is an indwelling sense of principle (*li*). As for the principle of examining paintings, if one has not mellowed his heart and mind, is not good at distinguishing painting materials, and is not a connoisseur of depth and breadth, then he will be unable to attain this principle.

Among paintings there are those that have purity of substance, and are limpid and bland; that are rustic and simple, but possess antique awkwardness; that are light and refined, and tersely beautiful; that are loosely arranged, and graceful and airy; that are wild and full of abandon, and endowed with aliveness; that have lonely distances that are deep and far-reaching; that are dark and dim, but meaningful; that are realistic, but relaxed and easy in manner; that are busy with detail but not confused; that are densely packed but not muddled. All of these were the accomplishments of painters of the three periods of antiquity [that is, Southern Dynasties, T'ang, and Five Dynasties] who advanced to the famed ranks of the "Inspired" and the "Excellent." Each was blessed with principle.

If a painting on first observation appears quite fathomable, but on careful study reveals marvelous effects and increasing profundity, such a painting is superior. On the other hand, if there is a painting which on first observation appears unfathomable and again does so on second glance, but after exhaustive study proves eccentric in principle and method, such a painting is inferior . . .

If a painting has truth, it may be transmitted to posterity. For a painting whose fame is not self-evident, there is the saying: "Where there is substance, fame will come of itself." Even if such elevation is not anticipated, the painting will of its own accord become famous. However, should a painting falsely acquire a good reputation at one time, it will in the end gradually diminish in fame. As the saying goes:

"Praise is in excess of substance." Even if a diminution in fame is not anticipated, it will occur of its own accord.

As a whole, in the appreciation of painting, how can one choose on the basis of some official's praise? Merely by looking at a painting one can consider it excellent if its style is pure and it has antique ideas; if its ink is marvelous and its brushwork subtle; if its scenery is quiet and secluded; if its ideas are far-reaching and its principles profound; if its manner is lofty in thought. Paintings not equal to such fineness can be dismissed as mere skilled and detailed works and are rarely examined.

In this generation there was Wang Shen [ca 1048–ca. 1103], a cultivated gentleman of the imperial family. He was well versed in literature and history and let his thoughts roam in maps and documents. During leisure time he would amuse himself with painting small pictures, many of which he would distribute among the families of the high-ranking officials and nobles. I fortunately received his favor and, each time there was a viewing of paintings, he would summon me to look at them together with him. Then he would discuss the subtleties of paintings, and talk about their fame and authenticity.

Unexpectedly one day at the Tz'u-shu Hall,[18] a Li Ch'eng was hanging on the east wall and a Fan K'uan on the west. Wang first looked at the work of Li Ch'eng and said: "Li Ch'eng's painting method was that of moist ink and fine brushwork. There are mists that move lightly, and it is as if a thousand miles were right before one's eyes; there is an abundant spirit that is almost tangible." Then he looked at the painting of Fan K'uan and said: "It is just as if the densely packed mountain ranges were lined up before one's eyes. The strength of spirit is heroic and unfettered, and the force of brushwork is mature and vigorous. Truly, is not one of these paintings of the civil sphere and the other of the military?" The appropriateness of his words, it seemed to me, could indeed be called criticism that penetrates to the very marrow. It is essential to know the main points of standards and methods. Then you will be able to distinguish between what is inferior and superior, what is right and wrong. Then it can be said that you are a true connoisseur of subtle understanding! If a person is unable to judge paintings, then he is just like the traveler on the road who cannot distinguish between good and evil—is it not sad?

> *SSCCC*, "Concerning Acumen in the Examination of Paintings." *CKHLLP*, pp. 674–675, 676.

18. The "Hall of Conferred Books" was the name of a library owned by Sung Shou (991–1040).

Kuo Hsi as Court Artist

Kuo Hsi (after 1000–ca. 1090)

{In my possession is a handwritten record of my father's [on events] after Shen-tsung's ascension [in 1067].}

On the 15th of March, 1068, when the minister Fu Pi [1004–1083] was serving as a magistrate in Ho-yang [Honan province], on the receipt of a rescript from the central government, I accompanied him with due honors to the capital [K'ai-feng].

First of all, I was commissioned by the provincial administrator Wu Chung-fu [1011–1078] to do murals for the provincial office; then I was summoned by the governor of K'ai-feng Shao K'ang [1014–1074] to make a six-paneled screen of snow scenes in the prefectural hall; next at the Municipal Water Affairs office, on the invitation of an old friend Inspector Chang Chien-fu [?], I painted a six-paneled screen of pines and rocks; next Wu Ch'ung [1021–1080][19] became an assistant provincial official and summoned me to make screens of distant views in wind and snow for the walls of the subprefectural hall; also for the censor's hall, at his behest, I did a six-paneled screen of water and rocks in wind and rain; also at the [Buddhist temple] Hsiang-kuo-ssu, behind the spirits on Li Yüan-chi's west wall mural, I did a level distance view of a stream in a valley; next I was granted an imperial dispensation to make a screen for the Tzu-ch'en Hall [in the Imperial Palace] along with Ai Hsüan, Ts'ui Po, and Ko Shou-ch'ang; next with Fu Tao-yin and Li Tsung-ch'eng I did a screen for the small hall [near the inner East Gate],[20] next I was graciously informed by the Imperial Academy of Calligraphy attendant Sung Yung-ch'en [d. 1100], who transmitted the imperial decree, that I was summoned to go to the Imperial Academy of Calligraphy to do screens and scrolls for the Emperor [Shen-tsung], both small and large, I can't remember the number. There was a decree that I was to specially receive the title of "artist-in-apprenticeship" at that Academy. At the time, since my parents were old, I begged to return home but this was not allowed. Again I begged to visit my parents, and it was ordered that it be as I requested. On imperial command, I made two paintings of "autumn rain" and "winter snow" as a present for the Prince of Ch'i, and I also

19. Wu Ch'ung, who married Li Ch'eng's granddaughter, may have been the patron who introduced Kuo Hsi to the court.

20. See Alexander Soper, *Kuo Jo-hsü's Experiences in Painting (THCWC)* (Washington, D.C.: ACLS, 1951), p. 60.

did a folding screen for the study [?], also the screen for the imperial throne, also two autumn scenes with misty peaks as a present for the Koreans, also two sets of landscapes of the four seasons, also paintings and screens of "spring rain" and "clearing skies." The Emperor was extremely pleased and favored me with a promotion to artist-in-attendance. He also sent down an order to do a pair of screens, one of trees and one of rocks, for two walls of the Jade Flower Hall; also to do "colored spring mountains" and "hidden snow in winter depths." Also I received an order in regard to the eleventh hall of the [Imperial Shrine] Ching-ling Palace: on the screen in front a large boulder was made in eleven pieces with fragments behind it, both large and small, of an incalculable quantity. {There are separate entries below for some of the works discussed here.}

> *LCKCC,* excerpt from section 6, "Notes on Paintings": Kuo Hsi's hand-written record of his career at K'ai-feng, with comments in braces by his son Kuo Ssu (d. after 1123).

Kuo Ssu (d. after 1123)

Shen-tsung [r. 1067–1085] said one day to Liu Yu-fang [an official-in attendance?]: "Kuo Hsi's painting connoisseurship is highly developed; whenever we have him evaluate the painting masters of the empire, he always has informed opinions. Take out the famous paintings from Han and Chin times on that are in the Archives and have Kuo Hsi judge their categories [of quality].

Thus, in the past my father thoroughly investigated what was stored in the imperial collection and classified one by one each famous work. Others of our family have unfortunately not seen these originals . . .

IMPERIAL SCREEN: PAINTING OF WHIRLING SNOW IN THE NORTH WIND. Shen-tsung ordered [the Overseer of the Inner Palace Bureau] Sung Yung-ch'en [d. 1100] to prepare to make an imperial felt screen, which was extremely rare. He favored [Kuo] with an imperial rescript that said: "Kuo Hsi can be ordered to paint an imperial screen." My father did a painting entitled *Whirling Snow in the North Wind:* its scene was a grove of trees on a large bank with a great wind blowing in the sky dispersing clouds in disorder; in a large portion of it there was snow fluttering about. As at the time there was a drought, Shen-tsung was very pleased when he saw it and considered it to be of supernatural subtlety seeming to be in motion. Then, from the privy purse, he took a precious, embroidered gold belt and gave it to my father, saying: "This gift has been granted to you because of the unique quality of the imperial painting; others have not received this treatment" . . .

JUI-SSU (SAGACIOUS THOUGHTS) HALL [THE SO-CALLED "COOL HALL" RESTORED BY SUNG YUNG-CH'EN]. It is shaded all around by cultivated bamboo and luxuriant trees so that even in the heat of summer it is cold. In this hall blue-green stone was carved into sea creatures, fishes and dragons, in fine openwork of high translucency. A diverted stream was hidden, gurgling below, and above it was placed the imperial bed. Truly it might be called a "Cool Hall." The Emperor said: "Unless there are Kuo Hsi's paintings, it will not be suitably matched." Thereupon he commanded Sung Yung-ch'en to transmit a rescript ordering my father to do portable screens for the four sides (the screens that encircled the hall were all like this). I have heard that the scenes were all of pines and rocks in level distance views. This scenery of landscape's lofty beauty caused people who saw it [to feel] elevated. Among the nobles and gentry there were those who loved to celebrate [the screens] in poetry, and there were hundreds of these palace poems. One such couplet was: "Mountain peaks encircling the hall join with the circuit of blue-green / In the paintings one often sees the name [or fame] of Kuo Hsi." It refers to these [screens].

JASPER FORD PAVILION [THE JADE FLOWER HALL SCREEN], IN THE BACK GARDEN [OF THE PALACE]. I have heard that Sung Yung-ch'en together with Yang Yen [?] brought from Ch'ien-t'ang [Hang-chou] a specially constructed pavilion and placed it on a freshly dug-out pool. When the Emperor visited it, he said: "Too bad that there aren't any lotus flowers." Yung-ch'en answered: "Will Your Majesty come tomorrow to admire the lotus flowers?" The Emperor said: "Yung-ch'en, you are promising too much. How is that possible if there are no lotus flowers?" Yung-ch'en replied: "Then let me be punished by Your Majesty." The following day, lotus flowers filled the pond. The Emperor took his ease there and was very pleased. That night Yung-ch'en had bought up the potted lotuses in the capital [K'ai-feng], and sunk them into the foundations of the pond, causing thousands of stems to lean against the bank. The Emperor said: "For this pavilion's screen, we really must have Kuo Hsi's painting." Accordingly, [my father] brushed out a large picture.

GREAT EASE PALANQUIN SCREEN [ALSO CALLED THE "NINE DRAGONS PALANQUIN"]. Shen-tsung had it specially designed for the Empress Dowager, and its artifice was indescribable. The Emperor said: "We must also have Kuo Hsi paint a folding screen, which should have a bit of color." When my father had done it as required, the Emperor was extremely pleased with it.

JADE HALL [SCHOLARS' PRECINCT] FOLDING SCREEN. Having renewed the Chancellery and the Privy Council, Shen-tsung also established new official buildings near the imperial precinct. On the Jade

Hall's completion, he especially sent the high official [Palace Messenger] Chang Shih-liang to transmit the imperial decree: "The Han-lin Academy is a place of literary brilliance. You, sir, have a son who is studying books. You should both put your ideas into a painting." My father retired to his study for several days, and then in one sweep completed [the screen]: its scenery was of spring mountains. Infused with the feelings of spring, the attitudes of all beings were joyful, and onlookers were as pleased as if in the realm of the Ssu-ming and T'ien-mu [mountains of Chekiang]. As Su Shih's poem says:

> The Jade Hall is closed at dawn on an idle spring day;
> Inside are spring mountains painted by Master Kuo.
> With the chirping and flocking of young sparrows, I rise up
> from a doze:
> White waves and dark cliffs are not of this world.

No doubt this picks out the chief essentials by getting at the truth and expressing the circumstances.

In the spring of 1117 [Kuo Ssu returned to K'ai-feng to deliver an official report to Hui-tsung who commented on Shen-tsung's fondness for Kuo Hsi's paintings] . . . In a succeeding audience the Emperor also granted the special favor of a personal interview and forthwith promoted me to the Imperial Archives. At the present time, when I investigate my father's remaining records and look into things touched by his hand, I see the great profusion of gifts and favors bestowed by Shen-tsung during his reign eras [1068–1085], such as belts conferred, promotions granted, ranks endowed, garments bestowed, and innumerable lesser gifts, all of which cannot be adequately recorded. Moreover, in a flourishing period of great peace, an official career of being favored by the Emperor is what the world respects.

There is still more than this that could be described [in the imperial collection]. At the same time, my father's works are also in private collections, hence I cannot record them all. I merely list the most famous ones.

LCKCC, "Notes on Paintings."

5

Sung Literati Theory and Connoisseurship

COMMENTS by literary men constituted the earliest writings on painting, and from the beginning they tended to focus on subject matter and the act of creating. By T'ang times the major works of art criticism were written by scholar-officials who had access to important collections and were adept in calligraphy if not in painting. The proper approaches to connoisseurship and a comprehensive history of painting were defined in the *Li-tai ming-hua chi*. Far more limited in scope were the poems or descriptive appreciations by literary men on specific paintings. Still, because of an author's fame, later scholarly writers more often quoted these comments than the specialized texts on painting. Indeed, a distinguishing feature of Sung literati theory is that it did not refer to the authorities of T'ang criticism. Instead, its most revered models were Wang Wei (701–761), who illustrated his own poetry, and Tu Fu (712–770), whose pertinent lines had already been culled by the T'ang critics.[1]

It is easy to identify Wang Wei's influence on Sung art theory as a symbol of the complementary aspects of painting and poetry. Tu Fu's legacy is somewhat harder to define, but his lines often provided a starting point for later colophons written on landscapes or horse paintings. In general he seems to have appreciated convincing representation and liveliness or vitality in these subjects. Other writers focused on the artist's inner state in Taoist terms, but still displayed the T'ang concern for formal likeness. This position is most fully stated by the poet Po Chü-i (772–846), who wrote: "There is no fixed [formula for] skillfulness in painting; resemblance is its skill . . . [But] learning that

1. See the entries on Wu Tao-tzu, Han Kan, and Wang Tsai from the *TCMHL* and the *LTMHC* in chapter 2 at "Definition . . ." and "Landscape."

is in one's bones and marrow is achieved by mental art, and skill matching creation comes from natural harmony."[2] A scholar-artist who exemplified this balanced point of view was Chang Tsao (8th century), who is reported to have said: "Externally all creation is my master. Internally I have found the mind's sources."[3] Chang's vigorous depiction of pines and rocks while in a trance-like state was recorded by the poet-recluse Fu Tsai (d. ca. 813), who commented: "When we contemplate Master Chang's art, it is not painting, it is the very Tao itself. Whenever he was engaged in painting . . . for him, things lay not in the physical senses, but in the spiritual part of his mind."[4] This type of Taoist inner visualization is often described by the early twelfth-century critic Tung Yu. On the other hand, in a position characteristic of the Sung literati, Tung takes issue with Po Chü-i's definition of art: "How can it only be resemblance that is valued."[5] Not surprisingly, literati theorists chose selectively from the literary legacy of the T'ang and generally tended to reject a simple appreciation of formal likeness.

The problem of representation remains at the core of many discussions of painting. A Confucian view is offered by Ou-yang Chiung (896–971), who emphasized the equal importance of formal likeness and spirit resonance in painting. Like another Five Dynasties writer, the earlier landscapist Ching Hao, Ou-yang Chiung thought in terms of the dichotomy between substance and ornament in the *Lun-yü* (Analects) and opposed outward beauty to inward reality. And like Ching, he was still aware of the Six Laws of painting. More subtle comments on this subject were presented by the Sung scholar-official Ou-yang Hsiu (1007–1072), who stressed the difficulties of depicting ideas (*i*) and conveying mood (*ch'ü*) in landscape, or suggesting the somber aspects of supernatural beings. With Ou-yang Hsiu, we enter the realm of literati art theory, since he compared painting to poetry (and vice versa) and was the master of Su Shih (1037–1101).

By the late eleventh century influential scholar-officials had become the arbiters of cultural taste. Su Shih held high office only briefly, but as a literary genius and convivial wit, he was the center of a group of

2. For an excerpt from the Po Chü-i record, see the first entry in chapter 2 at "Appreciation and Connoisseurship"; also Susan Bush, *The Chinese Literati on Painting: Su Shih (1037–1101) to Tung Ch'i-ch'ang (1555–1636)* (Cambridge, Mass.: Harvard University Press, 1978), pp. 65–66.

3. See the entry on Chang Tsao from the *LTMHC* in chapter 2 at "Landscape."

4. Fu Tsai's record is excerpted as the first entry in chapter 2 at "Social Status and Creative Activity"; also see Michael Sullivan, *Chinese Landscape Painting of the Sui and T'ang Dynasties* (Berkeley: University of California Press, 1980), p. 66.

5. See below in this chapter under "Definition, Animation, and Expression."

men who painted or wrote about painting. Under his sponsorship painting came to be considered one of the social arts like poetry and calligraphy, emotional outlets for the gentleman. Like them it was produced in an atmosphere of friendly competition at informal gatherings with the same brush, ink, and paper. The subjects of these paintings were often old trees and rocks or ink bamboos, themes of moral significance in which the character of the artist could be displayed in calligraphic strokes. Since Su Shih and his friends were famous as writers, calligraphers, and moral exemplars, their works were treasured by later collectors as fragments that revealed their personalities. Painting could thus be thought of as a "mind print," like a personal signature where style indicated the man.[6] The views of Su and his circle were expressed in this frame of reference and usually written in the form of poems or colophons on paintings.

Su Shih's pivotal role can be gauged from Teng Ch'un's list of the literati who had written on painting. Included in this chapter are writings by Su's master Ou-yang Hsiu; Su himself, along with his brother Ch'e (1039–1112); and Su's disciples and friends: the two Ch'ao cousins, Pu-chih (1053–1110) and Yüeh-chih (1059–1129); Huang T'ing-chien (1045–1105); Ch'en Shih-tao (1053–1101); Li Ch'ih (1059–1109); and Mi Fu (1052–1107).[7] Furthermore, since Su Shih's writings cover a broader spectrum than those of the others, they can suggest the scope of literati interests. Su was the first to define "scholars' painting" in these words, insisting on distinguishing it from the work of artisan-painters. He also linked painting to poetry, referring to the T'ang poets Wang Wei and Tu Fu, and discussed the Tao of painting with his brother Ch'e. In poems of a Taoist inspiration, Su stated that true naturalness in art was the result of a trance-like state, and he valued spontaneous creation over practiced technique. On the other hand, one of his more carefully reasoned prose pieces distinguished between constant form and constant principle (*li*) and indicated in a Neo-Confucian vein that the latter was only to be understood and recreated by a superior man. Again, on the question of representation, his strongest statement against formal likeness was phrased in a poem, but in prose passages he recognized the importance of the painter's observation of a subject. His record of 1077 on Wang Shen's Precious Painting Hall best expressed the gentleman's approach to collecting

6. See Kuo Jo-hsü's discussion of this topic in chapter 3 at "Expressive Style and Quality."

7. See the passage from *Hua-chi*, Book 9, in chapter 3 at "Classification by Social Status."

and appreciating art. On the highest level of connoisseurship, style for him reflected the character of the artist, and his most moving poems and colophons were written on the ink bamboos of his late friend Wen T'ung (1019–1079). Similarly, Su Shih himself could be seen in his art, according to the Neo-Confucian philosopher Chu Hsi (1130–1200).

Other aspects of literati art theory are brought out in the writings of members of Su's circle. The poet Huang T'ing-chien, commenting as a calligrapher and connoisseur, emphasized the importance of concentration developed through the study of Tao and practice of Ch'an meditation. Mi Fu defined art as a game and mentioned a landscape's mood or flavor (*ch'ü*). His son Mi Yu-jen (1072–1151) would label his works "ink plays" and write of sketching the true flavor of cloudy scenes. Both men served in the capacity of connoisseurs at the Sung court, and the elder Mi's writings include the *Hua-shih* (History of Painting) in which the critiques often have a highly individualistic tone. More workaday in manner are the sober assessments of Li Ch'ih in his *Hua-p'in* (Evaluation of Paintings), a descriptive catalogue of a collection extant around 1100. This work provides the needed background to literati art theory by indicating the types of earlier and contemporary paintings that were to be seen at the time.

Other comments, mainly by later Sung writers, show how widespread the elitist concept of painting was and explore some of the variations on this theme. A later eleventh-century figure painter, Chang Tun-li, who was an imperial relative by marriage, defended the status of painting in the limited moral terms first expressed in the Han Dynasty. Others referred to anecdotes about T'ang painters to illustrate their argument that an artist must be a man of superior character and attainments, an opinion also held by Chang Yen-yüan in the T'ang. By the late twelfth century the poet-recluse Liu Hsüeh-ch'i claimed that none of the modern "painter-scholars" had the learning or technical mastery of the literati artists of the past. This view was to be echoed by numerous later writers. In general the most conservative opinions were expressed in connection with figure painting, which was characterized in terms of the dichotomy between form and spirit. On the topic of portraiture, the poet Ch'en Shih-tao mentioned "transmitting the spirit" and its "harmony (*yün*)" and thus came closer than any other member of Su's circle to using the terms of traditional art criticism.

Perhaps because of the political reaction against Su Shih and his

group, two critics who were active in the early twelfth century show no sign of being directly influenced by him. One of these men was Huang Po-ssu (1079–1118), who wrote *Tung-kuan yü-lun* (Further Discussions from the Eastern Tower), and the other, Tung Yu, whose opinions on paintings appear in *Kuang-ch'uan hua-pa* (Tung Yu's Colophons on Painting). Both these men were known as the foremost connoisseurs of Hui-tsung's reign (1101–1126) and wrote on calligraphy as well as painting. Of the two writers, Tung Yu is the more interesting and obscure. He evidently had contact with such literati artists as Li Kung-lin (1049–ca. 1105) and Wang Shen (ca. 1048–1103) around the turn of the century, though his life-span and official service extended through the end of the Northern Sung (1127). As a professional critic, he wrote many of his colophons as detailed explanations of subject matter and could focus on minor points of argument. However, he rose to the height of lyricism when interpreting the nature of artistic creativity. In these passages, replete with Taoist references, Tung seems closest to the spiritual approach of Huang T'ing-chien; the act of creation is described as the union of subject and object in keeping with the Ch'an attitude toward nature. Because of the transmission of Tung's text in manuscript form, some of its obscurities may be the result of textual corruptions. However, there can be no doubt that Tung drew on the classics of Taoist philosophy for uses peculiarly his own when describing the main focus of his interest, the artistic process and its appreciation by an understanding critic.

Of a more practical nature were the writings of two thirteenth-century connoisseurs, Chao Hsi-ku (active ca. 1195–ca. 1242) and Chou Mi (1232–1298). Chao's *Tung-t'ien ch'ing-lu chi* (Compilation of Pure Earnings in the Realm of the Immortals) is a handbook for connoisseurs and collectors, dealing with the care and appreciation of all sorts of art objects including lutes, ink-stones, and bronzes as well as pieces of calligraphy and paintings. The preface, filled with Taoist references, emphasizes the enduring and revitalizing pleasures of connoisseurship, pleasures that are spontaneous and thus pure. A scholarly point of view is quite evident in Chao's characterizations of specific artists and their works, and he underlines the close connection between calligraphy and painting. His technical observations on Mi Fu's art are of particular interest, as well as his cautions about viewing and mounting scrolls. Chou Mi's *Yün-yen kuo-yen lu* (Record of What Was Seen as Clouds and Mists) contains notes on the paintings that he was able to observe in various collections and at times approaches

the modern concept of a catalogue in recording certain seals and colophons on them. Chou's work was written in the early Yüan period and is particularly known for its list of the paintings collected after 1295 by his friend Chao Meng-fu (1254–1322), the younger scholar-official who would eventually stimulate a new wave of literati painting and theory in the fourteenth century.

Alexander Soper has translated the *Hua-p'in* of Li Ch'ih in its entirety. Excerpts from Chao Hsi-ku's *Tung-t'ien ching-lu chi* are based on the version by Sarah Handler; those from Chou Mi's *Yün-yen kuo-yen lu* are based on Nancy Price's translation. Hsio-yen Shih and Susan Bush are responsible for the remaining material. The topic headings in this chapter underline the different aspects of painting as it was discussed by Su Shih and his friends and followers.

The Painter as Artisan or Scholar

Su Shih (1037–1101)

The literary work of Wen T'ung (1019–1079) is the least of his accomplishment (*te*, "virtu"), and his poetry, the minor part of his writing. What is not used up in the poetry overflows to become calligraphy and is transformed to become painting. Both are what is left over from poetry. Those who appreciate his poetry and literary work are increasingly few. As for those who love his accomplishment as they love his painting—alas!

Looking at scholars' painting is like judging the best horses of the empire: one sees how spirit (*i-ch'i*) has been brought out; but when it comes to artisan-painters, one usually just gets whip and skin, stable and fodder, without one speck of superior achievement. After looking at a few feet or so, one is tired. This work by Sung Tzu-fang [late 11th–early 12th century] is truly scholars' painting (*shih-jen hua*) . . .

The brushwork of Master Yen Su [d. 1040] is wholly divine and brilliantly fresh. It has left behind the calculations of the artisan-painter and achieved the poet's purity and beauty.

Master Chu Hsiang-hsien [active ca. 1095–1100] of Sung-ling can write but does not try to pass the examinations, and is good at painting but does not attempt to sell it. He says: "I write to express my mind and paint to set forth my ideas, that is all."

> Excerpts from various colophons on painting; see Bush, pp. 12, 29–31: texts 3, 38, 40, 45; also *CKHLLP*, pp. 630, 49 (in part).

Chang Tun-li (active ca. 1068–ca. 1102)

Although painting's role in the arts is small, its effects of causing people to examine the good and warning against the evil, and of exhorting people to see and hear [such precepts], have benefits. How can it be relegated to the masses of common artisans?

> Quoted in his entry by T'ang Hou, *Hua-chien* (Criticisms of Painting); and cited in *CKHLLP*, p. 68.

Li Ch'ih (active late 11th–early 12th century)

Li Kung-lin (1049–ca. 1105) was among the first three in the examinations for the doctorate and was famous for his literary scholarship. He studied Buddhism and apprehended the Tao, with a profound mastery of their subtleties. As a support of the dynasty he was celebrated on all sides. He made so extensive a collection of bells, tripods, old vessels, jade emblems, and rare curios that his house was packed full [of treasures]. He had a refined love of painting. His mind was imbued with imaginative subtleties, so that in very truth he created ineffable wonders, for Heaven had endowed him with talents that far surpassed the common mean . . . Consider now this icon [of an Avalokiteśvara with a long girdle]. Assuredly it is not anything that the vulgar [artisan] could imitate, yet its girdle is exceptionally long, half again as long as the body. He has produced something strange and abstruse that amazes the vulgar, without losing the qualities in which he is supreme.

> *Hua-p'in* (Evaluation of Paintings, *HP*).

Cheng Kang-chung (1088–1154)

One cannot know all the painters of the T'ang Dynasty, but even speaking of two, Cheng Ch'ien [8th century] and Yen Li-pen [d. 673], the skill or clumsiness of their use of the brush [cannot be judged because their works are] difficult to obtain and examine. However, some people now take their remaining works to sell, treating them like old masters, and placing Ch'ien above Li-pen without hesitation. Why is this? Ch'ien had great talents and was a Confucian scholar, [his character was as beautiful as] the iridescent peacock against a rose-flushed sky. When relaxed by wine, he would release his ideas, investigate the appearances of things, and speed them to his brush

tip. Spying on Creation itself, he recognized Heaven's character (*t'ien-hsing*). Thus, his dotting of ink on a piece of paper could be enjoyed naturally. Li-pen worked at painting from childhood and was mean and petty as a person, so that in his time he was not lauded for talents or skills. Bearing his shame and streaming perspiration, he bore his ink palette while wearing official accoutrements![8] Thus, though he could copy and describe to perfection, he had no points of excellence. I have written these words to examine contemporary painting. For, if one has vitality (*ch'i-wei*) within one's breast, one's work cannot be ordinary; while the brushwork of artisans will certainly not give even one glimpse of the divine (*shen*).

From his collected works, *Pei-shan wen-chi*, cited in *CKHLLP*, p. 69.

Ch'en Shan (active ca. 1174)

A T'ang poem has the lines: "Tender green twig tipped red with a dot; / Gladdening spring hues require no more." I heard that, in olden times, these lines were once used to test painter-artisans. Most competed by embellishing flowers with dots of spring hues. These were not selected. Only one person painted a beautiful lady leaning on the balustrade of a lofty pavilion, misty and obscure, within the shade of a green willow. All the artisans admired this work. It may be described as excelling at the embodiment of a poet's conception. Hsüan-tsung of T'ang [r. 713–756] used to appreciate the lotus of a thousand leaves. Once he pointed at [his favorite concubine] Yang Kuei-fei and asked his attendant courtiers: "How would you describe her in terms of the flower?" One then said: "Spring hues of the Imperial Palace, / Visible the four seasons through." This approximated the idea. But could those vulgar painter-artisans have described it?

Excerpt from *Men-se hsin-hua*, cited in *CKHLLP*, p. 85.

Liu Hsüeh-ch'i (active ca. 1192)

Simulating the myriad phenomena by wielding the brush and coloring silk is part of the painter's art. However, if his eyes do not have a discriminating refinement and his mind is filled with vulgar influences, though his skill should reach subtlety, its commonness and baseness will not escape a discerning eye. Such a painter will exert his mind in vain, for his works will only serve as a subject for current gossip, and

8. See chapter 2 at "Social Status and Creative Activity" for the details of this allusion.

he would be better off to refrain from painting. Looking back at painters of the past who were famous for their display of this one art, I see that they were all literati and talented scholars. If they did not set forth figures, landscapes, Buddhist images, or demons and divinities, then they made many-storied buildings and towers, flowers and bamboos, or birds and beasts. Probably they could not as yet depend solely upon one glance to attain the totality of the myriad phenomena or empathize with all styles to grasp the beauty in a multitude of works. If such masters as Chang Seng-yu [6th century], Yen Li-pen [d. 673], and Wu Tao-tzu [8th century] were incapable of these [syntheses], how could the innumerable painters who were inferior to them have claimed such ability for themselves? Those known in antiquity as painter-scholars were all famous in their time. From their immersion in the classics and histories, their experience and knowledge were extensive and clear, and their mental capacities free and vigorous. On viewing their easy grace, one realizes that they have the dignified nobility of Taoist immortals. Hence, when they expressed this with brush and ink, conceptions and images are quiet and relaxed, so that one can treasure and enjoy them ceaselessly. Today's painter-scholars have only a popular reputation and cannot by any means be seen as equal to the ancients. Some, compelled by their lack of material means, give way to the demands of vulgar folk. If one asks them: "Can you paint this?" the answer will be: "I can." "Can you paint that?"—again "I can." Then, sucking the brush and revolving thought, they will vaguely paint in total confusion. Because of their inadequacies, in a moment a bird will become a crow; when painting a dragon, they will make it resemble a dog. Looking at the divine strangeness and refined subtlety of the ancients, I find that none of these [modern] painters can come up to them. And if such is the case, one cannot put the blame entirely on painter-artisans. Although painter-artisans fix their aims on the pupils of the eyes,[9] not all are still confined to just that.

> Cited in *P'ei-wen-chai shu-hua-p'u* (Encyclopedia on Calligraphy and Painting Commissioned by the K'ang-hsi Emperor, *PWCSHP*), Book 15, and in *CKHLLP*, p. 73.

9. This refers to a statement attributed to Ku K'ai-chih [ca. 345–ca. 406], that, in portraiture, a person's spirit is best described in the dotting of the pupils of the eyes; see the *Lun-hua* extract in chapter 1 at "Technique." Compare this formulation, apparently considered primitive by Sung times, with other statements in this chapter's sections on "Form and Principle" and "Form and Spirit."

Chao Hsi-ku (active ca. 1195–ca. 1242)

Hsü Hsi [d. before 975] was a retired scholar of the Southern T'ang Dynasty [923–934] who was extremely well versed in the classics and histories. He effortlessly caught the flavor of nature (*t'ien-ch'ü*) in his painting of reeds in winter, overgrown plants, water fowl, and wild ducks. Huang Ch'üan [ca. 903–968] was a Painting Master to Meng, the Prince of Shu [ruler of Szechwan 935–965], and so he gazed upon the rich and noble. His painting mainly consisted of gardens and blooms as [gorgeous as] patterned brocades. Truly, they were like [the court ladies who embellished themselves with] layers of powder, being made without outlines. His peacocks, mandarin ducks, and other ornamental birds move with a sense of life (*sheng-i*) . . .

The background of Ho Tsun-shih[10] [active ca. 921–923] is not known. Chou Chao was an official-in-attendance of the Painting Academy during the Hsi-ning era [1068–1078]. In their paintings of cats and dogs, Ho had the air (*ch'i*) of a scholar-gentleman, while Chou had an artisan's manner. However, both painters possessed vitality and naturalness . . .

Sung Ti [1013–1083] painted "The Eight Views of the Hsiao and Hsiang [Rivers]" without first giving them titles. Later people took it upon themselves to supply such titles as *Autumn Moon on [Lake] Tung-t'ing*. Nowadays, those painters who fix titles to their works before [painting them] are not scholars.

The present age is deficient in painters. At the beginning of the Southern Sung [1127], there were still several painters such as Chao Po-chü [active ca. 1120–1162], Hsiao Chao [active ca. 1130–1160], Li T'ang [1050s–after 1130], Li Ti [ca. 1100–after 1197], Li An-chung [ca. 1117–1140], Su Ch'i, and Wu Tse [the last two unidentified]. At present there are absolutely no painters of renown. [Contemporary painters] describe form sketchily without the essential spirit (*ching-shen*). Scholar-gentlemen consider painting to be a menial's occupation and generally will not stoop to practice it. None of them know that one can only begin to paint after one has assimilated myriad books, filled the eyes with remarkable relics of earlier times, and traveled over half the empire. How, then, can painting be considered a menial's occupation?

> *Tung-t'ien ch'ing-lu chi* (Compilation of Pure Earnings in the Realm of the Immortals, *TTCLC*); see Bush, pp. 113–114: texts 181, 180, 179, 182; *CKHLLP*, pp. 1048 and 87 (in part).

10. Ho Tsun-shih was not this painter's name, but an honorific, "The Reverend Ho."

Liu K'o-chuang (1187–1269)

The great masters of previous generations such as Ku K'ai-chih [ca. 345–ca. 406], Lu T'an-wei [5th century], and Wu Tao-tzu [8th century], were all unable to do without color. That is why their names are listed under the two words "red" and "green" [used in early times to denote painting]. Li Kung-lin [1049–ca. 1105] was the first to sweep away these cosmetics. His pale brush and light ink were lofty, elegant and surpassing, like a great scholar living in retirement, wearing coarse garments and straw sandals; his life was simple and far from the world of ordinary men. He had no need to enhance himself with fancy embroidered robes and ceremonial headdress. Ah truly, his should be regarded as the supreme art of the nation!

> Quoted in the *PWCSHP*, Book 83, a colophon on a painting of arhats by Li Kung-lin.

Character and Style

Su Shih (1037–1101)

The bamboos that grew on the cliffs to the north of the Prefect of Ling-yang's home were forked [?] bamboos. One, when it had not yet shed its sheath, was harmed by tree grubs; the other was imprisoned in a deep crevice. That is why they had these [strange] shapes . . . [that Wen T'ung, 1019–1079, painted and Su Shih had engraved so that] art lovers will be moved and startled by this extraordinary sight and, moreover, will see in their imagination the noble character of my late friend, bending but not yielding, just like the bamboos.

> Bamboos chilled but preeminent,
> Trees lean but enduring,
> Rocks homely but distinctive,
> These are "the three beneficial friends."
> Their brilliance makes us befriend them;
> Their independence forbids their being constrained.
> I think of this man—
> Alas, can I ever meet him again?
>
> A colophon and a poem on paintings by Wen T'ung; see Bush, pp. 34 and 101: texts 52, 53, and 154.

Li Ch'ih (late 11th–early 12th century)

For wooden buildings, towers, and pavilions, Kuo Chung-shu [ca. 920–977] created a style of his own that is most uniquely marvelous. Roof beams, girders, pillars, and rafters are shown with open spaces between as if to permit movement through them. Railings, lintels, windows, and doorways look as if they could really be passed through, or opened and shut. He used an infinitesimal to mark off an inch, a tenth of an inch to mark off a foot, a foot to mark off ten feet; increasing thus with every multiple, so that when he did a large building everything was to scale and there were no small discrepancies. No one who was not extremely meticulous and knowing, whose complexity was not thus held within regular bounds, would have been capable of this. And yet, in his service at court, Kuo was irresponsible and undisciplined, a vagrant contemptuous of society . . . This picture of "[Immortals] on a Tower" has the kind of exquisite precision [described above]. At the same time, it is more than exquisitely precise. It has aloofness, simplicity, profundity, and a spirit free from worldly contamination . . . It is this picture most of all that has taught me how wonderful he was. Confucius spoke of [being able to] "follow out what his heart desired without transgressing the right." Chuang-tzu spoke of those who are "wild and reckless indeed, and yet tread in the way of magnanimity." Here was one who, as a man, was just as unconventional as the latter types, yet, as a painter, had quite as much discipline as the former. Thus, one who knows the subtle principles of the world easily and spontaneously attains a happy mean [as in this painting]. However, to make Kuo act [as a person] in an orderly and calculated way was exhausting, and so he found it . . .

Shih K'o [10th century] was unruly by nature and contemptuous of the world. Therefore, his painting brush was bold and free, and whether or not he kept to the rules, he was always original. Thus, to display his versatility, he might do figures that were grotesque or perverse . . .

HP.

Chu Hsi (1130–1200)

As for Tung-p'o [Su Shih], he possessed lofty and enduring qualities and a firm and immovable appearance. One might say that he resembled these "bamboo gentlemen" and "rock friends" [which he painted]. After a hundred generations, when men look at this painting, they will still be able to see him in their minds.

See Bush, p. 103: text 156.

Poetry and Painting

Ou-yang Hsiu (1007–1072)

[The poet Mei Yao-ch'en, 1002–1060, noted the following require-
ments for a good poet:] He must be able to paint some scene that is
difficult to depict, in such a way that it seems to be right before the
eyes of the reader and has an endless significance that exists outside
the words themselves—only then can he be regarded as great . . .

> Ancient paintings depict ideas and not forms;
> Mei's poems sing of things but conceal no emotion.
> Few are those who understand abandoning form to realize
> ideas,
> No less in looking at painting than in poetry.

Excerpts from "Remarks on Poetry" and a poem on a picture of "Turn-
ing Oxcarts"; see Bush, pp. 23–24: text 23.

Su Shih (1037–1101)

> When one savors Wang Wei's poems, there are paintings in
> them;
> When one looks at Wang Wei's pictures, there are poems . . .

> Tu Fu's writings are pictures without forms,
> Han Kan's paintings, unspoken poems . . .

> When Master Han Kan painted horses, they really were
> horses;
> When I, Su, write a poem, it is like seeing a painting.
> Po Lo [the legendary judge of horses] is no longer in the
> world, nor is Han;
> Who now is competent to judge this poem or this painting? . . .

> Though Master Wu Tao-tzu was supreme in art,
> He can only be regarded as an artisan-painter,
> Wang Wei soared beyond images,
> Like an immortal crane released from the cage . . .

> From ancient times on, painters have not been common men,
> Their subtle thoughts are produced substantially as in poetry.
> Mount Sleeping Dragon's retired scholar is basically a poet;
> Thus, he [Li Kung-lin] can cause thunderbolts to crash on the
> Dragon Pond.

Excerpts from poems on paintings; see Bush, pp. 25, 27, 29, and 30:
texts 24, 25, 33, 39, 41.

Huang T'ing-chien (1045–1105)

> In the sound of heartbreak there is no form or shadow;
> No sound emerges with painting, yet it too is
> heartbreaking . . .

Some time ago, Li Kung-lin did a painting for me of Li Kuang [a Han general, who escaped capture by] snatching a horse from a Hsiung-nu lad and galloping southward while clasping the boy. He had the lad's bow and was shown pointing it fully drawn at the horseman chasing him. When you followed the path that the arrow would take if released, you saw that the enemy horseman would be hit and fall. Kung-lin said to me with a smile: "If an ordinary artisan had done this painting, he would certainly have made the arrow actually strike the pursuing horseman." From this I gained a deep understanding of the structure of painting. It is essentially the same as literary composition, but it is hard to find people who understand (*shen-hui*) this.

> Excerpts from colophons on Li Kung-lin's paintings; see Bush, p. 25: text 27, and excerpt quoted in the *PWCSHP*, Book 15.

Li Kung-lin (1049–ca. 1105)

I make paintings as a poet composes poems, simply to recite my feelings and express my nature.

> Excerpt from *Hsüan-ho hua-p'u* (Catalogue of Paintings in the Hsüan Ho Collection, *HHHP*), ca. 1120, biography, see Bush, p. 27: text 35.

Ch'ao Pu-chih (1053–1110)

> Painting depicts the shapes outside of things;
> It is essential that these shapes be not altered.
> Poetry conveys the meaning beyond painted forms;
> It is imperative that it contain a picture's air.
> Why should I look at painting now?
> When I see the poem [by Su Shih praising a wild goose
> painting], the goose is really there.

> Excerpt from a poem; see Bush, p. 26: text 30.

Huang Po-ssu (1079–1118)

The red and the green [that is, painting] is like literature. If [the writing of] Hsieh Ling-yün [385–433] can be described as a lotus

emerging from water, natural and lovable; then [that of] the Director of the Imperial Banqueting Court Yen Yen-chih [384–456] is like a woven patterned brocade covered with embroidery, its chased designs filling the eyes. Probably the distance between the natural and the embroidered is so great that it cannot be spanned.

If one looks at the remaining works by T'ang masters, Hsüeh Chi [649–713] was famous for his bird painting but, though his style reached far, his brush was weak; Hsiao Yüeh [active early 9th century] was famous for his bamboo painting and, though his brush was vigorous, it lacked harmony (*yün*). Each of these two painters had only one specialty in which he concentrated all his refinement, and so both were incomplete. How then could prunus, bamboo, and birds all have flowered from their brush-tips? The relaxed flavor (*ch'ü*) and far-reaching tone (*yün*) of this painting by Master Shih-ch'un can truly be esteemed. Conceptualizing (*i*) these brush movements is like conceptualizing in literature. How then can even the divine eminence of the words issued by Hsieh Ling-yün be sufficient for envy?

> *Tung-kuan yü-lun* (Further Discussions from the Eastern Tower), Book B, a colophon on a bamboo painting scroll by a noble of the Imperial House.

Calligraphy and Painting

Huang T'ing-chien (1045–1105)

In studying calligraphy, copying can frequently catch formal likeness, but generally one takes pieces of earlier calligraphy and, by looking at them closely, reaches a state of complete absorption (*ju-shen*). When one comes to the excellent places, one's attention should not be divided. This is the essential route to complete absorption . . .

When the ancients studied calligraphy, they did not copy exactly. They spread out the writing of a predecessor on the wall and looked at it in complete absorption. Then, when they put brush to paper, it was in accordance with the writer's ideas.

> Excerpts from colophons; see Bush, p. 50: text 92.

Mi Yu-jen (1072–1151)

Yang Hsiung (53 B.C.–A.D. 18) considered written characters to be the depictions of the mind. If he had not comprehended basic prin-

ciples, he could not have reached this conclusion. As for the definition of painting, it is also a depiction of the mind. In the past everyone who was of an exceptional talent worked in this way, but how can the common commercial artisan be expected to understand?

> Excerpt from a colophon recorded in *Shih-ku-t'ang shu-hua hui-k'ao* (Pien Yung-yü's Notes and Records on Calligraphy and Painting, *SKTSHHK*), II, Book 13; see Bush, p. 73: text 138; also *CKHLLP*, p. 685.

Chao Hsi-ku (active ca. 1195–ca. 1242)

Yang Wu-chiu [1097–1171] . . . studied the standard script form of Commander Ou-yang Hsün [557–641] and came close to his model in the forcefulness and incisiveness of his brushwork. When he used this ability to paint plum blossoms, his painting surpassed that of [the Ch'an monk] Chung-jen [active 11th–12th century] . . . Moreover, his writing of poetry was clear and fresh, with not a trace of vulgarity. What a pity that, during his lifetime, he never met men such as Huang T'ing-chien and Su Shih! . . .

To speak of a painting "without brush traces" does not mean that its ink is pale, vague, and without definition. It is precisely the same as [the work of] a good calligrapher who conceals his brush tip, like drawing in the sand with an awl or making a seal impression in paste. In calligraphy, the concealing of the brush tip depends on the handling of the brush in a firm yet playful way. One who is able to understand the technique of a good handling of the brush will comprehend the statement that great paintings are "without brush traces." Therefore, an ancient master like Sun Chih-wei [11th century] and a modern like Mi Fu [1052–1107], being good at calligraphy, were also as a matter of course good at painting; being good at painting, they were as a matter of course accomplished calligraphers. Calligraphy and painting are, in fact, a single thing.

> *TTCLC*; see Bush, pp. 114–115: texts 183, 184; *CKHLLP*, pp. 86–87 (in part).

The Tao and Painting

Su Shih (1037–1101)

Someone said to me: "When the retired scholar Li Kung-lin [1049–ca. 1105] did a painting of his 'Mountain Retreat,' it was to enable later men who enter the mountains to trust their feet and walk, nat-

urally finding roads and paths as if they had seen them in a dream or recognized them from a former life. They would see the streams and rocks, the grasses and trees of the mountains, and know their names without asking; they would meet the fishermen, woodcutters, and hermits of the mountains and recognize each man without even knowing his name. Is this not a powerful feat of unfailing memory!"

I say that it is not. If paintings of the sun often resemble ricecakes, it is not because of forgetting about the sun. When drunk one doesn't drink through the nose; in a dream one doesn't grasp things with the toes; [one acts] according to instinct (*t'ien-chi*) without forcing oneself to remember how. When the retired scholar was in the mountains, he was not preoccupied with any single thing, and thus his spirit communed with all things, and his knowledge encompassed all the arts.

However, there is Tao and there is skill. If one has Tao and not skill, then, although things have been formed in one's mind, they will not take shape through one's hands . . .

bamboo first comes into being, it is only an inch-long shoot, but its joints and leaves are all there. It develops from [shoots like] cicada chrysalises and snake scales to [stalks like] swords rising eighty feet, because this development was immanent in it. Now when painters do it joint by joint, and add to it leaf by leaf, will this be a bamboo? Therefore, in painting bamboo one must first have the perfected bamboo in mind. Then, when one takes up the brush and gazes intently, one will see what one wants to paint and rise hurriedly to pursue it, wielding the brush forthwith to capture what was seen. It is like the hare's leaping up when the falcon swoops. If it hesitates in the slightest, all will be lost. Wen T'ung [1019–1079] taught me in this way, and I could not achieve it, but understood the way it should be done. Now if one knows how it should be done and cannot do it, inner and outer are not one, and mind and hand are not in accord. It is a fault stemming from lack of study. Thus, the reason why one may see things in the mind, but be awkward in executing them, is that what one sees clearly in everyday life is suddenly lost when it comes to putting it into practice. Does this apply only to bamboo? When Su Ch'e [my younger brother] composed the "Ink Bamboo Prose Poem" for Wen T'ung, he wrote: "The butcher merely cut up oxen, but a nourisher of life learned from him; the wheelwright Pien carved wheels, but the reader of books agreed with him.[11] Now, when

11. These allusions are to two stories in *Chuang-tzu*, Books 3 and 13; see James Legge, *The Sacred Books of China: The Texts of Taoism* (New York: Dover, 1962), pt. I, pp. 198–200, 343–344.

you make use of these bamboos and I take you to be a man of the Tao, is this wrong?" Ch'e had not yet painted, and so he grasped Wen T'ung's ideas and nothing more. As for me, how can I just understand his ideas? I also understand his method . . .

Then can the Tao definitely not be sought? I say that the Tao can be made to come (*chih*) but cannot be sought. What do I mean by "made to come"? [The famous military strategist of the 6th century B.C.] Sun Wu said: "A skilled fighter makes the opponent come to him and is not made to go to the opponent." [Confucius' disciple] Tzu-hsia said: "Mechanics dwell in their shops so as to accomplish their works. The superior man learns in order to make his Tao come." When something comes (*chih*) by itself to us without any seeking for it, this is what may be called "made to come." In the south there are many divers who live in the water every day. At seven they wade, at ten they can float, and at fifteen they are able to dive. Could the divers be what they are without effort? They have grasped the Tao of the water. If one lives in water every day, then at fifteen one will grasp its Tao. If one has not known water from birth, then although full-grown, one will be afraid at the sight of a boat. Thus, a hardy man from the north, who questions the divers to seek their method of diving and then tries out what they tell him but in the Yellow River, will inevitably drown. Therefore, everyone who does not study and insists on seeking the Tao is like a northerner learning diving.

> Excerpts from "On Li Kung-lin's 'Mountain Retreat' Picture," "Record of Wen T'ung's Painting the Bent Bamboos of Yün-tang Valley" and "Parable of the Blind Man and the Sun"; see *CKHLLP*, pp. 629, 1026–1027, and Bush, pp. 36, 37 and 40: texts 59 (in part), 60, 65.

Su Ch'e (1039–1112)

Wen T'ung . . . [said]: "Now, what I love is the Tao which I release in bamboo [painting]. At first, when I lived in retirement on the south slope of Mount Ch'ung, I made my home in a grove of tall bamboo, looking and listening without awareness so that they did not affect my mind. In the morning the bamboo were my friends; in the evening they were my companions. I drank and ate amongst them, and stopped and rested in their shade. If one looks at the different aspects of bamboo, there are many . . . These are the ways in which bamboo is bamboo. At first, I looked and enjoyed them. Now I enjoy them without consciousness of doing so. Suddenly, forgetting the brush in my hand and the paper in front of me, I rise up instantly and make

bamboo in quantities. How is the impersonality of Creation itself different from this?"

The visitor said: "Now, the butcher merely cut up oxen, but a nourisher of life learned from him; wheelwright Pien carved wheels, but the reader of books agreed with him. There is one principle (*li*) in all things, only its followers start from different points. All the more so, then, in the case of your making use of bamboo, was it wrong when I took you to be a man of the Tao?"

Wen T'ung said: "You were right."

"Ink Bamboo Prose Poem"; see Bush, pp. 38–39: text 62.

Wang Ch'in-ch'en (11th century)

We know, indeed, that spiritual excellence is not easy to
 describe.
But if one's heart is in accord with the Tao, one can know
 how to do it.
There is surely a single principle in literature, calligraphy, and
 painting.
Have we not heard of Wang Wei's "In a former life I must
 have been a Painting Master."

Excerpt from a poem; see Bush, p. 28: text 37.

Tung Yu (active early 12th century)

The *Pine Grove* painting in the collection of the monk Hui-yüan was by an artisan of the past from the Chiang-nan region [south of the Yangtze River]. Someone had written a poem attached to it. The other day, I added my words describing the circumstances of its acquisition. Hui-yüan thus expressed his censure: "To enjoy things is to encumber the mind. To be unable to forget one's love of things also dulls [the mind]. Furthermore, you are writing to draw attention to this object. Will it not increase people's delusions or add to their encumbrances? In the past, the priest Hsüan-lan [651–734] had attained the *dharma* beyond the mind, forgetting self and things, not dwelling on resentments or desires. Chang Tsao [8th century] painted the priest's wall with an old pine so that he would have something beautiful to see; Fu Tsai [d. ca. 813] heard about this and wrote a eulogy; Wei Hsiang [unidentified] appended a poem to it. People called them the Three Paragons. The following day, Hsüan-lan on seeing them had the wall replastered, saying: 'They had no business to scratch up my walls.'

The meaning of this is, how can one even preserve loved things within the mind? Moreover, it is far worse to fix on one thing unremittingly." I answered him: "If one is only sincere and released within, though things are manifold, when manifested in images and revealed in forms, they cannot be considered encumbrances. If these are nourished within oneself in profound stillness, since one sets up no target, things cannot leave their barbs. How then can the scratchings of other people be considered irritations to oneself? You should try viewing them. If [someone] is said to be unable to forget scratchings on the wall, yet able to forget the encumbrance of things, one can indeed know that [painting] is not an irritation to the mind" . . .

Though artisans may claim a number of skills for themselves, success is found only by focusing on one of these [skills], by which they create with refinement. As for subtle understanding of a choice of technique and essential immersion in the response to feeling, practical function may be ignored yet the spirit will still be gained. One can find this only in those [painters] who produce works without hesitation . . .

If through pursuing one of the arts a man can attain harmony with the Tao, this is what the ancients called "approaching skill" . . .

Those who look at paintings by Li Ch'eng [919–967] are first impressed by the forms and then suddenly seem to forget them. Most people are astonished and think the works divinely inspired, but can their experience [of the paintings] be a true view? Li was a first degree graduate from Chi-hsia [Shantung]. His attitude toward mountains, forests, streams and rocks, was that of one who lived in retirement amidst peaks and valleys. He was born loving piled-up mountain ranges, the density of gorges, and the height of peaks. He stored his love in his mind and, with time, it became part of him. He concentrated on it without relaxing, forgetting even objects themselves until an exceptional clarity was contained within his breast, and he could preserve it without effort. Then, one day, he suddenly saw many mountains spread out before him [in his mind's eye], emerging in close and massed array. When, in a hazy glow of clearing mists, each part corresponded from below to above, he gradually released these [images], unable to hold them back. For what has been transformed by the art of the mind comes forth when it is time, making use of painting to lodge what is released. Then cloud and mist, wind and rain, and the transmutations of thunder follow in turn. When the time has come, the painter suddenly forgets his physical self, and what he sees in-

stinctively (*t'ien-chi*) is all mountains, and so he is able to achieve their Tao. Later men who try to understand [his art] through his paintings do not know that these were done unconsciously. They say that there are traces of his brushwork that can be imitated and attempt to find them in his compositions. These people are without even "one hill and one valley" in their breasts.

> *Kuang-ch'uan hua-pa* (Tung Yu's Colophons on Painting, *KCHP*) Books 1 and 6, colophons on a *Pine Grove* painting owned by the monk Hui-yüan, a hell cycle by Wu Tao-tzu, and a painting by Li Ch'eng; also see Bush, pp. 52 and 53: texts 95, 96.

Mi Yu-jen (1072–1151)

People know that I am good at painting and vie to obtain my works, but few realize how I paint. Unless the eye of true perception is in their foreheads, they cannot perceive it, and one cannot look for it in the paintings of ancient and [other] modern artists. My condition in the world is like that of one hair in the ocean, tranquil and colorless. Often I sit in meditation in a quiet room, forgetting all the worries of the mind and sharing my wanderings with the emptiness of the blue void.

> Excerpt from a colophon recorded in *SKTSHHK:* see Bush, p. 74: text 139.

Chao Hsi-ku (active ca. 1195–ca. 1242)

In Li Ch'eng's paintings of landscape, the precipitous peaks rise vigorously, with the profusion of a work of nature; tall trees lean below cliffs, forming shady bowers in secluded elegance; yet, as one's eyes gaze afar into the distance, there are isolated roadways austerely leading to remote dwelling places. His use of ink is rather thick, but his modeling strokes are clearly distinguished. When one sits in concentration to contemplate his paintings, clouds and mists suddenly appear; a sparkling river flows for a thousand miles; and his divine transformations take myriad shapes. I once saw a pair of his hanging scrolls. Whenever I faced them, I lost all consciousness of my physical surroundings and was in the midst of their innumerable cliffs and gorges.

> *TTCLC.*

Naturalness in Painting

Su Shih (1037–1101)

> When Wen T'ung painted bamboo,
> He saw bamboo and not himself.
> Not simply unconscious of himself,
> Trance-like, he left his body behind.
> His body was transferred into bamboo,
> Creating inexhaustible freshness.
> Chuang-tzu is no longer in this world,
> So who can understand such concentration?

> A poem on a Wen T'ung painting; see Bush, p. 41: text 66.

Huang T'ing-chien (1045–1105)

> Hills and valleys were naturally in his [Su Shih's] breast from
> the beginning.
> Hence he made old trees twisted by wind and frost.

One might say that these men [depicted, the Seven Talents of the Chien-an era in the Han Dynasty, 196–219], were all poets, and so isn't this [painting's detailed] brushwork deficient in hills and valleys? I say that, as for "one hill and one valley," they must be naturally within a man's mind and then he will have them. How can they be attained merely in brushwork? . . .

If the painter has incipient bamboo in his breast, then from trunk to branches it will flourish; if he has perfected bamboo in his breast, then brush and ink will fuse with things. It is like the ferryman's not having seen a boat and yet being able to manage it because of his readiness. Now, as for coming to enlightenment at the appropriate moment, so that brush and ink will achieve the same results as natural creation, how could it be sought elsewhere? The cook's cutting up of oxen and the woodworker Ch'ing's carving of a bell-stand went with their having clarity in themselves and a concentration of vitality like divinities, so closely united that nothing could come between; only then could they achieve excellence.[12]

> Excerpts from a poem and two colophons, one on a painting of the Seven Talents, one on ink bamboo; see Bush, pp. 46–48: texts 80, 81, 86.

12. Besides the allusion to the *Chuang-tzu*, Book 3, referred to previously, there are two references to Book 19; see Legge, *Sacred Books of China: Texts of Taoism*, pt. II, pp. 15–16, 31–32.

Mi Fu (1052–1107)

Tung Yüan [10th century] had much tranquility and naturalness (*t'ien-chen*). The T'ang Dynasty had nothing in this category. He is placed above Pi Hung [active later 8th century]. In recent years there has been no one to equal him in the lofty style of the "inspired class" (*shen-p'in*). His mountain peaks appear and disappear; his clouds and mists reveal and conceal; without the ornamentation of a cunning flavor (*ch'iao-ch'ü*), he captured their natural character. [His trees] dense and green in misty tones, with their trunks and branches thrusting forth vigorously, all have a sense of life (*sheng-i*). There are creeks with bridges, fishing reaches, and small islands in shifting light—a very slice of Chiang-nan . . .

[In Li Ch'eng's *Pine and Rocks*] the trunk thrusts upward in a majestic curve, and the branches cast shadows with their luxuriant growth. Where the knotholes are indicated, he did not use circles of ink but put down one big dab to run throughout the trunk, going over it lightly with a palely inked brush. Thus it is like the work of nature. On the opposite side, a textured boulder juts up, rounded and glistening; at the crest of a bank the brushwork ends. The foot of the rock is on a level with a rock in the water, and below that he used light ink to indicate an appropriate amount of water. Hence this is a ledge that goes straight down into the water. It is not like those of common imitators that are done in vertical or slanting strokes and, even worse, lack ground and water effects beneath, seeming to float in midair. If brash critics claim that Li Ch'eng lacks "feet," no doubt they have never seen a genuine work . . .

Because Li Kung-lin [1049–ca. 1105] modeled himself on Master Wu Tao-tzu, he was never able to escape his influence. I chose Ku K'ai-chih [ca. 345–ca. 406] for his lofty antiquity instead and did not let one brushstroke be in Master Wu's manner. Also, the tone of Li's brushwork was not high. I make the eye-pupils, facial patterns, and bone structure according to their own natural character (*t'ien-hsing*). This is not something one can do by following a model . . .

Sun Chih-wei's [10th century] painting of the planets are most oddly different. They do not resemble [types] traditionally believed in by people. He was an original person. However, his paintings were formed by arriving at an "untrammeled" style of creation, tranquil yet with a vital movement. Though his brush moved in light swoops, it never curved about; students [of this technique] could never achieve it, for he had his own full and vigorous air in emulation of the ancients . . .

Fan K'uan's landscapes have the towering heights of Heng and T'ai

[the sacred mountains of the North and East]. His far-distant mountains are usually shown straight on and give the effect of being broken off abruptly. Late in life he used a great deal of ink and did not distinguish between rocks and earth. No man in the present dynasty has surpassed him. His mountain streams spring from the depths of nowhere; his waters seem to have a voice of their own.

> Hua-shih (Painting History, *HS*), excerpt; see also Bush, pp. 72–73: text 137; *CKHLLP*, pp. 653, 652, 459, 460.

Ch'ao Pu-chih (1053–1110)

> When Wen T'ung painted bamboo,
> He had the perfected bamboo in his breast.
> Its development was like the spring rain,
> Bringing out the earth's greenness.
> When the stimulus arrives, thunder comes forth from the
> ground,
> And myriad shoots spring up in cliffs and valleys.

> Excerpt from a poem on a bamboo painting, see Bush, p. 47: text 85.

Li Ch'ih (active late 11th–early 12th century)

In the painting of tigers by [the Taoist adept] Li Kuei-chen [active ca. 907–921], the appearance of the fur is clear and luxuriant and the eyes glaring so that one realizes how they could spread terror among all the other beasts. Once he made a platform on a big tree in the mountains, from which to look down and study the actual look of tigers. Sometimes, again, he would put on a tiger skin and caper about in his courtyard, deliberately imitating their actions. At the sight of this picture [one realizes that] its naturalness (*tzu-jan*) could never have been so readily attained without that sort of understanding and empathy.

> *HP.*

Tung Yu (active early 12th century)

Those who discuss painting say that hills and valleys had been formed within [Wu Tao-tzu's] breast, so that when he was aroused, they came forth in painting. Therefore, there are no traces of things left behind, yet the scene is produced in accord with what was seen. No doubt his

nature was in harmony with external nature. When Li Kuang [d. 125 B.C.] first shot at a rock [thinking that it was a tiger], his arrow buried itself up to its feathers. Later he never triumphed over a rock. Having seen it as a rock, he found it impenetrable. When his spirit (*shen*) was fixed, one shot and he had succeeded. An even more subtle explanation would be that man contains ability within himself [alone] . . .

Those who discuss painting say that to be subtle in achieving a sense of life (*sheng-i*) and to be capable of not deviating from the truth is all there is to it. Through this one can reach perfect artistry. If one asks what a sense of life consists in, they will answer that it might be called naturalness (*tzu-jan*); if one asks about naturalness, they will then say that whatever cannot differ from the truth has it [naturalness]. Moreover, if one looks at all living things on earth, they are just the transformations of one vital energy (*ch'i*). Its functioning and modifications are appropriate in each case; no one is conscious of the process, and so it is achieved naturally. Nowadays painters believe in subtlety (*miao*). But if, in outlining forms and setting forth colors, one seeks for things to match and imitates what they resemble, completing the work in a certain order, then all is human effort from start to finish. How can it be in harmony with naturalness?

Now, if a painter reaches the point of forgetting that he is painting, how can he be concerned with forms? Unless a man is enlightened, he cannot attain this . . .

If one is able to be unconscious of horses and without the hindrance of looking at horses, forms will disappear abruptly as if extinguished and nonexistent. When the completed image is prepared and lodged in one's breast, it will suddenly emerge without one's knowing how it did so. Then, prancing and soaring, it will enter the scene on the silk. At first one will not be aware of it, but the horse that appears in front of one will be a true horse. If one has released the image, it will be a true horse. How will there ever be any other [kind of] horse?

Po Chü-i [772–846] said: "Painting is without a fixed [formula of] skillfulness; resemblance is its skill." But, is what is valued in resemblance the same as formal resemblance? What is valued in resemblance is achieved without planning . . . How can it only be resemblance that is valued? For we know that one who does not consciously try to paint finds what is before created things. In general, the arrangement of forms to produce images comes from a sense of life and is obtained by naturalness. One waits for it to appear in one's breast. It is like the unfolding and blooming of flowers and leaves. Only after this is it externalized by making use of the hand and recording in colors. One never seeks likeness first and then lodges one's conceptions in it . . .

All of Yen Su's [active first half of 11th century] paintings depended on what he had seen. He never built in the void or chiseled emptiness, adding or subtracting as he wished. If one asked about this, he would say: "What comes from human invention loses the quality of naturalness" . . . As for the depicting of forms, it cannot be discussed unless the profound attainments of a divine invention (*t'ien-chi*) are grasped and completed in the mind.

When Ts'ao Pa [8th century] did horses, he truly achieved artistry, but he had the bother of not being able to do without seeing horses. Therefore, when horses appear before [a painter] and he carefully completes all their parts, this is not being able to advance toward the Tao . . . In painting horses, Li Kung-lin [1049–ca. 1105] was able to capture the forms of a myriad horses, but unable to get what is formless. I once said to him: "You, Sir, could truly achieve the art of not judging horses by forms. If one can really do without forms and does not concentrate on them, even if they do not enter one's eyes, they will naturally be correct in one's mind. If, in seeking [to paint] horses, one reaches the point of not seeking but obtaining them naturally, I know a true horse will emerge.

Landscape consists in composition, in its effects of relative distance and openness, and a skillful painter's additions or reductions depend on his divine invention. He concentrates on collecting many views and putting them on silk, and if he does not lose the effect of naturalness and can totally capture their atmosphere without there being any evidence of his brush technique, then his work will be completely excellent. Thus, when a former writer mentioned paintings without true mountains and living water, was this not the meaning? Yen Su painted for his own pleasure and was extremely good at making true forms in landscapes, but he never painted without due preparation. He would travel, searching everywhere, and when his spirit was aroused by what he saw, he would store his exhilaration in his heart. The immensity in his breast naturally produced hills and valleys. Only when his inclinations had taken an appropriate turn did he let them come forth. If one investigates his paintings from the point of view of forms, they are all completely what he saw. He could not paint his thoughts into them. He designated himself as "one able to transmit"; only real landscape went into his paintings, hence all his pictures were made from what he had seen. People certainly cannot understand this, and even if they were able to understand, they would not necessarily comprehend his intentions.

Po Lo [the legendary expert in judging horses] posted about the world, searching everywhere, and encountered nothing but horses. The cook who was good with his knife maintained [its sharp edge]

for nineteen years and knew of no whole oxen in the world. Thus, I know that, when Fan K'uan [active ca. 990–1030] released his brush, nothing escaped him. Therefore, he could wield his brush as one with his spirit, so that his divine invention moved of itself to encounter things. Although he was unaware of the way [forms] were developing and expanding, they came of themselves. Then, suddenly, the T'ai-hang and Wang-wu mountains would rise before him, joining together so that they could not be concealed. In recording his success, one should place him on a par with the Immortal K'ua-ngo . . .

I would say that Yen Su's painting is first in naturalness (*t'ien-jan*). His gaining of excellent insight was not managed through accumulation of effort. One can imagine him loosening his clothes and expanding his consciousness, his mind roaming and his spirit set free in myriad mountains and forests, so that there would be feeling and response in a state of concentration. Therefore thunderclaps, wind, and rain, could be suddenly before him and he would not withdraw. At such times, how could there be a [conscious] painter?

> *KCHP*, Book 1, 3–6: colophons on four landscape paintings by Yen Su, a peony painting by Hsü Hsi (d. before 975), a painting by Li Ch'eng (919–967), a horse painting by Ts'ao Pa, a painting of flowering trees by Li Yüan-pen (unidentified), a horse painting by Li Kung-lin, and a landscape painting by Fan K'uan; see also Bush, pp. 54–61: texts 105, 97, 101, 103, 104, 106, 98, 99, 108, 113, 110 in part.

Chao Hsi-ku (active ca. 1195–ca. 1242)

Mi Fu often roamed among rivers and lakes. Each time he moved his abode he invariably selected a place where the landscape was luminous. He was not at first a born painter; later he imitated what he had seen day by day, and in the end captured the flavor of nature (*t'ien-ch'ü*). In his ink plays he did not always use the brush, but sometimes [worked] with paper screws, squeezed-out sugar cane, or a lotus pod and could make a painting with all of these. His paper was not sized and he refused to do a single stroke on silk . . .

> *TTCLC*; see also Bush, p. 116: text 186; *CKHLLP*, p. 1235.

Spontaneity in Painting

Su Shih (1037–1101)

> When my empty bowels receive wine, angular strokes come
> forth,

And my heart's criss-crossings give birth to bamboo and rock.
What is about to be produced in abundance cannot be
 retained,
And will erupt on your snow-white walls . . .

What is divinely imparted in a dream is retained by the mind;
Awakened, one relies on the hand, forgetting brush
 technique . . .

Why should a high-minded man study painting?
The use of the brush comes to him naturally.
It is like those good at swimming,
Each of whom can handle a boat.

> Excerpts from poems on paintings; see Bush, pp. 35–36: texts 56,
> 57, 58.

Huang T'ing-chien (1045–1105)

Now, the reason why Master Wu Tao-tzu [8th century] surpassed his
teacher was that he learned from the mind, so that whatever he did
was excellent. When the Administrator-in-Chief Chang Hsü [active
first half of 8th century] did not cultivate other skills [than calligra-
phy], the use of his intelligence was undivided, and so he was able to
become absorbed spiritually (*ju yü shen*). For, if the mind is able not
to be distracted by external things, then one's original nature will be
preserved intact, and all things will emerge in profusion as if [re-
flected] in a mirror. Why should this depend on licking ink, sucking
the brush, and squatting down, before painting? Thus, I say that if
[the monk] Tao-chen wishes to obtain excellence in brushwork, he
should [first] obtain excellence of the mind . . .

The retired scholar Tung-p'o [Su Shih] played with Master Brush
and Master Paper, making a dried-out stump, an old tree, a clump
of dwarf bamboo, and bits of hills. The force of his brush was un-
restrained in lonely scenes with wind-blown mists. Perhaps what is
easy for an enlightened man and hard for an artisan is like impressions
made in seal paste. Frosty branches and windblown leaves had first
formed in the painter's breast.

> Excerpts from colophons on ink-bamboos by the monk Tao-chen and
> Su Shih; see Bush, pp. 50–51, 71: texts 94, 131.

Mi Fu (1052–1107)

Why is it necessary to recognize difficult characters?
We laugh at Yang Hsiung [53 B.C.–A.D. 18] for his troubles.

From ancient times on calligraphers
Have not understood the characters they used.
It must all be a game (*hsi*);
One shouldn't think about clumsiness or skill.
If my mind is satisfied then I am content;
When I release the brush, the game is over.

Excerpt from a poem on calligraphy; see Bush, pp. 71–72: text 134.

Ch'en Shih-tao (1053–1101)

Each time Pao Ting of Hsüan-ch'eng painted tigers, he would sweep and clean the room and screen off sound by blocking the door and sealing the windows, then he would seek to obtain clarity within this cave-like dwelling. He would drink a measure of wine, remove his clothes, and sit on the floor, then he would rise to pace and gaze, and spontaneously see a true tiger. Then, he would drink another measure of wine, take up his brush and flourish it once. His conception [of the moment] having been exhausted, he would leave, not waiting for [the painting] to be completed.

From *Hou-shan t'an-ts'ung* (Ch'en's Collected Comments), cited in *CKHLLP*, p. 1029.

Lo Ta-ching (active ca. 1224)

In general, when painting horses, one must first have the complete horse in one's mind. If one can store up the essential spirit of horses and appreciate their excellent qualities, after a while, one will have a complete horse in mind. If one begins to paint relying on this conception, wonders will arise naturally (*tzu-jan*). This is what is called "When thinking is not diffuse, one is concentrated in the spirit." As Huang T'ing-chien wrote in a poem, "Master Li Kung-lin paints the bones and also the flesh; / Lowering his brush he produces horses like broken bamboo."

The use of the word "produces" (*sheng*) is extremely good here. Since he had a complete horse in mind, it was produced from a brush tip without his first thinking of forms to copy . . . Tseng Yün-ch'ao, Wu-i [unidentified], is good at painting insects and, as the years pass, he becomes increasingly skillful. I once asked him from whom he had learned. Wu-i laughed and said: "How is there any method that could be transmitted in this? When I was young I caught insects, kept them in a cage, and observed them for whole days and nights without tiring.

Then, fearing that their spirit was not complete, I went to look at them in a grassy spot and from this first grasped their nature (*t'ien*). When I start to paint, I don't know whether I am an insect, or whether the insect is me. This is probably not any different from the workings of Creation as it produces things. How could there be a transmittable method?"

> From *Hao-lin yü-lu*; see Bush, pp. 63–64: texts 116, 117; *CKHLLP*, p. 1030.

Form and Principle (Li)

Su Shih (1037–1101)

Once when I discussed painting, I said that men and animals, buildings and utensils, all have constant forms; as for mountains, trees, water and clouds, although they lack constant forms, they have constant principles. If constant form is lost, everyone knows it; when constant principle is inappropriate, even connoisseurs may not realize it. Therefore, all those who are able to deceive the world for the sake of a reputation are sure to make use of what is without constant form. Though the loss of constant form stops with what is lost and does not spoil the whole, if constant principle is not correct, then all is lost. When the form is inconstant, then one must take care about its principle. The artisans of the world may be able to create the forms perfectly, but when it comes to the principles, unless one is a superior man of outstanding talent, one cannot achieve them. In bamboo and rocks and leafless trees, Wen T'ung [1019–1079] can truly be said to have grasped their principles. Now they are alive and now dead; now they are twisted and cramped, and now regular and luxuriant. Their roots and stems, joints and leaves—sharp and pointed or veined and striated—have innumerable changes and transformations. They are never once repeated, yet each part fits in its place, in harmony with divine creation and accord with man's conceptions. Is this not because of what the [emancipated scholar] had lodged there?

> *Ching-yin-yüan hua-chi* (Record on Painting in the Ching-yin Temple); see Bush, p. 42: text 69; *CKHLLP*, p. 47.

Mi Fu (1052–1107)

Generally, [in painting] animals and human figures, one does a sketch and it resembles [the object], but in doing landscapes, reproduction

will not succeed. In landscape, the level at which the mind is satisfied is high . . .

When Su Shih paints bamboo in ink, they rise straight from the ground to their tips. I asked him: "Why is it that you do not follow their joints as divisions?" He answered: "When bamboo is born, does it follow its joints for growth?"

> *HS*; see also Bush, p. 68: text 120; *CKHLLP*, pp. 653, 1031.

Huang Po-ssu (1079–1118)

Those of antiquity who had a deep understanding of painting captured the conception while forgetting the image. They did not have to maintain a constant technique in copying forms or placing objects. Those who look at the works of Ku K'ai-chih [ca. 345–ca. 406], Lu T'an-wei [5th century], Wang Wei [701–761], and Wu Tao-tzu [8th century] will sometimes see that this was so with them; for example, snow and banana-palms in the same scene; peach, pear, and hibiscus all flowering together; or hands larger than faces; or chariots wider than gateways. Vulgar artisans could not help but change to follow such examples after one glance, relying on their stupid eyes. Thus, [it is like] Chiu-fang Kao [the legendary judge of horses] who discarded the criterion of color to select from horses' underlying excellence. This is something that only the true connoisseur can know.

> *Tung-kuan yü-lun* (Further Discussions from the Eastern Tower), Book B, a colophon on a picture of "T'ang Dynasty People on an Excursion."

Tung Yu (active early 12th century)

How can it be that what man knows with ease must be difficult to paint, while what is difficult to know is easy to paint? The belief is that dogs and horses are easy to investigate, while demons and divinities are difficult. Those in the world who discuss matters of principle must know that demons and divinities are no different from people, while the shapes of dogs and horses will not be skillfully [represented] without penetrating their principles even though one achieves verisimilitude. However, those who recognize principle in this world are few. Who, then, should discuss these matters with painters and investigate requirements? Thus, if one should meet a person who understands principle, he will say that demons and divinities require principle and not formal likeness, while in painting dogs and horses, though they require formal likeness, one should also seek their prin-

ciples. Therefore, skill in dogs and horses is usually difficult . . .

Though one who looks at things may not have first probed their principles, if the principles are there, he will be able to investigate them thoroughly and need not seek them within formal likenesses . . .

People who discuss painting in this period have all missed the significance of the ancients [such as Ku K'ai-chih, ca. 345–ca. 406, and Hsieh Ho, ca. 500–535?, in their considerations of portraiture]. They do not know there is nothing unreal about landscape, grasses and trees, insects and fish, and birds and beasts. If, indeed, one has lost formal likeness and, painting a tiger, causes it to resemble a dog, can it then be said to have captured reality? Li Ch'eng [919–967] was of the scholarly class, pure and free. Therefore, his painting reached the ultimate in marvels, to the point that no traces of his brush technique can be sought, and no point of his beginning the brushwork can be recognized. Then, too, he was able to exclude any vulgar atmosphere. Where he surpassed others was not in achieving true forms. In his landscapes, trees, and rocks, with their mists and haze, the operations of a divine invention and the interactions of *yang* and *yin*, were all swiftly expressed in a most startling way, so that people were unable to comprehend it. That is why one says that vitality (*ch'i*) is produced by the brush, which leaves it within the image. Thus, to paint yet reach the point of forgetting painting, that is the suitable gauge of form . . .

Fan K'uan [active ca. 990–1030] was an ardent lover of landscape. Concentrating his spirit and releasing his will, he captured it within his mind, then had to manifest it externally. He would loosen his garments and become expansive, encountering mountains, forests, streams and rocks. Had [even such famous warriors as] Meng Pen and Hsia Yü met him, they would have lost their courage. Therefore, he could grasp Mount Sumeru and enclose it within a mustard seed, for his vitality could contain [the experience of landscape] and have it in abundance without viewing the mountains again. Those who suck their ink and lick their brushes, hastening to everyone's beck and call, could never reach this skill or follow in his path. People today, who do not understand real mountains and seek to paint them, pile up rocks and heap up earth so that they may aggrandize themselves. How can they know about releasing the mind in the act of creation, the creator capturing things as he encounters them? This is to make a true painting.

KCHP, Books 2–4, 6: colophons on scrolls of dogs playing and a dragon by Wu Huai (10th century) in the Imperial Collection, a landscape by

Li Ch'eng and another by Fan K'uan; see also Bush, p. 60: text 111 (in part); *CKHLLP*, p. 656.

Chou Mi (active later 13th century)

Huang T'ing-chien's colophon [on Li Kung-lin's painting of five horses] reads, "I once commented that Li as a person, in conduct and demeanor, was like certain Hsiehs of the Southern Dynasties.[13] Yet officials and grandees at court often bemoan the fact that, despite his having been in imperial service for so long, he still burdened himself with the activities of calligraphy and painting. I told them: 'Li is a man who has hills and valleys within his breast. This master does not strive after petty fame and fortuitous emoluments' " . . .

Tseng Yü's [1073–1135] colophon reads, "In 1090, when examinations were announced and I came to the capital, I met Huang T'ing-chien at the Temple of the Drinking Pond (P'u-ch'ih Ssu). Huang was just writing a colophon on a slip of paper for Chang Chung-mou [unidentified] about Li Kung-lin's depiction of the five divine horses. He told me: 'Strange, indeed, was Li's painting of a dappled horse from Man-ch'uan in the Imperial Stable! When he put down his brush, the horse died! Apparently, what happened was that the essential soul of the divine steed was completely drawn away by the tip of Li's brush. Truly, this is one of the most remarkable events of all times, and so I should write a few words to record it' " . . .

I, Chou Mi, note that this incident does not appear in other records. Was there some prohibition at the time [because both Huang and Tseng had been censured and banished from court] so that people did not dare to speak of it? Wang Ling's [1032–1059] prose-poem on Han Kan's [8th century] horses also says, "I have heard the story that three horses died in one day, their dead souls arriving at the paper [scroll] as their vitality ended."

> *Yün-yen kuo-yen lu* (Record of What Was Seen as Clouds and Mists), Book A.

13. For example, Hsieh An (320–385) was noted for his extreme composure in difficult situations: see Richard B. Mather, tr., *Shih-shuo Hsin-yü: A New Account of Tales of the World* (Minneapolis: University of Minnesota Press, 1976), pp. 189–190, 192–193.

Definition, Animation, and Expression

Ou-yang Chiung (896–971)

Within the Six Elements [of painting], only two, formal likeness and spirit resonance are of the first importance. If a painting has spirit resonance, but not formal likeness, then its substance will dominate over its pattern, if it has formal likeness, but not spirit resonance, then it will be beautiful but not substantial.

> *Shu pa-kua tien pi-hua ch'i-i chi* (A Record of the Curiosities in the Wall Paintings of the Hexagram Hall at Shu), quoted in the *I-chou ming-hua lu* (Record of Famous Painters of I-chou in Szechwan), Book A.

Ou-yang Hsiu (1007–1072)

Those who excel at discussing painting often say, "It is easy to be skillful in painting demons and divinities." This is because formal likeness is difficult in painting, and we do not see demons and divinities. However, is it not also difficult [to convey] the somber aspects of the *yin* transformed in a sudden upsurge and reaching the ultimate in oddities, so that a viewer is startled to the utmost, and when he has quieted and can look with attention, [he sees] innumerable shapes and attitudes painted with simple brushwork yet complete in conception?

> Excerpt from a colophon, cited in the *CKHLLP*, p. 42.

Su Shih (1037–1101)

> If anyone discusses painting in terms of formal likeness,
> His understanding is close to that of a child.
> If someone composing a poem must have a certain poem,
> Then he is definitely not a man who knows poetry.
> There is one basic rule in poetry and painting;
> Natural genius and originality . . .
>
> The older generation's Wen T'ung [1019–1079] could truly
> portray bamboo,
> The younger generation's P'o [Su Shih's son Kuo, 1072–1123]
> now transmits the spirit of rocks . . .

Ancient and modern painters of water usually make level views with fine strokes. The best of them are able to do no more than create

the waves' ups and downs in a way that demands our touching them, which means that depression and elevation are taken to be excellence in painting. But, this style, just like [a] woodblock print's use of wet paper, strives for skill in trifles . . .

When Huang Ch'üan [ca. 903–968] painted flying birds, their necks and legs were both stretched out. Someone said: "If flying birds draw in their necks, then they stretch out their legs; if they draw in their legs, then they extend their necks. They don't have them both stretched out." When I investigated the matter, it was indeed so. From this we may conclude that, when it comes to people who look at things but fail to see them correctly, even as painters they will be incompetent. How much worse it would be with things of major importance! Therefore, a gentleman must emphasize study and be fond of asking questions . . .

The difficulty in transmitting the spirit [that is, portraiture] lies in the eyes . . . and then in the facial contours. Once, on seeing the shadow of my own cheek bones appear by the light of a lamp, I asked someone to trace it on the wall without defining eyebrows or eyes. Those who saw the result all burst into laughter, recognizing that it was me. If the eyes and cheek bones are like a person, but not the rest of the face, one can add to or subtract from [the proportions of] eyebrows and nostrils to gain a likeness. Portraiture and phrenology have the same Tao. If one wishes to capture the nature (*t'ien*) of a person, the method should be in secretly searching for it among a multitude [of traits]. These days, the subject is made to dress himself up and sit formally, to fix his eyes on one object and wear a pompous expression. How, then, can [a painter] recreate the person's nature? Each of man's ideas and thoughts has a place [of expression], either in the brows and eyes, or in the nostrils . . . I once saw the monk Wei-chen [unidentified] doing a painting of Tseng the Duke of Lu, which at first was not very much like him. One day the monk went to see the Duke and, upon returning, said happily: "I have caught him." Then he added three wrinkles at the outer edge of the eyes, which were only faintly visible. He made him have a lowered head but an upward gaze, the brow lifted and wrinkled. Consequently, there was a very close likeness.

Excerpts from poems and colophons on painting; see Bush, pp. 26, 33–34: texts 31, 51, 50; and the "Ch'uan-shen chi" (Record of Portraiture) cited in *CKHLLP*, p. 454; also see pp. 628, 1028.

Mi Fu (1052–1107)

When people talk of Meng Hsien of Shensi, they note that he is a present-day follower of Wu Tao-tzu [8th century] and uses the brush for painting murals on silk [instead of walls], with each of his strokes like the cut of the knife. Tao-tzu used to leave as soon as he had finished the outlines of a painting, and his disciples would embellish it with colors, and then they probably used his own brush to add some daubs to finish it. They no doubt feared losing fidelity [to the original sketch], and so their brushwork was as regular as knife cuts. Thus it follows that Meng Hsien has only seen the wall paintings and not the original [conception]. As for his dotting in the pupils of eyes, he uses thick ink, and the sharper it is the more its spiritual tone (*shen-ts'ai*) is lifeless. Again, when he paints people's faces, their mouths, noses, and eyes will be too close together in the breadth of expanse from ear to ear. Wu Tsung-yüan [d. 1050] is the same. In Master Wu's painting, the hands [of his figures] were all different, but not because he made a deliberate point of this. Each one held an individual object, hence the principle [in each case] was naturally dissimilar. Tsung-yüan, however, made over twenty figures in *The Heavenly Kings Crossing the Sea*, who were all raising their hands aloft, and it seemed as if every hand was made in a distinct fashion. On unrolling it, one burst into involuntary laughter: it was as if a troupe of demons and deities were playing a gesturing game. Yet the vulgar take this to be skill! . . .

I feel that in landscape painting, past and present masters learned from each other, and few departed from vulgar styles. Thus, I wield my brush without hesitation and make mostly hazy clouds to conceal brilliant light and do not attempt any detailed conceptions in trees and rocks. When any resemblance that pleases me is sought by a connoisseur, I only make three-feet wide horizontal scrolls suspended from a three-foot roller . . . Still less do I make large paintings, and I lack any trace of the vulgar spirit of Li Ch'eng and Kuan T'ung.

Ch'en Ch'ang from the Chiang-nan area [south of the Yangtze River] uses the "flying white" brush [that is, a dry brush which will leave open spaces between hairs] to make trees and rocks which have a pure and untrammeled conception. He is not skilled in figure painting, but, in cut-off branches and blooms, he also uses an untrammeled brush. One stroke will produce a branch, and a scattered dotting with colors a flower, for he wishes to rival Creation itself.

HS, excerpts; see *CKHLLP*, p. 460 (in part).

Ch'en Shih-tao (1053–1101)

There are portraits of Ou-yang Hsiu both in his own family's collection and in that of Su Hsün [1009–1066], which are considered to be correct. Generally speaking, Su's version is supreme in [spirit] harmony but deficient in formal [likeness], while his own family's version has formal likeness but is deficient in spirit harmony. A loss of formal likeness and spirit harmony alike would produce a painting like a shadow silhouette, which would not be a portrait.

> From *Hou-shan t'an-ts'ung* (Ch'en's Collected Comments), cited in *CKHLLP*, p. 64.

Li Ch'ih (active late 11th–early 12th century)

The average professional painter is capable only of depicting things with fixed forms, and so is baffled by the shifting shapes of water and fire. At the beginning [of his career], Chang Nan-pen [active from 880s] studied water painting along with Sun Wei, and both men mastered its methods. Nan-pen, however, decided that he preferred to be superior in one specialty rather than to share ability with another. Therefore, he concentrated on painting fire until he alone could capture its wonders . . .

The picture *Roaming Immortals* is the work of Kuan T'ung [10th century] of the T'ang . . . T'ung accomplished wonders in his landscapes but lacked skill as a figure painter. Each time he had a work which matched his conception, he had to call on Hu I to take charge of the figures. In this picture the divine immortals are the work of the latter.

Great rocks rise thickly, towering to an immense height. The color of refined iron, they are free from any sort of pollution or vulgarity, either above or below. All their sides are sheer so that no human tracks penetrate there, but only deep caverns and winding gorges. There are surpassingly fine vistas of towers and belvederes, fairy grottoes, phoenixes and cranes, flowers and bamboo. The venerable ones who roam about are all winged and plumed, airily poised as if looking for a wind to carry them off. How could this be anything but the abiding-place of genii and spirits? In the rows of rocks seen on left and right, each displays its own effect, whether domed or pointed, tall or short, far off or near at hand. In the flat-lying rocks seen at various levels, each displays its own form, whether squared or rounded, broad or narrow, thin or thick. Brushwork and ink are carried out sketchily. Thus, they are able to stimulate one's mind and eye and to make one seek out the significance and flavor . . .

The pictures *Brambles and a Hawk* and *A Bulfinch on a Mulberry Branch* are both the works of Chung Yin [the retired scholar] of the Southern T'ang Dynasty [923–976] . . . His painting brush was as lofty and tranquil as it was simple and profound. He was skilled in the use of ink, his brush strokes blending together so that none stood out sharply. For tree trunks and birds' plumage he used light colors which he considered completed as soon as his idea was realized.

The average painter of eagles and badgers, falcons and hares, hawks and pheasants, sparrow-hawks and sparrows, or the like, will always do the birds in a pouncing, attacking pose, to show off their fierceness. The bird of prey depicted by Yin sits on a dead branch, looking very relaxed and at ease, but with its eyes fixed on quail down in the grass. One realizes that it wants to catch them and is hunching itself together to execute what the military call "the vulture attack," for which concealment is the essential. [The painter] lets one imagine how those snowy-tufted old feet never strike down in vain.

The average painter of bulfinches will usually give them such ornamental features as hoops, pretty ladies, carved cages, or colored cords. Although these may be cunningly executed, nevertheless, in sum they are vulgar and unpleasant. Yin's bulfinch sits on a branch of mulberry, with a sense of extreme preoccupation. At one side is a big tree with green bark and lichen patches. Below, a bamboo thicket grows thick and dense. The whole atmosphere of the countryside in a spring breeze is diffused before one's eyes. At the same time the tree is an old one that leans far over and shows no boughs or branches; and, although the bamboo stalks are many, the view seems still incomplete . . .

A picture called *Cranes and Bamboo* . . . is the work of Hsü Hsi [d. before 975]. [One sees] a thicket of growing bamboo, whose roots, stalks, joints, and leaves, are all done in dark ink with a coarse brush, while the intervening details are sketchily dotted and smeared in with blue and green. Despite this, the tips seem to aspire to brush the clouds in their lonely fashion. Two pheasants with fresh, bright plumage are quietly pecking away underneath. Their bills look as if they were about to cry; their spurs seem about to move. Modern professional painters, in rendering feathered creatures, consider minutely graded washes to show skill. A single wing may look [real enough], but the whole body will often lack any larger completeness. Here, although wings and plumage have not been gone over several times with graded washes, he has so distributed his several hues that they constitute a coordinated whole, in which the sense of life and truth

of pose are fully expressed. No one would have been capable of this who did not naturally create marvels.

HP.

Tung Yu (active early 12th century)

One bullock has a hundred forms, and the forms are not repeated. Yet it is not that it is born with different forms, but rather because that which causes its forms differs [with circumstances]. Painters consider this their chief labor in learning. How can they not know this? If one uses a human being's standards of physiognomy to look at bullocks, then one knows that they are of a single form; if one uses a bullock's standards, then its differences of form and shape will be even greater [than in paintings of them]. Just as with the faces of human beings, how could there be a limit of a hundred [types]? Furthermore, it is said that viewers [of bullocks] also seek for their so-called innate nature (*t'ien*). Basically, if this is brought out, then a hundred bullocks are more or less of one character. But when one does this viewing . . . how can their hundred physical structures not all be before one? Those who understand bullocks do not seek for this. Rather, they look at various types in action or at rest and, having seen, obtain those forms which are of a hundred shapes, and then lodge them in painting. This, especially, is something that cannot be reached by making forms [alone] . . . If one wishes to understand what painters see, one must follow the animals in their natural environment and seek them afterward, then one will know what a real bullock is!

When Chan Tzu-ch'ien [active mid–late 6th century] made standing horses, they all gave the effect of being in motion, and his reclining horses gave the effect of prancing and rearing as if they could not be repressed . . .

Ku K'ai-chih [ca. 345–ca. 406], in his *Lun-hua,* said that painting places figures first [in importance], then landscapes, then dogs and horses, and finally pavilions and towers, never mentioning birds. That is why Chang Yen-yüan's criticism of painting placed birds in a lower position, to be followed by various kinds of insects.[14] Probably it was because capturing a likeness of their forms is difficult in painting, and also, human figures are superior in spirituality. If one explores their

14. See chapter 1 at "Problems in Representation" and chapter 2 at "Definition, Animation, and Expression."

principles, all things have their own spirituality, but I fear it is merely that few know how to explore this matter.

> KCHP, Books 1, 4, 6: colophons on scrolls of *A Hundred Bullocks* (anonymous), of horses by Chan Tzu-ch'ien, and of cicadas and sparrows by Ts'ui Po (active later 11th century). See *CKHLLP*, p. 1034 (in part).

Yüan Wen (1119–1190)

In painting, forms are easy but the spirit is difficult. Form is physical structure; spirit is the working of spirit. Those who study painting are frequently capable of capturing the physical structure of almost any human figure, but only a person who is outstanding mentally can reach the working of the spirit and is capable of demonstrating it.

> Excerpt from *Weng-yu hsien-p'ing*, cited in *CKHLLP*, p. 70.

Ch'en Yü (active ca. 1253)

Portraiture is not comparable to [any other] class of painting. Probably, this is because description of forms is not difficult; describing the mind is the only difficulty, and so description of a human being is especially difficult . . . Generally, in describing form one must also transmit the spirit; in transmitting the spirit one must also describe the mind. Otherwise nobles and commoners would be alike in visage though their minds differ. The valued and the worthless, the honored and the detested, how then would they be naturally differentiated? Even though they would have formal likeness, of what benefit would this be? That is why it is said that describing the mind is the only difficulty. Now, those who excel at discussing the description of the mind say that for one to observe the subject, there must be mental breadth, high understanding, and extensive discussion. Then, when one knows the person, he will flow forth from the brush exactly as he is.

> Excerpt quoted in *Shuo-fu*, cited in *CKHLLP*, p. 473.

Mood in Painting

Ou-yang Hsiu (1007–1072)

Loneliness and tranquility are qualities (*i*) difficult to paint and, if an artist manages to achieve them, viewers are not always able to perceive

this. Thus, birds' or animals' rates of speed are easy to see, being things of superficial perception (*i*), while relaxed harmony and awesome stillness are hard to shape, as feelings of far-reaching mood (*ch'ü*). As for the effects of height and depth, distance and recession, these are only the skills of the artisan-painter and not the business of refined connoisseurship.

> Excerpt from a colophon, see Bush, p. 69: text 126; *CKHLLP*, p. 42.

Mi Fu (1052–1107)

Chü-jan followed Tung Yüan [both 10th century] and there are many of his works current in this period. His atmospheric vitality is pure and pleasing, and he achieved naturalness (*t'ien-chen*) in his compositions. When Chü-jan was young, he made many [forms like] lumps of alum-crystal; when he was older, in his tranquility the flavor (*ch'ü*) was lofty . . .

In the landscape of a cloudy scene by Tung Yüan in my collection, when one unrolls the whole scroll, the structure of the mountains is both hidden and revealed; the branches of trees emerge and disappear. Its conception and flavor are lofty and antique.

Li Ch'eng's pale ink [landscapes] are like a dream; wrapped in mist, his rocks are like clouds in motion. There is much skill, but little sense of truth. Even though Fan K'uan's effects are heroic, his deep shading is like the darkness of night, and his earth and rocks are not distinguished. As for the reclusive aspects of profundity in material things, his quality is superior to that of Li Ch'eng.

Kuan T'ung's harsh mountains skillfully create the effect of the Kuan River [Shensi province], but his peaks and rounded summits are without much elegant atmosphere.

> *HS*, excerpts; see also Bush, p. 68: texts 122 (in part), 123; *CKHLLP*, pp. 652–653.

Ch'ao Yüeh-chih (1059–1129)

> A noble man can paint the charm (*ch'ü*) of the mountains,
> And the cool gusts as dawn comes from the rim of the sky;
> If he completely transfers this feeling onto a white silk fan,
> Where then are the dust and dirt of this world?

> From a poem on painting, see Bush, p. 27: text 36.

Li Ch'ih (active late 11th–early 12th century)

The Great Compassionate Avalokitésvara . . . a painted icon, is the
work of Fan Ch'iung [9th century] . . . Although its hands and arms
are so numerous, they balance each other on left and right in accord
with the conception. In its complexity it is Heaven's design, and one
sees nothing in excess. Each of the various attributes is rendered to
perfection. The brush strokes are like wire, but have an exquisite
strength and warmth, carrying out the minutest details to a wondrous
perfection.

HP.

Tung Yu (active early 12th century)

The viewing of this capital of an ancient state [Ying-ch'iu, the painter
Li Ch'eng's native region], can measurably increase one's joyful nos-
talgia. [In this act] one is aware that in seeking innate feelings (*pen-
hsin*), one will be able to obtain the sense of never having departed,
and, on seeing the sacred sites of the actual city, one's sadness will
decrease. Then, one is also aware that in losing innate feelings, one
can reverse the sense of never-ending grief. These two aspects are
differentiated into attainment and loss. Yet, when one is confused
and deluded and knows of no release, one can explore the sources
of the mind, that place already lost, and, unaware of seeking, return
to [the mind's] beginnings. People of today who know how to increase
joyful nostalgia fail to view reality; and those who diminish their
sorrow do so by seeing delusions. They often have such entangle-
ments!

Li Ch'eng [919–967] made a picture of the landscape of Ying-ch'iu,
achieving excellence in depicting images and composing views. In the
layout of mountain and stream, the revealing and concealing of ar-
chitecture, the emerging and disappearing of clouds, one can rec-
ognize the places if one seeks them in the painting. I have been away
from the region for ten years . . . yet I could really find my way in
the district . . .

Kuo Chung-shu's [ca. 920–977] picture *Wintry Groves and Hills at
Sunset*, although modeled upon Li Ch'eng's older version, nevertheless
creates a new pattern and superior standard. Its dry wind and old
trees, flat sandy reaches and still waters, scattered mists and coalescing
fogs, all convey [the effect of] past wanderings by a riverside, causing
one to sigh in sadness and melancholy. Its brushwork is naturally

placed and never restricted, yet its vitality is bound up with the myriad mountains used according to his conception and often is attained beyond formal likeness. People frequently fear [such a] vision which involves ties [with desires], and so it should never be indulged.

> *KCHP*, Books 4 and 6, colophons on paintings of his native place by Li Ch'eng and landscape by Kuo Chung-shu; see also Bush, p. 60: text 112.

Mi Yu-jen (1072–1151)

All my life I have known the exceptional sights of the Hsiao and Hsiang region [Hunan]. Each time I climbed and reached beautiful spots, I would always sketch their true flavor (*ch'ü*), making a long scroll to delight the eyes.

> Excerpt from a colophon recorded in *SKTSHHK*, II, Book 13; see Bush, pp. 68–69: text 125; *CKHLLP*, p. 684.

Connoisseurship

Su Shih (1037–1101)

A gentleman should rest his thoughts on objects [in passing] but must not fix his thoughts on them. If he [merely] rests his thoughts on objects, even insignificant things are enough to produce joy and even exceptional beauties are not enough to create obsessions. But if he fixes his thoughts on objects, even insignificant things are enough to create obsessions and even exceptional beauties are not enough to produce joy. Lao-tzu said: "The five colors can blind men's eyes; the five sounds can deafen men's ears; the five tastes can numb men's mouths; riding and hunting can madden men's minds."[15] Yet, the sages have never rejected these four [pleasures]; rather they have merely lodged their thoughts in them . . . How could these [experiences] be simply of sound, color, scent, and taste? Moreover, such joys never pall throughout a lifetime. Of all the things that may be enjoyed enough to gladden one, yet not enough to affect one, none are better than calligraphy and painting. But if anyone fixes his thoughts on them unremittingly, his misfortune will defy description . . . From my youth on, I have loved these two [arts]. I only feared that what my family had collected might be lost and only worried that what other

15. The *Tao-te ching;* see Legge, *Sacred Books of China: Texts of Taoism,* pt. I, p. 55.

people had might not be given to me. Then, I laughed at myself, saying: "I am poor in wealth and position, but rich in calligraphy. I think nothing of birth and death, but prize paintings. Is this not to be deluded and confused, and to lose one's guiding principles?" From that point on, I was no longer addicted. On seeing things that were attractive, I would occasionally still collect them, but if someone took them away, I would have no regrets. It is like the mist and clouds that pass before one's eyes or the [sounds of] various birds that strike one's ears. How can they not be received with pleasure? Yet, once they are gone, how can they be missed? Thus, these two things [calligraphy and painting] constantly give me joy and could never become my obsessions . . .

The knowledgeable create things; the capable explain them. These [two abilities] are not complete in any one person. The learning of gentlemen and the skills of artisans were only perfected [after a long period] from the Three Dynasties [of Hsia, Shang, and Chou] through the Han and T'ang. Therefore, poetry reached [its perfection] in Tu Fu [712–770], prose in Han Yü [768–824], calligraphy in Yen Chench'ing [709–785], and painting in Wu Tao-tzu [8th century]. Then, the transformations of past and present, and the abilities of all under the heaven, were complete.

Wu Tao-tzu's painting of human figures was as if he had taken their shadows by [the light of] a lamp. Moving backward or coming forward, all are seen from the side and emerge in profile. Whether straight or slanted, horizontal or vertical, each image had its increases or decreases, but obtained the sum of naturalness without missing by so much as a hair's breadth. He brought forth new conceptions from within the laws [of painting]; he sent out subtle principles beyond that of vigor itself. This is called "flourishing the knife with room to spare" [like the skillful cook butchering] or "whirling the axe to make a wind" [like the expert workman removing a speck of mud]. He stood alone in both past and present. In looking at other people's paintings, sometimes I cannot identify their artists. As for works [attributed to] Taotzu, one glance and I know whether they are genuine or false. Yet there are few authentic ones in this world.

> "On Wang Shen's Hall of Precious Paintings" and on a painting by Wu Tao-tzu, cited in the *CKHLLP*, pp. 48 and 455.

Huang T'ing-chien (1045–1105)

At first I could not appreciate painting, but then by practicing meditation (*ch'an*) I came to understand the efficacy of effortlessness, and by studying the Tao I realized that perfected Tao is simple. Then,

when I looked at paintings, I could completely understand their degree of skillfulness and quality, grasping their details and penetrating their subtleties. But, how can one discuss this with those who have seen little and heard less?

Excerpt from a colophon on painting, see Bush, p. 49: text 88.

Mi Fu (1052–1107)

I have seen seven or eight examples of "Barbarian Horses" by Li Tsan-hua, Prince of Tung-tan, and by Hu Kuei. However beautiful they may be, they are not pure enjoyments fit for the [collector's] study . . .

As for paintings in general, if people of today see something unfamiliar, [they] compare it with the works of the higher ranks of ancient painters; if there is some resemblance, then they compare it with the standard terms [of critical evaluation]. Those who are dilettantes and those who are connoisseurs are of two different classes. Connoisseurs talk about authenticity and quality, searching widely through literary records [for information]; or again, they may capture [the painting] within their minds, sometimes being able to paint themselves. Therefore, what they collect is always of the most refined quality. If people of recent times have the capital, their source [of selection] is not within the standards set by their intense love [of the art], but depends upon the eyes and ears of other folk. Those that can be termed dilettantes place brocaded covers and jade rollers on what they consider their precious treasures. If one should unroll [these scrolls], one would fall down with laughter. [When this happens to me] I abruptly sweep the table clear, shouting "This is shaming enough to cause one to perish!" . . .

Hsü Hsi's painting *Peonies in the Wind* has some thousands of leaves, but only three blossoms. One is right in front; another is on the right; while the third is behind all the stems and a tangle of leaves. The potholes of the rock are richly rounded; on top is a cat. I dislike painted cats and have often wished that I could cut it off . . .

In examining paintings, Buddhist subjects and narrative paintings that offer exhortations and warnings are superior. Next comes landscape with its inexhaustible flavor, hazy scenes with mists and clouds being especially fine. Next come bamboo, trees, water, and rocks, then flowers and grasses. As for court ladies, birds, and beasts, the aristocracy may enjoy viewing them, but they are not included among the purer enjoyments.

HS, excerpts.

Tung Yu (active early 12th century)

An official painting master said to me: "One can depend on mountains but not on water." What he meant was that mountains have peaks, cliffs, and valleys; mists and clouds, water and rocks; so that one can see them coiling in a line, with hidden connections. As for water, it has neither connecting links, nor curved patterns and slanted effects. One must plumb its depressions and elevations, and its separate currents. Therefore, it is most difficult to paint. Those who compete for superiority in attaining the unusual, and thus gain praise at the present time, are able to do no more than apply wrinkled patterns in rising wavelets. If they would then add river dragons and sea serpents appearing and disappearing, these could be an illustration of the *Shanhai ching* (Classic of the Mountains and Seas). They are even less like water. In the T'ang dynasty, when Sun Wei [active 880s] painted water, he had to intersperse mountains and rocks so as [to create effects of] startling surges and fierce waves, hence he lost the innate character of water. An attempt to make use of things to develop torrents and falls is not enough [to create] water. In former times, a wall painting in the temple at Ch'ü-yang [Shantung] had water painted in a way which people said was most odd, since its water patterns flowed smoothly, barely rising, as if in turbid flow and without rest. At the end, there were steps rising and connecting so that one knew that the wall was convex and concave from on high to below, and by means of this effect water was created. Thus, [the painting] was praised by common people who did not, at first, recognize its spuriousness.

In recent times Sun Po [unidentified] has begun to correlate ideas, making billowing waves, deep sources, flat ripples and fine [lined] flows. When blocked they surge upward; when released they leap forth. All emerge from conceptions beyond those of past people, forming new patterns and superior standards. He does not make use of mountains and rocks to form agitated leaps [of the water] but naturally completes a smooth flow; nor does he need sandy shallows to form rushing torrents but naturally creates dashing waves. He causes the water to turn and twist in curves or straight lines, rippling according to its flow. Its natural long lines, fine and continuous, are orderly and without confusion. This is real water. He used to say that skill in painting open waters requires uninterrupted circulation of waters; skill in painting agitated waters requires clarity for their eddies. If we should look at today's paintings with these two points in mind, they are truly worth a laugh! Now, their failure in open flows makes them look like ponds, and their wind-raised ripples are even

less like the circulation of flowing waters. When they paint continuous flows, then wave heads bubble up, and they look even more like block-printed wave patterns. How can one look for what is superior under heaven within the masses? If one wishes to know how to paint water, one must look at its source, then at its swellings, and finally at its flow.

> *KCHP*, Book 2, a colophon on a painting of water by Sun Po. *CKHLLP*, p. 654.

Chao Hsi-ku (active ca. 1195–ca. 1242)

Man lives but a single generation, like [the flash of] a white colt passing a crack [in the wall]. Passions and sorrows make up two-thirds [of this life], while freedom from care may exist in only one-third. Those who know and can make use of their lives are but one or two in a hundred. Even of those, most find their gratification in sound and color, having no understanding at all of our spontaneous pleasure. The delight of the eye is not based on color; the satisfaction of the ear does not depend on sound. I have seen that many venerable gentlemen of the older generation collect calligraphy exemplars, famous paintings, antique zithers, and well-aged ink slabs. These are the bounties to which I refer. When you are by a bright window at a clean table, neatly arranged and set in order, with seals and incense lying thereon, and have fine guests in noble array, reflecting each other's brilliance, then take out the wondrous works of past masters to contemplate the bird, seal, and snail scripts, the singular peaks and distant waters. Stroking bells and tripods, look yourself at the Shang and Chou dynasties. When spring waters flow into the ink palette of Tuan-hsi [Anhwei] stone and a zither of scorched *t'ung* wood gives forth a sound [like the tinkling of] jade pendants, you are no longer aware of dwelling among mortals. This is what the world calls "making use of pure blessings." What can surpass this? Such a scene is not necessarily surpassed even by the Bright Garden's Jade Pool [in the Land of Immortals]. How sad it is that so few people recognize this virtue! . . .

The ancients are far away. People of recent times are scarcely able to see even one stroke by Ts'ao Pu-hsing [*sic*, 3rd century][16] or Wu Tao-tzu [8th century]. How much less can we obtain the sight of works by such as Ku K'ai-chih [ca. 345–ca. 406] or Lu T'an-wei [5th century].

16. Ts'ao Chung-ta (late 6th century) should be substituted for Pu-hsing; see the excerpt from Kuo Jo-hsü's *THCWC*, Book 1, in chapter 3 at "Buddhist and Taoist Subjects."

That is why, in discussing painting, we should take what we have seen as the standard. If, pointing afar to the men of old, someone says: "this one is by Ku" or "that one is by Lu," not only will he deceive others, but, in fact, he will deceive himself . . . It is remarkable enough to obtain works by the number of men [famous in the present day]. When certain scholar-officials have acquired an original by one of them, the price will be no less than a thousand pieces of gold. Why is it necessary to search afar for the best of highest antiquity, with which neither ear nor eye has ever come into contact? . . .

Kuo Chung-shu [ca. 920–977], Shih K'o [10th century], Li Kuei-chen [active early 10th century] and Fan Tzu-min [12th century] were all unusual men. People often set out silk, brush, and ink palette, in expectation of their coming, and then would request a painting. When the work was nearly done, the painter would tear it to pieces. If anyone managed to obtain something by these painters, it was never more than a single or half scroll. Li Ch'eng [919–967] and Fan K'uan [ca. 960–1030] were both scholar-officials who, when they were inspired, would leave behind a few brush strokes. How could they have made scrolls in pairs? People of today sometimes consider a single scroll to be dubious. They are not worth talking to about painting.

Having selected some works by famous painters, you should not hang more than three or four in a room. After enjoying them a few days, you should exchange them for others. In this manner you will see all your scrolls and they will not be damaged by dampness on inclement days. Moreover, if they are frequently alternated, they will not become dusty, and, if you change the works by one or two masters, you will not tire of them. For viewing scrolls, you must invite only true connoisseurs and have one of them unroll them with great care. On the day you take the scrolls from their containers, the surfaces of the paintings should be lightly brushed with a horse tail or silk whisk, but on no account should one use a coir-fiber brush. In the room one should never burn incense of aloe wood, laka wood, or camphor, or any made with oil which would produce a great amount of smoke . . . The windows must have panes of oiled paper and the doors should be covered with lowered blinds. Before each painting, you should place a small table so as to protect it. The table should have nothing placed on it that might obscure sight of the painting, but perhaps only an incense burner, zither, or ink slab. In the height of summer the room will be too hot and humid for hanging scrolls on the wall. On very cold days the room can be gradually heated with a small fire until it reaches the temperature of an early spring day, then scrolls may be hung without danger. At night they should be taken

down and placed in their containers, since they could be harmed by frost.

Unless a painting has come loose, it should not be remounted frequently. There is not the slightest doubt that every mounting destroys some of the painting's essential spirit, and the same is true for manuscripts and calligraphy exemplars. The silk of antique paintings is so brittle that, when touched even lightly, it will invariably be damaged, and once ruined it can never be restored. The greatest precautions must be taken against stains left by wine or oil from food. One should, by all means, write these instructions on a piece of paper and paste it between the windows as a notice to visitors. Only then should guests be brought into the room for a viewing. Nevertheless, on account of this, some have been blamed by eminent guests. For this reason, if you have fine specimens of calligraphy and famous paintings, you should enjoy them yourself when you wish to. You should guard, by all means, against self-aggrandizement [through display] of rare objects, thereby becoming an advertiser of wares like a hawker. The same holds true for manuscripts and calligraphy exemplars. It is like [the case of] antique bells and tripods which are so brittle that one touch of the hand will cause them to crumble . . .

What is called "copying" is to put an original work on the table and, laying silk beside it, to reproduce it by imitating its brushwork. Unskilled artisans are completely unable to do this, and so they lay silk on top of the painting and trace it. If the ink is a bit thick, then it will go through and dirty the original, destroying its essential spirit. If one lends someone a scroll to trace, it is as good as throwing it away. Anyone who borrows a scroll without following these [precautions] is not a true connoisseur.

> *TTCLC*, preface and text. *CKHLLP*, pp. 86, 1233–1234 (in part, in different order).

Chou Mi (active later 13th century)

In the spring of 1275, the Privy Councillor Wang Ju-chi [?] . . . invited me to accompany him on an inspection round. I thereupon donned official robes and cap, bowed toward the Imperial Palace and toured the Hall of the Hill of the Tao [Tao-shan T'ang]. This hall had bamboo and rocks painted by Su Shih [1037–1101]. We went through the Studio of the Blue Heaven [Han-ch'ing Hsien] and ascended the armillary sphere platform where I observed that the bronze spheres had a color rich as silver or jade, and that their manufacture was

especially refined and delicate. Afterward, we walked along the Jade Sluice (Yü Ch'ü) and ascended to the Secret Repository Pavilion (Mi Ko). In the archives there were shelves on either side to store the documents of past dynasties, as well as calligraphy and painting by their emperors. Apart from these, there were over fifty huge chests lacquered red, all holding calligraphy exemplars and famous paintings of both the past and present. That day we only looked through the paintings within the "Autumn Harvest" and "Winter Season" [lots]. They were all adorned with mountings of phoenix- and magpie-patterned monochrome gauzes and had ivory rollers. Those with imperial inscriptions on them had gold-patterned gauzes added. On the front and reverse of each scroll there was a seal of the Imperial Secretariat. Although security has been extremely strict, fakes have often been substituted for genuine works, and they are extremely difficult to distinguish. Still, there are some fine works.

> *Yün-yen kuo-yen lu* (Record of What Was Seen as Clouds and Mists), Book B; see also R. H. van Gulik, *Chinese Pictorial Art* (Rome: IsMEO, 1958), pp. 201–202.

6

Yüan Criticism and Writings on Special Subjects

BY YÜAN TIMES the historical consciousness of Sung had deepened and both artists and critics were forced to confront the problem of models drawn from the past, that is, from art rather than nature. Although most of the writings of the period are by scholars or men with literary connections, two divergent outlooks are evident that may reflect a latent conflict between professionalism and amateurism. Treatises on special subjects begin to be more precise and technical, while the short comments of literati artists continue to express their own concerns on a general level. The tone of Yüan criticism was initially set by the highly influential scholar-official Chao Meng-fu (1254–1322), famous for his calligraphy and painting. He consistently disparaged formal likeness and praised what was lofty and antique, the concept or spirit of antiquity in art. Although these remarks only occur in a few colophons on painting, usually recorded by later cataloguers, their import is developed in detail by T'ang Hou (active ca. 1320–1330).

As a minor scholar-official, T'ang evidently had an opportunity to serve at the capital, where he made contact with Chao Meng-fu and K'o Chiu-ssu (1290–1343), another noted contemporary artist and connoisseur. From the dates of events in these men's lives, it seems likely that T'ang formulated his thoughts on art in the 1320s. His writings are generally divided into two works, the *Hua-lun* (A Discussion of Painting), which contains his notes on connoisseurship, and the *Ku-chin hua-chien* (Criticisms of Past and Present Painting), which deals with the styles of individual artists. More recent opinion has been that both works were part of one text originally entitled *Hua-chien*. T'ang's own comments in the *Hua-lun* are presented here in their entirety, but divided under separate headings.

His general discussions of connoisseurship elaborate the views of Su Shih (1037–1101) and Chao Meng-fu by insisting that formal likeness should be considered last, and he reinterprets the Six Laws as six methods of looking at painting. In remarks on the various genres, he notes that landscape is now generally placed at the top of thirteen categories, and he redefines Kuo Jo-hsu's trio of influential landscapists, by replacing Kuan T'ung with Tung Yüan, the tenth-century southerner of contemporary fame.

The more technical approach of Yüan connoisseurship is evident in the *Ku-chin hua-chien* excerpts on particular artists. For the first time the focus is squarely on a person's style or brush technique, which is now usually evoked by concrete description rather than by generalities. T'ang's opinions of well-known painters are based on his own experiences, though parts of this work (not excerpted) merely summarize Kuo Jo-hsü's views on past artists. As a scholar-official, T'ang remains appreciative of the Northern Sung literati but dismisses the Southern Sung Academy painters.

Far less individual in tone is the historical work of the late Yüan, the *T'u-hui pao-chien* (Precious Mirror for Examining Painting) of Hsia Wen-yen, with an author's preface dated 1365. Designed as a comprehensive history of painting, it quotes extensively from the writings of Liu Tao-shun, Kuo Jo-hsü, and T'ang Hou. It then gives short biographies of painters from the post-Han period on, relying on the *Hsüan-ho hua-p'u* and selectively treating only the famous masters of the early dynasties. Hsia's sole original contribution to general topics may be his redefinition of the levels of quality as indicated by the three classes of grading, and this follows a quotation from Kuo Jo-hsü on the first law of painting. Kuo's influence, and that of his follower Teng Ch'un, can also be seen in the preface by the poet Yang Wei-chen (1296–1370). Yang's art theory seems no more than a highly literal and overly credulous interpretation of the first law. A few of the biographies of Yüan literati artists in this work have been excerpted to introduce their writings on special subjects.

By Yüan times landscape was said to head the list of subject categories, and all artists of note made their mark in this genre. *Hsieh shan-shui chüeh* (Secrets of Describing Landscape) is a work attributed to Huang Kung-wang (1269–1354) that follows the tradition of Sung landscape texts in imagery and casual organization while focusing on the details of technique with the precision of the Yüan. The references to the styles of the tenth-century masters Tung Yüan and Li Ch'eng are appropriate for the period and for the art of Huang Kung-wang.

More in the nature of a painting album with sets of instructions to be followed in sequence is the *Hui-tsung shih-erh chi* (The Twelve Faults in Painting Tradition) written by the poet and painter Jao Tzu-jan around 1340. This text was evidently appended to a study by Jao of the styles of famous landscapists that is no longer extant. In contrast to the technical aspects of these two essays, colophons by Ni Tsan (1301–1374), as recorded by later editors, merely assess Yüan landscapists in a polite fashion and proclaim the amateur status of his own work.

Ni never included figures in his landscapes, and indeed none of the famous masters of the late Yüan were noted for their figure painting but specialized in more scholarly subjects. Still the painting of figures, and of portraits in particular, was highly esteemed for traditional reasons. As a Confucian scholar and northerner who preferred retirement to official service, Liu Yin (1249–1293) can represent the correct Neo-Confucian view of the early Yüan. In his short preface on a series of portraits, he stresses the necessary balance between formal likeness and the expression of the subject's personality. Of all the genres of painting, portraiture is of course most concerned with formal likeness, and how to achieve it in terms of physiognomy is explained by Wang I (active ca. 1360) in *Hsieh-hsiang pi-chüeh* (Secrets of Portrait Painting). This late Yüan artist specialized in portraiture and colored paintings, but his work was still appreciated by Ni Tsan, who added trees and rocks to a joint painting, and by another friend T'ao Tsung-i, who recorded the treatise on portrait painting in his *Cho-keng lu* of 1366.

Of the scholarly genres of painting as defined by T'ang Hou, "landscapes," "ink bamboos," "blossoming plums," and so on, bamboo was the subject canonized by the friendship of Su Shih and Wen T'ung (1019–1079) with a special significance for literary men. The connection between calligraphy and ink bamboo painting was particularly close, as was recognized in the imagery of treatises such as the *Mo-chu chi* (Record of Ink Bamboo) by Chang T'ui-kung. The parallel structure of this text may reflect the oral transmission of school traditions from master to pupil.

Illustrated manuals were used as guides in the practice of calligraphic strokes, and painting albums of a similar sort came into being when illustrations were combined with technical instructions. These specialist texts were the forerunners of works of more general scope, such as the late-seventeenth-century *Chieh-tzu yüan hua-chuan* (Mustard Seed Garden Manual of Painting). The most famous bamboo treatise of the Yüan was the *Chu-p'u* (Manual of Bamboo) by Li K'an

(1245–1320), who served as an official in Peking and in the Hang-chou region and was sent as an envoy to Annam (Vietnam) where he observed exotic forms of bamboo. In a long introduction, here excerpted in part,[1] he relates how he perfected his techniques for ink bamboos and colored bamboos by studying the works of Wen T'ung and Li P'o respectively. In the manual itself, he quotes extensively from the Northern Sung literati and in an academic tone emphasizes the importance of study. A preface by K'o Chiu-ssu's father, K'o Ch'ien (1251–1319), expresses a Neo-Confucian view of bamboo painting. The views of the noted Yüan painters of ink bamboo are also preserved in later compilations of their poems and colophons. Those of Chao Meng-fu and K'o Chiu-ssu again point out the analogies with calligraphy, while those of Wu Chen (1280–1354) and Ni Tsan are more subjective in character.

Ink prunus or blossoming plum painting was said to have been invented by the monk Chung-jen, Hua-kuang (late 11th–early 12th century), an associate of the Northern Sung literati. The *Hua-kuang mei-p'u* (Blossoming Light's Prunus Album) traditionally has been attributed to Chung-jen or his later follower Yang Wu-chiu (1097–1171) but is undoubtedly of later transmission in its present form. The oldest part may be the "Oral Secrets," not included here,[2] which is written in paired lines of four characters in length. The section on how the prunus assumes its shape, which treats the plum tree in terms of imagery current in Neo-Confucian philosophy, is unlikely to have been composed by a Buddhist monk. The more technical descriptions of form that follow have been omitted, but the first of the concluding sections, a general discussion of painting the prunus, is given here. Quite different in character is the *Mei-hua hsi-shen p'u* (Album of the Joyful Spirit of Plum Blossoms), a late Southern Sung album of prunus pictures with accompanying poems that was composed by Sung Po-jen around 1238 and reprinted in 1261. In the preface Sung explicitly states that these wood-block prints were not conceived of as models, like the designs of Chung-jen or Yang Wu-chiu, but as expressions of his love for blossoming plums. Furthermore, he emphasizes the associations of the prunus with the purity of the scholarly recluse and gives patriotic references at the end that are appropriate to the troubled times preceding the Mongol conquest.

1. For a translation of most of the introduction, see Osvald Sirén, *Chinese Painting: Leading Masters and Principles* (London: Lund Humphries, 1956–1958), IV, 39–42. For a complete translation, see Arthur Mu-sen Kao, "The Life and Art of Li K'an" (Ph.D. diss., University of Kansas, 1979), pp. 205–209.

2. For a prose translation of this section, see Sirén, *Chinese Painting*, II, 157.

Somewhat more technical comments on painting the plum tree are found in poems and colophons on paintings of bamboo and prunus together that are recorded in seventeenth-century catalogues. Chao Meng-chien (1199–ca. 1267), best known as a painter of ink narcissus, is thus credited with a "Prunus Album" of 1260 that concludes with a series of instructions phrased in poetry. And remarks on the development of the tradition of prunus painting were inscribed by Wu Chen in 1348 on a joint handscroll by Sung and Yüan masters that is apparently still extant in part. Apart from such fragments, the most revealing discussions of plum blossom painting in Yüan appear in the *Sung-chai mei-p'u* (Album of Plums from the Pine Studio), composed by a certain Wu T'ai-su around 1350. This work, an authentic mid-fourteenth-century manual that follows Sung art historians in classifying prunus specialists by social status, now exists only in four manuscript versions in Japan. Wu T'ai-su effectively expresses the latent conflict between the amateur's belief in spontaneous inspiration and the professional's need to have a manual as a learning tool. Hence he bridges the gulf between the expressive aims found in some poems and colophons by literati artists and the academic stress on training of the specialist treatises.

The translations in this chapter are based on those by Karen Brock, Arthur Mu-sen Kao, William Lew, and Chu-tsing Li. The Wang I text is a modification of the version by Herbert Franke. The topic headings in this chapter first highlight the general concerns of Yüan critics and connoisseurs and then introduce more specialized writings on the subjects of landscape, portraiture, bamboo, and ink prunus.

Spirit Resonance and Quality

Yang Wei-chen (1296–1370)

Calligraphy flourished in Chin times, and painting in the T'ang and Sung. Calligraphy and painting are one and the same. Scholar-officials who are skilled in painting must be proficient in calligraphy, since the techniques of painting are already there in the methods of calligraphy. Hence, how can painting be done by common or foolish people? During the Hsüan-ho era [sic] [1119–1126], the Emperor established the Wu-yüeh-kuan (Temple of the Five Sacred Peaks)[3] and summoned

3. Note that the Wu-yüeh-kuan was actually constructed from 1012 on; see chapter 3 at "The Emperor as Connoisseur and Artist."

a large number of the painters in the country. As in the examinations for the *chin-shih* degree, the Emperor formulated topics by which to choose candidates. Several hundred persons answered the summons, but most of them did not meet the Emperor's criteria. Thus, although the traditional practice of calligraphy and painting has standard models, the characteristics of the inspired and excellent come from one's inner quality and cannot be obtained by the use of standard models. For this reason a painting's excellence or inferiority lies in the loftiness or baseness of an artist's character. Whether one speaks of princes or nobles, officials or recluses, priests or women, if they only have this inborn quality, they can be among the sages, able to excel in their own dynasty and be famous in later times. As for those who do not have it, they may be able to do some imitations and even come close to standard models, but none of them will have their minds expressed and their thoughts transmitted in their own style. Thus, when one judges the high or low quality of painting, there is either the "transmission of likeness," or the "transmission of spirit." And the latter is "spirit resonance [hence] life-movement" (*ch'i-yün sheng-tung*). For example, a painted cat hung on a wall may stop the rats; a "Bodhisattva Crossing the Sea" may dispel the wind; a venerable sage or war-god can be prayed to and its voice will answer. Portrait painters of ability can attain their [subject's] essential spirit. Are these not examples of "spirit resonance [hence] life-movement" and of obtaining [the powers of] creation itself?

> Preface to *T'u-hui pao-chien* (Precious Mirror for Examining Painting, *THPC*), completed in 1365; cited in *CKHLLP*, p. 93.

Hsia Wen-yen (active later 14th century)

Therefore, "spirit resonance [hence] life-movement" comes from natural accomplishment, and one whose skill cannot be discovered by others is said to be of the inspired class. When the brush and ink techniques are sublime, the coloring is appropriate, and the expressive quality more than adequate, then one is said to be of the excellent class. One who obtains formal likeness and does not neglect the rules, is said to be of the skillful class.

> *THPC*, Book 1, "On the Six Laws and the Three Classes."

On the Subject Categories of Painting

T'ang Hou (active ca. 1320–1330)

Among the [categories of] painting, the most difficult to do is figures, for if both formal likeness (*hsing-ssu*) and placement (*wei-chih*) are adhered to, then spirit resonance (*shen-yün*) and lively expression (*ch'i-hsiang*) are lost. The paintings of Ku K'ai-chih [ca. 345–ca. 406] and Lu T'an-wei [5th century] are seldom seen in the world today. In the T'ang dynasty there were many famous hands, but Wu Tao-tzu [8th century] was the sage of painters, illustrious for eternity. During the Sung, Li Kung-lin [1049–ca. 1105] emerged as the only one who could compete with the old masters. If one had three paintings by Kung-lin, he could exchange them for one by Master Wu Tao-tzu; but two paintings by Master Wu could be exchanged for one by Ku or Lu, so great were the differences in their values.

Each of the old masters who were noted for painting had a category in which he excelled. For example, Cheng Ch'ien [8th century] of the T'ang Dynasty and Li Sheng [10th century] of the Shu were both well known for landscapes, but the *Hsüan-ho hua-p'u* places them in the category of figure painters. In the entries they were mentioned for their ability in landscape, but only their paintings of secular figures and immortals were collected. Other examples [of similar faults] cannot all be enumerated. I have wished to revise the *Hsüan-ho hua-p'u*, but unfortunately have not yet been able to do so . . .

If the ancients who painted realized their ideas, they often painted them repeatedly. For example, there are the "Wintry Groves" by Li Ch'eng [919–967], "Snowy Mountains" by Fan K'uan [ca. 960–1030], and "Misty River and Layered Peaks" by Wang Shen [ca. 1048–ca. 1103], and too many others to be enumerated . . .

A painting has guests and hosts; one should not make the guests dominate over the hosts. In speaking of landscapes, the mountains and water are the hosts; clouds, mists, trees, rocks, figures, birds, animals, and buildings are all guests. Furthermore, if a one-foot mountain is to be the host, then for all those guests the perspective and scale should be calculated and harmonized. In speaking of figures, these are the hosts; as for all the [accessory] guests their relative distance and positioning in the setting should be inferred accordingly . . .

Landscape is a thing naturally endowed with Creation's refinements. Whether cloudy or sunny, dark or gloomy, clear or rainy, cold or hot, and in morning or evening, day or night, as one rambles and

strolls, there are inexhaustible subtleties. Unless there are hills and valleys in your heart as expansive as immeasurable waves, it will not be easy to depict it.

Hence from the Six Dynasties through the beginning of the T'ang, although painters were numerous, in their brush technique and placement they profoundly grasped the spirit of antiquity. When men like Wang Wei [701–761], Chang Tsao, Pi Hung, and Cheng Ch'ien [all 8th century] appeared, they thoroughly instituted the principles [of landscape]. In the Five Dynasties, Ching Hao [ca. 870–ca. 930] and Kuan T'ung [10th century] also brought out new ideas and cleaned out previous defects. During the Sung Dynasty, Tung Yüan [10th century],[4] Li Ch'eng [919–967] and Fan K'uan [active ca. 990–1030] were the three painters who stood like the legs of a tripod. As no one among the ancients preceded them and no one was to follow, the method of landscape was perfected then. After these three masters, there were indeed two or three well-advanced followers, but in the end they never reached their level.

In discussing painting ordinary people will certainly say that it has thirteen categories[5] with landscape at the top and ruled-line painting at the bottom. For this reason people regard ruled-line painting as the easiest to do. They are unaware that even wood engravers and artisans are not able to exhaust the subtle aspects of high and low or looking down and up, square and circular or crooked and straight, distant and near or convex and concave, sharp and dull or refined and rough. All the more so, then, is it extremely difficult to thus convey one's thoughts onto silk or paper with brush and ink, compass and ruler, while seeking to adhere to the rules and standards. Each of the various categories of the ancients' paintings had its masters. There was no one in ruled-line painting during the T'ang. In the succeeding Five Dynasties there was only one man, Kuo Chung-shu [d. 977], and a few others such as Wang Shih-yüan, Chao Chung-i, and Tung Yüan.

4. Tung Yüan, an important figure by the fourteenth century, is substituted for Kuan T'ung in Kuo Jo-hsü's tripod; see chapter 3 at "Landscape."

5. Thirteen categories or genres of painting were defined by the thirteenth century. As listed by T'ao Tsung-i in *Cho-keng lu* (Chap. 28, last entry), they were: "(1) Buddha and bodhisattvas; (2) Taoist portraits of the Jade Emperors and other celestial kings; (3) [vajrapāni, demonic deities], arhats, and holy priests; (4) the dragon and tiger; (5) historical figures; (6) landscape in full compositions; (7) flowers, bamboo, and birds; (8) wild donkeys and other animals; (9) human activities; (10) boundary painting; (11) all forms of lower existence; (12) agriculture and sericulture; (13) decorative paintings in blue-and-green"; see Wai-kam Ho et al., *Eight Dynasties of Chinese Painting* (Cleveland: Cleveland Museum of Art, 1980), p. xxvi.

As for Wei Hsien and Kao K'o-ming [11th century], they are still lower than [Kuo, Wang, Chao, and Tung]. Recently, I have seen the Han-lin Academician Chao Meng-fu [1254–1322] teach his son Yung [b. 1289] to do ruled-line painting, while saying: "In all other kinds of painting it may be possible to fabricate to deceive people, but in ruled-line painting there has never been anyone who did not apply himself diligently in accord with the rules." This is the truth.

Excerpts from *Hua-lun* (A Discussion of Painting).

On Artists' Styles

T'ang Hou [active ca. 1320–1330]

The painting of Ku K'ai-chih [ca. 345–ca. 406] is like the spring silkworm emitting silken thread. When first seen, it appears plain and facile, and sometimes even deficient in formal likeness. But when one examines it closely, the Six Laws are all complete, and there is that which language and writing cannot describe. I once saw his *Huang Ch'u-p'ing Raising Up [Sheep from] Rocks, Yü of Hsia Regulating the Flood, Ode to the Goddess of the Lo River,* and a small *Heavenly King*. His brush concepts were all produced naturally like spring clouds floating in the sky or water flowing over the ground. In applying colors to the forms of figures, he used thick color to add slight details but did not decorate them gaudily. In his early years Wu Tao-tzu [8th century] imitated Ku K'ai-chih's paintings, largely approximating his placement and brush concepts. As a result, the Hsüan-ho and Shao-hsing rulers [Hui-tsung and Kao-tsung] wrote inscriptions certifying the genuineness [of these copies]. Connoisseurs should be aware of this.

Hsieh Ho [active ca. 500–535] said of Ku K'ai-chih's paintings, "his works did not come up to his conceptions, and his fame goes beyond the reality."[6] Recently, after I had seen these copies by T'ang men, I was able to understand that statement . . .

The brush technique of Wu Tao-tzu was so superior and marvelous that he was regarded as the painting sage for a hundred generations. In his early years he handled his brush in a broad manner, wielding it swiftly [in strokes] like water plants. His figures are fully rounded, with a sense of vitality and a lively movement. In his calculation and proportioning of square or round, level or upright, high or low, crooked or straight, there was nothing that was not as conceived. As for his

6. See chapter 1 at "Definition."

coloring, in the midst of dark ink lines he summarily applied slight washes, and a naturalness sprang forth from the double-thread silk, in what people call "Wu decoration." He had many followers in his own time . . . I once saw Wu Tao-tzu's *Icon of Ying-huo* [the Planet Mars], with a fierce and awesome image of a god amid burning flames. The brush concepts were superior and vigorous enough to be startling . . .

The Junior Assistant Wang Wei [701–761] was skilled in painting figures and landscapes. His brush concepts were pure and rich, and his paintings of *arhats* and Buddhas were extremely fine. During his life he enjoyed painting snowscapes, precipitous peaks, hanging plank-ways, mule-drawn carriages, traveling at dawn, fishing, snowy banks, village markets, and other subjects. The painting of the *Wang River* [*Estate*] scroll was his most famous work in existence. Because of the sublime feeling in his breast and the fitness of his ideas, whatever he painted was totally unlike [the works of] common painters . . .

Li Ssu-hsün [651–718] painted colored landscapes using gold and green in a dazzling way and initiated a tradition. His son, Li Chao-tao, varied his father's style and surpassed him in subtlety. Contemporaries called them "The Elder General Li" and "The Junior General Li" . . . Chao Po-chü [12th century] of the Sung imperial clan, whose style was Ch'ien-li, later imitated them. [His work] was attractive but lacked the antique spirit . . .

The naturalness (*t'ien-chen*) of Tung Yüan [10th century] was relaxed and his blandness (*p'ing-tan*) quite attractive. T'ang works lacked this quality, for he surpassed Pi Hung [8th century]. These were Mi Fu's opinions.[7] The landscape art of T'ang painters first reached perfection in the Sung, and Tung Yüan indeed stands above all other masters. His trees and rocks are subtle and rich, and his mountain peaks are clear and remote. During his early years alum-crystal mountaintops were rather numerous. In later years he cleansed himself of former practices . . . The Mi family, father and son [Fu and Yu-jen], used his traditional technique and from it derived new ideas that led to the establishment of their own school. But among those who inherited Tung Yüan's principal tradition, Chü-jan was the best. Tung Yüan's landscapes were of two types. In one done in monochrome ink, there were alum-crystal mountain tops, sparse forests and remote trees, level distances and hidden depths, and mountains and rocks painted with hemp-fiber texturing. The other type was in color, and textured patterning was minimal. The coloring was thick and antique.

7. These opinions are paraphrased from the *Hua-shih;* see Bush, p. 72.

Figures often were painted in red and green clothing, and he used white powder on their faces. Both types of works were beautifully executed . . .

Li Ch'eng [919–967] of Ying-ch'iu [Shantung] was from a family of Confucian scholars. He was of noble character and had lofty aspirations, and he lodged his ideas in landscapes. He utterly exhausted the subtleties of all the variations and shifts of mist and clouds, or the quietude and restfulness of water and rocks; the precarious or easy forms of the level distances, or the aspects of wind and rain or gloom and brightness. The critics thus regarded him as the greatest master of all times. Although many paintings have been traditionally attributed to him, those that are genuine are extremely rare. In his whole life Mi Fu saw only two that were authentic, so that he wanted to write "A Discussion of the Nonexistence of Li." This was because throughout his life Ch'eng painted only for his own pleasure. Since no force could compel him [to paint] and since [his works] could not be obtained with money, it is logical that few of his paintings have come down to us. Among the one hundred fifty-nine scrolls in the Hsüan-ho Imperial Collection, how could they really distinguish between the genuine and the false?

Fan K'uan [ca. 960–1030] was originally named Chung-cheng. Because of his broad-mindedness and generosity, people called him K'uan [the Expansive]. In the painting of landscapes he first learned from Li Ch'eng, but later lamented: "It is better to learn from Nature than to follow an individual." He then cast away his former methods and visited all the exceptional scenery in the Shensi region. His brushwork was vigorous, majestic, mature, and solid, and he truly captured the bone structure of the landscape. The landscapists of the Sung dynasty who surpassed those of the T'ang numbered only three—Li Ch'eng, Tung Yüan, and Fan K'uan. I have often evaluated them. Tung Yüan captured the spiritual essence (*shen-ch'i*) of the mountains, Li Ch'eng grasped the body and appearance of the mountains, and Fan K'uan obtained the bone structure of the mountains. Consequently, these three masters' [achievements] shine throughout ancient and modern times and can be considered the teaching models for a hundred generations. K'uan was especially proficient in painting snowy mountains which, when seen, make a person shiver with cold . . .

Kuo Hsi [after 1000–ca. 1090], from Ho-yang [Honan], followed Li Ch'eng. He was good at depicting aspects of the appearing and disappearing of mist and clouds and the hiding and revealing of peaks and mountains. He once discussed the painting of mountains, saying: "Spring mountains are gently seductive and seem to smile; summer

mountains seem moist in their verdant hues; autumn mountains are bright and clear, arrayed in colorful garments; winter mountains are withdrawn in melancholy, apparently asleep." If one looks at his theory, one can understand his painting. In my entire life I have seen about fifty of his genuine works, however the absolutely finest scrolls number no more than ten or twenty. Still, because of the precipitousness of his mountain tops, should his followers be deficient in his concepts, what they depict in the end may be flat and thin without the aspects of remote clouds and thick forests [to add depth and substance] . . .

The colored paintings of figures by Li Kung-lin [1049–ca. 1105] were first rate. Solely following Wu Tao-tzu, he shone brilliantly over all ancient times. In horse painting he followed Han Kan [8th century], but without using color and on "Pure Heart [Hall]" [type of] paper alone. Only when he imitated or copied old paintings did he use silk and colors. His brush technique was like the movement of clouds or the running of water, with ups and downs. When he did Buddhist images of heavenly kings, they were totally modeled after Wu Tao-tzu . . . In his last years, Kung-lin did paintings of a mature antiqueness and calligraphy that was also sophisticated . . .

The Emperor Hui-tsung [r. 1101–1126] had by nature a great taste for painting. His paintings of flowers and birds, mountains and rocks, and figures are all in the excellent class. His studies of ink flowers and ink birds can occasionally be placed in the inspired class. Among the emperors of various dynasties who were skillful in painting, only Hui-tsung can be said to have attained his concepts. In his time he established a painting school in which students were examined for their artistic skill in the same way as those selected for official appointment were judged on the quality of their essays. As a result, the skills of the period all reached the level of excellence . . . During this time of peace and prosperity, people from all parts of the world brought in tributes of precious birds, strange rocks, rare flowers, and wonderful fruits almost every day. Hui-tsung depicted them in his albums, with two sides to one leaf and fifteen leaves in one album, and entitled them *A Collection of the Sage Perceptions of Hsüan-ho.* These albums grew in number to several hundred and then to more than a thousand. If one calculates the excessive amount of state affairs, how could he have had the leisure to achieve this much? It must have been that contemporary Academy members would do imitations of his work to which he would selectively add inscriptions and seals alone. However, works actually done by Hui-tsung can be easily recognized at a glance . . .

Paintings of bamboo by Wen T'ung [1019–1079] are very rare. So far I have seen only five genuine works, but thirty fakes. I once saw a branch of down-swept bamboo painted on a screen on the wall of [the collector] Chang Ch'ien's "Antique Studio." The inscription read: "On the winter solstice of *chi-yu*, in the second year of Hsi-ning [1069], an ink play by Wen Yü-k'o of the Pa Prefecture." It was indeed an unusual work. Later, I saw three other silk-paintings whose inscriptions were all identical with this, and whose brush and ink technique was similar. There are likely many other versions around that I have not seen. But how could Yü-k'o do so many paintings in one day? Nevertheless, it is easy to decide whether they are genuine or fake when I see them.

Master Su Shih, Tung-p'o [1037–1101], had a brilliance for all times in literary achievements and also took an interest in ink plays. In his bamboo paintings he followed Wen T'ung. His withered trees and grotesque rocks often reveal new ideas. I have so far seen a work that he painted when he saw a bamboo grove, and trees and rocks among the chicken coops and pig pen of a country house, on the way to exile in Huang-chou [Hupei]. The textures of the bamboo leaves were finely done. Also, two other scrolls, *Twisted Rock and an Old Juniper* and *A Sea of Pines in a Vast Valley*, were seen in the Imperial Secretariat. Both of them were extremely unusual. As for his ink bamboos, I have seen fourteen scrolls in all. Generally they seek expression of ideas (*hsieh-i*) rather than formal likeness. I once owned his *Withered Tree, Bamboo, and Rock*, on which Mi Fu had written a poem . . .

Mi Fu, Yüan-chang [1052–1107], had talents that were lofty and supreme. His calligraphy technique entered the inspired class. In the Hsüan-ho reign, [when the Emperor Hui-tsung] established calligraphy and painting studies, he was chosen to be an Accomplished Scholar . . . In painting he enjoyed depicting portraits of the ancient sages, and in landscapes his style originated from Tung Yüan. Revealing a true naturalness (*t'ien-chen*), they are strange and unusual, and his withered trees, pines, and rocks often produce fresh ideas. However, not many of his works have been handed down to us. His son Yu-jen [1072–1151] continued the family tradition. His landscapes have a purity that should be cherished. Moreover, he modified his father's style slightly and perfected his own methods. The variations of his mists and clouds and the embellishments of his forests and streams have an endless sense of vitality (*sheng-i*). He treasured [his paintings] throughout his whole life and seldom gave them to others . . .

Among the Sung scholars who crossed to the south [at the beginning of the Southern Sung], there were many who were good at painting,

like Chu Tun-ju, styled Hsi-chen, Pi Liang-shih, styled Hsiao-tung, and Chiang Shen, styled Kuan-tao, all of whom painted landscapes and eroded rocks. As for the members of the Painting Academy, those who became well-known were Li T'ang, Chou Tseng, Ma Fen, and subsequently Ma Yüan, Hsia Kuei, Li Ti, Li An-chung, Lou Kuan, Liang K'ai and their like. I can somewhat appreciate Li T'ang, but, as for the others, I cannot wholly distinguish them [one from the other] . . .

> Excerpts from *Hua-chien* or *Ku-chin hua-chien* (Criticisms of Past and Present Painting). *CKHLLP*, pp. 476, 478, 479, 686, 687–688, 481, 1066, 478–479 (in part).

Scholars' Painting and the Spirit of Antiquity

Chao Meng-fu (1254–1322)

Among T'ang painters there were many who excelled in painting horses, but Ts'ao Pa and Han Kan [8th century] were the best, since their command of conceptions was lofty and antique, and they did not seek formal likeness. This is why they were superior to the mass of artisans. This scroll is, without doubt, from the brush of Ts'ao. The groom and the stable official both have a spirit of their own, which the vulgar would not appreciate.

> Colophon cited by T'ang Hou (active 1320s), in the *Hua-chien* (Criticisms of Painting).

The spirit of antiquity (*ku-i*) is what is of value in painting. If there is no spirit of antiquity, then, though there may be skill, it is to no avail. Nowadays, men who merely know how to draw in a fine scale and lay on rich and brilliant colors consider themselves competent. They totally ignore the fact that a lack of the spirit of antiquity will create so many faults that the result will not be worth looking at. My own paintings seem to be quite simply and carelessly done, but connoisseurs will realize that they are close to the past and thus may be considered superior. This is said for the cognoscenti, not for the ignorant.

> Colophon dated 1301, cited in the *P'ei-wen-chai shu-hua-p'u* (Encyclopedia on Calligraphy and Painting Commissioned by the K'ang-hsi Emperor, *PWCSHP*), Book 16; also see Bush, pp. 121–122: text 187.

From my youth on I have liked to paint several dozen sheets of narcissus daily, but I was not able to attain perfection. The fact is that

there is a specialized skill in each discipline, and what I always aimed at was to depict their likeness. If one wants to attain excellence wholly [through resemblance] in narcissus, trees, and rocks, not to speak of figures, animals, reptiles, and fishes, or birds and insects, how can this be done? Now, when I look at the ink flowers painted by my cousin Chao Meng-chien [1199–ca. 1267], in their crowding and scattering, each is in the proper order, and this is an extremely difficult feat. I can say that I certainly could not surpass it.

> Colophon on a painting of narcissus, cited in the *Shih-ku-t'ang shu-hua hui-k'ao* (Pien Yung-yü's Notes and Records on Calligraphy and Painting, *SKTSHHK*), II, Book 15; see Bush, p. 124: text 191.

Chao Meng-fu asked Ch'ien Hsüan [ca. 1235–ca. 1300]: "What is the painting of the scholar gentry (*shih-fu hua*)?" Hsüan answered: "It is the painting of amateurs." Meng-fu said: "True, but I have seen [works by] Wang Wei of the T'ang, and Li Ch'eng, Kuo Hsi, and Li Kung-lin of the Sung, which were all painted by high-minded gentlemen. Yet they transmit the spirit of things and exhaust their subtleties. As for recent men who have done scholars' painting, how very misguided they are!"

> Recorded by Ts'ao Chao in *Ko-ku yao-lun* (Essential Information for the Judgment of Antiquities), ca. 1387; see Bush, p. 165: text 243.

Yüan Literati Artists and Critics

Hsia Wen-yen (active later 14th century)

Chao Meng-fu [1254–1322], styled Tzu-ang, literary name Sung-hsüeh Tao-jen, was a member of the Sung imperial family and lived in Wu-hsing [Chekiang]. He served as an official, attaining the rank of Han-lin Academician, was given the title Lieutenant Governor of Chiang-che Province, and was awarded the title of Duke of the State of Wei, and given the posthumous title of Wen-min. His glories shone through five reigns, and his fame spread throughout the four seas. His calligraphy followed that of the two Wangs [Hsi-chih and Hsien-chih], and his painting, Chin and T'ang [styles]; all attained the inspired class . . .

Huang Kung-wang [1269–1354], styled Tzu-chiu, literary name I-feng, and also Ta-ch'ih Tao-jen, was a native of Ch'ang-shu in P'ing-chiang Prefecture. When young, he was in a special class for prodigies. He cultivated the three religions and became acquainted with various

arts. He was good in landscape painting and followed Tung Yüan [10th century]. In his late years, he transformed this tradition and achieved a style of his own. In his mountain tops with many cliffs and rocks, he developed a manner all his own . . .

Wu Chen [1280–1354], styled Chung-kuei, literary name Mei-hua Tao-jen, was a native of Wei-t'ang in Chia-hsing Prefecture. In landscape he followed Chü-jan [10th century]. His copies, imitations, and original compositions are all excellent. However, those that one usually sees around today are all works on which he did not concentrate, hence they are extremely sketchy and simple. He also painted ink bamboos and ink flowers.

Ni Tsan [1301–1374], styled Yüan-chen, literary name Master Yün-lin, was a native of Wu-hsi in Ch'ang-chou Prefecture. He painted woods and trees, level landscapes, and bamboos and rocks, all without a touch of dusty atmosphere of the cities. In his late years [he painted] in a sketchy and simple way to repay obligations. Thus [his works] appear to have come from two different hands . . .

Excerpts from *THPC*, Book 5.

On Mounting and Collecting

T'ang Hou (active ca. 1320–1330)

Every time Emperor Kao-tsung [r. 1127–1162] of the Sung sought out calligraphies and paintings, he would inevitably order Mi Yu-jen [1072–1151] to write authenticating colophons. Often Mi would be forced to subdue his own judgment for the occasion to fall in with the opinion of the Emperor. I have seen several scrolls of painting which were not very good, but their inscriptions are quite genuine. Those who study them must know about this.

When people of today collect paintings, they always want to adorn them with gold and jade, unaware that gold and jade are incitements to stealing. Incidents with previous people can serve as warnings . . .

The sketches of the ancients, called "powder studies" (*fen-pen*, preparatory sketches that could be used for pouncing copies) were often treasured and collected by our ancestors. Because they were freely done without concentrated effort, these have a natural quality. Many of the powder studies collected during the Hsüan-ho era [1119–1126] had an inspired subtlety, and in the Sung people already treasured them greatly . . .

In T'ang handscroll paintings, green brocade was always used for

the outside cover pieces, and inscriptions by famous scholars of the time were on the space for writing. During the Hsüan-ho and Shao-hsing eras [of the Emperors Hui-tsung and Kao-tsung], this ornamentation was cut off, and the look of ancient paintings was not to be seen again.[8]

In the mounting of T'ang paintings, purple brocade is usually used on the outer protecting flaps with red brocade as the inner lining strips, and corals are often inset to the roller ends as for the Buddhist *sūtra* scrolls of today.

At the end of the Sung there were many scholars and officials who did not know about painting. Although they had the reputation of being connoisseurs, they were very careless. Since the finest objects were in the imperial collection, not many were in the hands of the people, and those in circulation could be seized and taken away by the powerful. When [the Minister] Chia Ssu-tao [d. 1276] was in control of the country, he was interested in collecting. At that time, many who tried to follow and work under him made great efforts to find paintings to offer him. But today one generally finds that, among the works he possessed, the genuine and the fake are about half and half. Was it because contemporary knowledge was limited or because Chia Ssu-tao's powers of perception were not high that such provisional judgments came about? . . .

In dyed silk the upper area is deep [in color] and the lower, light. In smoke-darkened silk the upper area is black and the coloring very dark or light. In beaten silk, the texture is not straight and the silk is disorderly and broken. Only if it has been naturally aged will the silk be dark yet the pigments show up clearly. When examining paintings, one must not use the silk's lightness or darkness as a distinguishing feature . . .

In collecting paintings, our contemporaries generally value the ancient ones and slight recent ones. But in landscapes and flowers and birds, a number of Sung painters are far superior to the ancients. Paintings should be considered for their inspired subtleties regardless of their age. For example, Chao Meng-fu [1254–1322] of this dynasty and Wang T'ing-yün [1153–1202] of the Chin are unmatched by anyone during the two hundred years after the Sung crossed the river to the South. Though Mi Fu[9] collected many paintings from the [early]

8. See the "Record of the Scrolls in the Collection of the Emperor Kao-tsung," in R. H. van Gulik, *Chinese Pictorial Art* (Rome: IsMEO, 1958), pp. 205–212.

9. This paragraph follows two passages paraphrasing Mi Fu's comments on the appreciation of painting; see chapter 5 at "Connoisseurship," the second and fourth paragraphs in the Mi Fu section.

Chin, the Six Dynasties, the T'ang, and Five Dynasties, he also acquired and enjoyed the famous works of the Sung. If one does not look at a painting's quality, but considers how far away or near its period is, he is not a true connoisseur . . .

In collecting paintings, [subjects] like landscapes, flowers, and bamboo or water-eroded rocks should be on hanging scrolls so that they can be hung in a scholar's study. Handscrolls are necessarily the best for historical narratives or figure paintings . . .

When looking at paintings from the Six Dynasties, one should first look at the silk, then at the brush technique, and then at the spirit resonance. Out of ten, probably one or two can be believed to be genuine. Those that have inscriptions and seals of the imperial storehouse are all the more unlikely [to be so].

Old paintings were often cut up and rearranged randomly, then patched up and made whole. These deceptive practices began with [the mounter] Chuang Tsung-ku during Emperor Kao-tsung's reign.

Excerpts from *Hua-lun* (A Discussion of Painting).

Connoisseurship

T'ang Hou (active ca. 1320–1330)

When the ancients painted, they all had profound concepts. As they nurtured their ideas and manipulated their brushes, there was not one who did not have a purpose. Since fame does not fall on false scholars, the painters whose names have been passed down from age to age must have their outstanding qualities. There are thus Six Laws of painting, but those who grasp one or two are still able to achieve fame in the world. Hence those who grasp all of them are indeed noteworthy. In looking at paintings, modern men, who have neither learned from teachers nor examined documents, merely consider those that accord with their own ideas to be superior, and those that do not to be bad. However, when asked why they consider them to be good, they are bewildered and at a loss to answer. When I was seventeen or eighteen, I began to have impractical notions. On looking at paintings, I enjoyed them so much that I did not want them to leave my hands. On meeting connoisseurs, I would request instruction. I borrowed notes and documents everywhere, and savored their ideas in detail until I could more or less recite them. Having examined many well-known paintings and reflected upon the words of the ancients, I am beginning to arrive at a certain awareness. If one is not careful,

and merely listens to sounds and follows shadows, ultimately he will not become a good connoisseur . . .

One should not look at paintings under the lamplight, nor with wine by one's side after drinking to excess. Furthermore, do not show paintings to people without taste. To unroll a painting in an inappropriate manner is extremely harmful to it. As for the ignorant and deceitful, they insist upon looking at paintings and thoughtlessly criticize their quality and style. They basically lack understanding of these works and carelessly judge their genuineness or spuriousness. This causes one to become short-tempered.

The study of calligraphy and painting originally just served to accommodate the interests and personal expression of scholars. Those who had the means acquired [these works]; those who had a sensitive eye appreciated them. On beautiful days, when they were in fine spirits, they would gather together for no other purpose than to show and evaluate each other's collections, proudly exhibiting and comparing their unusual and rare works. The frivolous people of today are no longer like this. Even though their eyes can merely discern a few points, they will, when looking at the fine works belonging to others, purposely disparage and find faults in these, inventing clever schemes to make sure that they obtain them. If they do not succeed, then they will malign these works until their fame and value diminishes. As for scholars with disinterested connoisseurship, they certainly will not heed such arguments, but those who are not gifted with a sensitive eye are usually fooled. Should [the insensitive] themselves collect a work of art, they value the object as they would their own life, absurdly lavishing praise on it. If another person desires it, they will make difficulties and speak of obstacles until they receive a superior price. Since all these schemes are improper, one must discriminate with care.

The method of judging paintings should not be limited to a single approach, since each of the ancients had his own way of conceiving ideas and depicting images. How can we limit ourselves to what we have seen to measure the ideas of the ancients? One who is beginning to learn about viewing painting must be able to analyze essentials and subtleties and should look over notes and documents. Otherwise, even though he is versed in connoisseurship and is able on seeing a painting to distinguish quality, he will be confused and unable to reply when asked about the reasons for these aesthetic opinions. Even if he evades the issue for a while by reckless statements, his mediocre and faulty speech and his superficial and limited knowledge will become the object of derision for those who know. Therefore, it is essential to study.

The scions of good families should learn to look at calligraphy and painting, because if they are attentive, they will benefit in many other areas. All the famous men and venerable personages of the past, without exception, paid attention to these subjects. As Ch'en Shih-tao [1053–1102] said in a poem: "Now I am old and know that calligraphy and painting really have benefits. I only regret that my future years and months are few." The reading of this can cause one to sigh . . .

Among the excellent connoisseurs of the Sung, none surpassed Mi Fu [1052–1107]. This gentleman's talents were extremely lofty, and he often excelled others in establishing theories. None of his contemporaries, such as Liu Ching [1043–1100], Hsieh Shao-p'eng, Lin Hsi [early 11th century], Su Chi and his brother, can match him. Later on there was Huang Po-ssu, Ch'ang-jui [1079–1118], who wrote the *Fa-t'ieh k'an-wu* [Emendations to Calligraphy Exemplars] in which he was especially critical of Mi's errors. After having read and examined it in detail, I wrote my *Fa-t'ieh cheng-wu* [Minor Corrections on Calligraphy Exemplars] in which I pointed out Po-ssu's errors. If Mi Fu were alive again, he would not change my words.

When ordinary people discuss paintings, they are not aware of the inspired subtleties of brush technique and spirit resonance, but first point out the formal likeness. Formal likeness is the point of view of people without taste. In addition there is a class of educated gentlemen, who, when discussing the inspired subtleties of painting, will say: "In depicting a diagram of the twelve two-hour periods of the day, one shows twelve roving bees flying around in a circle; in depicting ladies, one renders variations in the twisting of their bodies and turning of their heads"; and more that cannot be enumerated. All of these distorted and misleading statements are made in order to attract attention.

When people of today look at paintings, they are primarily concerned with formal likeness, not knowing that the ancients regarded formal likeness as the least important aspect. Even the figure paintings of Li Kung-lin [1049–ca. 1105], the only important figure painter after Wu Tao-tzu [8th century], were never free from shortcomings in formal likeness, since their subtle points lay in the brush technique, spirit resonance, and expressive character (*shen-ts'ai*), and formal likeness came last. Master Su Shih [1037–1101] had a poem which said:

> If one considers formal likeness when discussing painting,
> His views are those of a child.

> If one composes poetry according to strict meter,
> It is known that he is not a true poet.[10]

During my life I have acquired from this poem not only the methods of looking at painting, but also an understanding of the way to compose a poem . . .

Painting plum blossoms is called sketching plum blossoms; painting bamboos is called sketching bamboo; and painting orchids is called sketching orchids. Why? Because painters should use ideas to sketch flowers of utter purity and not rely on formal likeness. As Ch'en Yü-i [1090–1138] said in a poem: "If the idea is adequate, do not seek for outward likeness; / In a former life I judged horses like [the expert] Chiu-fang Kao." Is this not the meaning? . . .

Looking at painting is like looking at a beautiful woman. Her manner, deportment, and character are all there apart from the body. People of today, when they view ancient painting, are certain to look first for formal likeness, next for the application of colors, and then for the story content. This is definitely not the method of connoisseurship . . .

As to the methods of looking at painting, first look at the spirit resonance (*ch'i-yün*), next at the brush conception (*pi-i*), formal structure (*ku-fa*), placement and coloring, and lastly at formal likeness. These are the Six Methods. When looking at such playing with brush and ink in which lofty-minded men and superior scholars have lodged their exhilaration and sketched ideas (*hsieh-i*)—landscapes, ink bamboos, blossoming plums and orchids, leafless trees and strange rocks, ink flowers and birds and so forth—one must be careful not to approach them in terms of formal likeness. One should first look at their naturalness (*t'ien-chen*) and then at the brush conception, so that in front of them one forgets about ink traces and brushwork. Then their meaning will be understood.

On viewing a painting, people of today often praise a work as it is being unrolled, without knowing the Six Methods. But when someone asks about its subtle points, they do not know how to reply. This is because they have by chance become familiar with it earlier and perhaps are adhering to former provisional opinions, without knowing the reasons for them. This is indeed something to be laughed at . . .

Painting is a thing that has indescribable subtleties. Because the ancients lodged their ideas in it, one must have a discriminating eye

10. This wording is slightly different from the version given in chapter 5 at "Definition."

in order to discern its principles. If someone's connoisseurship is not good, and further, if he does not read notes or documents or know the provenance, then, even in front of a famous work by Ku K'ai-chih [ca. 345–406] or Lu T'an-wei [5th century] he would be no better than a rat trying to hoard stolen gold. How could he understand its conceptual flavor? . . .

In general, if one is not expert in looking at painting, it will be difficult to make a fair judgment. This is a general shortcoming among the high and the low. When I was young and saw works of inspired subtlety, if they did not coincide to some degree with what I had seen, then I considered them to be fakes. Now I am not like that. Having experienced much, my doubts are diminished. Hence there must be substance in what the ancients have passed on to the world. They said: "When a lowly person hears of the Tao he laughs at it, but something not laughed at is not adequate to be considered the Tao." This is the meaning.

Excerpts from *Hua-lun* (A Discussion of Painting).

Landscape

Huang Kung-wang (1269–1354)

Painters of recent times have generally followed the styles of Tung Yüan and Li Ch'eng [10th century]. However, their brush techniques for trees and rocks differed. Students should pay careful attention to this.

Trees should be surrounded by branches and twigs on all four sides, so as to suggest their fullness and lushness. Trees must have their positions, or what painters call the "nexus" (*niu-tzu*). They must bend and interconnect properly, and each tree must have a sense of living growth. On leafy trees the branches are softened, and both the fronts and backs have branches that bend upward.

The method of painting rocks is to start with diluted ink, so that there can be changes and corrections, and gradually add richer ink over this. Only rocks within ten paces are real [in form]. Rocks must reveal three surfaces. When using the method of rectangular and circular shapes [together], the rectangular ones should outnumber the circular ones.

At the feet of Tung Yüan's mountain slopes are many fragmented boulders, as he painted the mountain formations of Chien-k'ang [the

Nanking area]. Tung's rocks are in the so-called "hemp fiber" texture stroke. Starting at the foot of a slope with an inclined brush, he began to paint the edges and texture strokes upwards and then would use diluted ink in graded washes for the deeply recessed places. The application of color is no different from this, but for rocks, the color should be applied heavily.

Tung Yüan's small mountain boulders are called "alum-crystal tops"; his mountains are filled with clouds and mist. They are all mountain scenes of Chin-ling [Nanking]. The technique for texture strokes should be saturated and soft. In the lower part there are sandy reaches, where one should use diluted ink in sweeping strokes that bend and wind and then again add diluted ink for gradation.

In mountains one speaks of three distances. What is called the "level distance" runs continuously without interruption from below. What is called the "broad" distance is [viewed] through separate openings in alignment from nearby. What is called the "high distance" is the remote scenery beyond [and above] the mountains.

The method of using the brush in landscape painting is called "connecting the muscles and the bones." There is a distinction between "having ink" and "having brush." When the brushwork within a depiction is blurred, this is called "having ink." When the technique of depicting is not done with a saturated brush, this is called "having brush." These are matters of utmost importance to the painter, since mountains, rocks, and trees are all rendered in these ways.

Generally speaking, trees should fill empty areas. Whether they be small or large trees, bending upward or downward, in front or back with dark or pale tones, each should not encroach on the others. Dense areas alternate with sparse areas, and one must achieve a balance. If a painter attains complete proficiency, then his brush technique will be accomplished effortlessly.

The subtle point of painting rocks is to blend some rattan yellow pigment into the ink so that it enriches the color naturally. Do not use too much of it, for too much will obstruct the brushwork. It is also subtle to add some shell-blue pigment to the ink occasionally. Such "Wu decoration" is easy on one's eyes and gives a scholarly air to the ink.

One should always have some sketching brushes in a leather bag. Then when one happens in a beautiful spot to see trees that are strange and rare, one can sketch and record them immediately, so that there will be an extraordinary sense of growing life. One should ascend towers and look at the "spirit resonance" of the vast firmament, study-

ing the variety of clouds. These will become scenes of mountain peaks. Li Ch'eng and Kuo Hsi both practiced this method. Kuo Hsi painted rocks like clouds, and the ancients called these "pictures originating from heaven."

In landscapes the water sources are the most difficult to paint. "Distant water has no waves; distant people have no eyes." Water comes from springs high up and moves ever downward; one must not break off its arteries, but should convey the source of its lively flow.

The tops of the mountains must bend and droop, twist and interchange, and the mountain ridges must all respond [to these movements]. This is the way of animating them. The multitudinous peaks seem to bow respectfully to each other, and the myriad trees all follow together, as if great generals were leading their troops in a dignified manner, with an unconquerable air. This will depict the forms of the actual mountains.

Buildings can be placed on the slopes of mountains and small boats in the water. By this means one achieves an air of life. In the mid-sections of mountains use clouds and mists in order to give the mountains an appearance of immeasurable height.

Most essential in the method of painting rocks is that their formal appearance not be distorted. Rocks have three surfaces; both the tops and the sides may be considered as surfaces. On picking up the brush one must decide on which to use.

At the foot of mountains are pools called water-shallows. If one paints these, there will be a great sense of life. They should be surrounded on all sides by trees.

Each boulder or rock should be painted freely and spontaneously with the style of a noble scholar, if one should add too much detail then one will become like an artisan painter.

In doing a landscape composition, one must first establish the theme before proceeding with the brushwork. If there is no theme, then the painting will never be complete. It is most important to record the scenic atmosphere of the four seasons. In spring a thousand things burst into life; in summer trees are luxuriant and variegated. In autumn the many forms are majestic in their decline; in winter the mists and fogs are somber and thin, and the appearance of the sky is blurred and dim. Anyone who can paint this is truly superior.

In painting the bases of slopes, Li Ch'eng always did them in several layers to make them look wet and thick. Mi Fu [1052–1107], in discussing Li Ch'eng's descendants, said that his sons and grandsons

prospered greatly, and many consequently became important officials. Thus, painting also has geomancy (*feng-shui*) in it.

Pine trees that do not reveal their roots symbolize gentlemen in retirement. Assorted trees symbolize petty men with their air of excelling glory.

In painting summer mountains when it is about to rain, one should use a well-soaked brush. When there are rocks piled up in small heaps on mountain tops, this is called "alum-crystal tops." One should use a well-soaked brush to build up their contours, and then go over them with pale shell-blue color. This will give them a kind of elegance and richness. Painting is thus nothing more than a matter of conception.

In winter scenes snow is used for the ground and the mountain tops should be gradated with thin white powder.

The method of painting landscape should be adapted to meet changing circumstances. First, remember not to confuse the texture strokes. The foreground and the background of the composition should be well balanced. Generally, in painting as in calligraphy, practice makes perfect. Painting on paper is difficult, but silk that is properly prepared with alum will take the brush strokes and colors well and be easy to look at. First, the theme must be chosen, then this [painting] will be known as of the "superior class." The old masters did paintings out of the fullness of their hearts and spread forth the scenery spontaneously. If one is in accord with the ideas and flavor of these ancients, then the technique of painting is perfected.

Good silk is prepared by wetting it with water, beating it on rocks to tighten the weave, and finally spreading it on a shelf [to dry]. The method of applying alum is as follows: in the spring and autumn alum and glue are in equal parts; on summer days there is more glue and less alum; and on winter days there is more alum and less glue.

When one applies colors, shell-blue should be brushed over the tops of rocks, and rattan yellow should be added to the ink of trees, so that they become rich and beautiful in appearance.

In painting, the most important word is principle (*li*). Wu Jung [d. ca. 903] had a poem which said: "The excellent artisan completely understands the principle of reds and blues [that is, painting]."

It is the use of ink that is hardest in painting. But one should simply first use diluted ink to build up [a painting] until it can be looked at; then use scorched, dry ink [chiao-mo] and heavy inks to distinguish the paths in fields or the near and the distant. Hence, on unsized paper, there will be very many well-saturated areas, meaning that [one should like] Li Ch'eng be as sparing of ink as if it were gold.

It is of utmost importance in painting to do away with these four qualities: erraticism, sweetness, vulgarity, and derivativeness.

> *Hsieh shan-shui chüeh* (Secrets of Describing Landscape), cited in *CKHLLP*, pp. 696–699.

Jao Tzu-jan (active ca. 1340)

The first [fault to be avoided] is overcrowded compositions. When painting a landscape, you must first place the silk in a bright and clean room; wait until your spirit is at leisure and your mind is settled, then you can conceive ideas. Whether on a small or a large scroll, these ideas are followed through in composition. If the painting silk exceeds that of several scrolls [in length], or if the wall exceeds several tens of feet [in width], it is necessary first to use a bamboo pole affixed with charcoal to sketch in place the lofty and low aspects of mountains, the large and small trees, buildings, pavilions and figures; each [element] in its proper position. Then, step away from it for several tens of paces, examining it carefully. If you see that it is acceptable, then use light ink and brush to approximate its definite forms. This is called the preliminary touch of the brush (*hsiao lo-pi*). After that, you may freely flourish and daub, and all will be appropriate. This was the careless and disdainful technique of the first Lord of Sung's [painter][11] and may be called "ideas preceding the brush." Moreover, [a painting] should be open and wide at its top and bottom, and loose and accessible on its four sides, so that it will be free and agreeable. If it were to be filled from heaven to earth, the painting filling the entire scroll, then it will have no loftiness of purpose (*feng-chih*). This should be your first consideration.

The second [fault to be avoided] is lack of distinction between the near and the distant. In painting a landscape, you must first divide the far from the immediate, making the high and low, and the large and small, all suitable. Although it is said that mountains are ten feet [in height], trees one foot, a horse an inch, and a figure one-tenth of an inch, [such a ratio] is only an approximation. If you adhere to this theory and paint a mountain one foot high, how large then should the figures be made? In general, foreground slopes, rocks and trees ought to be large, with appropriately scaled buildings, pavilions, and figures; distant mountain peaks and forests should be small, with appropriately scaled buildings, pavilions, and figures. In the far distance, there should be no figures. The ink should be light far away

11. For the *Chuang-tzu* incident, see chapter 1 at "Social Status."

and dark when near, the farther away the lighter. This is an unchanging proposition.

The third [fault to be avoided] is mountains without "vital veins" (*ch'i-mo*). In painting mountains in the middle of a painting, first establish one mountain to serve as the "host," and thereafter follow it when distributing the risings and fallings [of other mountains]. All of these should be linked by their "vital veins," thus having a continuous formal appearance. If the mountain tops rise in several layers, below there must be multilayered bases in order to support them. Depicting many mountain tops without bases is a great error. This is the general conception of a whole scene. If only the corner [of a mountain] appears [between other mountains], it need not follow this rule.

The fourth [fault to be avoided] is waters without sources. When painting a spring, it is necessary that it should flow from out of a mountain gorge, and above it there should be several layers of mountains, then its source will be lofty and distant. In level streams and small creeks, one must see the water's outlet. Cold sandbanks and shallow fords must show running ripples, so that the water seems alive. There are some who paint a waterfall for each fold of mountain, as if they were hanging towels on a rack. This is absolutely ridiculous.

The fifth [fault to be avoided] is scenes without levels and risings. The ancients did not distribute landscapes in one manner alone. Some were lofty and sharp; some were level and distant; some, turning and winding; some, empty and vast; and some rose in layers. Again, some had more groves, trees, and buildings; others had more figures and boats. Whenever they wanted to paint a picture, they had to establish an idea first. Whether a large screen or a great scroll, all had to accord with this.

The sixth [fault to be avoided] is paths without beginnings and ends. In a landscape, the effect of distance between the far and the near is entirely dependent on the clear separation of paths or roads. They must emerge and disappear. Some penetrate into forests and reappear at the water's edge; some are screened and cut off by large rocks, gradually becoming visible in mountain hollows; some are hidden by slopes and marked out by figures; others lead up to buildings yet are concealed by bamboo and trees. All of these create an inexhaustible range of landscapes.

The seventh [fault to be avoided] is rocks with only one face. Each painter of rocks has his own technique for their texture strokes (*ts'un-fa*). You ought to take the technique of the master you studied as your

own. [In all techniques] the best rocks must have tops and bases, and their faces must be divided in sharp angles.

The eighth [fault to be avoided] is trees lacking branches on all four sides. Painters of former dynasties had [special] techniques for painting trees. Generally, those that grow along precipices have mostly tangled and intertwined branches; those growing on slopes are lofty and straight. Trunks that reach the clouds have more [branches] on top, while those near water have more roots. Branches and trunks cannot only be divided between their left and right sides, they must also be represented as to front and back, using either single or partial branches. Foliage may be painted with single or multiple brush strokes. The distinction between flourishing and withering foliage must be done according to the four seasons. Then [the painting] will be entirely excellent.

The ninth [fault to be avoided] is figures [fixed] in stooped positions [of reverent attitude]. Figures in landscapes all follow their own schools. In a minutely executed figure, eyes and eyebrows should be clearly distinguished; for one rendered in dots and chisel strokes, the brush-work must be dynamic and antique. All figures must be dignified in their dress, and relaxed and elegant in deportment. You can study the techniques of the ancients and not make all of the figures which [variously] walk, look, carry burdens, or ride, in the single manner of stooped figures. [If you do this], then your faults will be many. Should one not be careful of such wild and loose practices?

The tenth [fault to be avoided] is buildings and pavilions in confusion. Although ruled-line painting ranks as the last specialty, storied buildings and multilayered pavilions must, in the space of a square inch, have their fronts and backs clearly distinguished. Their corners must be properly joined and their brackets must fit without confusion, in accordance with the rules and regulations of construction. This is the most difficult to do. Whether painting a riverside village or mountain cottages, their buildings should face in every direction and, even though you do not use a ruler, their construction should be in accord with the techniques of ruled-line painting.

The eleventh [fault to be avoided] is inappropriate atmospheric effect. No matter whether a painting is done with water and ink, or colors, or gold and jade-blue, the atmosphere must be rendered with ink and have proper lightness and depth. Thus, clear scenes should have an empty and bright sky; rainy and night scenes must be dusky and dark; snow scenes must be slightly brighter, not resembling those scenes of rain, clouds, fog, or mist. Green mountains and white clouds should be depicted only in summer and autumn landscapes.

The twelfth [fault to be avoided] is applying colors without proper techniques. This refers to colored and jade-blue paintings. In coloring there are light and heavy techniques. In the light one, use shell-blue on the mountains, composite green on trees and rocks, but do not use [lead white] powder to underpaint the figures. In the heavy one, use mineral blues and greens on mountains, as well as to decorate trees and rocks, and use [lead white] powder for underpainting the figures. In a gold and jade-blue painting, as soon as you begin to paint, even if you use texture strokes for rocks, leave one side of the rocks plain in order to cover it with shell-blue and composite green, then add mineral blue and green to wash the folds [of the rocks], and finally use the same pigments to apply texture strokes on some of them. For the foliage of trees, use mostly multiple brush strokes, then wash with composite green, and again add mineral blue and green to adorn them. Gold pigment should be used at the bases of rocks, on the tongues of sandy banks, and in cloud patterns. This method is only suitable for clear scenes at dawn or dusk, when radiance or brilliance is disproportionate and gleams seductively. Figures and buildings, though underpainted with [lead white] powder, also must be clear and light in color. Except in red foliage, do not carelessly use reds, golds, and other colors, then this will be the art of a master.

Painters such as the T'ang Dynasty's General Li Ssu-hsün [651–718] and Chao-tao—father and son—and the Sung Dynasty's Tung Yüan, Wang Shen [ca. 1048–ca. 1103] and Chao Ling-jang [active ca. 1070–1100] may all be taken as models. Japanese painting often commits these faults, as earlier people have noted. You must be attentive.

> *Hui-tsung shih-erh chi* (The Twelve Faults in Painting Tradition); cited in *CKHLLP*, pp. 691–694.

Ni Tsan (1301–1374)

Among painters of landscape, trees, and rocks in this dynasty, there are the Minister Kao K'o-kung [1248–ca. 1310] with his subtle and far-reaching spirit consonance (*ch'i-yün*); Chao Meng-fu [1254–1322] with his lofty and outstanding brush and ink; Huang Kung-wang with his all-surpassing, untrammeled and secluded spirit; and Wang Meng [ca. 1308–1385] with his pure and fresh elegance. While there may be differences between them in relative merit, I bow before all of them without complaint. Other than these [painters] I do not know. Even though this scroll is not one of Huang's greatest ideas, it has a noble spirit (*feng-ch'i*) of its own.

The Minister Kao K'o-kung, as one who set his goal on living a pure and noble life, retreating from the dust of this world yet uniting the glorious and the sullied in harmony, was a man for a thousand years. Living in Hang-chou, he walked out with a staff one day at leisure, taking along a bottle of wine and a book of poems. He sat on the banks of the Ch'ien-t'ang River and looked toward all the mountains of Yüeh [Chekiang]. With their rising and falling of hills and peaks, their clouds and mists appearing and disappearing, he seemed to have attained his goal. Devoting his spare time from governmental affairs and official writing to painting, he was one of those who tried to express themselves with complete freedom in their paintings.

What I call painting does not exceed the joy of careless sketching with the brush. I do not seek formal likeness but do it simply for my own amusement. Recently I was rambling about and came to a town. The people asked for my pictures, but wanted them exactly according to their own desires and to represent a specific occasion. [When I could not satisfy them,] they went away insulting, scolding, and cursing in every possible way. What a shame! But, how can one scold a eunuch for not growing a beard?

> Miscellaneous colophons and comments cited in the *CKHLLP*, p. 702 (in different order).

Figure Painting

Liu Yin (1249–1293)

T'ien Ching-yen of Ch'ing-yüan [now in Hopei Province] excels in painting true to life portraits. They not only achieve the ultimate in formal likeness, but also attain what Su Shih [1037–1101] called "expression" (*i-ssu*) and what Chu Hsi [1130–1200] called the "divine endowment" of noble style and spirit resonance (*feng-shen ch'i-yün*). Though formal likeness in painting is attainable by strenuous effort, expression and the divine endowment can only be fully understood by the mind after formal likeness has already reached the ultimate. There is no such thing as expression or the divine endowment outside of formal likeness. This is also something that can be learned by posterity yet continues what came from predecessors.

I once wrote a poem on a scroll painting saying,

> In smoke and shadow, on the edge of Divine Creation's annihilation,

> Who brings out clarity and beauty from the tip of his brush?
> Painters also have those who share the weakness for pure
> converse,
> And everywhere there is talk about nothing but the *Chuang-
> tzu.*[12]

This may serve as a warning to those who follow Ching-yen but do
not reach up to him.

> Preface to a poem on T'ien Ching-yen's portraits dated to 1275, cited
> in *CKHLLP*, p. 484.

Chao Meng-fu (1254–1322)

In painting the most difficult [subject] is the human figure. Imple-
ments [or vessels], costumes and manners, were also things of special
interest to the ancients. In this painting, everything has attained the
level of excellence. Even hair and facial expressions are vivid, as if
the figures were about to speak. Perhaps they may [even] exist in the
[divine] realm between emptiness and nonbeing. It is, indeed, an
inspired work.

In painting human figures, excellence lies in capturing character (*hsing*)
and emotion (*ch'ing*). This painting by Li Tsan-hua [active 930s] has
not only attained the forms and attitudes [of its subjects], but is also
equally accomplished [in portraying] both human beings and dogs.
Its success goes beyond that of brush, ink, and colors. It should be
treasured.

> Colophon on a painting of the Western Regions by Yen Li-pen (d. 673)
> as recorded by T'ang Hou (active 1320s) in the *Hua-chien* (Criticisms
> of Painting); and a colophon cited in the *CKHLLP*, p. 475.

Wang I (active ca. 1360)

Whoever paints a portrait must be thoroughly familiar with the rules
of physiognomy, for the disposition of the parts of people's faces is
like that of the Five Mountains or Four Rivers, each element being
different. Even if there are symmetrical areas, their expression and
color will differ according to the four seasons. Only during a lively

12. This reference to the Taoist philosopher (late 4th–early 3rd century B.C.) and
to Taoist metaphysical discourses is evidently derogatory.

conversation will they show their original and true character. Then I remain quiet and try to seek it, silently noting it in my mind. Even with my eyes closed, it is as if I had [the features] before my eyes and, when I release my brush, it is as if [the face] were already beneath the brush's tip. After that, I fix it down with pale ink and build it up in successive layers.

I begin with the left side of the nose (*lan-t'ai*), and then go to its right side (*t'ing-wei*). Then follows the tip of the nose. When it is finished, it becomes the center [of the composition]. If the bridge of the nose (*shan-ken*) is high, I start from its point of concentration (*yin-t'ang*) and go downward in one stroke; if it is low, I start from the side of the eye (*yen-t'ang*) and go downward in one stroke. If it is neither high nor low, then I start from a point eight-tenths or nine-tenths in distance [from the tip] and go downward in one stroke at each side.

Then follow the part between nose and mouth (*jen-chung*), the mouth, the sides of the eyes, the eyes, the brows, the forehead, the cheeks, the hairline, the ears, the hair, and the head. After that, I paint the contours of the face (*ta ch'uan*), that is, the face [as a whole]. It is necessary to proceed like this from one part to another so that not even a hair will be omitted or incorrect.

The artisans of modern times are like people who want to play the zither with pegs glued down and are ignorant of the Tao of change and movement. They ask [their subjects] to sit stiffly erect, with garments neatly arranged, like clay statues, then they begin to describe them. This is why they do not succeed even once in ten thousand attempts. How can one wonder at this? I cannot, in any case.

> *Hsieh-hsiang pi-chüeh* (Secrets of Portrait Painting), cited in *CKHLLP*, p. 485.

Bamboo

Chang T'ui-kung (active later 13th century?)

Now, ink bamboo painters began during the time of the T'ang Emperor Hsüan-tsung [r. 713–756] and later [their techniques] were transmitted to Hsiao Yüeh [active early 9th century]. They obtained inspiration (*te-i*) from looking at the bamboo's shadow. For this reason they painted ink bamboo for their associates.

Leaves should show light and dark. Branches and roots should exhibit front and back. Claw-like twigs should be well related to each

other; if one, isolate it, if two, form a pair, if three, bring them to-
gether; or five, group them. Bamboo of spring and summer grow in
soft gentleness; bamboo of autumn and winter are born harshly split.
When Heaven sends clear skies, leaves and twigs stretch upwards;
when clouds bring rain, twigs and leaves droop. When they follow a
wind, do not spread them out like the character for "one" (*i*); when
they bear rain drops, do not align them as for the character "man"
(*jen*). Transmit the rules from previous generations and make them
the standards for later ones. Generally, in bamboos, one looks for
layering of leaves, as in trees one sees the growth of branches. In
brushing on their leaves, the points should not resemble rushes and
their thinness should not look like willows. Three leaves must not look
like the character for "stream" (*ch'uan*), nor should five resemble the
hand. In sketching branches, tender ones should not stand upright;
old ones should not move diagonally. Trunks should not be like drum
stands, nor should joints resemble a crane's knees.

Bamboos should not be painted too quickly. If they are done too
rapidly, they will be hurried, and when they are like this they will
appear weak. They should not be done too slowly. If they are executed
too slowly, they will be dragged out, and when they are like this, then
their bones are thin. Yet they must not be fat, for then their body
will be muddy. They must also not be too thin, for then the form will
seem withered. Again, they should not be made long, for then they
will be unstable. Also, they should not be short, for then they will be
restrained and uneasy. Their leaves must be well divided between the
light and the heavy, and the branches ought to have a contrast of the
high and the low. When this is obtained in one's mind and responded
to through the hand, mind and hand being mutually responsive, then
all will be excellent. Works such as these will move the elegant scholar
to poetic expression and inspire the poet to singing lines. However,
if they do not recognize this inspiration, then they will not be able to
capture the ideas of bamboo.

The joints of a bamboo should be like [those of] a crane about to
rise, their forms resembling spoon handles. To obtain an effect of
richness of conception, layer the leaves as if they were stacked lances.
Follow the weather of the four seasons in sketching branches like
crouching dragons. Joints cannot have enough loftiness, for they must
be as [noble] as Su Wu [2nd–1st century B.C.] in exile on the steppes;
twigs cannot be too cluttered, for they should resemble Chang Hsü's
drunken [cursive] script. The body of a bamboo in repose should
resemble a jade dragon; the form of a bamboo with a dancing ap-
pearance should look like a golden phoenix turning its body. Tender

leaves and soft branches will not carry rain but will sway in the wind; mature branches and old joints must withstand frost and stand up in snow. When a bamboo is immature, it will have variations of dry and wet stems and branches. During wind and rain, its branches and leaves will rise or droop. When six, seven, eight, or ten bamboo grow together, they form a group or grove. When one, two, three, or five bamboo grow together, they will lean against a bank or huddle on dikes. Whether piled up or layered, their leaves are like neatly arranged birds' wings. Whether crooked or straight, their joints resemble dragon spines one atop another. Twigs may be fixed on the top sections and leaves may be attached to their tips. Twigs are excellent when they are healthy and lively; leaves are excellent when they are few and clear. Do not mix the bamboo of spring, summer, autumn, and winter, for they must follow the moods of snow, clear weather, wind, and rain. If twigs and leaves scatter and dance about, with an antique oddness and pure rarity, these will have reached the ultimate refinement of the excellent class.

Mo-chu chi (Record of Ink Bamboo); cited in *CKHLLP*, pp. 1061–1062.

K'o Ch'ien (1251–1319)

How fortunate it is that in recent times the family of bamboo met up with Master Li K'an, Hsi-chai, the senior academician of the Chi-hsien Academy.

Because Li absorbs the purest air in the world, his mind is clear and open, and his spirit is brilliant, both of which are congenial to the manner and disposition of "The Gentleman" [bamboo]. No wonder he loves bamboo so deeply and knows it so well. Moreover, he has traveled everywhere that bamboo grows, and none of its species are unknown to him. Thus, skilled in ink sketching and adept in recording and describing, he was able to produce both paintings and treatise. Such a chance for the family of "The Gentleman" could be said to happen only once in a thousand years. Nevertheless, if on seeing the paintings and treatise we say that there is nothing but bamboo there, we really do not understand bamboo, nor do we understand the author, Master Li. A proverb says: "A gentleman is comparable to bamboo because of their similar virtues." What people may describe and paint are only the form, the color, and the type of bamboo; what neither description nor painting can encompass are the virtues for which bamboo stands. Bamboo stems are hollow (*hsü*) [empty-hearted, standing for the virtue of humbleness]. When hu-

mility is applied in dealing with everyday life, it is Li's personality which is neither proud nor selfish and obstinate. The nature of bamboo is to be straight (*chih*) [standing for the virtue of rectitude]. When uprightness is expressed in the cultivation of disposition, it is Li's lofty and pure nature, vast and open mind, and correct manner in getting along with people. Bamboo's joints (*chieh*) are clear-cut (*chen*) [like the virtue of chastity]. When this virtue is associated with efforts in carrying out serious responsibilities, it is expressed in Li's accomplishments at court as a model of human behavior and in his action as an envoy to a country thousands of miles away [Annam], where his speech subdued three divisions of troops. All of these are great uses of bamboo's virtues.

During his leisure time Li expressed his inspiration in his bamboo painting, and his paintings and treatise have become in turn the things which bamboo represents in itself. [People should not view his bamboo merely as types of bamboo but should perceive its essence, represented in Li K'an's accomplishments.] If one is able not to look at bamboo as bamboo but to seek its supreme unborn nature beyond all form and color, then Li's own character can be visualized. Ah! He has "held on to virtue" and "taken pleasure in art,"[13] but can his ideas and interests be communicated to common people?

> Excerpted from the preface to Li K'an's *Chu-p'u* (Manual of Bamboo), written in 1319; included in the *Chih-pu-tsu-chai ts'ung-shu* edition.

Li K'an (1245–1320)

From the beginning of the Sung Dynasty onward, ink bamboo was very popular. Wen T'ung [1019–1079] was the last master. He was like a bright sun ascending in the hall and outshining the torch fire, or the sound of a great bell which overwhelms the smaller sounds of pots and kettles. One so majestic as Su Shih [1037–1101] yielded a lifelong allegiance to him. Are there men in the world, wishing to enjoy the field of this wonderful art, who are still ignorant of their standard and guide?

For color bamboo I take Li P'o [10th century] as my master, and for ink bamboo I follow Wen T'ung. Yet, when I was carving a swan, it became more like a duck. I knew that I should be ashamed, because I was only an unworthy follower of the great masters. Fortunately, I

13. For these phrases from the *Lun-yü* (Confucian Analects), see Legge, *Chinese Classics*, I, 196.

am living as an official in the capital city under this glorious dynasty when cultural refinement flourishes richly. As a petty official, I have made several journeys which have given me the honor of meeting able and worthy men in many places and, through conversation with them, I have learned special points about bamboo. I have also done my best in collecting pictures for several years. Of ink bamboos, I first saw works of Wang T'ing-yün [1151–1202] [and initially of his son, Wan-ch'ing]; ten years later I saw the works of Wen T'ung; and again, three years passed before I saw bamboo paintings in color by Hsiao Yüeh [early 9th century] and Li P'o. Since it was so difficult for me to get this far, how much more difficult must it be for poor scholars who live and study in retirement?

Whenever I was not occupied by official duties, I devoted myself to this art. The longer I devoted myself, the better I loved it. Heaven fulfills men's wishes! I traveled ten thousand miles: I ascended K'uai-chi [in Chekiang province], passed through Wu and Chu [Kiangsu and Hupei provinces], crossed over the Min Mountains and rivers, and went through forests in the south and east. Whenever I traveled, I looked only for "The Gentleman" [bamboo] and examined all its species most carefully, paying close attention to shapes and colors, conditions of growth and flourishing, age and quality.

A few years ago, through the far-reaching power of the court, I was sent to Chiao-chih [Annam]. There, deep in bamboo country, I examined strange species and classified a great number by analyzing their resemblances and differentiating their special features. Because I did not quite trust what had been written about bamboo, I took great pains in comparing and analyzing, until I forgot the distinction between myself and the bamboo. With regard to bamboo painting, I can say I have detected the wonderful skill and intention of men of old. Nevertheless, it is not easy to become versed in an art.

A *tz'u* poem says: "One who carves pictures and seals is not a great man." A commentary given in the dictionary *Erh-ya* says: "How could insects and fishes be magnificent?" A man who devotes himself to such a petty skill as painting may be decried by men of fame. Yet I love bamboo and feel happy with it; indeed my interest in it has grown into a passion. I fear that other people in the world who suffer from the same "disease" but are so far removed from antiquity will have no opportunity to gain knowledge about [painting] traditions; therefore, I have given here complete descriptions of the two perfect methods of Li P'o and Wen T'ung and have carefully written down what I have learned in former years. Withholding nothing, I have also given an account of what I have learned about things that should be

avoided in painting, hoping that people of future generations may not regret paying attention to this book . . .

Wen T'ung revealed the secrets [of bamboo painting] to Su Shih when he said: "When bamboo first comes into being, it is only an inch-long shoot, but its joints and leaves are all there. It develops from [shoots like] cicada chrysalises and snake scales to [stalks like] swords rising eighty feet, because this development was immanent in it. Now when painters do it joint by joint and add to it leaf by leaf, will this produce a bamboo? Therefore, in painting bamboo one must first have the perfected bamboo in mind. Then, when one takes up the brush and gazes intently, one will see what one wants to paint and rise hurriedly to pursue it, wielding the brush forthwith to capture what was seen. It is like the hare's leaping up when the falcon swoops. If it hesitates in the slightest, all will be lost."

Su Shih said: "Wen T'ung taught me in this way, and I could not achieve it. Now, if one knows how it should be done and cannot do it, one's inner and outer parts are not one; the mind and hand are not in accord. It is a fault stemming from lack of studying."

If Su Shih thought that he could not do it because he had not studied enough, what then of later people? They may know that bamboo painting does not consist of making it joint by joint and piling up leaves, but if they have not conceived the perfected bamboo in their minds, where could it come from? They covet the distant and lofty, trying to skip over preparatory stages, and give themselves up to emotion and personality. They sweep the brush to the east and daub it on the west, thus feeling that they have released themselves from the limits of brush and ink to attain naturalness. Therefore, one should proceed by each joint and leaf, considering the [proper] method and continuing to practice without fatigue. If one has truly gathered strength over a period of time, until one has reached [the point of] nothing coming from study, then one will have the confidence of a perfected bamboo within the mind. Only then can one grasp the brush to pursue it forthwith, seeking what one has seen [in the mind]. Otherwise, if one only grasps the brush to gaze fixedly [at the bamboo], what will one see that must be pursued? He who is able to follow the [proper] rules and standards will not create any defects of his own. Why should one be afraid of not accomplishing this? Even if one adheres too closely to the rules and standards [at first], after a time one will pass beyond them. However, he who is hasty and reckless will never, I fear, be able to grasp the rules and standards or accomplish anything. Consequently, the student must start from the rules. Only thus can he reach his goal . . .

Ink bamboo's composition is the same as in pictures with colored bamboo but, if the four elements of stems, joints, branches and leaves are not rendered according to the rules, it is simply a waste of effort, since the painting will never be complete. Generally, there are dark and light shades in mixing the ink, and a heavy or light manner of applying the brush. When moving it to and fro one must know the right directions, [the ink's] density or thinness, and [the stroke's] coarseness or delicacy, then one will see either luxuriance or aridity. In this way leaf after leaf is placed on the branches, and branch after branch on the joints. Huang T'ing-chien [1045–1105] said: "If the living branches do not correspond to the joints, then the leaves will be confused and not at the places where they belong." Each brush stroke must have a sense of life; each side must gain naturalness. The four sides must fit together completely; the branches and leaves must have the movement of life; only then is there a perfected bamboo.

Although there have been many bamboo painters in both past and present, few have gained a foothold in his methods. If they do not suffer from being too sketchy, they fail in excessive detail; or roots and stems are quite good but branches and leaves have faults; or compositions are more or less right but the front and back are wrongly arranged [spatially]; or leaves look like knife cuts; or bodies resemble stiff boards; their vulgarity and coarseness cannot be adequately described. Among them there may be some who differ from the ordinary types and they can probably achieve [a certain] beauty, but as to achieving excellence, I sincerely fear that they will never have the time to do so. Only Wen T'ung, a genius endowed by Nature, as well as a sage with innate knowledge, moved his brush as if aided by divinities to achieve subtleties in harmony with natural creation. He kept within the rules and yet roamed beyond the dusty world. He could indulge in all the desires of his heart without transgressing the rules. Therefore, I follow his methods, illustrating them with pictures, so that later students will not fall into vulgarity and crudity, but will know what their task should be.

> *Chu-p'u* (Manual of Bamboo), excerpts from author's introduction and treatises "On Painting Bamboo" and "On Ink Bamboo," the latter cited in *CKHLLP*, pp. 1051 and 1055.

Chao Meng-fu [1254–1322]

Rocks like the "flying white" [brush stroke], trees like the great seal script:

To sketch bamboo also demands conversance with the "Eight
 Methods" [of calligraphy].
If there should be one who is capable of this,
He must know that calligraphy and painting have one origin.

Poem on bamboo painting; cited in *CKHLLP*, p. 1063; see also Bush,
p. 139: text 228 (in part).

Wu Chen (1280–1354)

When I begin to paint I am not conscious of myself,
And suddenly forget about the brush in my hand.
If the butcher or wheelwright were to return,
Would they not recognize this feeling again? . . .

When Wen T'ung painted bamboo, he did not see bamboo;
When Su Shih wrote poetry, he was not aware of that poem;
The old Korean silk-floss paper has the chill of ice and snow,
So I playfully sketch a scene of wintry cold in cliffs and
 valleys . . .

The feelings in my heart cannot be stilled;
I lodge them in the criss-crossing of some bamboo
 branches . . .

How unyielding its joints [virtue] in the frost;
How preeminent its silhouette in moonlight;
If one knows the principle of the Void,
What cares can one harbor in the mind? . . .

I took ink to be a plaything,
And, on the contrary, through it became a slave.
If I had been careless [and not studied] at that time,
How could I now slave in obscurity? . . .

The truth of depicting bamboo lies first in ink play. Nevertheless,
to amuse oneself is more meaningful than any other activity. Now,
K'o-hsing [?] asks for my works. Though I, an old and useless man,
have been deeply involved [in bamboo] for fifty years, I have never
succeeded in achieving one perfectly satisfactory stroke. This is only
because of an inability to improve. You must work hard and long
until you can forget that you are using brush and ink, then you will
believe that my words are true.

Excerpts from *Mei-tao-jen i-mo* (Ink Remains from the Plum Taoist);
see Bush, pp. 132–133: texts 210, 211, 212, 209, 214.

K'o Chiu-ssu (1290–1343)

In sketching bamboo trunks, use the seal script methods; in branches use the "draft" script method; in leaves use the *pa-fen* [formalized clerical script] method or Yen Chen-ch'ing's [709–785] method of downstrokes to the left; in trees and rocks, use the traditional ideas of the "open hairpin" or "traces of leaks on the walls."

All who paint "kicking" branches ought to use the methods of the "running" script. Among the ancient experts, only the two masters Wen T'ung and Su Shih could do this. Wang T'ing-yün [1151–1202] from the North attained their manner and, in the present dynasty, Kao K'o-kung [1248–after 1310], Wang Wan-ch'ing [the son of T'ing-yün], and Chao Meng-fu, were not far from them. Those of the older generation have gone, and I alone seem to understand their interests.

Colophons on bamboo painting; cited in *CKHLLP*, p. 1064.

Ni Tsan (1301–1374)

Chang I-chung [?] always likes my bamboo paintings. I do bamboo simply to express the untrammeled spirit (*i-ch'i*) in my breast. Then how can I judge whether it is like something or not; whether its leaves are luxuriant or sparse, its branches slanting or straight? Often when I have daubed and rubbed awhile, others seeing this take it to be hemp or rushes. Since I cannot bring myself to argue that it is truly bamboo, then what of the onlookers? I simply do not know what sort of thing I-chung is seeing.

Colophon dated to 1368, quoted in the *PWCSHP*, Book 16; also see Bush, p. 134: text 216.

Prunus

Hua-kuang mei-p'u

A plum tree assumes its shape from the functioning of material force (*ch'i*). Its flowers of positive material force (*yang*) symbolize heaven; its trunk of negative material force (*yin*) symbolizes the earth. As a result, each of these has five representative numbers by which they are distinguished into odd and even to form all variations.

A stem, from which a flower comes, is symbolized by the Absolute (*t'ai-chi*) and is represented by a nail stroke. An ovary, from which a

flower emerges, is symbolized by the Three Powers (*san-ts'ai*) [heaven, earth, and man] and is represented by three dots. A calyx, from which a flower also comes, is symbolized by the Five Elements (*wu-hsing*) [metal, wood, water, fire, and earth] and is represented by five leaves. The stamens, from which a flower is formed, is symbolized by the Seven Cosmic Bodies (*ch'i-cheng*) [Mercury, Venus, Mars, Jupiter, and Saturn, or the five planets, plus the sun and the moon] and is represented by seven stalks. Fading, in which a flower realizes its end, is shown in the repeated numbers of the absolute and is represented by nine variations. All these elements from which a flower comes into being belong to the positive material force and are represented by odd numbers.

Roots, from which a plum tree originates, are symbolized by the two poles of the Absolute (*erh-i*) and are represented by two bodies. The trunk, from which a plum tree develops itself, is symbolized by the four seasons and is represented with four directions. Branches, from which a plum tree forms itself, are symbolized by the Hexagrams (*liu-yao*) and are represented by six constituents. Twigs, from which a plum tree prepares itself, are symbolized by the Eight Trigrams (*pa-kua*) and are represented by eight knots. The tree, in which the plum perfects itself, is symbolized by the full number and is represented by ten types. All these elements from which a plum tree comes into being belong to the negative material force and are represented by even numbers.

Furthermore, the flowers blooming in front of us are in the shapes of discs (*kuei*), all in the round. Those blooming with their backs towards us are in the shapes of rectangles (*chü*), all in the square. Drooping branches are in the shapes of discs, facing down as if to cover some vessels. Upturned branches are in the shapes of rectangles, rising up as if to hold something. So are the stamens. A full blooming flower is in the shape of old or mature positive material force, and so it has seven stamens. A fading flower is in the shape of old or mature negative material force, and so it has only six stamens. A half-blooming flower is in the shape of young positive material force, and so it has only three stamens. A flower bud is in the shape of the cosmos before the separation of heaven and earth. Though its body and stamens have not yet been formed, its principle (*li*) is already manifest. Thus, it is represented by one nail stroke and two dots, without the third dot, for with the heaven and earth not yet separated, the human essence (*jen-chi*) has not been established. However, a calyx is in the shape formed after heaven and earth have been settled. Thus, it is something that has taken its own shape rather than being formed by

Nature. From this those who know the process can carry it further . . .

A GENERAL DISCUSSION ON PAINTING PLUM BLOSSOMS. When the trunks are clear, then the blossoms should be thin; when twigs are delicate, then the flowers should be rich. On intertwined branches the flowers are abundantly strung together; on separated twigs the calyx, stamens, and pistils, are scattered.

First draw the tree [trunk], next the body [branches], and, lastly, the twigs. Make the long [branches] like arrows and the short like lances. When their "universe" is high, they intertwine to the top. If their space is narrow, they must not fill it.

In making several branches by the side of a precipice, with unusual branches and dispersed flowers, one needs only to show the plums half in bloom. In making them spread out by a breeze and washed by rain, with relaxed branches and elegant flowers, one needs to show only their separate brilliance. In making them veiled in mist and surrounded by fog, with tender branches and elegant blossoms, one needs only to show their smiling flowers overflowing the branches. In making those close to the wind and wrapped in snow, with old trunks and few branches, one must only spread the ink [to make] a light wash for limp blossoms. In making them frozen by frost and reflecting the sun, with deep voids and steep verticality, one only needs to show tiny flowers and a soothing fragrance. Students must know this.

There are various types of expression (*ko*) in plum blossoms. Some are sparse but graceful; some abundant but unyielding; some aged but fascinating; some clear but robust. How could they be of one kind? There are those that grow on mountain peaks; others in mountain valleys; those along fences; those along rivers and lakes. Their branches differ in density and in length. One must look into this.

> *Hua-kuang mei-p'u* (Blossoming Light's Prunus Album), traditionally attributed to Yang Wu-chiu (1096–1171) or the monk Chung-jen (active late 11th–early 12th century); cited in *CKHLLP*, pp. 1041–45.

Sung Po-jen (active ca. 1238–1261)

Having had an excessive fondness for plum blossoms, I cultivated a garden in which to plant them, built a pavilion from which to view them, and printed the *Ch'ing-chü chi* (Book of the Pure and Lean Flowers) with which to glorify them. However, I often regretted my inability to fathom all the subtle qualities (*ch'ü*) of the plum blossoms. Is this not similar to the case of my ancestor, the Venerable Sung Ching [663–737], who became earnestly interested in clouds because of his inability to explore fully the characteristics of plum blossoms

in his *T'ieh-shih-hsin-ch'ang fu* (Prose Poem on a Heart of Iron and Stone)?

When the plum blossoms bloom, my whole heart is as pure as frost and my shoulders are as cool as moonlight. I walk to and fro tirelessly about the bamboo fence and thatched hut; I smell the stamens, blow the petals, rub the fragrant parts, and chew the pollen. I also silently enjoy their various attitudes—lying low or stretching high, bending down or facing up, branching out or joining together, and folding up or opening wide. Their chilly attitudes reveal qualities of extraordinary purity and antique sublimity unspoiled by a single touch of mundane interests. How are they different from the two gentlemen of Ku-chu [the hermit brothers Po-i and Shu-ch'i of legend], the four hoary-headed hermits of Mount Shang [in the later 3rd century B.C.], the six recluses of Chu-hsi [including the poet Li Po in A.D. mid-8th century], the eight immortals of wine-drinking [also poets and scholars of the mid-8th century], the nine venerable old gentlemen of Lo-yang [thirteen scholars and poets of the 11th century], and the eighteen scholars of Ying-chou [members of the Hall of Literature in the 7th century], all of whom freed themselves from the bondage of the physical self as if they ate nothing of mortal food. Such people are totally different from those described in the *T'ao-hua fu* (Prose Poem on Peach Blossoms) or *Mou-tan fu* (Prose Poem on Peonies) [both now unknown].

Therefore, I depict the various features of plum blossoms, from their new buds to their full blooms, from their florescence to their decline. Altogether I accumulated more than two hundred paintings. After some time I culled those which were less appealing and kept only one hundred of them, each of which has its own attitude. I also wrote a poem in ancient [or regulated] form for each of them. Together they are entitled an "Album of Plum Blossoms."

Actually, the description of the joyful spirit of plum blossoms resembles that of peonies, bamboo, and chrysanthemum. With such models, this could be called a model book. Nevertheless, this book is different. I had them carved on woodblocks and printed as a book privately, with the intention of sharing my pleasure with lovers of plum blossoms. Using my leisure time to work on such unimportant business, I might be asked what it will do for our society. Will I be criticized for doing something worthless? Still, how can there not be some like-minded gentlemen who, when these flowers are not yet in bloom, would like to examine my book at their leisure in order to fill their minds with images stretching out diagonally on Mount Ku [like those viewed by the poet Lin Pu, 967–1028] or reflecting the loneliness

of Yang-chou, so that not a single day passes without their seeing plum blossoms and throughout their lives they will never forget these flowers.

I do not paint ink plum blossoms here for the sake of establishing them [as models], since we already have Chung-jen and Yang Wu-chiu with individual styles that are beyond my ability.

A friend said with a laugh: "This type of flower preserves 'whiteness' and collects 'fragrance.' Their yellow and red fruits can relieve the thirst of three armies [as they did in the campaign of Ts'ao Ts'ao, 155–220] and serve as an ingredient for the [delicious] 'golden tripod soup.' The writing of this book should, thus, inspire people to be loyal to their rulers and patriotic to their country, so that those who go out to serve as generals in the field or enter the court to serve as ministers of the land can straighten their girdles and hold erect their tablets in order to make the world as peaceful as Mount T'ai. Now, you are only interested in such scenes as half of a tree showing in the garden grove after snow or a diagonal branch thrusting out suddenly over the garden fence by the water. These are only themes composed in the cold. Why do you take the insignificant for the essential?" I rose and thanked him, saying: "I have the same idea, which is expressed on the last page of my book, entitled 'The Shang tripod waiting for its soup.' "[14] The friend clapped his hands and said joyfully: "Indeed, the printing of this album is not in vain. It is not a worthless effort for a worthless cause, without benefit for mankind. It should be publicized far and wide." I thus noted down these words for posterity.

> *Mei-hua hsi-shen p'u* (Album of the Joyful Spirit of Plum Blossoms), preface.

Chao Meng-chien (1199–ca. 1267)

> Sketch densely flowers and branches, sketch lightly the twigs.
> For scaly and wrinkled old trunks, the ink is slightly drier.
> The brush separates in three "kicking strokes" to form the
> petals.

14. Presumably this refers to the "golden [bronze] tripod soup" above, and reinforces the patriotic themes of loyalty to a dynasty and desire to be of service. The tripod (*ting*) is a bronze sacrificial vessel, emblematic of dynastic rule because of its importance in the time of the Shang Dynasty (16th to 12th centuries B.C.). A Shang ruler once compared his minister to the plum, like salt an essential ingredient in life-nourishing soup. For this and other references to plum lore, see William John Hoar, "Wang Mien and the Confucian Factor in Chinese Plum Painting," Ph.D. diss., University of Iowa, 1983, p. 91 ff.

Pearly iridescence shines over the whole picture, with skillful
 "pepper dots."
Delineate intricately the "bee's whiskers" and crystallize the
 "smiling dimples."
Draw firmly a long line to make a "mouse's tail."
When the wind first becomes strong, all are blown to one side.
As if branches were buried in half-dissolved snow.
With pines and bamboo surrounding them, they make light
 and dark patterns;
With water ripples appearing on the surface, they seem to
 float gracefully;
At twilight they cover the bright moon;
Against clear and shallow streams and mountains, they extend
 short bridges;
In crowdedness they lean against each other amicably;
In quietness they stand back to back in loneliness.
Even a drop of ink from the brush can form an ink-play;
As you move the brush freely across the scroll, there is no
 true depiction.
Yet you are suddenly aware of a finished work—spring in its
 abundance,
And you might then recall the places you once wandered
 about in a drizzle.
All in all, this is nothing more than the methods of Yang Wu-
 chiu and T'ang Cheng-chung.
How can those who follow spend but one morning's effort?

Colophon on a handscroll of bamboo and prunus dated to 1260; cited
in *CKHLLP*, pp. 1049–1050.

Wu Chen (1280–1354)

The making of ink plays is done by scholar-officials in the time left
over from their literary occupations when they indulge in their in-
terests of the moment. They are extremely unconventional in com-
parison with "professionals." In sketching plum blossoms and drafting
bamboo, Wen T'ung [1019–1079] and the monk Chung-jen displayed
excellent techniques, and at the time there were many who followed
them. Only Yang Wu-chiu changed black into white and made a new
departure. Although his followers [such as T'ang Cheng-chung, early
13th century] were supposed to have modeled themselves after him,
their skills were in formal likeness, and they forgot to return [to their

model], and so they gradually approached the professionals' "sketching from life" (*hsieh-sheng*) and considered it essential to bring out true resemblance. I once saw a poem by Ch'en Yü-i [1090–1138] on ink plum blossoms which said: "If the meaning is there, don't seek for outward likeness" . . .

> Inscription dated to 1348 on an ink prunus painting now in the Liaoning Museum; cited in *SKTSHHK*, II, Book 15; see Bush, p. 131: text 207.

Wu T'ai-su (active mid-14th century)

In the play with brush and ink by scholar-officials, excellence consists of the meaning (*i*) being there, not in the attempt to capture formal likeness. However, it is hard to do away with forms and have sufficient meaning, which is why this album was made. Generally, if representation does not conform to the [standards given in] such albums, where can one find a model? When, after long imitation, one's style is identical [with the model], and brushwork and meaning fuse, one leaves the "Competent" class and enters the "Inspired." Then, one can look on the album as a tool to be discarded.

Throughout my life I have been addicted to the plum tree. Whenever I saw its flowers by bridges over streams and mountain post stations, or by river paths and country pavilions, I had to walk around and gaze at them. When my mind had grasped them, my hand invariably responded. At this time, when self and things were both forgotten, and mind and aims both soared aloft, who could be concerned with the contents of an album? . . .

Connoisseurs often approved [of my work], but I did not presume to be satisfied and simply studied pictures of no less than ten thousand plum trees. Now, if I am slightly tipsy and my spirit is aroused, and I make a sketch in a state of exhilaration, it is certain to conform with the rules. If there was no album, how could I achieve this? . . .

ON THE SUBTLE PRINCIPLE OF THE PRUNUS. Sketching plum blossoms and making poems are essentially the same. In other words, as the ancients said: "Painting is soundless poetry and poetry, painting without sound." Thus, a painting's success in conveying ideas is comparable to a poem's having excellent verses. Whether they come from happiness and joy, or worry and sorrow; whether they come from excitement and agitation, or resentment and anger; they are all occasioned by the feelings of a moment. There are thirteen genres of painting, but blossoming plum is not in the list because its air of rising

above the world is beyond the scope of common people. Therefore, when it comes from happiness and joy, the branches are clear-cut and slender, and the flowers, poised and charming; when it comes from worry and sorrow, the branches are sparse and bare, and the flowers, haggard and chilled; when it comes from excitement and agitation, the branches are twisting and strong, and the flowers, unfettered and unbridled; when it comes from resentment and anger, the branches are antique and eccentric, and the flowers, wild and vigorous. Can this be a genre of painting? As an old poem says: "When feelings are depleted, mountains lack color; / When the mind is preoccupied, water is not clear." That is the meaning. If anyone wants to paint, he should elevate his feelings above all things. Let the conception precede the brushwork. This is what is meant by "whatever is ample inside, takes shape outside."

THE ESSENTIAL THEORY OF INK PRUNUS. Ancient and modern gentlemen who sketched plum blossoms instituted a new tradition that does not belong to any of the usual genres of painting. It is called "playing with ink," and by splashing ink one makes forms. When one is moved by inspiration, grasping it in the mind and responding to it with the hand, one then makes blossoming plums. If they grow near bamboo hedges or thatched cottages, on a river bank or by the side of a bridge over a stream, on top of a mountain or at the edge of water, they will only lack fragrance. Moreover, one cannot capture them by force; nor can one sing a poem about them. Their essence is lofty and independent, rising above the vulgarity of the world. In this way, plums are exquisite and divine. Unless a man is a worthy scholar-gentleman, how can he recapture this? If any later gentleman wishes to acquire this obsession, it should not be disclosed to him easily. If one finds the right man, then it can be transmitted . . .

A DISCUSSION OF THE PRINCIPLE. The scholar-officials of earlier times not only expressed [the plum's beauty] in words, but also brushed it in paintings. [Recently] only in the works of Chung-jen and Yang Wu-chiu was the originality overwhelming and the excellence profound. Unless they had grasped [the subject] in their minds and responded to it through their hands, they could not have done this. There is no other reason for it except that they fathomed the quintessence of creation and approached reality when they painted . . .

ON STUDYING LIKENESS. "If the meaning is there, do not look for outward likeness; / In a former life [the painter] judged horses as Chiu-fang Kao." This couplet describes one who has reached the zenith. On the other hand, there are many who study and do not do

well, who take this as an excuse. This is really laughable. Now, if one studies without seeking likeness, can this be called studying? Hence, I have written this simply in hopes of having other painters' opinions on it.

> *Sung-chai mei-p'u* (Album of Plums from the Pine Studio), excerpts from the preface and Books I and II; see Bush, pp. 142–145: texts 230, 233, 232, 236, 235, 234, 231.

Biographies of Painters, Critics, and Calligraphers
Glossary of Chinese Terms
Glossary of Chinese Names and Titles
Annotated Bibliography
Index

Biographies of Painters, Critics, and Calligraphers

AI HSÜAN (ACTIVE CA. 1068–1085). From Chin-ling (Nanking). A flower and bird specialist, he used watered pigments to create a sense of movement in a style that differed from the Academy tradition of the Huang family. His beaten-down grasses and thorns were said to give an effect of wildness, and he did refined paintings of quails. He was responsible for four single cranes in the Tzu-ch'en Hall screen done in collaboration with Ts'ui Po and others. *HS; HHHP*, 18; *THCWC*, Soper tr., pp. 66, 182 n. 548. *LCKCC*, "Hua chi." Cahill Index, 4. *TSHCJMTT*, pp. 54–55.

CHAI YÜAN-SHEN (EARLY 11TH CENTURY). From Ying-ch'iu (in Shantung province). He was a close imitator of Li Ch'eng's landscape painting and traced copies that created problems of authentication. *SCMHP*, 2; *HHHP*, 11; *THCWC*, Soper tr., pp. 58, 173 n. 503. *TSHCJMTT*, pp. 303–304.

CHAN TZU-CH'IEN (MID TO LATE 6TH CENTURY). From Po-hai (in Shantung province). Under the Sui (581–609), he was Honorary Grandee and Governor General of the Princes' Guard. He was particularly noted for his courtly landscapes, influential in early T'ang, but he also painted Buddhist images (on walls and paper), portraits, and horses. See *LTMHC*, 8, Acker tr. II, 195–196; also I, *passim*; Cahill Index, 1. *TSHCJMTT*, pp. 14–16.

CHANG CHI-PO (ACTIVE LATE 5TH CENTURY UNDER THE SOUTHERN CH'I DYNASTY). A muralist and a fan painter, he taught Ch'ü Tao-min, with whom he is grouped. In the T'ang dynasty, his handscroll entitled *Cultivating Fields for the Emperor* was recorded and described as being some thirty (Chinese) feet in length. *KHPL; LTMHC*, 7, Acker tr. II, 153–154. *TCHCJMTT*, pp. 20–21.

CHANG CHIEN (ACTIVE CA. 1125). Active in Hsiang-chung (Hunan province). A man of reclusive tendencies, he is said to have been an attendant (*tai-chao*) in the Han-lin Academy in Hui-tsung's reign. He was ordered to survey famous scenery in the south and paint a selected "Eight Views (of the Hsiao

and Hsiang Rivers)." Before his return, the Northern Sung capital (K'ai-feng) fell to the Jurchen. *THPC,* 3; *TSHCJMTT,* p. 252.

CHANG CHIH (ACTIVE CA. 150), TZU (T.) PO-YING, HAO (H.) YU-TAO. A calligrapher credited by later critics with the invention of the "modern cursive" script noted for its fluid interconnections, he was known in his time as Ts'ao-sheng, the Sage of Grass (or Cursive) Script. He is reported to have written at home on the silk that was to be used for making clothes and to have practiced daily by a pond that eventually turned into ink from the washings of his ink stone. *CKJMTT,* p. 941; also *LTMHC,* Acker tr. I, lv, 177.

CHANG HENG (78–139), T. P'ING-TZU. From Nan-yang (in Honan province). Best known as an astronomer and mathematician, he is also a distinguished writer. He graduated from the university at Lo-yang and was employed as a keeper of records in Nan-yang. In 107 he finished the *Liang-ching fu* (Prose Poem on the Two Capitals) which describes life under the Han Dynasty at Ch'ang-an and Lo-yang. He then entered imperial service and was mainly concerned with astronomical and meteorological records. There is a legendary story about his sketching a monster with his toes. *Hou-Han shu [ESSS],* 89. *LTMHC,* 4, Acker tr., II, 12–14. Also J. Needham, *Science and Civilization in China,* III; E. R. Hughes, *Two Chinese Poets.*

CHANG HSÜ (ACTIVE CA. 700–750), T. PO-KAO. From Wu (or Kiangsu province). A noted calligrapher, he and his follower Huai-su created the "wild cursive" style of rapid writing in which forms are exaggerated and strokes and characters are frequently connected. He served as chief of Civil Servants at Ch'ang-shu (in Kiangsu province). His calligraphy was often done while he was intoxicated, and then he would even use his hair dipped in ink as a brush. He claimed that his brush technique was inspired by the music of drums and flutes or the jostling rhythm of palanquin bearers, and that its spirit derived from Kung-sun Ta-liang's sword dancing. He was popularly called Tien, the Madman, or Ts'ao-sheng, the Sage of Grass (or Cursive) Script. *Hsin T'ang shu [ESSS],* 202. *CKJMTTT,* p. 931.

CHANG HSÜAN (ACTIVE FIRST HALF 8TH CENTURY). From Ch'ang-an (in Shensi province). He was considered the foremost painter of court scenes in his time. His favorite subjects were palaces and gardens, saddle horses, gentlewomen, and young nobles. He is said to have liked to paint women and babies, and his recorded pictures included *A Wet-Nurse Holding an Infant, A Rope Swing,* and *The Lady Kuo-kuo (Sister of the Imperial Concubine Yang) Setting Forth on an Excursion. TCMHL; LTMHC,* 9, Acker tr., II, 248–249. Cahill Index, 1. *TSHCJMTT,* pp. 241–242.

CHANG HUAI-KUAN (ACTIVE FIRST HALF 8TH CENTURY). From Hai-ling (in Kwangtung province). Between 713 and 742, he served as an official in the Han-lin Academy. He is the author of extant works on calligraphy and of *Hua-(p'in) tuan* (Judgments on Paintings), which is no longer extant as a whole but is evidently quoted in the *Li-tai ming-hua chi. TCMHL,* pref.; *LTMHC,*

Acker tr., II, 53–54 n. 44. *THCWC,* Soper tr., pp. 1, 114 n. 34. *CKJMTTT,* p. 975.

CHANG MO (3RD CENTURY). Known as a "Sage of Painting," he is said to have excelled in figure subjects. By the 9th century the following works were attributed to him: a screen, an image of Vimalakīrti (a legendary Buddhist layman), miscellaneous "plain" (ink monochrome) drawings, and a scroll of "Beating the Silk." *KHPL; LTMHC,* Acker tr., II, 30–31. *TCHCJMTT,* p. 28.

CHANG NAN-PEN (LATE 9TH CENTURY). Active in Ch'eng-tu (in Szechwan province). He was a painter of Buddhist temple murals, who was particularly noted for his mastery of fire in the flaming aureoles of tantric images. *ICMHL; HHHP,* 2; *HP; THCWC,* Soper tr., pp. 25, 135 n. 246. *TSHCJMTT,* pp. 254–255.

CHANG SENG-YU (ACTIVE LATE 5TH–MID 6TH CENTURY). From Wu-(hsien in Kiangsu province). The most prominent painter of dragons and Buddhist and Taoist subjects under the Southern Ch'i and Liang dynasties, he held several posts at the Liang court that may have been largely titular, including the post of keeper of paintings in the Chih-pi Pavilion. Around 495, on imperial command, he worked at the T'ien-huang Temple, where in addition to an image of the Vairocana Buddha he painted murals of Confucius and his ten disciples, which effectively protected the temple in the time of Buddhist persecutions. He executed many murals in the Buddhist temples constructed by Emperor Wu of the Liang (r. 502–550) and also did portraits from life of members of the imperial family and high officials. He has no individual biography in the dynastic histories, but there are two references to his paintings of specific subjects: one, a Buddhist image; the other, a portrait of a prince. His style remained influential through the 7th century. *HHP; LTMHC,* 7, Acker tr., II, 173–179. Also see *Liang shu* [ESSS], 54; *Nan shih* [ESSS], 53. *TCHCJMTT,* pp. 29–33.

CHANG SHAN-KUO (FIRST HALF 6TH CENTURY, UNDER THE LIANG DYNASTY). Chang Seng-yu's son. He imitated his father's art but did not equal it. In T'ang times scrolls of Buddhist subjects under his name were still extant, as well as temple murals done jointly with his brother. *CKKSHS; LTMHC,* 7, Acker tr., II, 179. *TSHCJMTT,* p. 32.

CHANG (SUN, T.) T'UI-KUNG (H. CHUNG-MIN, CH'I-YÜN). Yü Chien-hua suggests that Chang T'ui-kung, the unidentified author of *Mo-chu chi* (Record of Ink Bamboo), is Chang Sun (late 13th to early 14th century?), from Wu-chün (in Kiangsu province). A contemporary of Li K'an, he was known for his ink bamboos done in the outlined method; his landscapes after Chü-jan were less successful. *THPC,* 5; Yü, *CKHLLP,* II, 1062; *Yüan Index,* p. 1089.

CHANG TSAO (MID TO LATE 8TH CENTURY), T. WEN-T'UNG. From Wu-(hsien in Kiangsu province). A literary figure who excelled at painting pines and rocks, and landscapes, he used the "broken ink" *(p'o-mo)* technique presumably to define his subjects in a series of initial washes or strokes. His paintings

were widely acclaimed in the capital, Ch'ang-an. Certain high officials rec-
ommended him to the positions of Acting Auxiliary Secretary in the Bureau
of Sacrifices and Assistant Functionary for the Salt and Iron Monopoly. He
was later demoted to Sub-Prefect of Heng-chou (in Hunan province) and
then transferred to Chung-chou (in Szechwan province). Most of his paintings
were destroyed in contemporary uprisings, and his treatise on art, *Hui-ching*
(Realm of Painting), is no longer extant. *TCMHL; LTMHC,* 10, Acker tr., II,
283–285. *TSHCJMTT,* p. 243.

CHANG TSE (5TH CENTURY UNDER THE LIU-SUNG DYNASTY, 420–478). Noth-
ing is known of him except that he was considered an original painter by
Hsieh Ho. *KHPL; LTMHC,* 6, Acker tr., II, 146.

CHANG TUN-CHIEN (ACTIVE EARLY 9TH CENTURY). From Ch'ing-ho (in Hopei
province). As a young painter at the T'ang capital, Ch'ang-an, in 803, he
showed the poet Po Chü-i some ten scrolls of landscape and trees, atmospheric
views, birds and animals, barbarians and amusements, and flowers and insects.
He was also a connoisseur and collector. *TSHCJMTT,* p. 244; see Bush, pp.
65–66. Also *LTMHC,* 3, Acker tr., I, 238.

CHANG TUN-LI (ACTIVE CA. 1068–CA. 1102). From Pien-liang (K'ai-feng, Honan
province). A military official, he married the daughter of the former emperor
Ying-tsung in 1068 and held posts at court. Around 1102 he became Regional
Military Commissioner for the Pacification of Remote Territories; he died in
service and was rewarded with a posthumous title. According to the 14th
century critic T'ang Hou, he excelled at painting historical figures in the style
of Ku K'ai-chih and Lu T'an-wei. Later writers confused him with the 12th
century Li T'ang follower, Chang Hsün-li. *Sung shih [ESSS],* 464; Sung Index,
pp. 2410–2411. *TSHCJMTT,* pp. 250–251. Compare Sung Index, p. 2401;
TSHCJMTT, p. 255; Cahill Index, 4.

CHANG YEN-YÜAN (CA. 815–AFTER 875), T. AI-PIN. From Ho-tung (in Shansi
province). The best-known T'ang writer on art, he was the editor of the *Li-
tai ming-hua chi* (Record of Famous Painters of All the Dynasties) which is
dated to 847 in a section of the first chapter. From a family of high officials,
he was educated in calligraphy and painting through studying the collection
of his grandfather, Hung-ching. Around 947 he was promoted to Auxiliary
Secretary in the Ministry of Sacrifices, and, after 874, became a Minister in
the Grand Court of Appeals. Sometime after 847 he compiled the *Fa-shu yao-
lu* (Essential Records of Calligraphy Exemplars), a collection of writings on
calligraphy from Later Han through T'ang that is still extant. *Chiu T'ang shu*
[*ESSS*], 129; *Hsin T'ang shu,* 127; *CKJMTTT,* p. 943. Also *LTMHC,* 1 & 9,
Acker tr., I, 132, 136 ff.; II, 239. *TSHCJMTT,* p. 242.

CHAO CHUNG-I (FIRST HALF 10TH CENTURY). Toward the end of T'ang his
family fled from the capital, Ch'ang-an, to the state of Shu (Szechwan prov-
ince), where he served as painter-in-attendance in the Academy at Ch'eng-
tu and painted temple murals. In the family tradition, he specialized in Buddhist

and Taoist demonic divinities and architectural subjects. *ICMHL; THCWC,* Soper tr., pp. 35, 148 n. 360. *TSHCJMTT,* pp. 308–309.

CHAO HSI-KU (ACTIVE CA. 1195–CA. 1242). From I-ch'un (Yüan-chou in Kiangsi province). A member of the Sung imperial family mentioned in the genealogical tables of the dynastic history, he is the author of the connoisseur's manual, the *Tung-t'ien ch'ing-lu chi* (Compilation of Pure Earnings in the Realm of the Immortals) which was written around 1242 when he was in retirement at the Southern Sung capital. In it he mentions holding office at Ch'ang-sha in the era of 1195–1201 and returning to I-ch'un in 1240, when he may have begun to write. *CKJMTTT,* p. 1397. See *Sung shih,* 217; *TTCLC,* 9.

CHAO LING-JANG (CA. 1070–CA. 1100), T. TA-NIEN. A fifth-generation descendant of the founder of the Sung dynasty. Active at the Northern Sung capital (K'ai-feng). He reached the military rank of Ch'ung-hsin Army Deputy Regional Commandant and Supervisor and was posthumously enfeoffed as a duke. A collector of early pieces of calligraphy and paintings, he preferred the arts to the usual pastimes of the nobility and was exceptionally skilled at draft script. In painting, he was noted for his scrolls of river views and for small scenes of hills and bamboo clumps after his famous contemporary Su Shih. Chao's snowscenes were said to be done in the manner of the T'ang poet-painter Wang Wei, and his first paintings as a youth were inspired by Tu Fu's verse on the 8th century landscapes of Wei Yen and Pi Hung. A fan painting by Chao was highly praised by Emperor Che-tsung (r. 1068–1086) and other works received more guarded praise from the poet Huang T'ingchien. *HHHP,* 20; *HC,* 2, tr. in part in Sirén, II, 71–72. Cahill Index, 4. *TSHCJMTT,* pp. 314–316. Sung Index, p. 3444.

CHAO MENG-CHIEN (1199–CA. 1267), T. TZU-KU, H. I-CHAI. From Hai-yen (in Chekiang province). An eleventh-generation descendant of the founder of the Sung dynasty, he received a classical education and passed the *chin-shih* examination in 1226. He served in several minor posts near the capital, becoming frustrated with official life, but in the 1260s became a Han-lin Academician and then Prefect of Yen-chou. A skilled writer, he was the friend of leading literati at the capital such as the poet Chiang K'uei and the collector Chou Mi, and literary anecdotes emphasize his exceptional personality. In painting he specialized in ink trees and flowers, and probably was the first to paint the plum, bamboo, and pine together in the scholarly theme of "The Three Friends of Wintertime." He is particularly noted for long scrolls of narcissus, outlined in light ink in the *pai-miao* manner. He is said to have carried on Yang Wu-chiu's tradition of painting blossoming plum, which is described in poetic prose in his *Mei p'u* (Prunus Album). Sung Index, pp. 3518–3519; *Sung Biog.,* 2. *THPC* 4. Cahill Index, 4. *TSHCJMTT,* pp. 329–331.

CHAO MENG-FU (1254–1322), T. TZU-ANG, H. SUNG-HSÜEH AND OU-PO. From Hu-chou (in Chekiang province). A descendant of the first Sung em-

peror and a cousin of Chao Meng-chien, he became the most famous callig-
rapher and painter of the early Yüan dynasty. He received a classical education
in the imperial college at Hang-chou and held a minor post under the Sung
dynasty before retiring on its fall to Wu-hsing where he studied, wrote, and
painted. In 1286 he was invited by Khubilai Khan to serve at the Mongol
court and was initially attached to the Board of War. In 1295 he returned to
Wu-hsing with a collection of old paintings, and thereafter was in and out of
office, eventually becoming Governor of the regions of Kiangsi and Chekiang
and serving in the Han-lin Academy. He was awarded posthumous titles.
During his life he played the role of a patron of the arts as well as their chief
practitioner. In his calligraphy, he was influenced by Wang Hsi-chih and the
styles of Six Dynasties steles carved in the north. In painting, he also synthe-
sized earlier modes and stressed the essential "sense of antiquity" as the key
to scholars' art. His animal and figure paintings look back to the T'ang dynasty,
and after 1295 his landscapes and pines and rocks reflect the influences of
both the Li Ch'eng-Kuo Hsi and the Tung Yüan-Chü-jan traditions. His
brilliance as a calligrapher is particularly evident in paintings of bamboos and
rocks. A wife and son were both accomplished painters. *Yüan shih* [*ESSS*],
172. *THPC*, 5. Cahill Index, 6. See Li, *Autumn Colors*, pp. 11 n. 1, 18–20, 22.

CHAO PO-CHÜ (CA. 1120–CA. 1162), T. CHIEN-LI. A seventh-generation de-
scendant of the founder of the Sung dynasty. He followed the court to Hang-
chou on the fall of Northern Sung in 1127. There, as related by a friend of
his great-grandson (Chuang Su in *HCPI*), an official happened to present
one of Chao's paintings to Emperor Kao-tsung, who then summoned the
artist and treated him as a relative who had undergone hardship, giving him
the military post of Director of Soldiers and Horses for East Chekiang. Chao
died in office, and hence left few works behind. He was particularly known
for his "green and blue" landscapes with elegant figures in courtly settings,
but he also did flower and bird paintings as well as a scroll of junipers and
garden rocks. His paintings were usually small in scale, but Kao-tsung once
ordered him to paint a screen for a palace hall and richly rewarded him.
Chao's style was perpetuated for a while by his brothers and a few followers.
HC, 2; *HCPI*, 1 (see Bush, p. 96). *Sung Biog.*, 2; Cahill Index, 4. *TSHCJMTT*,
pp. 324–326.

CHAO YÜN-TZU (LATE 10TH CENTURY). Active in Shu (Szechwan province).
Known only by his nickname "Cloud-like," which indicates a boisterous tem-
perament, he was a Taoist recluse noted for his figure paintings of Taoist
Immortals done in a broad, sketchy manner. *THCWC*, Soper tr., p. 48.
TSHCJMTT, pp. 310–311.

CHAO YUNG (CA. 1289–CA. 1362), T. CHUNG-MU. Son of Chao Meng-fu. He
held office as an attendant in the (library of the) Hall for Assembling the
Sages and as a Co-Administrator in the Administration of Hu-chou Prefec-
ture. In the family tradition, he followed Tung Yüan in landscape painting
and also did bamboo and rocks. He was especially good at figures and horses

and noted for his calligraphy in regular and seal scripts. *THPC*, 5; *CKHCJMTTT*, p. 614. Cahill Index, 6.

CH'AO PU-CHIH (1053–1110), T. WU-CHIU, H. CHING-CH'IEN, KUEI-LAI-TZU. From Chü-yeh (in Shantung province). From a literary family, he was noted as a poet and a disciple of Su Shih, the great Sung writer. Su praised his poetic descriptions, written at the age of sixteen or seventeen, of the scenery near Hang-chou. In 1079 Ch'ao placed first in the *chin-shih* examination and in examinations for the various boards held at the capital, K'ai-feng, and became a friend of the prominent poets of the time. He had a long official career, serving in different provincial posts as well as working at the capital as a Staff Author in the Imperial Archives for some fifteen years. Taking the poet T'ao Ch'ien as a model, he eventually retired and constructed a Kuei-lai (Returning Home) garden, where he studied and wrote and painted. His sketch of the concept (*i*) for a *White Lotus Society* handscroll, which was finished in color by the professional artist Meng Chung-ning, was much copied. In it Buddhist images, figures and pavilions, trees and landscapes, and animals were painted in the styles of specific T'ang and Sung masters. He died when he was on the way to take up office again. *Sung shih*, 444; Sung Index, pp. 1953–54; *Sung Biog.*, 1. *HC*, 3. Cahill Index, 4. *TSHCJMTT*, pp. 166–167.

CH'AO YÜEH-CHIH (1059–1129), T. I-TAO, H. CHING-YÜ. From Ch'ing-feng (in Hopei province). A cousin of Ch'ao Pu-chih, he received the *chin-shih* degree in 1082, and was recommended by Su Shih on the basis of his writings, but between 1086 and 1093 he was removed from a provincial post because of tax registering policies. Toward the end of his life he was employed in the Imperial Archives and appointed to the Han-lin Academy. He was well read, versed in calligraphy, and good at painting and poetry. His paintings were of small landscapes and birds, and in particular of autumnal scenes with geese such as that described in Huang T'ing-chien's poem on his *Snow Geese*. He is said to have caught the realistic aspect of these scenes as well as their mood. Sung Index, pp. 1954–55; *CKWHCTTT*, #2197. *HC*, 3. Cahill Index, 4. *TSHCJMTT*, p. 167.

CH'EN CH'ANG (11TH CENTURY). From Chiang-nan (the area south of the Yangtze). He did trees and rocks in the "flying white" calligraphic technique and cut, flowering branches in ink and colors. The only record of his work is Mi Fu's appreciation in *HS*, #144, Vandier-Nicolas tr., pp. 122–123.

CH'EN HUNG (8TH CENTURY). From K'uai-chi (in Chekiang province). A court painter who excelled in portraits, he was summoned to the palace by Hsüan-tsung (r. 713–756). In 727 he worked on the collaborative picture of the imperial troops lined up at the Golden Bridge in Lu-chou (Shansi province) on the Emperor's return from sacrificing at Mount T'ai, and depicted the Emperor on his favorite horse, White Shining Night. Ch'en carried on Ts'ao Pa's tradition of horse painting and also did scenes of hunting and court dancing. In portraiture he followed Yen Li-pen and painted Hsüan-tsung and his family in a procession of worshippers in a Taoist mural in the Hsien-i

Temple at the capital. He was continually summoned to do portraits of Hsüan-tsung and of his successor Su-tsung (r. 756–763). Ch'en held a military post at court and possessed an extensive collection of paintings. *TCMHL; LTMHC*, 9, Acker tr., II, 263–264; also I, 275. *THCWC*, Soper tr., p. 76. Cahill Index, 1. *TSHCJMTT*, pp. 229–230.

CH'EN SHAN (ACTIVE CA. 1174–1189), T. CHING-FU, H. CH'IU-T'ANG. From Fu-chou (in Fukien province). A man of outstanding talents of the early Southern Sung period, he left behind a literary collection as well as the extant *Men-se hsin-hua* (New Discussions on Killing Lice), an encyclopedic work written from a pro-Buddhist point of view that denigrated the writings of Su Shih and the conservatives. Ch'en Shan is presumably not the early Southern Sung painter of this name who specialized in birds and flowers thought to be better than the works of Sung professionals. Sung Index. p. 2482. *CKWHCTTT*, #2425.

CH'EN SHAN-CHIEN (LATE 6TH–EARLY 7TH CENTURY). From Wu (or Kiangsu province). A figure painter under the Sui dynasty (589–617), he took Cheng Fa-shih and Yang Tzu-hua as his models. By T'ang times his copies and tracings often passed as originals by the two sixth century masters. *CKKSHL; LTMHC*, 8, Acker tr., II, 203–204. *TCHCJMTT*, pp. 26–27.

CH'EN SHIH-TAO (1053–1101), T. LU-CH'ANG, WU-I, H. HOU-SHAN. From Hsü-chou (in Kiangsu province). A poet and a disciple of Su Shih, he was already recognized as a unique talent by the age of sixteen or so. From a family of scholar-officials, he received a good classical education and on the merit of his writings was recommended to teaching positions in the provinces and in the capital by Su Shih and others in the era 1086 to 1093. After resigning from such a post, he was eventually summoned to be a provincial secretary. A man of high integrity, he accepted his humble circumstances, but died prematurely of exposure to cold at a celebration of the winter solstice at the capital, where he refused the fur garment offered by a relative of a different political persuasion. The T'ang poet Tu Fu was his model, and a collection of Ch'en's poetry is extant. *Sung shih*, 444; Sung Index, pp. 2607–08. *CKWHCTTT*, #2178.

CH'EN SHU (LATE 8TH CENTURY). From Yang-chou (in Kiangsu province). As a follower of Pien Luan, he painted birds and flowers, excelling in coloring. *TCMHL; LTMHC*, 10, Acker tr., II, 290.

CH'EN T'AN (LAST HALF 8TH CENTURY), T. HSÜAN-CH'ENG. A descendant of an early T'ang Secretary of State, he passed the examinations in classics and served in several administrative posts. In 798 he became Prefect of Heng-chou (in Hunan province) (or Lien-chou [in Szechwan province]), then Im-perial Planning Commissioner for Yung-chou (in Kwangsi province) as well as a Vice-President of the Tribunal of Censors. He painted landscapes of the border regions on imperial command. *TCMHL; LTMHC*, 10, Acker tr., II, 285–286. *TSHCJMTT*, p. 230.

CH'EN YÜ (D. 1275), T. CHUNG-WEN, H. TS'ANG-I. From Ch'ung-jen (in Kiangsi province). Under a special imperial decree for commoners, around 1253 he expounded on texts at the Lecture Hall of the Eastern Palace and was attached to the Ch'i-hsi Hall to compose verses on imperial command. A collection of his writings is extant. Sung Index, p. 2458; *CKWHCTTT* #2977.

CH'EN YUNG-CHIH (EARLY 11TH CENTURY). A native of Yen-ch'eng in Ying-ch'uan (in Honan province). Made a painter-in-attendance in the Northern Sung Academy in the era 1023–1032, he is said to have resigned from a collaborative project of temple murals in 1034 and returned home, where he was much sought after for paintings but only produced a few at his own pleasure. He was a skillful painter of Buddhist and Taoist subjects, men and horses, landscapes and trees, unsurpassed in fineness of details if overly comprehensive and meticulous. *SCMHP; HHHP*, 11; *THCWC*, Soper tr., pp. 53, 168 n. 475. Cahill Index, 4. *TSHCJMTT*, p. 232.

CHENG CH'IEN (D. CA. 761), T. JO-CHI. A native of Cheng-chou (in Honan province). He was a great scholar, knowledgeable in the fields of geography, astronomy, pharmacology, and military history, as well as a noted practitioner of calligraphy, poetry, painting, and lute-playing. He wrote and illustrated some of his poems as a present for Hsüan-tsung, who praised this combination of the arts as the "Three Perfections of Cheng Ch'ien." In 750 he became a Scholar of the Hall of Literary Expansion, a literary academy that the Emperor established especially for him. Around this time, when poverty led him to practice writing on persimmon leaves, he was a drinking companion of the poets Tu Fu and Li Po. During the rebellion of 756 he was forced to accept office, and hence was later sent into exile where he died. He is said to have been good at landscape painting. *Hsin T'ang shu*, 202; William Hung, *Tu Fu*, p. 66. *TCMHL; LTMHC*, 9, Acker tr., II, 258–259; *THCWC*, Soper tr., p. 80. Cahill Index, 1. *TSHCJMTT*, p. 341.

CHENG FA-SHIH (LATE 6TH–EARLY 7TH CENTURY). Active in Ch'ang-an (in Shensi province). Toward the end of Northern Chou (557–581), he held the posts of Grand Governor-General, Auxiliary Ministerial Vice-President of the Left, and Model General, and was also enfeoffed as a viscount. Under the Sui he had the rank of Honorary Grandee. In the style of Chang Seng-yu, he did portraits of scholars and nobles, and painted beautiful women in gardens and court settings. He was responsible for several murals in Ch'ang-an temples, and his followers included Ch'en Shan-chien and Yen Li-pen. *LTMHC*, 8, Acker tr., II, 196–197. Cahill Index, 1. *TCHCJMTT*, pp. 41–42.

CHENG KANG-CHUNG (1088–1154), T. HENG-CHUNG, H. PEI-SHAN. From Chin-hua (in Che-kiang province). He gained a *chin-shih* degree in 1132 and held an administrative post as an Imperial Vice-Commissioner in the frontier region of Shu (Szechwan province). His drastic measures for governing were approved, but eventually he was dismissed because of the severity of his administration. He was shifted to other provincial posts and then exiled to Feng-chou (in Kwangtung province) where he died after many years. Several

works of his collected writings are extant. *Sung shih,* 370; Sung Index, pp. 3702–04; *CKWHCTTT,* #2347.

CHI CHEN (11TH CENTURY). He was a very close follower of the great early Sung landscapist Fan K'uan. *THCWC,* Soper tr., p. 59.

CHIA SHIH-KU (ACTIVE CA. 1130–1160). From K'ai-feng (in Honan province). A figure painter, who served as painter-in-attendance in the Southern Sung Painting Academy at Hang-chou, he studied Li Kung-lin's *pai-miao* technique of using outlining alone for definition and painted Buddhist images and secular recluses. *THPC,* 4. Cahill Index, 4. *TSHCJMTT,* pp. 284–285.

CHIANG SHAO-YU (D. 501). From Po-ch'ang (Po-hsing, in Shantung province). A versatile technician known for his skill in drawing and stone engraving, he was rewarded with official posts despite a lack of scholarly education and is one of the few recorded painters of the Northern Wei dynasty (368–534). He first served at Ta-t'ung (Shansi province) as a soldier and then became a professional scribe, gaining a post in the Imperial Grand Secretariat. Ultimately he held four offices concurrently: Grand Engineer in Charge of the Supervisorate of Works, Vice-President of the Court of Imperial Sacrifices, General of the Front (Guard), and Commissioner in Charge of Control of Waters; he was rewarded with posthumous titles. His achievements included establishing the style of court costumes, designing and remodeling palace halls, and planning the new capital and the imperial water-ways at Lo-yang (in Honan province). *Hou-Wei shu [ESSS],* 91; *BMFEA,* 32 (1960), 59–60. *LTMHC,* 8, Acker tr., II, 187–188. *TCHCJMTT,* pp. 42–43.

CHIANG SHEN (CA. 1090–1138), T. KUAN-TAO. From Ch'ü-chou (in Chekiang province). Classified as a recluse in *Hua-chi* 3, he is said to have been just on the point of being presented at court when he died. He was known for his pale landscapes in the manner of Tung Yüan and Chü-jan and also for paintings of water buffaloes. *HC,* 3; *THPC,* 4. Cahill Index, 4. *TSHCJMTT,* p. 57. Sung Index, p. 524.

CH'IEN HSÜAN (B. CA. 1235–D. AFTER 1301), T. SHUN-CHÜ, H. YÜ-T'AN. From Wu-hsing (in Chekiang province). One of the "Eight Talents of Wu-hsing" and an associate of the younger Chao Meng-fu, Ch'ien was a *chin-shih* degree graduate of 1262 known for his classical learning but did not hold office under the Mongols. He evidently painted under the influence of drink and frequently changed his artistic names to guard against imitations being passed off as his works. His figure paintings were after Li Kung-lin; his landscapes in the "blue and green" style, after Chao Po-chü; and his flowers and birds, after Chao Ch'ang but in a new manner. *THPC,* 5. Cahill Index, 6; J. Cahill, "Ch'ien Hsüan and His Figure Paintings," *ACASA* 12 (1958), 11–29.

CH'IEN KUO-YANG (ACTIVE 713–742). He was a well-known portrait painter who was also noted for doing flowering trees. *TCMHL; LTMHC,* 9, Acker tr., II, 231. *TSHCJMTT,* p. 371.

CHIN MING-TI (THE CHIN EMPEROR MING, SSU-MA SHAO) (299–325), T. TAO-CHI; TITLE: SU-TSUNG (R. 323–324). The eldest son of the Emperor Yüan (r. 317–322) by a concubine, he was noted for his precocious intelligence, his interest in literary and martial studies, his love of metaphysical discussions, and his skill in technical matters. He studied calligraphy with Wang I, whom he treated with great respect. He also was particularly good at painting Buddhist icons and was knowledgeable about connoisseurship. Among the paintings attributed to him in T'ang texts were illustrations to the Mao text of the *Book of Songs*, to texts on *Famous Women*, to the "Prose Poem on the Nymph of the Lo River," and "Excursion on the Pure Lake" (of the Shang-lin Park of the late 3rd century B.C. capital). *Chin shu* [*ESSS*], 6; also see 77. *SSHY*, Mather tr., p. 568. *KHPL; LTMHC* 5, Acker tr., II, 24–28. *TCHCJMTT*, p. 7.

CHING HAO (LATE 9TH–EARLY 10TH CENTURY), T. HAO-JAN, H. HUNG-KU-TZU. From Ch'in-shui (near K'ai-feng, in Honan province). The most famous landscapist of the early Five Dynasties period, he was a Confucian scholar with a good classical education who served in a minor post until the fall of the T'ang dynasty in 907. Thereafter he retired to the Hung-ku valley of Mount T'ai-hang (in northern Honan) where he presumably lived by farming: hence his literary name. Sometime between 895 and 907 he was commissioned to paint a mural of the "Kuan-yin of Mount Potalaka" at the Shuang-lin Monastery in K'ai-feng and about this time may have taught landscape painting to Kuan T'ung. Later at the request of a monk he painted six screens with mountains, streams, pines, and rocks for a monastery at Yeh-tu (Ta-ming, in Hopei province). He described his approach to painting pines in the *Pi-fa chi* (A Note on the Art of the Brush), alternatively entitled *Hua shan-shui chüeh* (Secrets of Painting Landscape). *WTMHPI; HHHP*, 10; *HS; THCWC*, Soper tr., pp. 6, 26, 136 n. 260. *Sung Biog.*, 2; Cahill Index, 2. *Ching Hao's "Pi-fa chi,"* Munakata tr., pp. 50–56 (hereafter cited as *PFC*). *TSHCJMTT*, pp. 164–166.

CHOU CHAO (LATE 11TH CENTURY–EARLY 12TH CENTURY?). Said to be a painter-in-waiting in the late Northern Sung Painting Academy, he specialized in dogs, doing puppies in playful attitudes amidst bamboo and rocks. *HC*, 7; *TSHCJMTT*, p. 143.

CHOU FANG (B. CA. 730–D. CA. 800), T. CHUNG-LANG, CHING-YÜAN. From Ch'ang-an (in Shensi province). Known as the best portrait painter of his time, he was of noble birth and reached the rank of Administrator-in-Chief in the prefecture of Hsüan-chou (in Anhui province). He started painting human figures and Buddhist subjects for the aristocracy, initially following Chang Hsüan but soon developing his own style. He was famous for doing beautiful women of high rank but also painted Buddhist murals at Ch'ang-an such as the new type of "Water and Moon Kuan-yin" executed for the Sheng-kuang Temple. *TCMHL; LTMHC*, 10, Acker tr., II, 290–292. Cahill Index, 1. *TSHCJMTT*, pp. 136–138.

CHOU MI (1232–1298), T. KUNG-CHIN, H. TS'AO-CH'UANG. Lived at Wu-hsing and Hang-chou (in Chekiang province). A writer and collector, he was from a family of scholar-officials that had fled south after the Chin dynasty took over North China in 1126. He served as an official in Nanking and I-hsing (in Kiangsu province) and later at Hang-chou, but retired as a loyalist after the Southern Sung capital fell to the Mongols in 1276. Saddened by its fall and the loss of his home at Wu-hsing in 1277, he lived with a relative at Hang-chou and devoted himself to writing and connoisseurship. He is known as a poet and chronicler of life at the end of Southern Sung and also as a calligrapher and amateur literati painter. He was a close friend of several important artistic figures, Chao Meng-fu in particular. Among his extant writings is *Yün-yen kuo-yen lu* (Record of What Was Seen as Clouds and Mists), which lists the major collections that he viewed in the region. Sung Index, pp. 1446–47; *Sung Biog.,* 1. *THPC,* 5; *TSHCJMTT,* p. 144.

CHOU TSENG (EARLY 12TH CENTURY). A Northern Sung academy painter who is said to have been somewhat better than his contemporary Ma Fen. Besides doing small scenes with autumn birds, Chou painted long landscape scrolls. *HC,* 7; *TSHCJMTT,* p. 143.

CHU CHING-HSÜAN (9TH CENTURY). From Wu (Kiangsu province). He was a scholar in the Han-lin Academy and the author of the *T'ang-chao ming-hua lu* (Record of Famous Painters of the T'ang Dynasty), composed around 840. He may also have been the writer Chu Ching-yüan (an alternative version of the name) active during 841–846, who served in the Crown Prince's household and left behind a recorded collection of poetry in one scroll. *CKJMTTT,* p. 261; see *CKWHCTTT,* #1588, *Hsin T'ang shu,* 60, p. 1614.

CHU HSI (1130–1200), T. YÜAN-HUI, CHUNG-HUI. Born at Hui-chou (in Fu-kien province). A famous Neo-Confucian philosopher, he was also a states-man, historian, poet, and literary critic. He received a *chin-shih* degree in 1148 and held official positions such as district keeper of records and prefect under four emperors. But as an outspoken critic of the administration's policies he was usually out of office; he obtained the post of temple guardian so that he would be able to study, write, and discuss his ideas. His synthesis of Neo-Confucian thought, proscribed as a "false learning" in the late 1190s became the new orthodoxy after his death. In the realm of painting, apart from his opinions on portraiture there was a small self-portrait in Wu Tao-tzu's style transmitted through wood-block printing that was attributed to him. *Sung shih,* 429; Sung Index, pp. 587–597; *Sung Biog.,* 1. *TSHCJMTT,* p. 61.

CHU HSIANG-HSIEN (ACTIVE CA. 1094–1100), T. CHING-CH'U, H. HSI-HU YIN-SHIH. From Sung-ling (in Chekiang province). In his youth he studied Tung Yüan and Chü-jan's landscapes, but then evidently created his own style by applying wash heavily, at times with grit, to achieve effects of lighting and texture. He also did large screens. *HC,* 4. Cahill Index, 4. *TSHCJMTT,* pp. 59–60. Sung Index, p. 617.

CHU SHEN (LATER 8TH CENTURY). From Wu-hsing (in Chekiang province). Well-known around 780 as a landscape painter, he also did the subjects of bamboos and trees, pines and rocks, and eminent Buddhist monks. He painted on scrolls and temple walls and had a reputation in the south and at the capital, Ch'ang-an. *TCMHL; LTMHC*, 10, Acker tr., II, 277. *TSHCJMTT*, p. 58.

CHU TUN-JU (1081–1159), T. HSI-CHEN, H. YEN-HO. From Lo-yang (in Honan province). He moved south at the end of Northern Sung, was granted a *chin-shih* degree in 1135, and served in the judicial system in the region of Eastern Chekiang. He was a skilled poet and song writer and a good landscape painter. His paintings became known in high circles and were presented to Kao-tsung, who was appreciative. But Chu denied the authorship of these works in order not to have to paint, for advancement as it were, before the Emperor along with Mi Yu-jen. *Sung shih*, 445; Sung Index, pp. 615–616. *HC*, 3; *TSHCJMTT*, p. 60.

CHÜ-JAN (ACTIVE CA. 960–980). From Chiang-ning (Nanking). He was a Buddhist monk-painter in the K'ai-yüan Temple. After the fall of Southern T'ang in 975 he followed the deposed ruler to the Northern Sung capital (K'ai-feng) and lived there in the K'ai-pao Temple, where he painted a notable set of murals in the Scholars' Hall. His hazy landscapes in the southern manner were modeled after his teacher Tung Yüan. At first Chü-jan piled small stones on rocky peaks of a rugged character, but ultimately he preferred simpler effects. His style was praised by Mi Fu and became influential by the end of the Sung dynasty. *SCMHP; HHHP*, 12; *HS; THCWC*, Soper tr., pp. 61, 175 n. 518. *Sung Biog.*, 2, Cahill Index, 2. *TSHCJMTT*, pp. 37–38.

CH'Ü TAO-MIN (LATE 5TH CENTURY, UNDER THE SOUTHERN CH'I, 479–502). He studied painting with the muralist and fan painter Chang Chi-po but surpassed him. Their style continued to be influential in the early sixth century. *KHPL; LTMHC*, 7, Acker tr., II, 153, 182. *TCHCJMTT*, p. 54.

CH'Ü T'ING (ACTIVE CA. 841–846). He specialized in landscape painting. His work, described as "painstaking and ingenious," was not highly praised by contemporary critics. *TCMHL; LTMHC*, 10, Acker tr., II, 296. *TSHCJMTT*, p. 387. *PFC*, Munakata tr., pp. 44–45.

CHUANG SU (LATE 13TH CENTURY), T. KUNG-SHU, H. LIAO-T'ANG. From Ch'ing-lung-chen (Shanghai). He was a minor official in the Imperial Archives but left this position on the fall of Sung and returned to Shanghai, where he collected eight thousand scrolls of calligraphy as well as many paintings. His writings include *Hua-chi pu-i* completed in 1298, a selection of short, critical biographies of Southern Sung artists in two parts. Sung Index, p. 2728.

CHUANG-TZU (CA. 365–CA. 290 B.C.) (CHUANG CHOU), T. TZU-HSIU. From Meng (or Anhui province). Little is known of his life, except that he held a minor clerkship at Ch'i-yüan (in southeastern Honan province) in his native state of Sung for a while. His reputation as the most influential follower of

Taoism rests on the text attributed to him of which Books 1–7 are considered likely to be his, and the remainder added by disciples into the Han dynasty. See Feng Yu-lan, *A History of Chinese Philosophy*, tr. D. Bodde, p. 172 *et passim*.

CHUNG-JEN (D. 1123), H. HUA-KUANG CHANG-LAO. From K'uai-chi (in Chekiang province). A Buddhist monk who painted blossoming plum, he lived in the Hua-kuang Temple in Heng-chou (in Hunan province). He was a close friend of Huang T'ing-chien, who wrote comments on some of his paintings. The *Hua-kuang mei-p'u*, a treatise on the prunus, was attributed to him but is actually a fabrication of a later period largely based on the fourteenth-century *Sung-chai mei-p'u* by Wu T'ai-su. See Shimada, "*Shōsai baifu teiyō*," *Bunka* 20 (1956), 96–118; Cahill Index, 4. Also Sung Index, p. 4379. *HC*, 5. *TSHCJMTT*, pp. 53–54.

CHUNG YIN (10TH CENTURY), T. HUI-SHU. From (Mount) T'ien-t'ai (in Chekiang province). As his name indicates, he was a recluse, and his paintings were highly appreciated at the Southern T'ang court. He was especially known for his birds of prey and bamboo and trees, done with an eye for three-dimensional effects with graded tones of ink and color. He also painted landscapes and secular figures. Seventy one of his paintings in the Hsüan-ho imperial collection were destroyed at the fall of Northern Sung. *WTMHPI*; *HHHP*, 16; *HP*; *THCWC*, Soper tr., pp. 30, 90, 143 n. 317. *TSHCJMTT*, pp. 375–376.

CHUNG YU (151–230). A native of Ch'ang-she (in Anhui province). He was a famous calligrapher, particularly noted for his *li* or "official" script ultimately modeled on Ts'ai Yung's writing. Toward the end of the Han dynasty he arranged the escape of the last emperor from Ch'ang-an and was thereafter employed by the powerful Ts'ao Ts'ao in a successful campaign against the Hsiung-nu barbarians, which eventually led to his enfeoffment as a marquis under the following Wei dynasty. *Wei shu* [*ESSS*], 13; *Hou-Han shu*, 66, p. 2050. *BD*, #521.

FA-CH'ANG, better known as MU-CH'I (H.) (CA. 1200–CA. 1270). From Shu (Szechwan province)? He studied Ch'an Buddhism and painting with abbot Wu-chun (d. 1239) at the Ching-shan Temple in Hang-chou and later established the Liu-t'ung Temple nearby. His works were appreciated by contemporary Japanese monks, and ink paintings of Buddhist figures, landscapes, animals, birds, fruits, and flowers have been preserved in Japan. There is some confusion about the facts of his life because of a twelfth-century Chinese monk with the name Mu-ch'i. A visiting Japanese monk of the later thirteenth century is said to have painted at Hang-chou in Mu-ch'i's style using his seal. *HCPI*; *THPC*, 4; *TSHCJMTT*, pp. 127–129. Cahill Index, 4; Loehr, *Great Painters*, pp. 219–221.

FAN CH'ANG-SHOU (ACTIVE MID 7TH CENTURY–CA. 664). A well-known early T'ang painter of Buddhist subjects and figures in landscape settings, he was

a Director of the Cavalry, rising to the rank of captain under the Director of Instruction. A follower of the sixth-century muralist Chang Seng-yu, he painted temple murals at the capitals of Buddhist assemblies or Paradises, including illustrations of the prescribed stages of meditation in which landscape elements figure. He was also particularly noted for his genre subjects of country village scenes and customs on handscrolls or folding screens with believable landscape backgrounds. He did a version of Yen Li-pen's *Drunken Taoist Priest*. *TCMHL; LTMHC*, 9, Acker tr., II, 223–224. *TSHCJMTT*, pp. 152–153. Also Alexander Soper, *Literary Evidence for Early Buddhist Art in China*, p. 28.

FAN CH'IUNG (MID 9TH CENTURY). Active in Ch'eng-tu (in Szechwan province). A specialist in Buddhist imagery such as Bodhisattvas, Guardian Kings, and disciples, he painted temple murals in the late 830s and was again particularly active after 847, when Buddhism regained favor. *ICMHL; HHHP*, 2; *HC; THCWC*, Soper tr., pp. 23, 133 n. 234. Cahill Index, 1. *TSHCJMTT*, p. 153.

FAN K'UAN (CA. 960–CA. 1030) (FAN CHUNG-CHENG), T. CHUNG-LI. From Hua-yüan (in Shensi province). Little is known of the life of the greatest landscapist of the early Northern Sung, but his preferred nickname, K'uan, indicates the broadness of his outlook. He wandered in the landscape near Lo-yang (in Honan province) and spent the end of his life at Mounts Chung-nan and T'ai-hua (in Shensi province). He is said to have first followed Li Ch'eng, or alternatively Ching Hao in dry brushwork, but then to have learned from nature, meditating in the landscape and studying both objects and their inner meaning. His paintings were noted for their strong effects of snow storms or shifting clouds, as well as for close views of rock faces with dense foliage on top, large boulders protruding at the water's edge, and dark-toned earth and tinted architecture. The texturing of his rock surfaces was later described as "rain-drop" or "sesame-seed" strokes. No contemporary follower came close to him, but his style was revived to some extent by Li T'ang in the 12th century. *SCMHP; HHHP*, 11; *HS; SSCCC; KCHP; THCWC*, Soper tr., pp. 57, 171–172 n. 498. *Sung Biog.*, 2 (2); Cahill Index, 4. *TSHCJMTT*, pp. 153–155.

FAN-LUNG (EARLY 12TH CENTURY), T. MAO-TSUNG, H. WU-CHU. From Wu-hsing (in Chekiang province). He was a Buddhist monk who followed Li Kung-lin's method of *pai-miao* outlining of figures without shading. He did Buddhist and secular figures in landscape settings and won Kao-tsung's praise. *HCPI; THPC*, 4. Cahill Index, 4. *TSHCJMTT*, p. 201.

FAN TZU-MIN (ACTIVE CA. 1130–1160). A Taoist priest known for his paintings of water buffaloes, he also did flowers and fruits in ink. There were murals by him of water buffaloes as well as flocking birds and fruit in a Taoist monastery, the T'ien-ch'ing Temple in T'ai-chou (in Chekiang province). Cahill Index, 4. *TSHCJMTT*, pp. 155–156.

Fu Tao-yin (active later 11th century). From Ch'ang-an (Shensi province). A landscapist who painted wintry forests, trusting his own powers of observation. The peak of his career was evidently the collaboration with Kuo Hsi and Li Tsung-ch'eng on a screen for the small hall near the inner East Gate: Fu did a scene of pines and rocks on one of the wings. *THCWC*, Soper tr., p. 60. *LCKCC*, "Hua chi." *TSHCJMTT*, p. 201.

Fu Tsai (d. ca. 813), t. Hou-chih. From Ch'i-hsiang? (or Szechwan province?). A T'ang poet, he first lived as a recluse on Mount Lu (in Kiangsu province). He then was recommended for office, and his positions included that of Recorder for Wei-kao (in Szechwan province) and Censor in the Inspectorate. *CKWHCTTT*, #1441.

Han Cho (active ca. 1095–ca. 1125), t. Ch'un-ch'üan, h. Ch'in-t'ang. From Nan-yang (in Honan province). The author of the *Shan-shui Ch'un-ch'üan chi*, a treatise on landscape painting which is dated to 1121, he is said to have painted landscapes and eroded rocks. According to the epilogue to this text, he came to the capital K'ai-feng in the era 1094–1098, when Wang Shen evidently became his patron. Under Hui-tsung (r. 1101–1126), he served as official-in-waiting on the Calligraphy Board of the Han-lin Academy, and then as Secretary and Director on the History Board, and was also awarded honorary titles. *SSCCC;* see Robert J. Maeda, *Two Twelfth Century Texts on Chinese Painting*, pp. 1–2. *TSHCJMTT*, p. 381.

Han Fei (d. 233 b.c.). Son of a duke of the state of Han (in western Honan province). He was the leading philosopher of the Legalist School, which accepted the absolute authority of the ruler and advocated controlling the people through punishments and rewards. He served the Ch'in state and influenced its policies. *Shih-chi* [*ESSS*], 63; Liao Wen-kuei, *The Complete Works of Han Fei-tzu*, I, xxvii.

Han Kan (b. ca. 715–d. after 781). From Lan-t'ien (in Shensi province). The most famous horse painter of the T'ang dynasty, he also did portraits and temple murals of Buddhist subjects, monks, and demons. When employed as a runner for a wineshop, he is said to have been recognized by the poet Wang Wei for his talent in sketching horses on the ground. In the era 742–755 he was summoned to the palace, and he attained the office of Assistant in the Court of the Imperial Treasury. In his horse painting, he first studied the art of General Ts'ao Pa, but through observing the horses in the imperial stables he developed a more realistic manner. *TCMHL; LTMHC*, 9, Acker II, 260–263. Cahill Index, 1. *TSHCJMTT*, pp. 376–379.

Ho Chen (active early 12th century). From Yen-an (in Shensi province). (The last character of his name is given incorrectly in the Li Ch'eng-sou text.) A former military man, he painted figures, landscapes, and old trees and pines, using Kuo Hsi's technique. Around 1120 he outclassed his competitors dramatically when painting a large-scale mural of a wintry grove for a Taoist monastery, the Pao-chen Temple. *HC*, 6; *THPC*, 3; *TSHCJMTT*, p. 260.

Ho Tsun-shih (early to mid 10th century). From the Chiang-nan area or from Szechwan province. A Taoist recluse on Mount Heng (in Hunan province), he received the name and honorific of "Reverend Ho" because he responded "ho ho" to questions about his origin, name, and age. He was especially noted for paintings of cats in lifelike poses, and he also did flowers and garden rocks as ink plays. *SCMHP; HHHP,* 14; *THCWC,* Soper tr., pp. 67, 183 n. 554. *CKHCJMTT,* p. 131.

Ho Yen (ca. 190–249), t. P'ing-shu. From Nan-yang (in Honan province). From a family of officials, he was raised at the Wei court and married a princess. A devotee of "pure conversation," he is noted for his interest in the Book of Changes and the Taoist classics, and for his collection of prose-poems. *Wei shu,* 9; *SSHY,* Mather tr., pp. 523–524.

Hsia Kuei (active first half 13th century), t. Yü-yü. From Ch'ien-t'ang (Hang-chou, in Chekiang province). He was a painter-in-attendance in the Academy of Painting and was awarded a golden belt for his excellence in landscape painting. Like Ma Yüan, his equally famous contemporary, he worked in the tradition of Li T'ang, using ink boldly in "large axe-chip" strokes and using washes to create the influential Southern Sung Academy manner. *HCPI; THPC,* 4. Cahill Index, 4. *TSHCJMTT,* pp. 168–170.

Hsia Sen (mid 13th century), t. Chung-wei. Hsia Kuei's son. His brush-work was rather weak, but his trees and rocks were painted in his father's manner. *THPC,* 4. Cahill Index, 4. *TSHCJMTT,* p. 170.

Hsia Wen-yen (14th century), t. Shih-liang, h. Lan-chu sheng. From Hua-t'ing (in Kiangsu province). A Sub-Prefect of Yü-yao (in Chekiang province), he was versed in painting and edited a collection of artist's biographies, *T'u-hui pao-chien,* preface dated to 1365, in five scrolls. *THPC,* pref.; Yüan Index, p. 861.

Hsiang Jung (late 8th–early 9th century?). According to the *LTMHC,* he was a retired scholar of Mount T'ien-t'ai (in Chekiang province) and the teacher of the eccentric landscapist Wang Mo. His painting was said to have an astringent quality, and he is recorded as doing pines and weathered rocks. In *THPC* his relation to Wang Mo is reversed. *LTMHC,* 10, Acker tr., II, 298, 299. *TSHCJMTT,* p. 267.

Hsiao Chao (active ca. 1130–1160), t. Tung-sheng. From Hua-tse (in Shansi province). Good at poetry and calligraphy, he had been reduced to banditry at the end of Northern Sung, when he encountered his future master Li T'ang in the T'ai-hang mountains. Hsiao followed Li to Hang-chou and became a painter-in-attendance at the Academy of Painting and once did a famous set of large-scale murals on short notice for Kao-tsung's Cool Hall. Hsiao's calligraphy was in the antique script of the stone drums, and his long landscape scrolls and figure paintings were especially noteworthy for their strange pines and rocks in his rich ink and strong brushwork. *THPC,* 4. Sirén,

II, 100; Cahill Index, 4. *CKHCJMTTT*, pp. 699–700; *TSHCJMTT*, pp. 382–383.

HSIAO YÜEH (EARLY 9TH CENTURY). From Hang-chou (in Chekiang province). In the early 820s he was an Official in Charge of Tuning Pitchpipes, who was noted for his character. He painted monochrome bamboos, which were appreciated by the poet Po Chü-i, and he also did flowers and birds. *TCMHL; LTMHC*, 10, Acker tr., II, 296. *HHHP*, 15; *CKHCJMTTT*, p. 699; *TSHCJMTT*, p. 382.

HSIEH HO (ACTIVE CA. 500–535?). A fashionable portrait painter active at the southern capital, his work was not highly praised by Yao Tsui (535–602), and only one painting of a Taoist immortal was ascribed to him in T'ang times. He is now known only for the text of the *(Ku)hua-p'in(-lu)* (Classification of Painters) which contains the famous version of the Six Laws of painting. *HHP; LTMHC*, 7, Acker tr., II, 156–162. *TCHCJMTT*, pp. 50–51.

HSÜ CH'UNG-SSU (LATE 10TH–EARLY 11TH CENTURY?). Hsü Hsi's grandson. A flower and bird specialist, he was evidently active at the Southern T'ang court and then at the Northern Sung capital. Although he was chiefly known for his "boneless" paintings of flowers done in color alone, he and his brothers painted a variety of subjects, including court beauties, fruit trees, herbs and insects, and ponds with fish and birds. *SCMHP; HHHP*, 17; *HS; MCPT; KCHP; THCWC*, Soper tr., pp. 63, 96–97, 100–101, 177–178 n. 524. Cahill Index, 4. *TSHCJMTT*, pp. 193–194.

HSÜ HSI (10TH CENTURY, D. BEFORE 975). From Chung-ling (near Nanking). From a Chiang-nan family of scholar-officials, he chose to live in retirement; he became a famous painter of flowers and birds whose work was appreciated by the last ruler of Southern T'ang. Hsü's individual manner of "sketching ideas" was contrasted to that of his rival, Huang Ch'üan. Hsü's subjects of cut branches, animals and birds, fishes and insects, vegetables and fruits were taken from country gardens or streams, and his technique was to sketch simply, often on paper, first using ink broadly and then adding slight coloring. He had no true successors. *SCMHP; HHHP*, 17; *HP; HS; MCPT; THCWC*, Soper tr., pp. 62–63, 102, 176–177 n. 522. *Sung Biog.*, 2; Cahill Index, 2. *TSHCJMTT*, pp. 190–193.

HSÜEH CHI (649–713), T. SSU-T'UNG. From Fen-yang (in Shansi province). From a family of scholar-officials, he was a third degree *(chin-shih)* graduate with literary talents, who was noted for his calligraphy after Yü Shih-nan and his painting after Yen Li-pen. Hsüeh, who became President of the Ministries of Rites and Public Works and was granted honorific rank and enfeoffed as a duke, held a succession of offices until 713 when he was involved in an intrigue and took his life. He painted flowers and birds, and figures and Buddhist images, but he was known especially for his cranes (with bamboos) done on the six-fold screen. *Chiu T'ang shu*, 73; *Hsin T'ang shu*, 98; *CKWHCTTT*,

#1147; *BD*, #726. *TCMHL; LTMHC*, 9, Acker tr., II, 245–247. *TSHCJMTT*, pp. 373–374.

HsÜN HsÜ (CA. 218–289), T. KUNG-TSENG. From Ying-ch'uan (in Honan province). From a family of scholars and officials, he rose to high office under the Wei and Western Chin dynasties and is chiefly noted as an authority on music who revised the laws of harmony. There is an anecdote in the *SSHY* about his skill in portraiture. In T'ang times handscroll illustrations of "Famous Women" were recorded as being by him. *Chin shu [ESSS]*, 39; *SSHY*, Mather tr., p. 532. *KHPL; LTMHC*, 5, Acker tr., II, 28–30. *TCHCJMTT*, p. 14.

HU CH'IEN (10TH CENTURY). Son of Hu Kuei. He painted nomadic scenes and horses but did not equal his father. *HHHP*, 8; *TSHCJMTT*, p. 158.

HU I (EARLY 10TH CENTURY), T. P'ENG-YÜN. From An-ting (Yen-an, in Shensi province). He was a painter of Taoist and Buddhist subjects and secular figures, and of architectural subjects and horses and carriages or wagons in particular. An associate of the painter-connoisseur Chao Yen, an Imperial Son-in-Law of the Later Liang (907–922), Hu did tracing copies of master-works and painted figures for other artists occasionally. *HHHP*, 7; *THCWC*, Soper tr., pp. 27, 28, 86–87, 139 n. 288. *TSHCJMTT*, p. 157.

HU KUEI (10TH CENTURY). Lived at Fan-yang (in Hopei province). A Khitan by origin, he was a noted animal painter active during the Later T'ang Dynasty (923–935), who specialized in crowded nomadic scenes done with clear brush-work and fine shading. *WTMHPI; HHHP*, 8; *THCWC*, Soper tr., pp. 25–26, 136 n. 257. Cahill Index, 2. *TSHCJMTT*, pp. 157–158.

HUAI-SU (737–AFTER 798), T. TS'ANG-CHEN; FAMILY NAME CH'IEN. From Ch'ang-sha (in Hunan province). A Buddhist monk, he devoted himself to calligraphy in his later years, piling up worn brushes in a "tomb of brushes" and often practicing on banana leaves instead of paper. He was a specialist in draft script, writing in a "wild cursive" manner modeled on that of Chang Hsü. The poet Li Po admired Huai-su's writing. He has been confused with a seventh-century monk-painter also named Huai-su. *CKJMTT*, p. 1745; Ecke, *Chinese Calligraphy*, #17.

HUANG CHÜ-PAO (10TH CENTURY), T. TZU-YÜ. Second son of Huang Ch'üan. He served with his father as a painter-in-attendance at the Han-lin Academy in Ch'eng-tu (in Szechwan province) and advanced to a post in the Board of Waterworks, but died before the age of forty. He was skilled at flowers and birds and pines and rocks as well as at a form of the squared official script. His painted garden rocks were exceptional in shape and texturing. *ICMHL; HHHP*, 16; *THCWC*, Soper tr., pp. 34, 147 n. 357. *TSHCJMTT*, p. 275.

HUANG CHÜ-SHIH (10TH CENTURY). Huang Ch'üan's son? According to *THPC*, Ch'üan had five sons, and Chü-shih was the signature inscribed on a bird painting in Sung Kao-tsung's collection. *THPC*, 2.

HUANG CHÜ-TS'AI (933–AFTER 993), T. PO-LUAN. Huang Ch'üan's youngest
(?) son. A painter-in-attendance in Ch'eng-tu and after 965 in K'ai-feng at
the Northern Sung court, he often did large-scale paintings as temple murals
or on palace doors and screens. With his father he produced presentation
paintings for diplomatic gifts; one of them, entitled *Autumn Mountains*, he
later verified as a connoisseur for the Sung imperial collection. His usual
subjects were flowers and birds and animals, for which he must have employed
the "boneless technique" in colors with minimal or no outlines as was standard
in early Sung flower and bird painting. However, he also did Buddhist and
Taoist temple murals of dragons and of water and rocks, as well as figure
paintings. *ICMHL; SCMHP; HHHP*, 17; *THCWC*, Soper tr., pp. 20, 61–62,
175–176 n. 519. *Sung Biog.*, 2; Cahill Index, 2. *TSHCJMTT*, pp. 275–276.

HUANG CH'ÜAN (903–968), T. YAO-SHU. From Ch'eng-tu (in Szechwan prov-
ince). In 919 he became painter-in-attendance at the Han-lin Academy of the
Former Shu state, and he served under the Later Shu for forty years (925–
965), while also holding a variety of honorary titles and positions. In 944 he
painted murals of the six cranes that were presented to the Shu court and
in 953 with Chü-ts'ai decorated the Hall of Eight Trigrams; in each case his
bird paintings were so realistic that they were said to have attracted other
birds. His art was called "sketches of life," and he did individual studies of
birds and animals in fine line with light washes and coloring as models for
Chü-pao. Although best-known for flowers and birds in color, Ch'üan also
did figures and landscapes and was praised for his ink bamboos and for a
sunning turtle done in ink. In 965 on the fall of Later Shu, Ch'üan followed
its ruler to the Sung court where he served for three years more. *ICMHL;
SCMHP; HHHP*, 16; *HP; HS: THCWC*, Soper tr., pp. 20, 33–34, 75, 146–
147 n. 350. *Sung Biog.*, 2; Cahill Index, 2. *TSHCJMTT*, pp. 272–275.

HUANG HSIU-FU (LATE 10TH–EA LY 11TH CENTURY), T. KUEI-PEN. From Chiang-
hsia (in Hupei province). He traveled much, studied Taoist alchemy and
pharmacology, and was good at calligraphy and at painting in the manner
of Ku K'ai-chih and Lu T'an-wei. In a post at Ch'eng-tu (in Szechwan prov-
ince), he associated with literati and painters and wrote down his impressions
of the tenth-century Shu murals in the *I-chou ming-hua lu* (pref. d. 1006),
which treats painters active from 758 to ca. 965. *ICMHL*, pref.; *CKWHCTTT*,
#1944; *TSHCJMTT*, pp. 277–278.

HUANG KUNG-WANG (1269–1354), T. TZU-CHIU, H. I-FENG, TA-CH'IH, CHING-
HSI TAO-JEN. From Ch'ang-shu (in Kiangsu province). A leading literati land-
scapist, he was a child prodigy adopted at an early age by a Mr. Huang of
Wen-chou (in Chekiang province). He worked as a private secretary, passed
his examinations, and became a legal clerk in Su-chou. Around 1314 because
of irregularities in tax collection, he was imprisoned briefly. Sometime there-
after he retired from official life, wore Taoist clothes, and worked for a while
in Sung-chiang as a professional diviner. Interested in syncretic philosophy,
he established the "Hall of the Three Teachings" in Su-chou in 1334 and

later withdrew first to Hang-chou and then to the nearby Fu-ch'un Mountains, the subject of his most famous painting, done between 1347 and 1350. Although by temperament a recluse, he had disciples and associated with several well-known poets and artists. His notes on painting technique, *Hsieh shan-shui chüeh* (Secrets of Describing Landscape), were published in T'ao Tsung-i's *Cho-keng lu* of 1366 and describe his own style, in which the Tung Yüan tradition predominates but there are traces of Li Ch'eng motifs and compositions. *THPC*, 5; *CKHCJMTTT*, p. 541; *Yüan Masters*, pp. 11–20. Cahill Index, 6; Cahill, *Hills*, pp. 85–88.

HUANG PO-SSU (1079–1118), T. CH'ANG-JUI. From Shao-wu (in Fukien province). A writer and connoisseur, he received a *chin-shih* degree in 1100 and served as President of the Board of Revenue and Population in the region of Honan. In the era 1111 to 1117 he was a Secretary of the Imperial Archives. An able writer of poetry and prose, he was well educated and could decipher bronze inscriptions. He was an accomplished calligrapher in a variety of styles and is reported to have copied ancient paintings such as Yen Li-pen's *Literary Society*, featuring unconventional figure types. His opinions on art are recorded in *Tung-kuan yü-lun* (Further Discussions from the Eastern Tower). *Sung shih*, 443; Sung Index, p. 2898. *TSHCJMTT*, p. 277.

HUANG T'ING-CHIEN (1045–1105), T. LU-CHIH, H. FU-WENG, SHAN-KU. From Feng-ning (in Hung-chou, Kiangsi province). A poet and calligrapher, he is best known as the founder of the Kiangsi school of poetry, but he is also one of the four great Sung calligraphers, noted for his cursive script. He passed his *chin-shih* examination in 1067 and served as a provincial magistrate before being appointed as a professor in the National University and then as one of the compilers of Emperor Shen-tsung's Veritable Records. Involved in political controversies, he was frequently exiled and died at one such post (in Kwangsi province). His poetic principles have a modern cast, since he emphasized the creative reworking of earlier literary materials. As a connoisseur of painting, he wrote many poems and colophons on his friends' scrolls, and his Ch'an Buddhist interests led him to associate with monks such as the prunus painter Chung-jen. *Sung shih*, 444, Sung Index, pp. 2903–09. *Sung Biog.*, 1 (in German); Wu-chi Liu and Irving Lo, *Sunflower Splendor*, pp. 590–591.

HUANG WEI-LIANG (10TH CENTURY). Huang Ch'üan's younger brother (or son?). He is also said to have been a painter-in-attendance at the Han-lin Academy of the Shu state and again at the Northern Sung court. *MCPT*; *CKHCJMTTT*, p. 540.

JAO TZU-JAN (MID 14TH CENTURY), T. T'AI-HSÜ, H. YÜ-SSU SHAN-JEN. (No place of origin is known, but Mount Yü-ssu is in Hsia-chiang in Kiangsi province.) According to one source, he painted in Ma Yüan's style of landscape. He is the author of *Hui-tsung ehr-shih chi*, a text on landscape painting technique in one scroll. *CKHLLP*, II, p. 694.

KAO HSÜN (EARLY 12TH CENTURY). From K'ai-feng (in Honan province). He first imitated Kao K'o-ming in landscape painting and produced excellent garden rocks, but in his old age, when this style was popular among academy painters, he began to study Fan K'uan's manner. He also did flower and bird paintings. *HC; THPC*, 3; *TSHCJMTT*, p. 176.

KAO I (LATE 10TH CENTURY). A Khitan who moved to Cho-chün (in Hopei province). A noted painter of Buddhist and Taoist demons and divinities and of nomadic scenes and horses, he started out at the capital (K'ai-feng) as a peddler of drugs who drew pictures on his wrappers. Then, after 976, a wine-shop owner presented one of his paintings of demons to the founder of the Sung dynasty, hence Kao became a painter-in-attendance at the Han-lin Academy and received commissions to do Buddhist temple murals. *SCMHP; THCWC*, Soper tr., pp. 47–48, 162 n. 422. *TSHCJMTT*, pp. 173–174.

KAO K'O-KUNG (ORIGINAL NAME SHIH-AN) (1248–1310), T. YEN-CHING, H. FANG-SHAN. Lived at Fang-shan (near Peking, Hopei province). From a Uighur (?) family originally from Ta-t'ung (in Shansi province), he received a classical education and became a successful official from the Western Regions and a notable landscapist of the early Yuan dynasty. He served at court from 1288 on in the Boards of Works, of Civil Service, and of Justice, and also governed two provinces, living for a time in Hang-chou. When he died he was President of the Board of Justice. He may have been active as an artist only toward the end of his life. In landscape painting, he is said to have first studied Mi Fu and his son, and then Tung Yüan and Li Ch'eng, and indeed his style is a synthesis of these manners. His ink bamboos were after Wang T'ing-yün. Yuan Index, pp. 1013–15. *THPC*, 5. Cahill Index, 6. *CKHCJMTT*, pp. 331–332.

KAO K'O-MING (FIRST HALF 11TH CENTURY). From Chiang-chou (in Shensi province). In 1008 he entered the Han-lin painting bureau, and because his wall paintings won imperial favor he was made a painter-in-attendance and allowed to wear purple robes and the gold fish pendant. His range was wide: he was praised in 1034 for completing large-scale landscape murals of the four seasons for palace apartments and around 1050 for a narrative hand-scroll of auspicious dynastic events which had small figures in imperial trappings placed in architectural or landscape settings. His best work was said to be small views in round fans or couch screens, done with a great deal of ingenuity but a certain lack of freedom. *SCMHP; HHHP*, 11; *THCWC*, Soper tr., pp. 59, 94, 174 n. 512. Cahill Index, 4. *TSHCJMTT*, p. 175.

KO SHOU-CH'ANG (ACTIVE CA. 1068–1085). From K'ai-feng (Honan province). A flower and bird specialist who served as painter-in-attendance in the Academy of Painting, and whose range of subjects included bamboos, grasses and insects, and vegetables. His bird paintings were noted for a sense of life and were done with refinement and simplicity. He was responsible for the flowering fruit trees in the collaborative screen done with Ts'ui Po and others

for the Tzu-ch'en Hall. *HHHP*, 18; *THCWC*, Soper tr., pp. 67, 182 n. 549. *LCKCC*, "Hua chi." *TSHCJMTT*, pp. 285–286.

K'o Ch'ien (1251–1319), t. Tzu-mu, h. Shan-chai. From Hsien-chu, T'ien-t'ai-hsien (Chekiang province). A Neo-Confucian teacher in his native region, he was the father of K'o Chiu-ssu, an ink bamboo painter in Li K'an's tradition. Yüan Index, p. 750 (dates in arabic numerals are incorrect).

K'o Chiu-ssu (1290–1343), t. Ching-chung, h. Tan-ch'iu. From T'ai-chou (in Chekiang province). A connoisseur from a scholarly family, he was well read in poetry and literature and could transcribe inscriptions on bronze and stone. Under Emperor Wen-tsung (r. 1330–1333) he was attached to the K'uei-chang Pavilion and appointed Professor of Literature in the Academy of Scholars, and he was in charge of examining the scrolls of calligraphy and painting in the imperial collection. Thereafter he retired to live in Su-chou. As a literati painter, he followed Wen T'ung in doing ink bamboos and old trees and was also good at ink flowers. *Yüan shih*, 35; Yüan Index, pp. 750–752. Cahill Index, 6.

Ku Chün-chih (active ca. 457–465). From Wu (or Kiangsu province). He was a disciple of Chang Mo but his paintings were very rare. In T'ang times murals by him were extant in a Buddhist temple at Yung-chia (in Chekiang province) as well as one recorded portrait of a Master Yen, probably Yen Shih-ch'i who was honored for exceptional virtues in 427 under the Liu-Sung dynasty (420–478). *KHPL; CKKSHS; LTMHC*, 6, Acker tr., II, 143–144; also I, 152–153, 162. *TCHCJMTT*, p. 60. Also see *Sung shu [ESSS]*, 91, for Yen Shih-ch'i.

Ku K'ai-chih (ca. 345–ca. 406), t. Ch'ang-k'ang, h. Hu-t'ou. From Wu-hsi in Chin-ling (Wu-chin, Kiangsu province). From the eleventh century on he was the best-known painter of the Six Dynasties period, and his reputation was no doubt partially based on the anecdotes recorded of him in early literature, as well as on the paintings and texts attributed to him. His father had been an official, and he himself managed to survive in the service of several of the dominant political figures of the time such as Governor Yin Chung-k'an (d. 399), although his eccentricity prevented him from rising very high in official posts. He was said to have excelled at three things, being "perfect in painting, perfect in literary composition, and perfect in foolishness." Around 364 he did a famous mural of the Buddhist layman Vimalakīrti for a temple at the southern capital (Nanking), and he is known to have painted portraits of contemporaries and historical figures. By the T'ang dynasty his reputation was very high, and three texts were recorded under his name as well as various paintings including illustrations of "Famous Women" and portraits of the so-called "Seven Sages" (of the Bamboo Grove). *Chin shu*, 62 (in Chen Shih-hsiang, tr., *Biography of Ku K'ai-chih*); *SSHY*, Mather tr., p. 542. *KHPL; HHP; LTMHC*, 5, Acker tr., II, 43–57; also I, 378–379. Cahill Index, 1. *TCHCJMTT*, pp. 54–59.

KUAN-HSIU (832–912), ORIGINAL NAME CHIANG HSIU, T. TE-YIN (-YÜAN), H. CH'AN-YÜEH TA-SHIH. From Chin-hua (in Chekiang province). From an impoverished family of scholar-officials, he became a monk at an early age, but his studies included classical texts and poetry. In the final half-century of the T'ang Dynasty, he traveled in regions bordering on the Yangtze River, eventually spending the last decade of his life in Ch'eng-tu (in Szechwan province) under the state of Former Shu. There he was honored as Ch'an Buddhist master, poet, calligrapher, and painter. One collection of his poetry survives, and one type of "mad cursive" script goes under his family name. Nonetheless, he is most famous for his visionary images of the Buddha's disciples or Lohans, said to have been painted after Yen Li-pen, where foreign features are expressively exaggerated by repeated lines that are echoed in the Chinese type of landscape setting. Ch'an Buddhist images of later production in ink on paper in a free "cursive" style are also placed in his tradition. *ICMHL; HHHP,* 3; *THCWC,* Soper tr., pp. 38, 152 n. 394. *TSHCJMTT,* pp. 197–199. *Sung Biog.,* 2; Cahill Index, 2; Loehr, *Great Painters,* pp. 54–58.

KUAN T'UNG (EARLY 10TH CENTURY). There are different characters for his given name. Active in Ch'ang-an and Lo-yang under the Later Liang (907–923). He is said to have studied painting in the T'ai-hang Mountains (of Honan province) with Ching Hao but to have eventually formed his own manner, becoming one of a triad of influential landscapists in early Northern Sung times. The harsh rockiness of his mountains and the dense grouping of his trees may have derived in part from the T'ang artist Pi Hung. The figures in his paintings are said to have been provided by Hu I. *WTMHPI; HHHP,* 10; *HP; HS; THCWC,* Soper tr., pp. 19, 29–30, 141–142 n. 307. *Sung Biog.,* 2; Cahill Index, 2. *TSHCJMTT,* pp. 388–390.

KUO CHUNG-SHU (CA. 920?–977), T. SHU-HSIEN. From Lo-yang (in Honan province). The most famous architectural painter of the beginning of the Sung dynasty, he was equally noted for his difficult temperament. A child prodigy, he passed special examinations in the classics and in poetry, was appointed to prefectural office around 948, and then employed as a scholar under the Later Chou around 952. After quarreling under the influence of drink, he was banished, and eventually became a wandering Taoist hermit in the mountains of the Shensi region, associating with high officials, and painting for friends when he was inspired. He was skilled at the seal and official scripts of calligraphy and wrote studies on ancient types of writing. In painting he practiced an equally precise and archaic genre, depicting architecture in the T'ang style that was detailed and realistic. But he also did woods and rocks in his own manner, and occasionally tossed off abbreviated sketches. Around 976 under the Sung he briefly served as Registrar in the Directorate of Education and was loaded with honors by the Emperor. Yet again he was involved in scandal, and this time flogged and banished. He died on the way to his post of exile in the Shantung region, having foreseen his death. *Sung shih,* 442; Sung Index, pp. 2140–42; *Sung Biog.,* 2. *SCMHP;*

HHHP, 8; *HP; THCWC*, Soper tr., pp. 44–45, 155–156 n. 421. Cahill Index, 2. *TSHCJMTT*, pp. 217–218.

Kuo Hsi (after 1000–ca. 1090), t. Shun-fu. From Wen-hsien in Ho-yang (Honan province). In his youth he painted in a detailed fashion and completely captured Li Ch'eng's manner, particularly in wintry forests with trees done in "crab-claw" strokes. His brushwork became increasingly strong as he grew older, and he did large-scale screens or murals. He served as an artist-in-apprenticeship in the Academy of Calligraphy under Shen-tsung (r. 1067–1085) and was appointed artist-in-attendance. His scenes of pines and rocks or seasonal landscapes commissioned for various palace halls were highly appreciated by the Emperor, and the landscape screen done for the Jade Hall of the Han-lin Academy was praised in Su Shih's verse. Kuo considered his best work to be four scrolls of landscape with weathered rocks presented to the Confucian temple at Wen-hsien after his son Ssu had passed his middle-level examinations. Around 1085 he painted twelve large screens of landscape subjects for the Taoist Hsien-sheng Temple. A Taoist approach to nature is evident in the *Lin-ch'üan kao-chih* (The Lofty Message of Forests and Streams), his notes on painting edited by Kuo Ssu by 1117. Sung Index, p. 2124. Suzuki Kei, "Kuo Hsi and the *Hua-chi* in the *Lin-ch'üan kao-chih chi*," *Bijutsushi*, 30 (1981), 1–11. *HHHP, 11; THCWC*, Soper tr., pp. 60, 174–175 n. 516. Cahill Index, 4. *TSHCJMTT*, pp. 219–220.

Kuo Jo-hsü (active last half 11th century). A grandnephew of Chen-tsung's empress. His family was originally from T'ai-yüan (in Shansi province). From a family of high officials with imperial connections, he served as a minor official at the Northern Sung court and in 1074 went in an embassy to bear New Year's greetings to the Liao, after which he was degraded and became an assistant commissioner in a palace workshop, the Wen-ssu yüan, that manufactured the court insignia. He is best known as the author of the *T'u-hua chien-wen chih* (Record [of Things] Seen and Heard in [connection with] Paintings) which records incidents and biographies of artists active from 841 through 1074 but may have been completed in the period 1080–1085. *THCWC*, Soper tr., pp. 102, 105–109. Sung Index, p. 2143; *CKHLLP*, p. 62.

Kuo Ssu (d. after 1123), t. Te-chih. From Wen-hsien (in Honan province). Hsi's son. He is said to have elevated his family through his studies, and after taking his *chin-shih* degree in 1082 he served as an official in such posts as provincial administrator in the region of Shensi province, and in 1117 was appointed Scholar attached to the Lung-t'u Pavilion in the Imperial Archives. Hui-tsung once ordered him to illustrate the *Shan-hai ching* (Classic of Hills and Seas), and one of these paintings, the auspicious horse, was thought to be much in the manner of Ts'ao Pa and Han Kan. Nonetheless, in the opinion of his contemporaries, although he had a deep understanding of painting he could not make a name by it. On becoming an official, he began to collect his father's works, and he also edited and supplemented Kuo Hsi's painting manual, *Lin-ch'üan kao-chih (chi)*. Ssu's sons, active in Shu (Szechwan province),

also did paintings of horses and trees. Sung Index, p. 2114. *HHHP*, 11; *THPC*, 3. Cahill Index, 4. *TSHCJMTT*, pp. 220–221.

LI AN-CHUNG (ACTIVE FIRST HALF 12TH CENTURY). Active at K'ai-feng (in Honan province) and Hang-chou (in Chekiang province). There is conflicting evidence about his dates and offices, but around 1000 he seems to have been an artist-in-apprenticeship of the Han-lin Bureau of Calligraphy, hence officially a calligrapher although he worked as a painter. He went on to become painter-in-attendance in the Bureau of Painting and was honored with a military rank. After the fall of Northern Sung he served in the same office at the Southern Sung court and was awarded the golden belt. Two of his sons were also painters. He specialized in flowers and birds and animals in motion, and he was particularly noted for his birds of prey. *THPC*, 4; Ho Wai-kam et al., *Eight Dynasties of Chinese Painting*, pp. 33–34. *Sung Biog.*, 2; Cahill Index, 4. *TSHCJMTT*, p. 117.

LI CHAO-TAO (ACTIVE CA. 670–730). Son of Li Ssu-hsün. He attained the office of Vice-President of the Right to the Crown Prince's Secretariat but was popularly called the Younger (Lesser) General Li because of his father's rank. Best known for his courtly landscapes in the blue-and-green manner and particularly praised for his seascapes, he also painted birds and animals. Contemporary critics differed as to whether or not he surpassed his father. *TCMHL; LTMHC*, 9, Acker tr., II, 243–245. Cahill Index, 1. *TSHCJMTT*, pp. 86–87.

LI CH'ENG (919–967), T. HSIEN-HSI. From Ying-ch'iu (I-tu, in Ch'ing-chou, Shantung province). From a family of Confucian scholars descended from the T'ang imperial clan, he lived in the unsettled period of the Five Dynasties, and his circumstances evidently precluded an official career. He is said to have had a classical education and to have been an able musician and writer, and around 957 he went to K'ai-feng in hopes of employment by recommendation. On the death of his patron he turned to poetry and song writing, drinking and landscape painting, the occupations of a frustrated talent. During this time he may or may not have had dealings with a wine-shop owner, Mr. Sun, who sponsored several artists. Eventually Li was invited to stay with another patron outside the capital. On his journey he reportedly died of drink at an inn in Huai-yang (Honan province). Around 988, after his son Chüeh became a scholar-official, he requested a posthumous title for his father which was granted. Li Ch'eng became the model of the scholar artist, and his painting was highly appreciated by Shen-tsung (r. 1067–1085). Its themes were wintry forests with misty distances, the level views and rolling ranges of the Shantung area. *SCMHP; HHHP*, 11; *HS; MCPT; KCHP; HC; THCWC*, Soper tr., pp. 46, 159–160 n. 434. Cahill Index, 2. *TSHCJMTT*, pp. 98–101. See Ho Wai-kam, "Li Ch'eng and the Mainstream of Northern Sung Landscape Painting," *Proceedings of the International Symposium on Chinese Painting* (Taipei: National Palace Museum, 1972), pp. 251–283.

LI CH'ENG-SOU (CA. 1150–AFTER 1221). From Hsiang-chung (in Hunan province). He is erroneously placed in the fourteenth century by one source, *Hua-shih hui-yao*. Information about his life comes from *Hua shan-shui chüeh* (Secrets of Painting Landscape) for which he wrote at least the preface and the epilogue, the main portion of the text being identical with the so-called Li Ch'eng "Secrets of Landscape." There the date corresponding to 1221 is given, and it is indicated that he had studied painting for over sixty years. The text has a provincial flavor, since it records the sights of the Hunan-Hupei area and mentions local painters such as Cheng Chien. See *Mei-shu ts'ung-k'an*, I, p. 149; *MSTS*, series 3, pt. 9, vol. 1, p. 49.

LI CH'IH (1059–1109), T. FANG-SHU, H. CHI-NAN. A native of Yang-ti (in Honan province). One of Su Shih's devoted disciples who mourned and memorialized him, Li was an impoverished scholar whose literary ability led to posthumous respect. His extant writings include two literary collections and the *Hua-p'in* (Evaluations of Paintings), a descriptive catalogue of the collection of an imperial relative, which was written around 1100 in Hsiang-yang (in Hupei province). *Sung shih*, 444; Sung Index, pp. 887–888. Alexander Soper, "A Northern Sung Descriptive Catalogue of Painting," *JAOS*, 69 (1949), 19.

LI K'AN (1245–1320), T. CHUNG-PIN, H. HSI-CHAI TAO-JEN. From Chi-ch'iu (near Peking, Hopei province). A scholar-official, he served the Mongol regime from 1282 on as a provincial administrator in the regions of Chekiang and Kiangsi, and by 1312 became President of the Board of Civil Service, and was honored by a posthumous title. As a literati painter, he did old trees and rocks, and specialized in ink bamboo, first following the northern tradition of Wang T'ing-yün and his son Wan-ch'ing, and then that of the earlier Wen T'ung. His colored bamboos were after Li P'o, and he also studied different species from nature during his journeys through South China. He is the author of the *Chu-p'u* (Manual of Bamboo), which describes the rules of this genre. Yüan Index, pp. 473–474. *THPC*, 5. Cahill Index, 6.

LI KUEI-CHIEN (ACTIVE EARLY 10TH CENTURY). From Chiu-ch'i (near Hang-chou, Chekiang province). A Taoist adept and eccentric, he was good at painting landscape, trees, bamboos, wild birds, and oxen and tigers in motion. He traveled widely and had an interview with the founder of Later Liang (907–923) in North China. *HP; HHHP*, 14; *THCWC*, Soper tr., pp. 28–29, 141 n. 297. *TSHCJMTT*, p. 335.

LI KUNG-LIN (1049–1105/6), T. PO-SHIH, H. LUNG-MIEN CHÜ-SHIH. From Shu-ch'eng (in Anhwei province). A literati painter from a distinguished family of scholar-officials, he passed the *chin-shih* examination in 1070 and served in minor prefectural posts before becoming an editorial officer in the Secretariat and then an investigating censor. He reportedly suffered from a form of arthritis that paralyzed his right hand for three years, and in 1100 he retired to his home region. He had studied ancient scrolls of calligraphy and painting in his father's collection, and he also became a collector and an expert

connoisseur of all types of art objects, including bronzes and jades. He painted in the company of Su Shih and members of his circle, although he was also friendly with Su's chief political opponent Wang An-shih (1021–1086). For copies of ancient paintings Li used colors on silk, but for his own characteristic *pai-miao* or "plain outlined" style he used fine brush lines on close-textured "Pure Heart Hall" paper. He is best known for horses, or horses from the imperial stable with their grooms, but his secular figure paintings included a vivid scene of gamblers. His interests in Ch'an Buddhism may have led to his invention of three new iconographic types of Kuan-yin images. He also did an imaginative illustration of the poet T'ao Ch'ien's famous poem on returning home to retirement, as well as scenes of his own country villa in the Lung-mien Mountain. *Sung shih*, 444; Sung Index, pp. 959–961; *Sung Biog.*, 2. *HHHP*, 7. Cahill Index, 4. *TSHCJMTT*, pp. 103–107.

Li Kung-mao (active ca. 1130–1160). Li An-chung's son. Active at Hang-chou. In the family tradition he painted landscapes, flowers, and animals but lacked his father's skill. *THPC*, 4; *TSHCJMTT*, p. 117.

Li Ling-sheng (active early 9th century). A T'ang individualist painter, he did landscapes and trees in a quick fashion "with a dot and a stroke." A modern scholarly opinion is that his manner influenced thirteenth-century Ch'an masters such as Liang K'ai, who used "abbreviated brushwork." *TCMHL; TSHCJMTT*, p. 90.

Li P'o (active ca. 937–975, under the Southern T'ang). His given name is variously written. From Nan-ch'ang (in Kiangsi province). He was a bamboo painter, who was praised for his fine spirit and lack of overly detailed skill in such themes as wind-blown bamboos or sparse bamboos braving the snow. *HHHP*, 20; *THCWC*, Soper tr., pp. 31, 143 n. 319. Cahill Index, 2. *TSHCJMTT*, p. 95.

Li Sheng (active late 9th–early 10th century). With the family nickname Chin-nu. From Ch'eng-tu (in Szechwan province). A precocious talent, he became the most influential landscapist of the Former Shu (908–925), painting in colors in meticulous detail. His style was first based on Chang Tsao's, but then developed from observation of the level distances and piled-up peaks of Shu scenery. He was popularly known in Shu as the "Lesser General Li" in a comparison with Li Ssu-hsün, yet his work was later confused with that of Wang Wei. His murals for a Buddhist temple in Ch'eng-tu were of famous mountains and scenic sites, but he also did Taoist subjects and secular figures. *ICMHL; HHHP*, 3; *HS; THCWC*, Soper tr., pp. 32, 145 n. 335. Loehr, *Great Painters*, pp. 84–85. *TSHCJMTT*, pp. 96–97.

Li Ssu-chen (d. 696), t. Ch'eng-chou. From K'uang-ch'eng in Hua-chou (Hopei province). A T'ang scholar-official and connoisseur, he served in the Hung-wen Kuan before requesting a prefectural post in the Chekiang region in the early 670s. He later returned to court and by 698 became Vice-President of the Right for the Tribunal of Censors until he was banished by the Empress

Wu. He received posthumous honors. He was widely read, talented in music, and adept in Taoist fortune telling; he is recorded as doing a *Picture of the Rites* as well as Buddhist and Taoist demonic divinities. His writings included critical classifications of poetry, calligraphy, and paintings, of which the last two were named the *Shu hou-p'in* and the *Hua hou-p'in*. The current version of the latter text is thought to be a Ming forgery on the basis of earlier citations. *Chiu T'ang shu*, 191; *Hsin T'ang shu*, 91; also see the bibliographical sections. *LTMHC*, 9, Acker tr., II, 250. *TSHCJMTT*, p. 84.

LI SSU-HSÜN (651–716/8), T. CHIEN-CHIEN. From T'ien-shui (in Kansu province). The best-known landscapist of the T'ang imperial family, he served in prefectural office before 684 and then went into hiding under the Empress Wu. In 705 he became President of the Court of Imperial Family Affairs and was enfeoffed as a duke. In 713 he was promoted to a military post and eventually became Senior General of the Left Imperial Warrior Guard. He was buried at an imperial tomb with posthumous honors. Five members of his family were good at calligraphy and at painting in color. Known as the "Elder General Li," he did landscapes with birds and animals, and herbs and trees, and was later considered the originator of the "blue and green" or "gold and green" decorative tradition of landscape. *Chiu T'ang shu*, 60; *Hsin T'ang shu*, 78. *TCMHL*; *LTMHC*, 9, Acker tr., II, 242–243. Cahill Index, 1. *TSHCJMTT*, pp. 84–86.

LI SUNG (ACTIVE CA. 1190–CA. 1230). From Ch'ien-t'ang (Hang-chou, in Chekiang province). He first worked as a carpenter and was expert in drawing guidelines. Then he was adopted by the artist Li Ts'ung-hsün and became a painter-in-attendance, serving three Southern Sung emperors. He was a specialist in architectural subjects (*chieh-hua* or "boundary painting") but was also noted for his Buddhist and Taoist themes. His extant works are of secular figures (with an emphasis on genre details), landscapes, and flowers. *THPC*, 4. *Sung Biog.*, 2; Cahill Index, 4. *TSHCJMTT*, pp. 117–118.

LI T'ANG (B. CA. 1050–D. AFTER 1130), T. HSI-KU. From Ho-yang (in Honan province). By 1103 he was already known as a figure painter and in the 1111 to 1117 era he successfully competed to enter Hui-tsung's Bureau of Painting with a poetically suggestive landscape. He was good at all kinds of subjects. At the end of Northern Sung he fled to the south, accosted along the way in the T'ai-hang Mountains of Honan by the bandit Hsiao Chao who was to turn painter. After a time in Hang-chou as a professional without imperial patronage, Li T'ang was recommended to the court around 1130 and again became a painter-in-attendance, honored as well by a military title and the award of the golden belt. Kao-tsung wittily compared his art to that of Li (Ssu-hsün of the) T'ang, a comment that underlines the archaism in Li T'ang's colored landscape style. His angular forms and "small axe-chip" brush strokes greatly influenced later Academy landscapists, and his work may also be the source of the balanced asymmetrical composition consistently employed by

"one-corner" Ma Yüan. *HC; THPC*, 4. *Sung Biog.*, 2; Cahill Index, 4. *TSHCJMTT*, pp. 114–116.

LI TI (ACTIVE LAST HALF 12TH CENTURY). Probably from Ch'ien-t'ang (Hang-chou, in Chekiang province). The earliest source, *Hua-chi pu-i*, indicates that he was active under the second through fourth emperors of Southern Sung and this accords with the inscribed dates on reliable works (1174–1197) and with the fact that one son is said to have entered the Painting Academy in the mid-thirteenth century. The earlier dating given in *T'u-hui pao-chien* may be the result of a tendency to link Li Ti with Li T'ang; there Ti is also said to have been an Assistant Commissioner in the Painting Academy honored with the golden belt. His specialties were flowers and bamboo, and birds and animals in motion. He was not good at landscapes. *HCPI; THPC*, 4. *Sung Biog.*, 2; Cahill Index, 4. *TSHCJMTT*, pp. 116–117.

LI T'IEN (ACTIVE LATE 9TH–EARLY 10TH CENTURY), t. WEI-CH'ING. From Hua-yang (in Szechwan province). A scholar from former Shu territory, he was recommended for a *chin-shih* degree in 992 and became a Lecturer at the Imperial Academy and eventually a magistrate in the region of Szechwan. His writings consist of several literary collections and commentaries on Confucian and Taoist works. As an acquaintance of Huang Hsiu-fu, he wrote the preface to the *I-chou ming-hua lu* (Record of Famous Painters of I-chou) in 1006. *ICMHL;* Sung Index, pp. 851–852.

LI TSAN-HUA (899–936) (YEH-LÜ [P'EI, KUO- OR] T'U-YÜ) PRINCE OF TUNG-TAN (THE PO-HAI REGION OF EASTERN MANCHURIA), POSTHUMOUS TITLE: I-TSUNG. Eldest son of the founder of the Liao dynasty, he did not succeed to the throne and hence emigrated to China in 931 where he received his Chinese name at the court of the Later T'ang Dynasty (923–935). He painted Khitan chieftains and nomadic horses in color, and his brushwork is variously characterized as strong and quick or as weak. *Liao shih [ESSS]*, 72. *WTMHPI; HHHP*, 8; *KCHP; THCWC*, Soper tr., pp. 27, 139 n. 284. Cahill Index, 2. *TSHCJMTT*, p. 92.

LI TSUNG-CH'ENG (ACTIVE LAST HALF 11TH CENTURY). From Fu-chih (Shensi province). A landscapist who painted in Li Ch'eng's style, he used moist ink to do level distance views of river banks with wild trees. He did a variety of landscape subjects, including scenes of the four seasons, pines and rocks, and wintry forests, and titles attributed to him suggest atmospheric effects. Among his collaborative efforts at Shen-tsung's court was a side wing of a screen done with pines and rocks for the small hall near the inner East Gate. *SCMHP; THCWC*, Soper tr., pp. 19, 60, 173 n. 503. *LCKCC*, "Hua chi." Cahill Index, 4. *TSHCJMTT*, p. 102.

LI TS'UNG-HSÜN (ACTIVE CA. 1120–1160). Active in K'ai-feng and in Hang-chou. A painter-in-attendance during the Hsüan-ho period (1119–1126), he again held office in the south under Kao-tsung and was also honored by a military rank and the award of the golden belt. He painted Buddhist and

Taoist images, secular figures, and flowers and birds with exceptional placement and coloring. His adopted son Li Sung carried on his style of figure painting. *THPC*, 4; *TSHCJMTT*, p. 117.

Lɪ Yüᴀɴ-ᴄʜɪ (ᴀᴄᴛɪᴠᴇ ᴄᴀ. 1068–1078). From T'ai-yüan (Shansi province). A Wu Tao-tzu follower who specialized in Buddhist and Taoist subjects and secular figures, he restored the murals at the Hsiang-kuo-ssu Temple after they were damaged by water in 1065. In a competition with Ts'ui Po for this project, Li's work was judged superior since it retained his master's rules. *THCWC*, Soper tr., pp. 54, 97–98. *TSHCJMTT*, p. 103.

Lɪᴀɴɢ K'ᴀɪ (ʟᴀᴛᴇ 12ᴛʜ–ᴇᴀʀʟʏ 13ᴛʜ ᴄᴇɴᴛᴜʀʏ), ᴛ. Pᴏ-ʟɪᴀɴɢ. His family was originally from Tung-p'ing (in Shantung province). As painter-in-attendance at the Painting Academy in the era 1201 to 1204, when awarded the golden belt he is said to have simply hung it up and left. (An alternative interpretation is that he *never* hung it up, literally reveling in it.) He was unrestrained by nature, and when drunk he thought himself the social equal of anyone, hence his nickname "Crazy Liang." He painted figures and landscapes, Taoist and Buddhist subjects, and demons and divinities, surpassing his model Chia Shih-ku in refinement and freedom. Works in this style were appreciated by Liang's fellow academy painters, but he also painted in a sketchy manner with "abbreviated brushwork" as in certain Ch'an Buddhist subjects preserved in Japan. *THPC*, 4. Cahill Index, 4. *TSHCJMTT*, pp. 213–214.

Lɪᴀɴɢ Yüᴀɴ-ᴛɪ (Hꜱɪᴀᴏ I) (508–554), ᴛ. Sʜɪʜ-ᴄʜ'ᴇɴɢ. Seventh son of the founder of the Liang dynasty and its fourth emperor (r. 552–554). Blind in one eye, he nevertheless gained considerable distinction as a military leader and met his end in combat with the Western Wei invaders. A scholar inclined towards Taoism, he also evidently had ability as a calligrapher, painter, and sculptor and is recorded as doing a painting of Confucius and carving a sandalwood image, presumably of a Buddhist icon. He seems to have introduced two pictorial subjects drawn from court life that were later to become famous in T'ang versions by Yen Li-pen and Yen Li-te: "Foreign Guests at Court" and "Tribute Offering." An essay sometimes attributed to him, *Shan-shui sung-shih ko* (On the Categories of Landscapes and Pines and Rocks), is now generally considered to be an early twelfth-century forgery. *Liang shu*, 5; *Nan shih*, 8. *HHP; LTMHC*, 7, Acker tr., II, 169–170; also see I, 120–123. *TCHCJMTT*, pp. 47–48.

Lɪᴜ Aɴ (ᴅ. 122 ʙ.ᴄ.). Grandson of the founder of the Han dynasty and Prince of Huai-nan. His father, the first Prince of Huai-nan, was executed for treason. He also was accused of plotting against the throne and took his own life. Esteemed for his musical and literary talents, he played an important role as an alchemist and a sustainer of Taoist thought during this time. He is best known for the compilation of the *Huai-nan-tzu*, which treats such topics as metaphysics, astronomy, and military strategy. *Shih-chi*, 118; *Ch'ien-Han shu* [*ESSS*], 44. See Joseph Needham et al., *Science and Civilization in China*, II, V, pt. 3. *BD*, #1269.

Liu Ching (1043–1100), t. Chü-chi. From Chien-chou (in Szechwan province). He gained a *chin-shih* degree in 1073 and was appointed as a lecturer in the classics. A poet and a great friend of Mi Fu, he painted trees and rocks and specialized in bamboo. Crab paintings are extant with his signature. *Sung shih,* 443; Sung Index, pp. 3862–63. *HC, 3; THPC,* 3. Cahill Index, 4. *TSHCJMTT,* p. 352.

Liu Hsiao-shih (7th century). A T'ang bird specialist who was sparing in his use of ink, he could evidently paint other subjects equally well. *LTMHC,* 9, Acker tr., II, 225–226. *TSHCJMTT,* p. 344.

Liu Hsüeh-ch'i (active ca. 1192), t. Hsi-chih. From Ch'ung-an (in Fukien province). Grandson of Chu Hsi's teacher and father-in-law, he was a Southern Sung poet and recluse who modeled his verse on Po Chü-i's. An extant collection of poetry and prose is under a literary name deriving from his country estate in the Southern Mountain: Fang-shih-hsien chü-shih. Sung Index, pp. 3994–95. *CKWHCTTT,* #2667.

Liu I (active first half 12th century), t. I-chih. From K'ai-feng (in Honan province). In the Hsüan-ho period (1119–1126) he was a painter on call in the inner palace but never got to see the Emperor. His specialty was flowers and birds studied from nature. He painted the precious objects and imported creatures in the palace gardens and was good at small scenes such as a lotus pond in autumn. After the fall of Northern Sung, he traveled in South China, sketching the exotic flora and fauna of the Ling-nan region. *HC, 6; THPC,* 3; *TSHCJMTT,* p. 352.

Liu K'o-chuang (1187–1269), t. Ch'ien-fu, h. Hou-ts'un. From P'u-t'ien (in Fukien province). A Southern Sung poet from a family of scholar officials, he was well educated and received a provincial appointment through privilege. He associated with a group of non-officials who wrote poetry, and his works were published after 1225 in the *River and Lake Collection of Poetry.* One verse on fallen plum blossoms was thought by government censors to have political implications, but he was acquitted through influence. In 1241 a *chin-shih* degree was conferred on him, and he was appointed to several positions, ending as a scholar in the Lung-t'u Pavilion of the Han-lin Academy before retiring from office. His collected literary works are extant. Sung Index, pp. 3949–50.

Liu Kung-ch'üan (778–865), t. Ch'eng-hsüan. From Hua-yüan near Ch'ang-an (in Shensi province). A noted T'ang calligrapher, he took his *chin-shih* examination around 806 and reached the office of Grand Secretary of the department of the Grand Secretariat Imperial, was enfeoffed as a duke, and given the honorary titles of tutor and guardian to the Heir Apparent. Known for his personal integrity, he said that if his mind was correct his brush strokes would also be correct. A popular writer of epitaph inscriptions, he was good at seal and standard scripts and founded a school of calligraphy. *Chiu T'ang*

shu, 165; *Hsin T'ang shu*, 163. *CKWHCTTT*, #1506. *THCWC*, Soper tr., pp. 82–83, 195: n. 647.

LIU TAO-SHUN (-CH'ENG) (ACTIVE MID 11TH CENTURY). From Ta-liang (K'ai-feng, in Honan province). Early bibliographies list him as the author of the *Sheng (Shen/Sung)-ch'ao ming-hua p'ing* and the *Wu-tai ming-hua pu-i (chi)*, collections of biographies of Sung and Five Dynasties artists respectively, with critical evaluations. The former text is mentioned in the preface to the latter which is dated 1059. *CKJMTTT*, p. 1476; *SHSLCT*, 4.4b-5b.

LIU T'IEN (ACTIVE LATE 5TH CENTURY, UNDER THE SOUTHERN CH'I, 479–502), T. SHIH-WEN. From P'eng-ch'ang (in Kiangsu province). From a wealthy and powerful family of officials, his own rank only reached that of Secretary in the Board of Civil Appointments. His skill in literary composition and his calligraphy in the seal and clerical scripts were thought to be noteworthy, and his paintings of court ladies were considered the best of the period. *Nan shih*, 39. *KHPL; LTMHC*, 7, Acker tr., II, 164–165. *TSHCJMTT*, p. 44.

LIU YIN (1249–1293), T. MENG-CHI, H. CHING-HSIU. From Yung-ch'eng (in Pao-ting, Hopei province). A writer and Confucian philosopher, he was a man of many talents, who served his stepmother filially after his father's early death. In 1282 he was recommended to the Mongol court on the basis of his learning and appointed Right Critic Advisor to the Heir Apparent, but he resigned and returned home when his stepmother became ill. When he was summoned again in 1291 to a high position, he firmly refused. Living quietly in retirement he wrote and edited a selection of his poems; his collected poetry and prose were compiled by friends and disciples after his death. *Yüan shih*, 171; *CKWHCTTT*, #3180. Cahill Index, 6.

LIU YUNG (EARLY 11TH CENTURY). A native of K'ai-feng (in Honan province). He was the chief follower of Kuan T'ung in landscape painting, but his brushwork was a bit finer. His works included landscapes of the four seasons and a waterfall screen. *SCMHP; THCWC*, Soper tr., pp. 19, 57, 172 n. 500. *TSHCJMTT*, pp. 347–348.

LO TA-CHING (ACTIVE CA. 1224), T. CHING-LUN. From Lu-ling (in Kiangsi province). After receiving a degree he was employed in the Judicial Service at Yung-chou (in Kwangsi province). His discussions of literary styles and his critical opinions are presented in *Hao-lin yü-lu* (The Autumn Dew of the Crane Grove). Sung Index, p. 4277. *CKWHCTTT*, #2833.

LOU KUAN (MID 13TH CENTURY). Active at Hang-chou (in Chekiang province). A painter-in-waiting at the Painting Academy around 1265–1275 or earlier, he studied Ma Yüan's brush technique and was good at painting landscapes and figures. Cahill Index, 4. *TSHCJMTT*, p. 334.

LU CHI (261–303), T. SHIH-HENG. From Hua-t'ing (in Kiangsu province). Both his grandfather and father were important officials in the Three Kingdoms' Wu Dynasty (222–280). On the death of his father the Grand Marshal

in 274, Chi and his four brothers succeeded to the command of the Wu army. After the Wu defeat, he withdrew into seclusion, devoting himself to study and to the composition of the *Pien-wang lun* (Discussions of the Fall of States). In 290 he went to Lo-yang (in Honan province) and was eventually appointed to a number of high posts but finally met his death through implication in the plots of the Chin princes. He remains important as a leading figure in the development of Chinese literature and literary criticism, being the author of the "Wen fu" (Prose-Poem on Literature). *Chin shu*, 54; *SSHY*, Mather tr., p. 554. *CKWHCTTT*, #0391. See M. G. Knoerle, "The Poetic Theories of Lu Chi," *Journal of Aesthetics and Art Criticism*, 25 (1966), 137–143.

Lu T'an-wei (active 460s–early 6th century). From Wu (-hsien?, in Kiangsu province). One of the most celebrated pre-T'ang painters, he was in constant attendance at the Liu-Sung court (in modern Nanking). He is said to have learned from Ku K'ai-chih but to have adapted the "single stroke" method of calligraphy to painting. He achieved renown in his own time for his skill in doing colored pictures. Primarily a portraitist, he is recorded as producing a likeness of Hsi K'ang (223–262) on imperial command. Paintings of historical figures like this poet and the other "Seven Sages of the Bamboo Grove," or of Confucius and his disciples, and portraits of officials or members of the Liu-Sung imperial family make up the bulk of the titles of extant works recorded for Lu in T'ang times. He also was credited with paintings of horses and monkeys, birds and insects, and poetic illustrations. His Buddhist murals in the Kan-lu Temple near modern Chen-chiang (in Kiangsu province) were described by such Sung writers as Su Shih and Mi Fu. *KHPL; TCMHL; LTMHC*, 6, Acker tr., II, 103–112; also I, 162, 372, 380–382. Also see *Liang shu*, 48. *TCHCJMTT*, pp. 23–25.

Ma Fen (Pen?) (late 11th–early 12th century). From Ho-chung (in Shensi province). In the era from 1086 to 1097 he gained a reputation for his paintings of Buddhist images in the family tradition. He also did figures, flowers and birds, and landscapes, and was particularly good at small scenes. Sketching from life, he produced a series of handscrolls of 100 geese, 100 apes, 100 oxen, 100 sheep, 100 deer. According to *THPC*, in the era 1119 to 1125, he became a painter-in-attendance at the Bureau of Painting. *HC*, 7; *THPC*, 3. Cahill Index, 4. *TSHCJMTT*, p. 177.

Ma Hsing-tsu (active ca. 1130–1160). Ma Fen's son (or descendant). Moved to Hang-chou (in Chekiang province). A painter-in-attendance in the Southern Sung Painting Academy, he did a portrait of Kao-tsung's favorite concubine and served as the Emperor's artistic advisor. He also painted flowers and birds and nomadic scenes. *HCPI; THPC*, 4. Cahill Index, 4. *TSHCJMTT*, p. 179.

Ma Lin (active first half 13th century). Ma Yüan's son. A painter-in-waiting at the Painting Academy under Ning-tsung (r. 1195–1224), he is judged not to have reached his father's status in art as in rank, and Yüan is said to have signed with Lin's name on occasion in order to help his son. Lin

painted landscapes and flowers and birds in the family tradition but may have followed Chia Shih-ku in the style of his figures. *HCPI. Sung Biog.*, 2; Cahill Index, 4. *TSHCJMTT*, p. 183.

MA YÜAN (ACTIVE 1190–AFTER 1225), T. CH'IN-SHAN. Son of Ma Hsing-tsu or Shih-jung. Lived at Hang-chou (Chekiang province). A painter-in-attendance in the Southern Sung Painting Academy, he is the most famous artist of his family, the co-founder with Hsia Kuei of the so-called Ma-Hsia style of Academy landscape painting. He evidently used both centralized and asymmetrical compositions, but later became known as "one-corner" Ma from the minimal character of certain designs. His foreground rocks were textured with "large axe-chip" strokes and given volume by dark ink washes, and he used staccato lines in the garments of his figures. He also painted flowers and birds. *HCPI; THPC*, 4. *Sung Biog.*, 2; Cahill Index, 4. *TSHCJMTT*, pp. 180–182.

MAO HUI-YÜAN (LATE 5TH CENTURY). Originally from Yang-wu (-hsien, Honan province). Under the Southern Ch'i Emperor Wu (r. 483–493), he held the post of Supervisor of the Imperial Ateliers. Erroneously charged with fixing the price of the mineral blue and green colors bought for use in painting for the Emperor, he was executed for this offense. He is said to have been a follower of Ku K'ai-chih and thus skilled at painting figures and demonic divinities. Although he evidently did various subjects, he was considered to be the best horse painter of his time and is listed as the author of the *Chuang-ma p'u* (Treatise on Caparisoned Horses), which is no longer extant. *KHPI.; LTMHC*, 7, Acker tr., 165–177; also I, 163. *THCWC*, Soper tr., p. 5. *TCHCJMTT*, p. 3.

MEI YAO-CHEN (1002–1060), T. SHENG-YÜ. From Hsüan-ch'eng (in Hsüan-chou, Anhwei province). A famous Northern Sung poet, he developed and perfected a style of poetry in tandem with Ou-yang Hsiu. From a family of scholar-officials, he entered the civil service through privilege. However, his literary talent was soon recognized, and he received an opportunity to take the *chin-shih* examination. Thereafter he served at court in a series of modest posts, ending as a staff member for the compilation of the T'ang history, but his real role was that of court writer, composing celebratory poems or documents on official occasions. His broad scholarship and his knowledge of classical poems underlay his own poetry, which explicitly aimed at vivid descriptions and indefinite meanings that were conveyed by a relatively plain diction. The patronage of influential figures and his own sociable personality contributed to the success of these poems, described as having an "archaic flavor" or a certain "blandness" by his friend Ou-yang Hsiu. *Sung shih*, 443; Sung Index, pp. 2683–84. *Sung Biog.*, 1; Liu and Lo, *Sunflower Splendor*, pp. 584–585.

MENG HSIEN (EARLY 11TH CENTURY), T. T'AN-CHIH. From Hua-chih in An-hua (in Kansu province). Usually known as "Little Meng," he was a figure specialist who formed his own style. According to Mi Fu, he worked on silk

in a broad technique derived from the T'ang murals of Wu Tao-tzu. Meng painted Buddhist and Taoist images, demonic divinities, figures and horses, and architectural subjects. The lively effects of his brushwork were appreciated, but the squashed proportions of his figures' features were commonly criticized. *SCMHP; HS; THCWC,* Soper tr., pp. 53, 168 n. 476. *TSHCJMTT,* p. 133.

MI FU (1052–1107), T. YÜAN-CHANG, H. HAI-YÜEH, CHIA-CHÜ TAO-SHIH. From Hsiang-yang (in Hupei province). A noted calligrapher and connoisseur, he came from a family that was probably of Sogdian origin and was known for military leaders but not scholars. His mother was a palace lady, and he grew up in the palace grounds at K'ai-feng. But most of his life was spent in South China, and he favored the southern tradition in calligraphy and painting, that of Wang Hsi-chih and of Tung Yüan and Chü-jan. Mi's eccentricities included an antique mode of dress and an obsession with cleanliness. Through his mother's influence he entered the civil service as a collator in the imperial library; then he served in various prefectural posts in the south for two decades before being promoted to a post near the capital. Finally in 1103 he was made a Doctor of the Imperial Sacrifices at the court, and around 1105 became Doctor of Painting and Calligraphy briefly. On separate occasions he presented gifts of calligraphy and of his son Yu-jen's painting to Emperor Hui-tsung. Mi Fu associated with the outstanding figures of the time, particularly with the writer Su Shih and the statesman Wang An-shih, and he also belonged to a group of collectors who traded scrolls of calligraphy and painting, and art objects like ink stones. His chief writings on art were the *Hua-shih* (History of Painting), completed by 1103, and the *Shu-shih* (History of Calligraphy), written between 1103 and 1107. These texts, which describe specific pieces with precision and record seals and inscriptions, were to be models for later cataloguers. In them Mi also expressed his strong preference for the tranquility and naturalness of the southern tradition in art, his model for calligraphy in the running script and for misty landscapes after Tung Yüan. *Sung shih,* 444; Sung Index, pp. 541–544. *Sung Biog.,* 2; Cahill Index, 4. *HC,* 3. *TSHCJMTT,* pp. 48–51.

MI YU-JEN (CA. 1072–1151), T. YÜAN-HUI. From Hsiang-yang (in Hupei province). Son of Mi Fu. The most gifted of Mi's sons and the only one to survive into adulthood, he was noted for his ability in calligraphy and painting. He never attained high rank in office, first serving in a prefectural post in 1119 and then for two years as a scholar in charge of the School of Writing established in 1122. Under the Southern Sung he fled from the Chin invaders in 1129 to the Kiangsu region, but it was not until a decade later that he served at court, first as an executive in the Ministry of War and then in 1145 as a scholar attached to the Fu-wen-k'o (Hall for the Diffusion of Literature). Pride in his family connections plus a certain indifference may have limited his career. In painting he expressed his ideas or feelings in misty landscapes done on silk, or more often on paper, with loose strokes and horizontal dotting. When at court he was unable to satisfy the requests for his works,

and it was said that he painted only for the Emperor. He also authenticated the scrolls in Kao-tsung's collection. *Sung shih*, 444; Sung Index, pp. 545–546. *Sung Biog.*, 2; Cahill Index, 4. *HC*, 3. *TSHCJMTT*, pp. 51–52.

NI TSAN (1301?–1374), T. YÜAN-CHEN, H. YÜN-LIN, YÜ. From Wu-hsi (in Kiangsu province). One of the four great Yüan landscapists, he was the youngest of three sons but inherited the family wealth in 1328. Well educated with artistic inclinations, he designed a famous garden and collected books and antiquities. Anecdotes stress his aloof and fastidious nature and his insistence on cleanliness parallels that of Mi Fu. Around 1335 to 1340 he took to a wandering life to dodge tax collectors, and by 1354 had given away his property to relatives and friends. He stayed with friends or at Taoist and Buddhist temples and lived on a house boat on Lake T'ai. In 1366 he went into hiding to escape persecution, but soon thereafter was able to return home, where he lived in retirement under the Ming regime. His poems and writings were collected during his lifetime, and numerous paintings done in his "inimitable" style are attributed to him. His empty river views are done with silvery ink, and in them shimmering rock masses are outlined with sideways strokes. He claimed that his ink bamboos were painted in a careless fashion. *Ming shih* [*ESSS*], 298; Yüan Index, pp. 837–839. *DMB*, II, 1090–93; *Yüan Masters*, pp. 25–33. Cahill Index, 6.

OU-YANG CHIUNG (896–971). From Hua-yang (Ch'eng-tu, Szechwan province). A poet with musical gifts, he served as an official under several different regimes in the unsettled Five Dynasties period. A drafting official in the Secretariat of the Former Shu, he followed his defeated ruler to Lo-yang (in Honan province) in 825. Eventually he regained his position under the Later Shu regime, then became a Han-lin Academician in 939 and finally Executive of the Chancellery in 961. After 965 he continued to hold high posts under the Sung Dynasty for a short while, and he played his flute in the company of the Sung founder. He aimed at refined craftsmanship and freshness in his poetry and once did a set of fifty didactic ballads after Po Chü-i. *Sung shih*, 479; Sung Index, p. 3747; *Sung Biog.*, 1.

OU-YANG HSIU (1007–1072), T. YUNG-SHU, H. TSUI-WENG, LIU-I CHÜ-SHIH. Born at Mien-chou (in Szechwan province); lived at Ying-chou (Fu-yang, Anwei province). A noted Sung writer, he memorized Han Yü's writings as a youth in Sui-chou (in Hupei province) where he was brought up in humble circumstances after his father's death. In 1030 he received the *chin-shih* degree and was assigned to secretarial duties at Lo-yang, the cultural center, where he became friends with the poet Mei Yao-chen. Involved in political factionalism in the capital, K'ai-feng, in 1036 and again in 1043, he was banished to a series of provincial posts, where he wrote his new account of the Five Dynasties period and composed his essay on "The Pavilion of the 'Old Drunkard,'" using this designation as a pen name. In 1057, again on the career ladder, he insisted that ancient-style prose after Han Yü be the standard for the doctoral examinations, which he was in charge of. The stars of this oc-

casion, Su Shih and his brother Ch'e, became his protégés. A political conservative, Ou-yang was in power only from 1060 to 1067, becoming an assistant councillor. Unsympathetic to Wang An-shih's reform policy, he nonetheless remained friends with him after resigning from office. A master of literature in all forms, Ou-yang also produced one of the earliest critical treatises on poetry. *Sung shih*, 319; Sung Index, pp. 3748–53. *Sung Biog.*, 1; Liu and Lo, *Sunflower Splendor*, pp. 586–587.

OU-YANG HSÜN (557–641), T. HSIN-PEN. From Lin-hsiang (in Hunan province). An able scholar, he became one of the four great T'ang calligraphers. He took office under the Sui dynasty, and at the beginning of the T'ang he was promoted to Supervising Censor because of his acquaintance with the founding emperor. His calligraphy was first based on Wang Hsi-chih's but soon surpassed it. His form of the running standard script was known beyond the borders of China in his lifetime and became a classic model for fourteenth-century practitioners. *CKWHCTTT*, #1019. *BD*, #1594.

PAO TING (FIRST HALF 11TH CENTURY). From Hsüan-ch'eng (in Anhwei province). Son of "Old Pao," a well-known tiger painter, he continued the family tradition but was not as able. *SCMIIP; IIP; THCWC*, Soper tr., pp. 68, 183–184 n. 562. *TSHCJMTT*, p. 41.

P'EI HSIAO-YÜAN (ACTIVE IN THE CHEN-KUAN ERA, 627–650). He was the author of the *Chen-kuan kung-ssu hua-lu* (Record of Paintings in Public and Private Collections in the Chen-kuan Era). In its preface his title is given as Drafting Official of the Secretariat. The text, written for an imperial patron, the Prince of Han, is said to be a list of 290 paintings that P'ei had seen, ranging from the 3rd century to 639 in date. However, the description in the preface does not exactly correspond to the present text, which may have been amended. P'ei may also have written a separate work on T'ang painters, since a few passages quoted by Chang Yen-yüan in the T'ang chapters of *LTMHC* are not in the text. *CKJMTTT*, p. 1379. *CKHLLP*, I, 17–18.

PI HUNG (ACTIVE MID 8TH CENTURY). From Yen-shih (in Honan province). Said to be the best painter of pines and rocks in his time, he was a censor around 750 and became First Secretary in the Imperial Chancellery in 767. He did a mural of pines and rocks in 743 in the Left Department Hall that were highly praised, and later when President of the Heir Apparent's Secretariat he did a section of a collaborative mural with Wang Wei and Cheng Ch'ien in the eastern courtyard of the Tzu-en Temple. *TCMHL; LTMHC*, 10. Acker tr. II, 278–279. *TSHCJMTT*, pp. 205–206. Also see *HS*, Vandier-Nicolas tr., p. 157, #184.

PI LIANG-SHIH (D. 1150), T. SHAO-TUNG. From Shang-tsan (in Honan province). He was good at painting such literati subjects as bare trees, bamboos, and rocks. A scholar who wrote on the Confucian classics and copied T'ang calligraphy in the standard script, he gained a *chin-shih* degree ca. 1131. When young he frequented dealers and collectors, and in office he sought out

antiquities, pieces of calligraphy and paintings and presented them to the court. He was promoted as a reward, and died in office, serving at the Fu-wen-k'o (Hall for the Diffusion of Literature). *THPC*, 4; Sung Index, pp. 2714–15. Cahill Index, 4. *TSHCJMTT*, p. 206.

PIEN LUAN (LATE 8TH–EARLY 9TH CENTURY). From Ching-ch'ao (near Ch'ang-an, Shensi province). A flower and bird painter who did murals for Buddhist temples at Ch'ang-an, he held the post of Administrator in Chief of the Bodyguard of the Right at the end of the eighth century, but left the court to live as an impoverished recluse in the Shansi region. He painted life-like birds and flowers in variegated colors and all sorts of plants such as mountain herbs and garden vegetables. His other subjects were sparrows and bamboos, bees and cicadas, cut flowering branches, and an auspicious fungus. *TCMHL; LTMHC*, 10, Acker tr., II, 288–289; also I, 275. Cahill Index, 1. *TSHCJMTT*, p. 388.

PO CHÜ-I (772–846), T. LO-T'IEN, H. HSIANG-SHAN. Born at Hsin-cheng (Honan province). A popular poet with broad sympathies, he took professional pride in his poetry, and his songs were famous as far away as Korea and Japan. From an old family from T'ai-yüan (in Shansi province), he was a recognized literary prodigy at fifteen but did not pass the *chin-shih* examinations until the age of twenty-nine. After a minor appointment in 802, he rose to become a member of the Han-lin Academy in 807 and held the title of Commissioner to the Left before his banishment to Chiang-chou (in Kiangsi province) in 815. There he built a retreat at Mount Hsiang and studied poetry with eight of his friends. He was eventually transferred to several posts, including those of Governor of Hang-chou in 822 and of Su-chou in 825 and finally became President of the Board of War in 841. He edited and arranged his collected writings and stored copies of them; his poems were engraved on stone by imperial command. *Hsin T'ang shu*, 75. *CKWHCTTT*, #1482. Liu and Lo, *Sunflower Splendor*, pp. 566–568.

SHEN KUA (1031–1095), T. TS'UN-CHUNG. From Ch'ien-t'ang (Hang-chou, Chekiang province). A noted Sung scientist, he was interested in astronomy, topography, the calendar, music, medicine, and divination, as well as the arts of calligraphy and painting. From about 1040 on he traveled widely to his father's successive posts and after 1054 was employed himself and dealt primarily with water control. In 1063 he passed the national examinations and was recommended for a court appointment in financial administration, but because of his interests in astronomy he became a director of the Astronomical Bureau in 1072. Thereafter he carried out several engineering and technical programs that were part of Wang An-shih's reforms and was sent on an embassy to the Liao in 1075. While engaged in fiscal reform in 1077, he was impeached and banished to Yen-chou (in Shensi province) where he directed military actions against the Tanguts. After a defeat, he was forced to leave official life, and in 1088 he retired to Ching-k'ou (in Kiangsu province) where he wrote *Meng-ch'i pi-t'an* (Casual Writings from the Garden of the Stream

of Dreams) covering a variety of topics including observations on painting. *Sung shih*, 331; Sung Index, pp. 676–677. *Sung Biog.*, 1; Nathan Sivin, "Shen Kua," *Sung Studies Newsletter*, 13 (1977), pp. 31–56.

SHIH K'O (LATE 10TH CENTURY), T. TZU-CHUAN. From Ch'eng-tu (in Szechwan province). Despite his Confucian studies, he became a painter, first following Chang Nan-pen and then his own free bent. In 965 on the fall of Shu, he came to K'ai-feng. There he was ordered to paint murals for the Hsiang-kuo Temple and given a position as a painter in the Academy. However, he preferred to return to Ch'eng-tu. He was witty and argumentative, and his painting specialty was antique and outlandish historical figures. He also did Buddhist and Taoist subjects. *ICMHL; SCMHP; HP; HHHP*, 7; *THCWC*, Soper tr., pp. 49, 164 n. 450; also see Soper, "A Northern Sung Descriptive Catalogue," *JAOS*, 69 (1949), 26–27. Cahill Index, 2. *TSHCJMTT*, pp. 44–46.

SHIH TAO-SHIH (LATER 4TH–FIRST HALF 5TH CENTURY). From a family of painters, he did illustrations of poems and was particularly good at figures, horses, and geese. He is said to have learned from Hsün Hsü and Wei Hsieh's art, and is best known for a painting of the dragon-like "Eight Coursers of King Mu." *KHPL; LTMHC*, 5, Acker tr., II, 82–84. *THCWC*, Soper tr., pp. 73, 187 n. 586. *TCHCJMTT*, p. 8. (Note: the "Admonitions . . . on Carts and Carriages" [Acker tr., II, 82 and n. 9] actually is a title referring to the "Submission" section of the *Meng fu* [The Nightmare], a prose-poem by Wang Yen-shou.)

SHIH TS'AN (5TH CENTURY). He was a horse painter under the Liu-Sung (420–479). In the ninth century a "plain" outlined drawing of horses in motion and a scroll of the "Eight Chargers" of King Mu were extant. *CKKSHL; LTMHC*, 6, Acker tr., II, 148.

SSU-MA CH'ENG-CHEN (D. 735), T. TZU-WEI (PO-YÜN). From Wen-hsien (in Honan province). The Taoist priest-painter Po-yün mentioned in Ching Hao's text is likely to be this man. He studied Taoism on Mount T'ien-t'ai (in Chekiang province) and in 727 was ordered by Hsüan-tsung to build a Taoist monastery on a mountain near Ch'ang-an, which was decorated with murals. Po-yün also wrote poems and was skilled in the seal and official scripts of calligraphy. *LTMHC*, 9, Acker tr., II, 257. Also *PFC*, Munakata tr., pp. 45–46. *TSHCJMTT*, p. 38.

SU CH'E (1039–1112), T. TZU-YU. From Mei-shan (in Szechwan province). The younger brother of Su Shih and a noted essayist, he also succeeded in the metropolitan examination of 1057 and received his *chin-shih* degree under Ou-yang Hsiu. In 1069 he was appointed to the staff of the Finance Commission but was soon banished because of opposition to Wang An-shih's policies. When the conservatives gained power in 1086, Ch'e served as Right Policy Critic. A member of the Shu party, he became a Han-lin Academician and held various important posts until 1094. Then he was degraded to local

governorships and in 1097 banished for several years. His rank was upgraded at the beginning of Hui-tsung's reign for a few years but then again lowered. He spent the end of his life writing in seclusion. His syncretic interests were reflected in his scholarly works, commentaries on Confucian classics and the Taoist Lao-tzu text as well as an historical study of antiquity. *Sung shih*, 339; Sung Index, pp. 4331–33. *Sung Biog.*, 1.

Su Shih (1037–1101), t. Tzu-chan, h. Tung-p'o chü-shih. From Mei-shan (in Szechwan province). Considered the greatest Sung poet, he is also one of the "Four Great Calligraphers of Sung" along with Huang T'ing-chien, Mi Fu, and the earlier master, Ts'ai Hsiang (1012–1067). He passed the *chin-shih* examination in 1057 and was sponsored by Ou-yang Hsiu. After a period of mourning for his father Su Hsün, he returned to court in 1069, but alignment with the conservatives soon led to his banishment to a series of provincial posts and even to a short imprisonment. Confined to Huang-chou (in Hupei province) from 1081 to 1084, he bought land to farm and constructed a study, his "Hall of Snow," on the "eastern slope," from which he took his literary name. There he wrote the famous prose-poems describing his journey to the Red Cliff on the Yangtze River. After Wang An-shih's death in 1086, he was recalled to court, became a Han-lin Academician, and was appointed to various posts. In 1089 he served as Governor of Hang-chou and in 1092 became President of the Board of Rites, but was banished shortly thereafter to a series of provincial posts further and further south, reaching the island of Hainan in 1097. After four years he was pardoned, but his health had broken and he died on his way north. Noted for his exuberant personality and his philosophical detachment, he became a literary model for later generations. His friendship with his cousin Wen T'ung, a specialist in ink bamboos, ultimately raised this genre of painting to a literati art with the status of poetry and calligraphy. His own sketches of trees and rocks or bamboos are described in his writings and those of Mi Fu. *Sung shih*, 338; Sung Index, pp. 4312–24. *Sung Biog.*, 1; Liu and Lo, *Sunflower Splendor*, pp. 589–590. Cahill Index, 4. *TSHCJMTT*, pp. 392–395.

Sun Chih-wei (early 11th century), t. T'ai-ku. From Mei-chou (in Szechwan province). A Taoist adept of peasant stock, he was a noted painter of Taoist and Buddhist subjects, such as the star gods or the Buddhist assembly painted as a mural in a Taoist temple at Ch'eng-tu. There are Sung descriptions of his paintings of a demon queller and of water scenes with fishes and dragons, as well as of animal subjects like tigers and oxen. *SCMHP; HP; HHHP*, 4; *THCWC*, Soper tr., pp. 48–49, 163 n. 447. *TSHCJMTT*, pp. 186–187.

Sun Shang-tzu (late 6th–early 7th century, under the Sui dynasty, 589–617). From Wu (or Kiangsu province). A known follower of Ku K'ai-chih and Lu T'an-wei, he was once a Chief Clerk in a subprefecture in Mu-chou (Chin-hua, Chekiang province). He was particularly noted for his paintings of demons and divinities done in the "trembling line" brush technique.

Ch'ang-an Buddhist temples had murals recorded as being by him. *LTMHC,* 8, Acker tr., II, 199–200; also I, 289–290, 302–303. *TCHCJMTT,* p. 19.

Sun Wei (Yü, originally) (late 9th century). From K'uai-chi (in Chekiang province). The one "untrammeled" artist of the *ICMHL,* he was a figure specialist who painted murals in the T'ang capital, Ch'ang-an, and after 880 at the Shu capital, Ch'eng-tu (in Szechwan province). He was good at secular figures, dragons in water, pines and rocks, and ink bamboos, and excellent at Heavenly Kings and demonic divinities. Of a careless disposition and fond of wine, he was particularly noted for his swift brushwork. *ICMHL; HP; HHHP* 2; *THCWC,* Soper tr., pp. 24, 134–135 n. 244; also Soper, "A Northern Sung Descriptive Catalogue," *JAOS,* 69 (1949), 29. Cahill Index, 2. *TSHCJMTT,* pp. 184–185.

Sung Hui-tsung (Chao Chi) (1082–1135). Shen-tsung's 11th son; the last emperor of Northern Sung (r. 1101–1126). He studied Taoism, pursued the arts, and was especially skilled in calligraphy and painting. In calligraphy he followed Huang T'ing-chien and developed his own aesthetic "slender gold" script. In painting he did blue-and-green landscapes under the influence of Wang Shen and depicted birds and flowers in the tradition of Ts'ui Po in color and in ink alone. He loved rare objects of all sorts, and is said to have drained the empire's resources to build an exceptional palace garden at Pienliang (K'ai-feng). His collections of calligraphy and painting were the largest known up to that time and were recorded in the Hsüan-ho catalogues. He also promoted the education of artists in 1104, and expanded the Bureau of Painting in the palace after 1110. His extravagances and the corrupt practices of ministers such as Ts'ai Ching are traditionally thought to have caused the collapse of the Northern Sung dynasty. When the Jurchen first invaded, he resigned the throne and took a Taoist title. After the fall of the capital in 1127, he was taken prisoner, and he died in Chin territory. *Sung shih,* 19–21; Sung Index, pp. 782–783; *Sung Biog.,* 1 (in German). *HC,* l. Cahill Index, 4. *TSHCJMTT,* pp. 317–320.

Sung Jen-tsung (Chao Chen) (1010–1063). Chen-tsung's 6th son; 4th emperor of the Sung (r. 1023–1063). Adopted by the Empress, he proved extremely filial, and, as his Temple name indicates, was benevolent toward his subjects, distributing medicine at the time of an epidemic. He promoted education and patronized literature. In painting, he did Buddhist themes and animals: his "ink gibbons" were said by Mi Fu to be extremely original. *Sung shih,* 9–12; Sung Index, p. 726; *Sung Biog.,* 1 (in German). *HS; THCWC,* Soper tr., pp. 41, 153 n. 401. *TSHCJMTT,* p. 312.

Sung Kao-tsung (Chao Kou) (1107–1187), t. Te-ch'i. Hui-tsung's ninth son. After his father and brother were taken captive by the Jurchen Chin, he was placed on the throne in Nanking in 1127, and ruled as the first emperor of Southern Sung through 1162. He narrowly escaped captivity himself in 1129, but eventually settled in Hang-chou, the capital after 1138. To preserve peace with the Chin, he signed treaties in 1141 and again in 1162. In Hang-

chou he fostered the arts, reconstituting an Academy (or Bureau) of Painting connected with the palace and rebuilding the imperial collections of calligraphy and painting. He wrote an essay on calligraphy, and in his own writing took the Northern Sung masters Huang T'ing-chien and Mi Fu as models before turning to the pre-T'ang Wang Hsi-chih. In painting he did figures, landscapes, and bamboos and rocks with a natural fluency. *Sung shih*, 21–32; Sung Index, pp. 771–773; *Sung Biog.*, 1 (in German). Cahill Index, 1. *TSHCJMTT*, p. 324. Ecke, *Chinese Calligraphy*, #23.

SUNG PO-JEN (ACTIVE MID 13TH CENTURY), T. CH'I-CHIH, H. HSÜEH-YEN. From Hu-chou (in Chekiang province). A descendant of the T'ang official Sung Ching, a man of integrity who wrote a "Prose Poem on the Blossoming Plum," Po-jen was a minor official who loved the prunus and celebrated it in painting and poetry in *Mei-hua hsi-shen p'u* (Album of the Joyful Spirit of Plum Blossoms). A postscript in the Chin-hua edition of 1261 indicated that the first edition of this volume was printed in 1238. Sung Index, p. 768; *CKWHCTTT*, #2887. *TSHCJMTT*, pp. 71–72.

SUNG TI (ACTIVE LATE 11TH CENTURY), T. FU-KU. From Lo-yang (in Honan province). Along with his older brother Tao, he gained a *chin-shih* degree and was appointed to a post on the Board of Revenue and Finances. In landscape painting he followed Li Ch'eng and was particularly known for his wintry forests and pines and rocks or for excessively atmospheric renderings of the views on the Hsiao and Hsiang Rivers. *HHHP*, 12; *HS; HC; MCPT; THCWC*, Soper tr., pp. 45, 157 n. 429. Sung Index, p. 743. Cahill Index, 4. *TSHCJMTT*, pp. 69–70.

SUNG TZU-FANG (LATE 11TH–EARLY 12TH CENTURY), T. HAN-CHIEH. Sung Ti's nephew. He painted landscapes in the family tradition, and, as Su Shih had suggested, also did autumnal scenes in color. Recommended by Teng Ch'un's grandfather for the post of Professor of Education in Painting, Tzu-fang served as chief examiner in the Institute of Painting (after 1104). His writings on painting, the *Hua-fa liu-lun* (Six Discussions of Painting Methods), were highly praised by Teng Ch'un. *HC*, 3; *THPC*, 3; *TSHCJMTT*, p. 70.

TAI SUNG (LATE 8TH CENTURY). Appointed an official under Han Huang in the region of Eastern Chekiang, he took him as a model in painting and became a specialist in water buffaloes in settings of mountains and marshes. *TCMHL; LTMHC*, 10, Acker tr., II, 295. Cahill Index, 1. *TSHCJMTT*, pp. 385–386.

T'AN CHIH-MIN (ACTIVE CA. 625–650). A follower of Tung Po-jen, he excelled in architectural subjects and held the post of Lieutenant-Colonel in the Relief Guard at the T'ang court. In praise of his skill his contemporaries referred to him as "Master T'an." A painting of his was entitled *Enjoying Spring Sports*. *TCMHL; LTMHC*, 9, Acker tr. II, 228. *TSHCJMTT*, p. 373.

T'ANG CHENG-CHUNG (EARLY 13TH CENTURY), T. SHU-YA, H. HSIEN-AN. Originally from Nan-ch'ang (in Kiangsi province), he lived at Huang-yen (in Che-

kiang province). A nephew of Yang Wu-ch'iu (Pu-chih), he gained fame as a painter around 1205, specializing in ink prunus, bamboo, pines and rocks, as well as ink flowers such as narcissus and epidendrum. He perfected the technique of depicting prunus blossoms by simply outlining them with ink wash so that they stood out against a darkened ground. His tradition was continued by a daughter and a brother. *THPC*, 4. Cahill Index, 4. *TSHCJMTT*, p. 267.

T'ANG HOU (ACTIVE EARLY 14TH CENTURY), T. CHÜN-TSAI, H. TS'AI-CHEN-TZU. His family were originally from Sha-yang (Huai-an, in Kiangsu province) but moved to Ching-k'ou (Chen-chiang, near Nanking). From a literary family, Hou served as Director of the Lan-t'ing Academy in Shao-hsing (in Chekiang province). He was later appointed Professor of Confucian Studies in two different localities but did not accept these posts. Eventually he served as a member of the Tu-hu fu presumably in the capital, Peking. Two texts on art are under his name, *Hua-chien*, criticisms of the paintings of past artists, and *Ku-chin hua-lun*, discussions of painting in general, but it is likely that both were originally part of the same book (now presented as *Hua-chien*). It refers to Chao Meng-fu, who died in 1322, and to discussions with K'o Chiu-ssu, which must have taken place in Peking around 1328, hence the text was probably composed circa 1320–1330. Ma Ts'ai, ed., *Hua-chien* (Peking, 1959), preface.

TAO-CHEN (LATE 11TH CENTURY). A monk whose original name is not recorded, he preached at the stone caves at Chin-chien (in Szechwan province) and painted ink bamboos for expressive aims but, according to Huang T'ing-chien, did not equal his model Wen T'ung. *HC*, 5; *TSHCJMTT*, p. 284.

TAO-FEN (LATE 8TH–EARLY 9TH CENTURY). From Shao-hsing (in Chekiang province). A monk-painter, whose original name is unknown, he associated with several scholar-artists of his time and was noted for his landscape paintings. *LTMHC*, 10, Acker tr., II, 298–299. *TSHCJMTT*, pp. 283–284. *PFC*, Munakata tr., p. 49 n. 70.

T'AO TSUNG-I (CA. 1316–1402), T. CHIU-CH'ENG, H. NAN-TS'UN. Originally from Huang-yen (in Chekiang province) but lived at Hua-t'ing (in Kiangsu province). Both he and his wife were related to the Sung imperial family. After he failed the first attempt at the *chin-shih* degree, he retired to private life and wrote and edited books. He refused office at the end of the Yüan Dynasty, but in early Ming was employed as a scholar. His writings include collections of his poetry and songs and biographies of calligraphers, as well as the *Cho-keng lu* of 1366, his study notes on the arts and on current affairs, in thirty scrolls. Also attributed to him is the *Shuo fu* compendium in one hundred scrolls. Yüan Index, pp. 1346–48. *DMB*, II, 1268–72.

TE-FU (ACTIVE UNDER THE LATER CHOU, CA. 951–960). From the region of Honan province. A monk-painter, he specialized in pines and rocks. His mural of a single pine and a single cypress in the Baptismal Precinct of the Hsiang-

kuo Temple (at K'ai-feng) was so famous in its time that it was inscribed by numerous officials and notables. He also painted scrolls of these subjects in which "spirit consonance was clear and untrammeled." *THCWC*, Soper tr., p. 38. *TSHCJMTT*, p. 337.

TENG CH'UN (12TH CENTURY), T. KUNG-SHOU. His family was originally from Ch'eng-tu (in Szechwan province). Both his grandfather and his father had *chin-shih* degrees and were promoted in office because of their contacts with ministers in the progressive party, Wang An-shih and Ts'ai Ching. His grandfather became a Privy Council Commissioner. Ch'un served as prefect of a commandary before returning to Shuai-lin (Ch'eng-tu) on the fall of Northern Sung. He is the author of *Hua chi* in ten scrolls, a continuation of Kuo Johsü's history of painting, containing the biographies of artists active from 1074 to 1167 as well as anecdotes about the past state of the art. *Sung shih*, 329; Sung Index, p. 3735. *Hua-chi*; *Hua-chi pu-i* pref., pp. 4–6.

T'IEN CHING-YEN (ACTIVE LATE 13TH CENTURY). From Ch'ing-yüan (in Hopei province). According to Liu Yin, he was skilled at seal and official scripts and good at portrait painting. Yüan Index, p. 255.

T'IEN SENG-LIANG (LATE 6TH CENTURY, UNDER THE NORTHERN CHOU, 557–581). From Ch'ang-an (in Shensi province). A painter who was a Commandant of the Guard for the Three Dukes under the Northern Ch'i Dynasty, around 577, on its surrender, he became a Regular Attendant at the Northern Chou court. He is said to have excelled in painting genre scenes of farming villages, and he collaborated with Yang Ch'i-tan and Ch'eng Fa-shih on murals in the small pagoda of the Kuang-ming Temple at Ch'ang-an. *LTMHC*, 8, Acker tr., II, 191–192; also I, 164, 167, 299, 300. *TCHCJMTT*, p. 7.

TOU MENG (LATE 7TH CENTURY), T. TZU-CH'ÜAN. A native of Fu-feng (in Anhui province?). He was well-known for his calligraphy, and served as Vice-Chancellor of the University for the sons of the State and Sub-Prefect of T'ai-yüan (in Shansi province). He is recorded as the author of the *Hua shih-i lu* (Amended Record of Paintings) which is no longer extant. Statements are quoted under his name in the *Li-tai ming-hua chi*. *CKJMTTT*, p. 1773. See *LTMHC*, 2, Acker tr., I, 206; *THCWC*, Soper tr., p. 5.

TS'AI YUNG (132–192), T. PO-CHIEH. A native of Yü in Ch'en-liu (in Honan province). Famous as a poet, calligrapher, and musician, as a Gentleman-of-the-Palace he collated the texts in the Eastern Tower and revised and wrote the versions of the classics that were cut in stone around A.D. 175 to serve as calligraphic models. He is said to have been an originator of the squared *pa-fen* style of writing, and his calligraphy, painting, and eulogies were known as the "Three Beauties" of the time. As a figure painter, he was commissioned to do portraits of officials from the Yang family on the walls of a department building, and in T'ang his name is associated with illustrations of the theme of illustrious women. He left his post in the upheavals of 184, then was

reappointed to a series of posts but ultimately died in prison. *Hou-Han shu,* 90B; *BD,* #1986. *LTMHC,* 4, Acker tr., II, 11–12. *TCHCJMTT,* p. 40.

Ts'ao Chao (ACTIVE CA. 1387–1399), T. MING-CHUNG. From Sung-chiang (in Kiangsu province). He came from a Shanghai family of literary men and collectors and is the author of the *Ko-ku yao-lun* in three scrolls printed in Nanking in 1387–88 and added to in a Ming edition of 1462. This text is a connoisseur's handbook that treats different types of art objects. *DMB,* II, 1296–98.

Ts'ao Chih (192–232), T. Tzu-chien. Third son of the Wei Emperor Wu (Ts'ao Ts'ao) (155–220); canonized as Prince of Ch'en and known as Prince Ssu-ch'en. Early recognized for his literary talent, he was favored to become heir-apparent and thus incurred the enmity of his older brother P'i or Emperor Wen (r. 220–226). His enfeoffments were frequently changed, as were those of other Wei princes, and he became increasingly depressed before his final illness. Noted for his gay life and undisciplined behavior, he was nonetheless an important poet who wrote in every literary form and associated with the celebrated figures of his time. *Wei shu,* 19. *SSHY,* Mather tr., p. 578. Liu and Lo, *Sunflower Splendor,* pp. 539–541.

Ts'ao Chung-ta (ACTIVE UNDER THE NORTHERN Ch'i, 550–577). From the "Kingdom of Ts'ao" (either Sogdiana, or Ts'ao-chou, in Shantung province). He was a court painter, who is said to have excelled at Buddhist icons which had spiritual efficacy and presumably were painted in an Indian "transparent drapery" style. However, in the ninth century his extant paintings were all portraits of Northern Ch'i personages or scenes with horses. *CKKSHS; LTMHC,* 8, Acker tr., II, 193; also I, 164. *TCHCJMTT,* p. 23. *THCWC,* Soper tr., pp. 17, 129 n. 194.

Ts'ao Pa (ACTIVE MID 8TH CENTURY). From Ch'iao-chün (in Honan province). A descendant of the Three Kingdoms Ts'ao family, he was good at calligraphy and painting and reached the rank of General of the Left Warrior Guards. He was particularly noted for his likenesses of imperial horses and portraits of ministers, done circa 755 on imperial summons. The poet Tu Fu emphasized that General Ts'ao caught the "spirit" in his paintings of horses in contrast to his pupil Han Kan, who only achieved formal likeness. *LTMHC,* 9, Acker tr., II, 260; Hung, *Tu Fu,* pp. 211–212. *TSHCJMTT,* pp. 222–223.

Ts'ao Pu-hsing (3RD CENTURY). From Wu-hsing (in Chekiang province). A professional painter in the service of the Three Kingdoms' Wu Dynasty (222–280), he is said to have turned a speck of ink into a lifelike fly when painting a screen in the presence of the Wu founder. The Emperor was reported to have tried to brush away the ink speck, deceived by its appearance. Ts'ao is also said to have painted a red dragon from life, and his painting, kept in the imperial storehouse, had the power to evoke rain when hung over water. In the tenth century, the monk Jen-hsien wrongly credited Pu-hsing with the

Ts'ao style of Buddhist drapery. *KHPL; LTMHC,* 4, Acker tr., II, 19–20. *THCWC,* Soper tr., p. 17. See *Wu shu* [*ESSS*], 18.

Tse-jen (early 11th century). From Yung-chia (Wen-chou, in Chekiang province). A monk-painter, he specialized in pines with a dragonish cast and apparently worked in ink alone. He studied the best points of earlier paintings of trees and rocks before forming his own expressive style. *THCWC,* Soper tr., p. 61. *TSHCJMTT,* pp. 357–358.

Ts'ui Po (active ca. 1050–1080), t. Tzu-hsi. From Hao-liang (Feng-yang hsien, in Anhwei province). Noted as a painter of birds, flowers, and bamboo, he became a painter-in-apprenticeship in the Painting Academy after his performance, ca. 1068, collaborating on an imperial audience screen with cranes and bamboo. However, because of his free and easy nature, he re-signed, and then painted only for the Emperor on special request. He did figure paintings and murals of Buddhist subjects for temples at the capital and elsewhere. But he was best known for his bird paintings, particularly his geese, and set a new fashion among Academy painters with his free yet thorough technique. One extant painting, *Two Jays and a Hare,* is dated 1061. *HHHP,* 18; *THCWC,* Soper tr., pp. 54, 65–66, 181 n. 541. *Sung Biog.,* 2; Cahill Index, 4. *TSHCJMTT,* pp. 208–210.

Ts'ui Yüan (77–142), t. Tzu-yü. From An-p'ing, Cho-chün (in Hopei province). A noted Han calligrapher, he wrote epitaphs and inscriptions for tablets and steles as well as prose-poems, admonitions, and eulogies. Orphaned at an early age, he was a good student and traveled to the capital to seek moral instruction from the Grand Chancellor. After his elder brother was murdered, he set out to avenge his death and then flee from justice. However, he was pardoned and returned home. Later he became a district magistrate for seven years, winning the people's praise. Around 142 he was transferred to the post of Minister of State for Northern Chi and, when implicated in taking bribes, was forced to bring evidence to vindicate himself at this time. Various pieces of his prose are extant. *Hou-Han shu,* 52; *CKWHCTTT,* #0148.

Tsung Ping (375–443), t. Shao-wen. From a family from Nan-yang (in Honan province); lived at Chiang-ling (in Hupei province). Son and grandson of distinguished officials, he was educated by a mother of exceptional brilliance and is classified as a recluse because he refused summons to office. He traveled to the famous mountains of central China and studied briefly on Mount Lu (in Kiangsi province) under the eminent Buddhist monk Hui-yüan (334–416) before family affairs required his return home. Later he became one of the foremost lay defenders of the Buddhist faith in contemporary controversies and wrote the *Ming Fo lun* (Discussion on Understanding the Buddha), which has a preface dated to 433. Toward the end of his life he is reported to have painted landscapes to be viewed in his room as a substitute for roaming in natural scenery. His *Hua shan-shui hsü* (Introduction to Painting Landscape) is best preserved in *Li-tai ming-hua chi,* 6, where most of the painting titles recorded for him are of figural subjects, including likenesses

of the Honorary Grandee Hsi K'ang (223–262) and the Monk Hui-ch'ih (337–412). *Sung shu,* 93; *Kao-seng chuan,* 5; see E. Zürcher, *The Buddhist Conquest of China* (Leiden: E. J. Brill, 1959), pp. 240–253 and *passim.* Also W. Liebenthal, "The Immortality of the Soul in Chinese Thought," *Monumenta Nipponica,* 8 (1952), 378–394. *KHPL; LTMHC,* Acker tr., II, 115–129. *TCHCJMTT,* pp. 10–12.

Tu Fu (712–770), t. Tzu-mei. Born at Kung-hsien (in Honan province). From a distinguished literary family from the region of Ch'ang-an, he was nonetheless unable to pass the imperial examinations but was finally granted a post in 755 just before the major mid-T'ang revolt. Rewarded in 757 for his loyalty to the Emperor, he became Commissioner to the Left in the Chancellery for a brief time before being exiled to a minor post in Shensi province. Thereafter he travelled to Ch'eng-tu (in Szechwan province) and ended his life on a voyage down the Yangtze River. He is famous for his poetry, which is written in a meticulous style and covers a wide variety of themes, including certain paintings. *Chiu T'ang shu,* 190; *Hsin T'ang shu,* 201. Hung, *Tu Fu;* Liu and Lo, *Sunflower Splendor,* pp. 555–558.

Tu Tu (active 76–89), t. Po-tu. A calligrapher of the Later Han, he was one of the originators of the draft or "grass" script, and along with Ts'ui Yüan one of the models for Chang Chih. *CKJMTTT,* p. 464. *LTMHC,* 2, Acker tr., I, lv–lvi, 177.

Tung Po-jen (active mid–late 6th century). From Ju-nan (southwest Wu-ch'ang hsien, Hupei province). An intelligent man, locally known as the "Sea of Wisdom," he was an excellent muralist and was considered the equal of the northern painter Chan Tzu-ch'ien. He reached the ranks of Imperial Household Grandee and General of the Department of Domestic Service, and evidently served the Northern Chou dynasty (557–581) before being summoned to the Sui court after 581. Particularly noted for his architectural subjects, he also did horses and Buddhist paradises. His screen paintings were praised, and his murals were done at the cultural centers of Chiang-ling, Lo-yang, and Ch'ang-an. *CKKSHS; LTMHC,* 8, Acker tr., II, 200–202; also I, 296, 297, 364.

Tung Yu (active first third 12th century), t. Yen-yüan. From Tung-p'ing (in Shantung province). In the era 1111 to 1118 he was summoned to serve as a Drafting Official of the Secretariat and an academician-in-waiting attached to the Hui-yu Pavilion, which housed the collection of Che-tsung (r. 1086–1100). At the end of Northern Sung he was in charge of the instruction of the crown prince's heir, and he led a group of supporters to Nanking in 1127 and continued to serve in minor posts under the Southern Sung. His literary works include studies of the Book of Changes and the Songs, as well as his collected colophons on calligraphy and painting, the latter published as *Kuang-ch'uan hua-pa* (Tung Yu's Colophons on Painting). Sung Index, pp. 3211–12.

Tung Yü (ACTIVE LATE 10TH CENTURY), T. CHUNG-HSIANG. From Pi-ling (Ch'ang-chou, in Kiangsu province). An artist who specialized in dragons and aquatic scenes, he served as painter-in-attendance in the Han-lin Academy of the Southern T'ang, and then followed the last ruler to K'ai-feng, becoming a painter-in-apprenticeship in the Northern Sung Painting Academy. He was known as "Dumb Tung" because of his stuttering. A seascape by him was one of the three masterpieces in the Ch'ing-ling Temple at Nanking, and he also did marine murals in the Jade Hall of the Han-lin Academy at K'ai-feng. He never received a reward for one of his imperial commissions, since the dragons in the mural frightened the Heir Apparent. *SCMHP; HHHP*, 9; *THCWC*, Soper tr., pp. 69, 96, 185 n. 568. *TSHCJMTT*, pp. 286–288.

Tung Yüan (D. 962), T. SHU-TA, H. PEI-YÜAN. From Chung-ling (near Nanking, Kiangsu province). Under the Southern T'ang (937–975), he served the second and third rulers in a post in the royal park administration. He is best known as a landscapist who worked in two manners, a "blue and green" colored style after Li Ssu-hsün and a monochrome ink-wash style associated with the poet Wang Wei, but traditional figure subjects were also attributed to him as well as themes of animals in landscapes such as grazing cattle, cattle and tigers, wild geese, and dragons. His wide lake landscapes done in light ink with massed dots and ropey lines, later identified as "hemp-fiber" strokes, were first appreciated by late eleventh century scholars such as Shen Kua and Mi Fu, and eventually became the models for the "Southern School" of landscape painting from the fourteenth century on. *HHHP*, 11; *HS; MCPT; THCWC*, Soper tr., pp. 46, 158–159 n. 433. *Sung Biog.*, 2; Cahill Index, 2. *TSHCJMTT*, pp. 288–290.

Wang Chih-shen (7TH CENTURY). From T'ai-yüan (in Shansi province). At the end of his career he held the post of Supervisor of the Imperial Workshops under Empress Wu (r. 684–705). He was noted for his skill in both calligraphy and painting, and in the latter followed Yen Li-pen, equalling him in portraiture. *LTMHC*, 9, Acker tr., II, 227. *TSHCJMTT*, p. 12.

Wang Ch'in-ch'en (LATE 11TH–EARLY 12TH CENTURY), T. CHUNG-CHIH. From Sung-ch'eng (in Anhwei province). From a family of scholar-officials, he was an accomplished student recommended to the Academy of Scholars and granted the *chin-shih* degree. He was employed as a Compiler in the Hall of Assembled Sages circa 1086–1100 and then as a prefect in the region of Turfan. Under Hui-tsung he was a functionary attending to the imperial edicts. An associate of many of the well-known conservative scholars, he collected numerous texts which he personally annotated. *Sung shih*, 294; Sung Index, p. 350.

Wang Ch'ung (CA. 27–CA. 100), T. CHUNG-JEN. From Shang-yü, Hui-chi (in Chekiang province). A skeptical philosopher, he was orphaned at an early age and known for his filial piety. He attended the university in the capital where he studied under Pan Piao (3–24), the historian who began work on the Han dynastic history. Returning to his native locale, Wang became a

teacher and held various minor posts in the area. His fame rests on two works, the *Lun-heng* in eighty-five chapters written around 82, and the *Yang-hsing shu* (Book of Character Cultivation) in sixteen chapters in around 96. *Hou-Han shu* 49; see Needham, *Science and Civilization in China*, II, 369 ff.

WANG HSI-CHIH (309–CA. 365), T. I-SHAO. His family was originally from Lang-yeh (in Shantung province). Taught by his uncle Wang I, Hsi-chih ultimately surpassed his mentor in fame and became the best-known Chinese calligrapher. He held a number of important civil and military posts, and was noted for his intellectual prowess, especially for his skills in debate. Much of his official life was spent in the Chekiang region, which he found particularly congenial because of its beautiful scenery and its eminent scholars. In 353 he composed an essay commemorating a meeting of literati at the Lan t'ing (Orchid Pavilion) in Shao-hsing, which has since been illustrated by many painters. His calligraphy was praised as "floating like clouds and erect as startled dragons." An essay on calligraphic brush technique, the *Pi-chen t'u* (Plan of Brush Strategy), which was attributed to him, is now considered a late sixth–early seventh-century forgery. Titles of paintings by him formerly extant are given in T'ang records: depictions of wild beasts, a self-portrait from a mirror image, and a fan with small figures. *Chin shu*, 80. *SSHY*, Mather tr., p. 586. *LTMHC*, 5, Acker tr., II, 40–41. *TCHCJMTT*, pp. 4–5. See R. Barnhart, "Wei Fu-jen's *Pi Chen T'u* . . . ," *ACASA*, 17 (1964), 13–25.

WANG HSIEN-CHIH (344–388), T. TZU-CHING. Wang Hsi-chih's son. Somewhat undisciplined, he never equaled his father in calligraphy but is still known for his draft and official scripts. He married a princess and fathered an empress and was President of the Central Secretariat at the time of his death. He was also said to be a skillful painter, able to transform spattered ink into a piebald cow. In Sung times a Taoist painting of magical amulets and deities with written incantations went under his name. *Chin shu*, 80; *SSHY*, Mather tr., p. 586. *LTMHC*, 5, Acker tr., II, 41. *TCHCJMTT*, p. 5. *HS*, Vandier-Nicolas tr., #118.

WANG HSIUNG (ACTIVE EARLY 8TH CENTURY). He served as Governor General at T'an-chou (Ch'ang-sha, in Hunan province), and excelled in painting the region in the vicinity of the Hsiang River in the manner of Li Ssu-hsün. *LTMHC*, 10, Acker tr., II, 269–270.

WANG I (276–322), T. SHIH-CHIANG. From Lin-i, Lang-yeh (in Shantung province). He was connected to the most powerful family of the time and related to the Eastern Chin Dynasty Emperor Yüan (r. 317–323). Wang I must have been among the first to exemplify the literati ideal. He achieved success in both civil and military service and was admired for his excellence in literature and music, as well as in calligraphy and painting. He was invited to execute Buddhist murals in both of the pagodas constructed for the Ch'ang-lo Temple at Wu-ch'ang (in Hupei province). Titles recorded for him in T'ang times are mainly of depictions of auspicious animals and wild beasts. *Chin*

shu, 76. *SSHY*, Mather tr., p. 589. *CKKSHS; LTMHC*, 5, Acker tr., II, 37–40. *TCHCJMTT*, p. 4.

Wang I (CA. 1333–CA. 1368), T. SSU-SHAN, H. CH'IH-CHÜEH-SHENG. Lived in Hang-chou (in Chekiang province). A precocious painter, he studied with the Su-chou landscapist and portraitist Ku K'uei. Wang is particularly noted for his small-scale portraits and is the author of *Hsieh-hsiang pi-chüeh* (Secrets of Portrait Painting) recorded by 1366 in the *Cho-keng lu*. Yüan Index, pp. 114–145. *THPC*, 5. Cahill Index, 6.

Wang Meng (CA. 1301/8–1385), T. SHU-MING, H. HUANG-HAO SHAN-CH'IAO, HSIANG-KUANG CHÜ-SHIH. Born in Hu-chou (in Chekiang province). Grandson of Chao Meng-fu. From a literary and artistic family, he was skilled in writing and calligraphy and painted in his grandfather's tradition. He served in a minor provincial post, but in the 1340s became a recluse at the Yellow Crane Mountain near Hang-chou. There he came to know other famous landscapists of the period, Huang Kung-wang and Ni Tsan. After 1368 he was one of the first to be appointed to office under the Ming Dynasty, and served for about ten years as Prefect of T'ai-an (in Shantung province). In 1380, because of a casual association with an official later condemned as a traitor, Wang was put into prison where he remained until his death. He was one of the Four Masters of late Yüan landscape. His early paintings of the 1340s were open river views in the Chao manner, but by the 1360s he had shifted to close-up scenes of vertical mountain ranges in the Tung Yüan/Chü-jan tradition. He also did ink bamboos. *Ming shih*, 285; Yüan Index, pp. 129–130; *DMB* II, 1392–95; *Yüan Masters*, pp. 33–38. Cahill Index 6.

Wang Mo (Hsia) (D. CA. 805). In the mid eighth century he traveled throughout the Chiang-nan region (south of the Yangtze) painting landscapes and trees and rocks. He is said to have studied painting with both Cheng Ch'ien and Hsiang Jung and to have volunteered for service in the Coastal Patrol in order to see the scenery along the coast. Known by one nickname as Wang of the Ink, he produced his works when inebriated by splashing ink on silk and then transforming the spots into landscape motifs. *TCMHL; LTMHC*, 10, Acker tr., II, 299–302. *HHHP*, 10. *TSHCJMTT*, p. 17.

Wang Shen (Hsien) (CA. 1048–CA. 1103), T. CHIN-CH'ING. His family was from T'ai-yüan (in Shansi province) but lived at K'ai-feng (in Honan province). A poet, calligrapher, musician, and painter, he became in 1069 the consort of a younger sister of Shen-tsung and hence is known by the title of Imperial Son-in-Law. He was a friend and patron of Su Shih, who shared his interest in collecting paintings. The Precious Paintings Hall was established in 1077 for Wang's collection. Because of his association with Su, Wang was dismissed from office in 1079, and in the following year on account of his treatment of his wife before her death, he was banished to Chün-chou (in Hupei province). There he observed the scenery and began to practice landscape painting. Both he and Su were recalled to the capital in 1085, and Wang's Western Garden was the setting of a famous literary gathering that

included the painter Li Kung-lin and Mi Fu, who advised Wang on collecting calligraphy. Toward the end of his life Wang was an associate of Chao Chi, the prince who became Emperor Hui-tsung, and recommended the painter Han Cho to him. Wang's colored landscapes were said to be painted in the gold-and-green (or blue-and-green) manner of Li Ssu-hsün, but for small scenes with distant views in ink he followed Li Ch'eng's brush technique. He also did ink bamboos after Wen T'ung. *Sung Shih*, 255; Sung Index, pp. 190–191. *Sung Biog.*, 2. *HHHP, 12; HC*, 2; *HS*, Vandier-Nicolas tr., #81. Cahill Index, 4. *TSHCJMTT*, pp. 27–29.

WANG SHIH-YÜAN (LATE 10TH CENTURY). Originally from Wan-ch'iu in Ju-nan (Honan province). His father was a muralist in the Wu Tao-tzu tradition. He himself evidently held office as an inspector and competed in architectural painting with the eccentric scholar Kuo Chung-shu, who served as his model in this genre. Although known as a specialist in architectural subjects, Wang also did secular figures after Chou Fang and landscapes after Kuan T'ung, as well as a large-scale painting of wintry trees. *ICMHL; SCMHP; HHHP*, 11; *THCWC*, Soper tr., pp. 45, 156–157 n. 428. *TSHCJMTT*, p. 20.

WANG TING (ACTIVE CA. 627). He held the office of President of the Imperial Grand Secretariat with honorific titles and painted bodhisattvas, eminent monks, and men and women in his free time. Around 627 he was commanded to paint an "Illustrated Herbal with Instructions and Warnings." Buddhist murals by him were in the Sheng-kuan temple in Ch'ang-an. *TCMHL; LTMHC*, 9, Acker tr., II, 226; also I, 293. *TSHCJMTT*, p. 12.

WANG T'ING-YÜN (1151–1202), T. TZU-TUAN, H. HUANG-HUA SHAN-JEN. From Liao-tung (in Liaoning province). A precocious writer and a *chin-shih* degree graduate in 1176, he served in the Han-lin Academy at Peking, reaching the rank of Compiler. He was good at poetry and skilled at calligraphy in the manner of Mi Fu's draft script. In painting he did landscapes, bare trees and rocks, and ink bamboos. One of his paintings is extant and was much appreciated by Yüan critics. He was the best-known artist of the Chin dynasty. *Chin shih* [*ESSS*], 126. *THPC*, 4. Cahill Index, 4. *TSHCJMTT*, p. 35.

WANG TSAI (ACTIVE CA. 760–CA. 805). From Western Shu (Szechwan province). In the last decades of the eighth century he lived at Ch'eng-tu and painted excellent screens of landscapes of the four seasons and of evergreens and rocks. He is best known from Tu Fu's poem on a landscape painting. *TCMHL; LTMHC*, 10, Acker tr., II, 277–278. *TSHCJMTT*, pp. 16–17. See Hung, *Tu Fu*, I, 169, 170.

WANG WAN-CH'ING (LATE 12TH–EARLY 13TH CENTURY), T. HSI-PO, H. TAN-YU. Wang T'ing-yün's nephew, adopted as a son. Good at poetry, calligraphy, and painting in the family tradition, he reached the post of a Provincial Secretary of the Bureau of the Right. His ink bamboos and trees and rocks were excellent; his landscapes were less good. *THPC*, 4. *TSHCJMTT*, pp. 35–36. Bush, " 'Clearing After Snow . . . ,' " *OA*, 11 (1965), 169 n. 27.

WANG WEI (415–443), T. CHING-HSÜAN. His family was originally from Lin-i, Lang-yeh (in Shantung province). From the illustrious Wang clan that produced so many literary figures and officials at the southern court, he passed the imperial examinations at the age of fifteen or so, but declined office initially, having inherited a title and post under the Director of Instruction. He later held several appointments at court briefly, rising to become Vice-President of the Imperial Grand Secretariat, after which he declined all further office and devoted his time to study. He was famous for his talents in literary composition, music, medicine, geomancy, and mathematics, and also noted for his calligraphy and painting. In the latter he followed Hsün Hsü and Wei Hsieh. The official biography quotes several of his letters, and the *Hsü hua* (Discussion of Painting) is extant in the *Li-tai ming-hua chi. Sung shu*, 62. KHPL; LTMHC, 6, Acker tr., II, 129–137. TCHCJMTT, pp. 5–6.

WANG WEI (701–761), T. MO-CHIEH. From T'ai-yüan (in Shansi province). Admired as a poet, musician, and painter from an early age, he received the *chin-shih* degree around 721 and became an Associate Secretary of Music but was later demoted to a provincial post in the Shantung region. After the death of his wife around 730 he remained single and became a devout Buddhist: his *tzu* derived from the transliteration of the Buddhist layman Vimalakīrti (Wei-mo-chieh). Before he was thirty he had briefly lived as a recluse on Mount Sung near Lo-yang, the Eastern Capital, and later on he withdrew to a scenic villa at Wang-ch'uan in the Chung-nan Mountains near Ch'ang-an. In 734 he returned to court as Advisor on the Right and rose steadily through the ranks in censorate positions, becoming a Policy Reviewer in 754. Forced to serve an illegitimate regime at the time of the An Lu-shan rebellion in 756, he was pardoned through the intervention of his brother Chin and eventually regained his former position; in 759 he was appointed to the high-ranking sinecure of Under-Secretary of State, all on the basis of his poetry. His villa at Wang-ch'uan was the subject of a series of poems written in a poetic dialogue; it also was the theme of a mural said to have been done by Wang at the Ch'ing-yüan Temple near T'ai-yüan as well as in a version on a screen at a Ch'ang-an temple. He was known for landscape painting in "broken ink" or ink wash, and he also did portraits, pines and rocks, and trees. It is suggested that artisans working under his direction produced much of his oeuvre, adding colors and details. *Chiu T'ang shu*, 190; *Hsin T'ang shu*, 202. Liu and Lo, *Sunflower Splendor*, pp. 550–552. TCMHL; LTMHC, 10, Acker tr., II, 265–268; I, 260, 276. THCWC, Soper tr., p. 80. Cahill Index, 1. TSHCJMTT, pp. 13–16.

WANG YEN-SHOU (CA. 124–CA. 148), T. WEN-K'AO, TZU-SHAN. From I-ch'eng in Nan-chün (Hupei province). Son of I, the famous compiler and annotator of the *Ch'u tz'u* (Songs of the South), Yen-shou had traveled in the Lu area (Shantung province) as a child. He visited the palace built there by Prince Kung, a son of the Han Emperor Ching (r. 156–140 B.C.), and wrote a prose-poem on his impressions. His other famous literary work, the "Meng fu" (Prose Poem on a Dream), is said to have been written after a nightmare,

which was considered inauspicious. His early death came by drowning while crossing the Hsiang River. *Hou-Han shu,* 80A. *CKWHCTTT,* #0173.

WEI-CH'IH (YÜ-CH'IH) I-SENG (7TH CENTURY). A native of Khotan who worked at Ch'ang-an (in Shensi province). Son of the Khotanese painter Po-chih-na active under the Sui dynasty, he was also sent to China as an artist before the middle of the seventh century. He served at the T'ang court as an officer of the Imperial Night Bodyguard and inherited the feudal rank of Prefectural Duke. He excelled at painting foreigners and Buddhist images, using the non-Chinese technique of a firm brush stroke "like bent iron and coiled wire." His votive icons, secular figures, and flowers and birds were all after foreign prototypes. Among his best-known murals were a thousand-armed Kuan-yin image against a background of flowers done as if in relief, and a *Subjugation (by the Buddha) of Mara (the Buddhist devil). TCMHL; LTMHC,* 9, Acker tr., II, 224–225; also I, 259, 262, 266, 272, 290. Cahill Index, 1. *TSHCJMTT,* pp. 199–200.

WEI HSIEH (MID 3RD CENTURY–MID 4TH CENTURY). One of the most valued painters in the early history of art, he was the subject of critical debate, but nothing is known of his life. He is said to have followed Ts'ao Pu-hsing, and like Chang Mo was called a "Sage of Painting." Recorded titles indicate that he painted illustrations of poetry (the "North Wind Ode") and of historical figures and didactic themes such as "Virtuous Women," as well as Buddhist images. *KHPL; LTMHC,* 5, Acker tr., II, 31–37; also I, 162. *TCHCJMTT,* pp. 45–46.

WEI HSIEN (10TH CENTURY). His family came from the region of Ch'ang-an (in Shensi province). The most famous pre-Sung painter of architectural subjects, he served the last ruler of Southern T'ang at Nanking and had the title of painter-in-waiting to the Inner Palace (Nei-kung feng). He was skilled at painting secular figures and palace architecture and had studied Wu Tao-tzu's style. A painting, *Lofty Scholars,* attributed to him by Emperor Hui-tsung, is extant in Peking. *WTMHPI; HHHP,* 8; *THCWC,* Soper tr., 37, 150 n. 380. Cahill Index, 2. *TSHCJMTT,* p. 362.

WEI WU-T'IEN (ACTIVE FIRST HALF 8TH CENTURY). From Ch'ang-an (in Shensi province). An animal specialist, he excelled at painting saddle horses and birds, and various kinds of wild and domestic beasts. He attained the rank of General of the Left Imperial Warrior Guards. In the era 713 to 742, he made frighteningly accurate images of the lions presented as tribute from a foreign country. His paintings of strange beasts circulated widely, and he also did murals in Buddhist and Taoist temples at Ch'ang-an. On the Hsüan-wu Gate he depicted the occasion when Hsüan-tsung transfixed two boars with one arrow, and he did the animals in the collaborative painting the *Golden Bridge,* portraying the pageantry on the Emperor's return from sacrificing at Mount T'ai. *TCMHL; LTMHC,* 9, Acker tr., II, 250–251. *THCWC,* Soper tr., p. 76. *TSHCJMTT,* pp. 148–149.

WEI YEN (8TH CENTURY). From Ch'ang-an (in Shensi province). From a family of painters, he lived for a while in Shu (Szechwan province) and painted figures and horses, eminent monks, trees and rocks, and landscapes. He was particularly noted for his horses and for his pines and rocks, and both of these subjects were celebrated by the poet Tu Fu. *TCMHL; LTMHC,* 10, Acker tr. II, 281–282. See Hung, *Tu Fu,* I, 169. *TSHCJMTT,* pp. 149–150.

WEN T'UNG (1018/9–1079), T. YÜ-K'O, H. HSIAO-HSIAO HSIEN-SHENG, CHIN-CHIANG TAO-JEN, SHIH-SHIH HSIEN-SHENG. From Tzu-t'ung, Tzu-chou (in Szechwan province). The most famous literati painter of ink bamboo, he also did scenes with fallen trees or stumps on screens and walls. He was a distant older cousin of Su Shih, who admired his gifts for poetry, calligraphy, and painting, and eulogized his depictions of ink bamboos. A *chin-shih* degree graduate in 1049, Wen served in various local administrative posts in the regions of Szechwan, Shensi, and Chekiang; in the last of these in 1078 he was Prefect of Hu-chou. At the capital, K'ai-feng, he had also been a professor of Imperial Sacrifices and a collator at the Chi-hsien Library. He died in transit to another post. His collected writings and attributed paintings are extant. *Sung shih,* 443; Sung Index, pp. 34–36; *Sung Biog.,* 2. *HHHP, 20; HS; THCWC,* Soper tr., pp. 45, 157–158 nn. 430, 431. Cahill Index, 4. *TSHCJMTT,* pp. 8–10.

WU CHEN (1280–1354), T. CHUNG-KUEI, H. MEI-HUA TAO-JEN. From Chia-hsing (in Chekiang province). He was one of the "Four Great Masters" of landscape painting in late Yüan according to later critics. Although he was well-known as a poet and did calligraphy in the draft script style, he did not attempt the examinations but used his education to earn a living as a diviner. Later he withdrew as a recluse and painted. His subjects were ink landscapes in the manner of Chü-jan and ink bamboos after Wen T'ung. Yüan Index, pp. 383–384. *THPC,* 5; *Yüan Masters,* pp. 20–25. Cahill Index, 6.

WU CHIEN (5TH CENTURY). Active at Lo-yang (in Honan province). He is known only as a popular painter at the capital Lo-yang. This would indicate that he was active under the Northern Wei dynasty (386–535) for which Lo-yang became the capital from 495 on. However, he is placed by Chang Yen-yüan under the southern Liu-Sung dynasty (420–479). This may be an error, or perhaps Wu was active at the southern capital and at Lo-yang subsequently. As noted by Kuo Jo-hsü, he was erroneously associated with the Wu style of drapery in Buddhist images. *KHPL; LTMHC,* 6, Acker tr., II, 145. *THCWC,* Soper tr., p. 17.

WU HUAI (OR CHIN) (10TH CENTURY). Active in the Chiang-nan region (south of the Yangtze). One of several Southern T'ang painters who specialized in dragons and water, catching the effect of dragons in motion. *SCMHP; KCHP; THCWC,* Soper tr., pp. 69, 184–185 n. 567. *TSHCJMTT,* p. 80.

WU T'AI-SU (ACTIVE MID 14TH CENTURY), T. HSIU-CHANG, H. SUNG-CHAI. From K'uai-chi, Shao-hsing (in Chekiang province). He is the author of *Sung-chai*

mei-p'u (Prunus Album from the Pine Studio), a manual on the painting of blossoming plums. Otherwise little is recorded of his life. He is known as a painter of the prunus, sometimes in combination with the pine, and he also did rue and narcissus in ink. Yüan Index, p. 388. Cahill Index, 6.

WU TAO-TZU (WU TAO-HSÜAN) (ACTIVE CA. 710–CA. 760). From Yang-chai (near Lo-yang, Honan province). The most famous muralist of the T'ang dynasty, he was particularly noted for his calligraphic treatment of Buddhist and Taoist subjects and founded an enduring tradition of religious art. An orphan from an impoverished family, through his natural talent he already excelled in painting in his teens. His calligraphy was like that of Hsüeh Chi; when he could not equal the style of one of his masters, Chang Hsü, he is said to have turned to painting. He served as Chief of Civil Servants in a subprefectural post in Yen-chou (in Shantung province) and then was summoned to court by Hsüan-tsung and given the title of Doctor of Instruction within the Palace, which meant that he could only paint on imperial command. At that time he changed his name to Tao-hsüan. He was promoted to instructor of the Crown Prince and obtained the rank of Companion to Prince Ning (d. 731), the Emperor's elder brother. Inspired by wine or by a sword dance, Wu was able to paint large-scale murals with bravura, yet he could also do finely detailed handscrolls. The subjects treated in the murals he painted for Buddhist and Taoist temples at the capitals, Ch'ang-an and Lo-yang, were Buddhist and Taoist icons, landscapes, dragons, figures, demonic divinities, animals and birds, architecture, trees and plants, and Hell scenes. In the "Wu style" of mural painting, striking three-dimensional effects were suggested by the repetition of loose, modulated brush strokes, and colors were lightly applied within ink contours. Artisans or restorers who laid on colors heavily were said to have ruined the conception. There was also a Wu style of swiftly executed landscape painting, which he did from his memory of the scenery of Shu (Szechwan province). In the collaborative painting, the *Golden Bridge*, done about 727, he worked on the bridge and the landscape, carriages and human beings, plants and trees, hawks, utensils, weapons, and tents. *TCMHL; LTMHC*, 9, Acker tr., II, 232–237; also I, 151, 156, 177 ff., 257 ff. *THCWC*, Soper tr., pp. 75, 76. Cahill Index, 1. *TSHCJMTT*, pp. 74–79.

WU TSUNG-YÜAN (-TAO) (ACTIVE CA. 1008 ON, D. 1050), T. TSUNG-CHIH. From the Po River region (Sung-hsien, in Honan province). A civil official who painted Taoist and Buddhist subjects, he reached the position of Vice-President of the Department of Parks, Lakes, and Mountains. He was from a family of Confucians, and through his connections at the age of sixteen he became Master of Sacrifices at a Confucian Temple; around this time he was also asked to paint murals at the Lao-tzu Shrine near Lo-yang. This is perhaps the temple at which he painted a famous mural of thirty-six rulers of Heaven and included a portrait of Chen-tsung's father. He worked in the local Wu Tao-tzu tradition of Lo-yang and is later said to have copied two of Wu's murals at K'ai-feng on small scrolls, mastering the moving quality of Wu's

brushwork. He was familiar with both the Ts'ao and Wu conventions of clinging or fluttering drapery. There are records of Buddhist icons by him in Honan monasteries, but his chief commissions were for Taoist temples. Thus in 1008 he was chosen out of three thousand applicants to head one of the two teams of one hundred painters who worked on the Yu-ch'ing-chao-ying Temple built in K'ai-feng from 1009 to 1014. Later in life he was not able to fulfill requests for paintings quickly. *SCMHP; HHHP,* 4; *THCWC,* Soper tr., pp. 43–44, 154 n. 412; 162 n. 444. Sirén, I, 158–160. Cahill Index, 4. *TSHCJMTT,* pp. 131–132.

YANG CH'I-TAN (ACTIVE LAST HALF 6TH CENTURY). Active at Ch'ang-an (in Shensi province). Under the Sui dynasty (581–618), he was a court painter with a superior honorary rank. Noted for his elegant style of ceremonial civil processions, he claimed to have taken the Sui courtiers and palaces as his models, and the titles of paintings recorded for him include imperial progresses. He also did Buddhist subjects such as *jātaka* illustrations or scenes from the Buddha's life, and one particularly noteworthy mural at the Kuang-ming Temple was done in conjunction with T'ien Seng-liang and Cheng Fa-shih. *LTMHC,* 8, Acker tr., II, 202–203; also I, 264, 299–301, 303. *TCHCJMTT,* pp. 38–39.

YANG HUI-CHIH (ACTIVE CA. 713–742). A native of Wu (or Kiangsu province). He first painted Buddhist and Taoist images following Chang Seng-yu's manner but then began to model them in clay after Wu Tao-tzu's painting became popular. Thus he gained equal fame with Wu as Chang's inheritor, but in a different branch of art. His sculptures were widespread throughout China from Kiangsu to Shensi province and were to be found in Buddhist and Taoist temples at the Sung capitals, K'ai-feng and Lo-yang. *LTMHC,* Acker tr., I, 280–281; II, 233. *WTMHPI; TSHCJMTT,* p. 293.

YANG TZU-HUA (ACTIVE MID TO LATE 6TH CENTURY). An inheritor of the Ku K'ai-chih tradition, he was considered particularly excellent in paintings of horses and figures. Under the Northern Ch'i Emperor Wu-ch'eng (r. 561–564) he was a Chief Editor in the Privy Repository and an Auxiliary Functionary for Honorary Regular Attendants. Referred to as a "Sage of Painting," he worked only on imperial command. Anecdotes stress the extraordinary vitality of his horses and his dragons, done on walls or on silk. *LTMHC,* 8, Acker tr., II, 190–191; also I, 167 (note that Yang did not work for the Northern Ch'i founder). *TCHCJMTT,* p. 38.

YANG WEI-CHEN (1296–1370), T. LIEN-FU, H. T'IEH-YAI. A native of K'uai-chi (in Chekiang province). A noted late Yüan poet from a literary family, he passed the *chin-shih* examination in 1327 and served as a magistrate of T'ien-t'ai and a salt administrator in Hang-chou before resigning his post because of ideals. After a decade of travel he was again in office in 1343, when he worked on the Sung, Liao, and Chin dynastic histories. From 1352 on he was unemployed apart from a brief stint of 110 days at the beginning

of Ming, after which he pled illness and returned home. He was known locally for his calligraphy and painting. *Ming shih*, 285. *DMB*, II, 1547–53.

YANG WU-CHIU (1097–1171), T. PU-CHIH, H. T'AO-CHAN LAO-JEN, CH'ING-I CHANG-CHE. From Ch'ing-chiang, moved to Nan-ch'ang (in Kiangsu province). A descendant of the Han writer Yang Hsiung, he excelled at calligraphy and painting and was also a skillful poet and song writer. Because of his opposition to the peace policies of Kao-tsung's court, he did not rise in office. In calligraphy he followed Ou-yang Hsiu, and he used Li Kung-lin's light ink outlining with an easy touch for ink paintings of prunus and bamboo, pines and rocks, and narcissus. He is said to have been the first to simply outline plum blossoms rather than depict them with color or ink wash, and he founded a school followed by his nephews. Although his name is given as an editor and co-author of the *Hua-kuang mei-p'u* (Prunus Album of "Blossoming Light"), this text is a later fabrication based largely on the fourteenth-century *Sung-chai mei-p'u* by Wu T'ai-su. Sung Index, p. 2942. *THPC*, 4. Cahill Index, 4. *TSHCJMTT*, pp. 278–280.

YANG YEN (727–781), T. KUNG-NAN. From Hua-ying (in Shensi province). From a family famous for filial piety for three generations, he served in various positions at the T'ang court and in 769 became Vice-President of the Imperial Grand Secretariat and the Imperial Chancellery. In 780 he was demoted to Vice-President of the Left for the Department of State Affairs and then banished to Hainan Island where he died. His calligraphy in the official script was highly praised, but nothing is recorded of his landscape painting in the official biographies. An anecdote reports that, when he was dismissed from court, he produced a screen of pines and rocks with extraordinary atmospheric effects for a friend and patron, who provided food and clothing for Yang's family and only then requested a painting. Yang was known to have a volatile temperament and is said to have been fond of wine. *Chiu T'ang shu*, 118; *Hsin T'ang shu*, 145. *TCMHL; LTMHC*, 10, Acker tr., II, 279–280. *TSHCJMTT*, p. 294.

YAO TSUI (535–602), T. SHIH-HUI. From Wu-k'ang, Wu-hsing (in Chekiang province). From a long line of officials and physicians, he was removed with his family to Ch'ang-an (in Shensi province) by the Western Wei troops who killed the Liang Emperor Yüan (r. 552–554). Yao had written the *Hsü hua-p'in* (Continuation of the Classification of Painters) for the Emperor evidently before 552, while in his midteens. At Ch'ang-an, Yao was summoned as a scholar to collate texts at the Lin-chih Hall and later became a secretary for the Prince of Ch'i. After his patron was executed in 578 he was without office until the founding of the Sui Dynasty in 581, when he became Doctor to the Heir-Apparent and was honored by enfeoffment. A man of exceptional loyalty, Yao wrote the biography of the Prince of Ch'i of the Western Wei (535–556) and sent it to the Sui Bureau of Historical Records. This virtue led to his execution, since he also took upon himself the accusations of treachery leveled at another patron and friend, the Prince of Shu. His biography records

only one title, *Liang hou lüeh* (Later Sketch of the Liang dynasty) in ten chapters. *(Pei-) Chou shu [ESSS]*, 47.

YEN CHEN-CH'ING (709–785), T. CH'ING-CH'EN. From Wan-nien (-hsien, Shensi province). One of the best calligraphers at the court of Hsüan-tsung, Yen gained a *chin-shih* degree in the 720s and served under three emperors. His posts included those of Censor, President of the Ministry of Justice, and Assistant of the Right in the Department of State Affairs, as well as Grand Tutor to the Crown Prince. He was famous for his integrity and was awarded a posthumous rank and title. In his midthirties, he studied with Chang Hsü and then wrote a treatise on calligraphy. Yen was best known for his regular script, but he also excelled in the cursive form of the draft script. His calligraphy was thought to express a direct "awkwardness," according to the Sung poet, calligrapher, and critic Su Shih. *Chiu T'ang shu*, 128; *Hsin T'ang shu*, 153. *BD*, #2461; Ecke, *Chinese Calligraphy*, #16.

YEN CHIH-T'UI (531–AFTER 591). His family was originally from Lin-i, Lang-yeh (in Shantung province). From a distinguished family of scholar-officials, he began studying Taoism under the tutelage of Hsiao I, the Liang Emperor Yüan. Later, while serving the Emperor, he was captured by Western Wei troops but escaped and found his way to his family's homeland in the Shan-tung region then ruled by the Northern Ch'i. He held a number of posts under the Northern Ch'i, then under the Northern Chou, and finally under the Sui dynasty before the unification of China in 589. He was famous for his scholarship, courage, and informal behavior, the latter brought on by his love of drink. His literary works include a prose-poem on his view of his life and the *Yen-shih chia-hsün* (Family Instruction for the Yen Clan). *Pei-Ch'i shu [ESSS]*, 45; *Pei shih [ESSS]*, 83. *CKWHCTTT*, #0977.

YEN LI-PEN (D. 673). From Wan-nien (-hsien, Shensi province). Younger son of P'i, a painter, carver, and carriage designer at the Sui court, he was the leading figure painter of the early T'ang Dynasty. Yen served the Crown Prince who became Emperor T'ai-tsung (r. 627–649) as an Auxiliary Functionary for Military Stores. In 626 he was ordered to paint the "Eighteen Scholars" of the Prince's court, and in 643 again summoned to do the portraits of the twenty-four "Meritorious Officials of the Lin-yen Pavilion," a painting for which the Emperor wrote the eulogy. Yen also painted the scene of the hunt in which the Emperor's younger brother killed a dangerous tiger with one arrow and collaborated with his brother Li-te on depictions of foreign tribute bearers and on the designing of imperial insignia and the like. Between 656 and 660 he was Chief Engineer in the Department of Works; then he succeeded Li-te as President of the Ministry of Public Works. In 668 Yen became President of the Imperial Grand Secretariat and was enfeoffed as a baron. Designated at court as "Divine Transmuter through the Reds and Blues," he studied the art of Chang Seng-yu and painted various subjects such as figures and horses, flowers and birds, and Buddhist icons. However, he was chiefly known for portraits of T'ai-tsung. *Chiu T'ang shu*, 77; *Hsin*

T'ang shu, 100. *TCMHL*; *LTMHC*, 9, Acker tr., II, 210–222; also I, 165. *THCWC*, Soper tr., pp. 74–75, 187 n. 586. Cahill Index, l. *TSHCJMTT*, pp. 363–366.

YEN LI-TE (ORIGINAL NAME JANG) (D. 656). From Wan-nien (-hsien, Shensi province). An artist in the family tradition, he was said to be unsurpassed in painting foreigners and was also known for his architectural studies. In 618 at the beginning of T'ang, as Chief of Service of the Imperial Wardrobe he designed costumes and accoutrements. After 627, under T'ai-tsung, he served in the Department of Public Works reaching the position of Chief Engineer, and was in charge of the construction of the imperial tombs. He supervised the construction of 500 battleships at Nan-ch'ang (in Kiangsi province) for the Korean campaign of 641 and accompanied the troops to design roads and bridges in the northeast. Later he was asked to build two imperial palaces and was promoted to President of the Ministry of Works. As Director of Works he oversaw the construction of T'ai-tsung's tomb, was enfeoffed as a duke, and received posthumous titles. His paintings, extant in Sung times, of an eastern barbarian and the Feng and Shan sacrifice were evidently done with assistants. *Chiu T'ang shu*, 77; *Hsin T'ang shu*, 100. *TCMHL*; *LTMHC*, 9, Acker tr., II, 209–210. *THCWC*, Soper tr., pp. 9, 74. *TSHCJMTT*, p. 363.

YEN SU (961–1040), T. MU-CHIH. His family were originally from Chi-chou (in Hopei province); he was from I-tu (in Shantung province). An accomplished scholar-official, he was an inventor as well as a noted landscape painter. A *chin-shih* degree graduate, he served at court before being banished to provincial posts because of factionalism. Under Chen-tsung (r. 998–1023) he was an under secretary in the Lung-t'u Pavilion, and he ultimately became President of the Board of Rites and was posthumously honored with a title. His inventions included an ingenious water clock. As a landscapist he followed Li Ch'eng, and painted legendary scenery and wintry groves, excelling in old trees and broken bamboo. His murals and screen paintings were to be seen in various official halls at the capital, K'ai-feng, and in Buddhist temples in the Honan region. *Sung shih*, 298; Sung Index, pp. 4008–09. *HHHP*, 11; *KCHP*; *THCWC*, Soper tr., pp. 42–43, 153–154 n. 409. Cahill Index, 4. *TSHCJMTT*, pp. 359–360.

YEN-TS'UNG (ACTIVE MID 7TH CENTURY). Active at Ch'ang-an (in Shensi province). The monk of this name quoted in *LTMHC* is presumably the author of the *Hou hua-lu*, identified as a T'ang monk in *THCWC*. He is taken to be the monk who went to the western capital, Ch'ang-an, to study at the Tz'u-en Monastery in 649. But whether, with the *ts'ung* in his name written with the jade radical, he is the author of sutra titles listed in the 660s is not provable. In any case, he is not the Sui monk with this version of the name, active as a translator in Lo-yang in the late sixth to early seventh century. The current *Hou hua-lu* is thought to have been reconstructed from different sources, principally the *LTMHC*, and has a preface added that is dated in accordance with 635 although the text treats a painter said to have been active three

decades later. *CKJMTT*, p. 650; *CKHLLP*, I, 386–389. *LTMHC*, 1, Acker tr., I, 144. *THCWC*, Soper tr., pp. 5, 113–114 n. 33; cf. Paul Pelliot, "Les Fresques de Touen-Houang," *RAA*, 5 (1928), 209 ff.

YEN YEN-CHIH (384–456), T. YEN-NIEN. Originally from Lin-i, Lang-yeh (in Shantung province). Active in the region of Nanking. An essayist and poet from a line of renowned officials, he was orphaned when young and lived in poverty. His official career began under the Eastern Chin (317–419), and he continued to high office under the Liu-Sung Dynasty (420–478). However, a combination of fondness for drink and a devastating verbal wit undercut his position at court and led to a curtailment of his responsibilities. Between 426 and 433 he lived as a recluse and did a considerable amount of writing. Hence he is known for his literary achievements. *Sung shu, 73. CKWHCTTT*, #0573. Also see *LTMHC*, 1, Acker tr., I, 65; also II, 18 (here the statement attributed to Yen Yen-chih should read: "Wei Hsü's archery was like Hsü Mo's painting in excellence).

YÜ SHIH-NAN (558–638), T. PO-SHIH. From Yü-yao (in Chekiang province). He was a famous calligrapher noted for his regular script. During the Sui dynasty he was a Secretary in the Imperial Library. After 627 he became a Scholar in the Imperial Hall of Study and eventually the Director of the Imperial Library. He was enfeoffed as a duke and awarded an honorific rank and a posthumous title. *Chiu T'ang shu, 72; Hsin T'ang shu, 102. CKJMTTT*, p. 1320; *BD*, #2529.

YÜAN CH'IEN (ACTIVE UNDER THE LIU-SUNG, 420–478). He seems to have followed Lu T'an-wei in figure painting but to have been more primitive in his rendering of women. Many titles of portraits and historical subjects were recorded as by him in T'ang times. In particular there was one scroll with a scene of Vimalakīrti in debate in which the Six Elements of painting were said to be complete, and it was "as though the spiritual efficacy is intuitively grasped." *KHPL; LTMHC*, 6: Acker tr., I, 13–15; II, 138–139. *TCHCJMTT*, p. 18.

YÜAN CHIH (5TH CENTURY). Son of Yüan Ch'ien. He showed promise in painting, but when still young fell victim to a brain disease (epilepsy?). Yao Tsui had seen sketches of two historical subjects by him. *HHP; LTMHC*, 6: Acker tr., I, 54–55, II, 140. *TCHCJMTT*, p. 18.

YÜAN WEN (1119–1190), T. CHIH-FU. From Ssu-ming (Mountain) in Yin (in Chekiang province). He enjoyed his studies as a youth and did not try to gain honors at the examinations but lived as a scholar-recluse. He is the author of *Weng-yu hsien-p'ing* (Idle Commentary from the Round Window), which contains his textual notes on the classics and histories and his discussions of poetic rhyme. Sung Index, p. 1849. *CKWHCTTT*, # 2475.

Glossary of Chinese Terms

ch'an (meditation) 禪
ch'ang (merits) 長
ch'ang-hsing (constant forms) 常形
ch'ang-li (constant principles) 常理
chen (reality, truth) 真
chen (clear-cut; upright; chaste) 貞
cheng (regular) 正
ch'i (tool) 器
ch'i (spirit) 氣
ch'i-cheng (seven cosmic Bodies) 七政
ch'i-hsiang (lively expression) 氣象
ch'i-li (vital strength) 氣力
ch'i-mo (vital veins) 氣脈
ch'i-wei (vitality) 氣味
ch'i-yün (spirit resonance) 氣韻
chiao mo (scorched ink) 焦墨
ch'iao-ch'ü (cunning flavor) 巧趣
chieh (joints; chastity) 節
chieh-hua (ruled-line painting) 界畫
chih (will) 志
chih (substance) 質
chih (a grammatical particle) 之
chih (to come) 至
chih (to make to come) 致
chih (straight; just) 直
chih-chüeh (consciousness) 知覺
chin-shih (advanced degree graduate) 進士
ching (scenery) 景
ching-shen (essential spirit) 精神
ching-shen-jou-t'i (energy and matter) 精

神肉體
ch'ing (clarity of emotion) 情
chü (rectangle) 矩
ch'ü (flavor) 趣
chüan (scroll, book) 卷
ch'uan (stream) 川
ch'uan shen (to transmit spirit) 傳神

erh-i (two poles of Absolute) 二儀

fa (method) 法
fen-pen (sketches) 粉本
feng (wind; customs; song) 風
feng-ch'i (noble spirit) 風氣
feng-chih (loftiness of purpose) 風致
feng-ko (noble manner) 風格
feng-shen (noble style) 風神
feng-shui (geomancy) 風水
fu (prose-poem, description) 賦

hao (literary name) 號
hsi (game) 戲
hsiang (images, appearances) 象
hsiao lo-pi (preliminary sketch) 小落筆
hsieh-i (to express ideas) 寫意
hsieh-sheng (to sketch from life) 寫生
hsin (mind) 心
hsin chih ling (spirit within mind) 心之靈
hsing (allegory) 興
hsing (disposition) 性

hsing (form) 形
hsing-jung (formal appearances) 形容
hsing-ssu (formal likeness) 形似
hsü (empty; humbleness) 虛
hsüeh-ch'i (circulatory system) 血氣
hua (transformation) 化
hua (to paint) 畫
hua (flowering) 華
hua (to measure) 劃

i (idea, imagination, meaning) 意
i (untrammeled) 逸
i (one) 一
i-ch'i (spirit) 意氣
i-ch'i (untrammeled spirit) 逸氣
i hsing hsieh shen (sketch ideas with forms) 以形寫神
i-ko (untrammeled class) 逸格
i-p'in (untrammeled class) 逸品
i shen (convey spirit) 移神
i-ssu (expression) 意思

jen (man) 人
jen-chi (human essence) 人極
jen-chung (portraiture term: between nose and mouth) 人中
ju-shen (complete absorption) 入神
ju yü shen (spiritually absorbed) 入於神
jun-tse (moist dampness) 潤澤

kao-ku (lofty antiqueness) 高古
ko (style) 格
ku (bone) 骨
ku-ch'i (bone energy, noble vitality) 骨氣
ku-chieh (bone articulation) 骨節
ku-fa (structural method, structure) 骨法
ku-i (spirit of antiquity) 古意
k'u-tsao (dry lifelessness) 枯燥
kua (to lay down) 掛
kuei (discs) 規

lan-t'ai (portraiture term: left side of nose) 蘭臺
li (principle) 理

ling (soul, quintessence) 靈
liu-ch'ang ((Six Merits) 六長
liu-fa (Six Principles, Laws, Elements) 六法
liu-yao (Six Essentials) 六要
liu-yao (hexagrams) 六爻

miao (subtlety, wonderful power) 妙
ming (destiny) 命
mo (ink) 墨
mo-ku-t'u (boneless painting) 没骨圖

niu-tzu (nexus) 紐子

pa-fen (a squared calligraphic style) 八分
pa-kua (Eight Trigrams) 八卦
pai-miao (plain outlined painting) 白描
pen-hsin (innate feelings) 本心
pi (comparison) 比
pi (brush) 筆
pi-i (brush conception) 筆意
p'ing-tan (blandness) 平淡
p'o-mo (broken ink, shading) 破墨

san-ts'ai (heaven, earth, man) 三才
shan-ken (portraiture term: bridge of nose) 山根
shen (spirit) 神
shen-ch'i (spirit vitality) 神氣
shen-hui (intuitive apprehension) 神會
shen, miao, neng (ko or p'in) (classifications) 神、妙、能（格、品）
shen-p'in (inspired class) 神品
shen-ts'ai (expressive character) 神彩
shen-yün (spirit resonance) 神韻
sheng (produces) 生
sheng-ch'i (life-force) 生氣
sheng-chü (vital parts) 生俱
sheng-i (sense of life) 生意
sheng-tung (vital movement) 生動
shih (dynamic configuration, momentum, effect) 勢
shih (substance, truth) 實
shih-fu hua (painting of scholar-gentry) 士夫畫

shih-jen hua (scholars' painting) 士人畫

shui-mo (monochrome ink technique) 水墨

ssu (thought) 思

sung (hymn) 頌

ta ch'uan (portraiture term: contours of face) 打圈

t'ai-chi (Absolute) 太極

tao (the Way; pursuit, method) 道

te (virtue) 德

te i (obtained inspiration) 得意

t'i-fa (basic methods) 體法

t'i wu (embodying entities) 體物

t'ien (innate nature) 天

t'ien-chen (naturalness) 天真

t'ien-chi (divine invention, natural genius) 天機

t'ien-ch'ü (natural flavor) 天趣

t'ien-hsing (natural endowment) 天性

t'ien-jan (naturalness) 天然

t'ien-li (divine principles) 天理

ting (summit) 頂

ting (bronze vessel, tripod) 鼎

ting chih (determine the material) 定質

t'ing-wei (portraiture term: right side of nose) 庭尉

t'ou (head) 頭

ts'un-fa (texture strokes) 皴法

ts'un-tan (texture-inking) 皴淡

t'u (depiction, picture) 圖

tzu (style, nickname) 字

tzu-jan (naturalness, spontaneity) 自然

tzu-jan fa (nature's pattern) 自然法

wen (literary; fine) 文

wei-chih (placement) 位置

wu (things, natural phenomena) 物

wu-hsing (Five Phases) 五行

wu-i (physical properties) 物宜

wu-wei erh ch'eng (formed without volition) 無為而成

ya (refined; ode) 雅

yang (positive material force) 陽

yen-t'ang (portraiture term: side of eye) 眼堂

yin (negative material force) 陰

yin-t'ang (portraiture term: top part of nose) 印堂

yin-yang (universal polarities) 陰陽

yün (resonance) 韻

yün (revolution) 運

Glossary of Chinese Names and Titles

Ai Hsüan 艾宣
An Lu-shan 安祿山

Chai Yüan-shen 翟院深
Chan Tzu-ch'ien 展子虔
Chang An-shih 張安世
Chang Chi-po 章繼伯
Chang Chien 張戬
Chang Chien-fu 張堅父
Chang Ch'ien 張謙
Chang Chih, Po-ying, Yu-tao (Ts'ao-sheng) 張芝、伯英、有道（草聖）
Chang Chung-mou 張仲謀
Chang Heng, P'ing-tzu 張衡、平子
Chang Hsü, Po-kao, Tien 張旭、伯高、顛
Chang Hsüan 張萱
Chang Hsün-li 張訓禮
Chang Huai-kuan 張懷瓘
Chang I-chung 張以中
Chang Lei 張耒
Chang Mo 張墨
Chang Nan-pen 張南本
Chang Seng-yu 張僧繇
Chang Shan-kuo 張善果
Chang Shih-liang 張士良
Chang (Sun?) T'ui-kung 張（遜）退公 (Chung-min, Ch'i-yün?) （仲敏、溪雲）
Chang Tao-ling 張道陵
Chang Tsao, Wen-t'ung 張璪［藻］、文通
Chang Tse 張則
Chang Tun-chien 張敦簡
Chang Tun-li 張敦禮
Chang Yen-yüan, Ai-pin 張彥遠、愛賓
Chao Chung-i 趙忠義
Chao Hsi-ku 趙希鵠
Chao Ling-jang, Ta-nien 趙令穰、大年
Chao Meng-chien, Tzu-ku, I-chai 趙孟堅、子固、彝齋
Chao Meng-fu, Tzu-ang, Sung-hsüeh, Ou-po 趙孟頫、子昂、松雪、鷗波
Chao Po-chü, Chien-li 趙伯駒、千里
Chao Sheng 趙昇
Chao Tsung 趙縱
Chao Yen 趙巖
Chao Yün-tzu 趙雲子
Chao Yung, Chung-mu 趙雍、仲穆
Ch'ao Pu-chih, Wu-chiu, Ching-ch'ien, Kuei-lai-tzu 晁補之、旡咎、景遷、歸來子
Ch'ao Yüeh-chih, I-tao, Ching-yü 晁說之、以道、景迂
Chen-kuan kung-ssu hua-lu (-shih) 真觀公私畫錄（史）
Ch'en Ch'ang 陳常
Ch'en Hung 陳宏
Ch'en Shan, Ching-fu, Ch'iu-t'ang 陳善、敬甫、秋塘
Ch'en Shan-chien 陳善見
Ch'en Shih-tao, Lu-ch'ang, Wu-i,

Hou-shan 陳師道、履常、無已、後山

Ch'en Shu 陳庶

Ch'en T'an, Hsüan-ch'eng 陳曇（譚）、玄成

Ch'en Yü, Chung-wen, Ts'ang-i 陳郁、仲文、藏一

Ch'en Yü-i 陳與義

Ch'en Yung-chih 陳用志

Cheng Ch'ien, Jo-chi 鄭虔、弱齊

Cheng Fa-shih 鄭法士

Cheng Kang-chung, Heng-chung, Pei-shan 鄭剛中、亨仲、北山

Chi Chen 紀真

Chia Shih-ku 賈師古

Chia Ssu-tao 賈似道

Chiang-hou 姜后

Chiang K'uei 姜夔

Chiang Shao-yu 蔣少游

Chiang Shen, Kuan-tao 江參、貫道

Chieh-tzu-yüan hua-chuan 介子園畫傳

(Ch'ien) Han shu （前）漢書

Ch'ien Hsüan, Shun-chü, Yü-t'an 錢選、舜舉、玉潭

Ch'ien Kuo-yang 錢國養

Chih-pu-tsu-chai ts'ung-shu 知不足齋叢書

Chin Mi-ti 金日磾

(Chin) Ming-ti, Su-tsung （晉）明帝、肅宗 (Ssu-ma Shao, Tao-chi) 司馬紹、道幾

Chin shih 金史

Chin shu 晉書

(Chin) Yüan-ti 晉元帝

Ch'in Kuan 秦觀

Ching-fu-tien fu 景福殿賦

Ching Hao, Hao-jan, Hung-ku-tzu 荊浩、浩然、洪谷子

Ching K'o 荊軻

Ch'ing 慶

Ch'ing-chü chi 清臞集

Chiu-fang Kao (Yin) 九方皋（歅）

Chiu T'ang shu 舊唐書

Cho-keng lu 輟耕錄

Chou Chao 周照

Chou Fang, Chung-lang, Ching-yüan 周昉、仲朗、景元

Chou Li 周禮

Chou Mi, Kung-chin, Ts'ao-ch'uang 周密、公謹、草窗

Chou Tseng 周曾

Chu Ching-hsüan 朱景玄

Chu Hsi, Yüan-hui, Chung-hui 朱熹、元晦、仲晦

Chu Hsiang-hsien, Ching-ch'u, Hsi-hu yin-shih 朱象先、景初、西湖隱士

Chu-p'u 竹譜

Chu Shen 朱審

Chu Tun-ju, Hsi-chen, Yen-ho 朱敦儒、希真、嚴壑

Chü-jan 巨然

Ch'u tz'u 楚辭

Ch'ü Tao-min 瞿道愍

Ch'ü T'ing 麴庭

Chuang-ma p'u 裝馬譜

Chuang Su, Kung-shu, Liao-t'ang 莊肅、恭叔、蓼塘

Chuang Tsung-ku 莊宗古

Chuang-tzu (Chou), Tzu-hsiu 莊子（周）、子休

Chuang-tzu 莊子

Ch'ui 倕

Ch'un-ch'iu 春秋

Chung Hung 鍾嶸

Chung-jen, Hua-kuang chang-lao 仲仁、華光長老

Chung-li Ch'un 鍾離春

Chung Yin, Hui-shu 鍾隱、晦叔

Chung Yu 鍾繇

Erh-ya 爾雅

Fa-ch'ang, Mu-ch'i 法常、牧谿〔溪〕

Fa-shu yao-lu 法書要錄

Fa-t'ieh cheng-wu 法帖正誤

Fa-t'ieh k'an-wu 法帖刊誤

Fa-yen 法言

Fan Ch'ang-shou 范長壽

Fan-chi 樊姬

Fan Ch'iung 范瓊

Fan K'uan (Chung-cheng), Chung-li 范寬（中正）、仲立

Fan-lung, Mao-tsung, Wu-chu 梵隆、茂宗、無住

Fan Tzu-min 范子珉
Fan Yeh 范曄
Fang-chang 方丈
Fu Hsi 伏羲
Fu Pi 富弼
Fu Tao-yin 符道隱
Fu Tsai, Hou-chih 符載、厚之

(Han) Ching-ti 漢景帝
Han Cho, Ch'un-ch'üan, Ch'in-t'ang 韓拙、純全、琴堂
Han Fei(-tzu) 韓非(子)
Han Fei-tzu 韓非子
Han Huang 韓滉
Han Kan 韓幹
Han Yü 韓愈
Hao-lin yü-lu 鶴林玉露
Ho Chen 賀真
Ho shu 河書
Ho Tsun-shih 何尊師
Ho Yen, P'ing-shu 何晏、平叔
Hou-Han shu 後漢書
Hou hua-lu 後畫錄
Hou-shan t'an-ts'ung 後山談叢
(Hou) Wei shu （後）魏書
Hsi K'ang 嵇康
Hsi K'uei 席夔
Hsi-shih 西施
Hsia Kuei, Yü-yü 夏珪、禹玉
Hsia Sen, Chung-wei 夏森、仲蔚
Hsia Wen-yen, Shih-liang, Lan-chu sheng 夏文彥、士良、蘭渚生
Hsia Yü 夏育
Hsiang Jung 項容
Hsiao Chao, Tung-sheng 蕭照、東生
Hsiao Yüeh 蕭悅
Hsieh An 謝安
Hsieh Ho 謝赫
Hsieh-hsiang pi-chüeh 寫像秘訣
Hsieh Ling-yün 謝靈運
Hsieh shan-shui chüeh 寫山水訣
Hsieh Yüan-shen 謝元深
Hsin T'ang shu 新唐書
Hsü Ch'ung-ssu 徐崇嗣
Hsü Hsi 徐熙
Hsü hua 叙畫

Hsü hua-p'in 續畫品
Hsü Yu 許由
Hsüan-ho hua-p'u 宣和畫譜
Hsüan-lan 玄覽
Hsüeh Chi, Ssu-t'ung 薛稷、嗣通
Hsüeh Shao-p'eng 薛紹彭
Hsün Hsü, Kung-tseng 旬勖、公曾
Hu Ch'ien 胡虔
Hu I, P'eng-yün 胡翼、鵬雲
Hu Kuei 胡瓌
Hua chi 畫記
Hua-chi 畫繼
Hua-chi pu-i 畫繼補遺
Hua-chien 畫鑑
Hua-fa liu-lun 畫法六論
Hua hou-p'in 畫後品
Hua-hsüeh pi-chüeh 畫學秘訣
Hua ku 畫估
Hua-kuang mei-p'u 華光梅譜
Hua-lun 畫論
Hua-p'in 畫品
Hua-p'in lu 畫品錄
Hua-(p'in) tuan 畫（品）斷
Hua shan-shui chüeh 畫山水訣
Hua shan-shui fu 畫山水賦
Hua shan-shui hsü 畫山水序
Hua-shih 畫史
Hua shih-i lu 畫拾遺錄
Hua-tuan 畫斷
Hua Yün-t'ai-shan chi 畫雲臺山記
Huai-nan-tzu 淮南子
Huai-su, (Ch'ien) Ts'ang-chen 懷素、（錢）藏真
Huang Chü-pao, Tzu-yü 黃居寶、辭玉
Huang Chü-shih 黃居實
Huang Chü-ts'ai, Po-luan 黃居寀、伯鸞
Huang Ch'u-p'ing 黃初平
Huang Ch'üan, Yao-shu 黃筌、要叔
Huang Hsiu-fu, Kuei-pen 黃休復、歸本
Huang Kung-wang, Tzu-chiu, I-feng, Ta-ch'ih 黃公望、子久、一峯、大癡
Huang Po-ssu, Ch'ang-jui 黃伯思、長睿
Huang-ti (Yellow Emperor) 黃帝

Huang T'ing-chien, Lu-chih, Fu-weng, Shan-ku 黃庭堅、魯直、涪翁、山谷
Huang Wei-liang 黃惟亮
Hui-ch'ih 慧持
Hui-ching 繪境
Hui-neng 慧能
Hui-tsung shih-erh chi 繪宗十二忌
Hui-yüan (333–416/7) 慧遠
Hui-yüan (early 12th century) 惠遠
Hung-jen 弘忍

I ching 易經
I-chou ming-hua lu 益州名畫錄

Jao Tzu-jan, T'ai-hsü, Yü-ssu shan-jen 饒自然、太虛、玉笥山人
Jen-hsien 仁顯

Kao Hsün 高洵 (珣)
Kao I 高益
Kao K'o-kung (Shih-an), Yen-ching, Fang-shan 高克恭 (士安)、彥敬、房山
Kao K'o-ming 高克明
Ko Hung 葛洪
Ko-ku yao-lun 格古要論
Ko Shou-ch'ang 葛守昌
K'o Ch'ien, Tzu-mu, Shan-chai 柯謙、自牧、山齋
K'o Chiu-ssu, Ching-chung, Tan-ch'iu 柯九思、敬仲、丹丘
Ku-chin hua-chien 古今畫鑑
Ku Chün-chih 顧駿之
(Ku) hua-p'in (-lu) (古) 畫品錄
Ku K'ai-chih, Ch'ang-k'ang, Hu-t'ou 顧愷之、長康、虎頭
Ku Shih-tuan 顧士端
Kuan-hsiu (Chiang Hsiu), Te-yin (-yüan) 貫休 (姜休)、德隱 (遠)
Kuan T'ung 關同 (仝)
Kuang-ch'eng 廣成
Kuang-ch'uan hua-pa 廣川畫跋
Kuang-ya 廣雅
Kung-sun Ta-liang 公孫大娘

K'ung Fu-tzu (Confucius) 孔夫子
Kuo Chung-shu, Shu-hsien 郭忠恕、恕先
Kuo Hsi, Shun-fu 郭熙、淳夫
Kuo Jo-hsü 郭若虛
Kuo Ssu, Te-chih 郭思、得之
Kuo Tzu-i 郭子儀

Lao-tzu 老子
Lei 雷
Li An-chung 李安忠
Li Chao-tao 李昭道
Li Ch'eng, Hsien-hsi 李成、咸熙
Li Ch'eng-sou 李澄叟
Li chi 禮記
Li Ch'ih, Fang-shu, Chi-nan 李鷹、方叔、濟南
Li K'an, Chung-pin, Hsi-chai tao-jen 李衎、仲賓、息齋道人
Li Kuang 李廣
Li Kuei-chen 厲歸真
Li Kung-lin, Po-shih, Lung-mien chü-shih 李公麟、伯時、龍眠居士
Li Kung-mao 李公茂
Li Ling-shen 李靈省
Li Po 李白
Li P'o 李頗 (坡、波)
Li Sheng, Chin-nu 李昇、錦奴
Li Ssu-chen, Ch'eng-chou 李嗣真、承冑
Li Ssu-hsün, Chien-chien 李思訓、建見
Li Sung 李嵩
Li-tai ming-hua chi 歷代名畫記
Li T'ang, Hsi-ku 李唐、晞古
Li Ti 李迪
Li T'ien, Wei-ch'ing 李畋、渭卿
Li Tsan-hua (Yeh-lü T'u-yü), Tung-tan wang 李贊華 (耶律突欲)、東丹王
Li Tsung-ch'eng 李宗成
Li Ts'ung-hsün 李從訓
Li Yin 李隱
Li Yü 李煜
Li Yüan-ch'i 李元濟
Li Yüan-pen 李元本
Liang-ching fu 兩京賦

Liang hou lüeh 梁後略

Liang K'ai, Feng-tzu 梁楷、風子

Liang shu 梁書

(Liang) Wu-ti 梁武帝

(Liang) Yüan-ti 梁元帝 (Hsiao I, Shih-ch'eng) 蕭繹、世誠

Liao shih 遼史

Lieh-nü chuan 烈女傳

Lieh-tzu 列子

Lieh Yü-k'ou 列禦寇

Lien-shan 連山

Lin-ch'üan kao-chih (chi) 林泉高致（集）

Lin Hsi 林希

Lin Hsiang-ju 藺相如

Lin Pu 林逋

Liu An 劉安

Liu Ching, Chü-chi 劉涇、巨濟

Liu Hsiang 劉向

Liu Hsiao-shih 劉孝師

Liu Hsieh 劉勰

Liu Hsüeh-ch'i, Hsi-chih 劉學箕、習之

Liu I, I-chih 劉益、益之

Liu K'o-chuang, Ch'ien-fu, Hou-ts'un 劉克莊、潛夫、後村

Liu Kung-ch'üan, Ch'eng-hsüan 柳公權、誠懸

Liu Tao-shun (-ch'eng) 劉道醇（成）

Liu T'ien, Shih-wen 劉瑱、士溫

Liu Tsung-yüan 柳宗元

Liu Yin, Meng-chi, Ching-hsiu 劉因、夢吉、靜修

Liu Yu-fang 劉有方

Liu Yüeh 劉岳

Liu Yung 劉永

Lo Ta-ching, Ching-lun 羅大經、景綸

Lou Kuan 樓觀

Lu Chi, Shih-heng 陸機、士衡

Lu ling-kuang-tien fu 魯靈光殿賦

Lu T'an-wei 陸探微

Lun-heng 論衡

Lun-hua 論畫

Lun-yü 論語

Ma Fen 馬賁

Ma Hsing-tsu 馬興祖

Ma Lin 馬麟

Ma Wu 馬武

Ma Yüan, Ch'in-shan 馬遠、欽山

Mao Hui-yüan 毛惠遠

Mei-hua hsi-shen p'u 梅花喜神譜

Mei p'u 梅譜

Mei-tao-jen i-mo 梅道人遺墨

Mei Yao-chen, Sheng-yü 梅堯臣、聖俞

Men-se hsin-hua 捫蝨新話

Meng-ch'i pi-t'an 夢溪筆談

Meng Chung-ning 孟仲寧

Meng fu 夢賦

Meng Hsien, T'an-chih 孟顯、坦之

Meng Pen 孟賁

Meng-tzu (Mencius) 孟子

Mi Fu, Yüan-chang, Hai-yüeh, Chia-chü tao-shih 米芾（黻）、元章、海嶽、家居道士

Mi Yu-jen, Yüan-hui 米友仁、元暉

Ming Fo lun 明佛論

Ming shih 明史

Mo-chu chi 墨竹記

Mou-t'an fu 牡丹賦

Nan shih 南史

Ni Tsan, Yüan-chen, Yü-lin, Yü 倪瓚、元鎮、雲林、迂

Nü-wa 女媧

Ou-yang Chiung 歐陽炯（迥）

Ou-yang Hsiu, Yung-shu, Tsui-weng, Liu-i chü-shih 歐陽修、永叔、醉翁、六一居士

Ou-yang Hsün, Hsin-pen 歐陽詢、信本

Pan 班

Pao Ting 包鼎

Pei-Ch'i shu 北齊書

(Pei) Chou shu （北）周書

Pei-shan wen-chi 北山文集

Pei shih 北史

P'ei Hsiao-yüan 斐孝源

P'ei K'ai 裴楷

P'ei Min 裴旻

Pi-chen t'u 筆陣圖

Pi-fa chi 筆法記

Pi Hung 畢宏
Pi Liang-shih, Shao-tung 畢良史、少董
Pien 扁
Pien Luan 邊鸞
Pien-wang lun 辨亡論
Po Chü-i, Lo-t'ien, Hsiang-shan 白居
　易、樂天、香山
Po-i 伯夷
Po Lo 伯樂

Shan-hai ching 山海經
Shan-shui chüeh 山水訣
Shan-shui Ch'un-ch'üan chi 山水純全集
Shan-shui lun 山水論
Shan-shui sung-shih ko 山水松石格
Shao K'ang 邵亢
Shen-hsien chuan 神仙傳
Shen Kua, Ts'un-chung 沈括、存中
Shen-nung 神農
Sheng (Shen/Sung)-ch'ao ming-hua p'ing
　聖（神、宋）朝名畫評
Shih-chi 史記
Shih ching 詩經
Shih K'o, Tzu-chuan 石恪、子專
Shih-ming 釋名
Shih p'in 詩品
Shih Tao-shih 史道碩
Shih 'Ts'an 史粲
Shu-ch'i 叔齊
Shu ching 書經
Shu hou-p'in 書後品
Shu ku 書估
Shu-shih 書史
Shu-tuan 書斷
Shun 舜
Shuo-fu 説郛
Shuo-wen 説文
Ssu-ma Ch'eng-chen, Tzu-wei (Po-
　yün) 司馬承禎、子微（白雲）
Ssu-ma Ch'ien 司馬遷
Su Ch'e, Tzu-yu 蘇轍、子由
Su Chi 蘇激
Su Ch'i 蘇起
Su Hsün 蘇洵
Su Kuo 蘇過
Su Shih, Tzu-chan, Tung-p'o chü-

shih 蘇軾、子瞻、東坡居士
Su Wu 蘇武
Sun Chih-wei, T'ai-ku 孫知微、太古
Sun Po 孫白
Sun Shang-tzu 孫尚子
Sun Wei (Yü) 孫位（遇）
Sung-chai mei-p'u 松齋梅譜
(Sung) Che-tsung 宋哲宗
(Sung) Chen-tsung 宋真宗
Sung Ching 宋璟
(Sung) Hui-tsung 宋徽宗 (Chao Chi)
　（趙佶）
(Sung) Jen-tsung 宋仁宗 (Chao Chen)
　（趙禎）
(Sung) Kao-tsung 宋高宗 (Chao Kou,
　Te-ch'i) （趙構、德基）
(Sung) Kuang-tsung 宋光宗
(Sung) Li-tsung 宋理宗
(Sung) Ning-tsung 宋寧宗
Sung Po-jen, Ch'i-chih, Hsüeh-yen 宋
　伯仁、器之、雪巖
(Sung) Shen-tsung 宋神宗
Sung shih 宋史
Sung Shou 宋綬
Sung shu 宋書
Sung Ti, Fu-ku 宋廸、復古
Sung Tzu-fang, Han-chieh 宋子房、漢
　傑
Sung Yung-ch'en 宋用臣

Tai Sung 戴嵩
T'an Chih-min 檀智敏
T'ang-ch'ao ming-hua lu 唐朝名畫錄
T'ang Cheng-chung, Shu-ya, Hsien-
　an 湯正仲、叔雅、閒庵
T'ang Hou, Chün-tsai, Ts'ai-chen-
　tzu 湯后、君載、采真子
(T'ang) Hsüan-tsung 唐玄宗
(T'ang) Su-tsung 唐肅宗
(T'ang) T'ai-tsung 唐太宗
(T'ang) Te-tsung 唐德宗
Tao-chen 道臻
Tao-fen 道芬
Tao-te ching 道德經
T'ao-hua fu 桃花賦
T'ao Tsung-i, Chiu-ch'eng, Nan-

ts'un 陶宗儀、九成、南村
Te-fu 德符
Teng Ch'un, Kung-shou 鄧椿、公壽
T'ieh-shih-hsin-ch'ang fu 鐵石心腸賦
T'ien Ching-yen 田景延
T'ien Seng-liang 田僧亮
T'ien Yu-yen 田遊岩
Tou Meng, Tzu-ch'üan 竇蒙、子全
Ts'ai Ching 蔡京
Ts'ai Hsiang 蔡襄
Ts'ai Yung, Po-chieh 蔡邕、伯喈
Ts'ang Chieh 倉頡
Ts'ao Chao, Ming-chung 曹昭、明中
Ts'ao Chih, Tzu-chien, Ssu-ch'en
 wang 曹植、子建、思陳王
Ts'ao Chung-ta 曹仲達
Ts'ao Pa 曹霸
Ts'ao P'ei 曹丕
Ts'ao Pu-hsing 曹不興
Ts'ao Ts'ao 曹操
Tse-jen 擇仁
Tseng Yü 曾紆
Tseng Yün-ch'ao 曾雲巢
Tso chuan 左傳
Ts'ui Po, Tzu-hsi 崔白、子西
Ts'ui Yüan, Tzu-yü 崔瑗、子玉
Tsung Ping, Shao-wen 宗炳、少文
Tu Fu, Tzu-mei 杜甫、子美
Tu Tu, Po-tu 杜度、伯度
T'u-hua chien-wen chih 圖畫見聞志
T'u-hui pao-chien 圖繪寶鑑
Tung-kuan yü-lun 東觀餘論
Tung Po-jen 董伯仁
Tung-t'ien ch'ing-lu chi 洞天清祿集
Tung Yu, Yen-yüan 董逌、彥遠
Tung Yü, Chung-hsiang 董羽、仲翔
Tung Yüan, Shu-ta, Pei-yüan 董源
 （元）、叔達、北苑
Tzu-hsia 子夏

Wang An-shih 王安石
Wang Ch'ang 王長
Wang Ch'iang, Chao-chün 王嬙、昭君
Wang Chih-shen 王知慎
Wang Ch'in-ch'en, Chung-chih 王欽
 臣、仲至

Wang Ch'ung, Chung-jen 王充、仲任
Wang Hsi-chih, I-shao 王羲之、逸少
Wang Hsien-chih, Tzu-ching 王獻之、
 子敬
Wang Hsiung 王熊
Wang I (276–322), Shih-chiang 王廙、
 世將
Wang I (14th century), Ssu-shan,
 Ch'ih-chüeh-sheng 王繹、思善、癡
 絕生
Wang Ju-chi 王汝濟
Wang Ling 王令
Wang Meng, Shu-ming, Huang-ho
 shan-ch'iao, Hsiang-kuang chü-
 shih 王蒙、叔明、黃鶴山樵、香光居
 士
Wang Mo (Hsia) 王默（墨）（洽）
Wang Shen, Chin-ch'ing 王詵、晉卿
Wang Shih-yüan 王士元
Wang Ting 王定
Wang T'ing-yün, Tzu-tuan, Huang-
 hua shan-jen 王庭筠、子端、黃華山
 人
Wang Tsai 王宰
Wang Wan-ch'ing, Hsi-po, Tan-yu 王
 萬慶、禧伯、澹游
Wang Wei (415–443), Ching-hsüan 王
 微、景玄
Wang Wei (701–761), Mo-chieh 王維、
 摩詰
Wang Yen-shou, Wen-k'ao, Tzu-
 shan 王延壽、文考、子山
Wei-chen 惟真
Wei-ch'ih I-seng 尉遲乙僧
Wei-ch'ih Po-chih-na 尉遲跋質那
Wei-Chin sheng-liu hua tsan 魏晉勝流畫贊
Wei Fu-jen 衛夫人
Wei Hsiang 衛象
Wei Hsieh 衛協
Wei Hsien 衛賢
Wei Hung 衛宏
Wei Hung-chi 韋弘機
Wei Kao 韋皋
(Wei) Ming-ti 魏明帝
Wei shu 魏書
Wei Tan 韋誕

Wei Wu-t'ien 韋无忝
Wei Yen 韋偃
Wen fu 文賦
Wen-hsin tiao-lung 文心雕龍
Wen-hsüan 文選
Wen T'ung, Yü-k'o, Hsiao-hsiao hsien-sheng, Chin-chiang tao-jen, Shih-shih hsien-sheng 文同、與可、笑笑先生、錦江道人、石室先生
Wen Yen-po 文彥博
Weng-yu hsien-p'ing 甕牖閒評
Wu Chen, Chung-kuei, Mei-hua tao-jen 吳鎮、仲圭、梅花道人
Wu Chien 吳暕
Wu Chung-fu 吳中復
Wu Ch'ung 吳充
Wu Huai (Chin) 吳懷（淮、進）
Wu Jung 吳融
Wu shu 吳書
Wu-tai ming-hua pu-i 五代名畫補遺
Wu T'ai-su, Hsiu-chang, Sung-chai 吳太素、秀章、松齋
Wu Tao-tzu (-hsüan) 吳道子（玄）
Wu Tse 吳澤
Wu Tsung-yüan (-tao), Tsung-chih 武宗元（道）、總之
Wu Yü 吳育

Yang Ch'i-tan 楊契丹
Yang Chu 楊朱
Yang-hsing shu 養性書
Yang Hsiung 楊雄
Yang Hui-chih 楊惠之

Yang Kuei-fei 楊貴妃
Yang Tzu-hua 楊子華
Yang Wei-chen, Lien-fu, T'ieh-yai 楊維真、廉夫、鐵崖
Yang Wu-chiu, Pu-chih, T'ao-ch'an lao-jen, Ch'ing-i chang-che 楊无咎、補之、逃禪老人、清夷長者
Yang Yen, Kung-nan 楊炎、公南
Yang Yen 楊琰
Yao 堯
Yao Tsui, Shih-hui 姚最、士會
Yen Chen-ch'ing, Ch'ing-chen 顏真卿、清臣
Yen Chih-t'ui 顏之推
Yen Li-pen 閻立本
Yen (Jang) Li-te 閻（讓）立德
Yen-shih chia-hsün 顏氏家訓
Yen Shih-ch'i 嚴世期
Yen Shih-ku 顏師古
Yen Su, Mu-chih 燕肅、穆之
Yen-ts'ung 彥悰
Yen Yen-chih, Yen-nien 顏延之、延年
Yin Chung-k'an 殷仲堪
Yü 禹
Yü-chi 虞姬
Yü Shih-nan, Po-shih 虞世南、伯施
Yüan An 袁安
Yüan Ch'ien 袁蒨
Yüan Chih 袁質
Yüan shih 元史
Yüan Wen, Chih-fu 袁文、質甫
Yüeh ching 樂經
Yün-yen kuo-yen lu 雲烟過眼錄

Bibliography

A. Collections of Texts on Painting

Chung-kuo hua-lun lei-pien (Chinese Painting Theory by Categories) 中國畫論類編.
Ed. Yü Chien-hua 俞劍華. 2 vols. Peking: Chung-kuo ku-tien i-shu, 1957.

Hua-lun ts'ung-k'an (Collected Reprints on Painting Theory) 畫論叢刊. Ed. Yü An-
lan 于安瀾. 2 vols. Peking: Jen-min mei-shu, 1962.

Hua-shih ts'ung-shu (Collected Works on Painting History) 畫史叢書. Ed. Yü An-
lan. 10 vols. Shanghai: Jen-min mei-shu, 1962.

Mei-shu ts'ung-k'an (Collected Reprints on Fine Arts) 美術叢刊. Comp. Yü Chün-
chih 虞君質. 4 vols. Taipei: Chung-hua ts'ung-shu wei-yüan hui, 1956–1965.

Mei-shu ts'ung-shu (Collected Works on Fine Arts) 美術叢書. Comp. Huang Pin-
hung 黃賓虹 and Teng Shih 鄧實. 4 series, 160 vols. Shanghai: Shen-chou kuo-
kuang she, 1911–1936. Revised edition Shanghai, 1947. Reprint in enlarged edi-
tion Taipei: I-wen, 1963, 1975.

P'ei-wen-chai shu-hua p'u (Encyclopedia on Calligraphy and Painting Commissioned
by the K'ang-hsi Emperor) 佩文齋書畫譜. Comp. Sun Yüeh-pan 孫岳頒, circa
1708. 100 books (*chüan*). Reprint Shanghai: Shao-yeh shan-fang, 1919.

Wang-shih shu-hua yüan (Master Wang's Selection on Calligraphy and Painting) 王
氏書畫苑. Comp. Wang Shih-chen 王世貞. 28 vols. 4 vol. addendum. Comp.
Chan Ching-feng 詹景鳳. 2nd wood block ed. Huai-nan shu-yüan, 1590.
Reprint Shanghai, 1922.

B. Texts Translated

Arranged chronologically, annotated, and with reference to editions currently
available (Bibliography A referred to in abbreviations), as well as to published
translations consulted.

Lun-yü 論語 (Confucian Analects). 20 bks. A record of Confucius's activities and
conversations compiled by his disciples. See J. Legge, tr., *The Chinese Classics,*
vol. 1, 1960 reprint, Bibliography C.

I ching 易經 (Book of Changes). 10 bks. A text on divination with interpretations of

the 3rd to 1st century B.C. See R. Wilhelm, tr., *I Ching*, 1976 reprint, Bibliography C.

Tao-te ching 道德經 (Book of the Tao). 2 bks. The philosophical text forming the chief canonical work of Taoism. See J. J. Duyvendak, tr., *Tao-te ching*, 1954. Bibliography C.

Chuang-tzu 莊子 (4th-3rd century B.C.). 10 bks. Essays by the Taoist philosopher, his disciples, and imitators. See H. A. Giles, tr., *Chuang-tzu*, 1961 reprint. Bibliography C.

Han Fei-tzu 韓非子 (ca. 280-233 B.C.). 20 bks. A compilation of writings attributed to the Legalist philosopher by later followers. See Burton Watson, tr., *Han Fei-tzu*, 1964. Bibliography C.

Huai-nan-tzu 淮南子, compiled at the court of Liu An 劉安, the Prince of Huai-nan (d. 122 B.C.). 21 sections. A syncretic text with elements of Confucianism and Taoism predominating, but also including aspects of Legalism and the *yin-yang wu-hsing* school. Taipei: Chung-kuo tzu-hsüeh ming-chu chi-ch'eng pien-yin chi-ching hui, 1977.

Wang Ch'ung 王充 (A.D. 27-97?), *Lun-heng* 論衡. 30 bks. A philosophical work examining ideas and beliefs of the past. See Alfred Forke, tr., *Philosophical Essays of Wang Ch'ung*, 1962 reprint. Bibliography C.

Ts'ao Chih 曹植 (193-232), quoted in the *Li-tai ming-hua chi*. See the introduction to chapter 1.

Lu Chi 陸機 (261-303), quoted in the *Li-tai ming-hua chi*. See the introduction to chapter 1.

Wang I 王廙 (264-322), quoted in the *Li-tai ming-hua chi*. See the introduction to chapter 1.

Ku K'ai-chih 顧愷之 (ca. 345-ca. 406), *Lun-hua* 論畫 (Essay on Painting), quoted in the *Li-tai ming-hua chi*. Fragments of an essay on painting techniques, dealing mainly with figural or narrative subjects; possibly confused and mixed in transmission with another text attributed to the same author, the *Wei-Chin sheng-liu hua-tsan* 魏晉勝流畫讚 (Eulogies on Famous Paintings of the Wei and Chin Dynasties); the original essay was supposedly on copying only. Yü Chien-hua 俞劍華 and Lo Shu-tzu 羅尗子, et al., eds. *Ku K'ai-chih yen-chiu tzu-liao*. Peking: Jen-min mei-shu, 1962. Bibliography E. See Alexander Soper, "Some Technical Terms," 1948 article, in Bibliography D, for some translations.

———*Hua Yün-t'ai-shan chi* 畫雲臺山記 (Record on Painting the Cloud Terrace Mountain), quoted in the *Li-tai ming-hua chi*. See Michael Sullivan, *The Birth of Landscape painting in China*, in Bibliography E for translation and discussion.

Tsung Ping 宗炳 (373-443), *Hua shan-shui hsü* 畫山水序 (Introduction to Painting Landscape), quoted in the *Li-tai ming-hua chi*. See Leon Hurvitz, "Tsung Ping's Comments on Landscape Painting," 1970 article, in Bibliography C for translation and comments. Compare with the translation and commentary given in Bush, "Tsung Ping's Essay on Painting Landscape," 1983 essay, in Bibliography D.

Wang Wei 王微 (415-443), *Hsü hua* 叙畫 (Discussion of Painting), quoted in the *Li-tai ming-hua chi*. See Michael Sullivan, *The Birth of Landscape Painting*, in Bibliography E for translation and discussion.

Hsieh Ho 謝赫 (active ca. 500–535?), (*Ku*) *hua-p'in* (-*lu*) 古畫品錄 (Classification of Painters), quoted in the *Li-tai ming-hua chi*. Its earliest known independent version in one book appears in a collection printed in the Ming Dynasty's Chia-ching reign (1522–1567). Early references to the text cite it as the *Hua-p'in* only; the Sung dynastic history names a *Ku-chin* 古今 *hua-p'in*; its present title was already recorded in the 3rd quarter of the 12th century. Wang Po-min 王伯敏 ed. *Ku hua-p'in lu; Hsü hua-p'in*. Peking: Jen-min mei-shu, 1959. See E. Zürcher, "Recent Studies on Chinese painting," in Bibliography D for the dating of its writing to the second quarter of the 6th century.

Yen Chih-t'ui 顏之退 (531–after 591), *Yen-shih chia-hsün* 顏氏家訓 (Family Instruction for the Yen Clan). For the relevant excerpt, see *CKHLLP*, p. 15. See Teng Ssu-yü, tr., *Family Instruction,* 1968. Bibliography C.

Yao Tsui 姚最 (535–602), *Hsü hua-p'in* 續畫品 (Continuation of the Classification of Painters), quoted in the *Li-tai ming-hua chi*. Its earliest independent version in one book appears also in the Chia-ching collection. References to it also give the titles *Hsü hua-p'in lu* or the *Hou* 後 *hua-p'in lu*. Now in one book, its preface indicates that two books were originally intended. It includes discussions of twenty painters from 501 to 552, arranged chronologically, since its author had some doubts about Hsieh Ho's system of classification, although he intended his work as a sequel to Hsieh's. Wang Po-min, ed., *Hsü hua-p'in* (see above, published with *KHPL*), Peking, 1959. See E. Zürcher, "Recent Studies," in Bibliography D for dating of the work.

P'ei Hsiao-yüan 裴孝源 (active ca. 627–660), *Chen-kuan kung-ssu hua-lu* 貞觀公私畫錄 (Record of Paintings in Public and Private Collections in the 627–650 Chen-kuan Era), quoted in the *Li-tai ming-hua chi*. Preface dated to 639 when the author was Grand Secretary at Court. Chang Yen-yüan also quoted from another text by the same author variously known as the *Hua-p'in lu* or *Hou hua-p'in*, now otherwise lost. Citations tend to confuse the two works. See E. Zürcher, "Recent Studies," in Bibliography D for discussion of the two.

Yen-ts'ung 彥悰 (active ca. 650), *Hou hua-lu* 後畫錄 (Later Record of Painting), quoted in the *Li-tai ming-hua chi*. Preface dated to 635; its author identified as a Buddhist monk. Two monks of similar name are known, a Yen-ts'ung 彥琮 (557–610) who catalogued *sūtras* at Lo-yang and another of the same name who was active in Ch'ang-an around 649–660. Doubts have been cast on the authenticity of the independent version, but arguments can be made that it derives from another work by Yen-ts'ung, cited as the *Hua-p'ing* 畫評 by the *Hsüan-ho hua-p'u*. See P. Pelliot, "Les Fresques de Touen-Houang," in Bibliography D, for the discussion in Appendix 2.

Li Ssu-chen 李嗣貞 (d. 696), *Hua hou-p'in* 畫後品 (Later Classification of Painters), quoted in the *Li-tai ming-hua chi*. Referred to in a preface to the *Hou shu-p'in* 後書品 by the same author, of circa 690, as a *Hua-p'ing* 畫評 with classification of painters, including four in an *i-p'in* 逸品 (untrammeled class). This work was known in the 12th century as a sequel to Hsieh Ho's and Yao Tsui's texts. Additional quotations from it appear in Tseng Ts'ao 曾慥, *Lei shuo* 類説, bk. 58, and the *Kuang-ch'uan hua-pa*, bks. 1 & 3.

———*Hsü hua-p'in lu* 續畫品錄 Currently attributed to the same author, it may be

related to the *Hua-p'in lu* censured in the preface to the *T'ang-ch'ao ming-hua lu* as a mere list of names, and to the *Hua-jen-ming lu* 畫人名錄 and *Ku-chin* 古今 *hua-jen-ming* recorded in 13th century bibliographical studies. See E. Zürcher, ''Recent Studies,'' in Bibliography D for discussion.

Wang Wei 王維 (701–761), *Hua-hsüeh pi-chüeh* 畫學秘訣 (Secrets of the Study of Painting). 1 bk. in 3 parts. This title is not recorded in the Sung dynastic history, but the text's language is similar to that associated with the Southern Sung Academy of Painting. The text deals mainly with landscape painting. Included in the *WSSHY* and *PWCSHP*. Also Wang Shen-jan 王森然 ed., *Shan-shui chüeh; Shan-shui lun* 山水訣, 山水論. Peking: Jen-min mei-shu, 1959.

―――― *Shan-shui lun* 山水論 (Discussion of Landscape). 1 bk, Originally the third part of the previous title, it is often confused with Ching Hao's *Hua shan-shui fu* and the *Shan-shui chüeh* attributed to Li Ch'eng. Included in the *WSSHY* and the *PWCSHP*. Also Wang Shen-jan, *Shan-shui chüeh*.

Tou Meng 竇蒙 (8th century), *Hua shih-i lu* 畫拾遺錄 (Amended Record of Paintings), quoted in the *Li-tai ming-hua chi*. This was written in reaction to Yen-ts'ung's criticism in the *Hou hua-lu*. See E. Zürcher, ''Recent Studies,'' in Bibliography D for discussion.

Chang Huai-kuan 張懷瓘 (active ca. 713–741), *Hua-tuan* 畫斷 (Opinions on Painting), quoted in the *Li-tai ming-hua chi*. Like the author's work on calligraphy, the *Shu* 書 -tuan, in having a three-grade classification system. Also quoted in the *I-chou ming-hua lu* in the entry for Chao Te-hsüan 趙德玄. See E. Zürcher, ''Recent Studies,'' in Bibliography D for discussion.

Chu Ching-hsüan 朱景玄 (active ca. 806–840), *T'ang-ch'ao ming-hua lu* 唐朝名畫錄 (Record of Famous Painters of the T'ang Dynasty). 1 bk. Also known as the *T'ang hua-tuan* or *Hua-tuan* 畫斷 in various bibliographic sources but given the current title in the *T'u-hua chien-wen chih*. Has a four-grade classification system, including the *i-p'in*. Previously in 3 bks., combined into 1 by 1025. Included in the *MSTS*. Reprint Taipei: I-wen, 1963. See Alexander Soper, tr., ''*T'ang ch'ao ming hua lu,*'' 1958. Bibliography C.

Chang Yen-yüan 張彥遠 (ca. 815–?), *Li-tai ming-hua chi* 歷代名畫記 (Record of Famous Painters of All the Dynasties). 10 bks. Completed in 847, probably at the same time as a companion work on calligraphy, the *Fa-shu yao-lu* 法書要錄 (Essential Record of Calligraphy Exemplars). Yü Chien-hua 俞劍華, ed., *Li-tai ming-hua chi*, Shanghai: Jen-min mei-shu, 1963. See William Acker, tr., *Some T'ang and Pre-T'ang Texts*, 1954 & 1974, Bibliography C. Also E. Zürcher, ''Recent Studies,'' in Bibliography D for review.

Huang Hsiu-fu 黃休復, *I-chou ming-hua lu* 益州名畫錄 (A Record of the Famous Painters of I-chou). 3 bks. Preface by Li T'ien 李畋, dated to 1006. Also known as *Ch'eng-tu* 成都 *ming-hua lu*. Notes paintings seen in Szechwan from circa 871 to 967, including lost works, by fifty-eight painters placed in a four-grade classification including the *i-p'in*. The work is quoted by Han Cho in the *Shan-shui Ch'un-ch'üan chi*. Included in the *WSSHY* and *HSTS*. Also Ch'in Ling-yün 秦嶺雲 ed., *I-chou ming-hua lu*, Peking: Jen-min mei-shu, 1964.

Ching Hao 荊浩 (ca. 870–ca. 930), *Pi-fa chi* 筆法記 (A Note on the Art of the Brush). 1 bk. Early bibliographic references name a *Shan-shui chüeh* 山水訣 *pi-fa chi, Hua*

shan-shui lu 畫山水錄, or *Shan-shui shou pi-fa* 山水受筆法. The work was probably put together in the Northern Sung Dynasty, that is, in the 11th century, and was already known to painters if not literati of Hui-tsung's period (1101–1126). See Kiyohiko Munakata, tr. *Ching Hao's Pi-fa chi*, 1974. Bibliography C.

—— *Hua shan-shui fu* 畫山水賦 (Prose-Poem on Painting Landscape). 1 bk. An imitation of Wang Wei's *Shan-shui lun*. Included in the *WSSHY*.

Liu Tao-shun 劉道醇, *Sheng-ch'ao ming-hua p'ing* 聖朝名畫評 (Critique of Famous Painters of the Present Dynasty). 3 bks. One hundred twenty painters of the Northern Sung Dynasty, divided into six categories of subject matter and three classifications, each with three grades. Included in the *WSSHY* and *CKHLLP*. Another text is found in Wang Yün-wu 王雲五, ed., *Ssu-k'u chüan-shu chen-pen* 四庫全書珍本, 5th ser. (reprint; Taipei, 1977), vol. 203; also included in *MSTS*, 6th ser. (Taipei: I-wen, 1975).

—— *Wu-tai ming-hua pu-i* 五代名畫補遺 (A Supplement on the Famous Painters of the Five Dynasties). 1 bk. Preface by Ch'en Hsün-chih 陳洵直 of 1059. Includes twenty-four painters divided into seven categories of subject matter. Included in the *WSSHY* and *CKHLLP*. Another version of the text is found in the *SKCS* and in the *MSTS*, 6th ser. (see references in entry above).

Kuo Hsi 郭熙 (after 1000–ca. 1090), *Lin-chüan kao-chih (chi)* 林泉高致（集）(The Lofty Message of Forests and Streams). 1 bk. Written ca. 1080? Compiled by Kuo Hsi's son Ssu 思 (active ca. 1080–ca. 1125), ca. 1110–1117. On landscape and painting techniques in six sections: the second and fourth with Ssu's comments; the fifth and sixth added by Ssu and including a summary of his father's career in *Hua chi* 畫記 (Notes on Paintings). The first section, *Shan-shui hsün* 山水訓 (Advice on Landscape Painting), was already in print by 1110 under the title of *Shan-shui chüeh tsuan* 山水訣纂 (Compendium on the Secrets of Landscape Painting). Included in the *HSTS* and *MSTS*. Also Chang An-chih 張安治, ed., *Kuo Hsi*. Shanghai: Jen-min mei-shu, 1963. See Shio Sakanishi, tr., *An Essay on Landscape Painting*, 1959. Bibliography C. For the *SKCS* text with the sixth section (*Hua-chi*) and a postface dated to 1117, see *Kuo Hsi "Tsao-ch'un t'u"* 郭熙早春圖 (Taipei: National Palace Museum, 1978). Also see the articles by Pao Sung-nien and Ch'en Shao-feng and by Suzuki Kei in Bibliography D.

Kuo Jo-hsü 郭若虛, *T'u-hua chien-wen chih* 圖畫見聞志 (An Account of My Experiences in Painting). 6 bks. Completed ca. 1080 or earlier. Huang Miao-tzu 黃苗子, ed., *T'u-hua chien-wen chih*, Shanghai: Jen-min mei-shu, 1963. See Alexander Soper, tr., *Kuo Jo-hsü's Experiences in Painting*, 1951 (text included). Bibliography C.

Shen Kua (or K'uo) 沈括 (1031–1095), *Meng-ch'i pi-t'an* 夢溪筆談 (Casual Writings from the Garden of the Stream of Dreams). 26 bks. from original 30. Written between 1086 and 1093; the title refers to the garden of this scholar's retreat. The book covers seventeen subjects including archaeology and history, the arts, literature, science and technology. Hu Tao-ching 胡道靜, ed. (with annotation), *Hsin chiao-ch'eng* 新校正 *Meng-ch'i pi-t'an*, Peking: Chung-hua, 1959. 2 vols., 609 entries. See Donald Holzman article "Shen Kua and His *Meng-ch'i pi-t'an*," in Bibliography D.

Shan-shui sung-shih ko 山水松石格 (On the Categories of Landscape and Pines and

Rocks), formerly attributed to the Liang Emperor Yüan 元帝 (r. 552–554). 1 bk.
The Liang Emperor Yüan specialized in figure painting, and this title is first
recorded in the Sung dynastic history. Part of the text is quoted by Han Cho in
the *Shan-shui Ch'un-ch'üan chi*, but without identification of the title. A Sung at-
tribution for its authorship seems likely. Included in the *MSTS*.

Shan-shui chüeh 山水訣 (Secrets of Landscape), formerly attributed to Li Ch'eng 李成
(d. 967). 1 bk. Internal evidence belies attribution of this text to the famous land-
scape painter; the contents are similar to the *Hua shan shui chüeh* by Li Ch'eng-
sou. The present text's preface is a later addition to what is now considered an
anonymous work of the 11th century. Included in the *MSTS*.

Mi Fu 米芾 (1052–1107), *Hua-shih* 畫史 (Painting History). 1 bk. Preface indicates
completion around 1103. What remains to us of the original work is fragmentary
and disordered, with anecdotes about painters and notes on various aspects of
connoisseurship. Included in the *MSTS*. Reprint Taipei: I-wen, 1963. See N.
Vandier-Nicolas, tr., *Le Houa-che de Mi Fou*, 1964. Bibliography C.

Li Ch'ih 李廌 (1059–1109), *Hua-p'in* 畫品 (Evaluation of Painting). 1 bk. Also
called *Te-yü chai* 德隅齋 *hua-p'in* after the collector's study at Hsiang-yang in
Hupei province. Neither a classification nor an evaluation of the twenty-two
painters mentioned, but a catalogue of the collection of Chao Ling-chih 趙令畤
whose postscript follows. Probably written in 1098 when the author was an of-
ficial in Hsiang-yang. See Alexander Soper, tr., ''A Northern Sung Descriptive
catalogue,'' 1949. Bibliography C.

Huang Po-ssu 黃伯思 (1079–1118), *Tung-kuan yü-lun* 東觀餘論 (Further Discussions
from the Eastern Tower). 2 bks. Originally ten books (*chüan*), the present text
was compiled by the author's son Jen 祁 in 1147. It deals mainly with
calligraphy. Included in the *MSTS*.

Tung Yu 董逌, *Kuang-ch'uan hua-pa* 廣川畫跋 (Tung Yu's Colophons on Painting).
6 bks. A manuscript of this text, dated to 1365, had a note that a *Shu* 書 -pa (Col-
ophons of Calligraphy) had been printed earlier. The author was active in the
first quarter of the 12th century, and shared the enthusiams of Su Shih and
Huang Po-ssu. The colophons deal mainly with the subject matter of figural and
narrative paintings, and less with landscape painting and flowers and birds. The
best edition was included in the *Shih-yüan ts'ung-shu* 適園叢書 compiled by Chang
Chün-heng 張鈞衡. Hu-chou, 1916.

Hua-kuang mei-p'u 華光梅譜 (''Blossoming Light's'' Prunus Album), attributed to
either Chung-jen 仲仁 (active second half of 11th century), or Yang Wu-chiu 揚
無咎 (1096–1169). 1 bk. Chung-jen is recorded in Teng Ch'un's *Hua-chi* as living
on Hua-kuang Mountain; Yang Wu-chiu added and signed an essay at the end
of the text. It is now considered a forgery, possibly after Sung Po-jen's *Mei-hua
hsi-shen p'u*, but it had already been recorded in the Yüan Dynasty. Included in
the *MSTS*.

Hsüan-ho hua-p'u 宣和畫譜 (Catalogue of Paintings in the Hsüan-ho Collection). 20
bks. Preface, supposedly by the Sung Emperor Hui-tsung 徽宗 (r. 1101–1126),
dated to 1120. The text was probably composed by officials of his painting
academy about works in the imperial collection. Two hundred thirty-one
painters are recorded in ten sections on different genres of painting, with social

rankings within categories. Included in the *HSTS*. Also Yü Chien-hua, ed., *Hsüan-ho hua-p'u*, Peking: Jen-min mei-shu, 1964.

Han Cho 韓拙 (active ca. 1095–ca. 1125), *Shan-shui Ch'un-ch'üan chi* 山水純全集 (Ch'un-ch'üan's [Harmonious and Complete] Compilation on Landscape). 5 bk. Author's preface of 1121. Attitudes of Southern Sung Academy painting are prefigured. Included in the *HLTK* and *MSTS*. See Robert Maeda, tr., *Two Sung Texts*, 1978. Bibliography C.

Teng Ch'un 鄧椿, *Hua-chi* 畫繼 ("Painting" Continued). 10 bks. Preface dated to 1167. Conceived as a sequel to earlier histories of painting such as the *Li-tai ming-hua chi* and *T'u-hua chien-wen chih*, the text includes two hundred nineteen painters and paintings of the period circa. 1075–1167, arranged by divisions of social status and subject matter. Included in the *HSTS*. Also Huang Miao-tzu, ed., *Hua-chi* (with *HCPI*) in Peking: Jen-min mei-shu, 1963. See Robert Maeda, tr., (in part) *Two Sung Texts*, 1978. Bibliography C.

Li Ch'eng-sou 李澄叟 (b. ca. 1150), *Hua shan-shui chüeh* 畫山水訣 (Secrets of Painting Landscapes). 1 bk. Author's preface of 1221. May be source for the *Shan-shui chüeh*. Included in the *MSTS*.

Chao Hsi-ku 趙希鵠 (active ca. 1195–ca. 1242), *Tung-t'ien ch'ing-lu chi* 洞天清祿集 (Compilation of Pure Earnings in the Realm of Immortals). 1 bk. Quoted in the *Cho-keng lu* and *Ko-ku yao-lun*. On antiquities, scholars' apparatus, zithers, calligraphy, and painting. Included in the *MSTS*.

Chou Mi 周密 (1232–1308), *Yün-yen kuo-yen lu* 雲烟過眼錄 (Record of What Was Seen as Clouds and Mists). 4 bks. Additional book by T'ang Yün-mo 湯允謨. A catalogue of objects, calligraphy, and painting, organized by collections with notes on quality. Included in the *MSTS*. Reprint Taipei: I-wen, 1963.

Sung Po-jen 宋伯仁 (active ca. 1238–1261), *Mei-hua hsi-shen p'u* 梅花喜神譜 (Album of the Joyful Spirit of Plum Blossoms). 2 bks. Author's preface of circa 1238; a postscript dates a reprinting to 1261. Intended to include two hundred types of plum blossom painting, of which one hundred survive in extant text. Written in the form of five-word verse. Included in the *MSTS*.

Li K'an 李衎 (1245–1320), *Chu-p'u* 竹譜 (Manual of Bamboo). 7 bks. from 20 extant in the 1420s. Author's preface of 1299; prefaces by others dating up to twenty years later, included in *Chih-pu-tsu-chai ts'ung-shu* 知不足齋叢書, comp. Pao T'ing-po 鮑廷博, 1776 (1882 edition). The current version of *Chu-p'u* is taken from a printed edition of circa 1465-1487. Included in the *MSTS*. Also in Wang Yün-wu ed., *Ssu-k'u ch'üan-shu chen-pen pieh-chi* 四庫全書珍本別輯 (reprint Taipei, 1975), vols. 204–205.

Huang Kung-wang 黃公望 (1269–1354), *Hsieh shan-shui chüeh* 寫山水訣 (Secrets of Describing Landscape). 1 bk. Included in the *HLTK*. Also Ma Ts'ai 馬采, ed., *Hsieh shan-shui chüeh* (published with Jao Tzu-jan's *Hui-tsung shih-erh chi*). Peking: Jen-min mei-shu, 1959.

Chuang Su 莊肅, *Hua-chi pu-i* 畫繼補遺 (A Supplement to "*Painting*" *Continued*). 2 bks., Preface says completed in 1298. Continues history of painting from 1165 on, as a sequel to Teng Ch'un's *Hua-chi*, with which it has been published in Huang Miao-tzu, ed., *Hua-chi*. Peking: Jen-min mei-shu, 1963.

Wu Chen 吳鎮 (1280-1354), *Mei-tao-jen i-mo* 梅道人遺墨 (Ink Remains from the

Plum Taoist). 1 bk. Preface by countryman Ch'ien Fen 錢棻 in the Ming Dynasty. Written in colophon form. Included in the *MSTS*. Reprint Taipei: I-wen, 1963.

Jao Tzu-jan 饒自然 (active ca. 1340), *Hui-tsung shih-erh chi* 繪宗十二忌 (The Twelve Faults in Painting Tradition). 1 bk. On landscape painting technique. The *PWCSHP* attributes this title to anonymous Sung Dynasty authorship. Included in the *HLTK*. Also Teng I-chih 鄧以蟄, ed., *Hui-tsung shih-erh chi*, Peking: Jen-min mei-shu, 1959.

Wu T'ai-su 吳太素, *Sung-chai mei-p'u* 松齋梅譜 (Album of Plums from the Pine Studio). 15 bks. Known in a 15th-century manuscript copy in the Municipal Asano Library, Hiroshima, Japan (one of several copies in Japan). Referred to by Li E 勵鶚 (1692–1752) in *Nan Sung yüan-hua lu* 南宋院畫錄, as the *Hua-mei ch'üan-p'u* 畫梅全譜 (Complete Manual on Plum Blossom Painting). Probable date circa 1350. See Shimada Shūjiro, ''*Shosai baifu* teiyō,'' 1956 article in Bibliography D.

Wang I 王繹 (active ca. 1360), *Hsieh-hsiang pi-chüeh* 寫像秘訣 (Secrets of Portrait Painting). 1 bk. Quoted in T'ao Tsung-i's *Cho-keng lu*. Earlier texts on portrait painting are lost; this work is therefore a rare source. Included in the *HLTK* together with the *Ts'ai-hui lu* 采繪錄 (Record on Color Painting). See Herbert Franke, tr., ''Two Yüan Treatises,'' 1950. Bibliography C.

T'ao Tsung-i 陶宗儀 (active 1360–1368), *Cho-keng lu* (Notes of T'ao Tsung-i) 輟耕錄. 30 bks. First edition in 1366. Miscellaneous essays on law, current events, calligraphy, and painting; particularly important for its many quotations. See Centre Franco-Chinois d'Études sinologiques, *Index du Tcho Keng lou*, Taipei: Ch'eng-wen, 1968 reprint of Peking edition.

Hsia Wen-yen 夏文彥 (1296–1370), *T'u-hui pao-chien* 圖繪寶鑑 (Precious Mirror for Examining Painting). 5 bks. with an additional book and supplement by Han Ang 韓昂 in 1519. Preface of 1365. Compiled from earlier writings on paintings, with the addition of information on contemporary painters; arranged by dynasties but not chronologically within each. Included in the *HSTS*.

T'ang Hou 湯垕 (active ca. 1322–1329), *Ku-chin hua-chien* 古今畫鑑 (Criticism of Past and Present Painting). 1 bk. Completed by Chang Yü 張雨 (1277–after 1329). A random survey of painters from the Three Kingdoms period to the Yüan Dynasty. Included in the *MSTS*.

——— *Hua-lun* 畫論 (A Discussion of Painting). 1 bk. Twenty-three entries on miscellaneous matters of connoisseurship. Included in the *MSTS*. With *Ku-chin hua-chien* in Ma Ts'ai et al., eds. *Hua-chien*. Peking: Jen-min mei-shu, 1959.

Chang T'ui-kung 張退公, *Mo-chu chi* 墨竹記 (Record of Ink Bamboo). 1 bk. Written in the form of a prose poem. Included in the *MSTS*.

Ts'ao Chao 曹昭, *Ko-ku yao-lun* 格古要論 (Essential Information for the Judgment of Antiquities). 3 bks. in an early Ming Dynasty edition. Preface of 1387. 13 bks. as enlarged by Wang Tso 王佐 in 1462 edition. An ''art enchiridion.'' Shanghai: Shang-wu, 1940. See Sir Percival David, tr., *Chinese Connoisseurship*, 1971. Bibliography C.

C. Translations Consulted

An asterisk indicates more than a single text included.

*Acker, William. *Some T'ang and Pre-T'ang Texts on Chinese Painting.* 2 vols. Leiden: E. J. Brill, 1954 & 1974. Original texts included.

*Bush, Susan. *The Chinese Literati on Painting: Su Shih (1037–1101) to Tung Ch'i-ch'ang (1555–1636).* 2nd ed., Cambridge, Mass.: Harvard University Press, 1978. Original texts included.

Chen Shih-hsiang. *Essay on Literature.* Portland, Me.: Anthoensen, 1953.

——— *Biography of Ku K'ai-chih,* Chinese Dynastic Histories Translations, no. 2. Berkeley: University of California Press, 1961.

David, Sir Percival. *Chinese Connoisseurship: The Ko ku yao lun.* London: Faber, 1971. Original text included.

Duyvendak, J. J. L. *Tao-te ching.* 2nd rev. ed. London: John Murray, 1954.

Forke, Alfred. *Philosophical Essays of Wang Ch'ung.* Leipzig: Harrosowitz, 1911. Reprint of 2nd ed.; New York: Paragon, 1962.

Franke, Herbert. "Two Yüan Treatises on the Techniques of Portrait Painting," *Oriental Art,* n.s., 3 (1950), 27–32.

Giles, H. A. *Chuang-tzu.* Reprint of 1926 ed.; London: Allen & Unwin, 1961.

Graham, A. C. *The Book of Lieh Tzu.* London: John Murray, 1960.

*Gulik, Robert H. van. *Chinese Pictorial Art.* Rome: IsMEO, 1958.

Hawkes, David. *Ch'u tz'u: The Songs of the South.* Oxford: Oxford University Press, 1959.

Hurvitz, Leon. "Tsung Ping's Comments on Landscape Painting."*Artibus Asiae,* 32 (1970), 146–156

Legge, James. *The Chinese Classics.* 5 vols. Reprint of 1890s ed.; Hong Kong: Hong Kong University Press, 1960. Original texts included.

——— *The Sacred Books of China: The Texts of Confucianism, Pts. 3–4: The Li Ki.* The Sacred Books of the East. Vols. 27–28. Ed. F. Max Müller. Oxford: Clarendon Press, 1885.

——— *The Sacred Books of China: The Texts of Taoism.* The Sacred Books of the East. Vols. 39–40. Ed. F. Max Müller. Reprint of 1891 ed.; New York: Dover, 1962.

*Lin Yu-tang. *The Chinese Theory of Art: Translations from the Masters of Chinese Art.* New York: Putnam, 1967.

*Maeda, Robert J. *Two Twelfth-Century Texts on Chinese Painting.* Michigan Papers in Chinese Studies, no. 8. Ann Arbor: University of Michigan Press, 1973.

——— *Two Sung Texts on Chinese Painting and The Landscape Styles of the 11th and 12th Centuries.* New York: Garland, 1978. Original texts included.

Munakata, Kiyohiko. *Ching Hao's Pi-fa chi: A Note on the Art of the Brush.* Ascona: Artibus Asiae, 1974.

*Sakanishi, Shio. *The Spirit of the Brush.* 4th ed. London: John Murray, 1957.

——— *Lin ch'üan kao chih. An Essay on Landscape Painting.* London: John Murray, 1959.

Shih, Vincent Yu-cheng. *The Literary Mind and the Carving of Dragons by Liu Hsieh.* New York: Columbia University Press, 1959.

*Sirén, Osvald. *The Chinese on the Art of Painting.* Reprint of 1936 (2nd) ed.; Hong

Kong: Hong Kong University Press, 1963.

Soper, Alexander. "A Northern Sung Descriptive Catalogue of Paintings (The *Hua P'in* of Li Ch'ih)." *Journal of the American Oriental Society*, 69 (1949), 18–33.

———— *Kuo Jo-hsü's Experiences in Painting (T'u-hua chien-wen chih): An Eleventh Century History of Chinese Painting*. Washington, D.C.: American Council of Learned Societies, 1951. Original text included.

———— "*T'ang ch'ao ming hua lu*: Celebrated Painters of the T'ang Dynasty by Chu Ching-hsüan of T'ang." *Artibus Asiae*, 31 (1958), 204–230.

Teng Ssu-yü. *Family Instructions for the Yen Clan: Yen-shih chia-hsün*. Leiden: E. J. Brill, 1968.

Vandier-Nicolas, Nicole. *Le Houa-che de Mi Fou (1051–1107)*. Paris: Presses universitaires de France, 1964.

*Waley, Arthur. *Introduction to the Study of Chinese Painting*. London: Ernest Benn, 1923.

Watson, Burton. *Records of the Grand Historian of China*. Translated from the *Shih chi* of Ssu-ma Ch'ien. 2 vols. Columbia University Department of History, Records of Civilization: Sources and Studies, no. 65. New York: Columbia University Press, 1961.

———— *Han Fei-tzu*. UNESCO Collection of Representative Writings: Chinese Series. New York: Columbia University, Press, 1964.

Wilhelm, Richard. *I Ching*. Bollingen Series 19. Reprint from 1950 ed.; Princeton: Princeton University Press, 1976. Original text included.

D. *Articles Consulted*

Aoki Takashi 青木喬. "Bokuchikuga shikō: Bun Dō chikuha o chūshin to shite 墨竹 畫史攷（文同竹派を中心として）." *Ritsumeikan bungaku* 立命館文學 (1960), 995– 1009.

Balfour, S. F. "Fragments from a Gallery of Chinese Women." *T'ien-hsia*, 10 (1940), 625–683.

Barnhart, Richard M. "Wei Fu-jen's *Pi-chen T'u* and the Early Texts on Calligraphy." *Archives of the Chinese Art Society of America*, 18 (1964), 13–25.

Bush, Susan. " 'Clearing after Snow in the Min Mountains' and Chin Landscape Painting." *Oriental Art*, n.s., 11 (1965), 163–172.

———— "Tsung Ping's Essay on Painting Landscape and the 'Landscape Buddhism' of Mount Lu." *Theories of the Arts in China*, ed. Susan Bush and Christian Murck. Princeton: Princeton University Press, 1983. pp. 132–163.

Cahill, James. "The Six Laws and How to Read Them," *Ars Orientalis*, 4 (1961), 372–381.

———— "Confucian Elements in the Theory of Painting." *The Confucian Persuasion*. Ed. Arthur Wright. Stanford: Stanford University Press, 1966. Pp. 115–140.

Chuang Shen 莊申. "Problems of the Author and Title of the *Hou-hua-lu*." *Bulletin of the Institute of History and Philology, Academia Sinica*, 37 (1967), 779–791.

Coomaraswamy, Ananda K. "The Theory of Art in Asia." *The Transformation of Nature in Art*. Cambridge, Mass.: Harvard University Press, 1934. Pp. 33–63.

Dōtani Kenyū 堂谷憲勇. "Rekidai meiga ki ronkō 歴代名畫記論考." *Shina bijutsu*

shiron 支那美術史論. Kyoto: Somei bunsei dō, 1944. Pp. 261–282.

Fong Wen. "*Ch'i-yün-sheng-tung*: 'Vitality, Harmonious Manner and Aliveness.'" *Oriental Art*, n.s., 12 (1966), 159–164.

Gibbs, Donald A. "Notes on the Wind: The Term 'Feng' in Chinese Literary Criticism." *Transition and Permanence: Chinese History and Culture*. Ed. David Buxbaum and F. Mote. Hong Kong: Cathay, 1972. pp. 285–293.

Hay, John. "The Human Body as a Microcosmic Source of Macrocosmic Values in Calligraphy." *Theories of the Arts in China*. Ed. Susan Bush and Christian Murck. Princeton: Princeton University Press, 1983. pp. 74–102

Hightower, J. R. "The Wen Hsüan and Genre Theory." *Harvard Journal of Asiatic Studies*, 20 (1957), 512–533.

Ho Wai-kam. "Li Ch'eng and Some Guiding Principles in Northern Sung Landscape Painting." Paper delivered at the Cleveland Symposium on Chinese Painting in March 1981.

Holzman, Donald. "Shen Kua and His *Meng-ch'i pi-t'an*." *T'oung Pao*, 46 (1958), 260–292.

Karlgren, Bernard. "Legends and Cults in Ancient China." *Bulletin of the Museum of Far Eastern Antiquities*, 18 (1946), 199–365.

Kawakami Kei 川上涇. "The Technical Art Terms of the 'Six Canons' of Hsieh Ho Translated into European Languages" (in Japanese with English excerpts). *Bijutsu kenkyū* 美術研究, 165 (1952), 155–170.

Kishida Tsutomi 岸田勉. "Bei Genshō ronkō 米元章論考." *Shigematsu sensei koki kinen Kyūshū daigaku Toyōshi ronso* 重松先生古稀記念九州大學東洋史論叢. Fukuoka: Kyushu University, 1957. Pp. 141–165.

Knoerle, M. G. "The Poetic Theories of Lu Chi." *Journal of Aesthetics and Art Criticism*, 25 (1966–1967), 137–143.

Kuo Shao-yü 郭紹虞. "Wen-ch'i te pien-hsi" 文氣的辨析, *Hsiao-shuo yüeh-pao* 小説月報, 20 (1929), 43–46.

Ledderose, Lothar. "Subject Matter in Early Chinese Painting Criticism." *Oriental Art, n.s.,* 19 (1973), 69–83.

Lee, Joseph J. "Tu Fu's Art Criticism and Han Kan's Horse Painting." *Journal of the American Oriental Society*, 90 (1970), 449–461.

Liebenthal, Walter. "The Immortality of the Soul in Chinese Thought." *Monumenta Nipponica*, 8 (1952), 378–394, (*Ming Fo lun* excerpt).

Lippe, Aschwin. "Li K'an und seine 'Ausführliche Beschreibung des Bambus'." *Ostasiatische Zeitschrift*, n.f., 18 (1942–1943), 1–35, 83–114, 166–184.

Loehr, Max. "Chinese Landscape Painting and Its Real Content." *Rice University Studies*, 59 (1973), 67–96.

Mitamura Taisuke 三田村泰助. "Godai Sōsho no sansuiga no imisuru mono 五代宋初の山水畫の意味するもの." *Ritsumeikan bungaku* 立命館文學 (1960), 783–812.

Naitō Torajirō 内藤虎次郎. "Tō izen no garon 唐以前の畫論." *Kokka* 國華, 141 (1901), 143–147.

Needham, Joseph. "Human Laws and Laws of Nature in China and the West." *Journal of the History of Ideas*, 12 (1951), 3–30, 194–230.

Pao Sung-nien 薄松年 and Ch'en Shao-feng 陳少丰. "T'u *Lin-ch'üan kao-chih*: *Hua-chi* cha-chi 讀《林泉高致·画記》札記," *Mei-shu yen-ch'iu* 美術研究 (1979) no. 3,

pp. 66–71.

—— "Kuo Hsi fu-tzu yü *Lin-ch'üan kao-chih* 郭熙父子与《林泉高致》" *Mei-shu yen-chiu* (1982) no. 4, pp. 62–69.

Pelliot, Paul. "Les Fresques de Touen-Houang et les fresques de M. Eumor-fopoulos," *Revue des Arts Asiatiques*, 5 (1928), 205–214.

Pollard, David E. "*Ch'i* in Chinese Literary Theory." *Chinese Approaches to Literature from Confucius to Liang Ch'i-ch'ao*. Ed. Adele Austin Rickett. Princeton: Princeton University Press, 1978. Pp. 43–66.

Rudolph, Richard C. "Kuo Pi, a Yüan Artist and His Diary." *Ars Orientalis*, 3 (1959), 175–188.

—— "Postscript to a Yüan Artist's Diary." *Ars Orientalis*, 4 (1961), 381–383.

Shek, Johnny. "A Study of Ku K'ai-chih's Hua Yün T'ai Shan Chi." *Oriental Art*, n.s., 18 (1972), 381–348.

Shimada, Shūjiro 島田修二郎. "Hakō Chūjin no shō 花光仲仁の序." *Hōun* 寳雲, 25 (1939), pp. 21–34.

—— "*Shōsai baifu* teiyō 松齋梅譜提要." *Bunka* 文化, 20 (1956), 96–118.

—— "Ri Shishin no garonsho 李嗣貞の畫論書." *Kanda hakushi kanreki kinen shoshigaku ronshu* 神田博士還暦紀念書誌學論. Kyoto: Kyoto University, 1957. Pp. 381–396.

Soper, Alexander. "Early Chinese Landscape Painting." *Art Bulletin*, 23 (1941), 141–164.

—— "Life Motion and the Sense of Space in Early Chinese Representational Art." *Art Bulletin*, 30 (1948), 167–186.

—— "Some Technical Terms in the Early Literature of Chinese Painting." *Harvard Journal of Asiatic Studies*, 11 (1948), 167–186.

—— "The First Two Laws of Hsieh Ho." *The Far Eastern Quarterly*, 8 (1949), 412–423.

—— "Standards of Quality in Northern Sung Painting." *Archives of the Chinese Art Society of America*, 11 (1957), 8–15.

—— "South Chinese Influence on the Buddhist Art of the Six Dynasties Period." *Bulletin of the Museum of Far Eastern Antiquities*, 32 (1960), 50–80.

Suzuki Kei 鈴木敬. "*Rinsen kōchi shu* no *Gaki* no *Gaki* to Kaku Ki ni tsuite 『林泉高致集』の「画記」と郭熙について" (English summary). *Bijutsushi* 美術史, 30 (1981), 1–11.

Taki Seiichi 瀧清一. "The 'Ku-hua-p'in lu' and the 'Hsü hua-p'in' " (in Japanese with English summary). *Kokka* 國華, 338 (1918), 3–7.

—— "On Books of Theoretical and Historical Studies of Painting Published in the T'ang Dynasty" (in Japanese with English summary). *Kokka* 國華, 394, 396, & 397 (1923), 304–310, 343–347, 379–383.

Tanaka Toyozō 田中豊藏. "*Rekidai meiga ki, Senwa gafu* no koto domo 歷代名畫記宣和畫譜の事ども." *Chūgoku bijutsu no kenkyū* 中國美術の研究. Tokyo: Nigen sha, 1964. Pp. 145–153.

Zürcher, Erik. "Recent Studies on Chinese Painting, I." *T'oung Pao*, 51 (1964), 377–422.

E. *Books Consulted*

Cahill, James. *Hills Beyond a River*: *Chinese Painting of the Yüan Dynasty, 1279–1368*. Tokyo and New York: Weatherhill, 1976.

———*An Index of Early Chinese Painters and Paintings*: *T'ang, Sung, and Yüan*. Berkeley: University of California Press, 1980.

Chang Kuang-pin 張光賓. *Yüan ssu ta chia* 元四大家 (The Four Great Masters of the Yüan) (English summary). Taipei: National Palace Museum, 1975.

Ch'ien Chung-shu 錢鍾書. *Kuan-chui pien* (Collected Reading Notes) 管錐編. 4 vols. Peking: Chung-hua, 1979.

Chou K'ang-hsieh 周康燮, ed. *Chung-kuo shu-hua lun-chi* 中國書畫論集 (Collected Essays on Chinese Calligraphy and Painting). Hong Kong: Chung-wen, 1971.

Chung Hung 鍾嶸 (active ca. 502–509). *Shih-p'in* 詩品 (Classification of Poets). Shanghai: Shang-wu, 1936.

Davidson, Martha. *A List of Published Translations from Chinese*. 2 vols. New Haven: Far Eastern Publications, 1957.

de Bary, Theodore, et al. *Sources of Chinese Tradition*. New York: Columbia University Press, 1960.

DeWoskin, Kenneth J. *A Song for One or Two*: *Music and the Concept of Art in China*. Michigan Papers in Chinese Studies, no. 42. Ann Arbor: University of Michigan, 1982.

Ecke, Tseng Yu-ho. *Chinese Calligraphy*. [Philadelphia:] Philadelphia Museum of Art, 1971.

——— "Emperor Hui-tsung, the Artist: 1082–1136." Ph.D. Diss., New York University, 1972.

[*Erh-shih-ssu shih* (Dynastic Histories) 二十四史.] Published separately in annotated editions. Peking: Chung-hua, 1959–.

Feng Yu-lan. *A History of Chinese Philosophy*. Tr. Derk Bodde. 2nd ed. 2 vols. Princeton: Princeton University Press, 1953.

Franke, Herbert, ed. *Sung Biographies* (I). Münchener ostasiatische Studien, Band 16; *Sung Biographies*: *Painters* (II). Münchener ostasiatische Studien, Band 17. Wiesbaden, 1976.

Giles, Herbert, ed. *A Chinese Biographical Dictionary*. Cambridge, Eng., 1898. Taipei reprint, n.d.

Goodrich, L. Carrington, ed. *Dictionary of Ming Biography*. 2 vols. New York: Columbia University Press, 1976.

Ho Wai-kam et al. *Eight Dynasties of Chinese Painting*: *The Collections of the Nelson Gallery-Atkins Museum, Kansas City, and The Cleveland Museum of Art*. [Cleveland:] The Cleveland Museum of Art, 1980.

Hoar, William John. "Wang Mien and the Confucian Factor in Chinese Plum Painting." Ph.D. Diss., University of Iowa, 1983.

Hughes, E. R. *Two Chinese Poets*. Princeton: Princeton University Press, 1960.

Hung, William. *Tu Fu*: *China's Greatest Poet*. 2 vols. Cambridge, Mass.: Harvard University Press, 1952.

Kao, Arthur Mu-sen. "The Life and Art of Li K'an." Ph.D. Diss. University of Kansas, 1979.

T'ang Sung hua-chia jen-ming tz'u-tien (Biographical Dictionary of T'ang and Sung Painters) 唐宋畫家人名辭典. Comp. Chu Chu-yü and Li Shih-sun 李石孫. Peking: Chung-kuo ku-tien i-shu, 1958.

Yüan-jen chuan-chi tzu-liao so-yin (Index to Biographical Materials of Yüan Figures) 元人傳記資料索引. Comp. Wang Te-i 王德毅. 5 vols. Taipei: Hsin-wen feng, 1979–1982.

Index

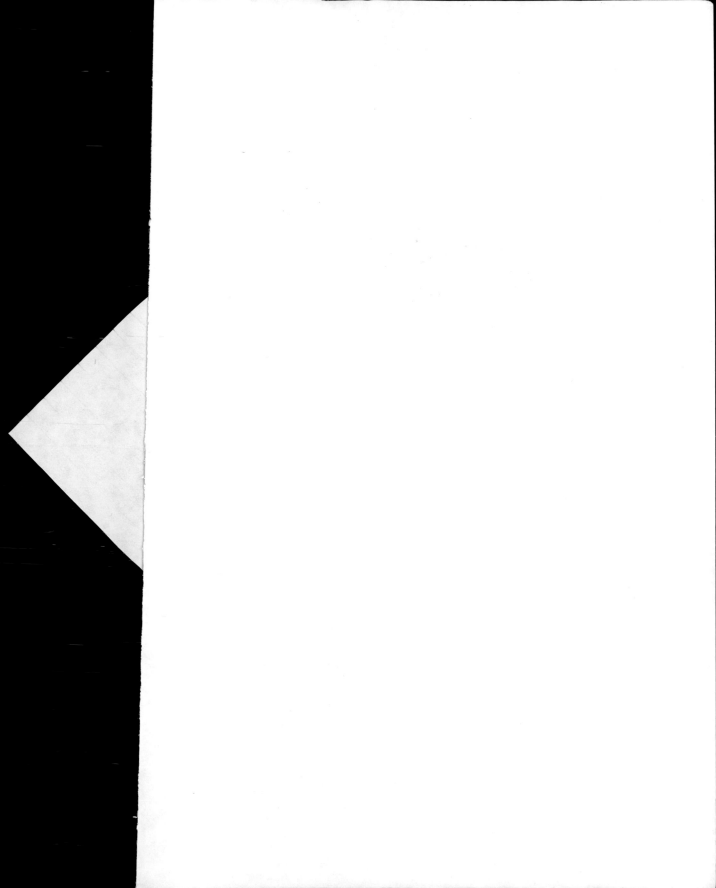

DATE DUE

DEMCO 38-297